COVER ILLUSTRATIONS

Front: Veronese *Venus and Adonis*, detail (Museo del Prado, Madrid)
Back: Titian *Portrait of Ranuccio Farnese as a Knight of Malta*
(National Gallery of Art, Washington)

THE EXHIBITION IS SPONSORED BY

THE SEA CONTAINERS GROUP

AND VENICE SIMPLON-ORIENT-EXPRESS LTD

Banking facilities have been provided by
Banca Nazionale del Lavoro
and assistance with transport costs has been received from
Alitalia
British Airways

We are grateful to Her Majesty's Government
for its help in agreeing to indemnify this exhibition
under the National Heritage Act 1980.

THE GENIUS OF
VENICE
1500-1600

EDITED BY JANE MARTINEAU
AND CHARLES HOPE

ROYAL ACADEMY OF ARTS LONDON 1983
Catalogue published in association with
WEIDENFELD AND NICOLSON LONDON

George Weidenfeld and Nicolson Limited
91 Clapham High Street, London SW4 7TA
ISBN 0 297 78322 X (casebound)
0 297 78323 8 (paperback)
Set in Monophoto Poliphilus, Blado and Sabon and printed by
BAS Printers Limited, Over Wallop, Hampshire
Colour separations by Newsele Litho Limited, Italy
Colour printed in Italy by Printers Srl for L.E.G.O., Vicenza

CONTENTS

PATRONS AND COMMITTEES

Her Majesty The Queen

Il Presidente della Repubblica Italiana,
Sandro Pertini

SPONSOR'S PREFACE

The Sea Containers Group and its member company,
Venice Simplon-Orient-Express Ltd., are honoured to be
sponsors of the Genius of Venice exhibition. Our
connections with Italy include ownership of the Hotel
Cipriani in Venice, and, as Sir Hugh Casson said at the
press conference for the exhibition, we own a Michelangelo
– the Villa San Michele in Fiesole (Florence) which has a
Michelangelo façade. Our Venice Simplon-Orient-Express
train to Venice and Florence has stimulated tourism from
Britain and other countries to Venice and perhaps indirectly
created new interest in the art of the Veneto, particularly in
painting and sculpture of the sixteenth century – the
region's greatest period for such art forms. We're told that
the exhibition is the most important display of Italian art
outside Italy for more than 50 years and the most important
such display of Venetian art ever. No wonder we're pleased
to be associated with such an important event! We hope
that you, once having seen the exhibition, share our
enthusiasm and give full marks to the Royal Academy for
having mounted such a tour de force, and we hope as well
one day to welcome you aboard our train or to one of our
hotels.

JAMES B. SHERWOOD
President, The Sea Containers Group

FOREWORD

The Genius of Venice (1500-1600) is an ambitious exhibition – a scholarly and magnificent survey of Venetian painting and its sister arts: sculpture, drawing and print-making, at the time of their greatest and most profoundly influential achievements during the sixteenth century. If for many people Giorgione, Titian, Tintoretto and Veronese are amongst the greatest of all painters, it is in part due to the genius of the city in which they lived and worked. Venice was the centre of a great commercial empire situated between East and West, possessing a model constitution to which other states looked with envy and admiration. Its unique, extravagant beauty stimulated artists to adopt an entirely original approach to painting.

'The Venetian mind, and Titian's especially as the central type of it, was wholly realist, universal and manly', wrote Ruskin in *Modern Painters*. He was speaking of the sixteenth century when many European artists were succumbing to the more effete influence of Roman and Florentine mannerism. While this influence did not leave Venice totally untouched, the Venetians' original way of handling paint, and especially their use of colour was to leave an indelible mark on all subsequent European painting.

The field covered by this exhibition quite properly extends beyond Venice itself into its hinterland, the *terraferma* which was under Venetian rule, since one of the exhibition's fundamental purposes is to demonstrate the close and mutually enriching interrelationship in the arts between Venice and its mainland empire. Thus great artists like Jacopo Bassano, whose work so perfectly reflects the countryside around the provincial town of Bassano, as well as Lorenzo Lotto, Bernard Berenson's favourite painter, are represented in unusual depth and splendour in the exhibition. Our only regret is that we have been unable to do full justice to the achievement of some of these mainland artists because of the delicate state of their paintings, many of which are on panel.

We are grateful to the many individuals who have worked so hard over the last two years to make this exhibition possible, in particular to Prof. John Hale and his team of scholars who have been responsible for the conception and realisation of the exhibition, for the choice of works to be shown and for the assembly of its catalogue. The generosity of lenders throughout the world has been outstanding. Very few requests for loans have been turned down and many paintings have been cleaned especially for the occasion. We have throughout been constantly encouraged by Professor Francesco Valcanover, Soprintendente ai Beni Artistici e Storici of Venice and Professoressa Filippa Aliberti Gaudioso, Soprintendente per i Beni Artistici e Storici of the Veneto. Finally to our sponsors, the Sea Containers Group and Venice Simplon-Orient-Express Ltd, we are greatly indebted. It was their faith in us and in our proposals that allowed us to proceed with our project. London is privileged to see such a magnificent assembly of works of art and we are confident we will receive an enthusiastic public response.

HUGH CASSON
President, Royal Academy of Arts

EDITORIAL NOTE

The following paintings will not be exhibited: 72, 126, 131, 137

Catalogue entries for the paintings, drawings and sculpture are
arranged in alphabetical order by artist, and the catalogue entries for
the paintings by each artist are in approximate chronological order.
The prints are arranged in chronological order.

All paintings are in oil on canvas.
The dimensions are given in centimetres to the nearest 0.5 cm
for the paintings, and in millimetres for the prints, drawings and maps;
height precedes width. The dimensions of the sculpture are in centimetres;
where only one measurement is given this indicates height.

References in the text and at the foot of the entries refer to the general bibliography.

Catalogue entries are signed with the initials of the following contributors:

E.H.H.A.	Edward Archibald	D.MCT.	David McTavish
B.B.	Bruce Boucher	E.M.	Eugenio Manzato
P.B.	Peter Barber	L.M.	Licisco Magagnato
D.S.C.	David Chambers	G.P.	Gaetano Panazza
G.M.C.	Giordana Mariani Canova	L.P.	Lionello Puppi
R.C.	Richard Cocke	A.F.R.	Anthony Radcliffe
G.D.	Gianvittorio Dillon	F.R.	Francesco Rossi
C.F.	Caterina Furlan	F.L.R.	Francis Richardson
J.F.	Jennifer Fletcher	G.R.	Giles Robertson
C.E.G.	Creighton Gilbert	S.M.R.	Stefania Mason Rinaldi
M.G.	Mina Gregori	P.R.	Paola Rossi
V.G.	Valerio Guazzoni	P.B.R.	Philip Rylands
C.H.	Charles Hope	D.E.S.	David Scrase
J.R.H.	John Hale	J.S.	John Steer
M.H.	Michael Hirst	S.S.	Simonetta Simonetti
P.H.	Paul Holberton	V.S.	Vittorio Sgarbi
P.B.H.	Peter Humfrey	C.T.	Christopher Terrell
M.J.	Michael Jaffé	M.F.T.	Maria Francesca Tiepolo
R.J.B.K.	Roger Knight	L.V.	Luisa Vertova
D.L.	David Landau	H.W.	Helen Wallis
M.L-J.	Manfred Leithe-Jasper	P.Z.	Pietro Zampetti

Translators
Peter Armour
Simonetta Fraquelli
Helen Glanville-Wallis
David McLintock

Exhibition Assistants
Simonetta Fraquelli
Elisabeth McCrae

PHOTOGRAPHIC ACKNOWLEDGEMENTS

The exhibition organisers would like to thank
the following for making photographs available.
All other photographs were provided by
the owners of the paintings.

Alinari, Florence fig. 5; Cat. 23, 107
Archivio Fotografico, Urbino Cat. 51, 55
Arte Fotografica, Rome Cat. 114
Autor Fotografie, Prague Cat. 132
Bacci, Milan Cat. 83
Camera Photo, Venice Cat. 32
Chomon-Perino, Turin D24
Cliché des Musées Nationaux Cat. D2, D5, D16, D22, D28, D32, D36, D39,
D41, D44, D50, D54, D56, D59, D72, D76, D79, D82, S14, S24, S28, S36
Corina Archives, Budapest Cat. 37
Courtauld Institute, London fig. 20

Fotografia di Bozzetto, Vicenza Cat. 1, 7, 9, 10, S5
Fotografia De Santi, Belluno Cat. 92, 93
Fotostudio Rapuzzi, Brescia Cat. 59
S. F. James, Wimborne Minster, Dorset Cat. 97
Osvaldo Böhm, Venice fig. 9; Cat. 112, S3, S4, S15, S40, S42
Pedicini Snc, Naples Cat. 94
Philip Wilson Publishers Limited Cat. S29, S26
Photo Ellebé, Rouen Cat. 38, 39, 136
Photo Studios Ltd. Cat. 5, 8
Presentations Audio Visuelles, Amiens Cat. 90
Prudence Cuming Associates Ltd. Cat. 97
Scala Istituto Fotografico Editorale, Florence Cat. 17, 40, 41, 45, 47, 48,
54, 69
Tom Scott, Edinburgh Cat. D33
Umberto Tomba, Verona Cat. 24
Warburg Institute, London fig. 14

VENICE AND ITS EMPIRE

J. R. Hale

The works of art in this exhibition were produced in the capital and in the subject cities of a great imperial power, feared in Italy and respected throughout Europe. To understand the mood in which they were produced we must forget the Venice of today, that aged waif of history whose beauty, lined as it is, can still coax tribute from protectors whose love is tinged with pity. Late in the fifteenth century Venice was known as a termagant, though a rich and sagacious one: 'you Venetians', warned the Duke of Milan, 'are wrong to disturb the peace of Italy, and not to rest content with the fine state that is yours. If you knew how everyone hates you, your hair would stand on end'; a sophisticated pilgrim exclaimed that 'it is impossible to tell or write fully of the beauty, the magnificence, or the wealth of the city'; and to a French ambassador 'it is the most triumphant city that I have ever seen . . . governed with the greatest wisdom, and serving God with the greatest solemnity'.

Praise of Venice by outsiders was nothing new. In 1364 Petrarch had celebrated 'the one home today of liberty, peace and justice, the one refuge of honourable men . . . Venice, rich in fame, mighty in her resources but mightier in virtue, solidly built on marble but standing more solid on a foundation of civic concord, ringed with salt waters but more secure with the salt of good counsel'. And such praise did not falter. Venice in the sixteenth century, the period covered in the exhibition, still attracted a steady stream of homage and was held almost in awe for its power, wealth, justice and wise government. Let us take just one more example. It comes from 1521. Venice is 'this most illustrious and noble city, than which none other is more famous for the immensity of its glory, the wisdom of its government, the long duration of its rule or for other features worthy of praise: the matchless convenience of its site, the magnificence of its admirable buildings, the wealth of incredible riches, its numberless subjects, the industry of excellent men, the infinite variety of its possessions, the divine institutions of the Republic, the immortal virtue of its nobles This is the famous city which, from small beginnings, has diffused its glory along the course of the sun; respected by all governments, all nations, all men; feared by its enemies, loved by its subjects, celebrated by all. This is the city which with eternal concord and inviolate liberty has eclipsed the example and fame of all other republics; queen of the sea, victorious in battle, defender of the Faith. . . . This is the city which in these recent wars has sustained the simultaneous assault of all Italy, all the nations of the West striking together. Undismayed by its wounds, it has always recovered itself, more eager, more victorious than ever.'

Now in taking this we should also take a grain of salt; it comes from a congratulatory address (from a spokesman for Vicenza) to a new doge. But it does convey the strain of pride and confidence that distinguished Venice in the late Renaissance from other Italian states; together with the city's wealth which – measured in terms of imperial revenue – grew steadily throughout the century, and an exceptional tolerance towards the free expression of non-political opinions and feelings among the Republic's subjects, this was an important element within the cultural atmosphere breathed by artists and their patrons.

Crucial to an understanding of that confidence is a picture, such as can be gathered from the maps and plans displayed in this exhibition (H9–18), of Venice's empire. The 'resources' mentioned by Petrarch comprised a skein of fortified harbours and their hinterlands stretching down the western Adriatic coast from Istria, via Zadar, Split and Kotor to Corfu, and on via the islands of Levkas, Kefalinia and Zakinthos, to Crete. This Mediterranean empire had been acquired solely for commercial reasons, to protect, provision and re-man the merchant galleys on their long haul to and from the Levantine ports where Venice bought the luxury goods on which its prosperity chiefly depended: Far Eastern spices (especially pepper), jewelry, drugs and dyes, Middle Eastern silks, cottons, ceramics and silverwares. Of all these possessions only Crete provided surplus revenue, but with the acquisition of Cyprus in 1489 Venice's colonial empire not only reached out some 2,200 km from the lagoon but became far more profitable.

Profits from the sea empire itself (apart from the trade it permitted), however, were slim compared with the revenues Venice was to derive from its conquests on the *terraferma*, the mainland, symbolised in Carpaccio's painting (Cat. 32) by the lion's stepping ashore. By the mid-fifteenth century these extended from Udine in the east, via Treviso, Padua, Vicenza and Verona, to Brescia and Bergamo in the west, and they enlarged Venice's earlier and meagre landholdings (which had been seized to ensure merely a supply of grain, meat and timber for the city's growing population and shipping) in order to keep the republic's re-export routes to the Alpine passes that led to northern markets free from political harrassment and the imposition of 'foreign' tolls.

This stepping ashore, profitable as it was intended and subsequently proved to be, was not undertaken without much head-shaking from conservatives; these felt that Venice should stay true to the old sea ways and keep clear of political entanglements among the chief political units of the peninsula – Milan, Mantua, Ferrara, Florence, Genoa, Siena, Rome, Naples. And they spoke up again when in 1509 Venice had to face 'the simultaneous assault of all Italy, all the nations of the West striking together.' Venice lost the battle of Agnadello in that year to a coalition whose porten-

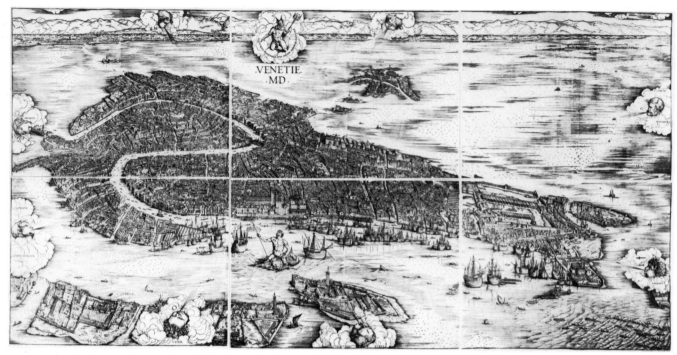

fig. 1 Jacopo de' Barbari *Bird's-eye View of Venice* (Cat. H1)

tous roll-call bears witness to the republic's covetable wealth as well as to the animosities its land conquests had left smouldering: the Kings of France and Aragon, the Emperor Maximilian I of Germany, Michelangelo's patron Julius II, that most irascible of popes, the Duke of Ferrara and the Marquis of Mantua.

Our period begins, then, on a note of desperate humilia-tion, with Venice's army falling back, shut out from cities eager to try new masters, to the margin of the lagoon itself, and with the mainland empire occupied by foreign troops. And this extraordinary reversal of fortune was psychologi-cally all the harder to bear because it followed the dismaying news that in 1498 Portuguese ships, under Vasco da Gama, had reached India via the Cape of Good Hope and looked

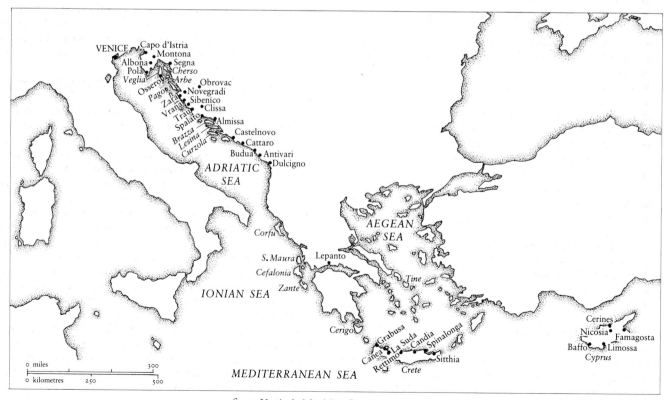

fig. 2 Venice's Maritime Possessions *c.* 1550

like diverting the spice trade from its Levantine outlets, and of the loss to the Turks in 1503 of two of Venice's most valued colony-ports in south-west Greece, Methoni and Koroni.

Yet by 1517 the *terraferma* empire had been recovered, by the 1520s the spice trade, though smaller in volume, had become as profitable as before, and the merchant convoys had adapted to a longer rhythm that carried them from Corfu to Crete with little regret for the lost ports-of-call. Tested on all fronts, Venice settled into the golden age of its culture with a more loyal subject population (for alien rule had proved harsher than the republic's) and a confidence not only higher than ever but buttressed by the amazed, if sometimes grudging, admiration of other states; 'celebrated by all'.

For Venice itself, unlike Milan or Florence or Rome, had never surrendered to siege during the wars of Italy that had begun in 1494 and only petered out in 1530; it had preserved its 'inviolate liberty'. If we look around the peninsula in that latter year the contrast justifies amazement. Milan and Milanese Lombardy had become a Spanish protectorate, the Kingdom of Naples and Sicily a Spanish colony. Florence had just had to surrender to an Imperial army. The Papacy fluttered uneasily between dependence on Spain and France. Genoa was a Habsburg satellite. The territorial pretensions of Mantua and Ferrara had been cut back to a pained provincialism. The Italian states, for so long contemptuous of the foreign 'barbarians', were now forced to pay homage to them, but not Venice.

Moreover, Venice had suffered no violent changes in its form of government. Indeed its republican constitution scarcely changed between the closing of the membership of the Great Council (Cat. H3) in 1297 and the republic's fall to Napoleon Bonaparte in 1797. And none of the few changes that did take place occurred during the Wars of Italy. Compared with Venice's great rival republic, Florence, the contrast is striking. In 1494 Florence exiled the Medici family, who for four generations had fairly tactfully directed the republic's fortunes, and adopted a more representative form of constitution. In 1512, with the aid of a Spanish army, the Medici returned. In 1527 they were exiled again, only to come back, with the help of another foreign army, in 1530, this time to rule as hereditary dukes and grand dukes.

Venice's survival as the only powerful republic in Europe was due, as a host of commentators were moved to admit, to 'the divine institutions of the republic'. They took their cue, it is true, from Venice itself, many of whose laws began 'this well ordered republic . . .', but the admiration was genuine. Venice seemed to have acquired a monopoly of that rarest of Renaissance commodities, political stability. How was it achieved?

The base of the constitution was provided by the Great Council. With some 2,000 members – too unwieldy to conduct day-to-day business – it was primarily the reservoir whence individuals were chosen to sit for short periods (lest they acquire too much power) on smaller councils. Of these the most important were the Senate, the chief policy-forming organ, some 200 strong, the College, which formulated the Senate's business and then saw to its execution, and the Council of Ten (usually, in fact, a body of 25 or so) which was responsible for state security and the handling of confidential diplomacy. Chairman of all these bodies was the doge, elected for life, but usually at an advanced age, through

a procedure elaborately devised to protect the post from self-seeking or party-supported ambition. Only a titular head of state, and denied political initiative, he was, according to his personality, potentially influential largely because of his enduring presence in bodies whose membership was constantly changing.

The secret, however, lay only partly within the constitutional machinery; it also depended on the character of a governing class unique in Europe. Its members, though they referred to themselves as '*nobeli*', were not nobles in the sense of being primarily attached to landownership and having a natural antipathy to central government. The Venetian patriciate contained no disturbing 'feudal' elements; it had defined itself through a shared success in commerce and the administration of the empire overseas. By 1325 it was a caste closed, save by hereditary right, to anyone, however rich he became, whose name was not then inscribed in the Golden Book. Unlike Florence, whose political processes were bedevilled by the absorption into the ruling class of territorial magnates and newly-rich families, such rivalries as there were between Venetian patricians did little to hinder the processes of government, and the Renaissance patriciate as a whole shared a strong sense of putting the interests of the state above their own. There were, of course, individual exceptions, but on the whole, and especially after the gaining of the land empire had doubled the caste's administrative and diplomatic responsibilities, the class that had an absolute monopoly of power had an automatic loyalty to the system that permitted it. 'The immortal virtue of its nobles': this was not just empty rhetoric.

Observers of sixteenth-century Venice, noting the grave decorum of the patricians and the sober relish with which they wore their patrician robes (as in the majority of their portraits), were also amazed by a social harmony which, within a population of some 145,000, allowed power to be wielded by so few. Of the social dissensions, let alone outright revolts, that characterised the other European states, Venice seemed (and, comparatively speaking, was) miraculously free.

It is natural for wealth to seek the prestige and protection of political rank as well. But on the whole the patriciate's commercial and fiscal system was seen to favour the rich non-patricians equally, and they avoided the expense and long absences from business involved in embassies, naval commands and governorships of subject cities which, together with council attendance when in Venice, were among the 'costs' of patrician status. The rich *cittadini*, as they were called, who comprised some seven to ten per cent of the population, provided, moreover, the government's civil service: from accountants and code-breakers to secretaries of the Senate and the Ten and the head of the service, the Chancellor himself ('the doge of the non-nobles', as a contemporary dubbed him), those *cittadini* who did not devote themselves to commerce or banking became identified with the values and purposes of the patricians they served and advised. The administration of the great charitable institutions, the *scuole*, like those of the Carità and San Rocco, for whom Titian and Tintoretto worked, was, too, in their hands, and their boards, like the major secretaryships, provided an informal honours system that acted as a palliative to blocked political ambition.

As for the vast majority of craftsmen, boatmen, shop-

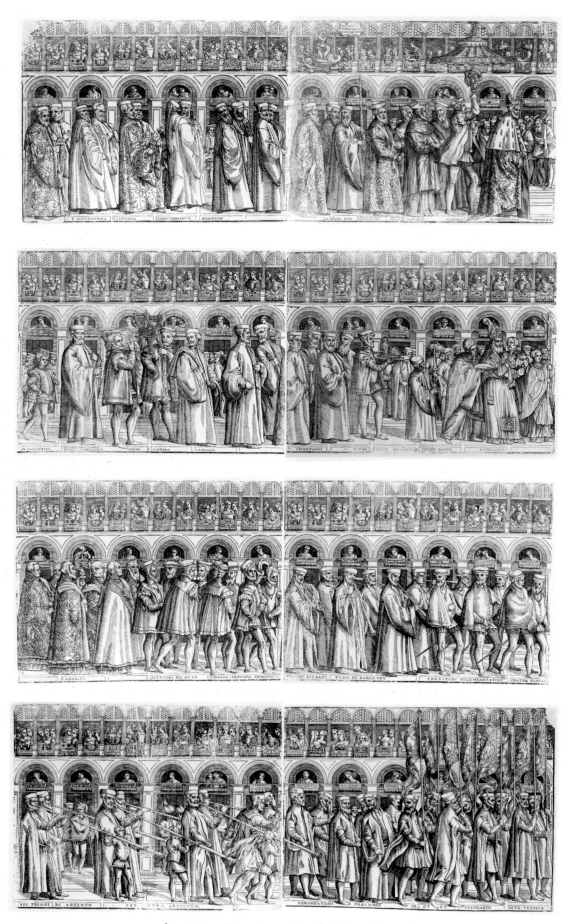

fig. 3 Matteo Pagan *Procession of the Doge* (Cat. H2)

keepers, labourers and servants, nowhere in Europe did they expect power; in Venice they were kept from the violent expression of grievances by reasonably full employment (an island city could deter job-seeking immigrants), a guild system whose complaints were considered sympathetically by government, and institutions, like the *scuole*, which cared with some adequacy for those who became too sick or old to work. Commoners too were represented in those great civic processions (fig. 3) which gave living form to the ideological notion that every section of the community had a part to play in 'the city which with eternal concord . . . has eclipsed the example and fame of all other republics'.

One such procession took place each St. Mark's day, 25 April, ending in the Basilica – the chapel of both St. Mark and the Doge – and thereby binding every social sector to re-commitment to the idea that the Evangelist (to whom on a visit to the then uninhabited Venice an angel had appeared and said '*Pax tibi, Marce* . . . Peace be with you Mark; this is where your body will be laid to rest') was the heavenly guarantor of the republic's special destiny: to endure and prosper, and to offer justice, liberty from outside interference and peace to its subjects.

No other Renaissance state used its patron saint to political purpose so effectively; wherever Venice ruled, there was, on pillar or plaque, St. Mark, not just to symbolise the republic's presence, but to license it. For in the illumination prefacing the Libro d'Oro of Doge Andrea Gritti (Cat. H6) the Evangelist holds out not his own book but a compilation of the laws of Venice that the doge must swear to obey, and which were, in a sense, those of the saint himself.

Together with the figure of St. Mark, or his lion with the open book quoting the angel's prophecy, the other themes that played a major role in Venetian political iconography were Justice and Peace (eg. Cat. H8), with Peace stressed all the more when, after its recovery of the mainland empire, Venice came to renounce expansion and proclaim the doctrine of a neutrality armed not just with the navy but with new fortifications round its cities (Cat. H16), a standing army of 9,000 men and a militia force of perhaps 40,000. That recovery confirmed at last the patriciate's preference for its land over its maritime empire. Its subjects, by collaborating in the expulsion of their foreign masters, had given Venice a vote of confidence, and this led, through increased land purchases and villa-building by Venetians, and through the coming and going of civic embassies and of petitions and their replies, to a steady closening of the personal ties between the *terraferma* and the capital, and an increased colouring of the former's cultural life by the art that was changing so rapidly and so wonderfully on the lagoon. How far that influence crossed, as land purchases hardly did, the river Mincio, which figured so largely in Venetian strategic thinking, whether it reached Bergamo and Brescia, for instance,

is one of the questions to which this exhibition hopes to stimulate an answer.

Just how far the imaginative change from an instinct to stress the sea and the east rather than the land and the west went, can be seen from the lack of shock when, in its struggle against the Turks of 1570–73, the republic won the Battle of Lepanto (Cat. 142, H19) but lost the war, being forced to give up Cyprus. Venice's medieval maritime enemies had been, after all, weak: an unsteady Byzantine Empire, and a trade rival, Genoa, operating from a base even further from the Levant than Venice's own. But from 1503 the Turk became an aggressive Mediterranean presence, as voracious for space by sea as on land. Venice had the role of 'defender of the Faith' forced upon it, but shouldered the extra costs of the garrisons and strengthened fortifications (Cat. H16, H17 and H18) that made uneasy coexistence possible, in a spirit of profit and habit rather than of crusade. To continue to think of Venice in the sixteenth century as 'a maritime republic' illuminates neither its psychology nor its culture.

Yet it was the continued presence of empire both by sea and land that gave force to the Myth of Venice, the image, that is, of Venice as a Renaissance Utopia: perfectly governed by a wise and selfless ruling class through a rationally balanced constitution; lacking in party or social tensions; and therefore so stable as to be able, against all the odds, to remain inviolate and independent. The image ignored flaws of character and system. So it has been dubbed a myth. But the glamour of empire diverted attention from the flaws, and when other countries fell to debating the merits of republican as against monarchical rule – in mid-seventeenth century England and Holland, and, later in the century, when constitutions were being proposed for Pennsylvania and New Jersey – the Venetian model was cited because it was offered by an equal. Other king-less polities could not compare. There was no Myth of Lucca, or Genoa, or of the Swiss Confederation.

But nowhere, of course, was the myth, and the confidence it fed, more potent than in the imagination of the Venetians themselves and of those who were drawn to work among them. One such immigrant, Pietro Aretino, the friend of Titian and one of the few writers anxious and able to articulate his feelings about art, in a letter of 1530 to Andrea Gritti praised 'the liberty of this great state.'

'So let us bow before her', he went on, 'and let us offer prayers on her behalf to God, whose benign Majesty . . . has willed that Venice shall rival the world itself in its eternal life – that world which is astounded that nature has placed her in so incredible a site, and that Heaven has been so generous to her in its gifts that she outshines in her nobility, magnificence, riches, palaces, churches, pious foundations, virtues, councils, empire, fame and glory, any other city that there ever was.'

PATRONAGE IN VENICE

J. M. Fletcher

In 1537 Titian's friend Pietro Aretino wrote to the architect and sculptor Jacopo Sansovino, warning him against returning to Rome, which he had left during the Sack ten years before. How could he contemplate exchanging the security of Venice, where he had even been given a house by the State, for the dangers of Rome, or Venetian senators for courtier prelates? Aretino was hardly an objective observer, but his letter raises two issues that deeply affected artistic patronage in Venice: the stability and safety of the city, and the absence of a court. A third factor of equal importance – wealth – is stressed in a short guide-book to Venice published in 1561 by Sansovino's son Francesco. This took the form of a dialogue between a visitor and his Venetian guide, who at one point boasted that there were more pictures there than in the rest of Italy put together. To this the visitor replied: 'As

you are the richest men in Italy, it is right and proper that you should also have more beautiful things than other people, for artists go where money flows and where people are plump and prosperous.'

Art is naturally tied to the economy; and Venetian art was bought with the ducat which, like today's dollar, was a highly respected international currency. One of Sansovino's most important commissions in Venice was to build a bigger Mint, and we can see in Tintoretto's *Santa Giustina and the Treasurers* (Cat. 110) magistrates who show their money bags to the Madonna. In their wills Venetians tell us how much they paid for their art: Giuliano Zancarol, a patron of Bellini, who gave 50 ducats for a picture of Christ, boasted that he has never minded how much he spent 'so long as it is beautiful.'[1] Gabriel Vendramin, one of the day's leading

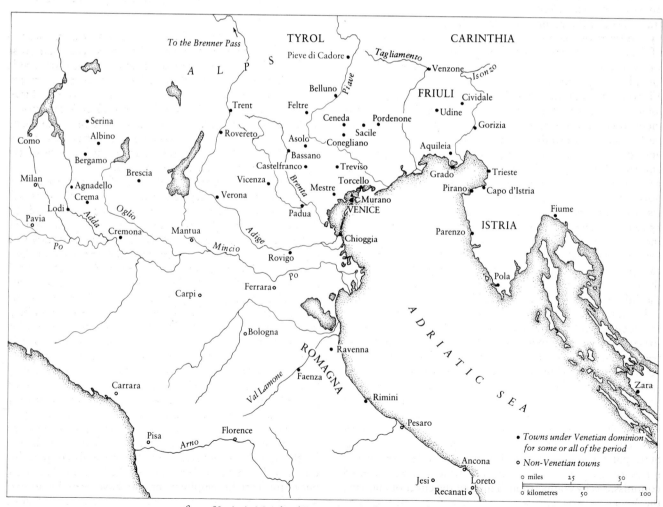

fig. 4 Venice's Mainland Possessions in the Sixteenth Century

connoisseurs who owned Giorgione's *Tempesta* (fig. 5) looked back on years of hard labour in the family firm which had earned him the collection that had brought 'a little rest and quiet' to his soul.

The absence of a court meant that Venice lacked the influence on taste of a single dominant family, as occurred in sixteenth-century Florence, but this was to some extent balanced by the ideology of the State and its leading members, in the emphasis on the continuity of institutions and in the constant proclamation of Venice's wealth and power. In these respects, it is often hard to distinguish between public and private patronage; between the activities of the government and other quasi-independent corporate bodies. As we consider the different types of patron – official, corporate and private – we shall see how this inter-relationship constantly came into play.

The State was not only a considerable patron in its own right, it also set the pattern for other types of patronage and in some cases exerted a direct or indirect control on individual initiatives. Its direct activity might involve the commissioning or purchase of works of art as diplomatic gifts, for example paintings by Bellini or Titian; but much more important was the construction and embellishment of government buildings such as the Fondaco dei Tedeschi (the warehouse leased to the German merchants; fig. 8), which was decorated with frescoes by Giorgione and Titian. This was evidently a relatively unprestigious commission, since it was given to comparatively young and untried artists. By contrast, most of the paintings in the Doge's Palace itself were by the foremost painters in the city. Thus the replacement of the celebrated and politically very significant cycle of canvases in the Sala del Gran Consiglio was entrusted first to Gentile Bellini together with his brother Giovanni and Alvise Vivarini, and later to Titian, Tintoretto and Veronese. Such jobs were eagerly sought by artists, not least because payment often took the form of lucrative sinecures, as well as perks such as free studio space, assistants paid by the State, and, in the case of Giovanni Bellini, exemption from guild control. Once in government service, artists could also act as sub-patrons in finding jobs for pupils and protégés. They also tended to abuse their position, so that Titian took no less than 25 years to execute a single picture. After about 1550 government interest in completing the decoration of the Palace seems to have increased, and after two disastrous fires, in 1574 and 1577, a major campaign was undertaken to replace the destroyed paintings in the minimum time. By then, it was evidently unthinkable that parts of the walls of the Palace should be without their painted adornment.

In granting individual commissions the personal role of the doge was seldom of great importance. It was customary for each to commission his own portrait, and during the sixteenth century it was expected that he would also order a votive painting, showing himself together with various saints; but some doges did not bother to do so. Only a few, in fact, such as the long-reigning Andrea Gritti, who did much to promote the careers of Titian and Sansovino, can be considered as major patrons in their own right. In general the Venetian government discouraged personality cults, and State patronage worked on a consensus system through a series of government departments which often awarded commissions by competition. This had the effect of allowing the Venetian nobility (the only class with political power)

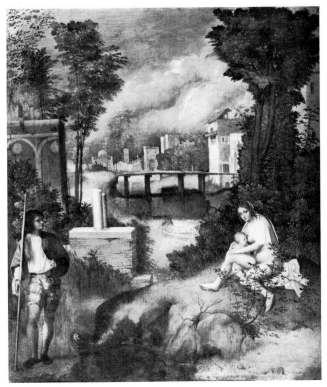

fig. 5 Giorgione *Tempesta* (Gallerie dell'Accademia, Venice)

an opportunity to learn about art while serving in departments with responsibilities for public works, while patricians who already enjoyed a reputation as art experts were able to develop their expertise through frequent co-option to special boards formed to supervise important projects. From such a position a prominent politician such as Marcantonio Barbaro could promote the ideas and career of his favourite architect Palladio, thus reinforcing that subtle interaction between the public and private sectors which is a distinguishing feature of artistic patronage in Venice.

Moving down the social scale, another important source of patronage was the lay confraternities, the Scuole, which were divided into Grandi and Piccole, large and small. By the sixteenth century these organisations, originally founded as flagellant companies, had been largely transformed into mutual benefit societies with special responsibilities for charitable activities. By then the patronage of the Scuole Grandi had become so lavish that they were criticised for diverting funds from charity to art, for building assembly halls as big as ballrooms, for decorating the façades of their buildings with harpies (fig. 9) and for their over-elaborate processional floats.[2] In their commissions for paintings the Scuole tended to follow the example of the government in the decoration of the Doge's Palace, both in the practice of adorning their buildings with cycles of vast canvases and elaborate painted ceilings, and in the choice of artists who had already proved themselves in government service. This was true particularly of the Scuola di San Marco, which was favoured by top civil servants, and which employed the Bellini brothers and later Tintoretto. The latter was also responsible for virtually the entire decoration of the Scuola di S. Rocco, but in this case his employment may have been due in part to the fact that his father was a silk dyer and that this Scuola

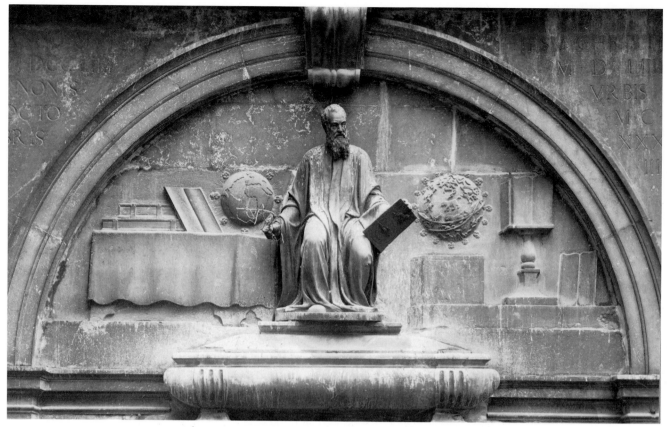

fig. 6 J. Sansovino *Tommaso Rangone* (S. Giuliano, Venice)

had a high proportion of textile workers and *tintori* on its books. This type of commission was not necessarily very lucrative, but the artists were generally admitted to membership of the relevant Scuola, sometimes, as in the case of Gentile Bellini, rising to key positions on the governing board. Tintoretto was given a life salary and a place on the board at S. Rocco. The Scuole also provided down-and-out painters with almshouses, and encouraged the successful with grants to help them marry off their daughters.

The government exercised a general supervisory role over the Scuole, and its permission was required, for example, when they needed to suspend their charitable activities in order to pay for their lavish headquarters. In the actual granting of commissions, the Scuole in theory exercised corporate patronage, but in practice the taste of the Guardian and management committee could be decisive. At San Marco there was Domenico di Piero, a rich jeweller who sold cameos to the Medici, and Tommaso Rangone, a distinguished patron of Sansovino, Vittoria and Tintoretto, while San Rocco had Martino d'Anna, of Flemish merchant stock, whose family had patronised Titian and whose palace façade was decorated by Pordenone (Cat. D43). In 1525 the board of the small Scuola di S. Pietro Martire asked the government to overrule the majority who wanted to order an altarpiece from someone 'who is not up to the job'. They offered to pay for the picture out of their own pockets, and in the petition, which was signed by Palma Vecchio, they insisted that the task must be done by 'one of the most pre-eminent in the said art'. The final outcome was Titian's spectacularly avant-garde *Death of St. Peter Martyr* (see fig. 14).[3]

Another important branch of corporate patronage was that of the religious orders. These varied enormously in social and intellectual tone, taste and wealth. Tales of monkish and nunnish philistinism are legion. For example, nuns cancelled a commission to Veronese, seduced by the miniaturist technique of a visiting Fleming;[4] and the Prior of the Frari thought the figures in Titian's *Assumption* (fig. 18) too big. But several orders displayed sophisticated artistic as well as musical taste: thus in the fifteenth century the intellectual Camaldolese at San Michele in Isola and the aristocratic nuns at San Zaccaria were innovative architectural patrons; Veronese received his great opportunity from the Jeronymite Prior of S. Sebastiano, a fellow-countryman from Verona, while Lotto developed a close relationship with the Dominicans at SS. Giovanni e Paolo, where he painted portraits of friendly monks dressed up as their patron saints, and reduced the price of *S. Antonino Distributing Alms* by 30 ducats on the understanding that the monks would pay for his funeral.

A distinctive feature of Venetian religious patronage was the role of community feeling within parishes, which was strengthened by the fact that non-noble householders elected their own parish priests. These could then truly represent the artistic wishes of the parishioners, by petitioning the government for grants to their churches and by organising public subscriptions for new altarpieces. Several priests personally paid for outstanding works of art. Thus Sebastiano's organ doors (Cat. 95, 96) and Veronese's altarpiece for S. Pantalon (Cat. 147) were financed either by or through priests. But in the decoration of churches private initiatives by laymen were also important, and the majority of altarpieces were commissioned by individual patrons as a focus

for masses in memoriam. On other occasions, a picture which the patron had kept at home during his lifetime would be bequeathed to his funerary chapel at his death.

Private patronage was often subject to State control. This was most obviously the case in matters involving the public image of Venice. In 1535, for example, two commissioners were appointed by the government to look into the city's embellishment, and the State also intervened to prevent private individuals from commemorating themselves in politically sensitive areas such as Piazza San Marco. Rangone (Cat. s39), who fancied a statue of himself on the façade of S. Geminiano on the Piazza, was side-tracked to a less prominent position on the façade of S. Giuliano (fig. 6). The activities of private patrons might also be affected by sumptuary laws, which could limit expenditure on interior decoration as well as on clothes and parties.[6] But Venetian private collections were certainly a source of civic pride. In his guidebook of 1581 Francesco Sansovino devoted a whole section to them, with special mention given to the Grimani and Foscari collections of antique sculpture, to the Priulis' paintings by Palma Vecchio and to the works by Bellini, Giorgione and Titian owned by Gabriel Vendramin; and important state visitors were often shown such private collections as well as the Treasury of San Marco.

In the fifteenth century virtually all pictures in private hands were religious subjects on panel, and most belonged to the type of Madonna and Child compositions made popular by Bellini and his workshop. But already some Venetians were showing an interest in the antique. As early as the 1440s Cyriac of Ancona met a Venetian sea-captain who kept a collection of ancient cameos in his cabin;[7] but at this date an interest in ancient art did not necessarily indicate a taste for modern art. After showing the Venetian humanist Ermolao Barbaro the Medici Palace collection in 1490, Piero de' Medici concluded that he did not 'understand much about sculpture', although he was interested in the age of the medals.[8] By the 1520s attitudes had changed, and antiquarian and aesthetic interests had come together. Giorgione was one of the first artists to work almost exclusively for connoisseurs, extending the narrow range of subject matter to include new picture types such as landscapes, reclining nudes, and ambiguous semi-portraits of beautiful boys and girls. It is clear from Michiel's descriptions that competitive collecting accelerated connoisseurship, sharpened the interest in provenance, and encouraged an appreciation for drawings, especially those that could be related to paintings[9]. The point is forcibly made in Lotto's *Portrait of Andrea Odoni* (Cat. 46), in which this connoisseur who owned better pictures than sculptures, including works by Titian, Palma Vecchio and Savoldo, is shown handling an antique statuette, a clear allusion to his more intellectually respectable collection of antiques. From Lotto's picture we would never guess that he also owned a bronze puppy, petrified snakes and a dried chameleon.

fig. 7 G. Bellini *Virgin and Child with Saints and Pietro Priuli* (Kunstmuseum, Düsseldorf)

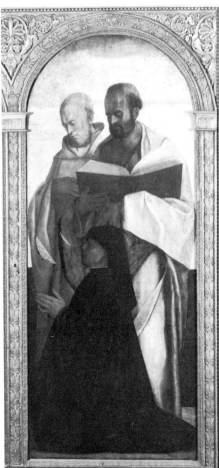

The prestige of antique art is probably one reason why in the early decades of the sixteenth century several Venetians seem to have been trying to inject classical imagery and classical style into their modern art. In 1501, for example, Cardinal Zen asked that his tomb should be 'as antique as possible'. By 1523 the government Procurators ordering a statue of the Magdalene from Bartolomeo Bon insisted that he use a classical style for drapery and hair.[10] Nor was such taste confined to sculpture, for in 1506 Dürer complained that the Venetians criticised his work because it was not 'antigisch' and so not good'.

In general it is easier to relate subjects rather than styles to patrons. Monks could feast their eyes on supper scenes by Veronese, while members of confraternities dedicated to the sacrament might meditate on the eucharist assisted by Tintoretto's Last Suppers and Washings of Feet (Cat. 101). Thus a Mystic Marriage of St. Catherine would make an ideal gift for a nun, but was also popular with newly-weds such as Lotto's patron Messer Marsilio (Cat. 44). Again, Odoni, who made money from customs duties on wine, had paintings of Bacchus and Ceres, goddess of plenty, on the façade of his house. He also followed the common Venetian habits of displaying a *Reclining Venus* in his bedroom and having his portrait painted. This last form of patronage had a perennial attraction for the Venetians, and on his first visit to Venice in 1541 Vasari was particularly impressed by patrician portrait collections going back four or five generations.

Pride in family often went hand in hand with a wider sense of obligation to the city and the State. Thus Vasari saw a *Supper at Emmaus* by Titian on show in the Doge's Palace, a present to the Republic by its owner who thought it deserved to be seen in a public place; and in 1555 a notary left another painting by Titian, an *Annunciation*, to the Scuola di S. Rocco, with the request that it should be prominently displayed. In 1528 Cardinal Grimani bequeathed not only his library, but also his paintings by Bosch and his classical sculpture to the State, while Andrea Loredan, who may have commissioned Sebastiano's *Judgement of Solomon* (Cat. 97), stipulated that his pictures should be kept together in his inalienable palace both for the 'decoration of the house' and for '*la patria*'.[11]

Venetian patrons, like Venetian art, came in different styles. The extrovert and flamboyant Rangone ordered that the model for S. Giuliano – the church which he had paid to renovate – should be carried in his funeral procession, but the secretive and humble Pietro Priuli insisted that his arms should not appear in his funeral chapel at S. Michele. Their contrasting styles are reflected in their donor portraits: Sansovino's Rangone (fig. 6), a nouveau riche from Ravenna, sits proudly elevated on the façade of S. Giuliano accompanied by a tri-lingual inscription testifying to his learning and generosity. Bellini's Procurator Priuli (fig. 7) kneels devoutly in an old-fashioned triptych wearing the old-fashioned hat (the *capuzzo*) that earned him his nickname.

The last word may be given to Giovanni Cornaro, a friend of Sanmicheli and one of a line of great patrons, for in his will of 1551 he demonstrates all the characteristics of an outstanding Venetian patron – pride in rank and family, business acumen and a love of beauty. Worried lest the art treasures of his late brother, and in particular a set of tapestries showing the life of Scipio Cornelio, from whom the family claimed descent, should be lost to Venice through sale to Rome 'where they are known', he urged his sons to preserve them and to keep them together, for not only were they 'beautiful and delicate', but also 'noble objects and worthy of princes'.[12]

1] Paoletti 1893, I, p. 112. Zancarol, who collected classical art, was a close friend of Tullio Lombardo.
2] Caravia 1541, sig. D r-Fiii r. For Caravia see Logan 1972, pp. 204–05.
3] Ludwig 1905, p. 69.
4] Ridolfi, ed. von Hadeln, 1914–24, I, pp. 328–29.
5] Prodi 1972, pp. 419–20.
6] Bistort 1912.
7] Ashmole 1957, p. 39.

8] Roscoe 1796, Appendix LXXXI, pp. 96–97.
9] Fletcher 1981, pp. 457–67, 602–08.
10] Paoletti 1893, p. 282.
11] Puppi and Olivato Puppi 1977, pp. 222–23.
12] Venice, Archivio di Stato, Sez. Notarile, Testamenti (A. Marsilio), Busta 1209, no. 492. I plan to publish an article in collaboration with Susan Connell on the implications of this document.

PATRONAGE ON
THE VENETIAN MAINLAND

Lionello Puppi

It is by no means easy to provide a brief but clear outline of the trends of patronage in the Venetian mainland territories during the sixteenth century, since we have to take account of a complex network of motives and aspirations, some of which actually contradict one another. Nevertheless, if one accepts that such patronage reflects above all a distinctive sense of mission on the part of the aristocracy, which was attempting to re-establish its position and adapt itself to the new circumstances brought about by the political and military crisis of the years around 1500, then it is possible to discern a coherent and plausible pattern.

The rout of Agnadello in 1509 had aroused real fears that the extinction of Venice was imminent. 'The affairs of the Venetian Republic', wrote Guicciardini, 'were plummeting with immense and almost awesome speed, with disaster continually heaped upon disaster, all hopeful proposals coming to nothing, and without the slightest sign to encourage even the hope that, having lost so great an empire, the people might at least preserve their liberty.' In fact, thanks largely to the loyalty of the rural and urban populace, and despite the widespread treachery of the provincial aristocracy, the Republic managed to survive the period of greatest threat and was soon on the path to recovery. Her prestige was increased by the fact that she had retained her independence while the rest of Italy had fallen under foreign domination, a fate made all the more painful because the concept of Italian liberty retained its appeal as an intellectual ideal.

Writing in 1535, but presumably recording his thoughts in 1509, Guicciardini himself notes that in the period of most acute danger, many people, 'reflecting more soberly upon the state of affairs, and upon how vile and disastrous was the reduction of all Italy into a state of enslavement to foreigners, felt extreme distress that so great a city, so ancient a seat of liberty, the glory of the name of Italy throughout the world, should fall into such complete extinction'. This reaction reflects primarily the self-awareness and pride of the more perceptive among the Venetians themselves. But by the time Guicciardini was writing, a new version of the myth of Venice had been born. The Republic now saw itself as a state whose power – by then established on a European scale – was based not on its maritime activities in the Mediterranean, but on its mainland possessions.

The price for Venice's revival was a decision not to expand the city's territory beyond the areas it had conquered in the fifteenth century. 'They had realised', observed the French Resident Guillaume Pellicier in 1542, 'that for the well-being and consideration of the State it would be best not to become embroiled in matters of war with anybody, but to seek and maintain peace with everyone'. In more specific terms, the Venetians had to strengthen their institutions and reorganise

their approach to their subject territories through a marriage of public initiative and private interest. In doing so, the Republic was once again claiming to be the model of an 'administration which is certainly most worthy to be examined and judged, and regarded with no less admiration in our own day than were those of the Spartans and Romans in ancient times', as the Florentine Donato Giannotti wrote in 1526. The comparison with Rome was also stressed by Sabellico: 'In sacredness of laws, in equity of justice and goodness, and in other even nobler ordinances the affairs of Venice, when compared with those of Rome, will not appear as fated to be inferior but as very much superior now that they have been renewed.' Another Venetian, Contarini, made much the same point when he wrote that 'There have been republics which openly tried to gain mastery over the whole of Italy and which . . . far surpassed the Venetian Republic in empire, territory and military glory; however, there is none which, in its institutions, laws directed towards the good, and happiness, can be compared to this republic of ours.' And in a similar vein Bodin was to proclaim that Venice, Athens and Rome were 'the most illustrious republics which have ever existed under popular rule', and to explain that although 'the most sacred laws' were administered by the aristocracy, the Venetian system was built upon a 'harmonious proportion which has made her the fairest and most flourishing of republics'.

In the last analysis, this is the theme of Utopia realised, a society brought into being and maintained by the type of man whom Palladio was to call 'the great Republican gentleman' or 'the gentleman of great splendour and ease', and whose civic role, social position and self-awareness rested upon the preservation of the status quo. Priuli, in his own way, already had a premonition of this when he wrote: 'In this hallowed city of Venice, it used to be merchants who were despised and vilified by all, and they received few honours, so that many merchants likewise used their money to buy possessions and other things so as to live off the income. And this was the ruin of Venice', because eventually 'when the Venetian nobles and citizens had become rich, they wanted to celebrate their success, and live and attend and give themselves up to pleasure and delight and to the green of the countryside on the mainland, with many other amusements, so abandoning navigation and seafaring, which were more vexatious and arduous'.

These developments created the need for a new approach to economic organisation and artistic expression. 'If I may ask', pleads Daniele Barbaro, 'I ask and ask again (that) my fellow-countrymen . . . should remember that, since they have both riches and the power to win honour by their achievements, they should take steps also to ensure that they are

not deficient in intellect and knowledge; they will succeed in this only when they bring themselves to realise that they do not know what in fact they do not know, nor can ever know without practice, hard work and science. And if they believe that the traditions in their workshops are of necessity incomparably skilled, they greatly deceive themselves, for in fact they are extremely faulty and bad traditions.' But to establish and preserve the new enterprise, to produce a tangible representation of the myth of Venice and the renewal of her empire, the exercise of 'practice, hard work and science' had to be firmly grounded in the 'true beauty and grace of the Ancients'.

The artists of the Veneto, wrote Pietro Bembo in 1525, 'within the narrow confines of their drawings, portray the forms of beautiful antique figures in marble and sometimes bronze which are lying around or are preserved and treasured publicly and in private, and the arches, baths, theatres and various other buildings which still stand in certain places there; then, when they plan to execute some new work, they examine those models, and, seeking to produce likenesses of them with artifice, they believe their labours will earn them the more praise the more nearly they manage to make their works resemble the ancient ones; so they work, aware that the ancient objects approach the perfection of art more closely than do those of more recent times'. Here, indeed, was a genuine manifesto for classicism, which acquired a topical resonance because of the prevailing ideological climate, however remote from reality this may have been.

Essential features of this reality were the adoption by the aristocracy in the mainland cities of a system of investment economy similar to that of the Venetian patriciate, and the fact that in these years membership of the city councils was increasingly restricted to the nobility. At the same time their traditional antagonism to Venice, mollified by the concession of a limited degree of administrative autonomy, found its only outlet at the level of municipal prestige. Moreover, the language in which such assertions were expressed was itself derived from the programme elaborated by the Venetians to proclaim the renewal of their empire. Now that political rivalry was tamed, punished and rendered unthinkable, it was replaced by a confrontation of ideas, a cultural challenge. By presenting the city as superior in its foundation or destiny, by exalting its glorious history and employing the rhetorical tools of humanism, this challenge would advance the city's claim to civic primacy, which would then be illustrated by its notable achievements in the present. This process of self-glorification involved the rediscovery and updating of the 'true beauty and grace of the Ancients', for which each city was a repository, inasmuch as it was a custodian of antique remains – the very treasures, incidentally, which Venice herself lacked. The spate of municipal eulogies which appeared in these years, therefore, was not so much a revival of the obsolete medieval *laudatio*, as a reflection, modelled on examples from the classics and the humanists, of the real tensions in the historical situation. To mention an analogy in another sphere, there is also unmistakable and significant evidence that cartography was subject to similar pressures, for producers of local maps were eager to invest the bare record of topographical data with symbolic allusions.

Patronage is above all an urban phenomenon, and even though it evolved through a combination of factors too com-plex and intricate to be reduced to a single rigid scheme, the feature of particular interest here is the element of cultural challenge. On the one hand, it is necessary to consider the initiatives taken by the citizen body as a whole, as represented in its communal councils and magistracies, and by the aristocrats as a distinct class in each city, or by those groups who acted collectively in their role as members of academies. On the other hand, it is equally important not to ignore the distinct, though complementary, impulse to promote the self-glorification of individuals, families and dynasties, a type of initiative in which the Venetian patricians resident on the mainland also participated. This kind of patronage, of course, often involved religious commissions for churches and other sacred buildings. It also encompassed the appearance of the collector, and particularly, though not exclusively, the collector of antiques, whose activity was intended both to provide a basis and a stimulus for the creation of works of art and to celebrate the city's claim to a 'magnificence' superior to that of Venice. It is therefore no accident that in the *Book of the Courtier* Baldassare Castiglione assigns to Ludovico Canossa, a Veronese – not, one should note, Venetian – nobleman active in several spheres of patronage associated with the notion of cultural challenge, the statement that the perfect gentleman 'should be able to judge the excellence of statues both ancient and modern, of vases, buildings, medals, cornices, intaglios and the like'.

A final element to be taken into account in this intricate pattern is the role of Venice herself. Although the Republic, interested in the orderly administration of her mainland heritage rather than in the creation of a monolithic national unity, came to allow the cities considerable freedom of action in the exercise of a cultural rivalry based on municipal pride, she reserved the right to set up, in places appropriate to the expression of her own political authority and rule, the symbols of St. Mark and the kind of unified architectural and artistic complexes that would demonstrate to the city the immutable presence of the 'Republic of the Venetians'. This brought into play the component of Venetian self-awareness discussed at the beginning of this essay.

In the space available it is impossible to justify fully and in detail, case by case, the reconstruction of the history of patronage on the mainland that has just been outlined. Taking the example of Verona, however, one can see the relationship between the execution of the public programme to recreate an antique classicism considered to be the city's birthright, and the care lavished by leading members of the aristocracy on their private collections. The public enterprise had already been inaugurated in the fifteenth century by Mantegna's altarpieces for S. Zeno and S. Maria in Organo, then continued with Falconetto's paintings of the *Triumphs of Caesar* on the façades of major buildings, and finally concluded when the Loggia del Consiglio was crowned with statues representing the five greatest citizens of Verona in antiquity. In short, it was a programme of civic glorification. Meanwhile, in the sumptuous settings of their family residences, which were thus explicitly identified as authentic *hospitia Musarum*, abodes of the Muses, the nobility were assembling outstanding collections, which demonstrated both an antiquarian fervour and a personal taste for contemporary art of an unusually wide-ranging and sophisticated kind. In the case of Vicenza, too, it is evident that there were

close links between the corporate initiatives taken by the aristocracy, acting either as a ruling elite or as a council of 'Olympians' in the Academy, in the erection of those monuments – from the Basilica to the Theatre – which expressed their corporate identity, and the private activities of the Porto, Chiericati, Thiene and Valmarana families, and above all of Giangiorgio Trissino (see Cat. 33), with his meeting-place for the Academicians at Cricoli, and of Girolamo Gualdo, who constructed the magnificent garden at Pusterla. Here at Vicenza the Republic also played its part, with commissions to Titian and Paris Bordone for frescoes celebrating its 'most sacred laws' in the Palace of Justice.

Without dwelling on other cities, such as Brescia and Treviso, we should at this point take into account a further effect of this kind of patronage. Although it did not exclude the employment of artists, even outstanding ones, based in Venice and working in a strictly Venetian idiom, it did in time stimulate lively activity on the part of competent local craftsmen, thus fostering an iconographic and stylistic renewal in the various provincial centres, each of which had already developed its own distinctive characteristics.

Padua affords a good example of this phenomenon, and especially noteworthy are the activities of Alvise Cornaro. It is clear from contemporary evidence that the leading craftsmen responsible for the sculptural and pictorial decoration of his two buildings, the Loggia and the Odeo, were the Paduans Tiziano Minio and Domenico Campagnola; and it has also been shown that the plan of the Odeo recalls the studio of Marcus Terentius Varro in his villa at Cassino, as reconstructed in a drawing by Giuliano da Sangallo, while the design of the Loggia depends on information provided by Serlio about the Villa Madama, itself a re-creation of Pliny's Villa Laurentina. In the very years in which the palace for the city council was being completed as an expression of the corporate identity of the Paduan aristocracy, Cornaro's two buildings constitute an analogous enterprise by a private individual. By openly recalling ancient Rome, his scheme also shows his desire to glorify himself as he takes on the task of encapsulating in a unified image the foundations of 'Paduanness' itself, the *Patavinitas* which was here proclaimed as the modern expression of an ancient – and therefore superior – destiny embracing the 'noble city of Padua'. The decoration too evokes the classical world, drawing on a wealth of information provided by Padua's zealous antiquarian collectors, and incorporating, in the abundant use of grotesques, an explicit reference to the Domus Aurea. Classical influences were also transmitted by way of Raphael, whose drawings, according to Michiel, were used by the artists – another example of the stimulus supplied by the passion for collecting. Cornaro's activities even extended to religious art, for he must have been one of the guiding spirits in the planning of the sculptural decoration for the shrine of St. Anthony, which was conceived as an evocation of the 'principles and formulae' of Roman imperial sculpture.

It was no accident that the craftsmen employed by Alvise Cornaro came to form the nucleus of a Paduan School, which, although sometimes augmented by artists from elsewhere, was consistently and coherently to reflect the Paduan ideology of the ancient primacy of the city of Antenor and Livy. The same ideology also lay behind the private commissions of other local patrons, from the house of Marco Mantova Benavides (another splendid 'abode of the Muses' and a temple to the art of rhetoric, which the patron practised) to the residences of the other leading families of Padua and of the Venetians who had settled there, and finally to the buildings owned by the religious organisations, which for the most part were controlled by the aristocracy. Nor did the Venetian government hesitate to draw on this ideology when it restored the Palazzo dei Capitani, 'the hall [which had once been] the ornament of the city' built on the site of the old palace of the Signoria. Here it commissioned a series of frescoes showing 'illustrious men and emperors' (the so-called 'Giants') to commemorate the tribute paid by Petrarch to the greatness of Padua.

Among those responsible for the iconographic programme for this project was Alessandro Maggi, 'the greatest historian of antiquity' in Padua, whose house was designed in imitation of Livy's. Maggi also worked on the programme for the triumphal entry of Bona Sforza in 1556; and here State patronage and the corporate patronage of the local aristocracy came together, in a collaboration between the artists of Padua and the official architect of Venice, Michele Sanmicheli. This enterprise stands as a unique but highly significant illustration of the extreme complexity of the historical situation we have been examining, for it reveals a remarkable phenomenon: the city moderated its challenge to the Venetian myth of imperial renewal while it reconciled, at the civic level, the ancient glory of Padua and the present greatness of the Republic.

ARCHITECTURE

Howard Burns

'In this most noble city of Venice', wrote Serlio in 1537, 'it is the custom to build in a way which is very different from that of all the other cities of Italy.'[1] In Venice buildings rested on oak piles which were driven, tightly packed, into the mud of the lagoon. Symmetrical layouts were desirable, so that structures could settle evenly 'and the walls take the load of the roof equally'.[2] Beam ceilings, with a one-to-one relation between the beams and the spaces between them, were safer and stronger than vaults (which could easily crack) for they had a certain elasticity, and tied the walls together. Wood, however, was costly (timber was also needed for ship-building) and its use increased the risk of fire. Fires in Venice were much commoner than elsewhere, and were the main reason for architectural renovation.[3]

Brick was the basic building material. Brickwork lies behind the stone veneers of costly buildings, and was employed with elegance and expertise by Palladio in the Convento della Carità (now the Accademia) and in his two great churches. Building stone was brought by sea from the Istrian coast: Istrian stone weathers well and can take a polish like that of marble.[4] In ordinary houses it was used at water level, for door and window surrounds and for cornices. Stone details were often ordered from the masons in standard shapes and sizes, and their repetition throughout the city gives Venice its attractive visual unity. Important structures were usually faced in Istrian stone, which can be cut easily into large columns or carved into ornate capitals and mouldings. Marbles, often coloured, were used in the most splendid projects, like Sansovino's Loggetta, or the Sala delle Quattro Porte in the Doge's Palace. The red stone of Verona was employed for chimney pieces, and for the red and white chequered pavements of churches.

The environment determined the layout of houses and palaces. Serlio writes that 'as Venice is very densely populated the available sites are restricted and have to be laid out with discretion, and there is not space . . . for great courtyards and many gardens.'[5] He also points out how most of a building's light needs to come from the main façade. In palaces this was on a canal or *campo*. Given security from invasion and Venice's renowned political stability, palaces and public buildings could have their facades pierced by more windows and *loggie* than was the case in Florence, where the traditional palace was a miniature stronghold, a protection against summer heat and the risk of tumult.

Even great houses in Venice are without a central *cortile* and tend to be deep and narrow in plan, with only a small courtyard at the back. Through the centre runs a hall, which on the upper floors served 'for receiving relatives at the time of weddings, and for holding banquets and parties'.[6] These central halls are lit by the group of large windows which one sees in the middle of Venetian façades. The side rooms (unlike the halls) had fireplaces so that 'when one gets up, one has the fireplace to hand'.[7] In palaces these rooms were adorned with hangings, paintings and gilded ceilings, though in terms of function they were rather grand bed-sitters. Rooms could not always be lit from the outside, so that light wells often had to be inserted. Expensive foundations and lack of space made it usual to construct two living floors above the damp ground floor. Between the ground floor and the first floor there was a mezzanine, used for servants, nannies, the small children and kitchens, and sometimes also by the owners themselves, as these low rooms would be cosier in winter.[8]

The cheaper housing developments of Venice anticipate the housing schemes of modern times.[9] A standard living unit of a few rooms was repeated on several floors and sometimes horizontally along the length of a block. A project by Palladio survives for a development of this sort, with pairs of apartments sharing access to a little courtyard with a well. Palladio shows his familiarity not only with Venetian housing, but also with Venetian ways of obtaining drinking water: the little circle which he draws in the outside walls are the pipes which conveyed rain water from the roof to the wells.[10] Rain water was also collected in the *campi* where it was filtered before reaching the public well.

The environment limited architects' choices: little flexibility was possible in planning palaces, and even churches were usually rebuilt on old sites. But despite these limitations, and the fact that Venetian patrons and *proti* (salaried architects and surveyors of works) were usually old (as in the Kremlin, only the old reached the top) Venetian architecture was vigorously innovative. Influential and cultured statesmen pushed for architectural change, and bypassed the local architectural hierarchy by invitations to gifted outsiders: the Florentine Jacopo Sansovino (1486–1570) came up from Rome; the Veronese architect Michele Sanmicheli (1484–1559) was also trained in Rome; Andrea Palladio (1508–1580) had worked in Vicenza.

Scamozzi observes that 'Venice has a great number of master builders and craftsmen in the building trades . . . for as the city is very large and populous, . . . and full of wealth, a very large number of buildings are always being built or rebuilt.'[11] A large group of patricians possessed vast fortunes, and the city's palaces impressed foreigners, not only by their size, but by what seemed, even to sophisticated Italians, an incredible profusion of carved stonework. 'He that will row through the Grand Canal', wrote William Thomas in 1549, 'and mark well the fronts of the houses on both sides shall see them more like the dwellings of princes than private men.'[12]

In the century after 1494 circumstances often placed the Venetian establishment with its back to the wall. In the field of architecture, as elsewhere, the response was generally rapid and effective. The worst of these crises was that of 1509, and the rethinking and reorganisation which followed had consequences not only for military and administrative policy, but also for architecture. There was a general renewal of the fortifications of the State, which from 1529 employed Sanmicheli as a military architect. In this capacity he designed the marvellous Porta Nuova and Porta Palio in Verona, and the gleaming and majestic fortress of Sant'Andrea al Lido, which guards one of the sea approaches to the city. He also designed the huge Palazzo Grimani on the Grand Canal.[13]

The technocratic bias of statesmen like Andrea Gritti (Doge from 1523 to 1538) had wide implications for architecture. It went with a recognition of the importance of prestige building and urban renovation as a means of impressing foreigners, of hinting at the wealth, know-how and determination of the Republic, and of boosting morale in a period when plague, famine and the Turks were constant menaces. Already in 1496 the diarist Malipiero recorded that 'a beginning was made this month on making the foundations of the Clock-tower ... and it will cost around 6,000 ducats. And although the building of the Palace has been somewhat suspended because of the Naples war, nevertheless, so that the city should not seem entirely without money, a start was made on this work.'[14] The need to avoid loss of face (and sometimes loss of state revenues) led to the rapid rebuilding of important buildings destroyed by fire: the Doge's Palace in 1483, the Scuola Grande di San Marco in 1485, the Fondaco dei Tedeschi in 1505 (fig. 8), and, most disastrous of all, the Rialto area, burnt down in 1514.[15] In each case the opportunity was taken to rebuild in a more impressive and functional way. The Fondaco, which served as warehouse, customs office, and hostel for the German merchants, had its plan regularised: from a central loggia one passes into a square arcaded courtyard. To compensate for the plain detailing, imposed by the Senate for reasons of economy, the exterior was decorated with frescoes by Giorgione and Titian.[16] The State also acted quickly after the fires of 1574 and 1577 which gutted the finest rooms in the Doge's Palace. But the final decision to rebuild the rickety wooden bridge at Rialto in stone was continually postponed. The technical problem of spanning the Grand Canal was considerable, but the real reason for lack of action was the cost. The present bridge (1588–91), designed by Antonio da Ponte using a single great arch (rather than the three arches favoured by Palladio and Scamozzi), cost 245,537 ducats; 16 bays of the Library had cost 28,000 ducats.[17]

The boasted similarities between modern Venetians and ancient Romans had, by the 1480s, encouraged the adoption of an *all'antica* style. It was characterised by ornate detail, and by free-standing columns, often raised on pedestals, as in Tullio Lombardo's Vendramin monument (*c.* 1493) and on the façade of the Palazzo Loredan Vendramin Calergi (begun 1502, completed 1509), which is usually attributed to Codussi (d. 1504).[18] Here for the first time a scheme of columns and pilasters was applied to a Venetian palace façade. By 1509 many leading patricians had become familiar with the architectural taste of Rome and Florence. Some, like Bernardo Bembo, had visited these cities as ambassa-

fig. 8 Fondaco dei Tedeschi, Venice; façade
(rebuilt after the fire of 1505)

dors; and the presence in Rome of Venetian cardinals from leading families increased contacts between the two centres. Venetian interest in Vitruvius had been stimulated by the much-read antiquarian romance, the *Hypnerotomachia Poliphili* (1499), and by the employment of the famous engineer and Vitruvian scholar Fra Giocondo, at a salary only slightly less than the ducat a day which he had demanded as 'I have to spend money on books and on the construction of various inventions, in which all my pleasure lies.'[19] With the publication of Fra Giocondo's illustrated Vitruvius (1511), of Serlio's architectural books (1537ff) of Daniele Barbaro's translation of Vitruvius (1556), illustrated by Palladio, and Palladio's own *Quattro Libri* (1570), Venice became the main centre for architectural publishing.

Antique influence is also evident in the church of S. Salvatore begun in 1507 after designs by Giorgio Spavento (Tullio Lombardo designed the details). This has a central nave vaulted with an alternation of domes and barrel vaults, and the main order, raised on high pedestals, anticipates the interior of Palladio's S. Giorgio. The war years (1509–17) and their aftermath saw a decline in building activity. The reconstruction of the Rialto (1520–22) was dictated by necessity; so too was the rebuilding by the Procurators of St. Mark's, who owned all the properties around the Piazza and

fig. 9 Scuola di San Rocco, Venice; façade by Scarpagnino

fig. 10 J. Sansovino, Marciana Library, Venice

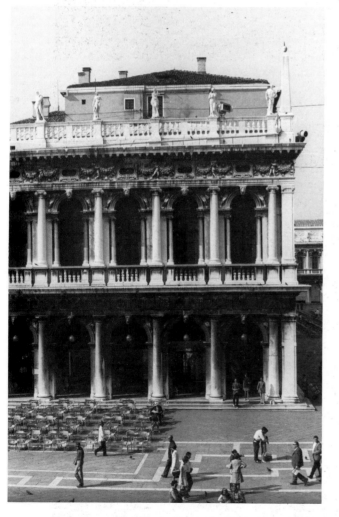

the Piazzetta, of the houses on the north side of the Piazza, again after a fire, 'in order to make it very beautiful for the glory of the city . . . in spite of the ear'[20] (fig. 12). In 1515 work began on the Scuola di S. Rocco, which was finished in 1549. The plan, with a columned lobby below, grand stairs, and an assembly hall and committee room above, follows the usual scheme for Scuole. What distinguished S. Rocco, and led the Scuola to be attacked for spending on display what should have been spent on charity, was the lavishness of the workmanship and decoration, which later included Tintoretto's famous paintings.[21] The façade, designed by Antonio Scarpagnino, is particularly extravagant, with its fluted columns, figured capitals, inlays of coloured stone, and little animals, including an elephant, on the plinths.

Scarpagnino's façade was probably meant to be 'antique', but it represents a taste which outside Venice was already outmoded. In Rome, Bramante had evolved a style not based on a profusion of bizarre motifs, but on formulae for the orders derived from a study of Vitruvius and the antiquities. Each order was seen as having a distinct personality, and as being appropriate for certain types of building. In the 1520s this approach had been introduced to Verona by Sanmicheli and to Padua by Falconetto. In 1528 Sebastiano Serlio, who had studied in Rome under Peruzzi, published engravings of the orders, which he followed up with his book on the subject (1537).[22] The new taste, favoured by Doge Gritti and other members of the political elite, and backed by influential intellectuals like Aretino and Pietro Bembo, was above all reflected in Sansovino's work. He had arrived in Venice in 1527, and in 1529 was appointed *proto* to the Procurators. For them he designed the Library (begun 1537, fig. 10), which Palladio called 'the most rich and ornate edifice that perhaps was ever built from the time of the ancients'.[23] It transformed the centre of Venice, not only by its majestic presence, but by setting the principal buildings in new relations to one another. Originally the huge campanile was hemmed in on two sides; by setting the corner of the Library back from the campanile Sansovino made the Piazza wider and even more impressive, and made it possible to see the Palace from the end opposite San Marco. He gave the Library only two storeys, Doric and Ionic, so that it should not rival the Doge's Palace in height, or seem too tall and narrow. Every detail plays its part in the composition, which is carefully thought out both for the frontal and raking views, and in relation to the Palace opposite. The larger number of columns on the upper level (the scheme of smaller columns carrying an arch is derived from the Roman arch at Aquino) balance those of the Palace's upper *loggie*, the balconies echo its balustrades, and even the oval windows in the frieze answer the roundels of the gothic tracery. One has only to change certain details in one's imagination to see how sure was the touch of the Florentine architect: the whole composition would be weakened if the little blocks in the balusters were removed – they reinforce a whole series of other chunky forms.

Sansovino held his position till his death at the age of 84: his reputation was only momentarily dented by the collapse of one bay of the Library in 1545. He responded fluently and competently to tasks as different as that of designing S. Francesco della Vigna, a church for Observant Franciscans dedicated to austerity; the Zecca (Mint), constructed with-

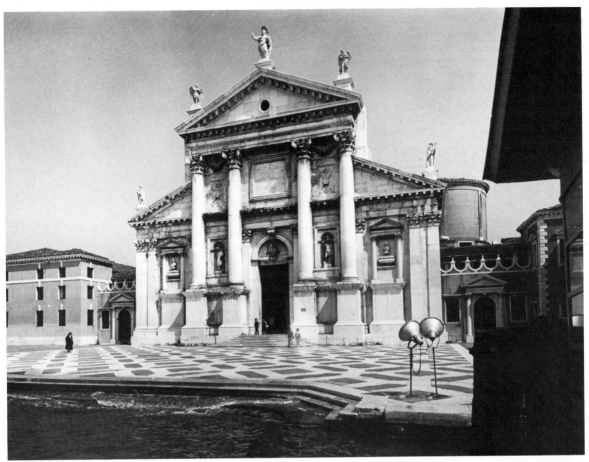

fig. 11 A. Palladio, S. Giorgio Maggiore, Venice

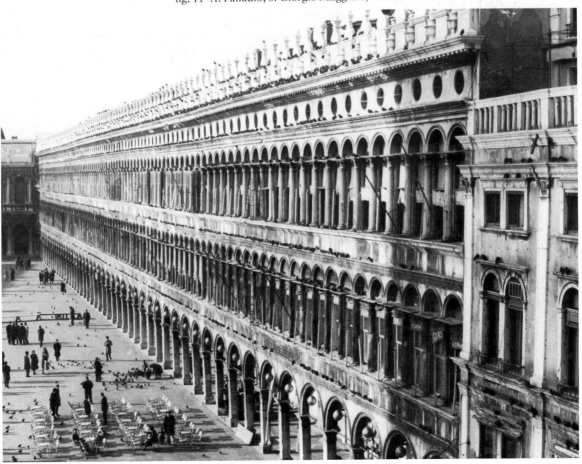

fig. 12 Procuratie Vecchie, Venice

out wood and with a suitably robust façade; the vast new palace for the Corner family; and the handsome, low-budget New Buildings at Rialto, constructed by the State as a source of rental income. But by 1560 a group of younger, highly educated patricians, just beginning to get to the top, seem to have regarded Sansovino as a brilliant reformer of Venetian architecture but as too unsystematic in his approach. For those who sought not only artistic flair and technical skill, but also an architecture based on principles and precise antique models, the great architect was now Palladio, who had made his name in Vicenza and had already designed numbers of villas for prominent Venetians.[24] In 1554 he had been turned down for the post of *proto* to the Salt Magistrates (responsible for public works), but through the Barbaro brothers and other patrician supporters he obtained a series of important Ventian ecclesiastical commissions. Then in the 1570s it was Palladio who was asked to design the votive church of the Redentore (1577–92), decided on by the Senate at the height of the 1575–77 plague, and to guide much of the restoration of the Doge's Palace after the fires of 1574 and 1577. His proposal to rebuild the Palace in his own style was rejected, despite Marcantonio Barbaro's eloquent support.[25] That Palladio should make such a proposal at all indicates something of the radicalism and disdain for local decorative traditions which distinguishes him from Sansovino, who always delighted in fusing Venetian and antique elements with the best in central Italian architecture.

Palladio's church of S. Giorgio Maggiore (fig. 11), designed in 1565, is perhaps his greatest masterpiece. He broke with Venetian tradition by creating a church which was brilliantly lit, finished in the interior in Istrian stone and brick covered in stone coloured plaster. The plan and elevation skilfully distinguish between different spaces and functions. The details are sensitively scaled to the whole: the overall effect is one of an extraordinary beauty and fitness. The order seems to grow up like a tree through the pedestals to the column bases, by way of flowing mouldings, to terminate in the capitals and entablature. The pilasters of the smaller order, which taper gently like columns, contribute to this organic, growing character.

The elimination of the public debt in the 1580s and 1590s brought with it the completion of the Redentore and the spanning of the Grand Canal by the new stone bridge.[26] Further palaces were constructed, most notably the handsome Palazzo Balbi (1582–90) designed by Alessandro Vittoria.[27] Palladio's old friends Marcantonio Barbaro and Jacomo Contarini outlived him, and continued to be regular members of official building committees. They transferred their support to another Vicentine, Vincenzo Scamozzi, who completed the Library and began the rebuilding of the south side of the Piazza.[28] The century thus ended, as it had begun, with intense building activity, which had never totally ceased despite war, plague and foreign threats.

The motives for building in sixteenth-century Venice were mixed: a desire to impress foreigners and to show them that Venice was not bankrupt or beaten, especially when this was near to being the truth; the necessity of replacing buildings destroyed by fire; the desire of very rich semi-public institutions like the Scuole and the great families to make a prominent mark; and a real love of architecture. The patronage of the Procurators, the Scuole and rich patricians cannot be considered as entirely autonomous: it was guided and controlled, like everything else, from the upper levels of the political establishment. Thus it was the State which partly subsidised the rebuilding of the Scuola di San Marco, which decided on the stair design at the Scuola di S. Rocco, and which put up 30,000 ducats for the rebuilding of Palazzo Corner.[29] All this was in line with the wording of a Senate resolution of 1535, with its perception of the role of effort and policy in the creation of Venice: 'our ancestors have always striven and been vigilant so as to ... provide this city with most beautiful temples, private buildings and spacious squares, so that from a wild and uncultivated refuge ... it has grown, been ornamented and constructed so as to become the most beautiful and illustrious city which at present exists in the world'.[30]

1] Serlio, IV, 1619, fol. 153v. On Venetian architecture in general see Paoletti, 1893; Heydenreich and Lotz 1974; Trincanato and Franzoi 1971; Howard 1980; Puppi (ed.) 1980.

2] Palladio, I, 1570, p. 52. On building techniques see Howard 1980, pp. 55–60; Sansovino 1663, pp. 381–83; Rusconi 1590; Fontana 1978.

3] Scamozzi 1615, Parte Seconda, p. 319.

4] For Palladio on bricks see Zorzi 1967, p. 89. On Istrian stone see Sansovino, 1663, p. 383; Scamozzi, 1615, Parte Seconda, p. 204.

5] Serlio, IV, 1619, fol. 153v.

6] Scamozzi, 1615, Parte Prima, pp. 242–43.

7] Sansovino, 1663, pp. 383–84.

8] Scamozzi, 1615, Parte Prima, p. 243.

9] Trincanato 1948; Schulz 1982.

10] London 1975, pp. 152–53 (Burns); cf. Sansovino 1663, p. 382.

11] Scamozzi 1615, Parte Prima, p. 86.

12] Thomas 1963, p. 65.

13] Gazzola 1960; Gallo, 1960; Puppi, 1971.

14] Malipiero, ed. Gar and Sagredo, 1843–44, p. 699.

15] Cessi and Alberti 1934, pp. 83–114.

16] Dazzi, Brunetti and Gerbino, 1941.

17] Cessi and Alberti 1934, pp. 171–223; Zorzi 1967, pp. 223–63; London 1975, pp. 123–28 (Burns); Maschio 1980, pp. 119–29; Lewis 1981; Burns 1979, pp. 119–20.

18] Puppi and Olivato Puppi, esp. pp. 221–26.

19] Dazzi 1939–40, pp. 876–80.

20] Howard 1980, p. 129.

21] Paoletti 1893, I, pp. 123–27; Malsburg 1976; Sohm 1978 (1981); Sohm 1978.

22] Dinsmoor 1942; Howard 1973.

23] Palladio, I, 1570, p. 5. On Sansovino see Tafuri 1969 and 1972; Howard 1975; Foscari and Tafuri 1983.

24] On Palladio see Magrini 1845; Zorzi 1959, 1965, 1967, 1969; Ackerman 1966; Puppi 1973 and 1975; London 1975 (Burns); Howard 1980; Lewis 1981; Foscari and Tafuri 1983, pp. 131ff.

25] London 1975, pp. 155–60 (Burns); Olivato, in Venice 1980, p. 102; Lewis 1981, pp. 204–05.

26] On Venetian public finance see Lane 1973, pp. 325–26.

27] Bassi 1976, pp. 124–30.

28] Barbieri 1952; Howard 1974; Howard 1975, p. 26.

29] Sohm 1978 (1981), p. 286; Sohm 1978, p. 148; Gallo 1960, p. 114; Howard 1975, pp. 132–46.

30] Zorzi 1967, p. 247.

ALTARPIECES

Terisio Pignatti

The purpose of this essay is to examine the development of the Venetian altarpiece as a compositional type during the sixteenth century, and in particular to show how this tradition was modified by the major artists of the period. For a variety of reasons this is by no means an easy task. Firstly, the period in question, spanning as it does the early Renaissance, the High Renaissance, Mannerism and the beginnings of the Baroque, was marked by radical changes in artistic theory, principles of composition and forms of expression. Secondly, within the orbit of Venetian painting there existed local schools with their own traditions and standards; and there was an especially marked discrepancy in quality between the products of Venice itself and those of the provincial centres of the mainland. Finally, it is often difficult to accommodate the very original and idiosyncratic contributions of the greatest masters within a rigid scheme of development. Nevertheless it is possible to discern some kind of pattern, whose origins can be traced back to the last quarter of the fifteenth century. At that time there emerged a distinctive formula for Venetian altarpieces, which was subsequently transformed in ways that can be seen in the present exhibition.

A starting point is provided by the visit which Giovanni Bellini must have made to Pesaro in connection with the commission for the grandiose *Coronation of the Virgin* (Museo Civico, Pesaro). This picture, which was almost certainly painted some time between 1471 and 1474, is radically different from an altarpiece which Bellini himself had painted about 1464 for the church of SS. Giovanni e Paolo in Venice. There he had remained faithful to the archaic formula of the polyptych, a scheme which continued to retain a certain popularity until the very end of the century, especially in the provinces. But in the Pesaro altarpiece the ornate frame of carved and gilded wood, enriched with a painted *Pietà* and 15 smaller pictures in the predella and uprights, surrounds a single large square panel which is treated as a unified space with a central vanishing-point. Within this space Christ and the Virgin are shown on an elaborate marble throne, flanked by four saints whose arrangement is analogous to an architectural niche, an impression accentuated by the pattern of foreshortened tiles on the floor. In its luminosity as much as in its architectonic grandeur this painting seems to reflect Bellini's direct experience of Piero della Francesca's altarpiece for the church of S. Bernardino in Urbino (now in the Brera, Milan), which dates from just this period.

Soon after his return to Venice, Bellini received a fresh impetus to follow the path on which Piero had set him, with the arrival in 1475 of another artist of exceptional originality, Antonello da Messina. In his altarpiece for the church of S. Cassiano in Venice (partly preserved in Vienna) Antonello showed the Virgin and saints framed by an architectural niche, much as Piero had done; but here for the first time the Virgin was placed on a high central throne, thus creating a stronger formal relationship between the figures and their setting. This scheme re-appeared, probably about 1487, in Bellini's *S. Giobbe Altarpiece* (Accademia, Venice), where the painted architecture was directly linked to the real architecture of the frame, giving the illusion of a chapel opening directly out of the church. The arrangement at S. Giobbe was to be further elaborated in 1510 by Carpaccio, whose *Presentation of the Virgin* (Accademia, Venice), painted for the altar immediately opposite Bellini's picture, provided a close counterpart to it.

At S. Giobbe Bellini gave the Venetian altarpiece the basic form which it was to retain well into the sixteenth century. He himself used a similar scheme in the church of S. Zaccaria in 1505 (fig. 20), and it was also adopted by lesser artists, for example by Alvise Vivarini, and by Cima in his altarpiece at Conegliano. Of course, each master modified the formula according to his own stylistic preferences; Bellini created diffuse chromatic harmonies by using subtle glazes, while Vivarini and Cima preferred clear smooth surfaces modelled by the harder light of the midday sun. In many altarpieces of these years we also find signs of a new pictorial interest in the natural world. Among works of the fifteenth century, this is true of Montagna's *Nativity* (Museo Civico, Vicenza) and soon after 1500 of Bellini's *Baptism of Christ* in Vicenza. But it was not until 1505 at S. Zaccaria that he created standard form of architectural structure in a landscape, establishing a formula that was to persist in Cima's work right up to his *St. Peter Enthroned* of 1516 (Brera, Milan). The most radical innovation in the process of combining the traditional scheme of the altarpiece with landscape, however, was taken by a younger artist who had emerged from the school of Bellini, namely Giorgione, in his picture at Castelfranco (fig. 13), painted about 1504.

In this masterpiece Giorgione profoundly modified the hieratic conception of the altarpiece established by Bellini, introducing a new kind of naturalism both in the setting and in the figures, which was to have a lasting importance throughout the sixteenth century. In its basic composition it may reflect the influence of Emilian artists such as Costa and Francia, but no less relevant was the contemporary intellectual climate in and around Venice, as manifested both in the interest in physical phenomena fostered by the study of Aristotle at Padua and in the arcadian poetry of Pietro Bembo, who is known to have been an admirer of Giorgione.

The freedom of expression and composition thus initiated by Giorgione soon found a widespread response among his

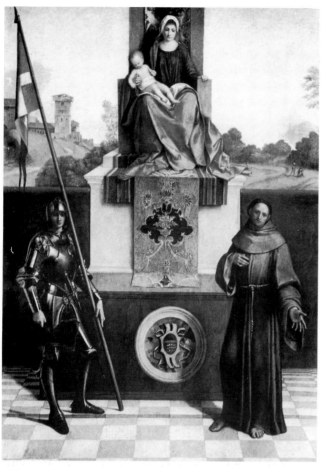

fig. 13 Giorgione, Castelfranco Altarpiece
(S. Liberale, Castelfranco)

reality of everyday existence to enter the sacred realm of the Virgin and saints.

In his *Assumption of the Virgin* (fig. 19), painted for the church of the Frari between 1516 and 1518, Titian's pre-occupation with sensual beauty and truth to nature even troubled the sensibilities of his Franciscan patrons. But his work was soon publicly acclaimed, and later Lodovico Dolce was to compare it to the masterpieces of Raphael and Michelangelo. Then in 1526, while he was still enjoying this success, Titian provided another picture for the same church, the *Pesaro Madonna*. Here again the real world is strongly in evidence, in the form of six members of the Pesaro family kneeling before a high podium on which are grouped the Madonna and saints. The composition is strikingly original, since the conventional frontal presentation is replaced by an oblique arrangement which emphasises the ascending movement towards the redeeming Virgin. In both these pictures a hitherto static type of design is transformed by dynamic movement and brilliant colour. This novel approach, which was to be Titian's greatest contribution to the tradition of the Venetian altarpiece, is still more evident in the most famous painting he ever produced, the *Death of St. Peter Martyr* (see fig. 14), which was installed in the church of SS. Giovanni e Paolo in 1530 and destroyed by fire in 1867.

The achievements of the other artists active in this period, both in Venice and on the mainland, are inevitably less significant. Probably the most influential of these lesser masters was Palma Vecchio, whose use of rich, sumptuous colour reveals a clear debt to Titian. He is particularly associated with a distinctive type of horizontal composition showing the Virgin with saints and donors in a landscape. The slightly pedestrian tone of his work, as well as his popularity in the provinces, contributed to the diffusion of this formula in the Venetian territory in Lombardy, where it exerted a certain influence on such painters as Previtali, Cariani and Licinio. There are links also between Palma and Lotto, especially during the latter's residence in Bergamo, where he developed an increasingly naturalistic style in which the emotions of the figures were echoed in the setting. Outstanding examples are the two great altarpieces of 1521, for S. Bernardino and Santo Spirito, in both of which Lotto used a formal scheme derived ultimately from Giorgione, but enriched by his personal experience of the work of Raphael. His profound sensitivity to the real world around him remained an important factor in his paintings of the 1530s for patrons in the Marches, such as the altarpieces at Jesi and Ancona (Cat. 49–50, 51). The ideals of another notable artist of this generation, Paris Bordone, place him somewhere between Palma and Lotto, at least in his earlier years; but he was more interested in colour than composition.

It is less easy to fit the altarpieces produced in other provincial cities into the pattern of development centred on Venice. Thus the major figures of the early sixteenth century in Verona, Cavazzola and Caroto, belong essentially to a tradition going back to Mantegna. The Brescian Romanino, by contrast, was at first more closely linked to the Venetians, for example in the altarpiece he painted in 1513 for the church of S. Giustina in Padua (now in the Museo Civico); but after he returned home his style became more naturalistic, under the influence of Leonardo's followers. The work of the other Brescians – Savoldo, Moretto and Moroni – shows a similar compromise between the aristocratic ideals

contemporaries, for example in Sebastiano's asymmetrically organised altarpiece for the church of S. Giovanni Crisostomo of 1510–11, although in this instance the example of the Florentine Fra Bartolomeo, who was in Venice in 1508, may also have been relevant. The clearest signs of Giorgione's importance, however, can be seen in the greater prominence given to landscape, especially by the aged Bellini in such works as the *St. Jerome* of 1513 (San Giovanni Crisostomo, Venice), the *Virgin and Eight Saints* of the same year (Murano) and the *Deposition of Christ* of 1515 (Accademia, Venice).

At about this time an equally revolutionary approach to religious painting in Venice was initiated by Titian, who emerged as an independent master around 1510. In a work of this period, the *Virgin and Child with St. Anthony and St. Roch* (Cat. 34), he was still deeply influenced by Giorgione, but in his picture of *Jacopo Pesaro Presented to St. Peter* (Cat. 113) he transformed the traditional altarpiece into a celebration, on a human rather than a celestial level, of a great Venetian family. The powerful realism of the figures probably reflects the impact made on the young artist by Dürer's *Madonna of the Rosegarlands* (Národní Gallerie, Prague), painted in Venice in 1506. In this masterpiece, which was a landmark in the development of Venetian naturalistic painting, Dürer had included portraits of the Pope and the Emperor as well as other contemporaries, thus allowing the

fig. 14 Martino Rota *Death of St. Peter Martyr*; engraving after the altarpiece by Titian formerly in SS. Giovanni e Paolo, Venice, destroyed by fire in 1867

of Venice and the realism of Lombardy. In the formal structure of their altarpieces they were often indebted to Venetian models, particularly to Palma and Lotto, but there was a greater emphasis on narrative content and, increasingly, a typically mannerist preciosity, as in Moroni's *Mystic Marriage of St. Catherine* of about 1570 (Cat. 67).

From the mid-1530s and more decisively after 1540 a new aesthetic ideal was taking root in Venice, derived from the Mannerism of Tuscany and Rome, which was superimposed on the traditional local idiom. At the time the contrast between these two approaches was seen in terms of '*buon disegno*', the central Italian preoccupation with form, and Venetian '*colore*', associated particularly with Titian. The effect on Titian's own work is immediately apparent, for example in his *St. John the Baptist* of about 1540 (Cat. 119), in which his concern for 'painterly painting' was subordinated to an assertion of Michelangelesque plasticity. Under the impact of Mannerism the Venetians soon abandoned the harmonious geometrical structures on which their painting had been based, as well as fidelity to nature and the unity

of time and space. Instead, their work became more unrealistic, more overtly dramatic and expressive. Even Titian adapted his style to this new conception of religious art, notably in his two versions of the *Martyrdom of St. Lawrence*, the first completed in 1559 (Gesuiti, Venice), the second in 1567 (Escorial).

A significant precursor of this development was Pordenone, whose altarpiece for the church of S. Giovanni Elemosinario in Venice (Cat. 78), painted about 1535, already shows mannerist features, both in the crowded and unnatural composition and in the rhythmic energy of the poses. But the most extraordinary manifestations of the new compositional structures appear in the paintings of Tintoretto, beginning around 1540. His *Christ Among the Doctors* (Cat. 99), for example, seems quite unrelated to any religious art produced in Venice up to that time. Another important innovator was Andrea Schiavone, who was largely responsible for introducing the sinuous figurative idiom of Parmigianino. He also played a major role in establishing a new type of composition in which figures and events are expressions of forms and feelings rather than geometrical images in an architectonic framework. Pictures such as his *Adoration of the Magi* (Cat. 89) of about 1547, or the *Adoration of the Shepherds* painted by his follower Mariscalchi around 1560 (Cat. 57), with their closely packed, highly agitated compositions, seem to anticipate the dynamism of the Baroque. The same is true of virtually the whole of Tintoretto's *oeuvre*, in terms both of the intense movement which pervades all the figures and of the dramatic nocturnal illumination, with the emphasis on broken highlights.

In the second half of the century several other artists were moving in the same direction, notably Jacopo Bassano and Palma Giovane, who approached the eclecticism of the Baroque, particularly in his figures, as for example in the *Pietà* of about 1611 (Cat. 71). Bassano, however, perhaps because he was brought up in the provinces, often seems to have been readier to revive compositional schemes more in keeping with the local traditions of the altarpiece. Particularly in his early works this was manifested by his choice of architectural motifs, and later by his arrangement of figures and by his adoption of a central vanishing-point, as in the *Adoration of the Shepherds* of around 1570 (Cat. 9).

The most serious attempt to reassert the distinctively Venetian approach to the altarpiece, however, was made by Paolo Veronese. In an early work such as his painting of 1551 for S. Francesco della Vigna in Venice (Cat. 133), he based his design directly in Titian's *Pesaro Madonna*. Later he tried to achieve a new equilibrium primarily through compositions based on a harmonious pattern of colours, for example in the altarpiece now in the Chrysler Collection, of 1562 (Cat. 135), or in the one he painted for S. Sebastiano around 1565. In such pictures the iconographic content is conveyed by brilliantly coloured figures arranged in the foreground, and by a highly refined draughtsmanship which gives his flowing forms a superhuman beauty. No painter better demonstrates how the intensely vital artistic culture of Venice was able to reject imported aesthetic ideals and once more assert the typically Venetian concern with chromaticism.

PORTRAITS

Lino Moretti

Portrait painting developed at an early date in Venice. Soon after 1339 Paolo Veneziano painted the portrait of the defunct Doge Francesco Dandolo together with his wife, who was still alive, over Dandolo's tomb in the Sala del Capitolo of the Frari. The figures are on the same scale as their patron saints (a very unusual feature for the period) and the faces appear to be authentic portraits, even if the style still follows the conventions of Byzantine painting.

In the reign of Doge Marco Dandolo (1365–68), a remarkable series of commemorative portraits of doges was started in the Sala del Maggior Consiglio in the Doge's Palace.[1] These portraits, which were destroyed in the fire of 1577, constituted a complete portrait gallery of heads of state painted by the greatest artists of each generation, from Guariento to Tintoretto. Between 1408 and 1422, in the same room, Gentile da Fabriano and Pisanello frescoed episodes from Venetian history (substituting an earlier cycle) and it seems likely that they introduced portraits into these scenes, particularly into that of the reconciliation of Frederick Barbarossa with the pope. Gentile was appreciated as a portrait painter in the early sixteenth century, when Antonio Pasqualino bought two 'very lifelike' portraits by him, and Michiel speaks of Gentile as if he were famous.[2]

The first independent portraits date from the second half of the fifteenth century. In Lazzaro Bastiani's *Portrait of Doge Foscari* (Museo Correr) the sitter is shown in profile, a format derived from Roman coins. Gentile Bellini was a distinguished portrait painter and was sent to Constantinople to paint the portrait of Mahomed II. Several portraits of doges were saved from a fire in the ducal apartments in 1483, and some by Bastiani (possibly the same ones) were recorded in 1581 as formerly in the Collegio of the 25. Perhaps these included the fragmentary portrait of Antonio Venier and Michele Steno shown seated in conversation (Museo Correr).[3]

In 1474 it was decided to substitute the historical frescoes in the Sala del Maggior Consiglio with paintings on canvas. This undertaking took almost a century to complete, only to be destroyed in the fire of 1577: Gentile and Giovanni Bellini, Alvise Vivarini, Carpaccio, Pordenone, Titian, Veronese and Tintoretto all contributed to the decoration. As well as Venetian patricians, famous Italian men of letters and poets were portrayed in these scenes; the list of names takes up a good four pages in Sansovino's *Venetia Città Nobilissima*.

This example was followed by the *scuole*, the lay confraternities run by merchants and citizens excluded from politics because they were not of noble blood (Venetian nobles were barred from entry to the *scuole* after 1500). In the fifteenth century members of the confraternities had been painted kneeling at the feet of their patron saints, as in Bartolommeo Vivarini's polyptych in S. Maria Formosa (1474) and the one he painted for S. Ambrogio (1477; Accademia, Venice). But when the *scuole* established their own premises, the members decorated the assembly halls with large canvases in which the members were portrayed participating in episodes from the life of a saint (Carpaccio's *St. Ursula Cycle*; Accademia) or witnessing miraculous events which took place in the city (cycle for the Scuola di S. Giovanni Evangelista by Gentile Bellini and others; Accademia). During this period there was a vast growth in the number of individual portraits, which were by now fashionable both with the patricians and the merchant classes.

Antonello da Messina's presence in Venice (1475–76) marked a turning point in the development of Venetian portraiture. His sharp perception of character, revealed in the slight curve of the lips or eyes, is combined with a remarkable sense of volume and depth, while his intense light effects were derived from the work of the Netherlandish artist Petrus Christus. The words of St. Jerome fit his portrait style perfectly: 'the face is the mirror of the spirit, and the silent eyes reveal the secrets of the spirit'. Giovanni Bellini immediately recognised the value of Antonello's compositional methods, but Bellini's instinctive habit of 'thinking in paint' was not accompanied by such a marked interest in the idiosyncrasies of the sitter's character, as can be seen in his masterpiece of abstraction, the enigmatic *Portrait of Doge Loredan* (National Gallery, London). The markedly three-dimensional quality of the figure, created by Bellini's use of light, underlines the relationship between painted portraits and contemporary Venetian sculpture.

According to Vasari, Giorgione also painted a portrait of Doge Loredan, but this official painting has been lost, and the identity of sitters in Giorgione's surviving portraits is either uncertain or unknown. Instead of concentrating on the individual's physical characteristics, Giorgione either portrayed their state of mind or emphasised one aspect of their personality. The lighting is usually shadowy, and these portraits were almost certainly designed to be displayed in the intimacy of 'studioli', among books, curios, statues, and other collector's items. After the Venetian defeat at the rout of Agnadello in 1509, when the very existence of Venice seemed threatened, it was fashionable to cultivate the melancholy illusion that 'litteris servabitur orbis' (the world will be saved by culture). The dark tonality and lack of outline of Giorgione's portraits are the artistic equivalents of the fleeting psychological glimpse we are afforded of the sitters, whose lips do not express character (as in Antonello's paintings) but are sealed, as if concealing a secret. Often the sitters are placed behind a parapet, and their hands are an import-

ant expressive element in the portrait. Objects with an emblematic significance and books are often included to emphasise the sitter's humanist culture and poetic sensitivity.

By the beginning of the sixteenth century portraits, apart from recording a sitter's appearance for posterity, had become status symbols. By painting portraits the artist defeated both time and death: Bernardino Licinio inscribed on the portrait of his brother's family (Cat. 41) that the painter 'prolongs life for them with their image, and his own with his art'.

Vincenzo Catena, a colleague of Giorgione's with connections in humanist circles, developed Bellini's schemes in his portraits, but adapted them to the taste of the High Renaissance. Palma Vecchio adopted the broad forms and fresh colour of Titian's youthful style, but rather than stressing the individuality of his sitters he tended to paint generalised ideal types, as is evident in his portraits of men and of voluptuous, blond women decked in luxurious clothes. Portraits of women became increasingly common during the sixteenth century; not only beauties were painted, but also solid citizens and women of a certain age.

The Bergamasque Bernardino Licinio was a follower of Giorgione, though for his portraits he developed a homely manner that suited his clients, who were often of modest stock. Paris Bordone was a pupil of Titian's, but also imitated Giorgione in his youth. In his *Presentation of the Ring to the Doge* (Accademia, Venice), painted for the Scuola di San Marco, he included a remarkable group portrait of dignitaries, each one highly individualised. But despite this he does not appear to have received any official portrait commissions.

Lorenzo Lotto remains apart from his contemporaries. In his youth in Venice he painted several portraits remarkable for their freshness, which retain something of the spirit of Alvise Vivarini and Dürer. Thereafter his restless spirit led him to Rome, to the Marche, and to Bergamo. His sitters seem to take on his own somewhat pensive, melancholic and God-fearing temperament. His figures are positioned obliquely, their heads slightly tilted; often his portraits have religious overtones; amulets, religious medallions, emblems and rose petals (an allusion to the brevity of life) are included; even the oblique lighting evokes a sense of transience. In spirit these portraits are very far from the assurance of the 'humanist' portraits of the beginning of the century: Lotto seems to oscillate between despising the base and vain qualities of earthly life and yearning for a return to simple Christian virtues. It is therefore understandable that he was never asked to paint the portrait of a doge or any other official, and that he himself preferred to paint portraits of married couples, even if they were a little unrefined and provincial; such commissions could inspire him to produce more poetic images, and to express sincere human emotions.

When Giorgione died in 1510, Titian, who must have been barely 20 at the time, was already a successful painter. From 1513 he secured several official commissions, and between 1521 and 1554 he painted the portraits of six doges in the Sala del Maggior Consiglio. Titian's sitters occupy space with greater confidence, and take up more of the canvas than in earlier portraits. Whereas Giorgione's portraits never exceeded the half-length, portraits now began to expand downwards well below the waist. At the same time full-length portraits first appeared in Italy (although not in

Venice). These were derived from German portraits and were soon extremely popular in Italian courts. There were only two precedents for this format in Italian painting: one by Carpaccio of 1510 (Lugano) and the other by Moretto of 1526 (National Gallery, London).

Wilde pointed out a fundamental characteristic of Titian's portraiture: from early in his career 'history painting exerted a fruitful influence on portraiture: motives and methods which had been invented for monumental compositions were drawn upon to enrich and transform the portrait'. In addition 'both public and artists in the Cinquecento looked for a kind of likeness different from what the previous century understood by this word.... The new likeness is intended to give not only the social position of the sitter, but also his character and the whole of his personality. This involves his status and rank, his profession, the power he wields and the position he holds'.[4] Titian's portraits, with their chromatic intensity, exuberant outbursts of colour, high rhetoric, ingenious compositional schemes and lucid and unrelenting psychological and moral understanding always enrich our intellectual experience.

It was customary for each doge to commission a votive painting of himself with the Madonna and some chosen saints to be placed in the Collegio or the Senate (eg. Catena's painting of Doge Loredan of c. 1505; Museo Correr). By the middle of the century the cult of personality had become so strong that it was accepted that the magistrates would also commission votive paintings for their offices. The Provveditori al Sale who held office between 1552 and 1553 placed a large votive painting of themselves with the Virgin in their rooms at the Rialto: before that date it had been customary to commission pictures of their patron saints which only included their coat of arms. The Provveditori were followed by the Camerlenghi (Chamberlains), another group of financial magistrates of the Rialto, and later the practice was adopted by officials at the Doge's Palace (the Avogaria and Censori). Whereas temporary and collegiate magistracies commissioned group portraits, the Procurators, dignitaries inferior only to the doge, had their own individual portraits in their rooms.

The artist who had, in effect, a monopoly of these official portrait commissions was the inexhaustable Jacopo Tintoretto. In addition to public portraits, he, assisted by his workshop, produced portraits of magistrates, senators and sea captains for their private residences. Even far less important officials would have their portrait painted, and the popularity of this type of portraiture demonstrates the extent to which Venetians identified with these official images of themselves and their society.

Tintoretto focussed attention on the face and hands of his sitters – the most revealing features – whilst the rest of the figure would be only summarily sketched; often he would repeat the same composition and lighting for different sitters; hence the obvious similarity between his portraits. Their success is proof that Tintoretto was the ideal interpreter of society at a time when the Renaissance conception of the individual was being superseded by a more conformist Counter-Reformation stereotype. To understand the change that took place in 30 years one only has to compare the *Portrait of Ottaviano Grimani* (Vienna), painted in 1541 by Licinio, which is still humanist in spirit, to Grimani's official portrait in the uniform of a Procurator painted in Tintoretto's

workshop in 1571 (Accademia, Venice).

In contrast, Paolo Veronese rarely painted official portraits, although in about 1562 he did execute a painting including eminent contemporary Venetians (now destroyed) in the Sala del Maggior Consiglio. His style of portraiture was unsuitable for official portraits; his luminous painting and harsh colour harmonies appealed to a very different clientele, to rich merchants and the landed aristocracy (who perhaps, like Doge Alvise I Mocenigo, despised the commerce which had created the wealth of Venice) and to the gentry of the *terraferma*. Veronese's style was ideally suited to represent the aristocratic ideals of these individuals who, because of their great wealth, could easily imitate the customs of the nobility. It was natural, therefore, for Sir Philip Sidney, who modelled his behaviour on Castiglione's *Book of the Courtier*, to choose Veronese to paint his portrait (now lost) when he went to Venice.

Pope-Hennessy remarked that Veronese '... was not a face-painter like Tintoretto, and his independent portraits are more decorative and more opulent. But more often than not, once the head is excised from its setting, it looks nerveless and a little dull. Analysis was alien to the cast of Veronese's mind. Yet when his heads are animated, they shed much of their flaccidity and take on a new liveliness'. This is true of the portrait of the parish priest of S. Pantalon, Bartolomeo Borghi, shown holding the dead boy in the altarpiece from his church (Cat. 147): 'there is nothing ostentatious or rhetorical about this image; it shows the priest in the role he played in life, his features stamped with pastoral solicitude'.[5]

During the sixteenth century Brescia and Bergamo, two Lombard cities under Venetian rule, produced artists who combined Venetian colour with Lombard realism. Girolamo Savoldo, a Brescian who spent many years in Venice, was a complex artistic personality. His austere, intense and pensive portraits with a restricted range of colours combine a slightly Giorgionesque mood with the intimacy of the Flemish style.

Alessandro Bonvicino, called Moretto, worked exclusively in Brescia and its environs, portraying the provincial aristocracy. He was influenced by Lotto and Savoldo, yet preserved the silvery tonalities of earlier Lombard painters, despite the occasional hint of Titianesque colour. The decoration of a room in the Palazzo Martinengo, Padernello (1543) with the portraits of eight noblewomen who look out on a landscape which apparently represents the family estate is indicative of the feudal society for which Moretto worked.

It is not clear exactly how Giovanni Battista Moroni, a Bergamasque pupil and collaborator of Moretto, came to know Titian's portraits; in any case, he adapted Titian's compositions to a different end: that of producing 'natural' portraits, as they were dubbed by Titian (who evidently had a very different conception of portraiture). Moroni's clients were the *jeunesse dorée*: city swells, country landowners and soldiers, who, following courtly conventions, would commission full-length portraits. They were acutely self-conscious, obsessed by their appearance, and their portraits are ostentatiously adorned with emblems and mottos in Latin or Spanish. It seems likely that Veronese knew these portraits. Moroni painted Venetian patricians who owned property in the provinces, but he also portrayed less exalted individuals, such as *The Tailor* (National Gallery, London); his sitters appear to have been caught unawares, and in their expressions reveal both their character and their idea of their position in society.

It is significant that for centuries many of Moroni's finest portraits (such as Cat. 66) were ascribed to Titian. Although we can see today the differences in their approach, we can also see not only that both artists, working at different ends of the Venetian domain, nonetheless shared basic assumptions about the role of art as a means of ennobling and recording the society of their day, but also that both of them exploited to the full the technical mastery in the handling of paint that was the special glory of the Venetian school.

1] Sanuto 1733, col. 664
2] Frimmel 1888, p. 78
3] Gallo 1943, p. 47, no. 2
4] Wilde 1974, p. 224
5] Pope-Hennessy 1966, pp. 287, 289

SELECT BIBLIOGRAPHY

Burckhardt 1898, (*Das Porträt in der Malerei*); Castelnuovo 1966; Pope-Hennessy 1966; Rearick 1981; Zeri 1976[2]

'POESIE' AND PAINTED ALLEGORIES

Charles Hope

In October 1510, very shortly after the death of Giorgione, Isabella d'Este wrote to a friend in Venice asking him to acquire 'a picture of a night', which she thought had been left in the artist's studio. Isabella's letter suggests that she did not know much about Giorgione; and what mattered to her about the painting was evidently not the subject, but the fact that it was of a type very unusual in Venetian art up to that time, a night scene. In fact, Giorgione's work seems to have been novel in two ways: he not only initiated a new manner of painting, rejecting the hard outlines of Bellini and his followers in favour of a softer style more suited to the representation of nature, he also seems to have been the first artist in the city whose output consisted predominantly of non-religious subjects for private collectors.

In attempting to account for these innovations, scholars have often speculated about the possible influence on Giorgione of contemporary literature and philosophy, something for which there is virtually no evidence in the surviving historical sources. But even granted that this high culture might have had some relevance for the subject-matter of his paintings, it is by no means clear why it should have prompted him to adopt a new style – a common enough phenomenon, after all, in the history of art. It is likely that the style came first, and that the subjects were then chosen to display its potential to the full, because in other respects these seem to have little in common with one another. One of the paintings recorded by his near-contemporary Marcantonio Michiel illustrated a traditional religious theme, St. Jerome

in the desert, which he then transformed by giving it a moonlit setting; another, *Aeneas and Anchises in the Underworld*, was taken from a familiar literary text, and this too was evidently a night scene; a third, the *Venus* (Dresden), was based on the legacy of classical mythology; while the *Tempesta* (fig. 5), which Michiel described simply as 'the small landscape on canvas with the storm, with the gypsy and the soldier', seems entirely enigmatic. Even now no one knows whether this is a representation of an obscure legend, a learned allegory, or just a picturesque landscape.

The best evidence, perhaps, that Giorgione's pictures were not particularly esoteric in their meaning is provided by the fact that while his stylistic innovations were widely adopted, the distinguishing feature of virtually all Venetian non-religious painting in the first half of the sixteenth century is the lack of learned or literary content. At the least, this suggests that most patrons in Venice at this period did not think that the subject-matter of paintings in private houses necessarily ought to be erudite. Titian's closest approach to Giorgione in both style and content, the *Three Ages of Man* (Edinburgh), is an allegory, to be sure, but of a transparently simple and rather commonplace kind; and even his so-called *Sacred and Profane Love* (Villa Borghese, Rome), which in the past has been considered a learned painting *par excellence*, based on abstruse ideas of neoplatonism, may have been a perfectly straightforward celebration of a marriage, showing the bride with Venus.

Many of the non-religious paintings of this period, in fact,

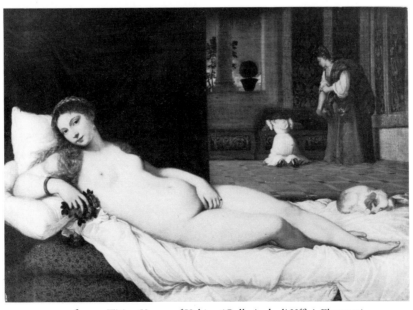

fig. 15 Titian *Venus of Urbino* (Gallerie degli Uffizi, Florence)

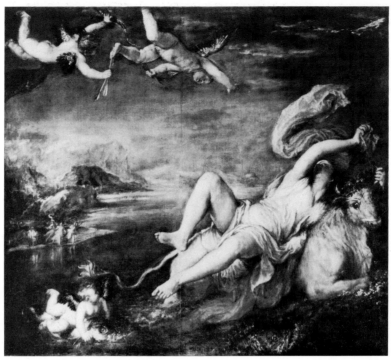

fig. 16 Titian *The Rape of Europa* (Isabella Stewart Gardner Museum, Boston, Mass.)

are virtually without conventional anecdotal content, notably the pictures of beautiful women produced by Palma Vecchio (Cat. 74), Titian and others. This was a type of painting that goes back to Giorgione himself; and it even includes Titian's so-called *Venus of Urbino* (fig. 15), which is almost certainly a representation of a mortal woman in a contemporary setting, not a goddess. The picture was described in 1538 by its first owner simply as 'the naked woman'; and the same phrase was used in 1598 by a man writing to the Duke of Urbino to ask for a copy. Evidently embarrassed by this request, the Duke asked that he should not be identified as the owner, and explained that he only kept this 'lascivious work' in his collection because it was by Titian; but he did not suggest that the painting actually belonged to the respectable genre of mythology. Even compositions by Venetian artists with several figures were often surprisingly unspecific in their subject-matter. Palma Vecchio's painting in Vienna (Cat. 77), for example, is often called *Diana and Callisto*, since art historians are accustomed to give pictures precise titles of this kind. But there is nothing in the composition to indicate the presence of Diana, and it seems just to show a group of nymphs bathing.

A picture such as Palma's would probably not have been acceptable to the Duke of Ferrara, Alfonso d'Este, who between 1518 and 1525 commissioned a series of Bacchanalian pictures from Titian, including the famous *Bacchus and Ariadne* (fig. 18). These were to decorate his study, and they were meant to be explicitly *all'antica* in both style and content; indeed, the subjects were largely based on descriptions of lost classical paintings. But when the Duke, who was evidently unaware of the casual attitude of Venetian artists to erudite subject-matter, commissioned the first painting in the series, Bellini's *Feast of the Gods* (National Gallery of Art, Washington), he did not bother to provide the artist with detailed instructions. This was understandable, because Alfonso simply wanted an illustration of a familiar episode from Ovid, the story of Lotis and Priapus. Unfortunately, the notion of classical authenticity meant nothing to Bellini, and he painted instead a mediaeval version of the legend which was readily available in a printed Italian paraphrase of the *Metamorphoses*. This was a popular subject in Venice, and may also have been used by Giorgione. But after Bellini's picture was finished, it had to be changed to satisfy Alfonso's requirements; and when Titian was first employed on the project he was given a specific text to follow.

In general, authentically classical subject-matter was almost always important to patrons elsewhere in Italy. The *Venus of Urbino* is exceptional in this respect; and when Titian supplied further pictures of reclining naked women to his non-Venetian patrons, he gave the figures the attributes of Venus or Danäe. The painting of *Danae* (Prado, Madrid) which he sent to Philip II of Spain in about 1550 encouraged the king to commission a whole series of mythologies based on Ovidian themes, which are among the artist's greatest and most influential works (fig. 16). Although some scholars have tried to argue that these were allegorical in intent, there is nothing in the many surviving documents about them to support this kind of reading. The term which Titian himself applied to them, *poesie*, makes it clear that they were meant to be regarded in the same way as poetry, in this case ancient poetry; and here it was the way in which the artist recounted the familiar myths, not some hidden meaning, that really mattered. This is made abundantly clear by a long eulogistic description of one of these pictures, *Venus and Adonis*, written by Titian's friend Lodovico Dolce in 1554 or 1555.

By this period there already existed in Venice, as in the rest of Italy, a quite distinct and developed pictorial language

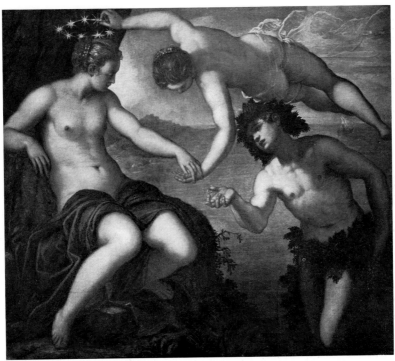

fig. 17 Tintoretto *Bacchus and Ariadne* (Doge's Palace, Venice)

for allegory very different from the kind of imagery that we find in Philip's paintings. Its basis was the use of individual figures to personify abstract qualities such as vices and virtues. This was a very old tradition in Italy, but at about this time new fashions in the decoration of public buildings and triumphal entries had led to a great expansion in the repertoire of such personifications. In Venice the earliest elaborate surviving examples are the ceilings painted by Veronese and his collaborators in the Doge's Palace, particularly those in the rooms of the Council of Ten, executed between 1553 and 1556 on the basis of a slightly incoherent programme devised by Daniele Barbaro, and the one in the Sala del Collegio, dating from about 1575–78. They include personifications very similar in character to those found in Florence and Rome in these years, but often with a less learned choice of attributes. Veronese's figure of *Industria*, for example, is not based on an erudite text, as one would expect in central Italy, but on a woodcut in a printed book, Marcolini's *Le Sorti*, which showed a woman sewing, with some ants beside her. Veronese retained the sewing-basket, but because ants would not have been visible in a ceiling painting he replaced them with a spider making a web, an equally self-evident symbol of industriousness, but one that contradicts the interpretation of the spider's web given in the most authoritative contemporary source, Valeriano's *Hieroglyphica*, where it is said to signify 'useless labour', a reading that can hardly have been meant in the context of the Doge's Palace.

Mixed in with such figures were the familiar classical gods, who were also to be understood as personifications – Mars representing military power, Neptune rule over the sea, and so on. Any intelligent observer, of course, would have understood that these figures were included for allegorical reasons, whereas in Titian's *Venus and Adonis*, for example, the goddess was merely the protagonist of a tragic and touching story. And it is the context, above all, that also makes it clear that a series of mythological themes painted in 1577–78 by Tintoretto for the Atrio Quadrato in the Doge's Palace, and now in the Anticollegio, were to be read as political allegories. These even include one of the subjects that Titian had painted for the Duke of Ferrara half a century earlier, *Bacchus and Ariadne*. But whereas Titian had shown the god's sudden encounter with Ariadne (fig. 18), Tintoretto depicted their marriage, with Venus crowning the bride with stars. Here Ariadne personifies Venice, born on the seashore and made immortal by divine favour (fig. 17).

Venetian painted allegories from the second half of the sixteenth century were to be of great importance for later artists throughout Europe; much more so, indeed, than works of this type by their contemporaries elsewhere in Italy. This was not so much because of their content – since in this respect Venetian programmes were distinctive only in their relative incompetence – as of their style, the way in which the great painters were able to make such abstractions plausible. Tintoretto's mythological allegories in the Doge's Palace, for example, were a major source for several of Ruben's most outstanding works, such as the *Consequences of War* (Palazzo Pitti, Florence); and the Flemish artist also retained an interest in the work of Veronese throughout his career. But the Bacchanals and *poesie* of Titian and later imitations by Veronese (Cat. 145, 146) were even more important for the seventeenth century, since they virtually created a new genre of painting. Indeed, it is one of the paradoxes of the history of art that the European vision of classical mythology was mainly established not in Rome, where the visible remains of antiquity were all around, but in Venice, and above all by Titian in his paintings for the Duke of Ferrara and the King of Spain.

THE HISTORIANS OF VENETIAN PAINTING

Charles Hope

The familiar outline of the history of Renaissance art, indeed the very idea of the rebirth of the visual arts, was first established by Giorgio Vasari, whose *Lives of the Most Excellent Painters, Sculptors and Architects* was published in Florence in 1550, with a second and much expanded edition appearing in 1568. Vasari divided his text chronologically into three sections. The first was devoted to the period before 1400, initiated in painting by Cimabue and Giotto, the second to the fifteenth century, when artists, particularly in Florence, learnt how to represent the natural world in a realistic way, and the third to the modern age, when the achievements of the ancients were matched and then surpassed, above all by Michelangelo and Raphael. This scheme gave pride of place to Florence and Rome, and its durability reflects Vasari's brilliance in creating a coherent history of developments in and around those cities. He knew much less about Venice and northern Italy, but his influence on later historians of Venetian art has been equally inescapable.

Everything that Vasari said about Venice in his first edition was based on recollections of a visit he had made to the city in 1541–42, before he had seriously begun collecting material for his book. As he described it, the development of painting there followed the pattern of central Italy, with the major figure of the fifteenth century Giovanni Bellini and the initiator of the modern style Giorgione, whose role was analogous to that of Leonardo da Vinci in Florence. According to Vasari, Giorgione was the first to reject the dry, hard and laboured style of Bellini, softening the outlines of his forms, introducing dark shadows and giving his pictures 'a formidable movement'; and these innovations were soon adopted by a much greater painter, Titian. In the 1550 edition Vasari had very little to say about Titian, because Michelangelo was the only living artist to be given a biography of his own. But he was scarcely more informative about dead Venetian masters, apart from Bellini and Giorgione. For the fifteenth century he did little more than provide a list of names, the most prominent being that of Carpaccio, with whom, surprisingly, he associated the sixteenth-century Brescians Moretto and Romanino; and among the moderns he mentioned only Palma Vecchio, Lotto and Pordenone, together with a few painters in Verona. For Vasari, in fact, Venetian painting was of no more than marginal interest.

While preparing his second edition he made a very brief trip through northern Italy in 1566, stopping in Venice for less than a week. During his stay he assiduously visited churches and public buildings, making notes about the pictures he saw, but he did very little to remedy his ignorance about the Venetian cities on the mainland. Although he now included extensive material on painters still alive, Vasari added only two biographies of Venetians. One was inevi-

tably devoted to Titian, then the most famous artist in Europe, the other to the mediocre Battista Franco, who had spent most of his career in central Italy. Other artists were also mentioned, but often without being given the prominence they deserved, for example Bonifazio, Schiavone and Jacopo Bassano. Vasari was a little more informative about Paris Bordone, but otherwise he provided a comprehensive account of the work of only two Venetian painters, both of the younger generation, namely Tintoretto and Veronese.

Given his very limited knowledge of Venice, it is not surprising that in 1568 Vasari did not really try to recount the recent history of Venetian art, but simply recorded what he had seen. His own tastes and preconceptions would in any case have made it difficult for him to have done much more. For Vasari, good art was primarily concerned with the idealised human figure, and it was necessarily based on *disegno*, the use of drawings to elaborate and perfect formal inventions conceived in the mind. *Disegno*, in fact, was the foundation of all the visual arts, and its greatest exponent was Michelangelo. But in Venice preparatory drawings were never as important in the creative process as they were in central Italy. Moreover, by the 1560s it was a commonplace that the outstanding quality of Venetian painting was *colorito*, the actual business of applying paint to canvas, which was a craft skill primarily concerned with the imitation of nature rather than an intellectual activity. Since Vasari's history of art was essentially a history of *disegno*, he therefore could not readily accommodate the Venetians in his scheme. Indeed, he regarded them as fundamentally misguided.

In his treatment of Venetian art, Vasari repeatedly returned to this theme. The revolution wrought by Giorgione, as he described it, was a new approach to *colorito* which allowed a more perfect imitation of nature. Similarly, Titian was characterised as an artist unrivalled in *colorito* but prevented from achieving supreme excellence because he did not recognise the importance of drawing. Palma Vecchio, too, was dismissed as an imitator of nature, whereas Schiavone, whose debt to Parmigianino, whom Vasari admired, was too evident to be missed, had for this reason 'sometimes produced good things by accident'. Tintoretto and Veronese presented a much greater problem, since Vasari was well aware of their exceptional talent. He could find nothing to criticise in the work of Veronese, but adopted a slightly patronising tone, calling him 'Paolino', implying that he was little more than a beginner and relegating his paintings to the biography of the architect Sanmicheli. Vasari's comments on Tintoretto were for the most part equally positive, and included many of his favourite terms of praise – rapid, resolute, capricious, extravagant, stupendous. But he also

complained that the artist did not give enough attention to perfecting his inventions and he deplored the lack of finish in his paintings. Vasari, in fact, always suspected that the bravura, sketchy type of brushwork favoured by so many Venetian artists was a means of concealing deficiencies in *disegno*.

What is missing from Vasari's text is any adequate explanation of how the Venetians of the later sixteenth century came to paint as well as they did. One might therefore have expected that this task would have been undertaken by one of the local writers on painting in the next century, Carlo Ridolfi and Marco Boschini. Ridolfi, indeed, set out to amplify Vasari's account and bring it up to date, publishing in 1648 a collection of biographies of the painters of the Venetian State, thus making explicit the geographical delineation of Venetian art already implied by his predecessor. Unfortunately, he had none of Vasari's gifts as a historian, and confined himself to describing pictures and recounting anecdotes without giving his material any coherent shape. Boschini, whose most important book appeared in 1660, was more perceptive; but his purpose was to challenge Vasari's critical standpoint, not his history. In particular, he denied the pre-eminence of *disegno*, arguing that this merely provided the painter with his framework, which he could only transform into great art by means of *colorito*, as the Venetians had been the first to recognise. Thus Boschini gave added authority to Vasari's contention that Venetian art was primarily concerned with *colorito*, at the same time greatly exaggerating the role of Giorgione, about whose work he knew almost nothing.

Boschini's greatest strength was in his recognition of the crucial importance of Venice for artists of the seventeenth century, an influence that involved not just *colorito*, but also figures and compositions of a kind very different from those used by the Mannerists of central Italy, such as Vasari. By his day this was generally admitted, but it did not lead to a substantial reconsideration of the history of Italian painting as a whole. Thus for Bellori, in 1672, the history of art was still centred on Florence and Rome, so that he could say without any incongruity that the Carracci had revived the dead art of painting in the 1580s, then adding a few pages later that this had happened after Annibale Carracci had met Tintoretto, Veronese and Jacopo Bassano in Venice, all of them very much alive. A less parochial view was first expressed in print in Modena in 1657 by Francesco Scanelli, who divided Italian painting into different 'schools'. The first was the Tuscan school, which reached its highest point in Raphael and then entered a catastrophic decline in the work of the Mannerists; the second was the school of the Venetian State, brought to perfection by Titian and maintained there by Veronese; the third was the Lombard school, whose greatest figure was Correggio. For Scanelli, as to some degree for Bellori, seventeenth-century painting was derived from these three sources, but in the first instance from Venice and Lombardy.

The notion of distinct schools, which inevitably underlined the differences between the Venetians and the despised Mannerists, was given its most intelligent statement by Luigi Lanzi in 1795. But rather than treating Venetian art as a single tradition he fragmented it still further into various subschools, headed respectively by Giorgione, Titian, Tintoretto, Jacopo Bassano and Veronese. By his time local antiquarians had begun to discover documents about Renaissance artists, and this enterprise became increasingly important in the nineteenth century. But even now, because of the evidence that has survived, we know much more about painting in Florence and Rome than in Venice, especially before 1550. Thus dates ranging over a decade or more are proposed even for major pictures by Titian, while no two scholars can agree about the attribution or precise chronology of paintings by Giorgione.

The art historian obviously not only has to establish who painted what, and when, but also to create a coherent pattern from this data, to place each artist in a wider context. In dealing with sixteenth-century Venice, scholars have been greatly influenced by the early historians. Thus it is generally agreed that Giorgione brought about a major change in the local tradition, introducing a new kind of naturalism based on a distinctive type of *colorito*; while to explain subsequent developments it is now customary to apply a historical scheme similar to that of Florence and Rome, where a 'classic' High Renaissance was supposedly replaced by the more overtly anti-naturalistic style of Mannerism. In Venice this change is usually said to have taken the form of a 'Mannerist crisis' around 1540, when the placid course of Giorgionesque naturalism was rudely interrupted by the introduction of formal elements from central Italy. Such borrowings permanently enriched the language of Venetian painting, but in the second half of the century a renewed assertion of the traditional concerns with naturalism and *colorito* led to a new 'classic' synthesis in the work of Titian, Tintoretto, Veronese and Jacopo Bassano.

This scheme has the merit of taking into account the manifest debt of many Venetians to their contemporaries elsewhere in Italy, as well as challenging the idea, common since the nineteenth century, that their art was largely hedonistic. But in several respects it seems inadequate. In particular, it involves a gross oversimplification of the situation before 1540, when the variety of styles current in Venice and on the mainland was greater than at any other period. To characterise Titian, Lotto, Palma Vecchio, Bordone, Bonifazio, Savoldo and Pordenone as naturalistic followers of Giorgione is to say very little about them, especially as the term naturalism is derived from Vasari, who used not to define a quality these artists possessed, but ones they lacked, namely a knowledge of the antique and an appreciation of *disegno*. Moreover, even Vasari recognised that this deficiency was only relative, as his enthusiastic comments on works by Titian and even Pordenone make clear. Neither of these painters was indifferent to developments elsewhere in Italy, and in Titian's case contemporary art in Florence and Rome was an important influence from the outset of his career. Against this background the Mannerist crisis, whose principal manifestation was the use of motifs derived from prints after artists such as Parmigianino and Michelangelo by a group of younger painters, notably Tintoretto, Schiavone and Bassano, was simply an extension of a practice already existing in Venice. To show that something new was involved one would have to argue that these painters believed that there was a fundamental stylistic distinction between Mannerism and the art of the High Renaissance. But there is no evidence that anyone in Venice, or indeed elsewhere, then thought this to be the case. Nor is there any indication that attitudes in Venice changed significantly later

in the century, let alone that there was any general reassertion of local ideals current before 1540. From this period only the work of Titian had a continuing relevance, while Tintoretto remained faithful to the idiom of Michelangelo, and Veronese created a personal style which included elements from Raphael, Giulio Romano, Parmigianino and the antique.

Rather than seeing the development of Venetian painting in terms of a pattern borrowed from elsewhere, it makes more sense to consider the local situation. For the first four decades of the century, unfortunately, the evidence about the attitudes of artists and patrons is very fragmentary. But it is clear at least that Giorgione's innovations in technique led to a decisive break with the hard, linear manner of Bellini and his followers, and that from about 1510, when Giorgione died, virtually all the younger artists abandoned the traditional conventions for figures and compositions, and introduced a greater sense of movement, larger forms and less symmetrical designs. Titian seems to have been the main innovator in this respect, but several other Venetians showed notable independence and originality, particularly Lotto. Today he seems an eccentric outsider, since his style has very little in common with the ideals of the High Renaissance in central Italy, but this does not seem to have been held against him by his patrons, who had no universally accepted standard, such as the antique, against which to judge new types of painting.

From the 1530s, however, conventions for figures and compositions ultimately derived from central Italy were increasingly adopted by Venetian artists, and from the early 1540s several of them, notably Tintoretto, Schiavone and then Titian, began to use a more open type of brushwork. It can be no accident that these developments coincided with a growth in critical and theoretical writing about art, which owed much to the criticism of rhetoric and poetry. This phenomenon also occurred in Florence and Rome, but its first important manifestation was in Venice, in the letters of Titian's friend Pietro Aretino. Common to all this literature was the tendency to divide the activity of the painter into various categories, such as *disegno*, *colorito* and invention, and to place a high premium on such qualities as grace, facility and decorum. At the same time, a few outstanding artists were constantly invoked as ideal models, above all Raphael and Michelangelo, but also younger painters like Parmigianino and Salviati. In most respects the critical standards proposed in Venice were no different from those current in central Italy; but there it was constantly emphasised that the basis of all art was *disegno*, whereas the Venetians attached as much importance to *colorito* and always included its foremost exponent, Titian, in the canon of great artists. In other words, within a generally accepted group of assumptions about the nature of art, which can loosely be summarised as the advocacy of a self-conscious stylishness, there were crucial differences in emphasis, reflecting diverse local traditions. For the artists of central Italy, the new criticism led to a codification of existing practice, whereas in Venice it had a more positive effect: not only were the painters encouraged to draw on a wider range of models, but also the presence and continuing activity of Titian sanctioned further innovation on the part of his younger contemporaries. As a result, in Florence and Rome we find an increasingly stereotyped form of Mannerism, while the Venetians took a different path. Even the most overtly Mannerist among them, Tintoretto and Schiavone, never adopted a working method based on elaborate preparatory drawings, but were the very artists who displayed the most extreme virtuosity in their brushwork; and Vasari was surely right in seeing the relatively loose and seemingly spontaneous handling of Titian's later paintings, particularly those for Philip II, as a prodigious demonstration of skill, rather than as mere naturalism (fig. 16). Even Bassano can be fitted into this framework of ideas; for the unidealised style of his late work is precisely appropriate to his chosen subject-matter.

Considered in these terms, it is possible to see painting in Venice, especially from the 1530s, as the most notable part of a wider Italian development. It is also easy to understand why only in the Veneto was the Mannerism of central Italy not adopted wholesale, except by a few painters of the second rank. Venice, after all, was one of the wealthiest and most stable cities of the peninsula, at least twice as populous as Florence or Rome, with an outstanding indigenous artistic tradition and a network of subject towns which were a constant source of new talent and a rich market for pictures. The present exhibition provides a unique opportunity to appreciate the strength of that tradition, which made Venice in the second half of the sixteenth century the pre-eminent centre of painting not only in Italy, but in the whole of Europe.

TITIAN AND VENETIAN COLOUR

John Steer

'Michelangelo for form and Titian for colour': this well-worn dichotomy, which originated in the Cinquecento itself, has recently been thrown into disarray by the discovery, as a result of cleaning, of the brilliance and subtlety of colour in Michelangelo's frescoes; and no-one who saw the many-splendoured display of variegated colour in the early six-teenth-century Florentine paintings in the Medici exhibitions of 1980 could doubt the importance of colour, or at least of colours, to central Italian artists. If this exhibition were of Florentine rather than Venetian sixteenth-century paint-ings the colours would be brighter, more variegated in hue and altogether more dazzling than what we see before us. Why then the importance given, from Vasari onwards, to Venetian colour?

In considering this question there are two difficulties. The first is an almost complete lack of information about what Venetian artists, and in particular Titian, actually thought about colour, if indeed they thought about it theoretically at all. From his writings it can be deduced that the Florentine Leon Battista Alberti, the author of the major fifteenth-century treatise on painting, did not have a conception of colour as a constituent of visual experience which could be applied to what happened in Venice in the first three decades of the sixteenth century. Venetian writers of the mid-century, particularly Pino and Dolce, were moving somewhat hap-hazardly towards an understanding of the role of colour in vision, based on their observations of what actually took place in Venetian painting at that time. But even their think-ing is very tentative and certainly does not constitute a coher-ent theory.

The second difficulty, which they did not face, is that the colour of Venetian paintings, which is more vulnerable than that of Florentine paintings because of the complexity of their paint structure, has often been radically changed and distorted by time. The favourite Venetian green, a copper resinate, tends to turn brown or even black, thereby robbing paintings of a fundamental colour dimension. The process is, alas, irreversible, and in the beautifully cleaned *St. John the Baptist* by Titian (Cat. 119) the marvellous blues are no longer matched, as they were intended to be, by an equal range and intensity of greens.

With this in mind we can nonetheless discover in Venetian colour, as it developed in the hands of Titian in the first two decades of the sixteenth century, three main tendencies: firstly, a severe limitation in the actual number of hues, which very much contrasts with the emphasis on variety in Florentine painting; secondly, a tendency to choose the pur-est hues in their richest and most saturated state; thirdly, the intention to arrange them in overall harmonies that are both simpler and more sophisticated than the mere balancing

of bright, contrasting colours that had gone before. These tendencies are remarkable in themselves, but they have their basis in a more fundamental change of which they are an expression. They depend on what amounts to a new mode of vision, which may be loosely described as 'perceptual' and still more loosely as 'realistic', a term applied by Titian's contemporaries, who saw in his handling of light and colour a way of recording in paint a sense of living reality not achieved before.

This new mode of vision is related to the theory of percep-tion – going back to antiquity, but alien to Alberti and the Florentine School – which takes colours as the primary and essential constituents of visual experience and considers them – rather than outlines – as the primary building blocks in our conception of form. Whether or not this view was theoretically understood by Venetian artists at the beginning of the century, and most likely it was not, it is certain that in the work of Giovanni Bellini from the 1490s onwards a change takes place that asserts this principle. Johannes Wilde compared the structure of Bellini's *Baptism* of 1500–01 in S. Corona, Vicenza, which is built up of patches of colour directly observed from nature, to that of a painting by Cézanne. This method, more boldly applied, is taken up by the early Titian and can be seen for example in *Jacopo Pesaro Presented to St. Peter* (Cat. 113).

Here the scene is built up without outline, in patches of colour, which stand for the form itself, its local colour and the modification of colour by light. So all the elements in the painting are integrated into a single system, in which the beauty of individual hues, so central to the Florentine tra-dition, is subordinated to an overall system of values drawn from the relationship of the colours to each other, and arising directly from the artist's perceptual experience of nature. It is the act of seeing the world in terms of colour that now forms the basis for painting; and it is because this aspect of visual experience is, by being translated into painting, here for the first time fully articulated, that the paintings convey to us, as they did to contemporaries, so intense a vibration of life. Titian in this very early work and, in a more deve-loped way, in the paintings which follow it, was making dis-coveries about the role of colour in vision that added a new dimension to European art.

But the system of colour which Titian evolved in the years between 1510 and 1520 owes its force and its subsequent influence not only to its direct relationship with visual exper-ience, but also to his power of organising that experience in ways which were to become norms for the future of paint-ing throughout Europe. The votive painting from Antwerp (Cat. 113) still includes a bright grass green and a soft warm brown, but the palette of what may be termed the 'classic

paintings' of the next decade, *Noli Me Tangere* (National Gallery, London) for example, and the *Assumption of the Virgin* in the Frari (fig. 19), depends on the sonorous accord of only three main colours: red, blue and green. The combination of richness and intensity of hue which Titian achieves in the individual colours is made possible by his use of the oil medium, but his desire to present these primary hues at such a level of saturated intensity and his way of putting them together is an aesthetic choice. Thus Titian limits his colours in order to bring them into a new kind of accord. 'The colourisation of which Titian was the originator', Theodore Hetzer wrote in German in 1935, 'is characterised by the fact that its fidelity to nature is bound up with an arrangement of colours which in its independent character displays the internal order of the world and its associations, relationships and connections'.

We may not wish to express ourselves so metaphysically, but in practice our experience of the essential rightness of Titian's colour harmonies confirms what Hetzer says, and shows that Titian achieves through colour a harmonious but active balance of opposing forces in a manner strictly comparable to what Raphael achieved through form. Moreover, in the attitude towards colour that the Renaissance inherited from antiquity and the Middle Ages there was material for a theoretical explanation of what Titian did.

The idea that all colours may be calibrated on a scale between black and white and have, according to their mixture of hue and tone, relative weights comparable to tones in music, is found in Aristotle. It justifies the view, proposed incidentally with regard to Venetian painting by Constable, that the harmony of colours has an intellectual as well as a sensuous base. It is also worth noting that Aristotle in *De Sensu*, among several somewhat contradictory theories about colour, described the primary colours which complete what we call the colour circle as red, blue and green, regarding yellow not as a colour in itself but as a constituent of light, an idea not incompatible with Titian's practice between 1510 and 1520. In his paintings of this decade, yellow as a local hue seems to be largely excluded: it only re-emerges in the robe of St. Peter in the *Pesaro Madonna* in the Frari painted between 1519 and 1526. Strong as the yellows are, in, for example, the *Assumption of the Virgin* (fig. 19), they stand for light.

But Titian, whose style and practice always varied enormously according to the nature of the commission, could not long be limited by the classically pure formulae of his early years; and the introduction of further pigments and hues, especially the orange realgar and the yellow orpiment, which play such an important role in, for example, the *Bacchus and Ariadne* (fig. 18) is, during the 1520s and 1530s, part of a decorative tendency natural to an artist brought up with the Byzantine heritage of the Pala d'Oro. Indeed, it is characteristic of Titian's approach to colour at this time that he handles pigments, especially the deeply saturated ultramarine of his skies and mountains, as precious materials in themselves, so that the colours in his court paintings, of which the *Bacchus and Ariadne*, painted for Alfonso d'Este, is an example, have the surface richness of an enamel.

It was the special wizardry of Titian in these years to retain the individual brilliance of a hue and yet relate it tonally to the whole. Differently formulated, the same skilful balance is present in the work of another artist of Titian's generation, Lorenzo Lotto, whose greatness as a colourist is especially revealed in this exhibition. Habit and tradition lead us, wrongly I think, to regard Lotto as an eccentric artist. But his understanding of the interaction of colour and light is hardly less than that of Titian, and can lead to effects as visually sophisticated as the overall sense of marine atmosphere in the great *St. Christopher, St. Roch and St. Sebastian* of the mid-1530s (Cat. 52). Here the muffled pinks and mauves of St. Roch are wonderfully related to the surrounding tones of aqueous grey-blue, and the scarlet and yellow of St. Christopher provide a clarion call of explosive colour in the centre of the composition. Expression rather than decoration is always the driving force behind Lotto's colour, and this is again superbly shown in the *Visitation* (Cat. 50). Here the hues are not decoratively balanced as they would be in Titian or Veronese, but create a tenderly moving contrast in the imbalance between the bright colours of the youthful Virgin and her attendants coming in from the right, and the muted violets and blues of the old people, Zacharias and St. Elizabeth, on the left.

A transformation in the handling of colour, in particular, in its relation to tone, is one of the chief developments in Venetian painting in the 1540s, the decade in which not only the younger generation of artists, but also the middle-aged Titian responded to the new developments in central Italian art. But whereas the new forms in Venetian art of the period can often be directly attributed to the influence of central Italy, this cannot be so with colour. What took place was a largely indigenous development which seems to have happened almost simultaneously among a number of younger and older artists. It can be studied in Andrea Schiavone's *Adoration of the Magi* (Cat. 89), probably datable to c. 1547. Here the intensity of the individual hues is so muted that the drama and movement of the painting depends not on the colours themselves, but on the interplay of warm and cool tones to which the colours are subordinate, an interplay which, in Schiavone's fluent painterly style, weaves like a knot of writhing snakes over the whole surface of the painting. Of course not all painting of the 1540s and 1550s is so concerned with chiaroscuro, but what we find almost universally is a movement away from the pure, primary colours of the classic phase towards much more complex systems of harmonies and dissonances built from mixed hues. These are often highly individual in character, and usually emerge from a darkened background. In a way this development can be seen as a parallel in Venetian terms to the complexities of the 'maniera' style of the mid-century in central Italian art; and from paintings in this exhibition it is possible to study this development in the sharp, rather acidulated hues and silvery tonality adopted by Jacopo Bassano (Cat. 8, 9) at this period, and also in some of the works of Tintoretto.

Tintoretto is not a great colourist, although he often uses exciting, even bizarre, colours. But his approach to colour is indicative of a general tendency at this time, because he detaches it from the direct relation to visual experience which it had in the hands of Titian, and makes it one element in a bravura system of picture-making as varied and inventive as any in the history of art. Although in the deeply moving late *Deposition* (Cat. 112) silvery colour and fluent trails of paint are set against the circumambient darkness, they remain sharply separated from their surroundings, and their character is expressive rather than realistic: only very rarely

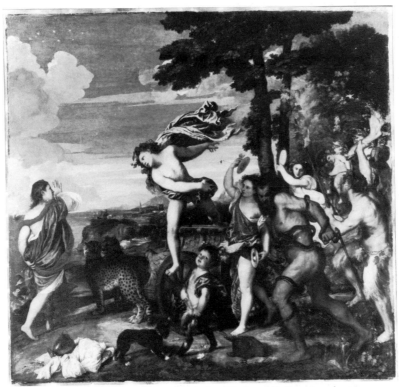

fig. 18 Titian *Bacchus and Ariadne* (National Gallery, London)

in Tintoretto do we find that reality of space and air which is fundamental, as will be suggested in a moment, to the late work of Jacopo Bassano and Titian.

Veronese also started from the principle of picture-making, but for him relationships of colour were, as they were not for Tintoretto, the fundamental constituent in his compositions. Although there is no evidence that he used any new pigments, Veronese's method of mixing and combining hues achieved a new level of decorative and expressive sophistication. But what is of particular interest here is the way in which in his late work he re-integrated this system of colour with a new understanding of chiaroscuro and related it more directly to visual experience. A superb example is the altarpiece from S. Pantalon (Cat. 147), in which the saint emerges from darkness into light, and all the colour values are related to the light and shade in such a way that they establish precisely the reality of the space in which the figures move.

Veronese's painting was made in 1587, but this development had been anticipated by Jacopo Bassano and Titian. In the work of Bassano it can be illustrated by the altarpiece of *St. Martin and the Beggar* (Cat. 10) or by the tiny *Susanna and the Elders* (Cat. 11). In the latter the distant buildings seem suspended in crepuscular twilight and in both the figures are evoked by what seem to be the final flashes of the dying light out of the thickening atmosphere. This vision is based on the artist's actual experience of the behaviour of colours in semi-darkness, and it is to this that the paintings owe their intensity and truth.

In two great late works by Titian (Cat. 130, 132) light and colour seem to emerge only with difficulty out of the surrounding darkness, but from his struggle to describe this phenomenon as precisely as possible, a reality of space and air is established so certain that it is almost tangible. Colour plays a part, but it is handled in a different way in each of the paintings. In the *Tarquin and Lucretia* (Cat. 130), an easel painting, broken areas of local colour are retained as part of the painting's close claustrophobic focus; in the *Flaying of Marsyas* (Cat. 132) it is not individual colours that tell, but an all-over emanation of broken touches, evoking a greenish-gold, that is spattered, appropriately to the theme, with reds like splotches of blood. Vision and expression are here so much one that they cannot, even for the purposes of discussion, be separated. But it can, I think, be said that in these paintings Titian's intense struggle to grasp in paint, through tone and colour, the physical realities of the scene is a fundamental part of their meaning.

For Titian as a colourist see:
T. Hetzer, *Tizian, Geschichte seiner Farbe*, Frankfurt, 1935; 2nd edition 1948

For colour in the Italian Renaissance in general see:
M. Barasch, *Light and Color in the Italian Renaissance Theory of Art*, New York, 1978 (including references to Dolce, Pino and other primary sources)

J. Gavel, *Colour: A study of its position in the Art Theory of the Quattrocento and Cinquecento*, Stockholm Studies in the History of Art, 32, Stockholm, 1979 (with useful material on classical writings on colour)

For Florentine colour in particular, but with further fundamental discussion of general value, see:
J. Shearman, *Andrea del Sarto*, Oxford, 1965, and ibid 'Leonardo's Colour and Chiaroscuro', *Zeitschrift für Kunstgeschichte*, XXV, 1962, pp. 13–47

CONSERVATION, RESTORATION, AND NEW FINDINGS

Francesco Valcanover

In recent years there has been increasing co-operation between academic and artistic institutions on the one hand, and scientific and technical laboratories on the the other. This has had a very beneficial effect on the practice of conservation and restoration, in that the danger of works of art suffering irreversible damage at the hands of ignorant or arrogant restorers has now been largely eliminated. The role of the restorer today is two-fold: to preserve the fabric of a painting or sculpture, and to recover, as far as possible, the unity of its original appearance. That these aims are now to a great degree being achieved owes much to the rigorous and objective guidelines formulated by the Istituto del Restauro in Rome.

As a result of the exceptionally severe flooding (the *acqua alta*) of 4 November 1966, the Soprintendenza ai Beni Artistici e Storici of Venice had to undertake a very wide-ranging programme of restoration, which has been supported by the increased financial aid made available by the Italian State and by the Municipality of Venice, as well as by countless contributions from private individuals both in Italy and abroad. This programme is based on a new conservation policy, which closely reflects the ideals and practice of the Istituto del Restauro in Rome. Whereas in the past there was an elitist and haphazard approach, in that only works of the highest quality were restored, now there is a systematic plan, based on research carried out in 1968 and financed by UNESCO, to conserve all the works of art of the historic centre of Venice and the islands.

In order to fulfil these ambitious aims, an effective organisation has been created, which works in close collaboration with the Soprintendenza ai Beni Ambientali e Architettonici, and which makes use of the latest scientific innovations and methods of conservation. Its task is to preserve not only panels, canvases, frescoes and sculptures, but also the buildings in which they are housed – in other words the entire artistic and historical wealth of Venice. One need only glance at successive issues of *Arte Veneta* to understand the scale and importance of this undertaking, which has already rescued more than 30 architectural complexes from centuries of neglect, and halted the deterioration of at least 50 pictorial cycles and numerous works of sculpture. Naturally the study of Venetian painting, and in particular that of its greatest period, the sixteenth century, has benefited enormously from this impressive campaign.

Just a few examples of the restoration work recently carried out in Venice will give an idea of what has been achieved. Giovanni Bellini's three important altarpieces for the churches of S. Pietro Martire, Murano (1488), S. Zaccaria (1505; fig. 20) and S. Giovanni Crisostomo (1513) have once again been revealed in their full glory after the removal of large areas of repaint and thick layers of varnish. As a result, we can now appreciate how Bellini's style evolved continuously throughout his career, from his early interest in the work of Andrea Mantegna, Piero della Francesca and Antonello da Messina to his intensely poetic late manner. In his last years indeed, he, together with Titian, anticipated and then surpassed the 'new style' of Giorgione. Another painter who drew on much the same fifteenth-century sources as Bellini was Carpaccio, but he was also indebted to the artists of Ferrara, as has become all the more evident now that the restoration of the *St. Ursula Cycle* (Accademia, Venice) is under way.

Restoration has also contributed significantly to our understanding of the development of Venetian painting in the first decades of the sixteenth century. Thus the confrontation between Giorgione's restored fresco of a female nude from the façade of the Fondaco dei Tedeschi (now in the Galleria Franchetti, Ca d'Oro) with the surviving fragments of Titian's frescoes from the same building, which were discovered in 1967, has enabled us to see the vast stylistic differences between the two artists that already existed in 1508. At that date Titian's work was imbued with a classicism equal to that of Raphael and Michelangelo, and it has little in common with Giorgione's contemplative sensibility and essentially naturalistic approach.

In the opinion of the present writer, the evidence of these frescoes from the Fondaco makes it clear that such paintings as the *Fête Champetre* (Louvre) and *Christ and the Adulteress* (Cat. 35) cannot be by Giorgione, as is still sometimes proposed, but must instead be by Titian. In these years, as the two organ shutters from S. Bartolomeo (Cat. 95, 96) especially restored for this exhibition demonstrate, Giorgione's most faithful follower in Venice was Sebastiano del Piombo, who left for Rome in 1511.

Our understanding of Titian's development after the death of Giorgione has also been increased through the restoration of his paintings in Venice. Thus we can appreciate better than ever before the extraordinary novelty of the *Assumption of the Virgin* of 1518 (fig. 19; Frari), which, with its sumptuous colouring, heroic forms and remarkable depiction of emotions, introduced a new type of altarpiece to Venice; while the composition of the *Pesaro Altarpiece*, finished in 1526 for the same church, seems to anticipate the Baroque style of the next century. A third important work which has benefited from the removal of earlier inaccurate restorations is the *Presentation of the Virgin* (Accademia), completed in 1538; and another aspect of Titian's style, his debt to Michelangelo and the mannerists, can be now seen in the vibrantly coloured *St. John the Baptist* (Cat. 119).

A careful analysis of these paintings, which were pro-

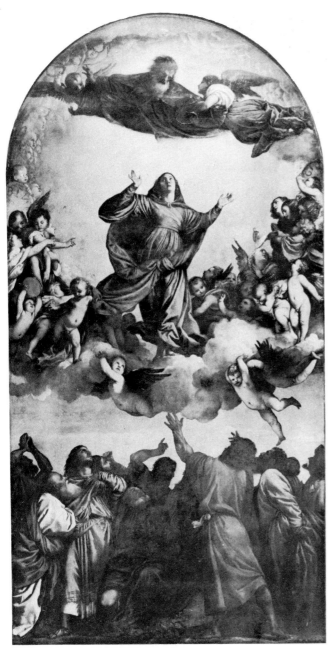

fig. 18 Titian *The Assumption of the Virgin* (S. Maria Gloriosa dei Frari, Venice)

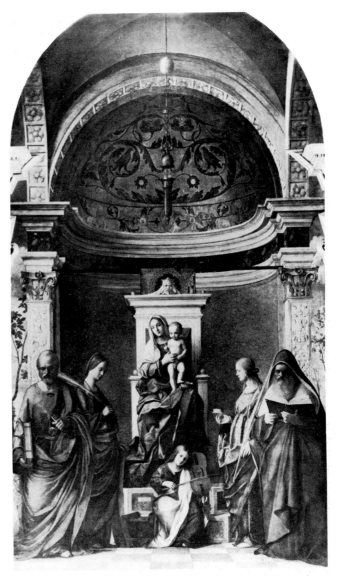

fig. 19 Giovanni Bellini, San Zaccaria Altarpiece (S. Zaccaria, Venice)

foundly influential for Venetian artists such as Palma Vecchio and Paris Bordone, makes it clear that the development of painting on the *terraferma* during the first half of the sixteenth century was very different. Savoldo, for example, seems to have been largely indifferent to many of the innovations of Giorgione and Titian. The removal of a murky layer of repaint and oxidised varnish from his *St. Anthony and St. Paul* (Accademia) has not only revealed a signature and a date, probably 1520, but also established that Savoldo looked principally to the rigorously formal style of Tuscany, to northern artists such as Hugo van der Goes and Dürer, and to the tradition of Lombard realism initiated by Foppa. Another artist working in Venice who was indebted to the

Lombards was Lotto, as, for example, in two paintings of 1528, the *Portrait of a Young Man* (Accademia) and the Carmine altarpiece, both of which have recently been cleaned. In the brilliant clarity of the colours, the tension of the compositions and the delicate characterisation, these have little in common with the contemporary works of Titian and his immediate followers.

Like Lotto, Pordenone spent much of his career on the *terraferma*, and the cleaning of his small altarpiece from S. Giovanni Elemosinario (Cat. 78) of *c.* 1535 has shown that even in Venice he too was less influenced by Titian than was hitherto supposed. The crowded composition, discordant lighting and strident colour revealed by the removal of the old varnish, indicate that his stylistic ideals were very different from those of his rival.

By 1550 Titian must have been aware that there were other artists who were no less original but even more gifted than Pordenone working in Venice. Tintoretto's *Miracle of the Slave* (Accademia, Venice), painted in 1548 for the Scuola

Grande di San Marco, was considered, before its restoration in 1966, to be an example of the most 'Titianesque' phase of his early, unsettled style. Today, however, it is clear that in this, his first public commission, Tintoretto's own artistic language was already established. The picture anticipates the characteristics of his mature style: the dynamic compositions, the virtuosity of his handling of paint, the provocative colour schemes and the violent sensation of tension created by his use of highlights. The extraordinary development of Tintoretto's sensibility and the formal means by which he expressed it are particularly apparent in several works that have recently been restored: the three canvases for the Scuola della SS. Trinità (Accademia, Venice), the organ shutters and other paintings in the chancel of S. Maria dell'Orto, and above all, the magnificent cycle of paintings for the Scuola Grande di S. Rocco. It is clear that Tintoretto refused all studio assistance for this last great undertaking, and we can observe that the evolution of his mature style falls into three distinct phases corresponding to the work in the Sala dell'Albergo (1564–67), the Sala Superiore (1576–81) and the Sala Terrena (1582–87).

Like Tintoretto, Paolo Veronese was trained in the mannerist tradition, but the mood of his paintings, which seem so perfectly to celebrate the optimism of sixteenth-century Venetian life, has little in common with the ambiguities and tensions commonly associated with mannerism. However, after the restoration of some of Veronese's pictures it is possible to see that in his choice of intense colours and his use of harsh highlights he remained faithful to his origins in Verona, even though he used these devices to new ends, for example in such works as the *Holy Family with St. John the Baptist, St. Anthony Abbot and St. Catherine* of *c.* 1551 (Cat. 133), the great decorative cycle in the church of S. Sebastiano, the magnificent *Feast in the House of Levi* (1573; Accademia, Venice), and the *Allegory of the Battle of Lepanto* of *c.* 1578 (Cat. 142), whose autograph status now seems beyond dispute. Finally, the San Pantalon altarpiece of 1587 (Cat. 147), which has been restored especially for this exhibition, is entirely typical of Veronese's late style: no longer joyously serene in spirit, but instead characterised by an almost lyrical melancholy, perfectly matched by the soft colouring and the subtle, shimmering lighting.

While Tintoretto and Veronese developed their individual styles, Titian advanced in sublime isolation. The restoration of *St. James the Apostle* (San Leo), and especially of the *Martyrdom of St. Lawrence* (Gesuiti) has revealed the incredible subtlety of Titian's late 'chromatic alchemy'. The *St. Lawrence* begun in 1548 but only finished in 1559, must be one of the most tragic and awesome of all sixteenth-century paintings. Titian's very personal style can also be recognised in the autograph parts of the votive painting of *Faith Adored by Doge Grimani* (Sala delle Quattro Porte, Doge's Palace), notably in such details as the figure of St. Mark, the warrior with the helmet, and the view of the basin of San Marco.

The restoration of Titian's intensely moving *Pietà* (Accademia, Venice), which is now in progress, is revealing the unique qualities of his late style, in which forms are created through an elaborate network of blended tones and fiery highlights. This phase, in which colour is submerged in mysterious shade and paintings appear to be unfinished ('*non finito*'), prefigures, and perhaps even surpasses, the late style of Rembrandt. Titian's contemporaries were unable to comprehend his late works, and the art dealer Niccolo Stoppio judged him both harshly and naively; he believed that the artist's weakened physical condition had impaired his creative genius.

While the restoration programme begun in 1966 has contributed to a greater understanding of these masterpieces of sixteenth-century painting, it has been equally important for the understanding of the minor painters of the century, particularly the later mannerist artists such as Palma Giovane, Pietro Malombra, Leonardo Corona, Antonio Vassillacchi, and Andrea Vicentino. Much of the recent research on these artists, which was published in the exhibition catalogue *Da Tiziano a El Greco: per la Storia del Manierismo a Venezia* (1981), has been stimulated by the re-emergence of paintings which were hitherto almost invisible.

The restoration of the decorative canvases in the Sala del Maggior Consiglio in the Doge's Palace, including the enormous *Paradise* designed by Tintoretto and executed by his workshop under Domenico Tintoretto between 1588 and 1592 (see Cat. 111), is still in progress. This campaign has, in particular, increased our knowledge of the importance of the workshop in the execution of the large-scale official decorative cycles undertaken by Tintoretto and Veronese in the Palace.

The restorers have been concerned not only with paintings and frescoes, but also with sculptures, notably those in the Galleria Giorgio Franchetti at the Ca d'Oro, including masterpieces such as the bronze reliefs by Camelio, Riccio (Cat. S15), and Tullio Lombardo. In several cases traces of the original gilding have been revealed. Amongst the many works in marble, a few should be mentioned: the extraordinary *Double Portrait* by Tullio Lombardo (incredibly, its autograph status was recently questioned), the group of portrait busts by Alessandro Vittoria, and Sansovino's masterpiece, the *Madonna and Child with Angels*.

Statues and carved decorations on the exterior of buildings have also been restored. Obviously sculpture of the thirteenth, fourteenth and fifteenth centuries has taken precedence, since it was most urgently in need of preservation; but some of the greatest sixteenth-century masterpieces have also been restored. These include the Loggetta in Piazza San Marco by Sansovino (fig. 26), the bronzes by Antonio Lombardo and Paolo Savin in the Zen Chapel, San Marco, and those by Tiziano Minio, Desiderio da Firenze and Francesco Segala on the font in the Baptistery of San Marco. Here too, the programme of conservation and restoration can be seen not as a short-sighted gesture in response to an immediate crisis, but rather as an undertaking of permanent cultural importance, carried out in the awareness of the profound importance of art for us all.

VENETIAN SIXTEENTH-CENTURY PAINTING – THE LEGACY

Francis Haskell

The heirs to the great flowering of Venetian art surveyed in this exhibition were to be found not in Venice itself (where talent declined precipitously at the end of the sixteenth century) but in Amsterdam, Antwerp and Madrid; Rome, Paris and London. Caravaggio and Annibale Carracci; Rubens, Van Dyck and Rembrandt; Poussin and Velázquez – these geniuses, whose example inspired and dominated European painting for some 250 years, as they still preside over our real and imaginary museums, drew much of their sustenance from Venetian painting, which thus moved from the borders of Italian art (to which Vasari wished to consign it) to the very centre. Some of these painters actually visited Venice itself, but some did not; for during the course of the seventeenth century Venetian pictures spread to cities throughout Europe. When the young Rembrandt was urged to go to Italy to improve his style, he claimed that there was no point in doing so, because it was easier to see Italian art concentrated in Amsterdam than to travel from town to town in Italy itself. We will see that this claim was not wholly unreasonable.

The process had begun in the lifetimes of some of the masters shown here. By the middle of the 1530s Titian had not only painted a famous portrait of the Emperor Charles V, but had also been invited to Spain to paint his wife and son. After some hesitation Titian declined to make the journey, but his pictures did so in increasingly large numbers, for members of the Habsburg court became by far his most important patrons, and it was for them that he painted some of his supreme masterpieces. Francis I of France was also

fig. 22 Teniers the Younger after Giorgione *The Finding of Paris* (Princes Gate Collection, Courtauld Institute Galleries, London)

painted by Titian (who had to make use of a medal to obtain a likeness, as he never saw the King) and tried unsuccessfully to attract the artist to his court; but on the whole it was the art of Florence and Rome rather than of Venice that was patronised and collected at Fontainebleau.

Tintoretto and Veronese were less widely known outside Italy than was Titian, though it seems that after 1576 some of Veronese's most splendid pictures were painted for the collection of the Emperor Rudolph II in Prague; and one can assume that his portrait of the young Sir Philip Sidney (now lost) must have attracted attention in England as Sidney's fame grew ever brighter.

At the very end of the sixteenth century there occurred the first major dispersal of Venetian pictures from their original destination. In 1598 Ferrara fell into the hands of the Papacy, and *The Feast of the Gods* by Bellini (and Titian), together with Titian's *Andrians, Bacchus and Ariadne* (fig. 18) and *Worship of Venus*, all of which had been painted for a special room in the castle of Alfonso d'Este, were taken to Rome. Their impact was not seriously felt for a generation, but thereafter it can hardly be exaggerated. In the 1620s Poussin was only the greatest among a number of leading artists in Rome who agreed that 'Titian never executed anything more gay, charming and beautiful, since art and nature are presented together with the greatest delicacy in every part'; and we constantly find beautiful echoes of these *Bacchanals* by Titian both in Poussin's own works and in those of other seventeenth-century painters – nowhere more so than in the wonderful transcriptions (in Stockholm) made by Rubens (at some uncertain place and date) of *The Andrians* and *The Worship of Venus*.

To the great distress of Italian artists, in 1638–39 these

fig. 21 Teniers the Younger *The Archduke Leopold Wilhelm's Picture Gallery* (Kunsthistorisches Museum, Vienna)

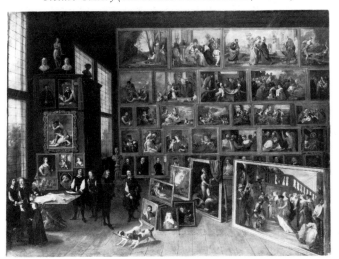

two paintings by Titian were sent to Spain, where the reign of Philip IV (1621–65) saw an astonishing accumulation of pictures by all the greatest Venetian masters. When Velázquez arrived in Madrid in 1624 he could already have seen the supreme group of Titians which had been assembled by Charles V and Philip II, and we are told that when Rubens paid his second visit there in 1628 he copied every Titian in the royal collection. Three years later Velázquez paid his first visit to Italy, during the course of which he apparently brought back to Spain further Venetian pictures (including a Bassano), and throughout this period others were arriving to enrich the collections of the King and his courtiers. It was in 1650, however, that Velázquez paid a second visit to Italy, for the specific purpose of buying works of art for Philip IV, and acquired masterpieces by Tintoretto and Veronese.

By then great pictures by these and other Venetian artists could also be seen elsewhere in Europe. During the sixteenth century the Gonzaga rulers of Mantua had been among the most active patrons of Venetian painters, and when in the 1620s their collections were sold to Charles I, London could almost rival the riches of Madrid in this field; for Lord Arundel, the Duke of Buckingham and other noblemen were also building up magnificent collections of paintings, among which Venetian works were given special prominence. The overwhelming majority of these were to leave England for ever during the Commonwealth, but the impact they made can happily still be seen in the portraits and very rare mythologies painted in England by Van Dyck (who himself owned some superb Venetian pictures, including Titian's *Vendramin Family*, now in the National Gallery, London).

While Charles I was still (just) alive, another great collection of Venetian (and other) paintings was broken up when Prague was looted by Swedish troops in 1648. Masterpieces by Veronese were sent to Queen Christina in Stockholm, and when a few years later she abdicated and began her travels through Europe she was able to add to them Titians of superlative quality. These pictures were eventually installed in her palace in Rome, and although much admired they did not, alas, stimulate the painters there as fruitfully as Titian's *Bacchanals* from Ferrara had done a generation earlier. Only one artist of real quality, Pier Francesco Mola, took full advantage of this new opportunity to study the finest Venetian art at leisure; and early in the eighteenth century the Queen's pictures once more resumed their travels – this time to France.

The dispersal of the collections of Charles I, the Duke of Buckingham and other English noblemen following the defeat of the Royalists in the Civil War brought more great Venetian pictures on to the market than ever before – or since; and many of the most famous museums in Europe still owe their principal holdings in the field to this extraordinary sale. Philip IV of Spain (who years earlier had presented Charles I with his first Titian) did well out of the occasion. And it is now that, for the first time, significant numbers of major pictures by Venetian artists came to Paris – though they were for the most part bought by a German banker who was acting on behalf of the Italian Cardinal (Mazarin), who was the effective ruler of France.

But it was the Low Countries that – temporarily – benefited most from the downfall of Charles I. For many years Amsterdam had been the centre of the European art trade, and outstanding Italian pictures were bought and sold there. It was this that prompted Rembrandt to claim that it was no longer necessary to go to Italy to study Italian art – and to be able to justify that arrogant claim by the marvellous use to which he put the opportunities open to him. Major Venetian pictures featured prominently in the private cabinets that were assembled in the city, and in 1648 the earliest (and most important) book devoted to the Lives of the Venetian Painters was dedicated to two brothers in Amsterdam who were building up a superb collection there: it is not unreasonable to think of these volumes as constituting, at least in part, an elaborate sale catalogue. And when Lord Arundel's pictures were transferred from London to Holland as the Civil War drew near, there were among them many attributed to Giorgione, Titian, Tintoretto and Veronese.

In the Habsburg Netherlands (which today constitute much of Belgium) Venetian pictures were equally accessible. Rubens himself had for a time owned a fine collection in Antwerp. He was not alone, and when in 1646 the Archduke Leopold Wilhelm, son of the Emperor Ferdinand II, was made Governor General of the provinces, he established in Brussels one of the greatest of all European collections of paintings, most of which are now in Vienna. For the lover of Venetian art his collection is the most evocative of all those built up in the seventeenth century, for, in his enthusiasm to make his treasures widely known, the Archduke instructed his chief curator, the painter David Teniers the Younger, to paint a number of views of his gallery (fig. 21). Even though the arrangement of what is to be seen in them may not be entirely accurate, these captivating views allow us to gaze at his pictures with the collector himself and his courtiers. We can see the ranks of Giorgiones and Titians and Tintorettos, some of them supreme masterpieces, some of them the unworthy recipients of optimistic attributions – and some sold from English collections. Moreover, not satisfied with this, the Archduke commissioned an illustrated catalogue of his collection (one of the very first ever to be produced), and in order to assist the engravers who were engaged on the task Teniers himself painted small copies on panel of some of the most admired works. A group of these panels can still be seen in the Princes Gate Collection (fig. 22), and through them (and others now scattered throughout the world) we can get a remarkable impression of the appeal made by Venetian painters of the Renaissance to the artists and amateurs of the seventeenth century – and also an invaluable record of the appearance of pictures that are now lost.

Venetian paintings continued to leave first Venice, then Italy, and then Europe; but by the second half of the seventeenth century superb examples were already to be seen in most centres where great new art was being produced. The impact made by such painting was by no means always welcomed by theorists. But to art lovers it may well seem to have been the one artistic influence that has been invariably beneficial.

32 Carpaccio *The Lion of St. Mark (detail)*

32 Carpaccio *The Lion of St. Mark*

35 Circle of Giorgione, attributed to Titian *Christ and the Adulteress*

36 Circle of Giorgione, attributed to Titian *Head of a Soldier* (fragment from *Christ and the Adulteress*)

34 Circle of Giorgione, attributed to Titian *Virgin and Child with St. Anthony and St. Roch*

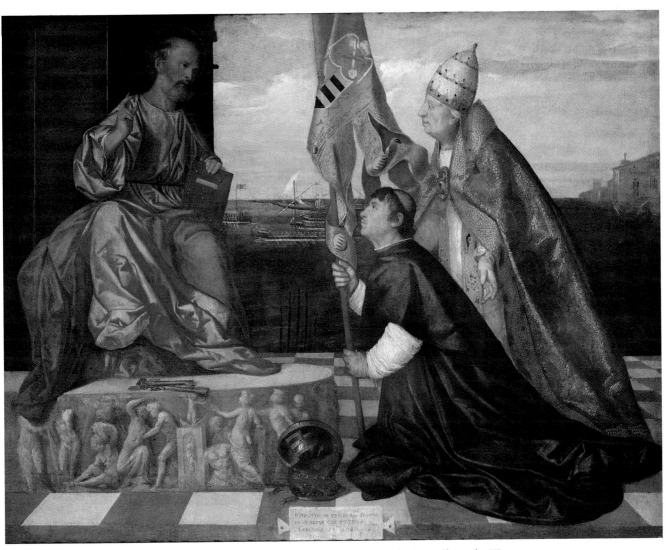

113 Titian *Jacopo Pesaro Presented to St. Peter by Pope Alexander VI*

97 Sebastiano del Piombo *The Judgement of Solomon (detail)*

97 Sebastiano del Piombo *The Judgement of Solomon (detail)*

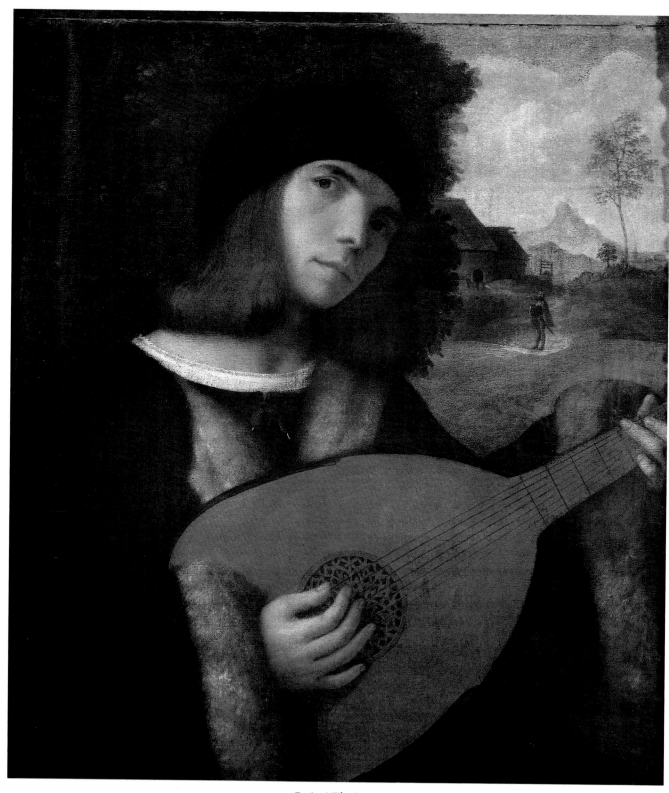

25 Cariani *The Lutenist*

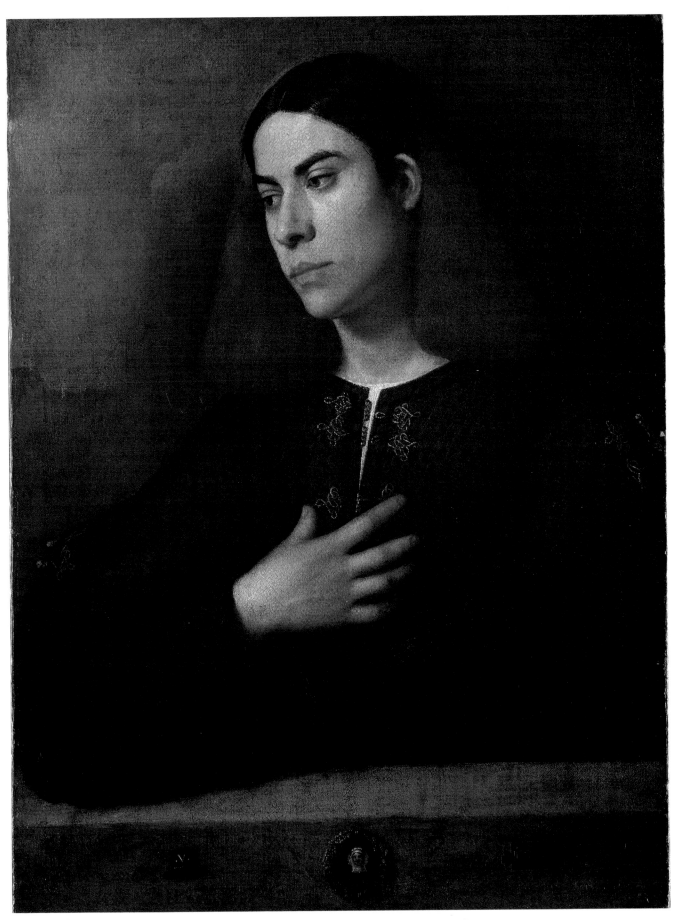

37 Circle of Giorgione, attributed to Vittore Belliniano *Portrait of a Young Man*

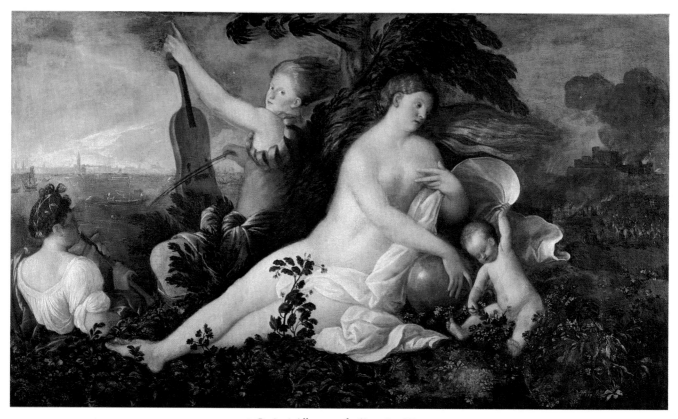

26 Cariani *Allegory of a Venetian Victory*

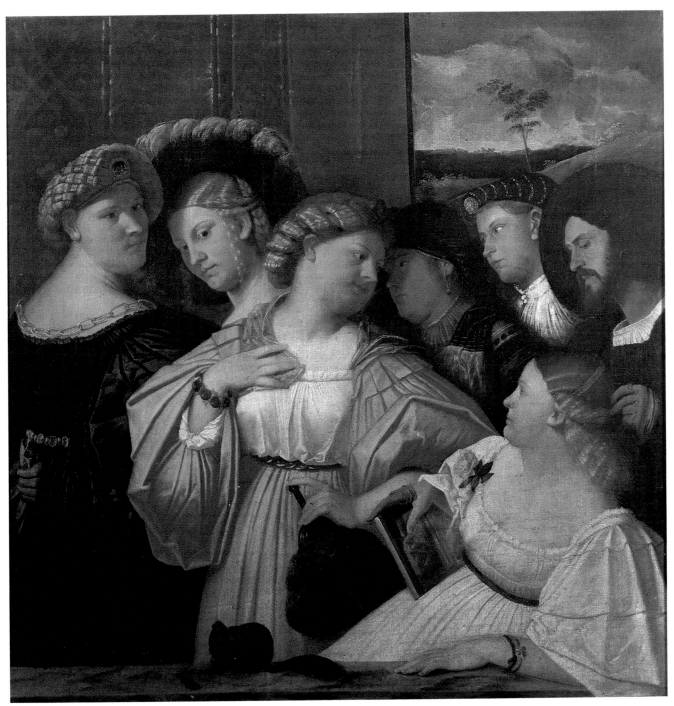

27 Cariani *Courtesans and Gentlemen (Seven Members of the Albani Family)*

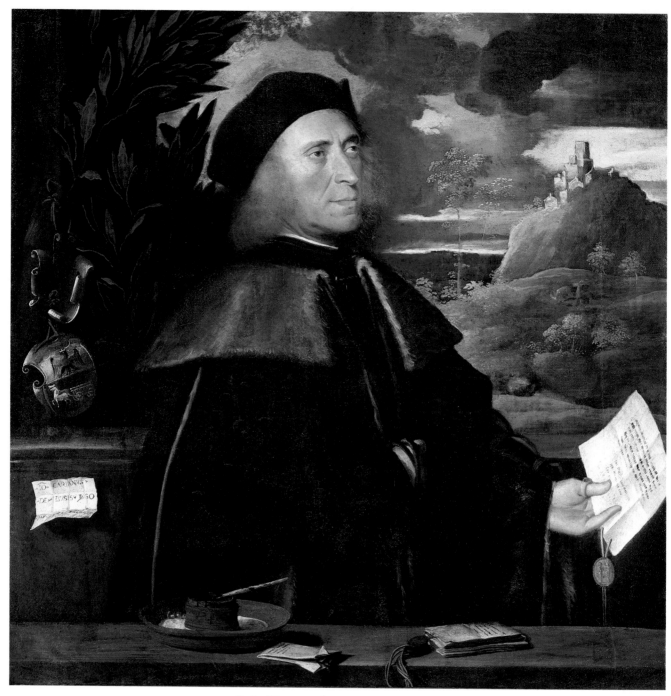

29 Cariani *Portrait of Giovan Antonio Caravaggi*

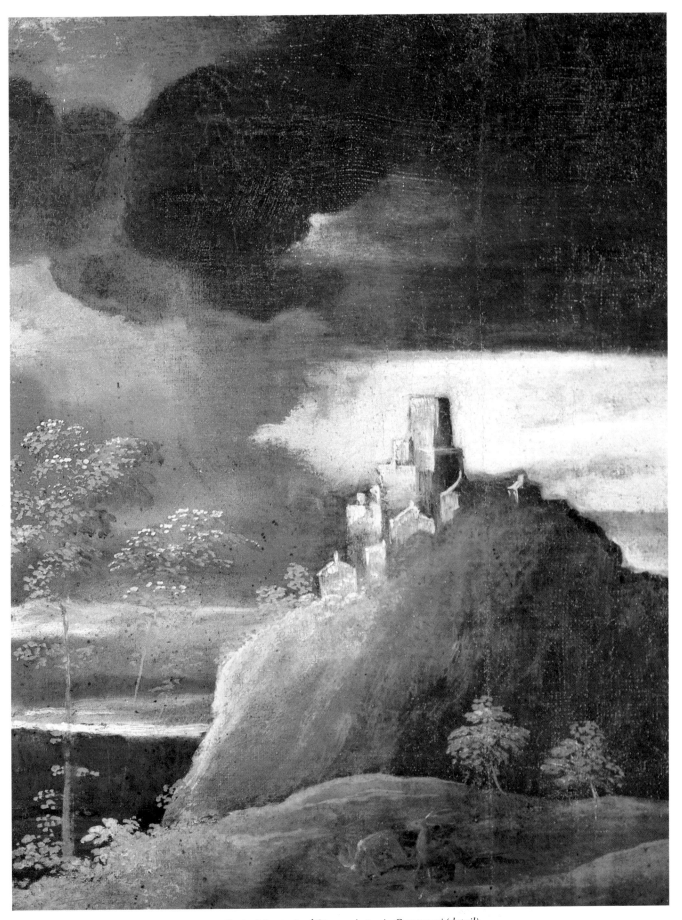

29 Cariani *Portrait of Giovan Antonio Caravaggi (detail)*

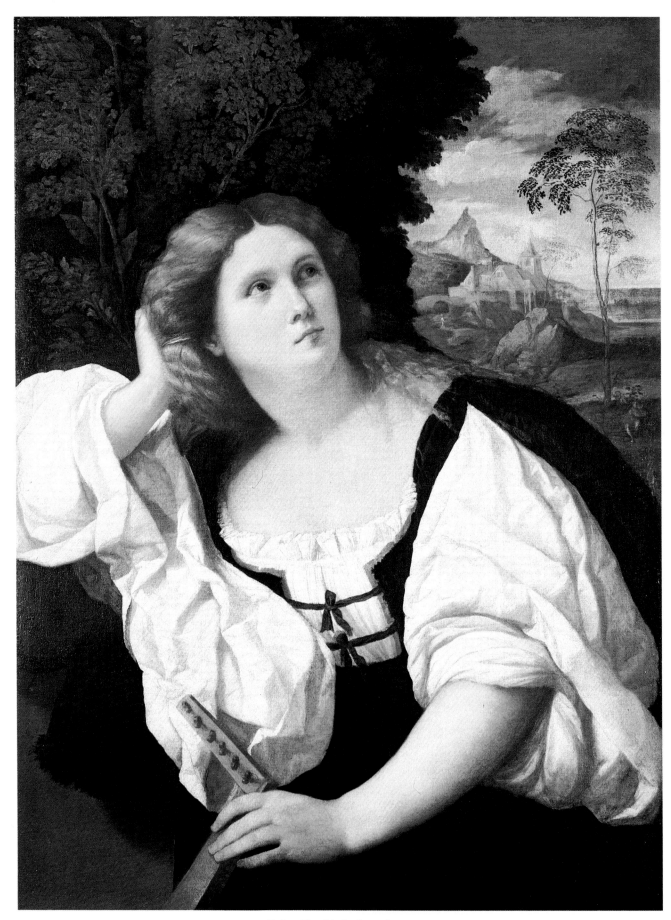

75 Palma Vecchio *Lady with a Lute*

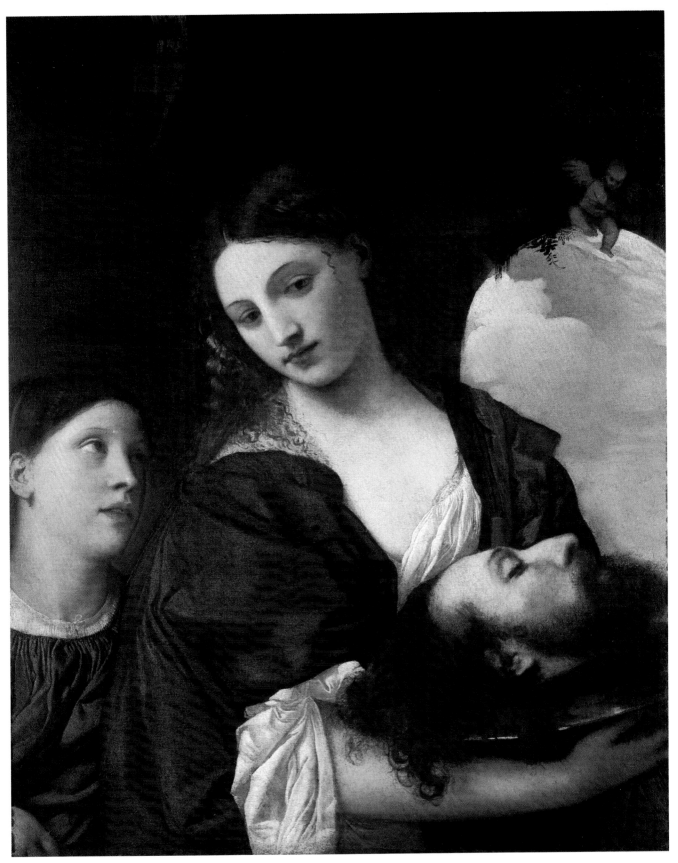

114 Titian *Salome*

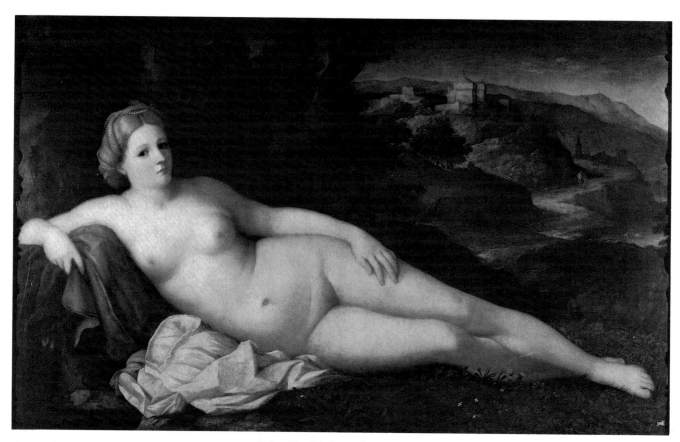

74 Palma Vecchio *Nymph in a Landscape*

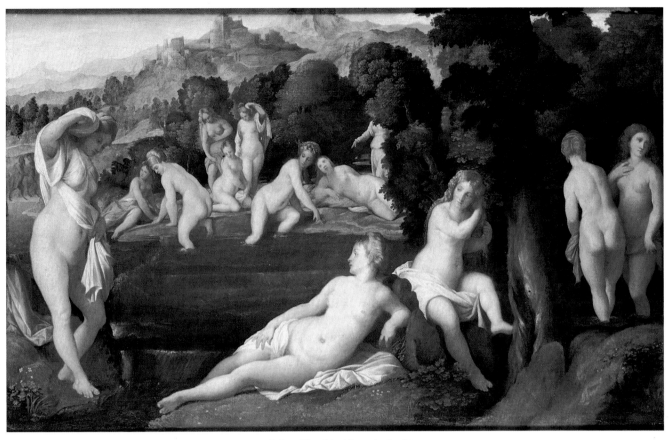

77 Palma Vecchio *Nymphs Bathing*

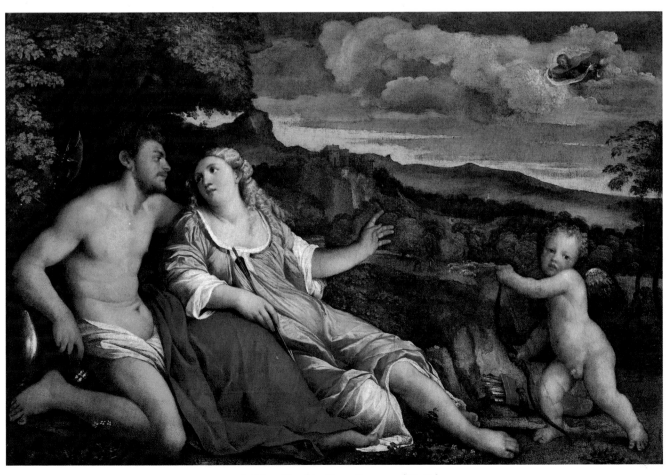

76 Palma Vecchio *Mars, Venus and Cupid*

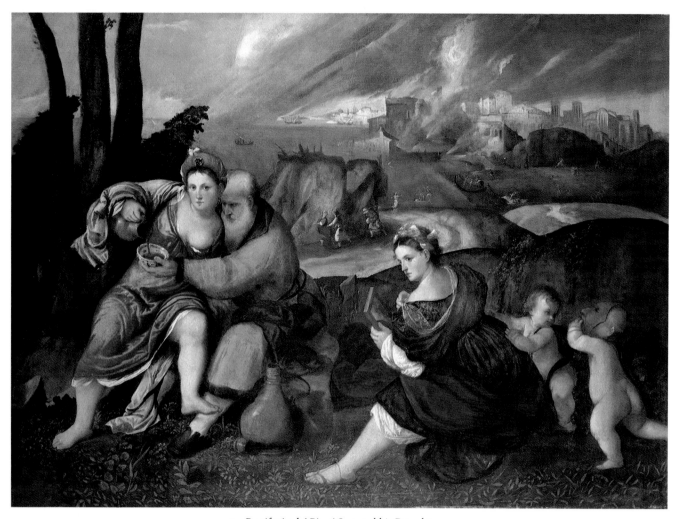

14 Bonifazio de' Pitati *Lot and his Daughters*

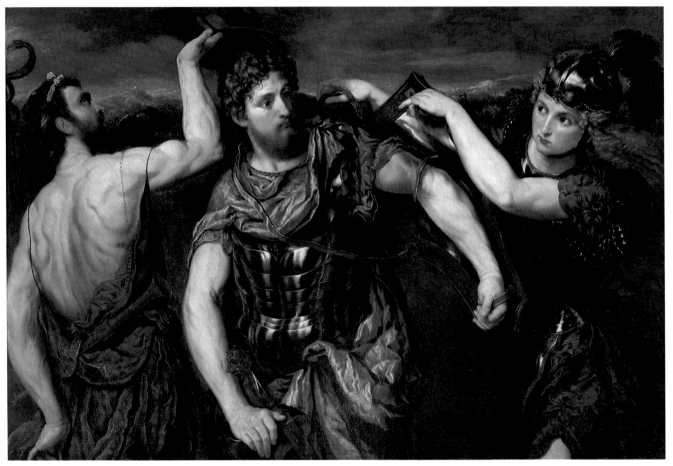

20 Bordone *Perseus Armed by Mercury and Minerva*

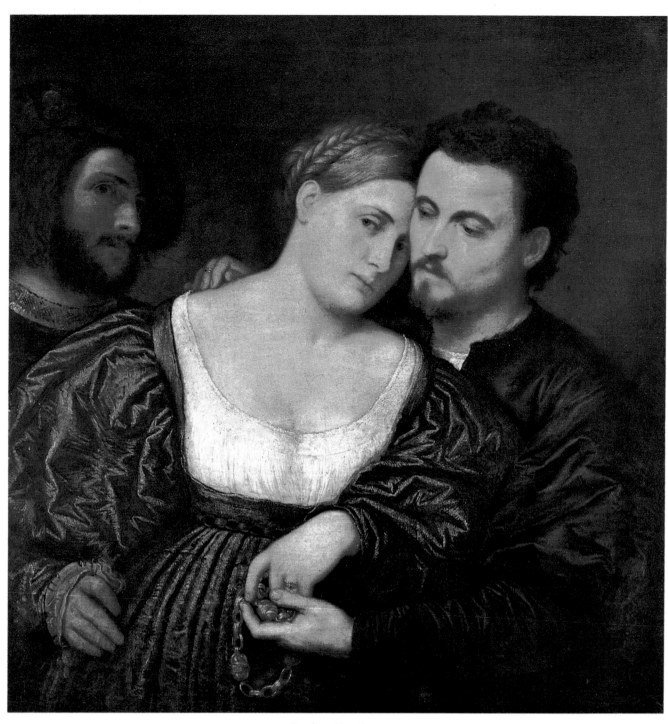

17 Bordone *Two Lovers*

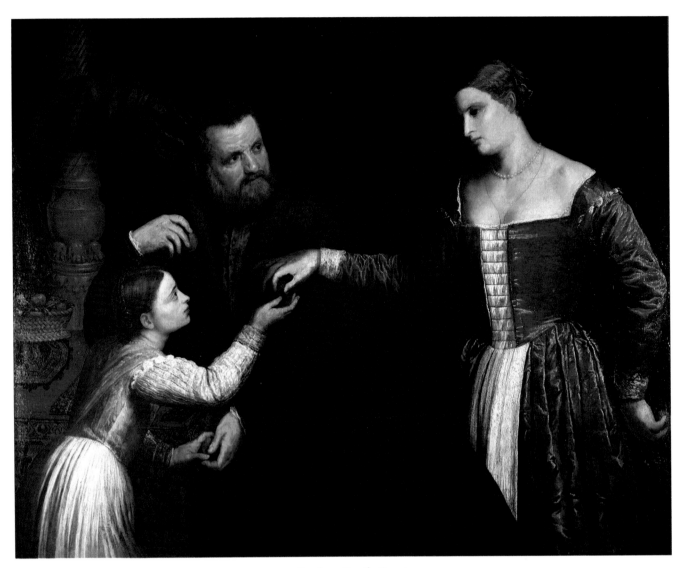

22 Bordone *Family Group*

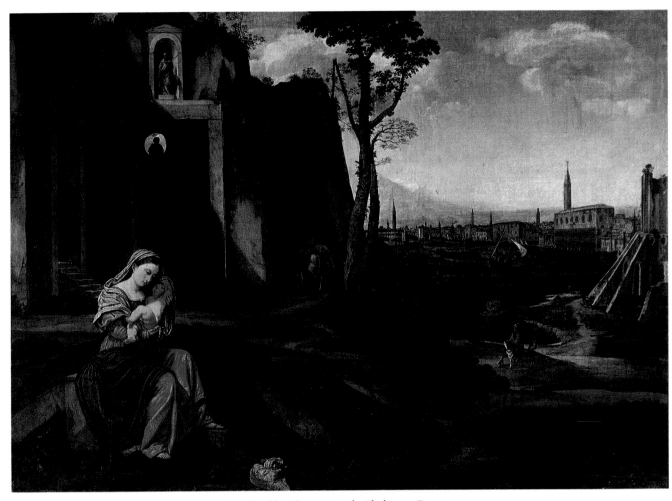

84 Savoldo *The Rest on the Flight into Egypt*

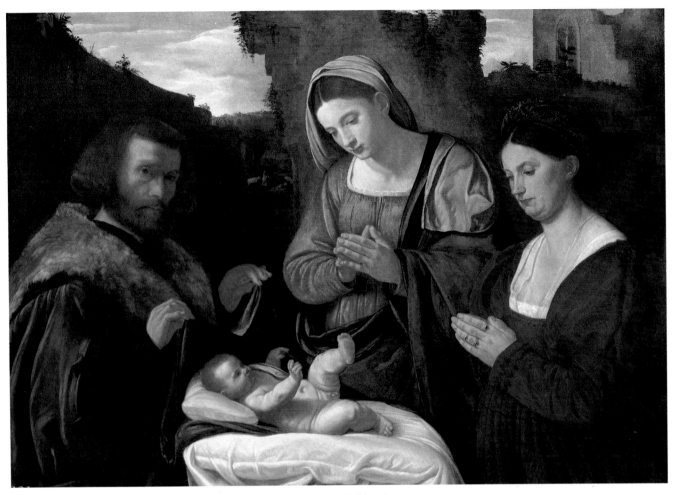

87 Savoldo *Virgin and Child with Two Donors*

85 Savoldo *Shepherd with a Flute*

86 Savoldo *Tobias and the Angel*

39 Girolamo da Treviso *Hagar and the Angel*

38 Girolamo da Treviso *Isaac Blessing Jacob*

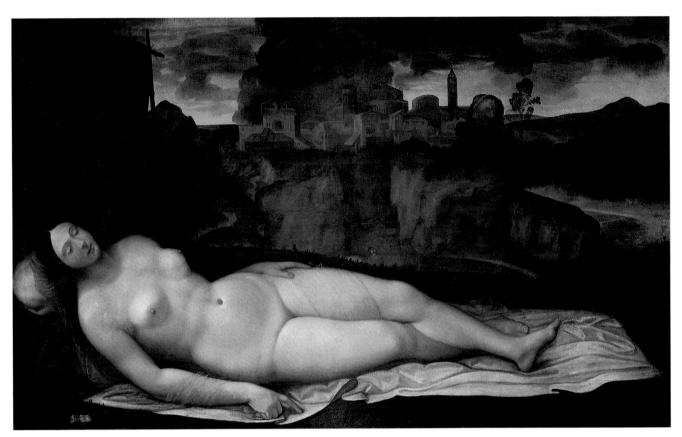

40 Girolamo da Treviso *Sleeping Venus*

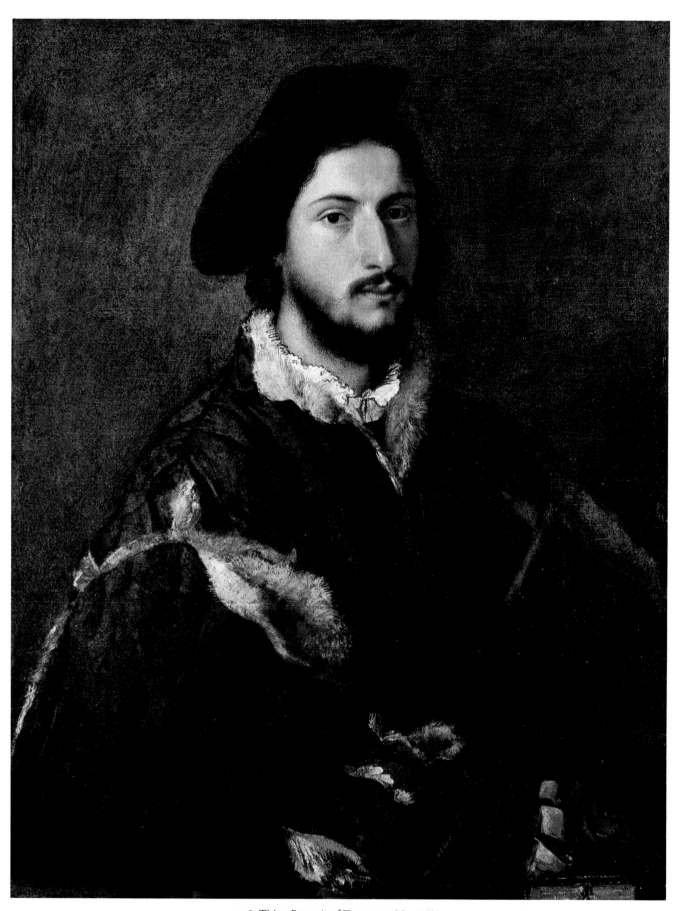

118 Titian *Portrait of Tommaso Mosti (?)*

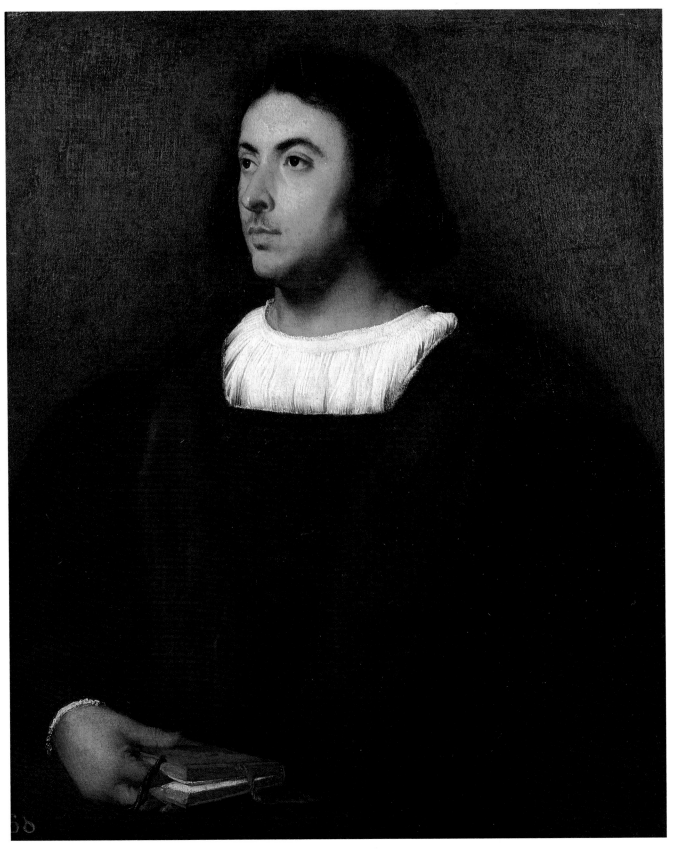

116 Titian *Portrait of a Man*

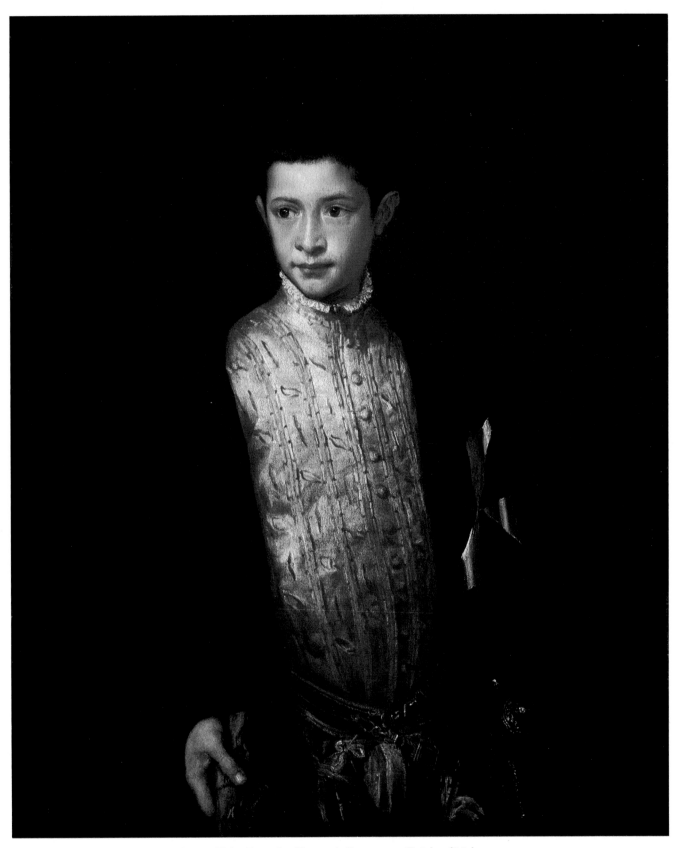

121 Titian *Portrait of Ranuccio Farnese as a Knight of Malta*

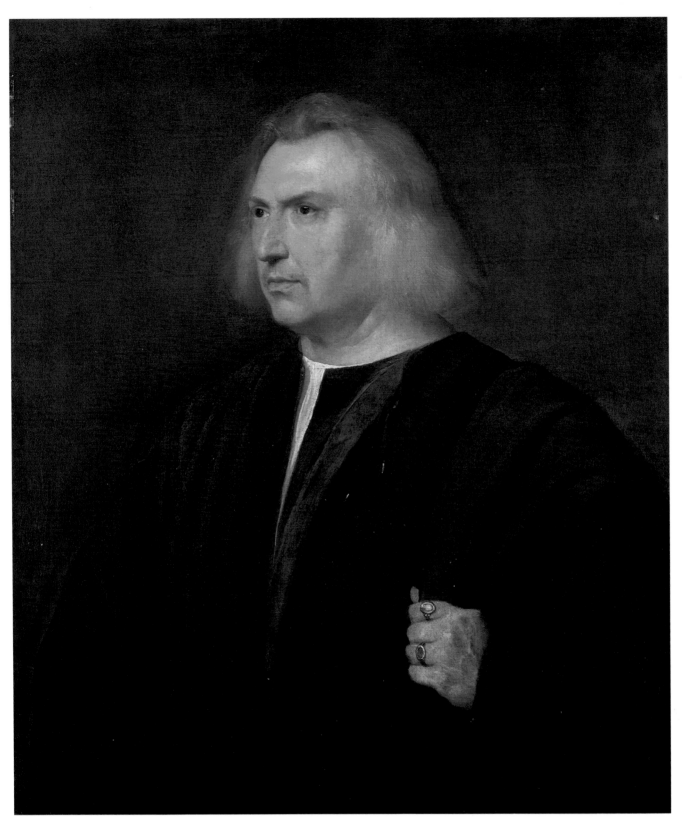

117 Titian *Portrait of a Man (called the Physician Parma)*

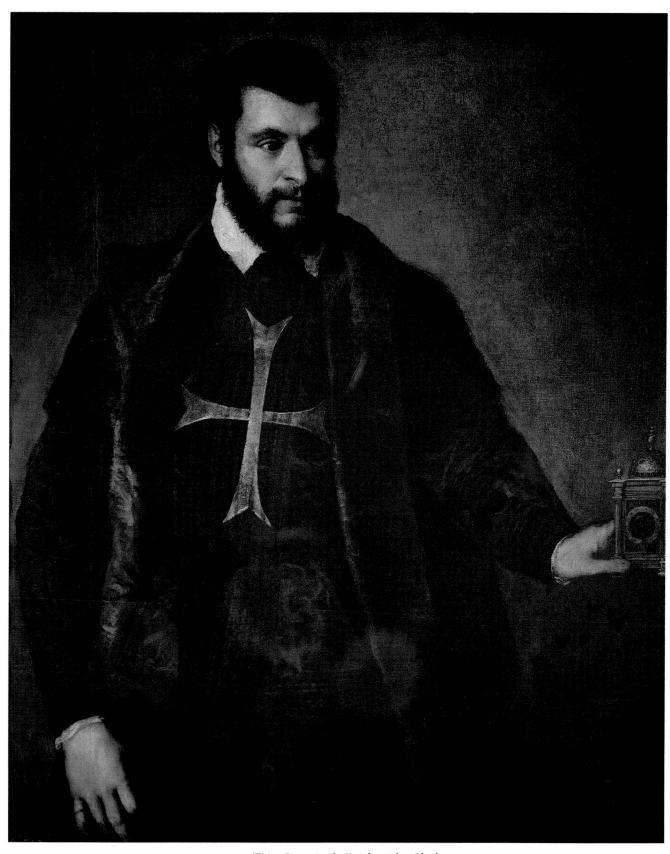

123 Titian *Portrait of a Knight with a Clock*

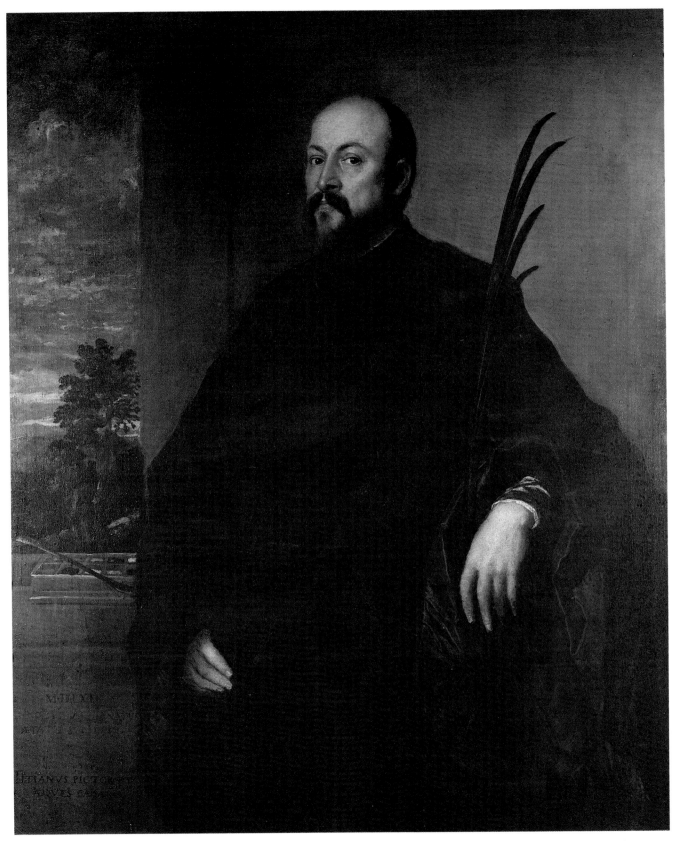

129 Titian *Portrait of a Man with a Palm (Antonio Palma?)*

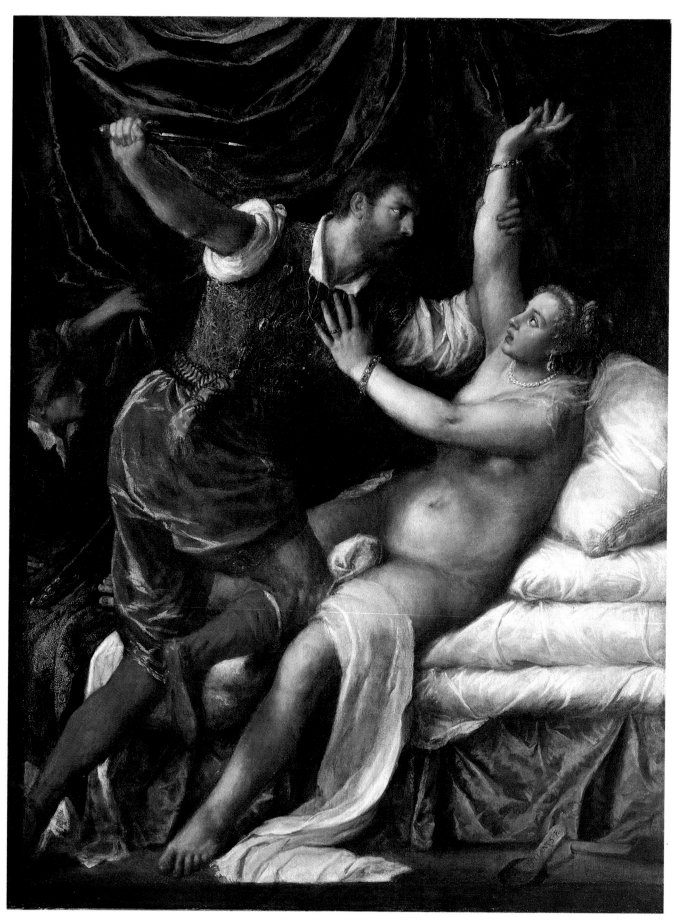

130 Titian *Tarquin and Lucretia*

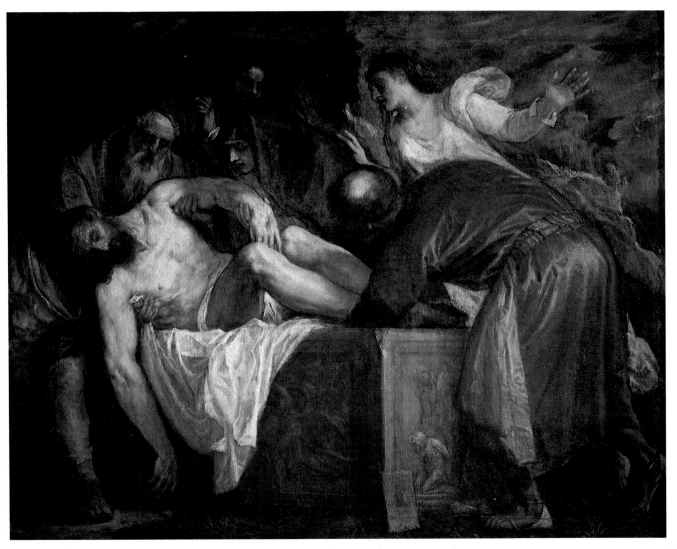

127 Titian *The Entombment*

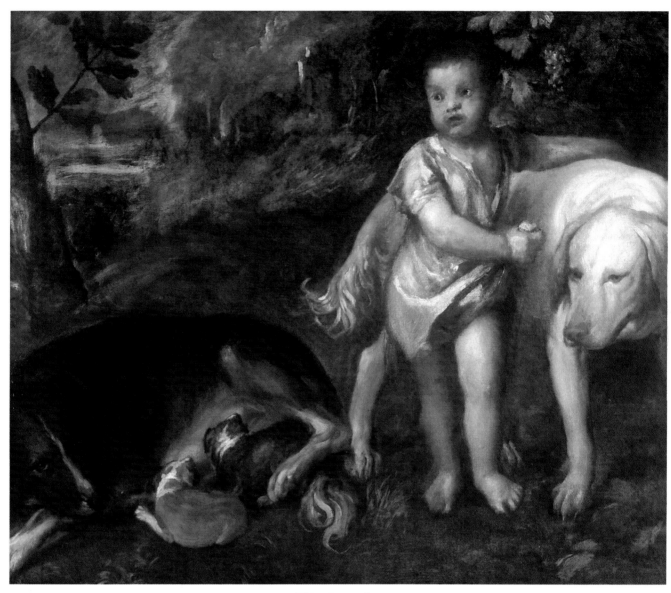

128 Titian *Boy with Dogs*

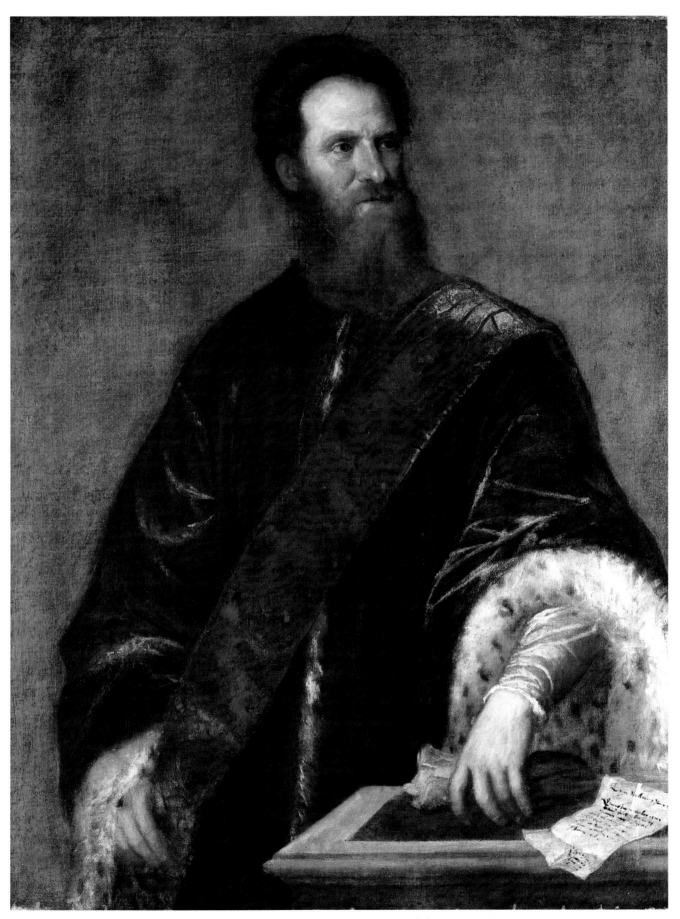

122 Titian *Portrait of Francesco Savorgnan della Torre (?)*

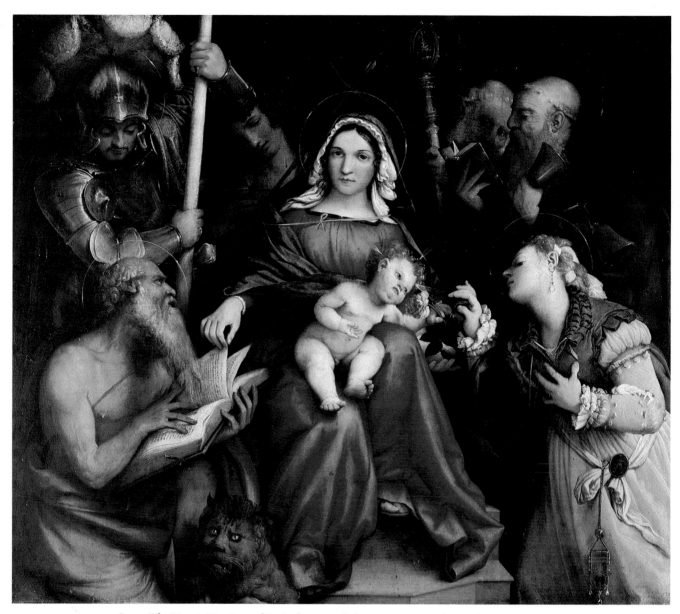

45 Lotto *The Mystic Marriage of St. Catherine with St. Jerome, St. Anthony Abbot and other Saints*

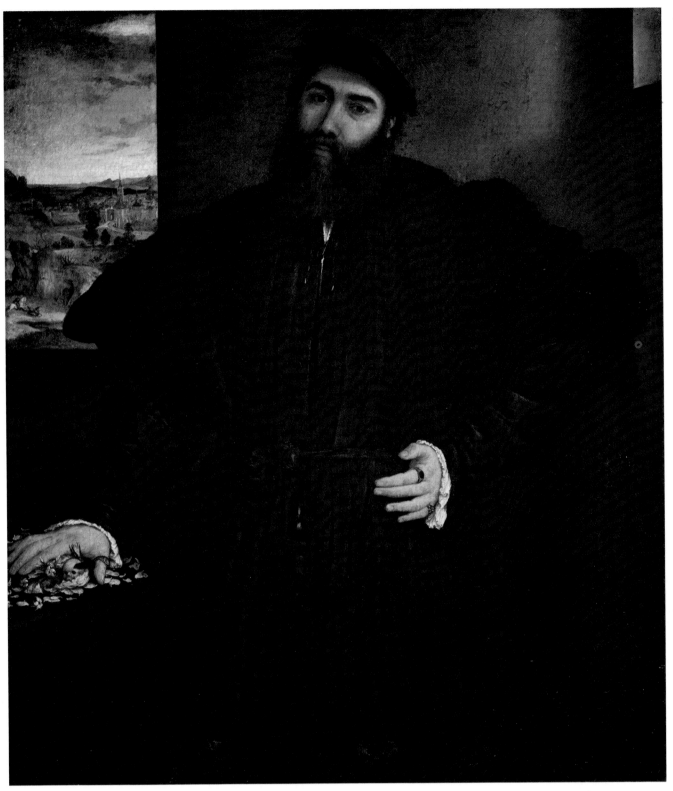

48 Lotto *Portrait of a Man*

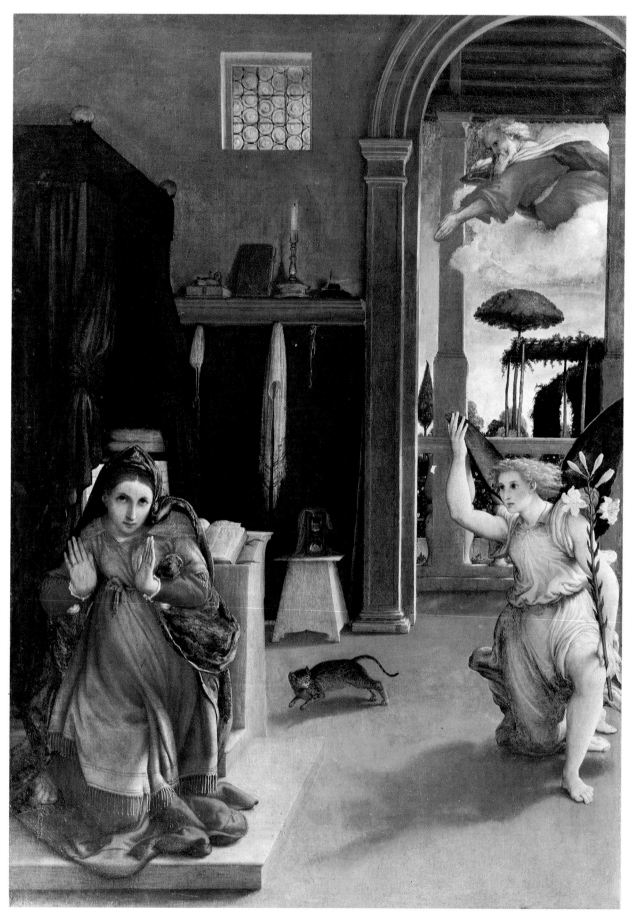

47 Lotto *The Annunciation*

49 Lotto *The Annunciation*

50 Lotto *The Visitation*

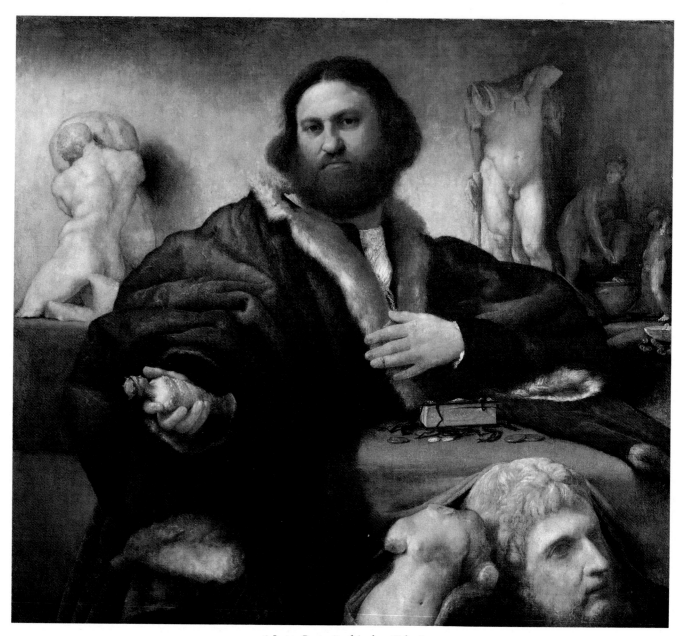

46 Lotto *Portrait of Andrea Odoni*

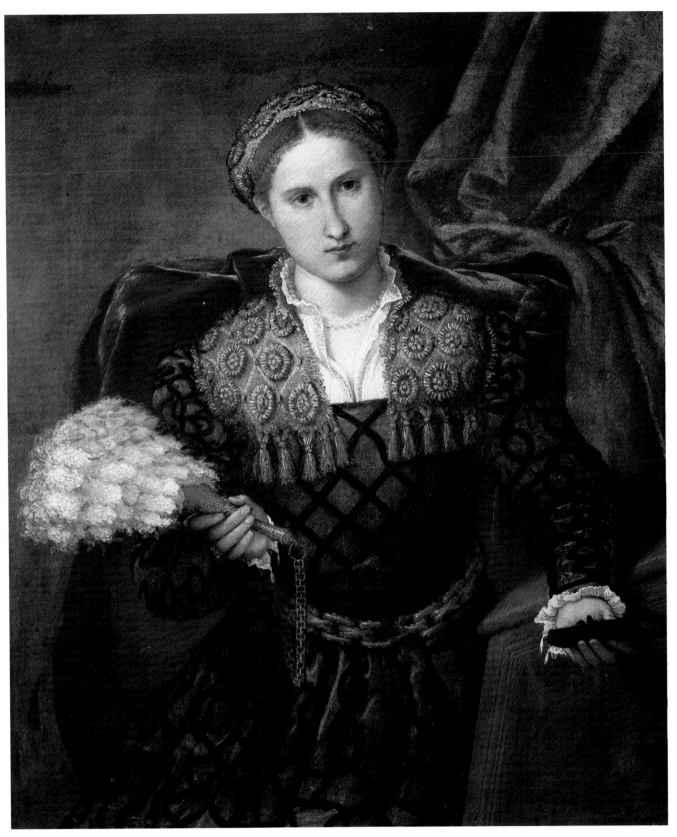

54 Lotto *Portrait of Laura da Pola*

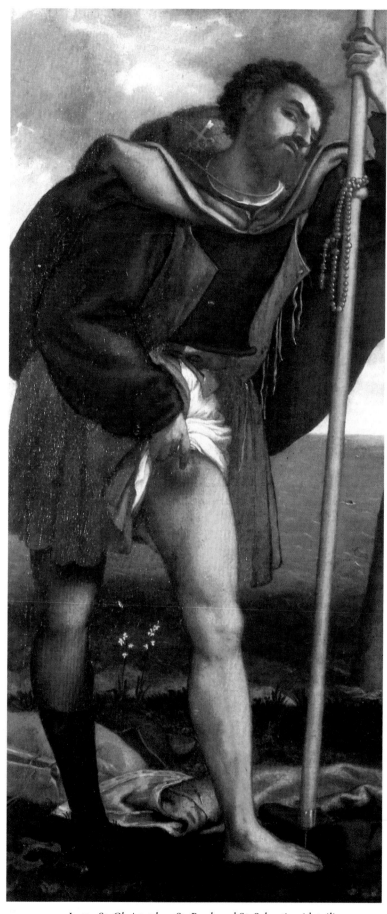

52 Lotto *St. Christopher, St. Roch and St. Sebastian (detail)*

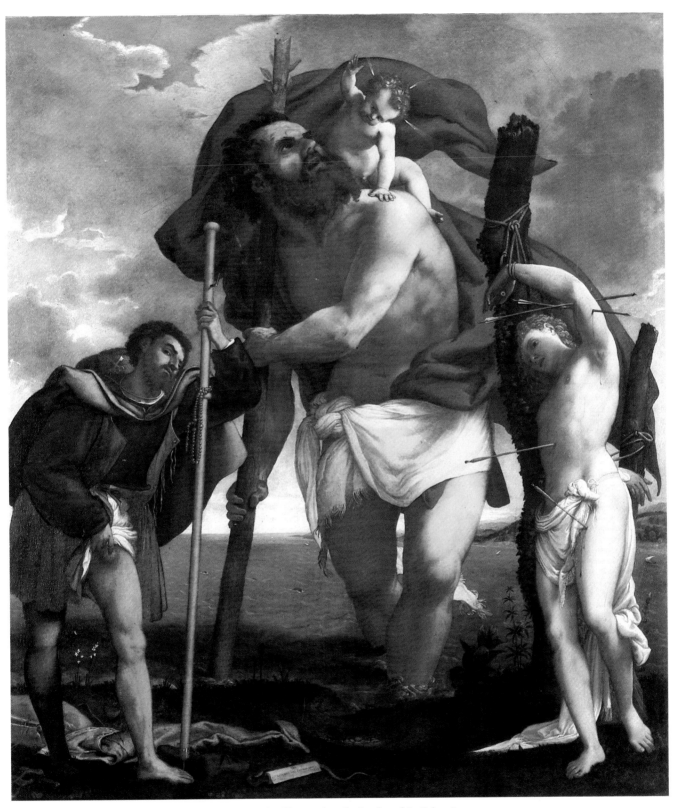

52 Lotto *St. Christopher, St. Roch and St. Sebastian*

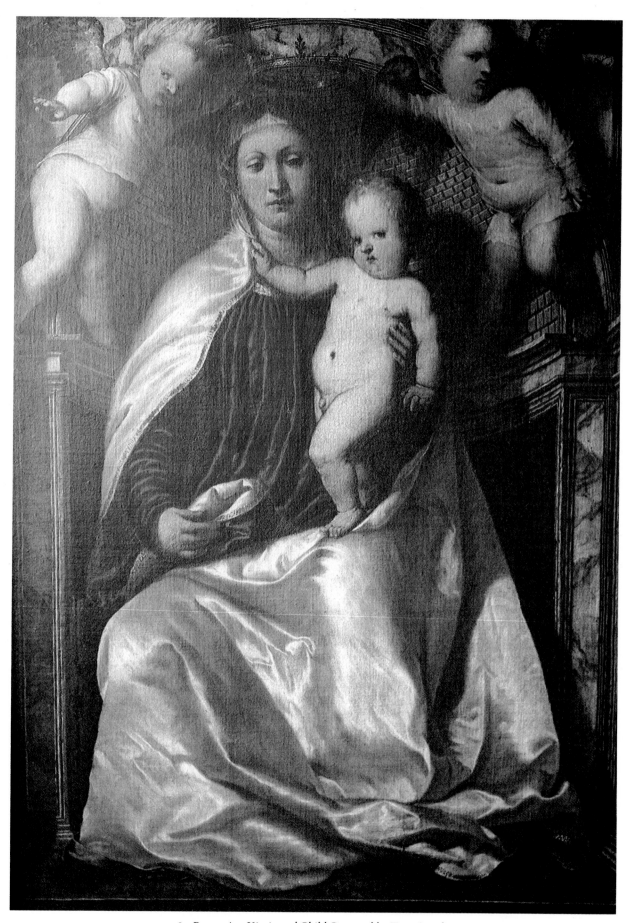

81 Romanino *Virgin and Child Crowned by Two Angels*

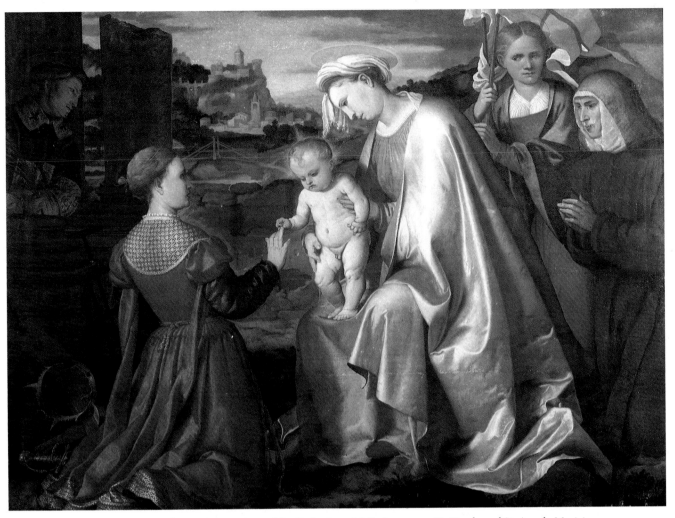

82 Romanino *The Mystic Marriage of St. Catherine with St. Lawrence, St. Ursula and St. Angela Merici*

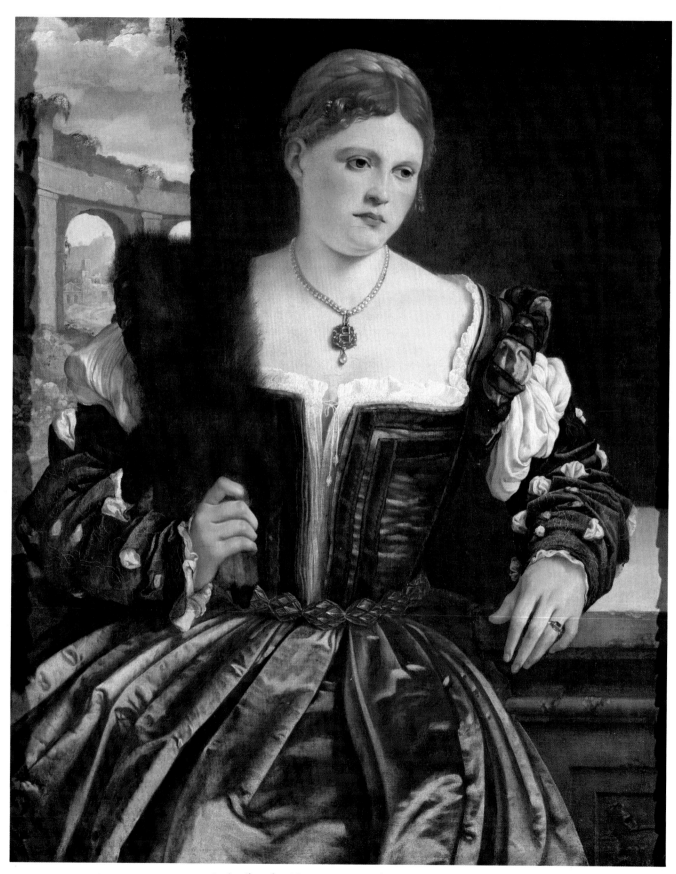

60 Attributed to Moretto *Portrait of a Young Woman*

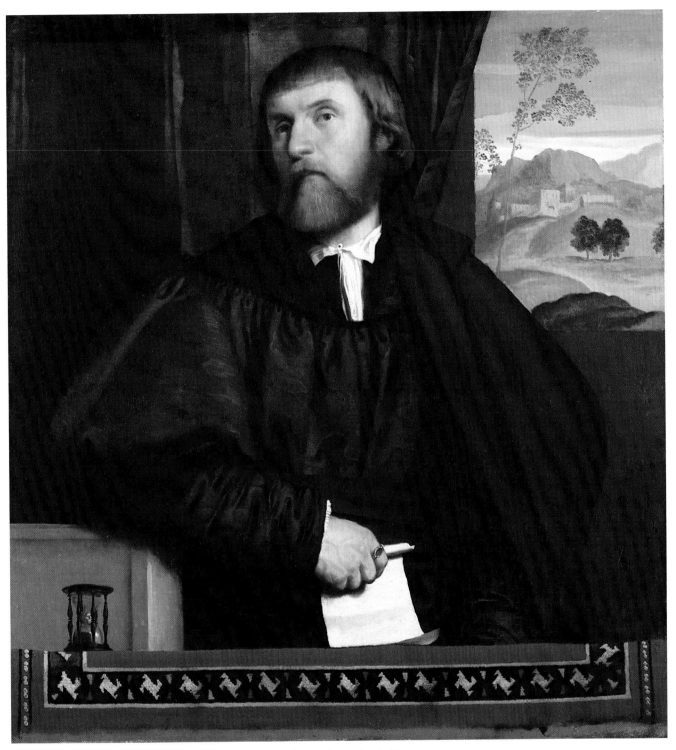

58 Moretto *Portrait of a Man*

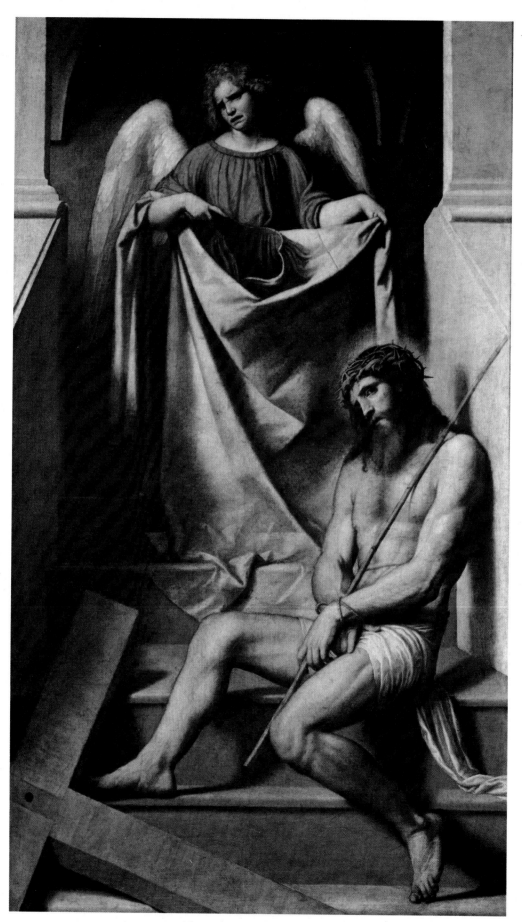

59 Moretto *Ecce Homo with an Angel*

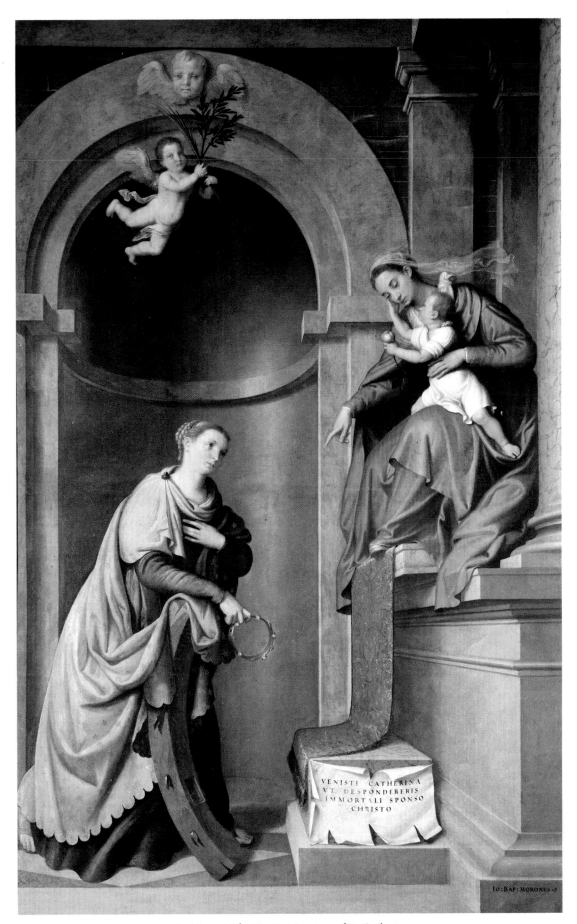

VENISTI CATHERINA
VT DESPONDERERIS
IMMORTALI SPONSO
CHRISTO

IO: BAP: MORONVS ·F

67 Moroni *The Mystic Marriage of St. Catherine*

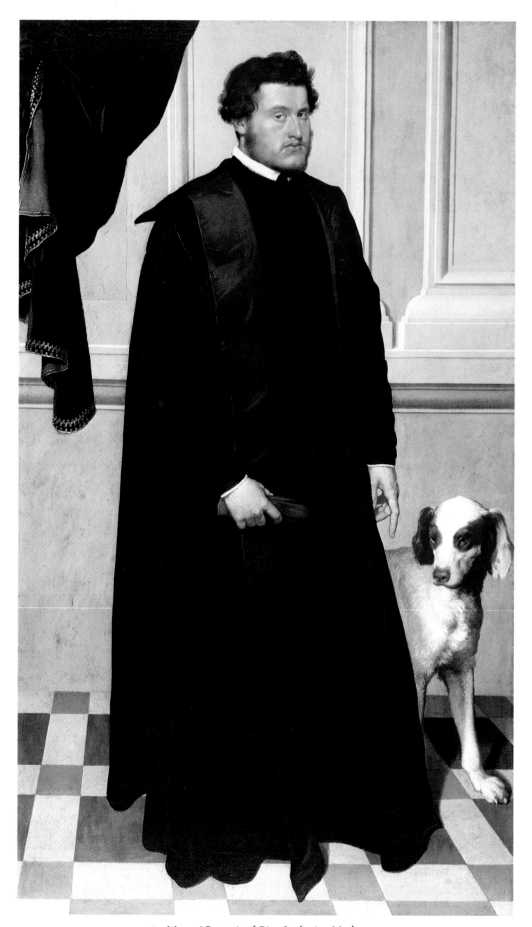

61 Moroni *Portrait of Gian Lodovico Madruzzo*

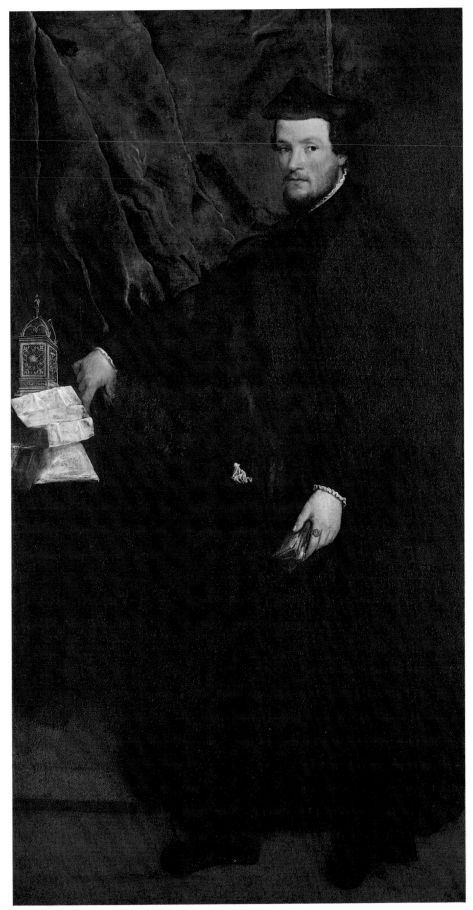

125 Titian *Portrait of Cristoforo Madruzzo, Cardinal and Bishop of Trent*

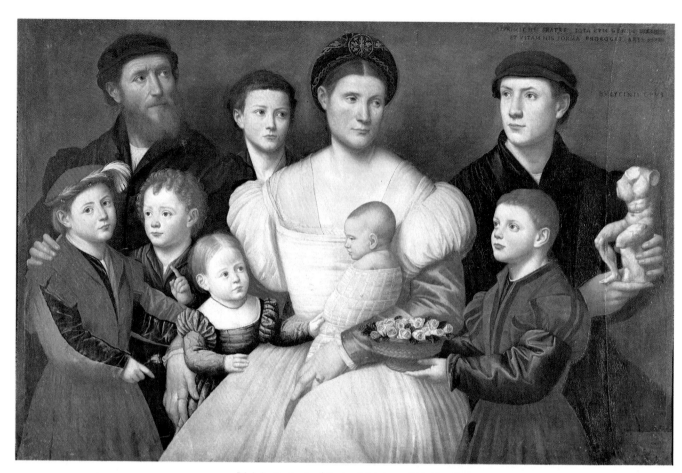

41 Licinio *Portrait of Arrigo Licinio and his Family*

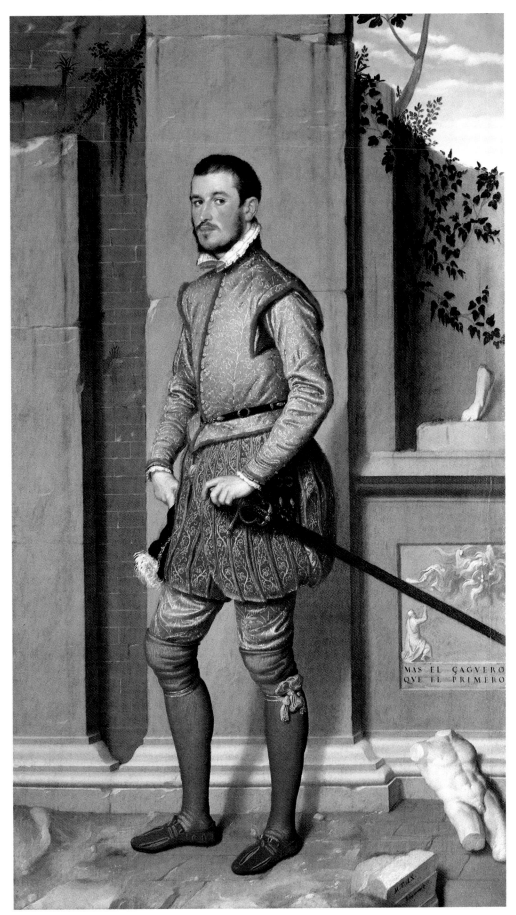

62 Moroni *Portrait of Gian Gerolamo Grumelli ('Il Cavaliere in Rosa')*

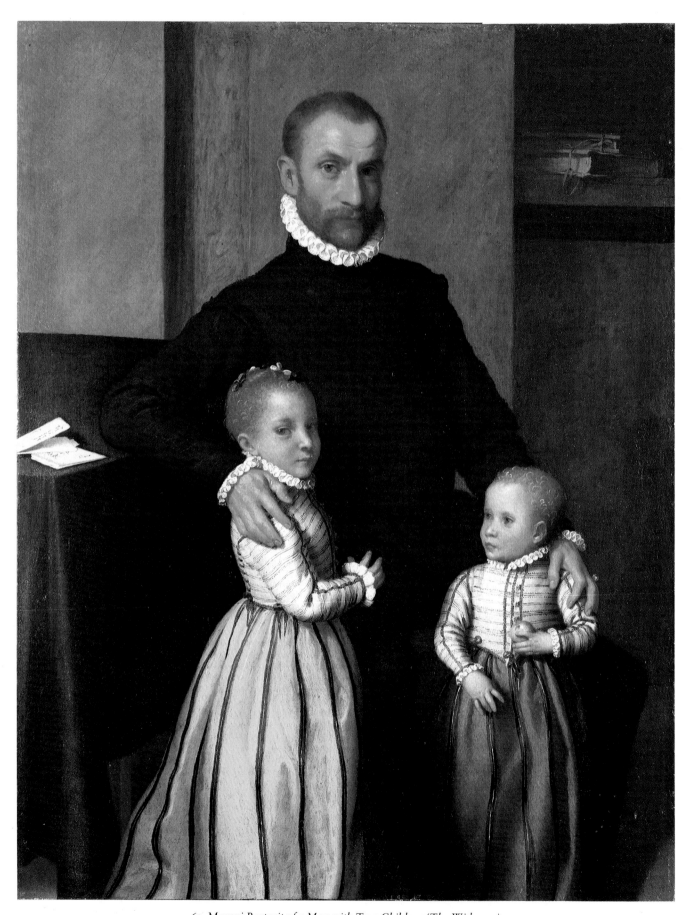

63 Moroni *Portrait of a Man with Two Children (The Widower)*

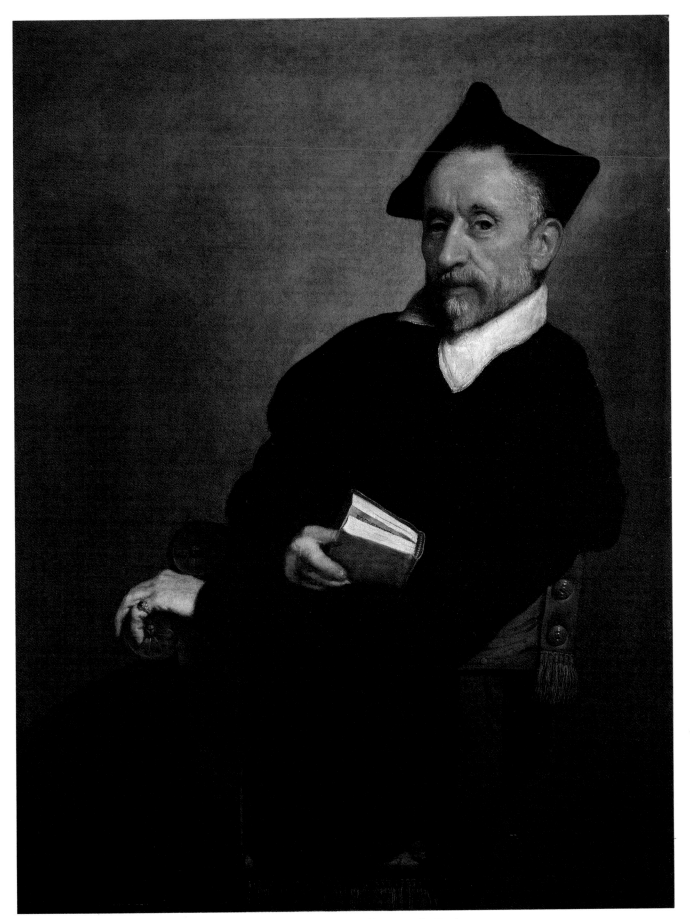

65 Moroni *Portrait of an Old Man with a Book*

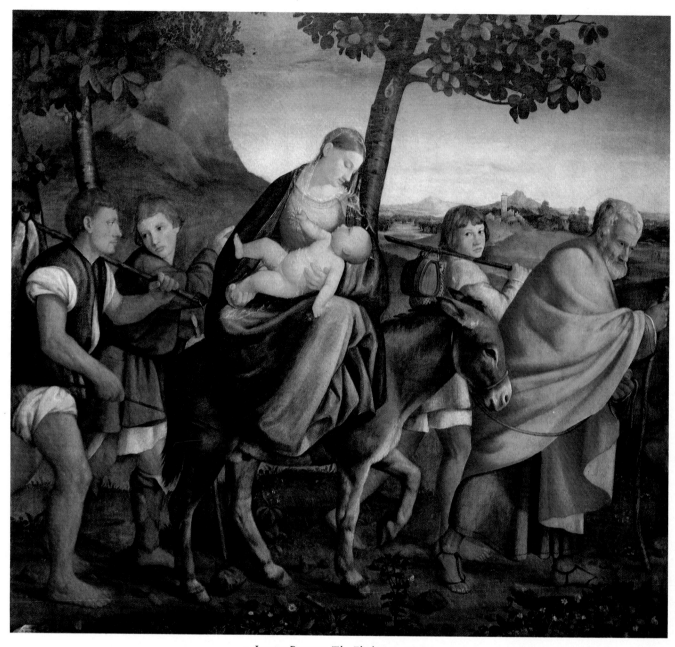

1 Jacopo Bassano *The Flight into Egypt*

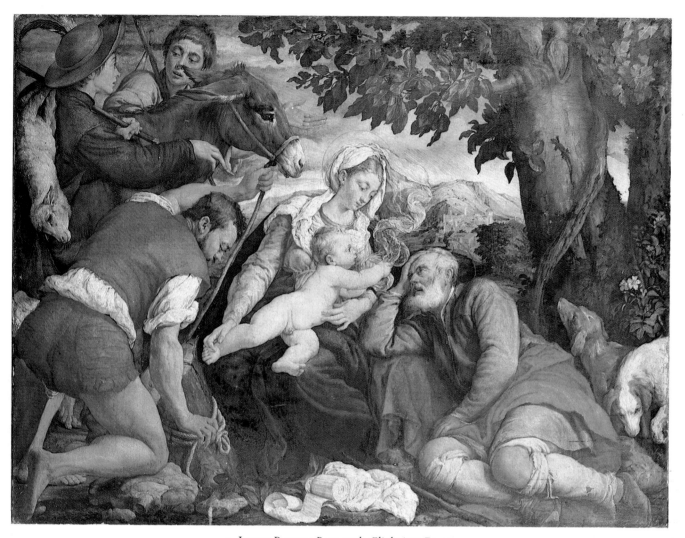

3 Jacopo Bassano *Rest on the Flight into Egypt*

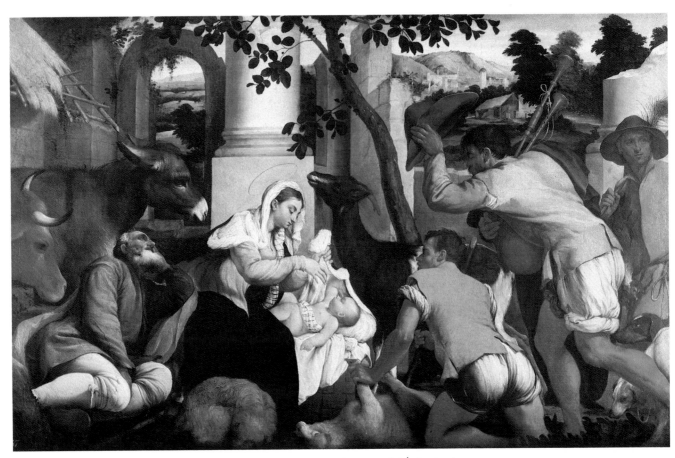

5 Jacopo Bassano *The Adoration of the Shepherds*

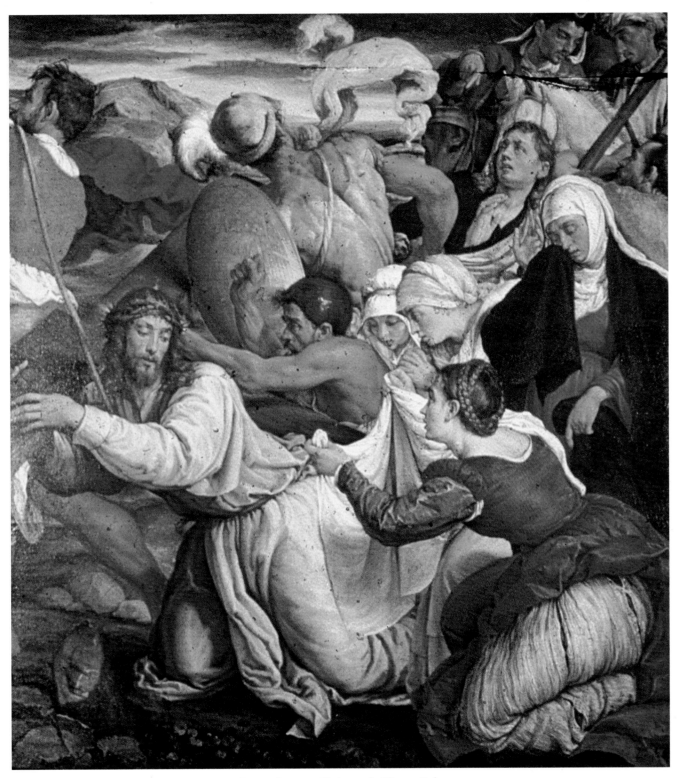

4 Jacopo Bassano *Christ on the Way to Calvary*

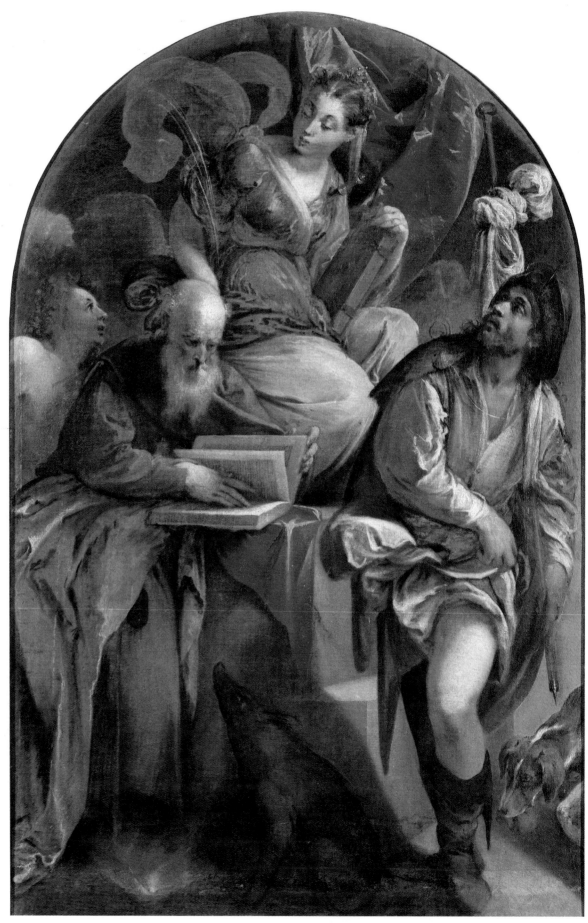

7 Jacopo Bassano *St. Giustina Enthroned with St. Sebastian, St. Anthony Abbot and St. Roch*

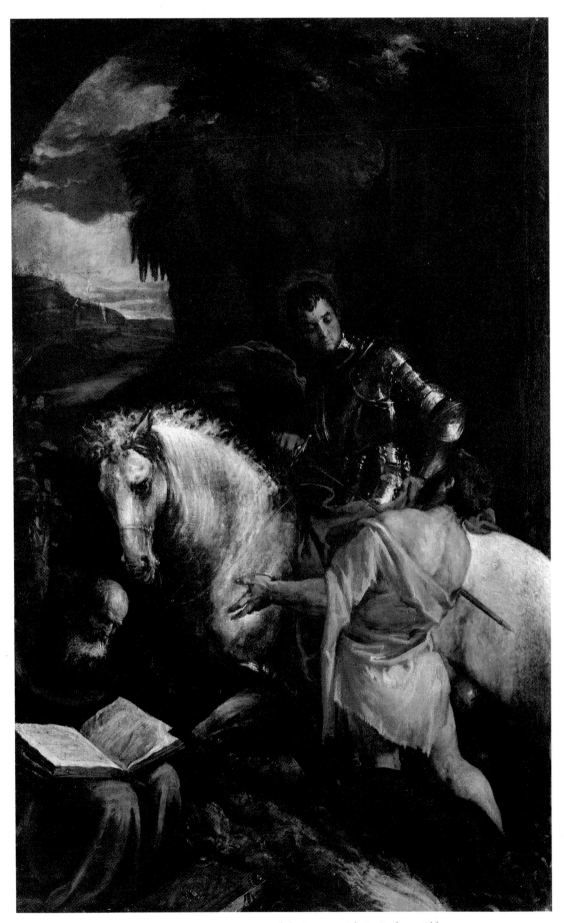

10 Jacopo Bassano *St. Martin and the Beggar with St. Anthony Abbot*

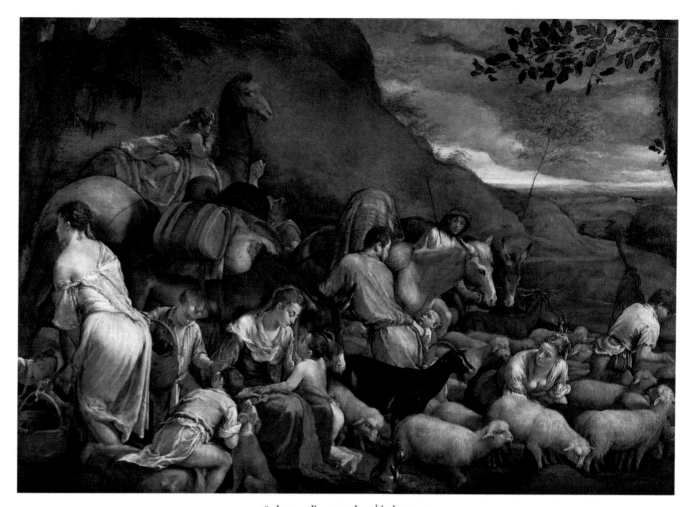

8 Jacopo Bassano *Jacob's Journey*

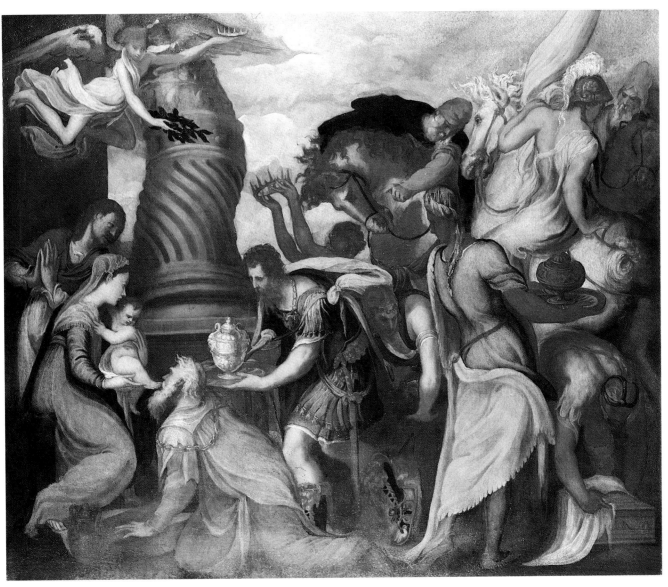

89 Schiavone *The Adoration of the Magi*

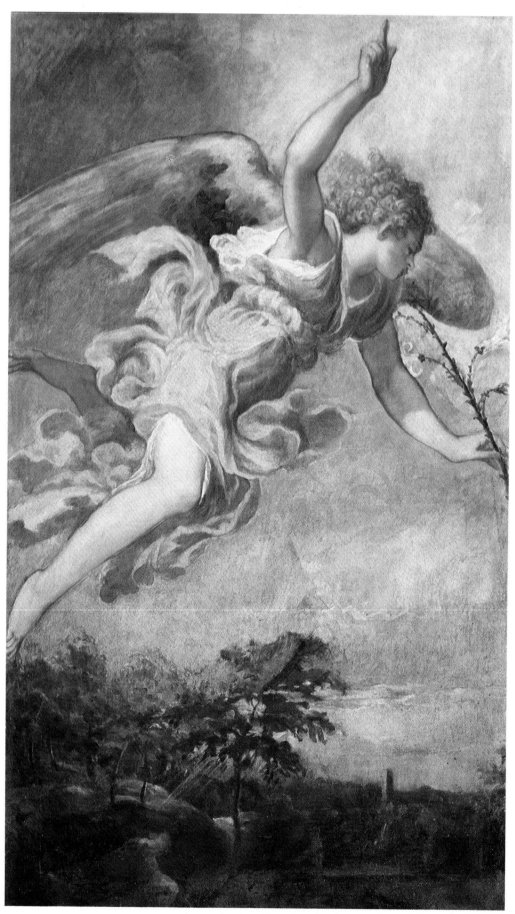

92 Schiavone *The Annunciation (Angel of the Annunciation)*

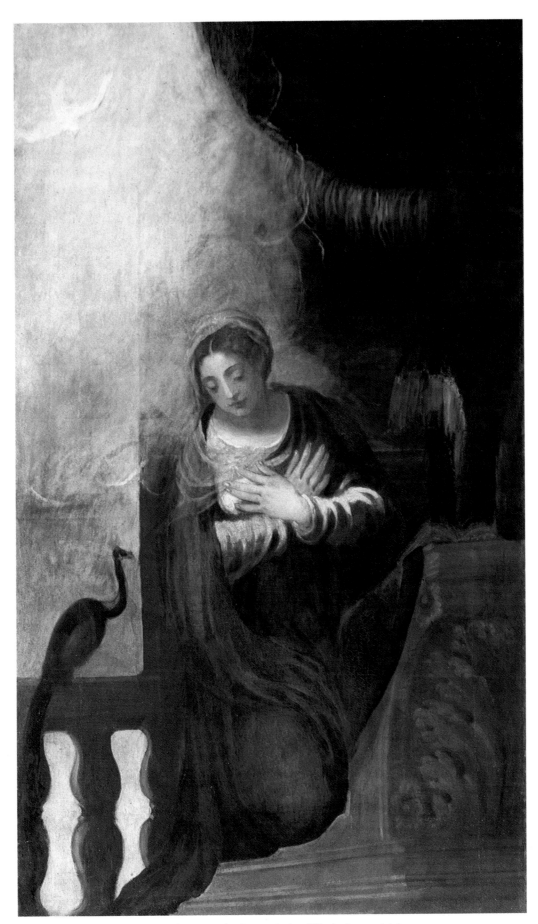

93 Schiavone *The Annunciation (Virgin Annunciate)*

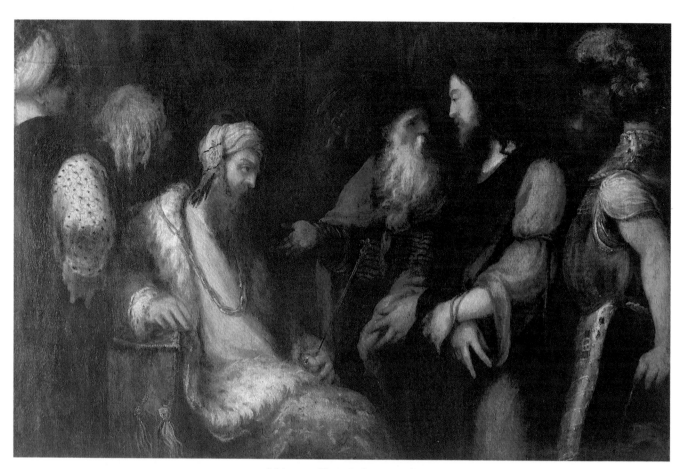

94 Schiavone *Christ Before Herod*

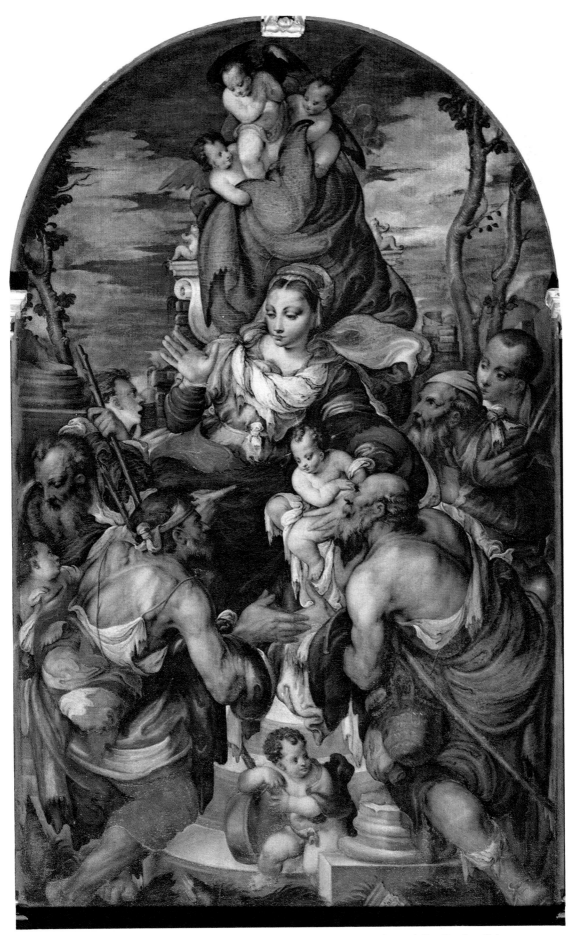

57 Pietro de Mariscalchi *The Adoration of the Shepherds (Madonna della Misericordia)*

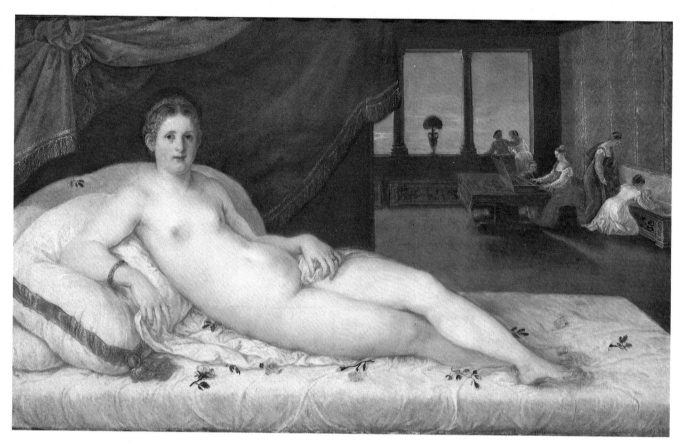

98 Sustris *Venus*

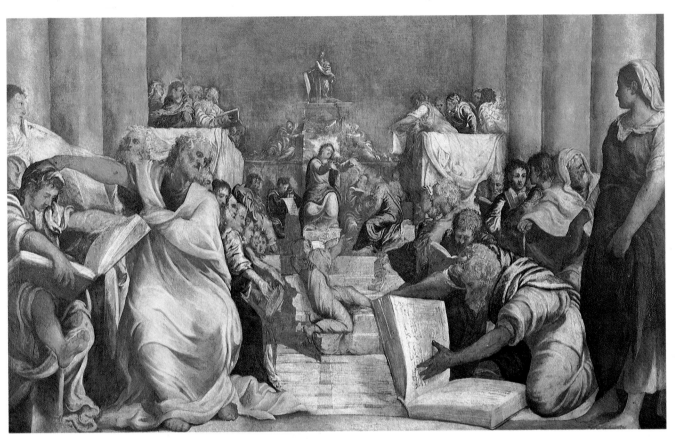

· 99 Jacopo Tintoretto *Christ Among the Doctors*

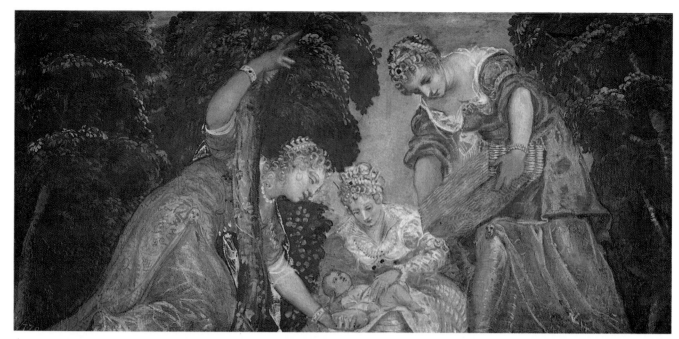

106 Jacopo Tintoretto *The Finding of Moses*

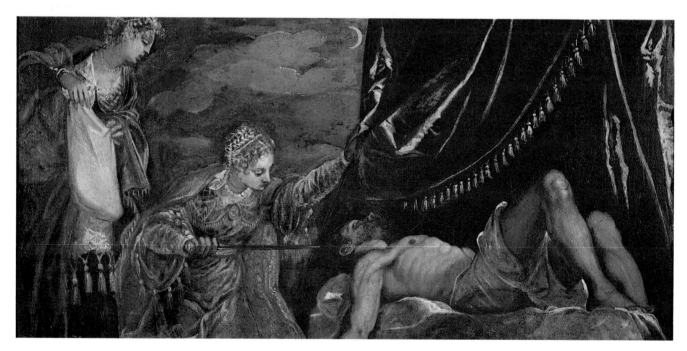

105 Jacopo Tintoretto *Judith and Holofernes*

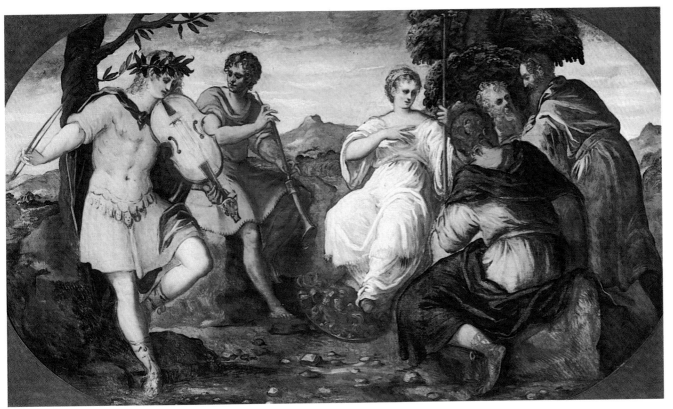

100 Jacopo Tintoretto *Apollo and Marsyas*

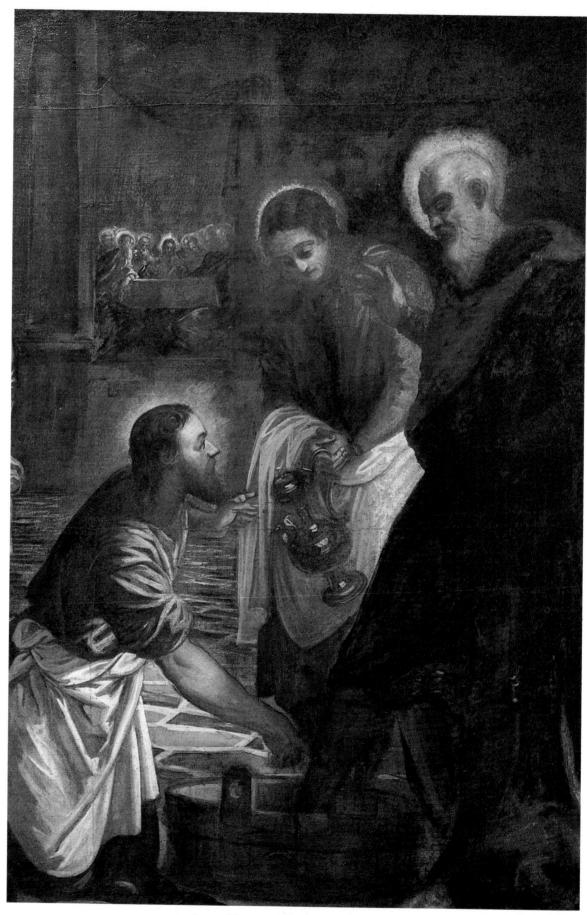

101 Jacopo Tintoretto *The Washing of Feet (detail)*

107 Jacopo Tintoretto *Pietà*

110 Jacopo and Domenico Tintoretto *Santa Giustina and the Treasurers*

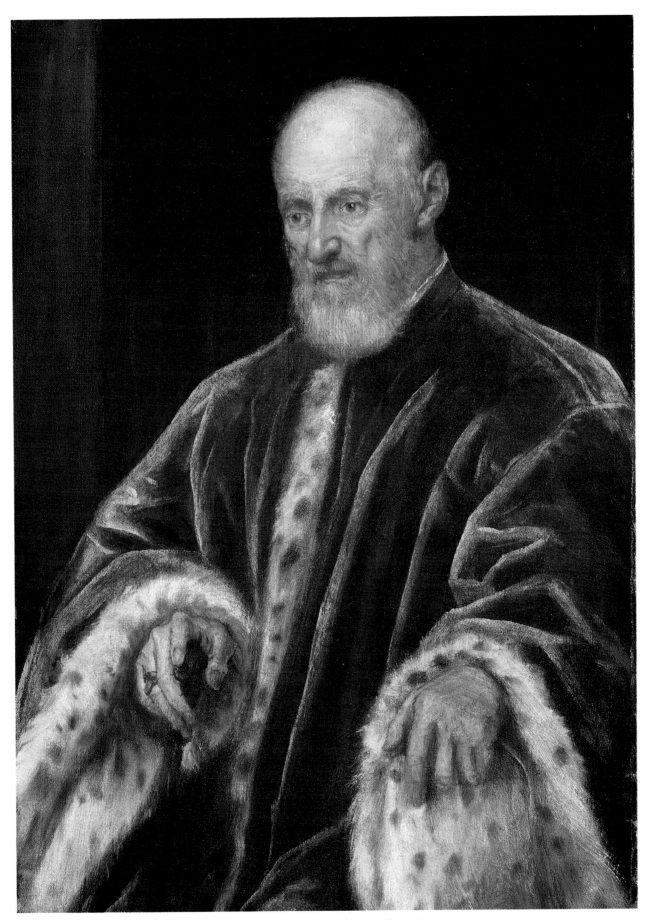

109 Jacopo Tintoretto *Portrait of an Elderly Senator*

111 Jacopo Tintoretto *Modello for 'Paradise'*

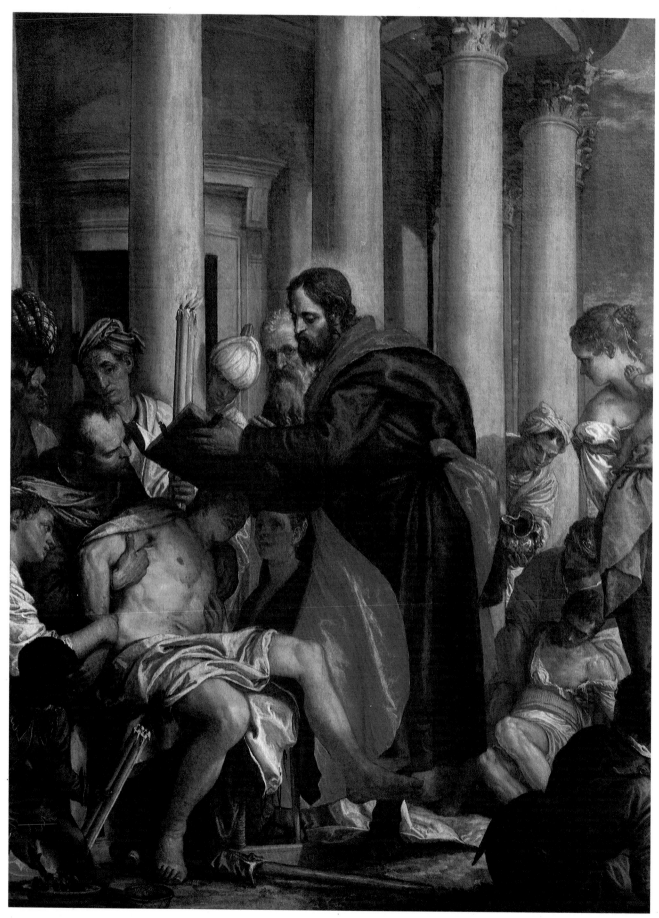

136 Veronese *The Miracle of St. Barnabas*

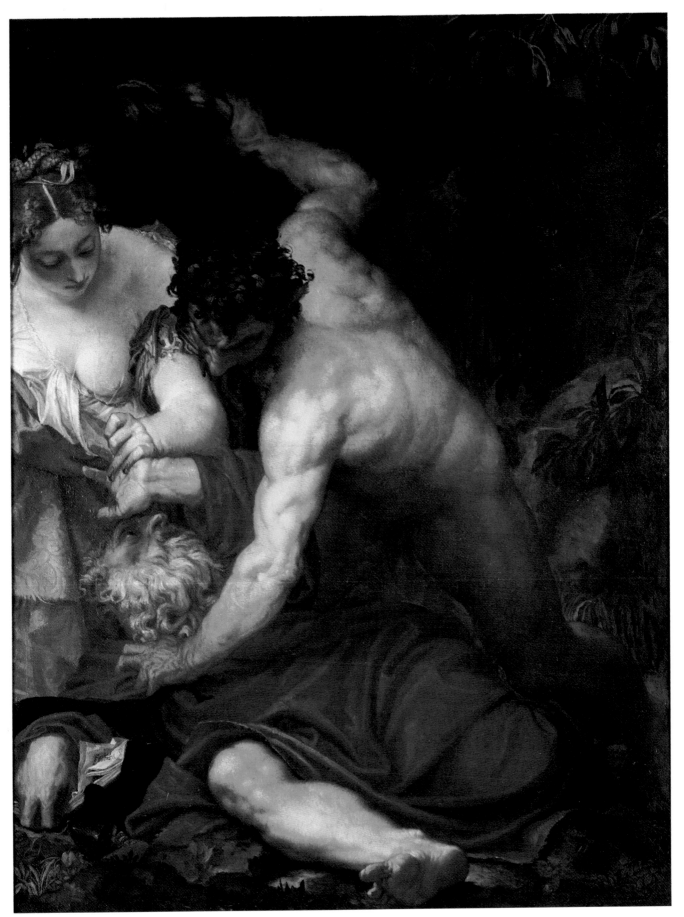

134 Veronese *The Temptation of St. Anthony*

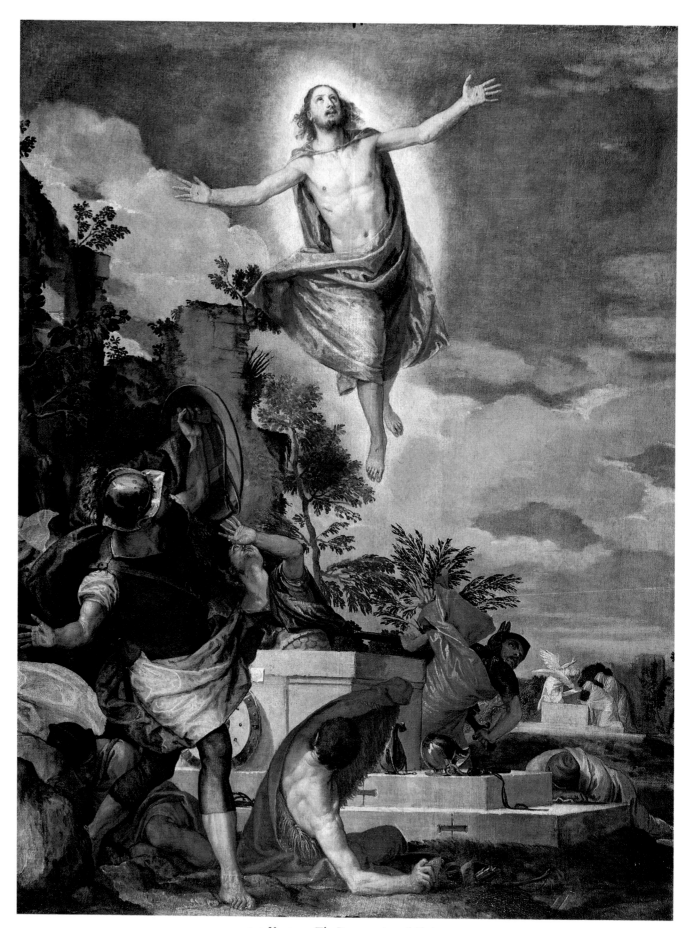

143 Veronese *The Resurrection of Christ*

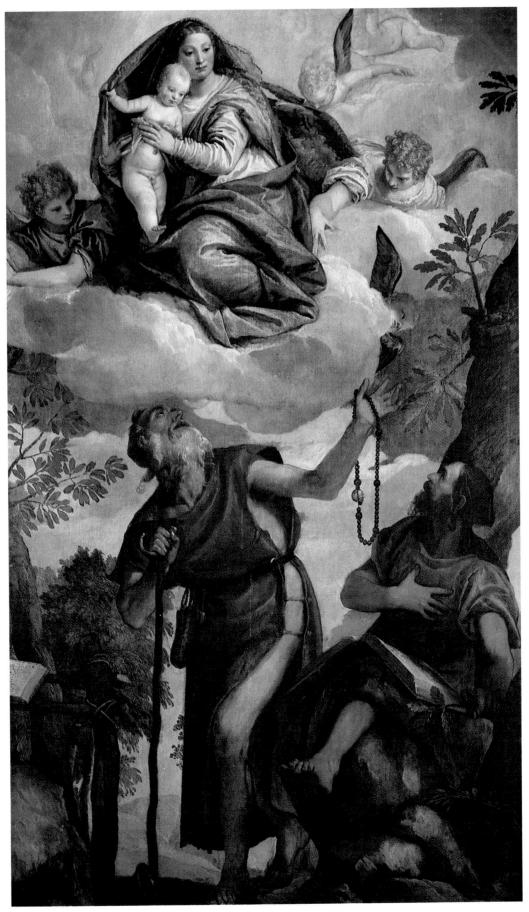

135 Veronese *Virgin and Child Appearing to St. Anthony and St. Paul*

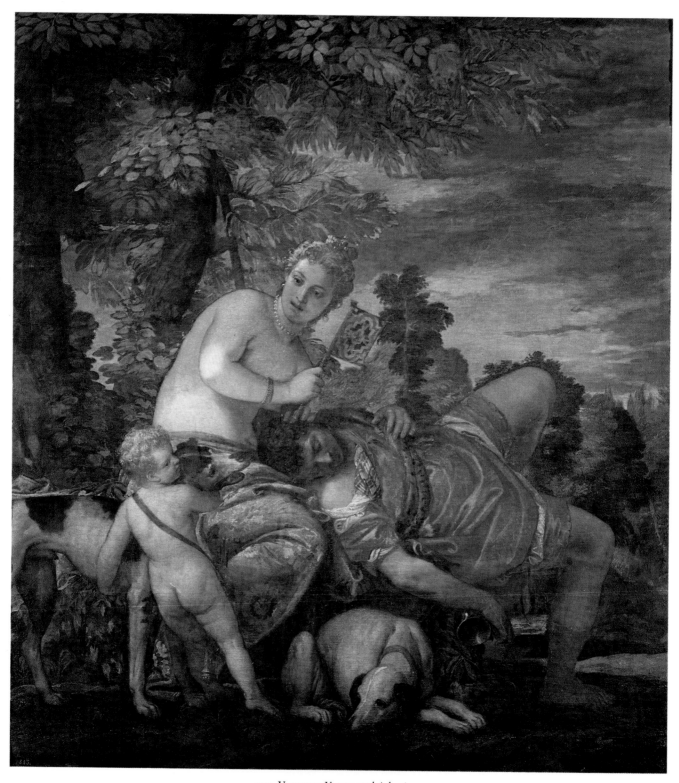

145 Veronese *Venus and Adonis*

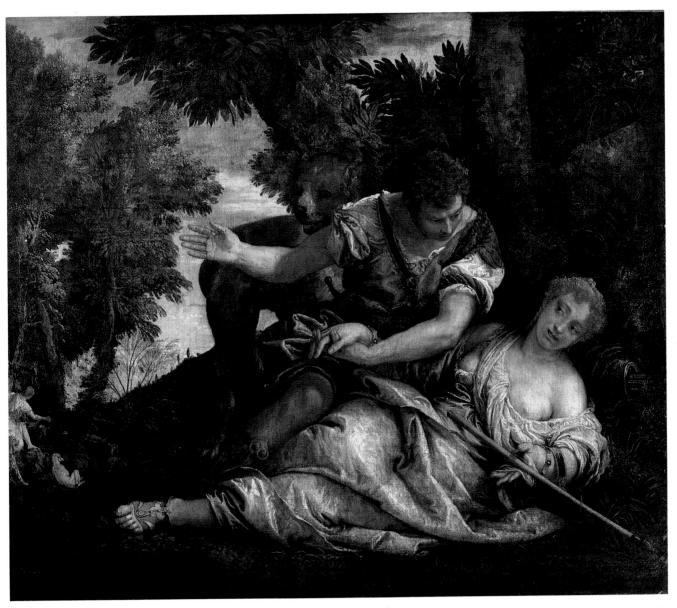

146 Veronese *Cephalus and Procris*

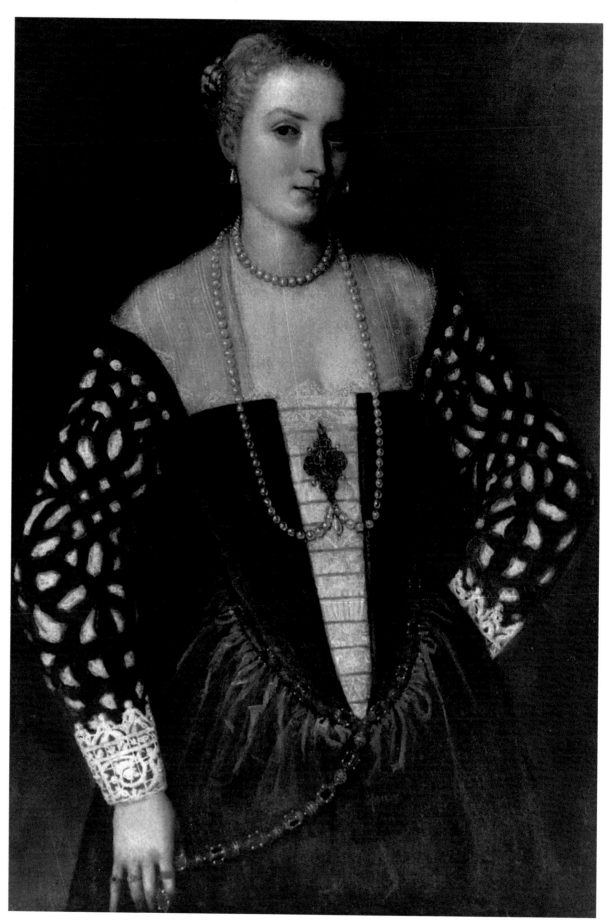

138 Veronese *Portrait of a Woman*

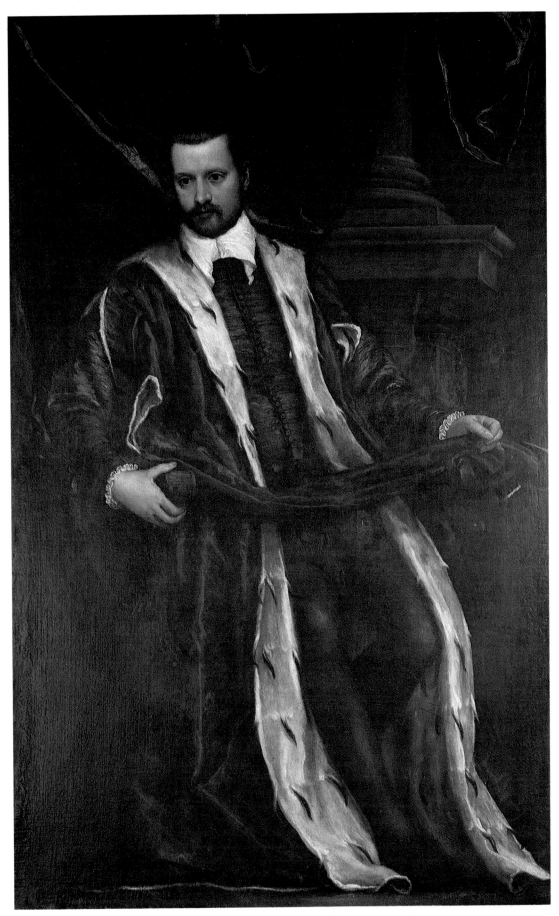

141 Veronese *Portrait of a Member of the Soranzo Family*

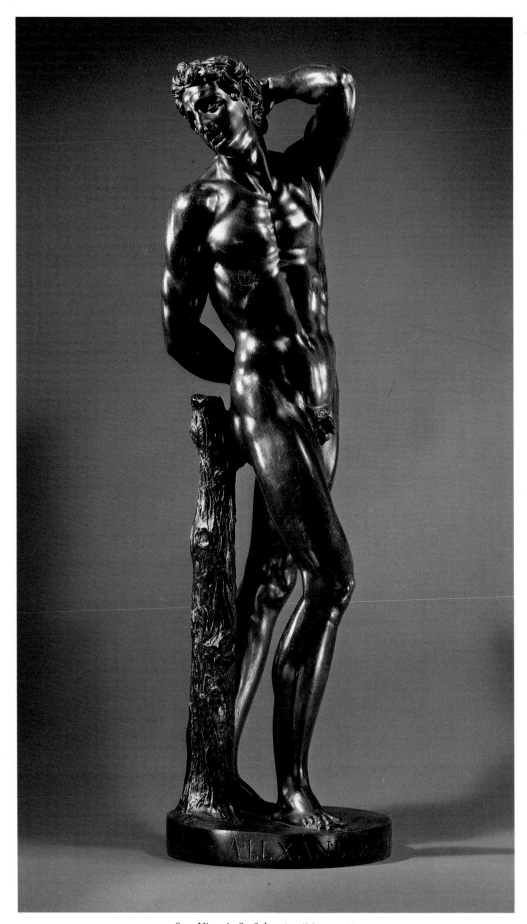

S37 Vittoria *St. Sebastian (Marsyas?)*

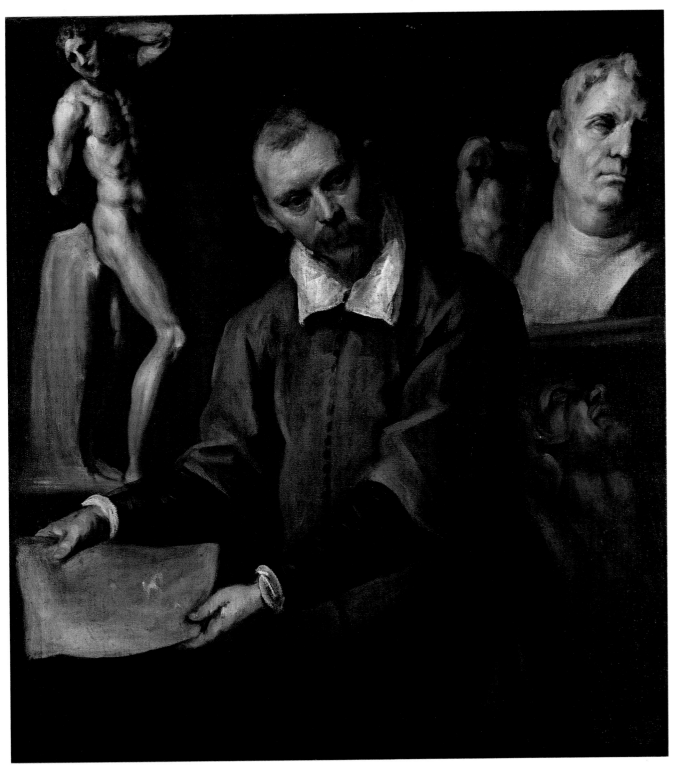

70 Palma Giovane *Portrait of a Collector (Bartolomeo della Nave?)*

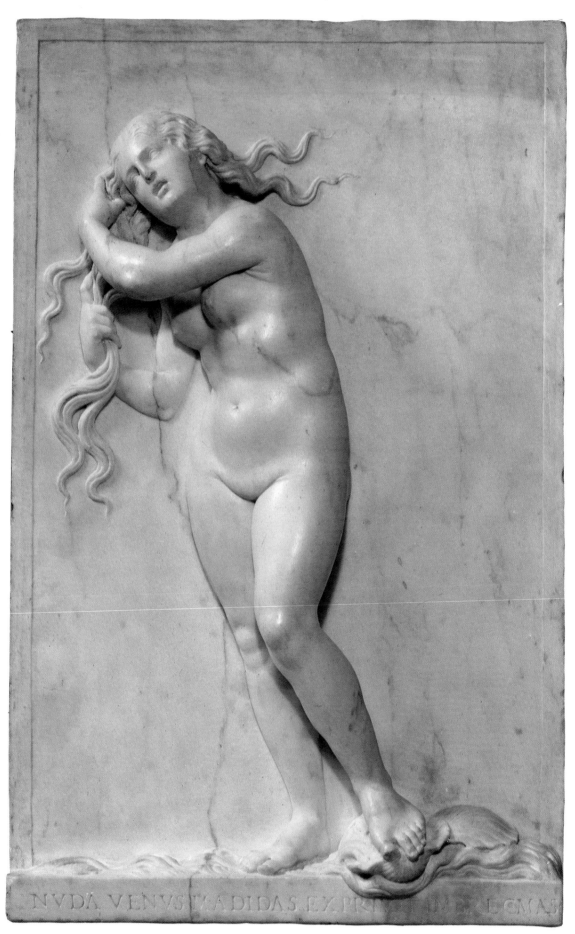

S13 Mosca *Venus Anadyomene*

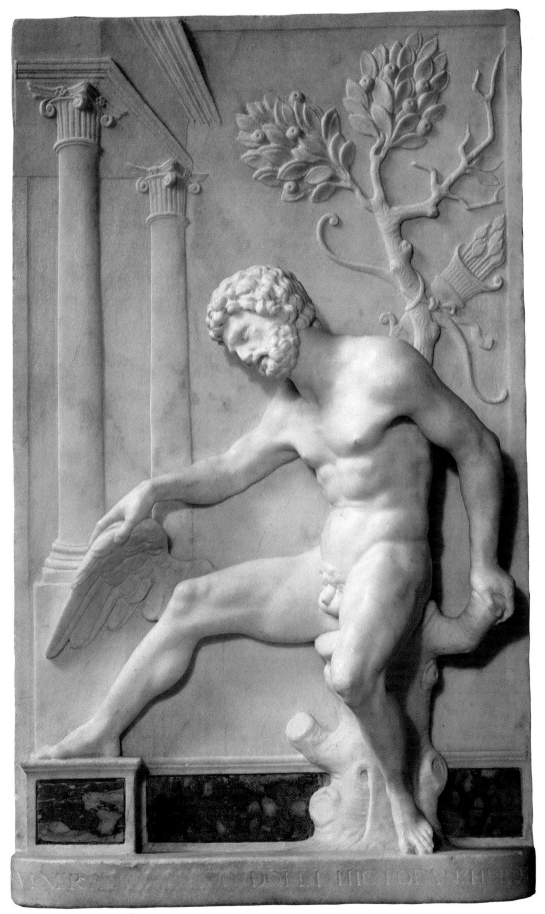

S9 A. Lombardo *Philoctetes*

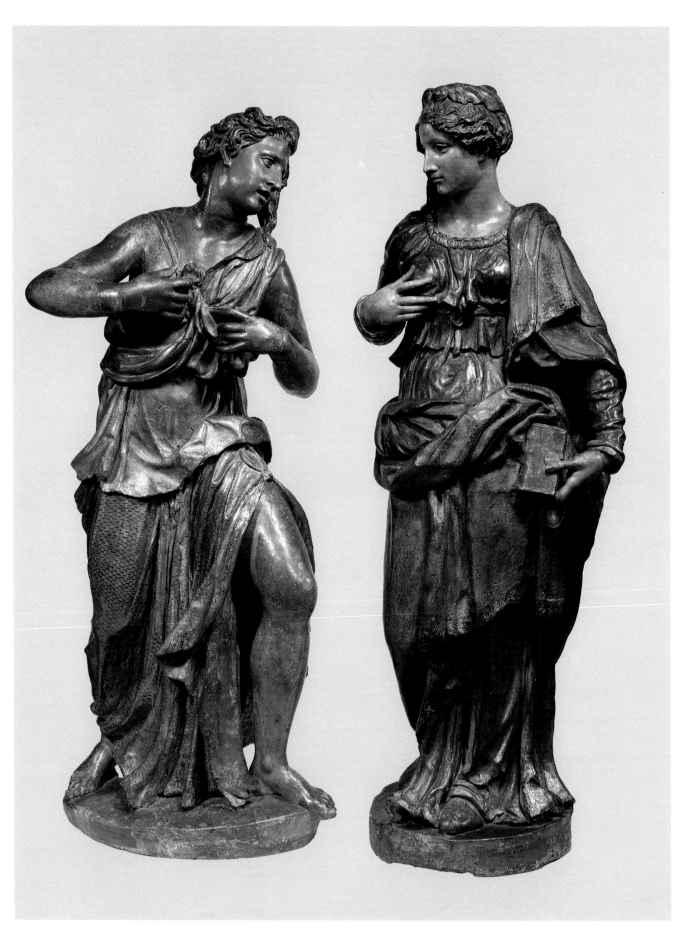

S29 J. Sansovino *The Annunciation*

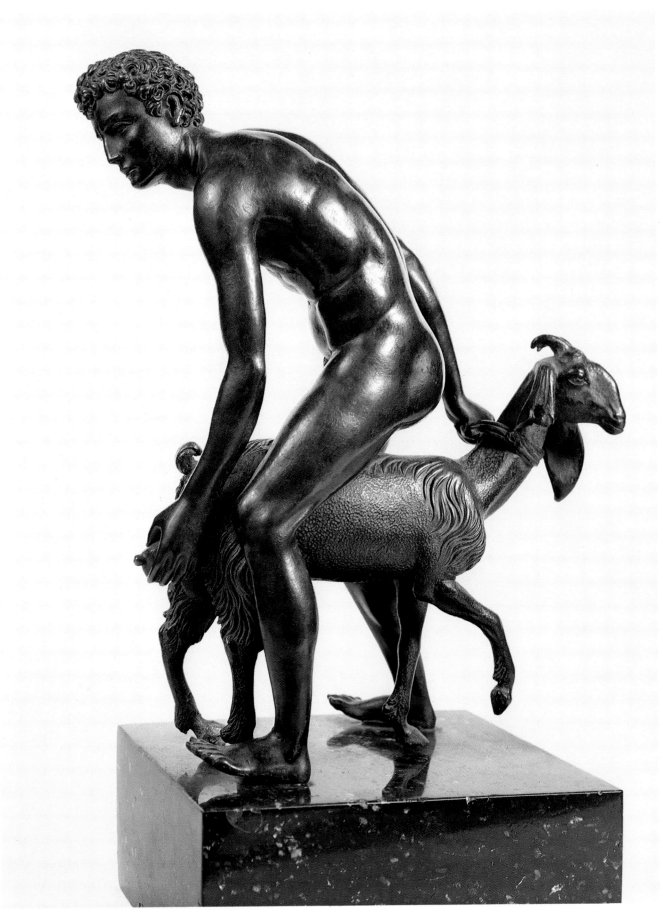

S19 Riccio *Curete Milking the Goat Amalthea (The Nourishment of Jupiter)*

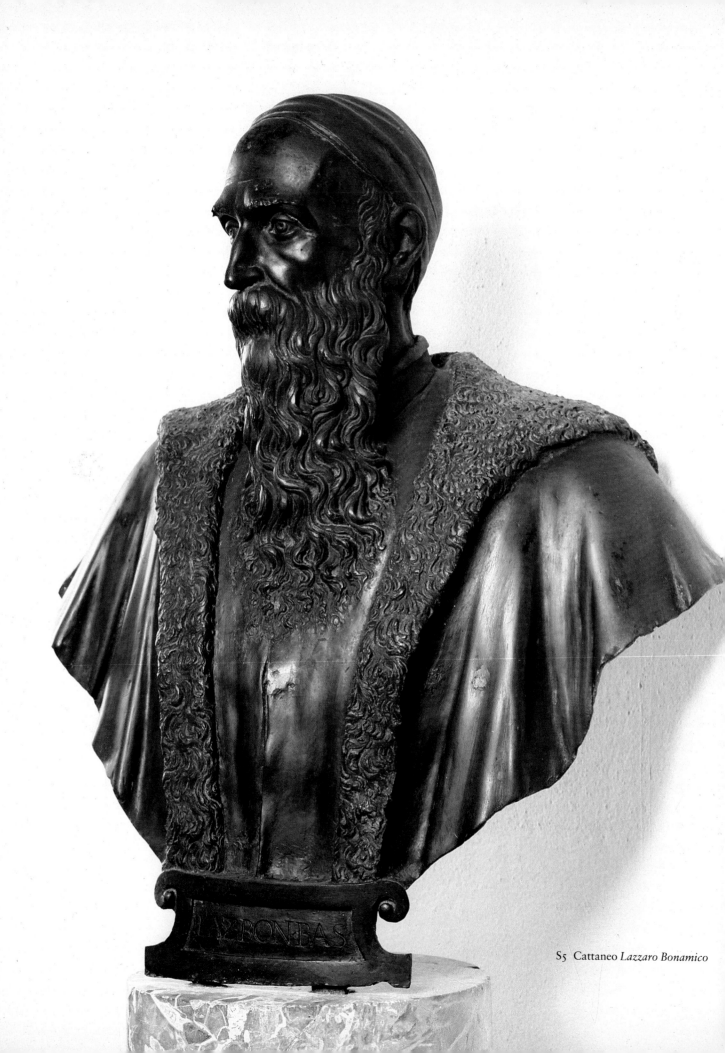

S5 Cattaneo *Lazzaro Bonamico*

THE CATALOGUE

Jacopo da Ponte, called

Jacopo Bassano

Bassano *c.* 1510 – Bassano 1592

Jacopo da Ponte (or dal Ponte; Rigon 1978, p. 174) was the son of Francesco, a mediocre painter of the Vicentine school. He was brought up near the Ponte Vecchio on the Brenta canal in the heart of the town of Bassano (Rigon 1980). The bridge was rebuilt on various occasions, most significantly by Andrea Palladio in 1570. By 1535, following a stay in Venice, Jacopo's personal style had emerged. At first he was influenced by Bonifazio de' Pitati and Titian, but prints also played an important part in the formation of his style, including the work of northern artists such as Dürer, Barthel and Sebald Beham, and also prints after paintings by Raphael and Salviati. These encouraged the mannerist elements in his style which became increasingly evident in the works of the late 1530s, such as the paintings for the Sala dell'Udienza and the Sala del Consiglio Communale (all now in the Museo Civico, Bassano), and the frescoes on the façade of the Palazzo Dal Corno (after 1538), the altarpiece of Borso, dated 1538, the *Martyrdom of St. Catherine* (Museo Civico, Bassano), the *Portrait of a Man of Letters* (Cat. 2), the *Christ amongst the Doctors* (Ashmolean Museum, Oxford) and the *Adoration of the Magi* (Edinburgh).

After 1540–42 Bassano was deeply influenced by Parmigianino, as can be seen in *The Flight into Egypt* (Pasadena), the *Adoration of the Shepherds* (Cat. 5), *The Rest on the Flight into Egypt* (Cat. 3), and the *Christ on the Way to Calvary* (Cat. 4). During the 1550s his extremely personal mannerist style and his exotic and sumptuous use of colour were fully developed. Masterpieces of this date include the *Decollation of St. John the Baptist* (Copenhagen), *Dives and Lazarus* (Cleveland), the *St. John the Baptist* of 1558 (Bassano), the *Adoration of the Magi* (Vienna), and the *St. Giustina Enthroned* (Cat. 7). Between 1545 and 1560 Bassano held an important position in Venetian painting; despite the fact that he worked in a small provincial town he was, together with Veronese and Tintoretto, one of the most influential painters in the Veneto apart from Titian. Although a pastoral element had always been present in his work, during the 1560s he combined a highly elaborate and artificial style with natural detail observed from nature as can be seen in *Jacob's Journey* (Cat. 8), and the *Adoration of the Shepherds* of 1568 (Cat. 9).

For many years it was thought that Jacopo ceased to paint after 1580 because in a letter from Jacopo's son, Francesco Bassano the Younger, to Niccolò Gaddi of 1581, Francesco said his father was unable to draw as he was losing his sight. However, during recent restoration, dates have been revealed on several paintings, most notably the date 1585 on the *Susanna and the Elders* (Cat. 11). A more careful analysis of the so-called 'genre' works of the 1580s, previously thought to have been shop productions, has revealed that they are the work of Jacopo (Ballarin 1966; Rearick 1967 and 1968; Pallucchini 1982). He was evidently active until the very end of his life, and, while preserving his own idiom and style, was profoundly influenced by Titian after the latter's death in 1576.

L. M.

I

The Flight into Egypt

183 × 198 cm
Signed: *Jacobus/a ponte*; below: the remains of an inscription, now obliterated
Museo Civico, Bassano del Grappa (no. 6)
[*repr. in colour on p. 108*]

This is Jacopo Bassano's first masterpiece; its composition seems to be derived from Giotto's fresco of the *Flight into Egypt* (Cappella degli Scrovegni, Padua) while the Virgin and Child appear to be taken from Titian's frescoed lunette in the Doge's Palace which is dated 1523. In 1775 Verci claimed that he could read the date 1534 on the painting, and Paroli transcribed the signature as '*Jacobus a ponte pingebat 1534*' (*c.* 1830, MS catalogue of paintings in the Sala della Congregazione Municipale, Bassano). But Arslan, who claimed that the inscription must have been illegible even before Paroli's day, believed that the work was later than the three canvases of the Sala del Consiglio – certainly later than that with the Soranzo coat of arms – and dated the picture 1535–36 (Arslan 1931). Longhi (1948) has rightly discerned that this work combines the old-fashioned style Jacopo would have learnt from his father with that of the more modern Bonifazio de' Pitati. This would suggest that the date of 1534 is correct, as Smirnova (1976) and Pallucchini (1982) believe.

L. M.

PROVENANCE
S. Girolamo, Bassano del Grappa; 1780, when the church was suppressed, passed to the Municipality; 1840 Museo Civico

EXHIBITIONS
Venice 1945, no. 107; Lausanne 1947, no. 58; Bassano 1952, no. 12; Venice 1957, no. 5

REFERENCES
Magagnato and Passamani 1978, p. 19; Pallucchini 1982², p. 17; Smirnova 1976

2

Portrait of a Man of Letters

76.2 × 65.7 cm
Signed on the letter on the left: *Jac. A. Ponte Bassanensis F. in Venetiis*
Brooks Memorial Gallery, Memphis, Tennessee; Gift of the Samuel H. Kress Foundation (61.208)

This is the only signed portrait by Jacopo Bassano, and the inscription states that it was painted in Venice. The identity of the sitter is unknown, but details such as one hand resting on an open book and a glove held in the other are derived from Lorenzo Lotto's portraits. The oriental carpet covering the table appears in several other paintings by Bassano including the *Madonna and Child with St. Anthony Abbot and St. Martin Abbot* (Alte Pinakothek, Munich, originally from Rasai, near Feltre), and the *Christ amongst the Doctors* (Ashmolean Museum, Oxford), as well as the *Dives and Lazarus* (Cleveland) and the

2

Decollation of St. John the Baptist (Copenhagen). It is likely that this rug was in Jacopo's house, or more probably in his studio, and may have been there since his youth; he continued to paint it until the 1550s. The versimilitude with which it is painted is typical of Jacopo's treatment of 'still-life' objects, which are often found in his paintings. The sitter appears to be distracted and unaware of the painter's presence. This is characteristic of Jacopo's naturalistic approach to his subjects; he was always a humble, yet subtle, observer of reality. It is generally agreed that the work can be dated *c.* 1540.

L.M.

PROVENANCE
Private collection, England; 1950 Samuel H. Kress Collection

EXHIBITION
Venice 1957, Portraits no. 2

REFERENCES
Arslan 1960, I, p. 46; II, fig. 26; Berenson 1952, pl. 95; 1957, I, p. 19;
Pallucchini 1982², pl. 7; Washington 1951, pp. 124–25 (W. Suida); Zampetti
1958, p. 19, pl. LXXIV

3
Rest on the Flight into Egypt

118 × 158 cm
Pinacoteca Ambrosiana, Milan (no. 40)
[*repr. in colour on p. 109*]

This painting of the late 1540s is of fundamental
importance in Jacopo's *oeuvre*. At this date he was still

influenced by Parmigianino; although some elements in the painting are observed from nature and emphasised by particularly strong colouring, the composition creates a restless sensation. It is crammed with incident and the figures are inextricably interlocked with one another; it almost seems as if the paint is trapped between the complex contours of the design, which is masterly (such total control of composition only reappeared in Jacopo's work of 1558–68). It is painted in a rich impasto in which warm tones predominate, so that there are no stark contrasts between the strident colours and the burnt earth pigments. The painting was formerly attributed to Titian.

L.M.

PROVENANCE
Cardinal Federigo Borromeo; 1618 donated by him to the Ambrosiana

REFERENCES
Falchetti 1969, pp. 262ff, with bibliography; Pallucchini 1982², pl. 15

4
Christ on the Way to Calvary

146 × 133 cm
The Earl of Bradford
[*repr. in colour on p. 111*]

Stylistically this work can be dated around 1545–50. Compared to the *Christ on the Way to Calvary* (Fitzwilliam Museum, Cambridge) which is almost contemporary, the figures, which are based on prints of recent Roman paintings, are more explicitly mannerist in style and may have been influenced by Schiavone. This is also true of the *Christ on the Way to Calvary* in Budapest which, according to the present writer, dates from just before 1550. The crowded composition of this painting is unlikely to have been deliberate, but is probably due to the painting having been cut on the left-hand side. As a result, the figures are thrust into the foreground, and the somewhat mannerist confusion of the composition is accentuated. In many respects the painting is closest to the *Decollation of St. John the Baptist* (Copenhagen), although the latter work is probably slightly later in date. Ballarin supported this view and has convincingly argued that an engraving of 1519 of Raphael's *Lo Spasimo di Sicilia* (Prado, Madrid) must have been known to several Venetian mannerists – including Sustris, Schiavone and Jacopo Bassano – and influenced their work.

L.M.

PROVENANCE
Probably acquired in Venice for Gerrit Reynst (died 1658) of Amsterdam;
donated to Charles II as part of the gift of the States of Holland (listed
as Jacopo Bassano); 1688 James II inventory, listed amongst the pictures
in custody of Catherine of Braganza (died 1705); between 1721 and 1727
Viscount Torrington; by descent to the Earls of Bradford

EXHIBITIONS
London 1960, no. 64

REFERENCES
Ballarin 1967, p. 98; Mahon 1950, p. 15, no. 15

5
The Adoration of the Shepherds

139.5 × 219 cm
Her Majesty The Queen
[*repr. in colour on p. 110*]

The view of the countryside of Bassano with Monte Grappa rising in the background is almost identical to that in *Rest on the Flight into Egypt* (Cat. 3), the *Good Samaritan* (Royal Collection), and the *Trinity* (Angarano). Stylistically this painting is closest to another *Adoration of the Shepherds* (Giusti del Giardino Coll., Verona) in which the classical ruins derived from Dürer also recur (as they do in the *Adoration of the Magi*, Edinburgh). The combination of observed reality in the landscape and classical motifs copied from prints is typical of Jacopo's work. There is a great contrast between Jacopo's pastoral scenes with 'antique' ruins and the almost contemporary studies of classical architecture by Andrea Palladio; Jacopo's dilapidated columns, broken arches and walls are purely decorative. It is generally agreed that the painting dates from the late 1540s, although Pallucchini (1982) and others place it after the *Adoration* in the Giusti del Giardino Collection. The present author suggests that it is close in date to the *Adoration of the Magi* (Edinburgh) and earlier than the Giusti del Giardino painting.

This work can probably be identified with the 'Nativity of Christ per Bassano' in Charles I's collection, which was valued at £35 in 1649, and should not be confused with a 'Birth of Christ with Four Shepherds' attributed to Tintoretto which was bought for the King's collection in 1637. Later it was attributed to Palma Vecchio, but was re-ascribed to Jacopo by Crowe and Cavalcaselle, who believed it was an early work coming between the *Adoration of the Magi* (Edinburgh) and the *Rest on the Flight into Egypt* (Cat. 3).

L.M.

PROVENANCE
1649 probably collection of Charles I, 'The Nativity of Christ per Bassano'; 1649 sold to De Critz; probably James II, George III, Hampton Court (as Palma Vecchio)

EXHIBITIONS
1822 British Institution, no. 120 (?); 1868 Leeds, no. 99; London 1946, no. 204; Venice 1957, no. 20; London 1964, no. 21; Montreal 1967, no. 183

REFERENCES
Crowe and Cavalcaselle 1871; Pallucchini 1982², pl. 13; Shearman 1983, no. 16, pp. 21–23 with full bibliography

6
Two Hunting Dogs

85 × 126 cm
Gallerie degli Uffizi, Florence (no. 965)

This painting is virtually unique in sixteenth-century art in that it is a study of two dogs painted for their own sakes, and not a fragment cut out of a larger picture; this is clear

6

from the composition, which places the animals on the main diagonals. The classical architecture in the background frequently occurs in Jacopo's work; here it acts as a frame to the view of Bassano dominated by Monte Grappa, leaving no space for figures except for the two most unusual protagonists. Ballarin (1964) drew attention to another slightly smaller painting (61 × 79.5 cm) of two dogs formerly in the collection of the Duke of Bedford: stylistically that painting is close to the *Rest on the Flight into Egypt* (Cat. 3), and can be dated 1546–47. He correctly dated the Uffizi *Dogs* to 1555, relating it to the *Dives and Lazarus* (Cleveland). The *Two Hunting Dogs* belongs to the most mannerist phase of Jacopo's career; here, typically, he emphasises the unpretentious simplicity of his subject matter.

Although this work has been somewhat neglected in the past, it is extremely important in Jacopo's *oeuvre* (Ballarin 1964). It is almost universally attributed to Jacopo; only Arslan has suggested Leandro Bassano as the author.

L.M.

PROVENANCE
1663 Cardinal Giovan Carlo de' Medici; 1668 Cardinal Leopoldo de' Medici (attributed to Titian); 1675 Uffizi

REFERENCES
Arslan 1960, p. 340; Ballarin 1964, pp. 55–61, 62–67; Florence 1978, no. 46

7
St. Giustina Enthroned with St. Sebastian, St. Anthony Abbot and St. Roch

170 × 112 cm
Parish Church, Enego; on deposit at the Museo Civico, Bassano del Grappa
[*repr. in colour on p. 112*]

This was originally part of a series of paintings which decorated the Arcipretale (the priest's residence) of one of the seven municipalities of the Altopiano of Asiago. The decoration included a fresco cycle which is now lost. Verci (1775) placed the *St. Giustina* in Jacopo's third period when

he was deeply influenced by Parmigianino; it can be dated shortly before 1560 (Magagnato 1952, Shearman 1976, Pallucchini 1982). Ballarin (1969) has pointed out the connection between this altarpiece and the drawing of *Diana in the Clouds* (D1) and observed that they are both deeply influenced by Veronese's work at Palazzo Trevisan, Murano, after *c.* 1557. The silvery colours of this small altarpiece suggest a return to Jacopo's early mannerist style; however, the mint greens, silvery whites, and translucent violets are treated more subtly than in his earlier style, with shimmering mother-of-pearl effects on the saint's bodice, and vivid highlights on St. Roch's tunic. This magical, delicate use of light is developed even more in *Jacob's Journey* (Cat. 8).

L.M.

PROVENANCE

Arcipretale, Asiago; Parish Church, Enego, on deposit at the Museo Civico, Bassano de Grappa

REFERENCES

Ballarin 1973, pp. 105, 108; Magagnato 1952, pp. 42–43; Pallucchini 1977–78, p. 48; Pallucchini 1982², p. 34; Sgarbi 1980, p. 59; Smirnova 1976; Verci 1775, p. 105

8

Jacob's Journey

127.8 × 183.5 cm
Her Majesty The Queen
[*repr. in colour on p. 114*]

On 8 September 1649 this painting was valued at £50 and attributed to 'Bassano in his first manner'. It has always been greatly admired, as the many copies indicate (Shearman 1983). In 1853 it was attributed to Leandro, but recently it has not only been ascribed to Jacopo but also considered to be one of the few 'pastoral' scenes which is entirely autograph. The dating of this important work is contentious: Arslan and Rearick dated it 1565, Bettini suggested 1568, Zampetti and Ballarin place it in the late 1550s, and Pallucchini believed it to be after 1562, probably closer to 1565.

The subject of the painting is uncertain. Zampetti has suggested that it represents Abraham's Journey rather than that of Jacob, but Shearman and the present writer prefer Jacob as the protagonist. A date of *c.* 1560 seems appropriate; it can be compared to the *Adoration of the Magi* (Vienna), and the *Parable of the Good Sower* (Thyssen Collection, Lugano). This is one of Jacopo's earliest pastoral scenes; stylistically there are still mannerist elements, and, as in the *St. Giustina* (Cat. 7), he demonstrates his extraordinary control of rich colours and complex light effects.

PROVENANCE

Charles I; 1650 sold to Willet; recovered at the Restoration; Charles II inventory

EXHIBITIONS

1831 British Institution, no. 100 (as Leandro Bassano); 1868 Leeds, no. 68 (as Jacopo); London 1946, no. 275; London 1960, no. 11

REFERENCES

Pallucchini 1982², pl. 28; Shearman 1983, no. 19, pp. 25–27 with full bibliography

9

Adoration of the Shepherds with St. Victor and St. Corona (The Nativity of S. Giuseppe)

240 × 151 cm
Museo Civico, Bassano del Grappa (no. 17)

This is one of only two paintings by Jacopo which is documented; it was placed on the high altar of S. Giuseppe, Bassano, on 18 December 1568 (Gerola). The other documented work is the *St. John the Baptist* (Museo Civico, Bassano) which was installed in the Chapel of S. Giovanni, S. Francesco, Bassano on 28 December 1558 (Sartori). In the ten years between these two fundamental works Jacopo's mannerist traits fell away; the evolution of his style between the late 1550s and the mid-1560s can be traced in this exhibition from the *St. Giustina Enthroned* (Cat. 7), and *Jacob's Journey* (Cat. 8). Another *Adoration* (Palazzo Barberini, Rome), probably immediately precedes the present work; however, in the earlier picture the format is horizontal, whereas here it is based on two interlocking

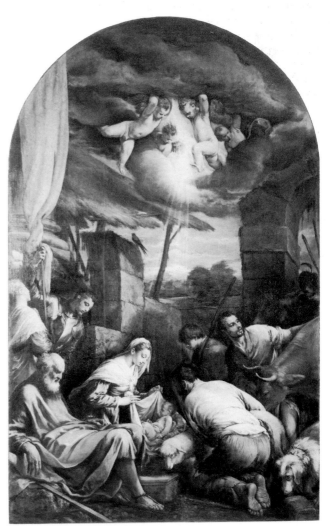

9

triangles, and the figures are situated around a horizontal circular plane (Verci). So the composition, which appears to be natural and spontaneous, is in fact subtly contrived.

The painting was frequently copied from the eighteenth century onwards; it has always been considered one of Bassano's best pastoral scenes.

L. M.

10

St. Martin and the Beggar with St. Anthony Abbot

165 × 105 cm
Museo Civico, Bassano del Grappa (no. 25)
[repr. in colour on p. 113]

This small altarpiece is one of the few works of the 1570s and 1580s from Jacopo's studio which is entirely autograph: this can be deduced from the contract of 1580 for a painting of *St. Apollonia and St. Agatha* in which Jacopo was requested to paint the altarpiece in a similar

way to that of 'St. Martin in the church of St. Catherine'. From this it would seem that the altarpiece was still considered a novelty, at least among the works Jacopo painted for the town of Bassano.

In this work there is no hint of Jacopo's 'genre' – or pastoral style – which he adopted in the very last years of his life. Like the slightly earlier *Baptism of St. Lucilla* (Museo Civico, Bassano) of 1574–75, Bassano here exaggerated the contrasts of light and shade of the twilight scene; but the reflection of the light on the drapery and the armour is closer to the harsh colouring of the *Nativity* formerly in the church of S. Giuseppe, Bassano (Cat. 9) than to the nocturnal scenes of Jacopo's last years, when he fell under the influence of Titian's late style.

L. M.

11

Susanna and the Elders

86 × 127 cm
Inscribed lower right: *J. B. f. 1585*
Musée des Beaux-Arts, Nîmes

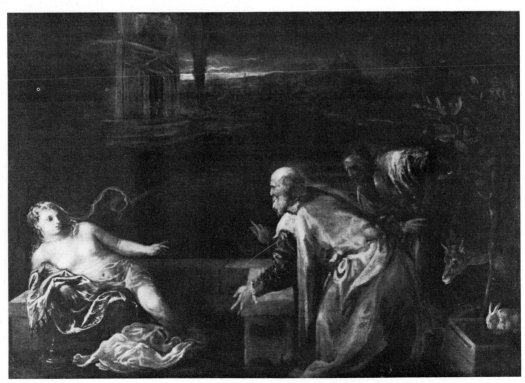

11

The date 1585 emerged on the painting when it was cleaned in 1965–66 (Shearman, Rosenberg, Ballarin). Previously it had been read as 1572 (Pallucchini 1944), 1576 or 1579 (Berenson 1957), or 1571 (Bettini 1933 and Rosenberg 1965). This new date is particularly revealing because previously a letter of Jacopo's son, Francesco, had been taken to imply that after 1581 Jacopo gave up painting. So the *Susanna and the Elders* was painted about five years after *St. Martin and the Beggar* (Cat. 10), and can be related stylistically to the *Diana and Acteon* (Chicago), as Pallucchini and Zampetti noted. From the mid-1580s Jacopo painted a series of dream-like nocturnal scenes influenced by Titian's late work which in some respects anticipate the luminous quality of Rembrandt's paintings (Rosenberg 1965); they possess an extraordinarily inventive freedom in their approach to their subject matter.

It is unlikely that the painting has been cut on the left, as has been suggested. The composition is based on crossed diagonals, with the old man's face in the centre, and the wall of Susanna's bath dividing the painting in half.

L. M.

PROVENANCE

Gower Collection (no. 580); 1875 Musée des Beaux-Arts, Nîmes

EXHIBITIONS

Amsterdam 1953, no. 2; Bordeaux 1953, no. 56; Venice 1957, no. 59; Paris 1965–66, no. 33 (Rosenberg, with full bibliography); Nice 1979, no. 2 (with full bibliography)

REFERENCES

Ballarin 1965, p. 239; Berenson 1957, I, p. 19; Bettini 1933, pp. 92–93; Pallucchini 1944, II, p. 38; Pallucchini 1959, p. 266; Pallucchini 1982², pl. 37; Shearman 1966, p. 67; Zampetti 1964, I, pp. 231–32

Bonifazio de' Pitati

Verona 1487–Venice 1553

Bonifazio de' Pitati was born in Verona in 1487 and lived there until 1505. He is first recorded in Venice in 1528, but he must have been there earlier, between 1515 and 1528, absorbing the influence of Giorgione, Titian and Palma Vecchio, and producing his first works. Some of Bonifazio's paintings dating from before 1530, such as *St. Mark Enthroned* (Corbolone), the *Sacra Conversazione* (Palazzo Pitti, Florence, no. 84), *The Rest on the Flight into Egypt* (Pinacoteca Ambrosiana, Milan) and the *Sacra Conversazione* (San Francisco, ex-Farrer Coll.), show his ability to rework characteristically Venetian compositions and colouring while also making use of what he had learnt from the contemporary paintings of Savoldo and Lotto.

In 1529 Bonifazio began work on the decoration of the Palazzo dei Camerlenghi at the Rialto, which took him and his collaborators about 20 years to complete; in 1530 he became a member of the *Fraglia* (the Venetian painters' guild). His mature style combined elements derived from both Raphael and Pordenone; his distinctive approach to narrative and his robust colour sense can be seen in *The Judgement of Solomon* of 1533, and in the *Massacre of the Innocents* (both Accademia, Venice). Around 1540 a more meditative tone enters his paintings. It is most evident in *Dives and Lazarus* (Accademia): in this work the landscape setting (close to those of Tintoretto) is combined with a restless decorative tension, which is even more evident in the later *Finding of Moses* (Brera, Milan) and which has affinities with the style of Paris Bordone.

Apart from his biblical subjects (in which narrative is combined with moralising overtones) and numerous *sacre conversazioni*, Bonifazio is famous for his many small panel paintings of historical, mythological and allegorical subjects that were made to decorate *cassoni* (marriage chests), headboards and other furniture. In these he displayed a seemingly inexhaustible imagination and miniaturistic attention to detail, and continued to develop his figurative ideas, in the last decade of his life adopting mannerist traits evident in elongated figures that show the influence of Schiavone and Parmigianino.

Bonifazio died on 19 October 1553 (parish records of S. Ermagora) after a long illness; he was married but childless. The scarcity of documentation and of signed and dated paintings, together with the enormous output of Bonifazio's studio, have made an evaluation of his work very difficult.

S. S.

REFERENCES

Faggin 1963, pp. 79–95; Ludwig 1901, pp. 61–78, 180–200; Ludwig 1902, pp. 36–66; Westphal 1931, with full bibliography

12

The Rest on the Flight into Egypt

109.9 × 170.8 cm
Art Gallery of South Australia, Adelaide

First recorded in 1854, when it was in the collection of Sir Archibald Campbell and attributed to Palma Vecchio, this painting was recognised by Westphal as a late work of Bonifazio's, stylistically close to the Bridgewater painting that she dated *c.* 1545–47. Faggin suggested it was by Domenico Biondo, a painter in Bonifazio's circle.

The relaxed and balanced composition is a fine example of Bonifazio's interpretation of the theme of the *sacra conversazione*, derived from Palma Vecchio's paintings of serene encounters between elegantly attired saints in the open air. Bonifazio emphasises the narrative content of the picture; the main story (*St. Matthew*, II, 14, with the addition of the Miracle of the Palm from Voragine's *Golden Legend*) is set in the foreground. In the background, on the left a young friar witnesses the scene, whilst on the right the landscape abruptly falls away into the distance. The unusually marked plasticity of the figures – especially of the playing children, who appear almost to break out of the painting – and the intense emotional bond between the Virgin and Child seem to reflect the influence of the work of Raphael, presumably known to Bonifazio through prints. The soft handling of colour which is characteristic of Bonifazio, the inclusion of details, such as the shepherd with a donkey, painted with a few rapid brush strokes, and the treatment of the spotted and stippled foliage make it likely that this beautiful picture dates from the late 1520s.

S. S.

PROVENANCE
Sir Archibald Campbell; 1947 Colnaghi's sale; Art Gallery of South Australia, Morgan Thomas Bequest

REFERENCES
Berenson 1957, I, p. 41; Faggin 1963, p. 95; Gaston 1977, pp. 36–41; Waagen 1854, III, p. 293; Westphal 1931, pp. 74, 76, 152

13

La Madonna dei Sartori (Virgin of the Tailors)

130 × 149 cm
Inscribed bottom right centre on the second step of the throne:
BONIF. / ACIO.F.;
dated on the first step of the throne in a scroll
M.D.XXXIII. / ADI.VIIII. / .NOVĒB.
Gallerie dell'Accademia, Venice (no. 1305)

The painting comes from the main altar in the Scuola dei Sartori (the Confraternity of Tailors), which was situated near the Campo dei Gesuiti; Boschini saw it there and said it was by Bonifazio. The identification of Sant'Omobono, patron saint of tailors, and the large pair of scissors resting on the step provide further confirmation of its provenance.

Since this is Bonifazio's only work that is signed and dated (1533), it is fundamental to any evaluation of his art. Although the composition follows the traditional altarpiece format (Bellini's influence is especially evident in the colonnaded niche in the background and in the overall symmetry of the composition), Bonifazio was also influenced by Palma Vecchio and, in terms of colour, by Titian. The painting reflects his concern with the

organisation of the figures in space, and his use of more monumental forms shows his precocious awareness of the mannerist style, even though the influence of Parmigianino and the Tuscans had barely reached Venice by this date. A narrative element is introduced through the inclusion of the beggar to whom Sant'Omobono gives alms. The pauper's pose is highly complex, yet he is observed objectively, a comparatively new development in Venetian art (Pallucchini 1950). This mature work illustrates Bonifazio's taste for rich and brilliant colours, and shows the development of his style towards a more flexible and lively narrative, which nevertheless always avoids dramatic excesses.

S.S.

PROVENANCE
Scuola dei Sartori; during the Napoleonic wars confiscated and chosen for the Royal Palace; 1945 transferred to the Gallerie dell'Accademia

REFERENCES
Freedberg 1971, p. 231; Moschini Marconi 1962, pp. 31–32, with full bibliography; Perissa 1981, p. 109; Sgarbi 1981, p. 55

14

Lot and his Daughters

125.5 × 167.5 cm
Chrysler Museum, Norfolk, Virginia, Gift of Walter P. Chrysler, Jr. (in memory of Della Viola Forker Chrysler)
[*repr. in colour on p. 68*]

The painting, ascribed almost unanimously to Bonifazio – although it has also been attributed to Cariani (Troche

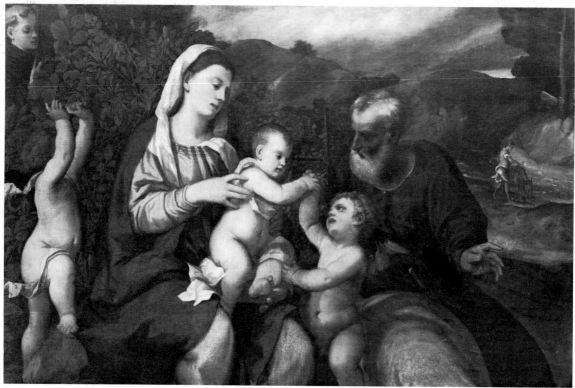

12

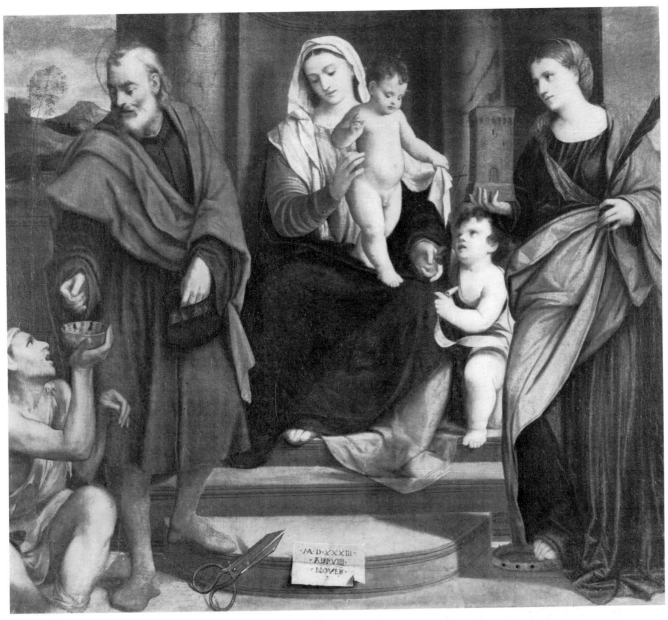

13

1934) – was probably painted around 1545. It combines several characteristically Venetian painting conventions. The approach to narrative is derived from Carpaccio: the entire story (*Genesis*, IX, 1–36), including the burning of Sodom and Gomorrah and the flight of Lot and his family, is used as a background to the central scene of the drunkenness of Lot and the incestuous designs of his daughters. The broad landscape setting derives from Giorgione, while the figures recall Palma Vecchio, and the daughter sitting in the foreground with a slightly apprehensive expression is close to Lotto. The subtle, decorative poses of the daughters have much in common with Paris Bordone's mannerist style, especially in the elaborate drapery, on which the light plays and is reflected in changing hues.

There is a strong moralistic and didactic flavour to the work, which is also an allegory of the conflict between *voluptas* and *virtus*. The women play a dual role in the painting: one holds a mirror, symbol of prudence but also of wisdom, and, in a wider sense, of intellectual knowledge, virtues diametrically opposed to the sterility of worldly pleasure. The theme of *voluptas* versus *virtus* is further enforced by the two playful putti: one wears a mask, an allusion to the dichotomy between truth and falsehood.

S.S.

PROVENANCE

Sir Coutts Lindsey, London; Arthur Ruck, Albemarle Agency Ltd., London; Giuseppe Bellesi, Florence; 1954 Julius Weitzner, New York; Walter P. Chrysler Junior, New York; presented by Walter P. Chrysler Junior to the Chrysler Museum

EXHIBITIONS

Portland 1956, no. 24; New York 1963, no. 7; Norfolk 1967–68, no. 8

REFERENCES

Berenson 1957, I, p. 43; Suida Manning 1956, p. 26; Suida 1954, pp. 159–60; Troche 1934, pp. 117, 123; Willard 1956, p. 47

Paris Bordone

Treviso 1500–Venice 1571

Born in Treviso, Bordone was in Venice by 1518 and probably trained there with Titian, whose influence was fundamental to Bordone's early style (see Cat. 15 and Cat. 17). During the 1530s he developed a more complex and articulated manner, as, for example, in the *Portrait of Nicolaus Korbler* dated 1532 (Liechtenstein Gemäldegalerie, Vaduz). *The Presentation of the Ring to the Doge* for the Scuola Grande di San Marco (Accademia, Venice), commissioned in 1533–35, shows Bordone's preference for architectural settings, derived probably from Serlio's architectural designs. Vasari stated that Bordone went to the court of François I at Fontainebleau in 1538, but this has been questioned by some later writers. His overtly erotic, mannerist style of the 1540s may have been inspired by this possible contact with the School of Fontainebleau.

Around 1540 Bordone was working in Augsburg for the Fugger family, and soon afterwards he was probably in Milan (Vasari), painting altarpieces (S. Maria sopra Celso) as well as a series of cabinet paintings of mythological and allegorical subjects. He continued to produce these throughout the 1540s and 1550s (*Mars and Venus in Vulcan's Net*, Dahlem Museum, Berlin; *Bathsheba*,

Cologne); evidently they appealed greatly to Bordone's wealthy clientele and contributed to his success. Outstanding examples of these cabinet paintings are two paintings of Bathsheba (Kunsthalle, Hamburg; Walters Art Gallery, Baltimore), the allegories in Leningrad (Cat. 21), Vienna, and Cat. 20. Several of Bordone's religious works, such as *The Baptism of Christ* (Cat. 23), and *The Annunciation* (Musée des Beaux-Arts, Caen) are also overtly mannerist in style.

Bordone was also a most successful portrait painter; the intimacy of his later portraits appears to reflect the influence of Lotto. After working in Treviso in 1557–58, he possibly went to France in 1559 to work at the court of François II (Orlandi; Federici); there he painted *The Battle of the Gladiators* (Kunsthistorisches Museum, Vienna) and the *Tibertine Sibyl* (ex-Mazarin Coll., now in the Hermitage, Leningrad (Formicheva 1971). He appears to have been influenced by the Second School of Fontainebleau, but the problem of the exact date of Bordone's visit to France, 1538 or 1559 (or whether, perhaps, he made two journeys there), is still unresolved. By 1565 Bordone is again recorded in Venice where, according to Vasari, he was one of the most famous artists of his day. He died in Venice in 1571.

G.M.C.

REFERENCES

Federici 1803, II, pp. 41–42; Formicheva 1971, p. 152; Orlandi 1753, pp. 410ff; Vasari (ed. Milanesi), VII, pp 461–66

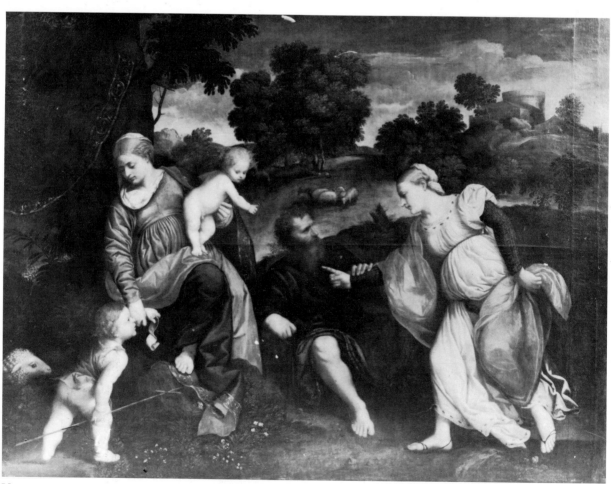

15

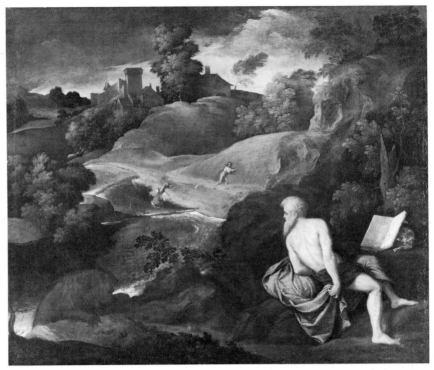

16

15
The Mystic Marriage of St. Catherine

149 × 260 cm
Doria Collection, Genoa

Ridolfi (1648) described a painting that would seem to match this one (although he failed to mention St. Joseph) in Leopoldo de'Medici's collection in Florence. There is another version in the Museum of Fine Arts, Boston.

This is one of Bordone's most successful early works and, given its similarities with the altarpiece in the Galleria Tadini, Lovere, it can be dated *c.* 1525. The bosky landscape, sumptuous colouring and vivid presentation of the main figures, who are linked together both emotionally and by gesture, are obviously derived from Titian's *sacre conversazioni* of 1510–20, and it seems to confirm Vasari's statement that Bordone trained in Titian's workshop. Certain motifs and figures are particularly Titianesque – the gesture of the infant Christ towards St. Joseph for instance, that of the Virgin towards St. John, and, above all, the magnificent St. Catherine, who recalls female figures in Titian's early works. But the clearly defined quality of the drawing is typical of Bordone and very different from Titian's style, which would explain why Ridolfi likened the painting in the Medici Collection to Palma Vecchio. Bonicatti (1964), however, detected an affinity between Bordone's work and that of Savoldo of the same date.

G.M.C.

PROVENANCE
By 1846 Doria Collection

EXHIBITIONS
Genoa 1946, no. 54 (Morassi)

REFERENCES
Berenson 1957, I, p. 46; Bonicatti 1964[1], p. 250; Canova 1964, pp. 7, 101, with bibliography; Morassi 1946, p. 54; Pallucchini 1946, p. 148; Ridolfi 1648, I, p. 233; Suida 1906, p. 143

16
St. Jerome in a Landscape

70.2 × 87 cm
Philadelphia Museum of Art, John G. Johnson Collection
(no. 206)

The splendid landscape that forms the most important part of the composition is closely related to the one in *The Mystic Marriage of St. Catherine* (Cat. 15), which would suggest that the painting dates from the early 1520s. The gentle undulation of the open green hills, the warm light bathing the scene, the lush treatment of the leafy branches and the inclusion of a shepherd and his sheep grazing in the pasture, while a dragon appears to scare the solitary passer-by, are all motifs deriving from Titian. In particular, St. Jerome's contorted, twisting movement recalls the 'difficult' poses used by Titian, particularly in the allegories made for Alfonso d'Este between 1518 and 1525. In the view of the present writer, the treatment of the figures in this painting is particularly close to that of the *Apollo and Ariadne* (Seminario Patriarcale, Venice), which is also attributed to Bordone (Canova 1964; Bonicatti 1964).

G.M.C.

PROVENANCE

By 1851 in the Leuchtenberg Collection, Munich; 1896 Leuchtenberg Collection, St. Petersburg; by 1905 Johnson Collection

REFERENCES

Berenson 1957, I, p. 48; Bonicatti 1964¹, pp. 249ff; Canova 1964, pp. 14–15, 98, with bibliography; Fredericksen and Zeri 1972, p. 32; Harck 1896, p. 430, no. 34; Philadelphia 1941, p. 13; Reinach 1918, p. 569; Sweeny 1966, p. 114

17

Two Lovers

95 × 80 cm
Pinacoteca di Brera, Milan (no. 105)
[*repr. in colour on p. 70*]

This is the earliest example of one of the erotic themes that later became a standard part of Bordone's repertoire; such paintings were evidently intended for rich Venetian connoisseurs. It can be dated *c.* 1525, and shows the influence of Titian on Bordone during the early part of his career.

In fact, while the woman's pose recalls that of Titian's *Young Woman at the Mirror* (Musée du Louvre, Paris) of 1515, the composition seems to be derived from the fascinating *Love Scene* (Casa Buonarotti, Florence), thought by some scholars to have been inspired by a lost work by Titian of about 1515 (Pallucchini 1952–53; Berenson, 1957; Valcanover 1960, 1969) and by others to be autograph (Suida 1933; Ballarin 1970–71). The affinities between the *Two Lovers* and the Florentine painting, of which other versions exist, are so striking that the latter has even been attributed to Bordone. However, if the painting is examined closely, the differences in style become evident: the picture in Florence is marked by rich, painterly brushwork and vibrant colour whereas Bordone's treatment of the scene is far more stylised and dull. The lyricism and sensuality of the master's prototype has been replaced by a banal scene of seduction, which is expressed by the ambiguous offer of a gift to the woman.

G. M. C.

PROVENANCE

1890 acquired from the Pinetti family, Milan, by the Pinacoteca di Brera

EXHIBITIONS

London 1930, no. 175; Venice 1955, no. 134

REFERENCES

Berenson 1932, p. 431; Canova 1964, p. 107, with full bibliography; Ricci 1907, pp. 228, 287

18

Knight in Armour

91.4 × 76.2 cm
Inscribed with fragments of verse on the tournament favour; later inscription on the back: CAROLUS V. PAR BORDONE F.
North Carolina Museum of Art, Raleigh, purchased with funds from the State of North Carolina (no. 52.9.148)

This is clearly not a portrait of the Emperor Charles v, as the inscription on the back suggests; it probably shows an eminent member of one of the Italian courts during the reign of Charles v when the Spanish dominated Italy. He is ostentatiously dressed in full armour. Perhaps the inscriptions on the tournament favour (a ribbon worn by a knight to indicate his loyalty to a lady) could shed some light on his identity; it is extremely unusual to find such a favour illustrated in a portrait, although some actual favours have survived in the Imperial Armoury in Vienna (information from A. V. B. Norman).

The monumentality and balance of the composition, together with the chromatic harmony of the painting, emphasises its similarities to Titian's court portraits during the early phases of his mature style (Pignatti 1979). This would suggest that the work may be a little earlier than 1540–45, the date originally proposed by the present writer.

G. M. C.

PROVENANCE

Archduke of Tuscany (?); 1838 Sir Abraham Hume (as Pordenone); 1851 Viscount Alford; by 1854 Earl Brownlow, Llandoff, Weybridge-on-Thames; Arthur L. Nicholson, Llandoff, Weybridge-on-Thames; 18 May 1933 Anderson Galleries, New York sale (lot 22)

EXHIBITIONS

Portland 1956, Los Angeles 1979–80, no. 24

REFERENCES

Bailo and Biscaro 1900, p. 131, no. 41; Berenson 1897, p. 87; Berenson 1957, I, p. 48; Canova 1964, p. 110; Fredericksen and Zeri 1972, p. 32; Pignatti 1979, p. 82, no. 24; Valentiner 1956¹, p. 77, no. 178; Valentiner 1956², p. 40; Venturi 1925–34, IX, iii, p. 1032

18

19

19
Portrait of a Man Holding a Letter

110 × 84 cm
Galleria di Palazzo Rosso, Genoa (no. 98)

This painting probably shows a young lover who is separated from his lady; he holds a letter which the lady, seen in the background under a loggia, is either receiving or sending by messenger.

As the painting is documented in the Brignole Collection from the eighteenth century, it is possible to identify it with the 'Portrait of Ottaviano Grimaldi of Genoa', said by Vasari (1568) to have been sent from Venice to Genoa together with a portrait of a 'Wanton Lady'. Vasari's statement has also been used to suggest that this painting is the pendant of the *Portrait of a Young Woman* in the National Gallery, London (Bailo and Biscaro 1900; Canova 1964); almost identical in size and with similar architecture in the background as well as a melancholic young man; it was said traditionally to have come from Genoa. Gould doubts the identification, pointing out that Ridolfi (1648), who was perhaps only paraphrasing Vasari's text, talked of a nude Venus. He believes that the pendant of the National Gallery *Portrait of a Young Woman* is probably the *Portrait of a Cavalier* (Uffizi, Florence), which was obviously made to commemorate a betrothal and which also has a similar architectural background, with a lady and a little cupid hovering above.

The three portraits seem to date from the 1540s, both stylistically and in the costume of the sitters (Gould 1959; Canova 1964). Their theme is that of problematic love, which was very popular in portraiture at that date and often illustrated by Paris Bordone: he portrays the themes of falling in love, betrothal, estrangement and conjugal love, as in the *Family Group* (Cat. 22). His partiality for subjects dealing with intimate sentiments, and the inclusion of symbolic motifs and still-life details such as the ring, brooches and the small wreath of carnations – a symbol of love – in the *Portrait of a Cavalier* in Florence, might suggest that Bordone was developing a sensitivity akin to that of Lotto.

G.M.C.

PROVENANCE
From at least 1756 Brignole Sale Collection, Palazzo Rosso; 1874 property of the Comune of Genoa

REFERENCES
Alizieri 1875, p. 165; Bailo and Biscaro 1900, pp. 52–53, 82, 124, no. 27; Berenson 1894, p. 91; Berenson 1932, p. 130; Berenson 1957, I, p. 46; Burckhardt 1907, p. 982; Canova 1964, p. 100; Gould 1959, p. 23; Grosso 1909, p. 70; Grosso 1932, p. 38; Jacobsen 1896, pp. 92, 94; Jacobsen 1911, p. 198; Suida 1906, p. 143; Venturi 1925–34, IX, iii, pp. 1010, 1032

20
Perseus Armed by Mercury and Minerva

100.3 × 153.7 cm
Signed indistinctly: *Paradis Bordono*
Birmingham Museum of Art, Birmingham, Alabama, (no. 61117; Samuel H. Kress Collection K 1631)
[*repr. in colour on p. 69*]

This is one of a group of mythological works in Bordone's mature style. The subject is probably Perseus before his battle with the Medusa. He is being armed by Mercury and Minerva: Mercury offers him the helmet of Hades, which made him invisible, and Minerva gives him her burnished shield, which acted as a mirror in which Medusa's head was reflected so that Perseus did not have to look at her directly. With these divine gifts the warrior's success was assured. The painting also illustrates the invincibility of strength and valour if these qualities are accompanied by shrewdness and wisdom. In both style and subject matter it is close to Bordone's *Mars and Venus in Vulcan's Net*, painted for Carlo da Rho in Milan (Dahlem Museum, Berlin), which, like the present work, combines a menacing atmosphere and bellicose subject with a delicately balanced composition.

It has been suggested that Bordone worked in Milan in the early 1540s, and in this case the painting, which has been dated to either 1535–45 (Longhi, Suida, Seymour) or the 1550s (Canova, Shapley), could quite reasonably be dated between 1545 and 1555. The treatment of the figures is similar to that in *The Baptism of Christ* (Cat. 23), although there they are set in a wider spatial composition.

This painting is closest to *Thetis and Vulcan* (Kress Coll., University of Missouri, Columbia), to *Venus, Flora, Cupid and Mars* (Cat. 21) and *Mars Disarmed by Cupid* (Kunsthistorisches Museum, Vienna). The last two illustrate anti-martial themes in a light-hearted manner.

G.M.C.

PROVENANCE

Edward Solly, London; sold 8 May 1847 Christie's, London (no. 17), bought by Captain Barrett; by 1868 Cook Collection, Richmond; Contini-Bonacossi Collection; 1949 Samuel H. Kress Collection, New York; by 1959 Birmingham Museum of Art

EXHIBITIONS

Leeds 1868, no. 51; Tulsa 1900; Washington 1961–62, no. 10

REFERENCES

Canova 1961, p. 88; Canova 1964, p. 75, with bibliography; Fredericksen and Zeri 1972, p. 32; Seymour 1961, pp. 121–26, 207–08; Shapley 1973, pp. 36–37; Suida 1959, p. 8

21

Venus, Flora, Cupid and Mars

108 × 129 cm
Signed on the lower left: PARIS BORDON F
The State Hermitage Museum, Leningrad (no. 163)

This is one of a series of paintings of mythological or allegorical scenes produced by Bordone in the 1540s and 1550s. The subject appears to be a celebration of the triumph of the pacifying virtues of love over the brutal force of arms. Flora is the goddess of virginal love and Venus the goddess of fertile love; Cupid hovers overhead crowning Venus and showering Flora with flowers, and the two goddesses serenely cross hands, exchanging flowers. Mars, in contrast, is almost hidden in the background.

A precedent for this work, both stylistically and iconographically, is the *Bathsheba* painted in Milan (Wallraf-Richartz Museum, Cologne), which is characterised by the same rather self-conscious erudition and a mannerist type of female beauty – sensual, yet cold and artificial. The painting can probably be dated 1545–55 if the hypothesis that Bordone was in Milan in the early 1540s is correct. The theme of Venus being crowned by Cupid was used by Lotto in the *Toilet of Venus* of *c.* 1540 (private coll., Bergamo) and it is likely that Bordone imitated that motif, which he also used in *Daphnis and Chloe* (National Gallery, London).

G.M.C.

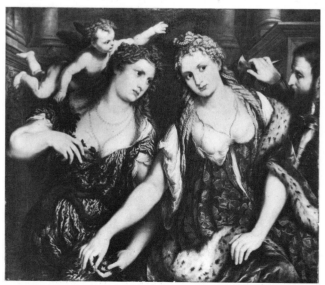

21

PROVENANCE

Between 1774 and 1783 entered the Hermitage

EXHIBITIONS

Göteborg 1968, p. 5; Milan 1976, no. 4; Moscow 1982, no. 8

REFERENCES

Berenson 1957, I, p. 460; Canova 1961, p. 88; Vsevolozhskaja 1982, p. 264, no. 62–63; Hermitage catalogue 1976, pp. 78–79

22

Family Group

119.4 × 150 cm
Signed: O. PARIDIS BORDON
The Trustees of the Chatsworth Settlement, Chatsworth, Derbyshire (no. 52)
[*repr. in colour on p. 71*]

This group family portrait, imbued with a sense of affectionate intimacy, shows the profound influence of Lotto on Bordone. The two artists must have met in Venice between 1545 and 1549; in October 1548 Bordone valued three portraits painted by Lotto for Francesco Cavalli, a dyer who lived in S. Stae, Venice (Zampetti 1969). It is possible that they met even earlier since Lotto was in Venice between 1540 and 1542 and in Treviso (where Bordone had many interests) between 1542 and 1545. Furthermore, both artists were friends and business associates of Francesco Beccaruzzi, the painter from Conegliano, during the 1540s.

This painting, which has been restored for the exhibition, is close in style to Lotto's *Family Group* (National Gallery, London), which can plausibly be identified as a portrait of Giovanni dalla Volta with his wife and children, painted in Venice in 1546–47 (Gould 1975). However, the muted colours of Bordone's painting, reminiscent of Tintoretto, suggest that it dates from the late 1540s. It is likely that Lotto's influence also stimulated the more intimate quality of some of Bordone's mature portraits, such as the *Portrait of a Knight* (Uffizi, Florence) and the *Portrait of a Man Holding a Letter* (Cat. 19). When the present painting was in the collection of Jan Six it was listed as 'Paris Bordone, his wife and daughter', probably because the man holds an apple, the attribute of Paris.

G.M.C.

PROVENANCE

23 Oct 1651 sold by the Commonwealth to Houghton and others; 6 April 1702 Jan Six sale, Amsterdam; Sir Gregory Page (as Titian); 2 June 1813 John Willet; Willet Sale (as Titian); G. J. Cholmondeley Sale; bought by the 6th Duke of Devonshire

EXHIBITIONS

British Institution 1821, no. 124 (as Titian); London 1950–51, no. 234 (as *The Family of the Painter* ?)

REFERENCES

Berenson 1957, I, p. 45; Canova 1964, p. 76; Gould 1975, pp. 134–35; Zampetti 1969, p. 60

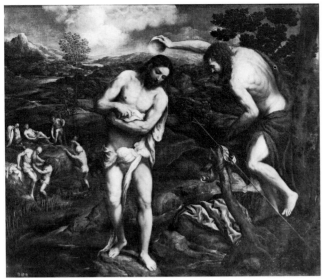

23

23
The Baptism of Christ

175 × 202 cm
Pinacoteca di Brera, Milan (no. 107)

This painting, which is conceived in an unusually grandiose manner, is important for our understanding of the development of Bordone's style during the late 1540s. The striking monumentality and the exaggerated twisting of the two nude figures in the foreground are overtly mannerist, and it is difficult to imagine that they could have been painted without the example of Titian's *St. John the Baptist* (Cat. 119) and his paintings of 1541–44, now in the Salute. Consequently it seems reasonable to suggest a date of 1544 for the present picture. The complexity of the influences on Bordone is demonstrated in the Baptist's group of followers: thus, for example, the figure of the man putting on his trousers is loosely derived from one of the bathers in Michelangelo's cartoon of the *Battle of Cascina*, which Bordone probably knew from a print. The marvellous landscape, although still in the Venetian tradition, is imbued with a rather pale light that makes it unusually attractive.

A '*Salvatore al Giordano*' by Bordone was recorded by Ridolfi (1648) in the house of Bernardo Giunti in Venice. An earlier example of this subject, with the figure of an angel instead of the bathers, is in the National Gallery, Washington (Shapley 1979, p. 77), and there also exists a preparatory drawing for the figure of Christ, or another similar figure, in the Uffizi, Florence (Tietze and Tietze Conrat 1944, no. 396).

G.M.C.

PROVENANCE
1650 bequeathed by Cardinal Cesare Monti to the Archbishop's Residence in Milan; from 1811 Pinacoteca di Brera

REFERENCES
Berenson 1957, I, p. 47; Canova 1964, p. 106, with bibliography; Latuada 1737, I, p. 78

Domenico Brusasorci

Verona *c.*1516–Verona 1567

Domenico Riccio, called Brusasorci, was the son of Andrea Riccio, a painter whose family came from Chiavenna. He is recorded in the census of Sant' Andrea in Verona and he was probably born around 1516. He seems to have been influenced less by his Lombard origins than by the mannerist style which reached Verona through the influence of both the Roman and Venetian Schools (Magagnato 1968). He was the foremost Veronese artist of the generation before that of Paolo Veronese. His earliest works probably date from 1545–50 (eg. *The Virgin with SS Sebastian, Roch, Monica, Augustine and two Donors*, Sant' Euphemia; the frescoes in the Muletta Chapel, S. Maria in Organo; a fresco cycle for the Casa di Fiorio della Sera, now in the Museo degli Affreschi, Verona). Together with Paolo Veronese, Paolo Farinati and Battista del Moro, Brusasorci was commissioned by Cardinal Ercole Gonzaga to paint one of a group of altarpieces for the Chapel of the Sacrament in Mantua Cathedral; his subject was *St. Margaret* (see also Cat. 134). He frescoed a *Fall of the Giants* (1555) in Palladio's Palazzo Iseppo da Porto, Vicenza, which shows his evident admiration for Giulio Romano's fresco of the same subject in Palazzo del Te, Mantua. There were also many paintings by Titian in Mantua at this time which would explain his influence on the *Portrait of Pase Guarienti* (Cat. 24).

From 1558 he worked with Battista Zelotti and the stucco-worker Bartolomeo Ridolfi on the decoration of the Sala dello Zodiaco in the Palazzo Chiericati, Vicenza. Once again in Verona, he painted the *Portrait of Bonuccio Moscardo* (c. 1561; Museo di Castelvecchio, Verona), and the vast cycle of 108 portraits of bishops interspersed with landscapes in the Salone of the Bishop's Residence at Verona, dated 1566. The *Martyrdom of St. Barbara* (S. Barbara, Mantua) dates from 1564.

Domenico died on 30 March 1567; his sons Giambattista and Felice were both artists, and the latter became the foremost Veronese painter in the early seventeenth century. Domenico was also gifted musically and was one of the founder members of the Accademia Filarmonica of Verona.

L.M.

REFERENCES
Magagnato 1968, p. 180

24
Portrait of Pase Guarienti

204 × 116 cm
Inscribed on the pedestal on the left: PASIUS GUARIENTUS / GUGLIELMI UTRIUSQ / IURIS DOCTORIS / FILIUS CENTU / CATAPHRACTORU / EQUITUM / GUBERNATOR / MDLVI
Museo di Castelvecchio, Verona (no. 267)

Pase Guarienti is portrayed in splendid armour as a commander of heavy cavalry. The armour was probably made in Brescia around 1550 (Boccia 1967, and forthcoming catalogue of armour at Castelvecchio, Verona), and the

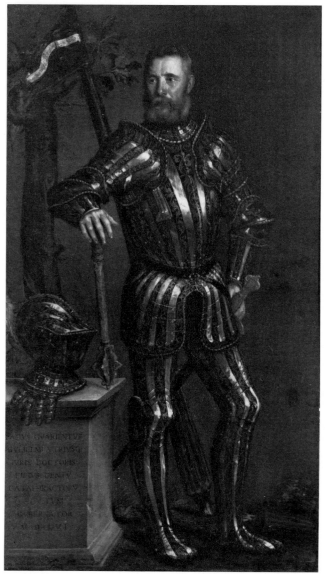

24

slightly later *Giovanni da Castaldo* (linked with Titian's stay in Augsburg), and finally the *Portrait of Prince Philip of Spain*, usually dated 1551 (Prado, Madrid). In all these portraits the brushwork carefully follows the form of the armour, animates it, and by means of flashing highlights gives it depth. Brusasorci followed this technique and thereby created a monumental portrait, one of the most unusual of the sixteenth century in Verona. Two paintings (both now in the Museo di Castelvecchio, Verona), the *Portrait of a Bishop*, and the *Madonna and Child with SS Ursula and Catherine*, have been attributed to Brusasorci; they probably date from immediately after his visit to Mantua in 1552.

L.M.

PROVENANCE
Guarienti Collection

REFERENCES
Ballarin 1971, p. 110; Boccia 1967, p. 332; Marinelli 1980;
Pignatti 1976, I, p. 219, Cat. A375; Verona 1980, p. 309
(Brognara Salazzari); p. 208, Cat. VIII, 7, note 1 (Marinelli)

Giovanni Cariani

Fuipiano val Imagna (?) *c.* 1485 – Venice after 1547

Cariani was probably born in the region of Bergamo, but he was trained in Venice (where he is recorded from 1509), first in Giovanni Bellini's workshop and then in the circle of Giorgione. The rediscovery of his lost altarpiece for Lonno, dated 1514 (Pallucchini 1982), and research by Ballarin (1968) have contributed to our understanding of his youthful style. Cariani was indebted to Bellini for his compositional schemes, but he also showed a precocious predilection for the themes of Giorgione that is evident in such works as *The Concert* (Warsaw) and *The Lutenist* (Cat. 25), and his use of warm colours, conception of landscape and delicate tonality show that he fully assimilated the early styles of both Titian and Sebastiano del Piombo.

A visit to Bergamo seems to have been of great importance for the development of Cariani's style: in 1517 he went there to paint the *Madonna and Saints* for S. Gottardo. This altarpiece, like other contemporary works such as *Judith* (ex-Neeld Coll.), was still conceived in the Venetian style, its bright colours and spatial conception reminiscent of Palma Vecchio; but soon afterwards other influences appear – those of Lotto, who was in Bergamo from 1512, and the Brescian painter Romanino, who was working in Cremona.

Cariani's finest qualities are revealed in a series of altarpieces for Crema that include *The Resurrection of Christ with St. Jerome and St. John the Baptist* (Cat. 28), *The Adoration of the Shepherds* (ex-Sackville Coll.), and a splendid group of portraits: *Courtesans and Gentlemen* (Cat. 27), *Giovanni Benedetto Caravaggi* (Cat. 30), *Francesco Albani* (National Gallery, London), *Giovan Antonio Caravaggi* (Cat. 29), *La Schiavona* (Accademia Carrara, Bergamo) and *The Musician* (Huntingdon Museum), all of which were painted within the space of a few years. To his Venetian sense of colour

painting is invaluable as a record of the armour of a mid-sixteenth-century Venetian knight. The sitter belonged to the S. Quirico branch of the noble Guarienti family which at that date was engaged in building a new residence at Bra'dei Filippini (Brognara Salazzari 1980). Pase, the son of Guglielmo Guarienti, was born in 1500 and died some time after 1563. He was a bachelor and left his fortune to his nephews. The portrait was in the Guarienti family collection until it was donated to the museum.

The problem of its attribution is still unresolved. Traditionally the Guarienti family attributed it to Veronese, a view accepted by Avena, von Hadeln, Fiocco and Berenson; but Tea (1920) suggested that it was by Caroto, and Coletti proposed Domenico Brusasorci; this was accepted by Arslan, the present writer, Ballarin and Pignatti. Recently Marinelli (1980) has suggested it is the work of Battista del Moro.

The precedent for the work must be three famous portraits of men in armour by Titian: the equestrian *Portrait of Charles* V (Prado, Madrid) dated 1548, the

Cariani now added a Lombard feeling for realism and light, and some of his works from this period – for example, *The Concert* (Heinemann Coll., Lugano) – foreshadow Caravaggio. Some frescoes by him have recently been discovered in the Citadel of Bergamo.

In 1523 Cariani returned to Venice. *The Madonna of the Doves* (Bergamo Cathedral), *The Visitation* (Kunsthistorisches Museum, Vienna), and *La Madonna Cucitrice* (Cat. 31) probably date from this period. In Bergamo again between 1528 and 1530, he painted the *Locatello Triptych* and the *Invention of the Cross* (Accademia Carrara, Bergamo). These cheerful, rustic scenes are very close to Palma Vecchio in style. The last years of his life are obscure; he lived in Venice and painted very little, and there is a visible decline in the quality of his works. His religious paintings of these years, such as the *Sacra Conversazione* (National Gallery, London), are less remarkable than his portraits (Oslo, Bergamo, Strasbourg), which are tinged with an air of melancholy and sometimes show a knowledge of German art (eg. the *Woman of Nuremberg*, dated 1536; Kunsthistorisches Museum, Vienna). This is also evident in a few small, lively, religious subjects, such as *The Way to Calvary* (Ambrosiana, Milan).

F.R.

REFERENCES

Ballarin 1968[1], pp. 242–44; Pallucchini 1982[1]

25

The Lutenist

71 × 65 cm
Musée des Beaux-Arts, Strasbourg (no. 236)
[*repr. in colour on p. 58*]

Now unanimously attributed to Cariani, *The Lutenist* is central to an understanding of both the relationship between Cariani and Giorgione and the intellectual climate of Venice in the sixteenth century. Cariani's choice of a musical theme, which reappears in *The Violinist* (Dijon) recently re-ascribed to him and *The Concert* (Heinemann Coll., Lugano) presupposes an allegorical and intellectualised conception of music in the spirit of the works of Giorgione (Bonicatti 1964). Music is a dream-like interlude in reality, a moment of reverie reserved only for a small circle of intellectuals.

However, although in its theme and, possibly, its ideological intent, the painting is Giorgionesque, in its technique it is much closer to Titian: the coarse treatment of the face, constructed in flat planes with particular attention paid to the individual features, is utterly different from Giorgione's portraits. Cariani probably painted *The Lutenist* in Venice (where it originally came from); it shows the first manifestations of a more naturalistic style, which finally blossomed in the *Courtesans and Gentlemen* (Cat. 27). Here he begins to move away from the Giorgionesque expression of noble melancholy (still evident in the Warsaw *Concert*) towards the visualisation of the sensation of immediate enjoyment created by the sound of music (as in *The Concert*, Heinemann Coll., Lugano), or

the sensation of drowsiness induced by a concert (*Musicians*, Accademia Carrara, Bergamo). Cariani abandons the subtle intellectual approach he had absorbed from his masters and instead heightens the emotive content of the image by directly expressing the sentiment of the lutenist, which is echoed in the stormy landscape opening out behind the decorative leafy screen.

F.R.

PROVENANCE
Private Collection, Venice; *c.* 1890 acquired by Bode for the Musée des Beaux-Arts

EXHIBITIONS
Paris 1935, no. 85; Venice 1955, no. 98; Paris 1965–66, no. 62

REFERENCES
Baldass 1929, p. 105; Bonicatti 1964[1], p. 88; Gallina 1954, p. 64; Haug 1926, p. 13; Haug 1938, p. 143; Mariacher 1975, pp. 64, 293; Pallucchini and Rossi 1983, forthcoming publication, with full bibliography; Troche 1934, p. 103; L. Venturi 1913, p. 235; A. Venturi 1925–34, IX, iii, p. 460; Zampetti 1955, p. 206

26

Allegory of a Venetian Victory

120 × 204 cm
Mario Lanfranchi, Rome
[*repr. in colour on p. 60*]

This painting, first noticed by Bassi-Rathgeb (1952, p. 39), has recently been researched by Sgarbi, who has confirmed its attribution to Cariani and studied its iconography. The theme of the painting is the contrast between Venice at peace, seen on the left of the picture, and the scene of war depicted on the right. In the centre is the figure of Fortune, or Chance, who will guarantee the peace of the city; she is accompanied by two figures symbolising nature and music.

The theme is typically Giorgionesque, but it has been carefully adapted to function as an allegorical celebration of a military victory. Sgarbi has suggested that this took place between the Peace of Cambrai (1512) and that of Noyon (1516), and has dated the painting between 1512 and 1515. However, the rounded, opulent figures and the lush landscape, both derived from Palma Vecchio, are often found in slightly later works by Cariani, such as the *S. Gottardo Altarpiece* dated 1518 (Brera, Milan), and it is more likely that he painted this allegory just before his visit to Bergamo. In certain respects the artist remained faithful to his training: the composition of the painting and the inclusion of a nude female were inspired by Titian's *Sacred and Profane Love*. However, the work also reveals knowledge of Savoldo's earliest Venetian paintings, such as *The Temptation of St. Anthony* (private coll., New York): the setting is very similar and both works share the detailed treatment of the leafy branches that is reminiscent of Flemish art, the vivid rendering of storm clouds and smoke over the burning city, the cold colouring and billowing forms of the drapery. Cariani's numerous contacts with the Brescian painter would therefore seem to have started early in his career; this work seems to anticipate the profound effect the Lombard school was to have on his later style.

F.R.

PROVENANCE
Castello Dentico di Frasso, Conversano (Bari); Manzolin, Rome;
1978 Mario Lanfranchi, Rome

REFERENCES
Mariacher 1975, p. 291, no. 46; Pallucchini and Rossi 1983, forthcoming
publication, with full bibliography; Sgarbi 1982, pp. 6–8

EXHIBITIONS
Bergamo 1799; Bergamo 1870; Bergamo 1875, no. 37; Lausanne 1947,
no. 43; Zurich 1948, no. 735

REFERENCES
Baldass 1929, p. 93; Crowe and Cavalcaselle 1871, II, p. 549;
Formicheva 1979, p. 163; Gallina 1954, pp. 65ff; Morelli 1891, p. 35;
Pallucchini 1966, p. 90; Pallucchini and Rossi 1983, forthcoming
publication with full bibliography; Safarik 1972, p. 527; Tassi 1973, I,
p. 38; Troche 1934, pp. 99ff; Venturi 1925–34, IX, iii, p. 465

27

Courtesans and Gentlemen (Seven Members of the Albani Family)

117 × 117 cm
Signed and dated: IŌ. CARIANVS. BGOMEVS. M.D.XVIIII
Private Collection, Bergamo
[repr. in colour on p. 61]

The traditional title for this painting is untenable, as the seven figures cannot be identified with any sixteenth-century members of the Albani family; nor do they resemble any portraits of the various members of the family. In fact, the painting probably represents the meeting of a group of gentlemen and some courtesans with their procuress. This is evident from the distinctive grouping of the figures, the showy, immodest dress of the women and certain symbolic attributes in the painting that have hitherto been overlooked: the mirror representing vanity, the squirrel symbolising parsimony, greed and lust, and the procuress's feather fan, which is a typical attribute of a courtesan.

The recognition of this painting as a profane representation of mercenary love emphasises the parallel between it and The Concert in the Heinemann Collection, Lugano (Pallucchini and Rossi 1983). Both works were inspired by the artist's desire to give a naturalistic treatment to a theme derived from Giorgione: in The Concert the theme is music, here it is a certain type of love. Cariani, however, concentrated not on the exalted sentiment behind such a theme, but rather on the physical presence of the figures, an approach that was typical of the Lombard school. To create this impression he used a composition based on diagonally intersecting blocks, which emphasise the spatial depth of the painting without sacrificing the expressive quality of the areas of colour in the background. The painting also displays a sensitivity to naturalistic elements, which was probably the result of Cariani's knowledge of the work of Lotto and Savoldo.

In many ways this painting contains some of the most innovative and remarkable pictorial solutions created by a painter of the new Venetian-Lombard school; this is true of details like the woman dressed in white who appears to lean out beyond the frame into 'real' space, the men who are lined up, one behind the other, in a psychological and emotional pecking order, and finally, the mirror, which isolates and reflects a minute fragment of reality.

F.R.

PROVENANCE
Albani family, Bergamo; Roncalli di Montorio Collection

28

The Resurrection of Christ with St. Jerome and St. John the Baptist

208 × 170 cm
Signed on the lower left: IOANES/CAR/IAN/VS/P.;
inscribed on the scroll along the bottom of the painting:
OCTAVIANVS VIC. EQVES. MDXX
Pinacoteca di Brera, Milan

This painting, signed and dated 1520, was commissioned by Ottaviano Vimercati, a member of the City Council of Crema and one of the chief figures in the defence of the city against the French. Vimercati died in 1520 and the painting was made for the altar of the family chapel in S. Pietro, Crema.

Although this Resurrection is one of Cariani's most important works, it has generally been considered to be a provincial, unrefined variation of a Venetian devotional type of painting, popularised by Bellini and already outmoded, with the addition of some Lombard realistic elements. It was formerly thought to be earlier than the Palmesque S. Gottardo Altarpiece (Accademia Carrara, Bergamo). But since the discovery that the S. Gottardo Altarpiece was commissioned in 1517 and delivered in January 1519, the order of the two paintings has been reversed, so that the Resurrection can now be seen as a work in which Cariani revived and elaborated a Bellinesque theme. The same is true of other contemporary works, such as the Baglioni Madonna (Accademia Carrara, Bergamo) and the Virgin with St. Peter (Galleria Borghese, Rome).

Although the 'apsidal' distribution of the saints is a rather archaic device, here it animates the composition, the monumentality of which is emphasised by the solid figures, whose forms are defined by light and by the open setting. The landscape is no longer a mere backdrop, but an integral and expressive part of the design that is reminiscent of Moretto, conceived in a blaze of flashing lights, evocative and mysterious, similar to works by Romanino and Altobello Meloni. The use of 'natural' light, as in The Concert (Heinemann Coll., Lugano) or Courtesans and Gentlemen (Cat. 27), shows Cariani to be a remarkably realistic painter: in the portraits of the patrons, for example, he invests the figures with a psychological awareness that is close to Lotto, but envelops them in a brilliant light, which enhances the plasticity of their forms and creates an equilibrium in the composition.

F.R.

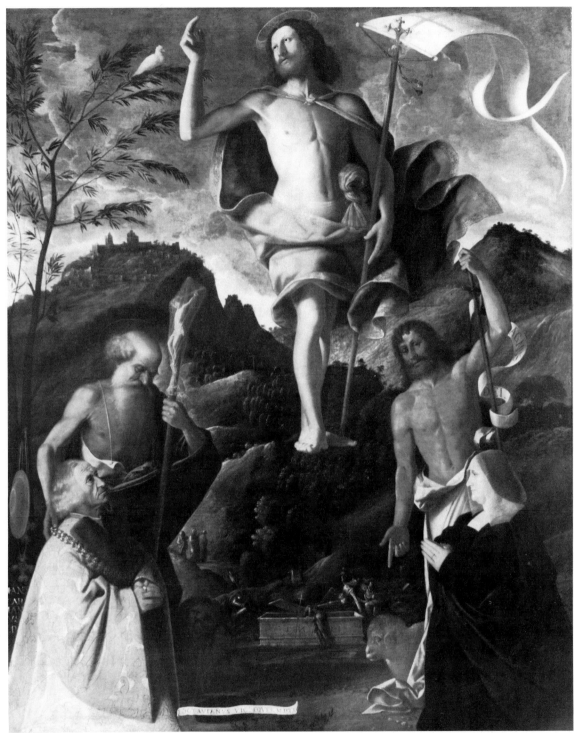

28

PROVENANCE
S. Pietro, Crema; Palazzo Vimercati, Crema; Conte Antonio Marazzi,
Milan; Conte Paolo Gerli, Villa Gaeta, Milan; 1957 presented to the
Pinacoteca di Brera

EXHIBITIONS
London 1930, no. 354; Zurich 1948, no. 733

REFERENCES
Baldass 1929, pp. 93 ff; Gallina 1954, pp. 66 ff; Grohn 1968, p. 311;
Mariacher 1975, p. 290, no. 40; Morelli 1886, p. 154; Pallucchini and Rossi
1983, forthcoming publication, with full bibliography; Safarik 1972,
p. 527; Troche 1934, p. 106, no. 26; Venturi 1925–34, IX, iii, p. 448

29

Portrait of Giovan Antonio Caravaggi

93.5 × 93.7 cm
Inscribed on the left on a white scroll: ĪO.CARIANVS. /DE BVSIS BGO
/ MESIS P.X.T; on the letter: .ĪO.ANT.I / CAR. (CAN)
(the last letters are indistinct)
National Gallery of Canada, Ottawa (no. 3568)
[repr. in colour in p. 62; detail on p. 63]

On the left of the painting there is a coat of arms, a black eagle on a gold ground above a horse-drawn chariot on a silver ground, which is identical to that in the *Portrait of Giovanni Benedetto Caravaggi* (Cat. 30). Mariacher (1975) believed that this was a portrait of the same sitter some 20 years later, but the man shown here – whose hair is blond, not white – is in fact Giovan Antonio Caravaggio, the elder brother of Giovanni Benedetto, who also lived in Crema and was probably a magistrate. The painting would seem to be closely connected with the other Caravaggi portrait of *c.* 1522, and it is unlikely that it dates from 1525–30 as Jarvis suggested (1957).

The two portraits almost seem to be a pair, given the symmetry of the poses, the continuity of the landscape backgrounds and the inclusion of the symbols of each brother's profession – the large book for the philosopher and doctor, Giovanni Benedetto, and the writing paraphernalia, parchment and seals for the magistrate Giovan Antonio. However, the slight difference in scale between the two portraits suggests that they are not exactly contemporary: the present painting seems a little earlier. The sharpness of the brushwork in the face and landscape recalls the portrait of Ottaviano Vimercati in *The Resurrection of Christ* (Cat. 28), while the Palmesque motif of the laurel bush was first used by Cariani in an earlier *Judith* (private coll., Milan). The coarse, angular qualities of the figure and the intense concentration of the sitter's face and gestures, qualities that are not present in the milder, more introverted Giovanni Benedetto, were emphasised by the artist.

F.R.

PROVENANCE
Marchesa Serra, Sampierdarena (Genoa); 1905 Adolph Thiem, San Remo; Knoedler & Co. New York; 1928 National Gallery of Canada

EXHIBITIONS
New York 1926, no. 1; London 1930, no. 382; Montreal 1949, no. 30; Los Angeles 1979, no. 15

REFERENCES
Gallina 1954, p. 40; Grohn 1968, p. 310; Hubbard 1956, p. 146; Jarvis 1957, p. 11; Mariacher 1975, p. 50; Pallucchini and Rossi 1983, forthcoming publication, with full bibliography; Troche 1934, p. 110, no. 45; Venturi 1925–34, IX, iii, p. 466

30

Portrait of Giovanni Benedetto Caravaggi

82 × 82 cm
Inscribed on the right:
IO.BENED. CARRAVAG.S/PHILOS.S ET MEDICVS/AC
STUDY PATAVINI/RECTOR ET LECTOR;
a little lower:
JOANIS/CARIANI/.P
Pinacoteca dell'Accademia Carrara, Bergamo (no. 675/74)

The coat of arms above the inscription on the right of the painting (a black eagle on a gold ground and a horse-drawn chariot on a silver ground) has been identified as that of Giovanni Benedetto Caravaggi from Crema. He was born in 1485, graduated in medicine and philosophy in Padua in 1507 and died some time after 1555 (Pallucchini and Rossi 1983). This portrait was probably painted in Bergamo *c.* 1522, just before Cariani returned to Venice.

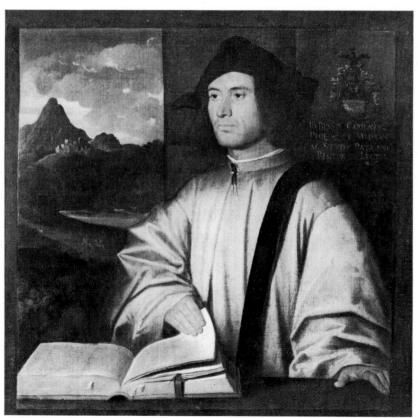

30

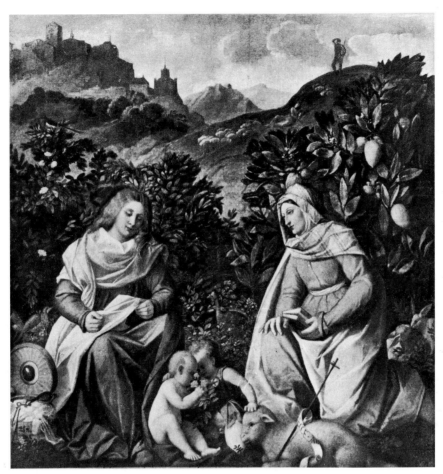

31

Of all Cariani's works, this painting has most often been associated with Lotto, who was also in Bergamo at this period. Certainly, both the sitter's expression and the inclusion of realistic details such as the open book are similar to Lotto's portraits. But the compact, geometric spatial construction is close to that of earlier works by Cariani, such as *Courtesans and Gentlemen* (Cat. 27). The doctor holds out his arm as if he were measuring space and the drapery is arranged in sharp, dihedral folds. The treatment of the face and clothing is delicate and the phosphorescent lighting of the grand, yet simple, landscape was obviously influenced by Titian, as were the recently rediscovered frescoes in the Citadel of Bergamo, dated 1521. This portrait should not, therefore, be considered a mere imitation of Lotto's style, but rather an attempt by Cariani to introduce into his fundamentally Venetian and Titianesque language a new conception of a portrait, more direct in presentation yet more subtle psychologically, like those he had seen in Lombardy.

F.R.

PROVENANCE
Crema; before 1833 Conte Lochis; 1859 Gallerie dell'Accademia Carrara

REFERENCES
Baldass 1929, p. 105; Crowe and Cavalcaselle 1871, II, p. 551; Gallina 1954, pp. 72ff; Mariacher 1975, p. 286, no. 14; Pallucchini and Rossi 1983, forthcoming publication, with full bibliography; Phillips 1913, pp. 158ff; Troche 1934, p. 116; Venturi 1925–34, IX, iii, p. 445

31

La Madonna Cucitrice (The Seamstress Madonna)

168 × 164 cm
Galleria Nazionale di Palazzo Barberini, Rome (no. 830)

The ostensible subject of this painting is the Christ Child and Infant St. John playing while the Madonna and St. Elizabeth look on, but it is probable that a symbolic meaning was also intended by the artist. The Madonna sits in front of a rose bush, beneath which are two quails, and St. Elizabeth leans against a lime tree before which two rabbits play. Both roses and quails were traditional symbols of virginity, while the lime tree and rabbits symbolised fertility; this can be read as an allusion to the two aspects of motherhood, the human and the divine, and can be interpreted as an unusual representation of the Immaculate Conception.

The painting is generally considered to date from the end of Cariani's career, probably from his second Venetian period (1524–1528), and until recently had been associated with the *Virgin with St. Anthony Abbot* (Alte Pinakothek, Munich). But the Munich painting has rightly been re-ascribed to Lambert Sustris (Pallucchini 1982), which makes it easier to define the distinctive characteristics of *La Madonna Cucitrice*. It is unusual in that it represents

a fusion between a Venetian and a Lombard style. On the one hand, the typology of the Virgin and the plump infants, the bushes with their broad, pointed leaves and the extensive landscape show the influence of Palma Vecchio, which is also evident in works such as *The Madonna of the Doves* (Bergamo Cathdral) and *The Visitation* (Kunsthistorisches Museum, Vienna), both of which date from the mid-1520s. On the other hand, details such as the rabbits playing in the shade, the marvellous still life of the untidy sewing basket – no wonder Venturi thought of Moretto – together with the domestic, pastoral air of the scene, are closer to the unaffected realism that had influenced Cariani during his time in Bergamo.

F.R.

Vittore Carpaccio

Venice 1460/65 – Venice 1525/26

The artist's name in Venetian dialect was Scarpazza; a considerable number of his works bear the Latin signature *Carpathius*: hence the Italian form Carpaccio. Except for a possible early visit to Rome, Carpaccio seems to have spent his entire career in his native city. His training is uncertain, but obvious formative influences include those of Gentile and Giovanni Bellini, and Antonello da Messina. Carpaccio is best known for his cycles of lively and festive narrative paintings, four of which survive almost complete (cf. Cat. D11, D12 and D13); he also made individual contributions to cycles involving other artists, including the most prestigious of all, that for the Sala del Maggior Consiglio in the Doge's Palace, destroyed by fire in 1577.

In accordance with Venetian tradition, his narrative paintings often include views of identifiable places (Cat. 32) and figures identifiable as portraits (Cat. D13). To judge from contemporary literary evidence, Carpaccio also enjoyed considerable fame as a portrait painter, mainly in the normal bust-length format. Although much of his best work was done before *c.* 1505, he remained capable of producing works of great charm and originality, and it is only his work after *c.* 1520 that shows an uninterrupted decline in quality. As a specialist in cyclical narratives rather than devotional altarpieces, Carpaccio was one of the first Venetian painters to use canvas more regularly and naturally than panel. His priming was often thin, barely hiding the roughness of the weave, and his handling of paint is normally sketchy and vivacious, anticipating sixteenth-century developments in its bold touches of pure colour.

P.H.

32
The Lion of St. Mark

130 × 368 cm
Inscribed on the left:
Victor Carpathius/A.D./M.D. XVI; on the book:
PAX/TIBI/MAR/CE E/VAN/GELI/STA/MEVS
Doge's Palace, Venice
[*repr. in colour on pp. 50–51; detail on p. 49*]

As the traditional emblem of the Evangelist St. Mark, the winged lion also symbolised the Venetian State, which since the ninth century had acknowledged the saint as its special protector. According to pious legend, the Evangelist's body was stolen from Moslem Alexandria by Venetian sailors and brought to Venice in 829, and divine sanction was given to its final resting place in the words quoted on the book: '*Pax tibi Marce Evangelista meus*' ('Peace unto you, Mark my Evangelist'). The possession of so sacred a relic was felt to endow the city with a quasi-apostolic status, while the winged lion aptly symbolised both the formidable power and the pacific intentions of the Most Serene Republic.

Carpaccio followed a well-established iconographical pattern in his representation of the lion, but characteristic of the artist himself was the inclusion in the left background of an accurate view of the Piazzetta di San Marco, as seen from the island of S. Giorgio Maggiore. To the left of the lion's head is the Doge's Palace, the seat of the Venetian government; next to it is the basilica of San Marco, the state church and shrine of the Evangelist; then comes the recently completed clock-tower, with its own winged lion in the upper tier; and to the far left is the campanile of San Marco, with the winged lion again visible on the attic storey. The original pyramidal spire at the very top had been destroyed by lightning in 1489, and its replacement, including the gilded angel set on its apex, was completed only a year or two before 1516, the date of Carpaccio's picture. Moored alongside the Piazzetta is a state barge; the ships emerging from the Arsenal on the far right allude to Venetian dominion of the seas. The painting was apparently intended to adorn the wall of a government office; the five escutcheons at the lower edge (belonging respectively to the Balbi or Zorzi, Dandolo or Gritti, Manolesso, Bragadin and Foscarini families) probably refer to the five officers who commissioned it.

P.H.

Vincenzo Catena

Venice (?) *c.* 1478/89 – Venice 1531

There is no record of either the place or date of Catena's birth; it is probable that he was born around 1480 in Venice, where he worked throughout his life. He is first mentioned in the inscription on the back of Giorgione's *Laura* in Vienna, dated 1 June 1506, where Giorgione is described as his '*Cholega*'. This association is surprising, since his earlier signed paintings show him to have been a rather naive follower of Giovanni Bellini, with no understanding of Giorgionesque innovations. He appears from his various wills to have been a man of some means and also to have had friends in Venetian humanist circles, including Antonio di Marsilio and Giovanni Battista Egnazio, and it may be that they encouraged Catena to support Giorgione before the latter artist had achieved official or widespread recognition. The connection with Giorgione is confirmed by the revelation, made evident by x-rays, that underneath Giorgione's *Self-portrait* (Brunswick) there is a Virgin and Child of a type which frequently recurs in Catena's work, and which was apparently his own invention.

Some years after Giorgione's death, Catena began to develop a style which was a sort of simplified revival of Giorgione's manner, and by 1520 he created a minor masterpiece in this vein in his *Martyrdom of St. Christina* in the church of S. Maria Mater Domini in Venice. He repeated this success at the same time (or a little later) in *The Adoration of the Shepherds* (Metropolitan Museum, New York). In portraiture he developed from a purely Bellinesque type of bust portrait to such works as the *Trissino* (Cat. 33), which recall, even if at a long remove, such works of Giorgione as the male portraits in the Dahlem Museum, Berlin and in Budapest (Cat. 37).

G.R.

REFERENCES
Robertson 1954

33
Portrait of Giangiorgio Trissino

72.5 × 63.5 cm
Musée du Louvre, Paris (no. 1252B)

The picture is neither signed nor documented and was formerly ascribed to Giovanni Bellini, but the attribution to Catena, first advanced by von Hadeln, is entirely convincing. Giangiorgio Trissino of Vicenza was a well-known scholar and author of the first classical Italian tragedy, the *Sofonisba*, and an epic poem, *Italia Liberata dai Goti*. He was the first patron of Andrea Palladio. The portrait came from the Trissino family as a likeness of Giangiorgio by Giovanni Bellini: the attribution is no longer tenable, but the identification is probably correct. On stylistic grounds one would judge that it dates from about 1527, when Trissino would have been 47.

G.R.

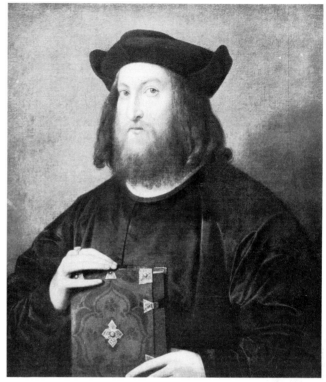

33

PROVENANCE
Trissino family, Vicenza; by 1912 collection of Baron Schlicting; 1915 bequeathed by Baron Schlicting to the Musée du Louvre

REFERENCES
Robertson 1954, pp. 12, 35, 67; von Hadeln in Thieme-Becker, VI, 1912, p. 182

Giorgio da Castelfranco, called

Giorgione

Castelfranco 1478(?) – Venice 1510

Giorgione has been acknowledged ever since his lifetime as a great artist and as a figure of capital importance in the evolution of Venetian – even of Western – painting. Yet there are few Renaissance artists of whom we have less certain factual knowledge.

We know from documents that he painted a canvas for the audience chamber of the Council of Ten in the Doge's Palace in 1507–08, and frescoes on the main façade of the Fondaco dei Tedeschi in 1508. We know from correspondence between Isabella d'Este and Taddeo Albano, her representative in Venice, that he died in October 1510 of the plague. And both sources call him Zorzo (or Zorzi) da Castelfranco, thus indicating his place of origin.

Vasari, writing 40 years later in 1550 – and then again, more fully, in 1568 – supplied further information, the accuracy of which is less certain. In the two editions of his *Lives of the Artists*, Vasari tells us that the artist was born in 1477 (1550 edition) or 1478 (1568 edition) and died in his 34th year; that he was called, from the greatness of both

his person and his spirit, Giorgione (Big George); that he was of humble family but, because he played the lute and sang 'so divinely', was accepted into the society of noble persons; that he studied initially 'with the Bellini' but later, having seen works by Leonardo, painted differently and in a way that was new not only for Venice but for all Italy; that he 'willingly taught with love what he knew'; and that he left, to lessen the loss implicit in his death, 'two excellent disciples' (*due eccellenti suoi creati*), Sebastiano del Piombo and Titian, the second of whom not only equalled but surpassed him. Vasari also enumerated paintings by Giorgione, but demonstrated thereby that the attributional confusions and disputes surrounding the master's *œuvre* were already well under way by the mid-sixteenth century.

An earlier and more reliable source for attributions to Giorgione are the notes of Marcantonio Michiel (dated between 1525 and 1543) on works of art in Venetian collections. Michiel, who was one of the 'noble persons' spoken of by Vasari and who could therefore have known Giorgione personally, mentioned 16 paintings by Giorgione, and his ascriptions are usually taken to have a quasi-documentary status. Of those 16 paintings, however, only three can quite certainly be identified with works now extant: the *Three Philosophers* in Vienna (finished, says Michiel, by Sebastiano), the *Sleeping Venus* in Dresden (finished, says Michiel, by Titian) and the *Tempesta* in Venice (fig. 5).

In addition, the *Laura* in Vienna is identified as Giorgione's by a circumstantial sixteenth-century inscription (and by its resemblances to the previous three works), the *Terris Portrait* in San Diego by a more fragmentary sixteenth-century inscription (and, again, by its style), and the *Madonna Enthroned* in Castelfranco (fig. 13) by its location in the cathedral of Giorgione's home town and, again, by its style. A semi-effaced remnant of Giorgione's Fondaco frescoes – approximately half of a female nude – is preserved in the Accademia in Venice.

These seven works constitute a nucleus of paintings which can be considered to be almost certainly by Giorgione. To them a nearly unanimous consensus of scholars has added three more: the *Portrait of a Young Man* (or *Giustiniani Portrait*) in the Dahlem Museum, Berlin; the *Judith* in Leningrad; and – though only relatively recently – the *Col Tempo* (Accademia, Venice). And perhaps the *Self-portrait* in Brunswick can now be thought of as approaching that status.

The many other paintings that have been ascribed to Giorgione, including some exceedingly famous and beautiful works, must be considered subject to dispute – a state of affairs to which the catalogue entries below testify. What is not disputed, and never has been, is the importance of this immensely gifted artist's contribution to a distinctively Venetian way of seeing and painting. The impact of that contribution is plain in the work of his immediate followers and seems by no means to be exhausted even now.

F.L.R.

REFERENCES

Morelli 1800 (Michiel); Pignatti 1971, with full bibliography; Richter 1937, with full bibliography; Vasari 1550 (Giorgione); Vasari 1568 (Giorgione, Titian, Sebastiano Viniziano, Bordone)

Circle of Giorgione
Attributed to Titian

34
Virgin and Child with St. Anthony and St. Roch

92 × 133 cm
Museo del Prado, Madrid
[*repr. in colour on p. 54*]

This picture was first recorded in the sacristy of the Escorial in 1657, with an attribution, very possibly due to Velázquez, to 'Bordonon'. This has been variously interpreted as signifying Pordenone, Bordone, and Giorgione ('Zorzon'; Baldass 1964). In 1871, Cavalcaselle attributed it to Francesco Vecellio, in 1893 Morelli to Giorgione. Schmidt suggested the young Titian in 1908, a view now accepted by most writers. Some, however, including Richter, Berenson, Baldass and Heinz, believe it is a work by Giorgione. Wilde (1974) declined to decide between the two.

All writers, to whomever they ascribe this small *sacra conversazione*, agree on its great beauty and high quality, and most writers date it around 1510. Wilde (1933) noted the very close similarity of motif between this painting and Domenico Mancini's signed and dated *Virgin Enthroned with an Angel* of 1511, a similarity which encompasses both the general configuration of the Virgin and details of her elaborately worked sleeve and veil. (The Mancini painting elaborates them still further.) This is generally taken to preclude a date after 1511 for the present painting; in fact, it need not do so were one to postulate either that the *Virgin and Child* depended on the much larger Mancini altarpiece rather than vice versa, or that Mancini was the author of both paintings – a theory which, rather surprisingly, no one has yet propounded. The quality of Mancini's Lendinara altarpiece is such as not absolutely to exclude either possibility, and the possibility that Mancini was author of both paintings especially should not be dismissed without consideration, for the present painting is not altogether typical for either Titian or Giorgione, and there are elements of paint handling and (compare Mancini's angel and the Christ Child in the present painting) of type, as well as of motif, that link the two paintings.

In the end, though, the present writer must side with the majority view that this is a work by the young Titian, acknowledging the often cited points of contact with such others works as the *Gipsy Madonna* (Kunsthistorisches Museum, Vienna) and the *Noli Me Tangere* (National Gallery, London), and acknowledging also that, although the exquisiteness of this small-scale picture is not in Titian's usual vein, it is not beyond his range, as occasional later paintings like the *Madonna of the Rabbit* (Louvre) demonstrate.

The connections with Giorgione's accepted work are principally with the Castelfranco altarpiece (fig. 13). These are visible in such general features as the generous spacing of the figures and also in more specific reminiscences: the Franciscan saint seems a free variation on his Castelfranco

counterpart and the Virgin still closer to hers – in the arrangement of her mantle and veil, the placement of her knees, the relationship between her figure and the brocaded backcloth, her pointed oval face, and her downcast eyes and pensive, introspective look. Even the Virgin, however, differs from the Castelfranco Virgin in the delicate linearity of her features and the discreet sumptuousness of her dimpled fabrics – both features that can be duplicated in early works by Titian, but not in Giorgione's certain works. And the *farouche* St. Roch seems, in his active and purposeful character, positively anti-Giorgionesque; in his pose, almost a premonition of such figures as the famous *St. Sebastian* from Titian's Brescia altarpiece of 1522. (The pose seems also, perhaps, related to that of the Baptist in Sebastiano's S. Giovanni Crisostomo altarpiece of 1510.)

This picture seems, then, to be a work by Titian in Giorgione's mode, in which his individual temperament and style are already in evidence. As such, it need not, in the view of this writer, be dated quite as late as the currently conventional *c.* 1510. The painting is unfinished, lacking the final surface layer of pigment in the Virgin's mantle and the lower part of the landscape, as well as in portions of the St. Anthony.

F.L.R.

PROVENANCE

c. 1650 presented by the Duke of Medina de las Torres to Philip IV of Spain; 1657 the Escorial

REFERENCES

Baldass 1964, p. 156; Crowe and Cavalcaselle 1871, II, p. 292; Freedberg 1975, p. 146; Gronau 1908, p. 425; Justi 1908, p. 140; Longhi 1927³, p. 218; Morelli 1893, p. 216; Pallucchini 1978, p. 27; Pignatti 1971, p. 126; Richter 1937, p. 228; Schmidt 1908, p. 115; L. Venturi 1913, p. 134; Wethey 1969, p. 174; Wilde 1933, p. 99; Wilde 1974, p. 118; Zampetti 1968, p. 94

Circle of Giorgione
Attributed to Titian

35

Christ and the Adulteress

139.2 × 181.7 cm
Glasgow Art Gallery and Museum
[*repr. in colour on p. 52*]

The first certain reference to this painting occurs in the 1689 inventory of the collection of Queen Christina of Sweden, in which it was attributed to Giorgione. Several earlier seventeenth-century references to paintings of this subject by Giorgione must refer to more than one work, and hence cannot certainly be associated with this one.

A copy often thought to be by Cariani (fig. 23) shows that the picture has been cut down on the right, excising most of a standing male figure, and also, less substantially, at the bottom; the standing figure's head and shoulders survive as a fragment (Cat. 36).

In 1945, Tietze-Conrat proposed – on the basis of the uncanonical outdoor setting and other unprecedented features – a re-identification of this subject as *Daniel and Susanna*, thereby connecting the painting with a contract between Alvise de Sesti and Giorgione, first mentioned by Urbani de Gheltof in 1869 and published by Molmenti in 1878, in which Giorgione undertook to furnish Alvise with four paintings of deeds of Daniel. The contract has disappeared and many scholars suspect it of being a fabrication by Urbani (others such exist); Hendy (1954) argued the contrary view, and, indeed, the action, personnel

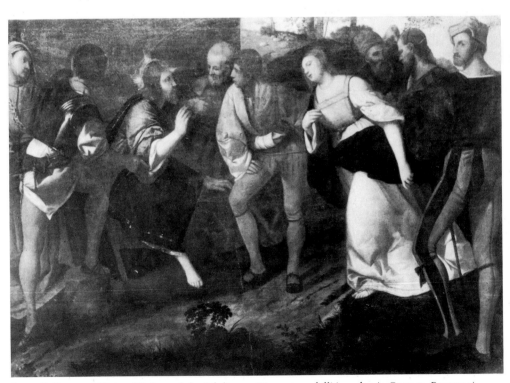

fig. 23 Follower of Titian *Christ and the Adulteress* (Pinacoteca dell'Accademia Carrara, Bergamo)

and setting do fit the apocryphal subject rather better than they do the New Testament one. Most scholars have nonetheless preferred the traditional identification, chiefly because restoration established that the male protagonist wore a cruciform halo (Ruhemann 1955). Pallucchini is an exception, as was Wilde, and the present writer would also wonder whether Daniel might be portrayed here as a prefiguration of Christ.

Few Giorgionesque paintings have been more hotly disputed as regards their authorship. The old ascription to Giorgione was questioned in 1871 by Cavalcaselle, who inclined toward Cariani; Lionello Venturi (1913) preferred Sebastiano del Piombo and Adolfo Venturi (1928) Romanino; in 1927 Longhi proposed Titian and he has been followed in this by perhaps the majority of scholars, both then and later. Zampetti (1955, 1958) thought of Mancini, perhaps copying a lost Titian; Richter (1937) hypothesised a collaboration between Giorgione and Titian, and Wilde (1974) suggested a Giorgione design largely executed by his studio. The difficulty of the attributional problem can be judged not only from the multiplicity of proposals, but also from the fact that several great scholars have changed their minds on the question: Lionello Venturi, for example, who proposed Sebastiano in 1913 and Giorgione in 1954, or Berenson, who in the course of a long career gave the painting successively to Cariani, Sebastiano, Titian and Giorgione.

Since 1955 the question seems to have narrowed down, for most scholars, to 'Titian, or Giorgione?' The majority answer 'Titian'; they include Gamba, Pallucchini, Valcanover, Baldass and Heinz, Morassi, Pignatti and Freedberg. A distinguished minority hold to Giorgione; they include Robertson, in part Wilde (see above), Wethey and Anderson.

Both parties, interestingly, date the painting within a year or two of 1510. For Giorgione's proponents, the work's principal *point d'appui* would be his frescoes of 1508 on the Fondaco dei Tedeschi, as known fragmentarily in engravings and as described by the sources; for Titian's partisans, the essential connection would be with *his* Fondaco frescoes (also 1508, and similarly known) and, even more, with his frescoes in the Scuola del Santo in Padua, dated 1511.

For the present writer the dilemma can be summed up as follows: the painting fits quite well with what the sources tell us of the character of Giorgione's Fondaco frescoes, and with Vasari's description (in his life of Titian) of the more advanced style that Giorgione arrived at 'circa 1507'. There are also tempting possibilities of documentary connections – with the four canvases of the deeds of Daniel mentioned above (if, indeed, the document in question is not spurious) or, alternatively, as Wilde suggested, with the canvas commissioned by the Council of Ten for their new audience hall in 1508. (His suggestion was presumably based on the size of the painting and the suitability of its subject – in either identification – to a site associated with the administration of justice. Hirst recently argued against this connection.)

On the other hand, it is less easy to associate this work with any of Giorgione's *surviving* paintings; indeed, the only ones of comparable size, the *Three Philosophers* and the Castelfranco altarpiece (fig. 13), are very different in character. And to this writer's eye there are many telling likenesses – in types, colour, composition, landscape elements, boldly gleaming surfaces – with Titian's Padua frescoes, and also with other works associated with Titian's early career, for example the *Gipsy Madonna* and *Jacopo Pesaro Presented to St. Peter* (Cat. 113).

For this writer, then, the likeliest solution would be that the picture is one of those of which Vasari speaks in the passage following his description of Giorgione's style cited above: '[Titian] adopted [Giorgione's] manner, imitating . . . his works so well that his paintings were sometimes confused with, and believed works by, Giorgione.'

Three supplementary observations might finally be made. First, the date of the painting would seem to be less close to the Padua frescoes of 1511 than many writers have placed it; here the painter still appears in some ways a kind of 'primitive' genius. Second, Richter's view of the painting as a work of collaboration between Giorgione and Titian remains one worth considering. Third, Zampetti's idea that Domenico Mancini might have had something to do with this painting perhaps deserves more attention than it has received: there are real affinities between this picture and Domenico's signed Lendinara *Madonna* of 1511 in some types and in the handling of fabrics. To this writer these seem best explained as derivations on Domenico's part.

F.L.R.

PROVENANCE
Possibly the *Adultera* attributed to Giorgione in 1661 inventory of Gio. Vincenza Imperiale; 1689 Queen Christina of Sweden; Orleans Collection; McLellan Collection

EXHIBITIONS
London 1893, no. 119; London 1909–10, no. 85; London 1930, no. 162; London 1950–51, no. 214; London 1953; Venice 1955, no. 47; London 1980, no. 11

REFERENCES
Baldass 1964, p. 169; Berenson 1894, p. 99; Castelfranco 1978 (Anderson), p. 73; Crowe and Cavalcaselle 1871, II, p. 547; Freedberg 1975, p. 138; Gamba 1954, p. 174; Hendy 1954, p. 157; Hirst 1981, p. 20, note 93; Longhi 1927³, p. 218; Molmenti 1878, p. 17; Pallucchini 1955, p. 13; Pallucchini 1978, p. 28; Pignatti 1971, p. 122, no. A.16; Richter 1937, p. 219; Robertson 1955, p. 176; Ruhemann 1955, p. 278; Tietze-Conrat 1945, p. 189; A. Venturi 1925–34, IX, iii, p. 812; L. Venturi 1913, p. 157; Wethey 1969, p. 168, no. X-4; Wilde 1974, pp. 115, 120; Zampetti 1968, p. 94, no. 34

Circle of Giorgione
Attributed to Titian

36

Head of a Soldier (?)

47 × 40.6 cm
Glasgow Art Gallery and Museum
[*repr. in colour on p. 53*]

This is an excised fragment of the upper right portion of the painting of *Christ and the Adulteress* (Cat. 35). It was first identified by Berenson (1928). As Richter and Pignatti noted, Titianesque characteristics are especially evident in this fragment and in the portions of the whole that

originally adjoined it: one might cite the piratical three-quarters profile and the bright blue Dolomitic crags, neither of which can be paralleled in works securely attributed to Giorgione.

F.L.R.

PROVENANCE

Queen Christina of Sweden (?); 1928 Paul Sachs; 1962 Mrs D. M. Alnatt 1962; 30 June 1971, acquired by the Glasgow Art Gallery at Sotheby's

EXHIBITIONS

Cambridge, Mass. 1953; Cleveland 1956–57; London 1980, no. 12

REFERENCES

See Cat. 35, with special reference to Berenson 1928

Circle of Giorgione
Attributed to Vittore Belliniano

37

Portrait of a Young Man

72.5 × 54 cm
Szépmüvészeti Muzeum, Budapest
Inscribed on the parapet: ANTONIVS. BROKARDVS MAR . . .
[*repr. in colour on p. 59*]

The subject has been variously identified as Antonio Brocardo (on the basis of a seemingly later inscription on the parapet, now half-effaced) and Vittore or Vincenzo Cappello of Treviso (on the basis of the images, inset in the parapet, of a hat inscribed with a v and a three-faced woman; *cappello* meaning hat and *tre viso* three face[s].) Both identifications are speculative, but the latter, suggested by Jacobs, is tempting.

The painting was first attributed to Giorgione in 1884 by Thausing, whose ascription has been endorsed by a sizeable segment of later opinion, although sometimes with reservations. The majority of scholars, however – especially within the past 30 years – have preferred to seek an alternative author. Among those that have been suggested are Pordenone, Licinio, Cariani, Titian and, most often, an anonymous Giorgionesque painter.

X-rays have shown that at one stage a window opening on clouds and mountains impinged on the upper left corner of the picture, and that the young man's gaze was directed upward towards it. Vague traces of landscape can still be detected behind the neutral background in that quadrant. The revisions seem, however, to have been made largely (at least) by the artist himself. Gould noted in 1978 that this painting shared an unusual *craquelure* pattern with the *Tramonto* (National Gallery, London) – for Gould a possible Giorgione – but also with a few other unrelated paintings. The picture's surface gives evidence of some abrasion and retouching.

This portrait in its present form is obviously close in type to several that have been credibly ascribed to Giorgione, notably the *Portrait of a Young Man* (or *Giustiniani Portrait*) in the Dahlem Museum, Berlin and (minus their special iconographic features) the *Col Tempo* (Accademia, Venice) and the *Self-portrait as David* (Brunswick). The

more expansive forms and more overt sentiment of this portrait, as compared with that in Berlin, would suggest a somewhat later date. Indeed, certain scholars have proposed dating it well into the second or even the third decade of the sixteenth century – in other words, after Giorgione's death. For this writer, a date very much after 1510 would seem, on the basis both of style and of such factors as format, costume and coiffure, unfeasible. The most likely date is perhaps *c.* 1507–*c.* 1512.

This *Portrait of a Young Man* is in many ways an epitome of the Giorgionesque portrait – in its colouristic infusion of austerity with richness, in its atmospheric qualities, in its evocation through gesture and gaze of an inward emotion arising from contemplation or self-communion, an emotion whose outward manifestations are understated and seemingly involuntary. It epitomises these qualities, moreover, with a subtlety and conviction that have impelled many scholars to consider it a Giorgione.

One should also note, however, that even in mood this portrait is more romantically single-minded, less ambivalent than those given to Giorgione by consensus or by documentation. And, at least in its current condition, it evinces few, if any, of the more specific earmarks of Giorgione's personal execution in morphology or in the handling of paint. 'Nor', as Pignatti puts it, 'does an attribution to the well-known artists of Giorgione's circle, like Cariani or Pordenone or . . . Titian really seem possible.' Nonetheless, one is reluctant to consign a painting of this quality and individuality to the limbo of 'anonymous follower of Giorgione'.

It would therefore seem premature, in the present state of our knowledge, to foreclose absolutely the possibility of an attribution to Giorgione. And this writer would tentatively proffer another possibility, which has not hitherto been entertained: that this portrait might conceivably be by Vittore Belliniano.

Vittore is an artist now known by very few works, but the one portrait by him that this writer knows in the original, the *Kneeling Man in a Landscape* signed and dated 1518, in Bergamo, shows him to be, in matters of technique and tone, a close and highly perceptive follower of Giorgione. Further, it shows very specific analogies with this painting: in the thin pigment and diffused, almost ethereal textures; in the austere colour scheme, setting a figure in black against a landscape dominated by autumnal browns; in the almost colourless flesh tones, lacking in the ruddy undertones usual for Giorgione; in some aspects of physiognomy and pose (the latter especially with the Budapest portrait's initial version); and in the romantic sensibility evident in the whole.

F.L.R.

PROVENANCE

Before 1863 János László Pyrker, Patriarch of Aquileia

EXHIBITIONS

London 1930, no. 155; Paris 1935, no. 192

REFERENCES

Castelfranco 1978 (Anderson), p. 73; Castelfranco 1979 (Ballarin), p. 236; Castelfranco 1979 (Gould), p. 254; Gronau 1908, p. 430; Jacobs quoted in Gronau 1908, p. 431; Kakay 1960, p. 320; Pigler 1968, p. 264, with full bibliography; Pignatti 1971, p. 118; Richter 1937, p. 211; Thausing 1884, p. 313; L. Venturi 1913, p. 256; Zampetti 1968, p. 98

Girolamo da Treviso

Treviso c. 1498 – Boulogne 1544

According to Vasari (1550), Girolamo da Treviso died in 1544 aged 46. He is first mentioned in a document of 3 November 1523 referring to a commission for a lost altarpiece for the Confraternity of S. Maria dei Servi, Bologna. As this was a commission of some importance, it is probable that by 1523 Girolamo was already well-known, as indicated by a reference to 'egregius vir magister Hieronymus quondam Thome de Trivisio pictor'.

Girolamo's only works which probably predate 1523 are the large woodcut of Susanna and the Elders of c. 1515 (Venice 1976, no. 10), the two small paintings exhibited here (Cat. 38, 39), The Holy Family with Simeon (Balduina, Padua), the slightly later Female Nude (Kunsthistorisches Museum, Vienna) and the Sleeping Venus (Cat. 40). A series of at least 13 woodcuts depicting Scenes from the Life of Christ after Girolamo's drawings by Francesco De Nanto (an engraver who worked in both Venice and Emilia), date from the early 1520s (Zava Boccazzi 1958).

The Noli Me Tangere (S. Giovanni in Monte, Bologna) must have been painted when Girolamo first arrived in Bologna; it shows the influence of Francia and Costa, while the figure of the Magdalen recalls that of the Virgin in Titian's Annunciation in Treviso Cathedral of c. 1520.

Between late 1525 and May 1526 Girolamo was working in the Guidotti Chapel in S. Petronio, Bologna; the decoration consists of eight grisaille wall-paintings in oil of The Miracles of St. Anthony of Padua, which are signed Hieronimus Tarvisius. This cycle shows the impact of Raphael's classicising Emilian followers on Girolamo, who was 'one of the most eclectic Venetian painters' (Pouncey 1961); he was susceptible to the influence of many Emilian painters, in particular the Ferrarese – Garofalo and Dosso – and Parmigianino. Whilst visiting Genoa in 1527–28 he painted the façade of the Casa Doria (Vasari), and it is probable he was able to see Pordenone's work at Cortemaggiore and Cremona, which influenced his fresco style. In 1531 he was in Venice where he painted an altarpiece (now lost) for S. Salvatore, and frescoed the house of Andrea Odoni (see Cat. 46), also painting frescoes in the Chiesa della Commenda, Faenza, and for S. Sebastiano, Castelbolognese.

The last work Girolamo painted in Italy was probably The Presentation of the Virgin in the Temple with St. Thomas of Canterbury for the chapel of the English students in S. Salvatore, Bologna (Pouncey 1953, 1961); apparently as a result of this commission Girolamo was offered the opportunity to move to England the following year and entered the service of Henry VIII as a military engineer. However, he did not completely abandon painting, as is confirmed by the small Anti-Papal Allegory (Royal Collection) of 1542–44 (Pouncey 1953). Girolamo died on 10 September 1544, during a cannon attack on the besieged city of Boulogne (Vasari, from a letter of Aretino).

G.D.

REFERENCES

Pouncey 1953, pp. 208–11; Pouncey 1961[1], pp. 209–10; Venice 1976[2], p. 83; Zava Boccazzi 1958, pp. 70–78, with bibliography

38

Isaac Blessing Jacob

55.2 × 73 cm
Oil on canvas, transferred from panel
Monogrammed lower left: HIRTV
Musée des Beaux-Arts, Rouen (inv. no. D 863.1.4)
[repr. in colour on p. 76]

This little painting and its pendant (Cat. 39) were first attributed to Girolamo Rizzo da Santacroce. Berenson suggested an attribution to Moretto, but Coletti (1936) published them as early works of Girolamo di Tommaso da Treviso and linked them stylistically to the Female Nude (Kunsthistorisches Museum, Vienna, no. 2647), the Sleeping Venus, (Cat. 40) and the Noli Me Tangere, Bologna. The Holy Family with Simeon (Balduina, Padua), rediscovered by Fiocco in 1949, was later added to the group. The monogram can be read Hieronymus Tarvisii (or Tarvisius as it is spelt in the Guidotti Chapel, Bologna); it is identical to that on the Sleeping Venus, the Balduina painting and a woodcut of Susanna and the Elders probably dating from c. 1515. The attribution to Girolamo has been generally accepted, but was opposed by Longhi (1940, 1946), who attributed the Sleeping Venus (Cat. 40) and this painting and its pair to Savoldo, despite the monograms. But it is difficult to doubt the attribution to Girolamo, especially since more is now known of his career (Zava Boccazzi 1958) and his eclecticism and stylistic inconsistencies have been recognised. Coletti suggested the pair could be dated 1520, prior to Girolamo's move to Bologna, and certainly they appear to be the work of a young artist. There is a striking contrast between the style and positioning of the figures, which is slightly archaic and reminiscent of Flemish painting, and the up-to-date painterly technique, clearly influenced by Giorgione.

The bare interior, animated only by the light falling through the windows, is unusual amongst Italian paintings of this period. The atmosphere is enhanced by the subtle use of colour, which is highlighted or subdued by the soft light, and there are few dark shadows even on the elaborate folds in the drapery. The landscape becomes a positive element in the composition; the white houses just visible on the distant mountains are obviously Giorgionesque in inspiration.

The resemblance between this work and paintings of old men by Savoldo, together with certain affinities with the work of the Lombard artist Giovanni Agostino da Lodi (pseudo-Boccaccino), explain why it was attributed to the Lombard-Venetian school, and why Moretto and Savoldo have been both suggested as the author.

G.D.

PROVENANCE
Campana Collection, Rome; 1863 bequeathed to the Musée des Beaux-Arts

REFERENCES
Berenson 1957, p. 90; Boschetto 1963, no. 1; Coletti 1936, pp. 174–78; Fiocco 1949[2], p. 160; Longhi 1940, p. 34; Longhi 1946, p. 63; Nicolle 1927, p. 5; Popovitch 1967, p. 124; Popovitch 1978, p. 147; Zava Boccazzi 1958, pp. 71–75

39

Hagar and the Angel

55.2 × 73 cm
Oil on canvas, transferred from panel
Musée des Beaux-Arts, Rouen (inv. D 863.1.3)
[repr. in colour on p. 76]

This painting is the pendant to *Isaac Blessing Jacob*
(Cat. 38). The artist's monogram appeared on it originally,
but was lost when the painting was transferred to canvas
in the last century. The artist has rather awkwardly adapted
an Annunciation composition to a meeting between Hagar
and the Angel, which creates a slightly naive effect. Despite
this, Girolamo displays pictorial inventiveness in this little
painting: there are touches of remarkable freshness and
spontaneity in his treatment of the angel with its large,
feathery wings, of the grey clouds and of the great rock on
the right.

This is the work of a young, provincial artist and
demonstrates Girolamo's susceptibility to various
influences, which he adapted into a personal pictorial
idiom. Coletti noted the influence of the figure style of the
'pseudo-Boccaccino' (Girolamo Agostino da Lodi), who
was active in Venice and the *terraferma* in the first years of
the sixteenth century: the figure of Ishmael is taken almost
directly from this painter's work. The angel is also
Lombardesque, stylistically a mixture between Giovanni
Agostino and Savoldo, whilst the elegantly dressed Hagar,
a twin of Rebecca in the companion picture, may recall
certain Madonnas by Previtali. The painting demonstrates
a remarkable painterly freedom in the treatment of the
background, in particular the leafy branches of the trees on
the top of the rock, which, like those in many of the early
works of Titian, whom Girolamo obviously imitated, are
cut in half by the frame. The presence of an almost identical
rock formation in one of Francesco De Nanto's woodcuts
taken from a drawing by Girolamo (*The Entombment*)
confirms the attribution of this painting to the artist.

G.D.

PROVENANCE
Campana Collection, Rome; 1862 bequeathed to the Musée des
Beaux-Arts

REFERENCES
Berenson 1957, p. 90; Boschetto 1963, no. 2; Coletti 1936, pp. 174–78;
Fiocco 1949², p. 160; Longhi 1940, p. 34; Longhi 1946, p. 63; Nicolle 1927,
p. 5; Popovitch 1967, p. 124; Popovitch 1978, p. 147; Zava Boccazzi 1958,
pp. 71–75

40

Sleeping Venus

130 × 212 cm
Monogrammed lower left: HIRTV
Galleria Borghese, Rome (inv. no. 30)
[repr. in colour on p. 77]

The painting is first mentioned, ascribed to Pordenone, in
the 1693 manuscript inventory of the Borghese Collection;
in the 1790 inventory it was attributed to Titian. In this
century it has been attributed to Cariani (by Berenson) and
Savoldo (by Venturi and Longhi). The latter also suggested
that it was the large nude by Savoldo mentioned by
Marcantonio Michiel as in the house of Andrea Odoni.
Coletti (1936) suggested the painting was by Girolamo da
Treviso and compared it to the *Female Nude*
(Kunsthistorisches Museum, Vienna, no. 2647), which had
already been ascribed to Girolamo by Wilde (1930) on the
basis of the seal reading H.R.T.V. on the back of the canvas.
Coletti argued that in the *Sleeping Venus* Girolamo
classicised a Giorgionesque motif, while the careful
modelling and elegant linear quality of the figure and the
inclusion of quattrocentesque elements reminded him of
female nudes by Lorenzo Costa, particularly his *Venus*
(Budapest). Coletti also suggested that there was a link
between these two nudes and the work of contemporary
Bolognese engravers.

In fact this rounded, statuesque figure is similar to those
in Giacomo Francia's prints, and even more direct analogies
can be made with Marcantonio Raimondi's classicising
prints, which influenced Francia. The relationship between
the sleeping Venus and the landscape, over which the clouds
are gathering before a storm or a holocaust, recalls
Marcantonio's so-called '*Dream of Raphael*' (Cat. P15), an
engraving supposedly inspired by a lost work of Giorgione
(Suida 1954). These ties with Bolognese art suggest that the
painting dates from the early 1520s, thus placing it between
the two Rouen pictures (Cat. 38, 39) and the work for
S. Petronio (1525).

The influence of Giorgione's Dresden *Venus*, and other
variations on the theme, is undeniable but very slight.
Girolamo's *Venus* no longer bears any relationship to the
classical prototypes of the sleeping nymph supporting her
head with her left arm, which inspired Giorgione and later
Titian, but she does recall an engraving after Titian of a
variation of the Bacchante in *The Andrians* (Rome 1976,
no. 58). Also, her crossed legs and the motif of the curtain
hanging behind her head are similar to those of the woodcut
in the *Hypnerotomachia Polifi* published in 1499, which
Saxl (1957) mentioned in connection with the Dresden
Venus. It seems unlikely that Girolamo was influenced by
Giorgione only indirectly through prints such as those of
Domenico Campagnola (Coletti); the treatment of the
landscape is certainly Giorgionesque and the freedom of the
painterly treatment of the red cloth on the left is worthy of
a true follower of Giorgione.

G.D.

PROVENANCE
1693 Borghese Collection

REFERENCES
Baldass 1957, p. 131; Berenson 1957, p. 90; Boschetto 1963, no. 3; Coletti
1936, pp. 172–74; Della Pergola 1955, pp. 126–27, with bibliography;
Fiocco 1957, p. 216; Gilbert 1959, p. 50; Longhi 1926, pp. 71–72; Longhi
1940, p. 33; Meiss 1966, p. 353; Saxl 1957, pp. 162f; Suida 1954, p. 158;
Zava Boccazzi 1958, p. 71, with bibliography

Bernardino Licinio

Venice *c.* 1490 – Venice *c.* 1550

Bernardino, the second son of Antonio Licinio, was born in Venice, but his family came from Poscante near Bergamo. His elder brother Arrigo was also a painter, but little is known of him except that he had a large family and is recorded in the list of members of the Scuola di San Marco in Venice in 1525 as '*assente dalla disciplina*'. Probably he joined the workshop of the more gifted Bernardino, who also trained Arrigo's son Giulio (1527–91) and used him as his assistant. Bernardino is last recorded in 1549, Arrigo in 1551. When their younger brother Zuane Battista, parish priest of S. Cassiano, made his will in 1565, both were dead and may have been for years. Vasari did not meet either of them during his Venetian sojourn, and Paris Bordone, their relative by marriage, did not provide Vasari with information about them, although he was busy advertising himself. This would explain why Vasari erroneously connected Bernardino Licinio with the Friulian artist Pordenone (Giovanni Antonio Sacchi) in his *Vita di G. A. Licinio da Pordenone e altri Pittori del Friuli* (1568). This confusion, which lasted four centuries, seems to have been caused by the elliptic inscription on an etching, printed by Bernardino's nephews Fabio, the etcher, and Giulio, the painter, which reproduced Pordenone's *Assumption* at Murano, a stronghold of the Licinio tribe.

Bernardino's identity and the quality of his work were saved from oblivion by his altarpiece in the church of the Frari, which is signed BERNARDINI LYCINI OPUS MDXXXV. This enabled connoisseurs to group other paintings around it, all of them antithetical to Pordenone's wild dynamic style, and the archival discoveries of Ludwig (1903) confirmed the separate identities of the two artists.

Several pictures by Bernardino have been ascribed to Giorgione, and Giorgione's *Portrait of A Young Man* (Cat. 37) used to be attributed to Licinio. The implications of this confusion are that Bernardino was trained in the workshop of Giovanni Bellini when it was under Giorgione's pervasive influence. Between 1515 and 1525 Bernardino joined Titian and Palma Vecchio in the production of half-length Madonnas with Saints and later his shop, like those of Titian and Bonifazio, provided altarpieces and *sacre conversazioni*. In the 1530s his figures become statuesque in an effort to imitate classical antiquity, and he even produced a series of 'Female Beauties' reminiscent of marble busts. The arrival of artists such as Giulio Romano, Jacopo Sansovino and Francesco Salviati, and the circulation of Raphaelesque prints, spread a taste for Roman art throughout northern Italy; but, unlike other Venetian painters, Bernardino translated this *romanismo* into placid, self-contained images, and consistently ignored, or repudiated, the tensions and drama of mannerism. It seems to have been contrary to his down-to-earth temperament, which is revealed in the humorous undertones of his earlier Giorgionesque Concerts and Seduction Scenes. Bernardino's predilection for a close-up viewpoint allowed him to excel in portraiture; most of his saints look like portraits. In this realism lies his affinity with Moroni.

L. V.

REFERENCES
Vertova 1975, I, with full bibliography

41

Portrait of Arrigo Licinio and his Family

118 × 165 cm
Inscribed in the upper corner:
EXPRIMIT HIC FRATREM TOTA CUM GENTE LYCINUS /
ET VITAM HIS FORMA PROROGAT ARTE SIBI;
signed below: B. LYCINII OPUS
Galleria Borghese, Rome (inv. no. 115)
[*repr. in colour on p. 104*]

From Francucci's list of 1613 one gathers that this was one of the first pictures acquired by Cardinal Scipione Borghese. Described by Scannelli (1657), and again by A. Venturi and L. Goldscheider, as a self-portrait of the artist with his family, the inscription in fact states clearly that 'Here Licinio portrayed his brother with all his family and thereby prolonged life for them with their image, for himself with his art.'

In the centre of the composition sits the mother, Agnese, with an infant in her lap, while the father tries to restrain two restless boys from teasing their little sister and the baby. Fabio, the eldest son, who trained as a goldsmith and became an etcher, is shown holding a statuette of the Belvedere *Torso*, while Giulio, the future painter, offers his mother a basket of roses. The wistful youth standing between his parents is Camillo, who was to become a renowned physician. Ludwig (1903), who ascertained the identity of these older sons, assumed that the younger offspring died in childhood because he found no mention of them in the Venetian archives.

The heads of Arrigo and Agnese offer a good example of Bernardino's compact and sensitive brushwork and appear to be his only contribution to this group portrait. The remaining heads betray a different quality and workmanship, shown also in other pictures from Bernardino's workshop: they share the same doll-like features, starry eyes and rigid draperies. In 1975 the present writer proposed identifying their author with Bernardino's brother Arrigo, who seems to have given up working independently in about 1525. The assumption that Arrigo collaborated with his younger brother is supported by this family group, in which Bernardino appears to have sketched the arrangement of the figures and painted the adults, leaving Arrigo to deal with the remaining portraits. A confirmed bachelor and a busy artist, Bernardino may have dreaded the very thought of those infantile sittings. The Latin inscription was probably added much later by the artist's nephews. Judging by the age of the sitters, this family portrait must have been painted around 1535.

L. V.

PROVENANCE
1613 Cardinal Scipione Borghese

REFERENCES
Ludwig 1903, pp. 44–57; Vertova 1976, pp. 429–30, repr. pp. 400, 401, 402, 455, with full bibliography

42

Man Holding a Missal

92 × 77 cm
Signed and dated:
MDXXIIII ANNO AETATIS LV / B. LYCINII
City Art Gallery, York (no. 738)

Because of Vasari's erroneous statement that Licinio was the family name of Giovanni Antonio Sacchi, called Pordenone, this portrait was attributed to him as late as 1929 (Brownlow Sale), and although the York catalogue of 1961 no longer confused the two artists, thanks to the signature, it still stated that Licinio was Pordenone's pupil, despite the existence of documentary evidence proving that the two artists had nothing in common.

The identity of the sitter is unknown. Berenson described him as a canon, the York catalogue as a *parroco*, making reference to the Vienna *Portrait of a Man in Blue* by Catena (Robertson 1954, no. 25) and to Molmenti (1885), who recalled the blue cassock of parish priests in Renaissance Venice. But the reference is misleading and the deduction pointless, for our sitter is dressed entirely in black. The expensive watered silk of his coat and undergarment indicate a high social status, and the antiphonary suggests an interest in music rather than a curate's chores. Fiocco praised the picture for its golden hue and Lottesque spirit.

L. V.

PROVENANCE
Palazzo Borghese, Rome; 1816 Sir Archibald Hume; 1846 Lord Alford; 1914 Lord Brownlow; Christies sold 3 May 1929 (lot 14) as Pordenone;

F.D. Lycett Green; 1955 presented by F. D. Lycett Green through the National Art Collections Fund to the City Art Gallery

EXHIBITIONS
London 1816, no. 89; London 1846, no. 106; London 1914, no. 38; York 1955, no. 13; London 1962, no. 45

REFERENCES
Molmenti 1885, p. 263; Robertson 1954, no. 25; Vertova 1975, p. 439, with full bibliography

Lorenzo Lotto

Venice (?) 1480 – Loreto 1556/57

Lorenzo Lotto was born in Venice in 1480, as he stated in his will of 1546 in which he declared his age to be 'about 66'. In other documents he repeatedly affirmed his Venetian origin, and that he was the 'son of Thomas'. Thus, the suggestion that he was of Bergamasque origin – often made in the past – should be rejected. The mistake probably arose from the long period he spent in Bergamo, and from Vasari in his *Lives of the Artists* (1568), in which he linked Lotto with Palma Vecchio (who was from Bergamo), although Vasari continued to refer to Lotto as a *'pittore viniziano'*. Ridolfi (1648) and Tassi (1793) claimed that the artist was Bergamasque, although Lanzi (1796) maintained he was Venetian. His origin is still controversial, partly because certain qualities of his style are quite distinct from the Venetian tradition of Bellini, Giorgione, and Titian.

Lotto is first documented working in Treviso in 1503. He then moved to the Marche where, in 1506, already a painter of some repute, he was commissioned to paint a polyptych for the church of S. Domenico, Recanati (signed and dated 1508). He next went to Rome, probably towards the end of 1508, and was commissioned to paint in the Vatican *stanze* alongside Raphael. In 1509 he was paid for some work there, but what he had painted remains a mystery; however, the exchange of influence between Lotto and Raphael is evident. In 1512 Lotto was working in Recanati and Jesi, where he signed a *Deposition* (Pinacoteca Civica, Jesi), and in 1513 he moved to Bergamo and signed the contract for an altarpiece commissioned by Alessandro Corleoni Martinengo for the church of SS. Stefano e Domenico, signed and dated 1516 (S. Bartolomeo).

The details of Lotto's life are largely deduced from his own writings: his letters and *Libro di Spese*, a combined diary and account-book which he began in 1538 and continued writing until his death. He remained in Bergamo until 1525; in 1526 he moved to Venice, but made prolonged visits to the Marche (1534–39) and Treviso (1542–45). In 1549 he went to Ancona and there, in 1550 in the Loggia dei Mercanti, he tried to raise money from an auction of his paintings. In 1552 *'per non andarmi avolgendo più in mia vecchiaia'* (not to become more confused in my old age), as he wrote, Lotto retired to live in Loreto, where he died either late in 1556 or early in 1557.

Lotto was the victim of incomprehension, even amongst his contemporaries, and was always considered to be outside the Venetian artistic mainstream, as can be seen from a letter of Aretino, dated 1548, in which Lotto's moral qualities are acknowledged but his artistic achievement is

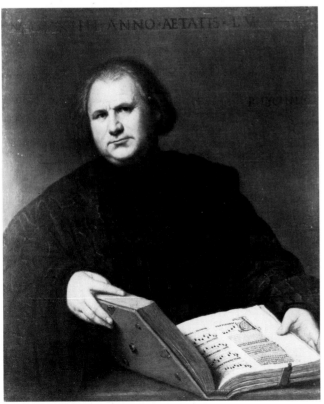

42

underrated; Lodovico Dolce (1557) was openly critical of his works. Recently there has been much discussion of Lotto's possible sympathy for the Protestant Reformation; but this may be due merely to his desire to express sincere and deeply felt piety in his work. Certainly his art is genuinely moral and committed in spirit.

P.Z.

43
The Mystic Marriage of St. Catherine with Niccolò Bonghi

172 × 134 cm
Signed and dated: *Laurentius Lotus 1523*
Pinacoteca dell'Accademia Carrara, Bergamo

Michiel recorded this painting in Bonghi's house: 'the painting of Our Lady with Saint Catherine and the Angel and with the portrait of M. Niccolò, was by Lotto's hand.' In the seventeenth century Ridolfi recorded that when the French invaded Bergamo, probably in 1528, a soldier had cut out the landscape background. Ridolfi believed that it had represented Mount Sinai, but others, more plausibly, have suggested that it was a view of the Città Alta (the upper city) of Bergamo.

Lotto in fact lived in a house belonging to Bonghi in the parish of S. Michele al Pozzo Bianco in Brescia, and the painting was made in part-exchange for the rent. When the painting was valued at 60 gold ducats Lotto was paid back a certain amount (Chiodi 1968). Although the lack of the

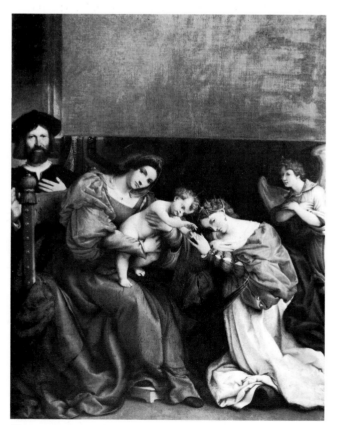

43

landscape creates an imbalance in the composition, the work preserves much of its vitality, largely because of the emotional and compositional unity of the figures.

The Virgin, the Child and St. Catherine are flanked on the right by the angel, and on the left by Niccolò Bonghi, who witnesses the mystic marriage as a vision. The portrait of Bonghi is one of exceptional insight and realism; it remained a model for all Bergamasque portraits until the eighteenth century.

P.Z.

PROVENANCE
Niccolò Bonghi, Bergamo; Giacomo Carrara (d. 1796)

EXHIBITIONS
Venice 1953, no. 49

REFERENCES
Banti and Boschetto 1953, p. 76; Bergamo 1975 (Zampetti and Cortesi Bosco), p. 44, no. 4, with full bibliography; Chiodi 1968, pp. 11–12; Mascherpa 1971, pp. 49–53; Mascherpa 1980, pp. 87–88; Pallucchini and Canova 1975, no. 69, p. 98; Zampetti and Cortesi Bosco 1975, p. 44

44
Double Portrait

98 × 118 cm
The State Hermitage Museum, Leningrad (no. 1447)

The couple are seated on either side of a table covered with an oriental carpet, in a room dimly lit by a window which opens out onto a distant landscape. The man points to a squirrel with his right hand, whilst with his left he holds a scroll inscribed HOMO NUN/QUAM. His wife affectionately rests her right arm on his shoulder and holds a small dog in her left hand. This double portrait, like that of *Messer Marsilio and his Bride* dated 1523 (Prado, Madrid), not only portrays a married couple but also emphasises their conjugal love. The man pointing at the squirrel symbolises that he would never (*homo nunquam*) act as the squirrel does and leave his partner when there is not enough to eat. The Leningrad picture can also be related stylistically to the small *Sacra Conversazione* (Costa di Mezzate, Bergamo) of 1522, whilst the woman (particularly her hairstyle) recalls the *Portrait of Lucina Brembate* (Accademia Carrara, Bergamo) which also dates from about 1523.

Berenson, Pouncey and Canova have all suggested that a drawing in the Rijksmuseum, Amsterdam is a preparatory sketch for the work, although Mascherpa believed it was a sketch made after the painting.

Berenson incorrectly supposed that this double portrait was painted in Venice in 1523 since he believed that Lotto lived in the city that year – due to a misinterpretation of a document relating to the *St. Lucy Altarpiece* (Jesi) commissioned from Lotto in 1523. He was supposed to deliver it to '*la spiaggia di Case bruciate*', a locality which is in fact near Jesi, not Venice. Certainly Lotto was not in Venice in 1523, and once the misunderstanding had been resolved this work could once again be seen in relation to his Bergamasque paintings.

P.Z.

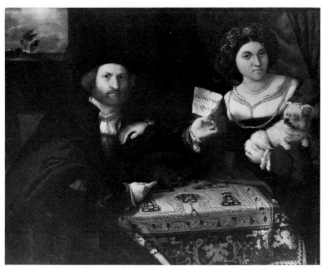

44

PROVENANCE
Giovanni and Jacopo van Buren, Antwerp (Ridolfi 1648);
also recorded by Tassi (1793); between 1773 and 1783 Castle of Gatchina,
St. Petersburg; Hermitage Museum, Leningrad

EXHIBITIONS
Leningrad 1972, no. 351; Milan 1977, no. 13; Washington, Los Angeles,
New York 1979, p. 81

REFERENCES
Berenson 1955, pp. 83–84; Hermitage catalogue 1976, p. 108, no. 1447;
Mascherpa 1971, pp. 56–57; Palluchini and Canova 1975, p. 98, no. 72;
Vsevolojskaia 1982, p. 274, no. 60–61

45

The Mystic Marriage of St. Catherine with St. Jerome, St. Anthony Abbot and other Saints

98 × 114 cm
Signed and dated: L. LOTUS 1524
Galleria Nazionale di Palazzo Barberini, Rome
[repr. in colour on p. 88]

This work was described by Lotto as one of the group of paintings made for Giovanni Casoto in 1524, so it dates from towards the end of the artist's time in Bergamo. Lotto described it thus: 'The painting for the room of Messer Marsilio and in the centre the Madonna with the Child in her arms'. He also describes the saints: 'on the right St. Jerome . . . St. George, St. Sebastian; on the left, St. Catherine, St. Anthony, St. Nicholas of Bari' (Zampetti 1969). So this was a devotional painting made for the same Messer Marsilio who had been painted by Lotto, together with his betrothed wife, in a famous painting of 1523 (Prado, Madrid).

Stylistically this *Mystic Marriage* fits in quite well with the group of works dating from these years, which includes *Messer Marsilio with his Bride*, the *Double Portrait* (Cat. 44) and the *Portrait of Lucina Brembate* (Accademia Carrara, Bergamo). Lotto had already painted another picture of the *Mystic Marriage of St. Catherine* (Cat. 43) in 1523, but this version is more complex and dynamic in

composition; the lighting is organised in a completely different way, based on violent contrasts of light and shade antithetical to the Renaissance ideals of serenity and balance in composition. It might be going too far to see in this work the influence of northern painting, but it is clear that the strange qualities of the painting may reflect Lotto's state of mind at that time, as might also be true of the contemporary frescoes in the Oratory at Trescore. There is an almost mystical intensity in the rapport between the infant Jesus and St. Catherine as she leans towards him with a gesture of extreme gentleness and pathos; movement and forms are accentuated by the intense lighting.

P.Z.

PROVENANCE
In the nineteenth century Palazzo Quirinale, Rome; Galleria Corsini;
Palazzo Barberini

EXHIBITIONS
Venice 1953

REFERENCES
Banti and Boschetto 1953, p. 77, no. 63; Caroli 1980, pp. 52–3;
Mascherpa 1971, pp. 58–61; Pallucchini and Canova 1975, p. 98, no. 74;
Zampetti 1969, p. 260

46

Portrait of Andrea Odoni

104 × 116.6 cm
Signed and dated lower left: *Laurentius lotus/1527*
Her Majesty The Queen (no. 72)
[repr. in colour on p. 92]

Michiel saw this portrait in Odoni's house in Venice, and recorded it in his note-book as 'the half-length portrait in oil of M. Andrea contemplating ancient marble fragments, painted by Lorenzo Lotto'. The painting is also mentioned by Vasari (1568).

Andrea Odoni was a renowned Venetian antiquary and collector; he is portrayed here holding a precious statuette in the Egyptian style of Diana of Ephesus, as if displaying it to a fellow connoisseur. Beccati identified some of the pieces scattered in untidy abandon around the collector (Berenson 1955). The fragment on the left is a reproduction of the *Hercules and Antaeus* (Uffizi, Florence) then in the Belvedere courtyard in the Vatican, which Lotto, like many other artists, would certainly have seen during his stay in Rome in 1509. In the right background, there is a small *Hercules*, a female nude and a small putto. In the foreground is a *Venus*, missing its arms and head; and a male head, which appears to be a late Roman piece. As is often the case in Lotto's portraits, the sitter's expression appears to be completely sincere and almost abandoned, if somewhat melancholy, as though the presence of so many tokens of past epochs were a reminder of the transitoriness of human life. It has also been suggested that the prominence given to the statuette of Diana of Ephesus – who was a symbol of Nature or Earth in the Renaissance – symbolises the eternity of Nature in contrast to the transitory quality of Man's achievements, as exemplified by the broken antique fragments (Burckhardt 1911). Lotto used light here both to animate the sitter, to bind him to

his surroundings and to create a psychological tension, as he did in *The Annunciation* (Cat. 47) and the *St. Lucy Altarpiece* completed in 1532 (Jesi).

P.Z.

PROVENANCE

1532 Andrea Odoni's house, Venice; Lucas van Uffelen, Amsterdam; 1639 acquired by Gerard Reynst; 1660 acquired by the state of Holland and presented to Charles II; Whitehall; Windsor; before 1776 Hampton Court

EXHIBITIONS

Venice 1953, no. 67 (Zampetti); Stockholm 1962, no. 81; London 1964, no. 7

REFERENCES

Banti and Boschetto 1953, p. 81; Berenson 1955, p. 131; Burckhardt 1911, pl. 314; Caroli 1974, pp. 235–52; Coletti 1953, pp. 3–16; Mascherpa 1980; Michiel (ed. Frizzoni) 1884, pp. 84ff; Pallucchini and Canova 1975, p. 109, no. 175; Shearman 1983, pp. 144–48; Vasari (ed. Milanesi) 1878–85, v, p. 249

47

The Annunciation

166 × 114 cm
Signed: *L. Lotus*
On deposit at the Pinacoteca Civica, Recanati
[*repr. in colour on p. 90*]

First mentioned in 1601, when Francesco Angelita saw it in the church of S. Maria dei Mercanti, Recanati, in 1894 the painting was judged to be 'very beautiful' by Gianuizzi, who dated it not later than 1526. Berenson suggested 1527/28 and Mascherpa believed it to be a late work, the culmination of a series of quite extraordinary variations on the theme of the Annunciation.

The painting is not dated, but it is signed in italics rather than the lapidary capitals preferred by Lotto in his youth (eg. in the 1508 polyptych); later he abandoned the Latin form and signed himself Lorenzo Lotto, as in the Ancona altarpiece (Cat. 53). In a letter dated 12 August 1527, Lotto wrote that he had abandoned a long planned trip to the Marche, but that he had sent two finished paintings there, 'of which I have not yet received any news, which leaves me rather anxious'. This *Annunciation* may be one of them; the other was probably a triptych for Jesi of which only the two lateral panels survive: *The Angel* and the *Virgin Annunciate* (Pinacoteca Civica, Jesi).

In this *Annunciation* Lotto abandoned the traditional format and instead showed a terrified Virgin visited by an angel who bursts upon her in a blaze of light: the apparition and the light violate the quiet chamber and create total panic and confusion. The young woman, cowering, her hands raised in an expression of fear and awe, turns towards the spectator as if seeking protection and help; the cat, symbol of evil, jumps away from the angel, mewing wildly. This interpretation of the Annunciation breaks completely with the dictates of sixteenth-century iconography. God the Father appears to be about to dive into the room from behind the clouds, adding to the confusion. Evidently the room had been serene and tranquil; the Virgin's domestic habits are indicated by the objects arranged along the shelf, from which hang her

night-cap and towel. The blond, adolescent angel, dressed in an ice-blue robe and with his hair swept back by flight, is the herald of confusion. The light plays a major role, intensifying the rich chromatic symphony of atonal colours in the Virgin's garments. The reds are pinky-blue, and the light insinuates itself between the folds and the facings until it reaches those defenceless and imploring hands.

This painting is in an almost perfect state of preservation, restored and relined by Pellicioli in 1953. Only the face of the angel has lost a few of its glazes after an earlier, more drastic cleaning. The original canvas has a rather handsome lozenge-shaped weave.

P.Z.

PROVENANCE

S. Maria dei Mercanti, Recanati; 1953 deposited at the Pinacoteca Communale, Recanati

EXHIBITIONS

Venice 1953, no. 73; Ancona 1981, no. 73, pp. 310–12 (Zampetti) with full bibliography

REFERENCES

Berenson 1956, p. 71; Caroli 1980 *passim*; Gianuizzi 1894, p. 41; Mascherpa 1980, pp. 112–13; Pallucchini and Canova 1975, pp. 109–10, with bibliography; Zampetti 1953, p. 49

48

Portrait of a Man

118 × 105 cm
Galleria Borghese, Rome
[*repr. in colour on p. 89*]

This portrait was listed in the 1682 inventory of the collection of Olimpia Aldobrandini as 'a painting on canvas portraying Lorenzo Lotto and painted by himself'. Later it was attributed to Pordenone, but Mundler re-ascribed it to Lotto and this has been generally accepted. It is still uncertain whether it is a self-portrait. Della Pergola (1952) compared the severe and introspective figure with the portrait of Lotto in the first edition of Ridolfi (1648) and decided that it was indeed the artist. But it is not easy to make such an identification, because there are several other paintings that have been suggested as self-portraits, including one in the frescoes at Trescore (Cortesi Bosco 1980). The triple portrait in Vienna, which in the past has been suggested as a self-portrait, has recently been identified as a painting of three brothers of the Carpan family, who were jewellers and friends of Lotto.

The composition is bold and severe; the figure stands in a simple setting, looking out as if he wishes to engage the spectator in conversation. His right hand rests on the table on which there are some rose petals and a small skull, both symbols of the ephemeral nature of earthly things and hence of death. In the segment of landscape that can be seen through the window on the left St. George is shown slaying the dragon. The allegorical significance of this scene is uncertain, but if it was intended as a reference to the name of the sitter, then this is obviously not Lotto's self-portrait. The painting is usually dated around 1530.

P.Z.

PROVENANCE
1611 Cardinal Ippolito Aldobrandini; by inheritance to Olimpia
Aldobrandini

EXHIBITIONS
Venice 1953, no. 83 (Zampetti)

REFERENCES
Banti Boschetto 1953, p. 84; Caroli 1974, pp. 235–52; Coletti 1953,
pp. 3–16; Cortesi Bosco 1980, pp. 124–45; Della Pergola 1952, pp. 187–88;
Mascherpa 1980, p. 114; Pallucchini and Canova 1975, no. 197, p. 113,
with bibliography

49 & 50

The Annunciation

Lunette, 103 × 152 cm
[*repr. in colour on p. 91*]

The Visitation

154 × 152 cm
Signed: *L. Lotus . . .*
Pinacoteca Civica, Comune di Jesi
[*repr. in colour on p. 91*]

These two paintings constitute an altarpiece, the lunette of
The Annunciation being placed over *The Visitation*. The
date is illegible, but it is generally agreed that the altarpiece
can be dated 1530–35. Lotto was in the Marche in 1535 and
remained there until 1539, and certainly these paintings
have stylistic similarities with other works of this period,
the last of which is the Cingoli *Madonna of the Rosary* of
1539. In one of the roundels illustrating the mysteries of the
life of the Virgin on the Cingoli altarpiece there is a small
Visitation, compositionally very like this present painting,
but set in the open air.

Here the meeting of the Virgin and St. Elizabeth takes
place in a homely interior: objects in everyday use are set
out along a mantelpiece and the gestures and poses of the
figures are those of simple, unsophisticated people. Lotto
employed a direct and simple narrative style to illustrate an
event of supernatural significance. In fact, the objects on the
mantelpiece and the scattered flowers are symbols of the
Virgin's divinity. *The Annunciation*, a subject dear to
Lotto, is intensely vibrant and imbued with contained
spirituality. The Virgin devoutly accepts the Will of God;
the atmosphere is very different from the drama of the
Recanati *Annunciation* (Cat. 47). In these paintings the
shifting light is all important. A preparatory drawing for
The Visitation was sold at the Hôtel Drouot in 1924, but
has since disappeared (Berenson 1955; Canova 1974;
Chiappini 1981).

P.Z.

PROVENANCE
Church of the Monte dei Minori, Jesi (Franciscan Observants); 1866
moved to the Pinacoteca Communale, Jesi, when the church was
deconsecrated

EXHIBITIONS
Ancona 1950, nos. 63, 64; Venice 1953, no. 801 (Zampetti); Ancona 1981,
no. 83, pp. 334–36 (Chiappini), with full bibliography

REFERENCES
Banti and Boschetto 1953, p. 84; Pallucchini and Canova 1975, p. 115;
Zampetti 1953, p. 51

51

Virgin and Child in Glory with St. Andrew and St. Jerome

251 × 139 cm
Signed and dated: *L. Lotus 1535*
Private Collection, Rome

This painting was indirectly mentioned by the historian
Alessandro Maggiori in 1832: 'In the church of St. Agostino
(at Fermo) there was formerly a very beautiful painting by
Lorenzo Lotto, which is now in Palazzo Bernetti.' In a guide-
book to Fermo of 1864, Curi described the copy that had
replaced the original painting on the sacristy altar in
Sant'Agostino as 'a good copy of a painting by Carlo Loth,
the Bavarian (seventeenth century). The original is in the
possession of Count Bernetti.' So Lotto was transformed
into Loth (Dania 1967).

The painting was lost for many years, but was traced by
the present writer and exhibited at Ancona in 1981. It is of
particular interest in that it confirms that Lotto was in the
Marche in 1535; this can also be surmised from a small
altarpiece by a local painter, Durante Nobili da Caldarola,
which is dated 1535 (S. Martino, Caldarola; see Ancona
1981, no. 82) and which is so strongly Lottesque that it is
unthinkable that it could have been painted without the
example of the master. In fact it seems probable that Lotto
actually helped his seventeen-year-old pupil; a comparison
of the two works reveals their iconographic and stylistic
links.

This altarpiece must have been the first of a group Lotto
painted in the Marche between 1535 and 1539; it was
followed by those at Ancona (Cat. 53) and Cingoli, the
latter completed in 1539. It seems almost to anticipate the
directives of the Counter-Reformation in its religious
intensity and fervour, while the realism of such details as
St. Andrew's dusty feet was later used by Caravaggio. The
ascetic expressions of the saints are intensified through
Lotto's use of cold, strong colours (unlike any he had used
before), and the whole scene is immersed in an all-pervasive
luminosity. This work marks a turning-point in Lotto's
conception of the devotional image of the Virgin who,
instead of being seated on a throne as in earlier *sacre
conversazioni*, is here transformed into a celestial vision.
Echoes of the painting are still found in Lotto's Sedrina
altarpiece of 1542.

P.Z.

PROVENANCE
S. Agostino, Fermo

EXHIBITIONS
Ancona 1981, no. 80, pp. 329–30 (Zampetti), with full bibliography

REFERENCES
Dania 1967, p. 73; Zampetti 1980, p. 52

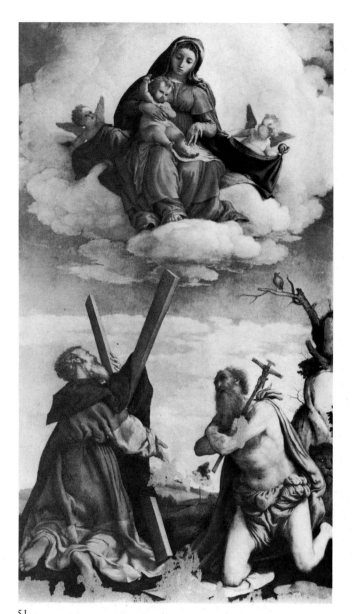

51

which in fact he never undertook, and in the same year he painted an altarpiece formerly in S. Agostino, Fermo (Cat. 51). It seems quite plausible that the present painting dates from that year or not long afterwards. Certainly there is no documentary evidence that Lotto was in Venice, Treviso or Bergamo at this date, while he appears to have been extremely active in the Marche: in 1532 he delivered the *St. Lucy Altarpiece* to Jesi, while the Fermo altarpiece is dated 1535, the *Madonna of the Rosary* (Cingoli) is of 1539 and the Ancona altarpiece probably dates from 1538. The present painting belongs to the same group, and was probably painted *c.* 1535.

This work, of great chromatic intensity, shows St. Christopher between St. Roch and St. Sebastian. All three saints were invoked for protection against the intermittent outbreaks of plague in the Marche at this time; Lotto himself wrote in one of his Bergamasque letters that epidemics were common throughout Europe during these years. The promontory of land jutting into the sea behind the saints corresponds quite closely to the bay of Ancona seen from the north; it is almost a fragment of real landscape. Trevisani recently suggested that the painting was a copy, but the hypothesis is untenable – not even his quotation of Vasari's reference to the work as a *tavola* (literally a panel, while in fact the painting is on canvas) is valid, since *tavola* was often used instead of *dipinto*, or painting, in the sixteenth century.

P.Z.

PROVENANCE
Church of the Madonna, Loreto; 1834 Palazzo Apostolico, Loreto (Ricci 1834, II, pp. 93–94)

EXHIBITIONS
Ancona 1981, no. 78, p. 326 (Varese), with full bibliography

REFERENCES
Banti and Boschetto 1953, p. 87; Pallucchini and Canova 1975, no. 210; Zampetti 1953, p. 52; Trevisani 1981, p. 388

52
St. Christopher, St. Roch and St. Sebastian

275 × 232 cm
Signed: *Laurentii Loti pictoris opus*
Pinacoteca, Palazzo Apostolico, Loreto
[*repr. in colour on p. 95; detail on p. 94*]

Vasari said that Lotto painted this picture before he finally moved to Loreto: 'He went to the church of the Madonna of Loreto, for which he had already made a painting in oil, which is in a chapel on the right as one enters the church' (Vasari 1568). Ridolfi (1648) stated that it was sent by Lotto from Venice to Loreto. Since the work is not recorded in Lotto's *Libro di Spese*, the note-book he kept from 1538, it seems reasonable to assume that it was painted before this date. In 1535 the painter was in Jesi for a commission,

53
Virgin and Child Enthroned with St. Stephen, St. John the Evangelist, St. Matthias and St. Lawrence

294 × 216 cm
Signed: *Lorenzo Lotto*
Pinacoteca Civica, Ancona

According to Vasari (1568), this altarpiece was in the church of S. Agostino, Ancona. It probably dates from between 1535 and 1539, when Lotto was in the Marche painting the altarpieces at Fermo (1535) and Cingoli; it is with this last altarpiece that this Ancona painting has certain iconographic similarities. It was in Ancona in 1538 that Lotto wrote the first entry in his *Libro di Spese*, and it is possible that this work dates from that same year. This is a work of intense devotional fervour; the harsh,

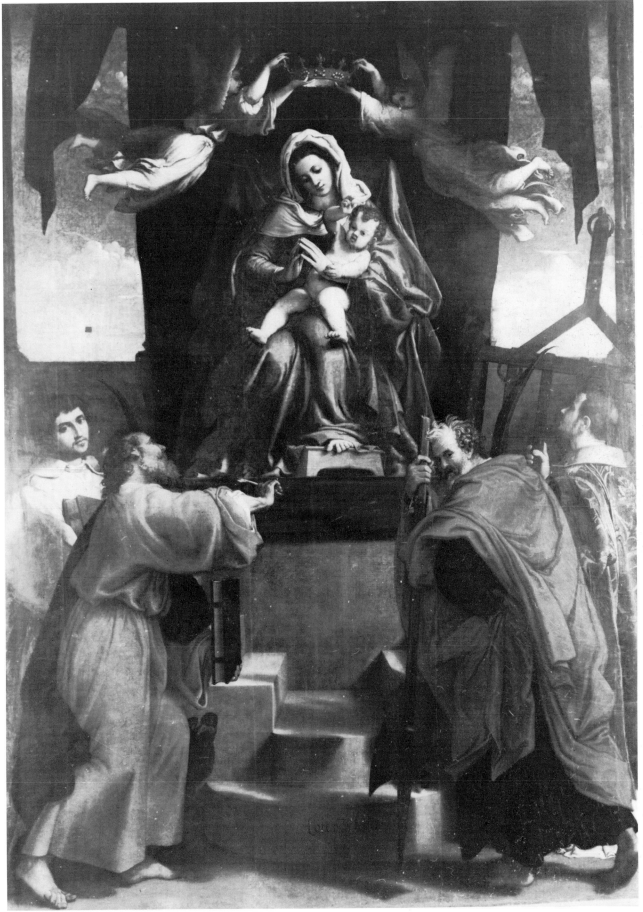

53

penetrating light coming from the left augments the sensation of restless spiritual tension. There is a preparatory drawing for the head of St. Matthias in the British Museum (Cat. D26).

P.Z.

PROVENANCE
S. Agostino, Ancona; in the nineteenth century the church was suppressed and the painting transferred to S. Maria della Piazza; late nineteenth century moved to the Pinacoteca Civica, Ancona; 1925 returned to S. Maria della Piazza; 1940 Palazzo Ducale, Urbino; 1950 Pinacoteca Civica

EXHIBITIONS
Ancona 1950, no. 66; Venice 1953, no. 93; Ancona 1981, no. 84, p. 336 (Zampetti), with full bibliography

REFERENCES
Banti and Boschetto 1953, p. 89; Canova 1975, p. 116; Caroli 1974, pp. 235–52; Zampetti 1953, p. 54

54
Portrait of Laura da Pola

91 × 76 cm
Pinacoteca di Brera, Milan
[repr. in colour on p. 93]

Lotto made the following note in his *Libro di Spese*: 'around the beginning of April 1543: Messer Febbo da Bressa, in Treviso, owes for two life-size half-length portraits of himself and of his lady, Madonna Laura da Pola'. The two portraits were finished in March 1544. The artist also noted that his work 'is worth, between good friends, 40 golden scudi in solid gold'; however, he had to make do with 30, 'and not all in ready money', although he also received 'a pair of large gilded peacocks', suggested in recompense by Messer Febbo. 'And so to keep my word I took as much as he offered.' (Zampetti 1969).

There is no positive proof, but it is generally accepted that the two Brera portraits can be identified as Febbo da Bressa and Laura da Pola, given that they are half-lengths, as Lotto states, and because stylistically they would seem to date from 1543–44. At that time Lotto had settled in Treviso, hoping he would be able to remain there, but in 1545 he left the city and returned to Venice because in Treviso 'I could not earn enough with my art to cover my expenses'. The fact that he had to accept what he considered to be inadequate payment is evidence of his financial difficulties.

Laura, a young woman, kneels at a *prie-dieu*. In her left hand she holds a small book and in her right a fan, which is attached to her belt by a chain. The splendour of her costume is to some extent moderated by her composed and thoughtful expression. Even if the colouring reflects Titian's art, the moral substance of the portrait is entirely Lotto's own. The sitter appears to be meditative and removed from reality. Berenson has rightly pointed out the close relationship between this portrait and the beggar woman, next to the veiled woman in profile, in *St. Anthony Distributing Alms* (SS. Giovanni e Paolo, Venice) of 1542.

P.Z.

PROVENANCE
Baslini Collection; 1860 acquired by the Pinacoteca di Brera

EXHIBITIONS
Venice 1953, no. 97

REFERENCES
Banti and Boschetto 1953, p. 90; Berenson 1955, p. 118; Caroli 1980, pp. 235–52; Pallucchini and Canova 1975, p. 118, no. 237; Zampetti 1953, with full bibliography; Zampetti 1969, p. 56

55
The Presentation of Christ in the Temple

172 × 136.5 cm
Pinacoteca, Palazzo Apostolico, Loreto

This is very probably Lotto's last work, painted in Loreto while he was a lay brother at the Santa Casa, not long before his death in 1556/57. This can be deduced from the fact that the work does not appear in a list of the paintings brought by Lotto from Venice, which were included in the sale he held in the Loggia dei Mercanti at Ancona in 1550. It was seen by Vasari (1568) in the Basilica at Loreto.

It is widely believed that the painting is partly unfinished, and that it owes its sketchiness and the congealed appearance of its dim, dull colours to its incomplete state. The composition is on two levels and derives from Lotto's drawing for *David and Goliath* for the intarsia of the choir stalls of S. Maria Maggiore, Bergamo; the artist obviously had this drawing with him since he noted that it was still present in the Ancona lottery. Subsequently it was lost.

Berenson described this painting as perhaps the most modern work by an Italian Old Master. Lotto, who had taken all his possessions to the shrine at Loreto and renounced his worldly goods and even his free will, perhaps wished to reflect the human condition in this work. Pignatti (1953) suggested that the old man at the open door high on the right might be a self-portrait. The old man acts as a witness to a life endured but enlightened by faith, which provides the only hope for wretched and suffering humanity, represented in the painting by the crowd of men and women gathered around the Christ Child – the symbol of faith, hope and human charity.

P.Z.

PROVENANCE
Santa Casa, Loreto; 1853 moved to the Palazzo Apostolico

EXHIBITIONS
Venice 1953, no. 108; Ancona 1981, no. 138, pp. 460–61 (Varese), with full bibliography

REFERENCES
Berenson 1905, pp. 235–36; Mascherpa 1980, p. 163; Pallucchini and Canova 1975, p. 10, no. 274; Pignatti 1953, p. 181; Zampetti 1953, pp. 38, 58; Zampetti 1980, p. 19

penitential themes, including the small *Christ at the Column* (Galleria Nazionale, Naples) and the *Christ Mourned* (Metropolitan Museum, New York). In his late style Moretto adopted a more controlled form of expression; here the grief-stricken figures are isolated from one another, but related directly to the spectator. The colours are restricted to a range of monochromatic silver-greys and dark browns illuminated by a single internal light source; to this Moretto has added a speckled reddish effect giving the impression that there is blood everywhere.

The sense of intense spiritual devotion in the painting was no doubt partly inspired by the devotional books available at the time – for example *L'Arte di ben pensare e contemplare la Passione* by Pietro da Lucca (Venice 1528) – but, above all, it can be related to *L'Arte dell'Unione*, an ascetic text by a Capuchin monk, Giovanni da Fano, printed in Brescia in 1536 (reprinted in 1548). In the text the union with Christ is set in a '*Palazzo*', and there is a description of a meeting between the bound Christ '*sputtacchiato, flagellato, coronato*' (spat upon, beaten, and crowned with thorns) and an attendant angel, who expresses '*gran fastidio . . . e malinconia*' (anguish and sorrow). The ascent of the staircase symbolises the purification of the soul. The painting embodies both ascetic and penitential themes and was originally in the Chapel of SS. Croci in the Cathedral, one of the most important chapels of the Brescian Confraternities. It is probable that the painting was intended to inspire the brothers in acts of piety.

V. G.

PROVENANCE
Duomo Vecchio, Brescia; Palazzo della Loggia, Brescia

EXHIBITIONS
Brescia 1878, no. 73; Paris 1935, no. 318; Brescia 1939, no. 100; Zurich 1948–49, no. 752

REFERENCES
Averoldo 1700, p. 54; Boselli 1954, pp. 111–12, 137; Bossaglia 1963, p. 1081; Carboni 1760, p. 136; Cassa Salvi 1966, no. 16; da Ponte 1898, p. 106; Faino 1961, p. 17; Freedberg 1975, p. 371; Gombosi 1943, pp. 58, 62–63, 99; Guazzoni 1981, pp. 52–53; Maccarinelli 1959, p. 77; Molmenti 1898, p. 84; Nicodemi 1927, p. 32; Paglia 1967, p. 280; Panazza 1959, p. 130; Venturi 1925–34, IX, iv, p. 134

Attributed to Moretto

60

Portrait of a Young Woman

101 × 82 cm
Kunsthistorisches Museum, Gemäldegalerie, Vienna (no. 1914)
[*repr. in colour on p. 98*]

The attribution of this portrait to Moretto has not been accepted universally, although it is the most convincing attempt so far to rescue the work from anonymity. The portrait was attributed to Paris Bordone by Engerth, perhaps on account of the similarity between the sitter and the woman in the *Two Lovers* (Cat. 17). Wickhoff cautiously ascribed the work to Bonifazio de'Pitati; Florigerio (Gamba) and Beccaruzzi (Berenson) have also

been suggested as the painter. Bernardini divined that the portrait was Brescian and ascribed it to Savoldo, and it has also been attributed to Lotto (Suida, Morassi, Benesch). Suida drew attention to certain stylistic characteristics typical of Lotto and Moretto. Baldass, followed by Wilde and Glück, attributed it to Moretto after restoration had revealed the high quality of the paintwork. This has subsequently been accepted by many art historians (A. Venturi, Gombosi, Fiocco, Gilbert, Heinemann).

Despite the distinctly Venetian colouring and the ample fullness of the figure, characteristics that are not apparent in his other portraits, there are elements which suggest that Moretto is, indeed, the author. Heinemann pointed out the use of a dry impasto, which is reminiscent of Moretto's technique. Beneath a subtle and delicate play of the shadows, the modelling of the face is compact and strongly defined, similar to that of some of Moretto's sure portraits, such as the *Fortunato Martinengo* (National Gallery, London). The treatment of the drapery, richly veined with highlights, is also Brescian, and the slightly abstract, contemplative mood is typical of Moretto, as is the landscape populated with ruins. This motif appears, in a similar though more elaborate manner, in Moroni's *St. Agnes* (Columbus, Ohio), which was painted when Moroni was still strongly influenced by his teacher Moretto.

The portrait can therefore be attributed to Moretto and probably dates from the 1540s, at which time Moretto was exposed to Venetian influence. The style of the woman's dress suggests a relatively late date and it is useful to compare it with that of a *Portrait of a Woman* by Licinio of 1540 (Pinacoteca Civica, Pavia). X-rays have revealed a pentimento around the neckline of her dress; originally it was far more modest.

V. G.

PROVENANCE
In the nineteenth century in the storerooms of the Imperial Gallery, Belvedere Palace, Vienna

EXHIBITIONS
London 1930, no. 419 (as Moretto); Brussels, Amsterdam, Paris 1947; Stockholm, Copenhagen 1948; London, United States of America 1949–52

REFERENCES
Baldass 1924, pp. 89–91; Benesch 1957, p. 412; Berenson 1905, p. 89; Bernardini 1911, p. 37; Boschetto 1963, p. 228; Boselli 1947, p. 299; Boselli 1948, p. 97; Boselli 1954, pp. 82–83, 132; Demus 1973, p. 29; Engerth 1884, p. 72, no. 94; Fiocco 1948, p. 331 (Vienna not Vicenza); Gamba 1924–25, p. 196; Gilbert 1955, II, p. 49; Glück 1928, pp. 475, 490; Gombosi 1943, pp. 35, 114; Gronau in Thieme-Becker 1931, p. 141; Morassi 1953, p. 296; Oberhammer, Klauner and Heinz 1965, p. 76, no. 579; Ruckelshausen 1975, p. 110; Schäffer, von Wartenegg and Dollmayr 1894, p. 51, no. 157; Suida 1932, p. 173; Tempestini 1977, pp. 81–82; Venturi 1925–34, IX, iv, pp. 185, 204; Vienna 1928, p. 138, no. 157; Wickhoff 1893, p. 136

Giovanni Battista Moroni

Albino (?) *c.* 1520–24 – Albino 1578

Moroni came from a landowning family of Albino, Val Seriana, and was probably born there around 1520–24. The son of an architect and stone mason, Francesco Moroni, it is likely that he was apprenticed to Moretto (Tassi) in 1532,

1550s. Mariscalchi also borrowed motifs from Bassano's works (from the *Madonna and Child* in Detroit, *The Assumption* at Asolo and the two paintings in Munich, which were painted for Rasai and Tomo, two towns near Feltre). In *The Adoration of the Shepherds* (Galleria Borghese, Rome), and *S. Giustina* (Cat. 7), Bassano seemed to suffer from a *horror vacui*, which directly influenced Mariscalchi. He was also influenced by De Mio, who came from Naples to paint two canvases in S. Maria in Vanzo, Padua. Mariscalchi emphasised the grotesque aspect of De Mio's style – for example, the disfigurement of the skin and the bent bodies of the shepherds – and in this way managed to create the disconcerting effect of a Neopolitan crib, with its blend of realism and folkloric fantasy, nature and artifice. Even the colours of the painting – subdued shades of violet, green, red and orange derived from Bassano – intensify this effect. The figures in the paintings for the predella and frame are ultimately derived from Schiavone; it was undoubtedly this that led Fiocco to believe there was a link between the two artists. The altarpiece would seem to date from a few years earlier than the small altarpiece now in the Getty Museum, Malibu, which is dated 1564.

V.S.

EXHIBITIONS
Venice 1946, no. 236; Feltre 1948; Venice 1981, no. 77

REFERENCES
Venice 1981, pp. 208–11 (Sgarbi), with full bibliography

Alessandro Bonvicino, called

Moretto

Brescia 1498 – Brescia 1554

Moretto probably trained either in Padua or Venice, but although this Venetian experience was fundamental for his art he did not forget his Lombard roots, particularly the sturdy realism of Vincenzo Foppa's art. Apart from rare visits to Bergamo, Milan and the Veneto, he spent most of his life in his native city, in a society devoted to the religious ideals of the Catholic Reformation. A prominent member of the Confraternity of the Sacrament and associated with Reformers such as Bishop Ugoni and St. Angela Merici, he carried out the wishes of his patrons, producing works with explicit doctrinal content (the cycle for the Chapel of the Sacrament in S. Giovanni, Brescia) and others specifically contemplative in mood (the *Coronation of the Virgin* in SS. Nazaro e Celso); in addition he painted religious subjects in everyday settings, anticipating Caravaggio in such works as the *Supper at Emmaus* (Pinacoteca Tosio Martinengo, Brescia) and *The Apparition of the Madonna* (the Sanctuary at Paitone).

The inner conflict present in Moretto's work, divided as it is between Venetian and Lombard influences and between classicism and realism, is due not to stylistic instability, but to a desire to conform to the varying needs of his religious patrons. After 1540, the leaders of the local Brescian church were increasingly influenced by the spirit of Tridentine reform and, in accordance with this, Moreto's work

assumed a new monumentality and austerity. This is exemplified in the organ shutters painted for the Seminary of Brescia and in the *Ecce Homo with an Angel* (Cat. 59).

V.G.

REFERENCES
Boselli 1954; da Ponte 1898; Gombosi 1943; Guazzoni 1981; Molmenti 1898

58

Portrait of a Man

87 × 81 cm
Metropolitan Museum of Art, New York, Rogers Fund 1928
[*repr. in colour on p. 99*]

Although most of Moretto's works are religious, he also produced a few very important portraits, which were fundamental for the development of Lombard portraiture and profoundly influenced Moroni at the start of his career.

This is an early work dating from before 1530: the relationship between the figure and the landscape beyond the curtain and the slight inclination of the man's head are reminiscent of the full-length *Portrait of a Man* of 1526 (National Gallery, London), and also of the so-called *Man Reading a Book* (Salvadego Collection, Brescia). The date of the painting is unknown, but its wide format is similar to that used by Moretto in other works dated between 1520 and 1525 (eg. the *Prophets* in S. Giovanni, Brescia).

The man has a pensive expression and his face is partly obscured by shadow; this is derived from Giorgione and is typical of Moretto. He used it to create a mood of psychological indecision and to emphasise the spiritual quality of the sitter, as Savoldo also did in his portraits. He is concerned both to convey the character of the sitter and to create a physical presence.

V.G.

PROVENANCE
Erizzo-Maffei Collection, Brescia; Marchese Ippolito Fassati Collection, Milan; Knoedler Gallery; 1928 acquired by the Metropolitan Museum (Rogers Fund)

REFERENCES
Berenson 1968, p. 278; Boselli 1943, p. 121; Burroughs 1928, p. 216; Crowe and Cavalcaselle 1912, p. 229; da Ponte 1898, pp. 76–77; Fenaroli 1875, pp. 15, 49; Fredericksen and Zeri 1972, p. 145; Gombosi 1943, pp. 34, 110; Gronau in Thieme-Becker, XXIII, 1931, p. 141; Venturi 1933, pl. 534; Wehle 1940, p. 160

59

Ecce Homo with an Angel

209 × 125 cm
Pinacoteca Tosio Martinengo, Brescia (no. 71)
[*repr. in colour on p. 100*]

It is generally agreed that this painting dates from the latter part of Moretto's career, between 1550 and 1554. During this period he produced other works with similar

of his to be found in churches throughout the city and beyond, together with those in private houses'. His style in the 1570s is exemplified by *The Feast of Herod* (Gemäldegalerie, Dresden), dated 1576. Some paintings previously accepted as the work of Mariscalchi – the *Sacra Conversazione* (ex-Menegoni Coll., Rome, present whereabouts unknown), the *Holy Family* (Ca d'Oro, Venice) and the *Sedico Altarpiece* – can now be attributed to a certain Gerolamo da Belluno, who, like Mariscalchi, trained under Schiavone.

V.S.

REFERENCES
Venice 1981, p. 208 (Sgarbi)

56

Portrait of Dr Zaccaria dal Pozzo

119.5 × 105 cm
Inscribed upper left: ANNO AETATIS SUAE/CII
Museo Civico, Feltre

This portrait was first attributed to Giorgione. Cavalcaselle suggested Pordenone; Berenson proposed Jacopo Bassano. Finally Fiocco, together with Fogolari, recognised it to be by Mariscalchi. Zaccaria dal Pozzo died in 1561, aged 102, and the portrait is obviously commemorative, which makes it possible to deduce the date of the picture. His features are similar to those in portraits by the Bassano brothers – closer to those by Leandro than those by Jacopo – and with a slight hint of Domenico Tintoretto.

Mariscalchi's originality lies in his predominant use of monchromatic colour, a greyish-yellow which is modified gradually from the background to the silk tunic of the figure, the folds of the drapery emphasised by luminous highlights. This painterly toning is derived from Schiavone, in particular from the *St. Peter and St. Paul* on the inside of the organ shutters for S. Pietro, Belluno dating from a few years earlier (see Cat. 92, 93). The slightly senile, if stern, expression of Zaccaria dal Pozzo is reminiscent of Lotto's portraits. Cavalcaselle noted, 'An attractive and lively figure – with a penetrating look – he doesn't look 102.' He also remarked on the fluidity of the paintwork and noticed the touches of red paint (now worn away) on the neutral colour of the gloves.

V.S.

PROVENANCE
Dei Collection; 1845 transferred to the Bishop's Seminary, Feltre; 1924 Museo Civico

EXHIBITIONS
Venice 1946, no. 235; Lausanne 1947, no. 63 (Pallucchini); Feltre 1948

REFERENCES
Arslan 1931, p. 343; Berenson 1899, p. 84; Berenson 1958, p. 114; Biasuz 1948, p. 16; Cavalcaselle (MS) 1866, fig. 12; Fiocco 1929, p. 212; Fiocco 1934, p. 20; Fiocco 1947, pp. 98, 100, 107; Fiocco 1949¹, p. 162; Fogolari 1929, p. 28; Gaggia 1930, p. 134; Gaggia 1933, p. 460; Pallucchini 1946, p. 145; Pallucchini 1948, p. 172; Thieme-Becker 1930, p. 86; Valcanover 1954, p. 43; Venice 1981, p. 208 (Sgarbi); A. Venturi 1925–34, IX, vii, p. 141

56

57

The Adoration of the Shepherds (Madonna della Misericordia)

187 × 113 cm
Inscribed: PET. S. DE/MARISCH. . .VICTORIS/FILIUS P
Feltre Cathedral
[*repr. in colour on p. 119*]

This large altarpiece was painted for the church of Sant'Anna, Feltre. It was commissioned by the Grafini and Zugni families, and their coats-of-arms are included in the lower part of the painting. All components of the altarpiece are still extant. The central painting is surrounded by 16 smaller scenes, all set in an elaborate wooden frame: at the top is *God the Father*, just below *The Birth of the Virgin*, in the spandrels two *Angels* and on the column bases *The Annunciation*; *St. Peter*, *St. Paul*, *St. Sebastian* and *St. Roch* are on the inner sides, and on the predella are scenes from the life of the Virgin.

The large central painting is known as the *Madonna della Misericordia*, perhaps because, in the second half of the sixteenth century, records of episcopal visitations refer to the altar (which is dedicated to Sant'Anna) as that of the 'Blessed Virgin of the Misericordia'. In fact, the subject of the main scene is the Adoration of the Shepherds, although it is somewhat incongruously set around a great marble throne on a circular base. This choice of composition, which culminates in the group of small angels who are supporting a green curtain, creates a sensation of tumultuous movement, verging on an almost oppressive confusion paralleled only in Bassano's work of the late

55

Pietro de Mariscalchi

Feltre *c.* 1520–Feltre 1589

Mariscalchi was trained in the circle of Schiavone, as is evident from the signed *Madonna and Saints* (ex-Agosti Collection, Treviso) and the *Farra Altarpiece*, documented between 1545–47. Before 1550 his style was somewhat dull and uninspired, but in the 1550s he moved closer to Bassano, as, for example, in *The Mystic Marriage of St. Catherine* (Museo Civico, Feltre) and the *Madonna and Child with St. Peter and St. Paul* (Arcipretale, Mel).

Thereafter Mariscalchi appears to have been influenced by the more radical Venetian mannerists, in particular

Giovanni de Mio. He must have known the two altarpieces by Bassano (now in Munich), which were originally in Rasai and Tomo, near Feltre. There is a stylistic advance in the *St. John the Baptist* (Feltre Cathedral), the *Portrait of Dr Zaccaria dal Pozzo* (Cat. 56) of 1560–61 and *The Adoration of the Shepherds* (*Madonna della Misericordia*) (Cat. 57), which also belongs to this period. Its predella is similar to the small altarpiece (ex-Chrysler Coll., now Getty Museum, Malibu), which is signed and dated 1564. During this period Mariscalchi enjoyed his greatest success and he received several important public commissions: according to Cambruzzi, the historian of Feltre writing before 1681, 'in 1563 he was a flourishing artist among the painters of Feltre ... this is evident from the many beautiful paintings

when his father was working in Brescia. Moroni stayed with his master again in 1543, and, even after he set up independently may have worked in collaboration with Moretto, possibly as his partner. After 1561 Moroni settled permanently in Albino. Stylistically he acts as a link between Bergamo, where Lotto worked for many years, and Brescia, which was the most avant-garde artistic centre in the Veneto, where Savoldo, Romanino and Moretto were active.

Sixteenth-century Brescian painting was fundamentally different from Venetian painting; it was rooted in the naturalistic tradition of Foppa and one of its characteristics was the use of harsh light effects. Brescian and Bergamasque painters were sympathetic both to Giorgione's innovations, particularly his technique of painting 'senza disegno' (without drawing; Vasari), and to northern painting. They also developed an empirical approach to art and attempted to achieve accurate optical and tonal effects which anticipate seventeenth-century painting, particularly that of Caravaggio. The objectivity of Moroni's early portraits stems from both this Brescian tradition and from northern art, which he could have seen at Trent, where he worked during the first two sessions of the Council for the Madruzzo family, of which the Prince-Bishop was a member.

Moroni was certainly one of the greatest portrait painters of the century. His portraits are usually divided into three groups: the early 'red' period, which lasted until c. 1560, characterised by a somewhat harsh northern realism; the 'brown' period, when a Venetian technique was combined with the influence of Spanish art and mores; and, finally, the 'grey' period in which he displayed a profound psychological understanding of his sitters and reflected the ethical values of the Counter-Reformation (Portrait of a Youth [dated 1567], Accademia Carrara, Bergamo; Portrait of Gian Girolamo Albani [Cat. 66]).

Although primarily a portrait painter, Moroni also produced religious works for Trent, Bergamo, and Albino; often both the composition and individual figures are based on works by Moretto. In these paintings his difficulty in devising compositions for narrative subjects is evident, but they share the intensity of colour and lighting of his portraits and, in fact, his sacred figures sometimes have the characteristics of portraits. At one stage he was influenced by Cremonese mannerism (eg. the Parre altarpiece of 1564–67 and Cat. 67), but the religious works dating from towards the end of his career epitomise the spirit of the post-Tridentine church in their intense expression of emotion and austere grey tonality.

M.G.

61
Portrait of Gian Lodovico Madruzzo

202.6 × 116.9 cm
The Art Institute of Chicago, Charles H. and Mary F. S. Worcester Collection (inv. no. 29.912)
[repr. in colour on p. 102]

This portrait and its pendant, Gian Federico Madruzzo (National Gallery of Art, Washington), together with Titian's Portrait of Cristoforo Madruzzo (Cat. 125), were all in the Castello Buonconsiglio, Trent, until 1658–59. In 1900 Moroni's two portraits were attributed to Titian. Oberziner identified the two young men by Moroni as Gian Lodovico and Gian Federico Madruzzo, nephews of Cristoforo Madruzzo; in 1859 Perini had identified the bishop and ascribed the two other paintings to Moroni. The three portraits approximate to each other in several ways, including their measurements. The identity of Gian Lodovico Madruzzo is confirmed by the similarity of his features with those on a medal (Kunsthistorisches Museum, Vienna) portraying him while still a youth, probably on the occasion of his nomination in 1549 as Assistant in the Bishop's residence at Trent.

Whilst the dating of the Portrait of Cristoforo Madruzzo is debatable – 1542 or 1552 (the later date being more probable) – the two Moroni portraits would fit between 1548 and 1552. They are stylistically close to the religious works Moroni painted in Trent (the artist had been called to the city probably by the Madruzzo family): the Annunciation originally in the Church of the Clarisse, dated 1548, and the Virgin in Glory with the Infant Christ and Four Fathers of the Church with St. John the Evangelist in S. Maria Maggiore (which, according to the documents recently discovered by Chini, dates from 1551–52). The Portrait of a Gentleman dated 1553 (Honolulu) and the Portrait of a Knight of 1554 (Ambrosiana, Milan) appear to be more mature stylistically.

The two portraits of the Madruzzos may have been painted in 1551–52 when Moroni was commissioned to execute the altarpiece in S. Maria Maggiore, Trent. Like Titian's Portrait of Cristoforo Madruzzo, they are conceived as full-length state portraits and are very different from the Brescian tradition, although Moretto had produced one earlier full-length portrait, the Portrait of a Knight of 1526 (National Gallery, London). Moroni was probably aware of northern traditions of portraits and would have been able to see some examples while he was in Trent between 1548 and 1552. These were the years of the first sessions of the Council of Trent – in which Cristoforo Madruzzo acted as one of the foremost mediators between the Church and the reformers. Moroni's interest in northern portraiture (in the early 1550s there were several portraits in Italy by Anthonis Mor) must be seen in this framework, which also explains the difference between his portraiture and contemporary Venetian portraits at that time.

In contrast to Titian's Portrait of Cristoforo Madruzzo, Moroni viewed the sitter with an objective clarity which seems to depend on the tradition of Holbein; there is little idealisation in the sharp and sober treatment. This was probably also inspired by the ideas of Erasmus, which were current in northern Italy at that time and influenced Moretto. The neutral grey background of Moroni's portraits, which emphasises their painterly qualities, and the perfect toning owe much to the example of Savoldo and Moretto.

M.G.

PROVENANCE

1658–59 Castello del Buonconsiglio, Trent; Madruzzo family; after 1681 taken from Charlotte of Lenoncourt, daughter of Ferdinando Madruzzo; 1682 in the house of the Roccabruna family, Via S. Trinita, Trent; 1735 passed by inheritance to the Gaudenti della Torre family; 1833 in the collection of Baron Isidoro Salvadori; 1906 James Stillman (Paris and New York); 1921–26 on loan to the Metropolitan Museum, New York; 3 February 1927, Stillman sale, New York (lot 27); Charles H. Worcester, on loan to The Art Institute, Chicago; 1930 donated to The Art Institute

EXHIBITIONS

Paris 1909; Chicago 1933, no. 129; Chicago 1934, no. 50; Dayton 1948, no. 12; Minneapolis 1952, no. 3; Bergamo 1979, no. 8

REFERENCES

Gregori 1979, pp. 251–53, no. 92, with full bibliography

62

Portrait of Gian Gerolamo Grumelli
'Il Cavaliere in Rosa'

216 × 123 cm
Signed and dated on the small stone in the foreground: M.D.LX. / JO. BAP. MORONUS; inscribed on the base of the imitation relief under the niche: MAS EL ÇAGUERO QUE EL PRIMERO
Count Antonio Moroni Collection, Bergamo
[repr. in colour on p. 105]

It is probable that this portrait is one of those recorded by Angelini (1720) in the Grumelli collection, and it was certainly mentioned by the historian Tassi, who referred to it as 'a marvellous full-length portrait of a man in Spanish dress'. The elegant gentleman is Gian Gerolamo Grumelli who, after losing his first wife, Maria Secco d'Aragona di Calcio, married Isotta Brembati in 1561; her portrait, still in the same collection, was for many years considered to be the pendant of this one. However, the two works were originally of different sizes and 11 centimetres has been added to the top of Isotta's portrait.

The Grumelli family owned holdings in Albino; possibly this could explain their patronage of Moroni. The family had ties with both the Church and Spain; in 1562 they were invested with the title of Counts of the Sacred Palace by Pope Pius IV and in 1574 Gian Gerolamo was chosen to accompany Cardinal Carlo Borromeo during his visit to the Bergamasque diocese. Grumelli undertook numerous public engagements throughout his life, and his interest in the arts was demonstrated in 1591, when he prevented a painting by Lotto being removed from S. Bernardino, Bergamo.

The elegant silhouette of the figure and the beauty of his costume is paralleled in portraits of Philip II and his dignitaries painted by Anthonis Mor and Titian, although this portrait, with its sumptuous red, is far more colourful. Both the style of the dress and the Spanish motto emphasise the Bergamasque nobility's passionate espousal of the Imperial Spanish cause following the Treaty of Cateau–Cambrésis of 1559, which set the seal on the Spanish domination of Italy. The strength of the Spanish influence is evident in other works by Moroni, including portraits of Spaniards like that of the Duke of Alburquerque (Berlin) dating from 1560.

It is possible that the red colour of Grumelli's attire had

a symbolic or heraldic significance; examples of this were quoted by Saxl (1938). The motto can be read 'more the last than first': originally incorrectly interpreted as an allusion to Grumelli's second marriage, which in fact took place a year after the date on the inscription; it is surely a declaration of humility, perhaps related also to the scene on the bas-relief of Elijah's ascent into heaven in a chariot of fire and the donation of his cloak to Elisha; but the precise significance remains obscure. Other symbolic elements in the painting, probably suggested to the artist by Grumelli – who like his wife Isotta Brembati, wrote poetry – are the broken statue representing the decay and vanity of earthly things and the ivy symbolising, in contrast, the constant and eternal quality of love, probably in this case that of marriage.

This famous portrait dates from Moroni's so-called 'red' period when his portraits were most sumptuous and in the Venetian idiom, in reaction to the earlier phase of his work in which realistic northern elements were more evident, as in the Portrait of Gian Lodovico Madruzzo (Cat. 61).

M.G.

PROVENANCE

1793 Casa Grumelli, Bergamo; 1794–1808 Count Moroni, Stezzano; 1824 Count Moroni, Bergamo

EXHIBITIONS

Bergamo 1870; Bergamo 1875, no. 107 or 108; Paris 1935, no. 323; Zurich 1948–49, no. 756; Milan 1953, no. 11; Bergamo 1979, no. 29

REFERENCES

Gregori 1979, pp. 100, 106, 237, with full bibliography; Saxl 1938

63

Portrait of a Man
with Two Children
'The Widower'

126 × 98 cm
On the letter: Al . . . Sng(?), and at the bottom 'Alb . . .' (Albino)
National Gallery of Ireland, Dublin (no. 105)
[repr. in colour on p. 106]

For years this painting was believed to be a self-portrait; it is certain that the family – a father (not necessarily a widower) and his two children – lived in Albino. Stylistically the painting can be dated c. 1563–65 (Lendorff), when Moroni was living in his home town. This dating is also confirmed by the costumes.

This is one of the earliest portraits in which Moroni adopted the tone of rigorous morality advocated by the Council of Trent. Here he shows more concern for portraying the inner spirituality of the figures than their physical appearance. This penetrating realism is also present in some of Moroni's important late works: the Portrait of Bernardo Spini (Accademia Carrara, Bergamo) and the Portrait of a Youth (National Gallery of Canada, Ottawa). It becomes even more apparent if we contrast the present portrait with the earlier Portrait of Amilcare Anguissola with his Children Minerva and Asdrubale by

Sofonisba Anguissola of 1559 (Hage Collection, Nivaagaard), which, in its more relaxed and informal atmosphere has affinities with Moroni's youthful style. It should be noted in this connection that the painting exhibited here has been attributed by Cock (1915) and Kunnel-Kunze (1962) to Sofonisba.

M.G.

PROVENANCE

Sir J. Hawley; 14 May 1858 Christie's sale; 1866 acquired in London

EXHIBITIONS

London 1884, no. 159; Dublin 1964, no. 37; London 1978, no. 9

REFERENCES

Gregori 1979, pp. 255–56, no. 99, with full bibliography

64

'Titian's Schoolmaster'

97 × 74 cm
National Gallery of Art, Washington D.C. (no. 641),
Widener Collection

For a long time this portrait was attributed to Titian, and in the eighteenth century it was called the *Portrait of Titian's Schoolmaster*. Neither its provenance nor the date at which it entered the Borghese Collection are known, but it is tempting to suggest that this painting, together with the other Titians now in the Galleria Borghese, Rome, was one of 71 canvases sold to Scipione Borghese by Cardinal Paolo Emilio Sfondrati in 1608.

When Anthony Van Dyck made a sketch of the work in 1622–23, he accompanied it with a reference to Titian, but he did not indicate exactly where the portrait was exhibited in the Borghese collections. Other references to the painting suggest that it was not in the villa built by Scipione Borghese outside the Porta Pinciana during the first half of the seventeenth century. Bellori (1664), writing after most of Cardinal Borghese's collection was transferred to the palace in Campo Marzio, ascribed the painting to Titian, together with the *Sacred and Profane Love*, and the attribution reappeared in subsequent inventories of the collection. J. Richardson Junior and other travellers are known to have admired the work greatly. The great collector Conte Giacomo Carrara of Bergamo was the first to ascribe it to Moroni, writing in a letter to Giovanni Bottari of 7 October 1766; Bottari and Tassi welcomed this attribution and the former added it to his notes on Vasari's *Lives of the Artists*. One of the first works by Moroni in an English collection, the painting was on show in Stafford House throughout the nineteenth century, and it was Waagen's favourite painting in the collection.

The portrait probably dates from the late 1560s, close to the *Portrait of a Lawyer* (National Gallery, London). It is one of Moroni's masterpieces of psychological penetration and objectivity, and the sitter, who is seated on a wooden 'Dante' chair, is portrayed in a remarkably unaffected pose. Moroni's use of light makes the figure stand out clearly against the background and the hands seem to be painted

64

from life. This unconventional portrait foreshadows the style of Caravaggio and Velázquez. It was much admired and several old copies exist.

M.G.

PROVENANCE

1622–23 Borghese Collection, Rome; 1664 in the Palazzo Borghese, Campo Marzio; by 18 March 1800 acquired by Mr Durand (and Robert Fagan?) from Marcantonio Borghese; W. Buchanan; 1810, first Marquess of Stafford, London; about 1908 Duveen, New York; 1909 P. A. B. Widener, Philadelphia; 1915 J. E. Widener, Elkins Park, Lynnewood Hall; 1940 National Gallery of Art, Washington D.C.

EXHIBITIONS

London 1818, no. 76; London 1871, no. 14; London 1893, no. 120

REFERENCES

Gregori 1979, pp. 111, 114, 312–14, no. 210, with full bibliography; Shapley 1979, pp. 339–40, no. 641

65

Portrait of an Old Man with a Book

98 × 80 cm
Pinacoteca dell'Accademia Carrara, Bergamo
[*repr. in colour on p. 107*]

This portrait, together with the *Portrait of a Young Man* dated 1567 (formerly in the Lochis Collection) is amongst the most important of Moroni's works in the Accademia

Carrara. In 1864 Charles Eastlake correctly likened it to the so-called 'Titian's Schoolmaster' (Cat. 64) then in the Duke of Sutherland's collection. The composition of both portraits, derived from prototypes by Titian and Anthonis Mor, is almost identical; this work is probably slightly later than the Washington picture and can perhaps be dated after 1575. Moroni's mastery of portraiture is evident here; he subtly probes the personality of his sitter whilst depicting him naturally. The hands are a striking example of his painting directly from life.

There has been some confusion between this portrait and another in the same gallery (no. 93), and it has been wrongly stated that this portrait came from Casa Bettami and then belonged to the Ospedale Maggiore, who donated it to the gallery. According to the present writer, however, the portrait exhibited here is more likely to be the *Portrait of an Old Man Seated in a Chair* sold to Count Moroni by Giuseppe Seradebati of Albino, who was probably a descendant of Giovan Luigi and Giovan Battista Seradobati, the notaries with whom Moroni was in frequent contact during the latter years of his life when he was living in his home town. If this is the case, the sitter can probably be identified with one of the notaries, more probably Giovan Battista, who is mentioned in documents concerning Moroni between 1565 and 1574.

M.G.

PROVENANCE
24 November 1758 bought by Giacomo Carrara in Bergamo for 220 lire; bequeathed to the Accademia Carrara (founded by Giacomo Carrara).

EXHIBITIONS
Milan 1953, no. 26; Bergamo 1979, no. 81

REFERENCES
Gregori 1979, pp. 112, 229–30, with full bibliography

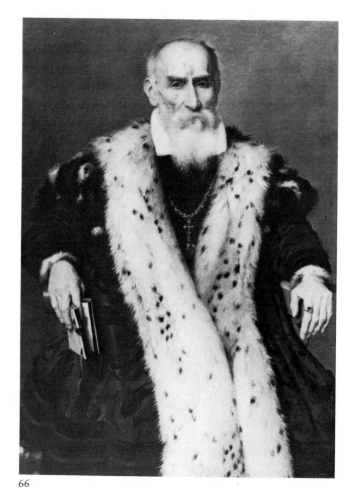

66

66

Portrait of Gian Gerolamo Albani

107 × 75 cm
Private Collection, Italy

Tassi related that a member of the Albani family who visited Titian was told by the great artist to go to Moroni in Bergamo to have his portrait painted, just as he also suggested that the Governors of the Venetian Republic, who were going to Bergamo, should see Moroni if they wanted 'a true and natural likeness' painted of themselves. Tassi believed the portrait mentioned in the story to be the one in Giuseppe Albani's home at that time, which he described so exactly that we can be certain it was the painting exhibited here. By the eighteenth century the painting had passed from the Albani to the Roncalli family; Charles Eastlake saw the work in their house in 1855 and 1857, when he offered to buy it. From the nineteenth century it has been considered one of the most important works of Moroni's so-called 'grey' period, dating from 1565–70 (Berenson, Lendorff, Longhi). Previtali's recent

suggestion that the painting dates from the 1590s and that it must be the work of Giovan Paolo Cavagna is untenable. Alternative attributions must be dismissed, given its high quality.

Previtali's hypothesis that the old man may be identified as the sitter in the 1560 portrait (Pinacoteca Tosio Martinengo, Brescia, no. 147) is also untenable. While it is true that both figures have a growth on their foreheads, they are not in the same place; it is also probable that the lipoma would have grown considerably during the intervening years. The present writer would like to propose that the sitter is Gian Gerolamo Albani, the most eminent member of the Albani family in the cinquecento. Born in 1509 and related by his marriage to Laura Longhi to the Marcello and Gradenigo families of Venice, he was created a *cavaliere aurato* by the Venetian government in 1529, and from 1555 held the office of the *Generale Collaterale* of the Republic. Rossi cites a three-quarter-length portrait of Albani dressed in the uniform of an officer of the Auxiliary Territorial troops, which would seem to correspond with the dress of the sitter in our painting: the lynx cape, the chain, the knight's cross and the medal of the Lion of St. Mark.

Gian Gerolamo Albani was accused of involvement in the murder of Achille Brembati who was assassinated by one of Albani's sons, and in 1563 was condemned to five years exile on the island of Lesina. He was stripped of his office of *Generale Collaterale*, but retained his knighthood. In

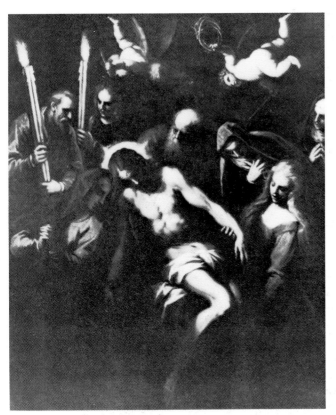

71

provocative paintings of blond women, sometimes half-length and sometimes reclining nudes (Royal Collection; Fitzwilliam, Cambridge; London, Dresden and Vienna). He also painted portraits and was the author of a large history painting, the *Sea Storm* (*c.* 1527–28, Scuola Grande di San Marco, Venice), which was highly praised by Vasari. While conservative in his compositions, he was quick to follow Titian in his adoption, in the 1520s, of a heroic treatment of the draped human figure. His works are marked by opulent colour, high finish and pale shadows, sunlit landscapes and a monumental, sedate figure style.

P.B.R.

REFERENCES

Ballarin 1965; Crowe and Cavalcaselle 1912; Fornoni 1886; Gombosi 1932; Gombosi 1937; Ludwig 1903; Mariacher 1968, with bibliography; Mariacher 1975; Spahn 1932

EXHIBITIONS
Reggio Emilia 1955, pp. 20–21

REFERENCES
Ciampi 1960, p. 10; Quintavalle 1957, pp. 136, 142; Ivanoff and Zampetti 1979, p. 552, no. 170, with full bibliography; Piccinini 1931, p. 83

Jacopo Palma il Vecchio

Serina (Bergamo) 1480(?) – Venice 1528

Nothing is known of Palma Vecchio before 1510, when he is first documented in Venice. His earliest extant paintings (1510–12) suggest that he may have trained there under Andrea Previtali, a fellow Bergamasque. During his short career, spent mainly in Venice, Palma Vecchio executed several altarpieces for Venetian churches, including two masterpieces: the *Polyptych of St. Barbara* for S. Maria Formosa (1522–24) and the *Adoration of the Magi* for Sant'Elena (1525–26; owned by the Brera, Milan). He also painted works for churches in the Veneto (Zerman and Vicenza) and in the valleys near Bergamo (Peghera, Serina, Zogno and Gerosa). The majority of his paintings, however, were for private clients and are now dispersed among museums and private collections.

Palma Vecchio specialised in two genres: first, the wide-format *sacre conversazioni* (in Venice, Naples, Vienna and Lugano), which created a market that was inherited by Bonifazio de' Pitati; and second, idealised and often

72*

Virgin and Child with St. Michael, St. Dorothea, Mary Magdalene and St. Joseph

102.5 × 109.5 cm
Národni Galerie, Prague (no. 194)

This is one of the finest of Palma's early *sacre conversazioni* and can be dated *c.* 1514. The crowded three-quarter-length composition derives ultimately from Giovanni Bellini's Madonnas. Compared to Palma's earlier *sacre conversazioni*, such as the *Madonna and Saints* in the Pinacoteca dei Concordi, Rovigo (no. 95), the harmonious group of the Madonna and standing Child has been perfected. The infant's awkwardness is gone, and visually he extends the movement towards the left initiated by the Virgin's knees, while the Virgin herself arches slightly to the right. She puts the gentle weight of her whole body into supporting the infant Christ and this gives her a ponderous energy that sets the other figures in motion. Mary Magdalene bends her head towards the Virgin's, as does St. Joseph, but the arching folds of his sleeve and the heavy weight of his book seem to swing his body in the other direction. St. Michael has the lively turning posture made fashionable in Venetian painting of the 1510s by pictures such as the *Cristo Portacroce* (Scuola di S. Rocco, Venice) and *The Three Ages of Man* (Palazzo Pitti, Florence).

The elderly bearded saint has been variously identified as Mark, Jerome and Peter. In an *Adoration of the Shepherds* by Palma of the same date (Zogno, Bergamo), St. Joseph appears in the same robes and with identical facial features, and this may therefore be the correct identification, which has already been suggested by Novotny (1960). This painting must have enjoyed considerable fame in the sixteenth and seventeenth centuries since there exists an unusually large number of early copies.

P.B.R.

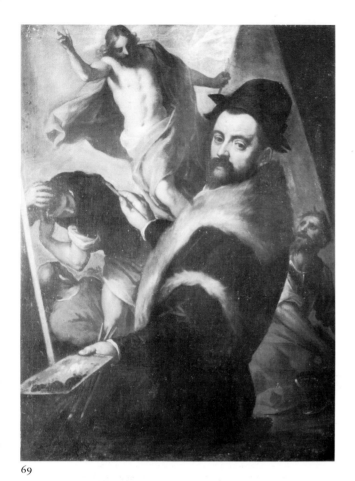

69

REFERENCES
Foscari 1933, p. 256; Ivanoff and Zampetti 1979, pp. 542–43, no. 105;
Mongeri 1872, p. 349; Pallucchini 1981, p. 34; Valcanover 1956, pp. 40–41;
Venturi 1925–34, IX, vii, p. 237

70

Portrait of a Collector
(Bartolomeo della Nave?)

118 × 103 cm
City Museum and Art Gallery, Birmingham (inv. P. 48.61)
[*repr. in colour on p. 139*]

In 1962 the painting was attributed to Annibale Carracci, and it was tentatively suggested that it might be a self-portrait of the Bolognese painter. In fact it is an autograph work by Palma Giovane, as guessed by Volpe (1962), who suggested this was a portrait of the sculptor Alessandro Vittoria, and dated it 1580. It has also been attributed to Sebastian Casser, a German pupil of Tintoretto, by whom we have only one mediocre painting, a *St. George and the Dragon* in S. Giorgio Maggiore, Venice (Cannon-Brookes 1970).

The identification of the sitter remains uncertain; Vittoria's appearance is well known and he can be excluded. The present writer believes this could be a portrait of a collector in his *Studio d'Anticaglie* (antiquarian's study) – referred to by Scamozzi in the *Idea*

Dell'Architettura (Venice 1615) – and that, more specifically, it could be a portrait of Bartolomeo della Nave, a friend of Palma Giovane who had, according to Scamozzi, 'gathered together almost 30 statuettes . . . and terracotta models, including the fine *St. Sebastian* by Vittoria, and . . . placed them in one of his rooms which he proudly shows to all the important people of Venice'. The diagonal thrust of the composition draws the eye from the collector in the foreground to the *St. Sebastian* on the left, which is identical to the bronze statuette of *St. Sebastian* leaning against a tree by Alessandro Vittoria (Cat. s37).

The delicate impasto, the warm, glowing sensation created by the predominance of violet and black, the use of chiaroscuro and the diagonal construction of the composition suggest that the painting probably dates from the end of the sixteenth century.

S.M.R.

PROVENANCE
Viscount Allendale; 30 June 1961 Christie's London sale, attributed to
Annibale Carracci (lot 73); Julius Weitzner; 1961 acquired by the City
Museum and Art Gallery, Birmingham

EXHIBITIONS
London 1962, p. 109 (Nicolson); London 1970, no. 10 (Cannon-Brookes)

REFERENCES
Ivanoff and Zampetti 1979, pp. 530–31; Mason Rinaldi 1977, pp. 96–99,
with full bibliography; Pallucchini 1981, p. 34; Volpe 1962, p. 111

71

Pietà

128 × 106 cm
Museo Civico, Reggio Emilia

This is a *modelletto*, with some variations, for the signed altarpiece by Palma Giovane in the cathedral at Reggio Emilia. The altarpiece, which can be dated *c.* 1612, was painted for the family chapel built on the orders of the Contessa Ruggeri Brami. Its date can be deduced from a letter written to the artist by the poet Rodolfo Arlotti at the time the painting was commissioned. The letter is undated, but mentions Palma's altarpiece of San Giacinto, which, it states, was finished four years earlier. As Arlotti died in 1613 and Palma did not receive any Emilian commissions before 1607, it is possible to date the altarpiece and the *modelletto* to 1612.

Palma Giovane painted this subject several times. This version conforms to Counter-Reformation taste and would have been much appreciated by his patrons. In the *modelletto* the scene is depicted at night, the two torches on the right being the only source of light. The bold chiaroscuro emphasises the drama of the subject and differs from the finished painting. The lighting intensifies the colours, especially the brilliant reds of the Magdalen and the Virgin, so that the angels appear to emerge from the darkness, and their hands and faces, together with the instruments of the Passion, illuminate the pale body of Christ, which is the spiritual and structural fulcrum of the composition.

S.M.R.

del Piombo painted in Rome (though unlike Moroni's, his Christ wears a white gown), by Moretto (Accademia Carrara, Bergamo) and by Romanino (Pinacoteca Tosio Martinengo, Brescia; Cat. 83). Calì has observed that the paintings of Christ carrying the cross were inspired in this period by such texts as the *De imitatione Christi* attributed to Thomas à Kempis and the *Beneficio di Cristo*. Such mystical literature and the spiritual writings of Erasmus had a profound effect on religious images intended to inspire contemplation through a personal identification with Christ.

The emotional effect of the image is strengthened by the intense, shimmering treatment of the flesh and drapery, which seems to anticipate the art of seventeenth-century painters. Even the deserted landscape emphasises the highly emotional and meditative character of the work. There is a parallel development after 1560 in the work of Barocci, although he reached similar solutions through very different means and in the context of a different artistic tradition.

M.G.

PROVENANCE
1793 S. Rocco, Albino; 1816 Parish church of San Giuliano, Albino

EXHIBITIONS
Bergamo 1920, no. 25; Bergamo 1979, no. 59

REFERENCES
Calì 1980, p. 18; Gregori 1979, pp. 221–22, no. 6, with full bibliography

Jacopo Palma il Giovane

Venice c. 1548 – Venice 1628

Jacopo Palma il Giovane, the great-nephew of Palma Vecchio, was born in 1548 (Rosand 1970), not – as previously thought – in 1544, but his early training is still a matter of speculation. Guidobaldo, Duke of Urbino, admired the young artist's talents whilst he was in Venice in 1564 and introduced him into a new circle of patrons. During a long sojourn in central Italy, first in Pesaro and then from 1567 in Rome, where he stayed for some eight years (Borghini 1584, Baglione 1642, Ridolfi 1648), Palma must have studied antique art as well as that of Michelangelo and the late mannerists, in particular the Zuccaris. The *Portrait of Matteo da Lecce* (Pierpont Morgan Library, New York), the only surviving work of this period, shows these influences.

Returning to Venice, Palma Giovane quickly established himself, and around 1578 he was commissioned to paint three scenes in the Sala del Maggior Consiglio in the Doge's Palace; they included *Venice Crowned by Victory*, which shows some of the qualities that were to make him the most prominent artist of his generation. For a brief period he was influenced by Titian, but he soon developed an artistic language of his own that incorporated various other influences, including those of Veronese and, above all, Tintoretto. Palma Giovane was the foremost Venetian artist of his day, sometimes capable of great sensitivity in the rendering of naturalistic elements, but more often utilising some of the more conventional mannerist formulae. He was the favourite painter of the Counter-Reformation clergy since his works were easily understood and dramatically effective, and also of the Venetian government, for whom he refurbished the Doge's Palace. Palma Giovane was extremely prolific, but over the years his style lost its originality, and by the end of his career it can at best be described as dull late mannerism.

S.M.R.

REFERENCES
Mason Rinaldi 1983, forthcoming publication; Rosand 1970, p. 149

69

Self-portrait

128 × 96 cm
Pinacoteca di Brera, Milan (inv. no. 109)

Although the dominant theme of Palma Giovane's vast *oeuvre* is that of the human figure, he rarely painted portraits and probably never saw himself as a professional portrait painter. From the scant collection of people he did paint, we can assume that most of his portraits were done for friends rather than as official commissions. Nevertheless, the portraits of his family and friends that Jacopo loved to insert amongst the onlookers in his historical and religious works, and his drawings of those in his immediate circle, are rendered with a particularly affectionate naturalism. Unlike his Venetian contemporaries, who continued to produce portraits based on those by Tintoretto, Jacopo's unaffected simplicity in characterising sitters and his ability to create contact between the figure and the outside world are far closer to Annibale Carracci.

This *Self-portrait* has a specifically calculated meaning: it is intended to demonstrate Palma Giovane's high social standing as the foremost painter of his day. Turning towards the spectator, the artist is adding the last touches to a painting of the Resurrection; his hat is tilted back and his black tunic is trimmed with fur. The figures around him are positioned in such a way that they create a halo effect. The artist appears to be about 40 years old, which would suggest an approximate date of 1590 for the work. This dating can be substantiated by comparing the treatment of the facial features with those of the figures in the paintings of the Crociferi, while in composition and painterly style the portrait resembles the ceiling of the sacristy of the church of the Gesuiti in Venice.

Palma Giovane's two other self-portraits (Querini Stampalia, Venice; Uffizi, Florence), which date from the early seventeenth century, are very different in style. The artist's face, wrinkled and with bags under the eyes, stands out against a plain background and reflects a disillusioned spirit, no longer the exuberant optimism of this earlier *Self-portrait*.

S.M.R.

PROVENANCE
Napoleonic inventory no. 445; 29 April 1911 presented by the State to the Brera

EXHIBITIONS
Warsaw 1956; Venice 1959, no. 1, pp. 3–4 (Mariacher); Venice 1981, no. 82, p. 222 (Mason Rinaldi), with full bibliography

1568 he left Lesina and went to Rome where, on 17 May 1570, he was ordained Cardinal.

Stylistically this portrait is close to *The Tailor* (National Gallery, London), which suggests that it dates from just before 1570 (Lendorff). Despite the realistic depiction of the lipoma and the pensive expression, the head is painted in a less intense manner than the hands, which are highlighted with exceptional clarity and may suggest that Moroni did not paint this portrait directly from life, but took the features from another portrait of the same man, as has been proved in the case of the *Portrait of Giovanni Bressani* (National Gallery of Scotland, Edinburgh).

M.G.

PROVENANCE
1720 Dr. Albani, Bergamo; before 1793 inherited by the Roncalli family, Bergamo

EXHIBITIONS
Bergamo 1870; Bergamo 1875, no. 19; Paris 1935, no. 324; Zurich 1948–49, no. 750; Milan 1953, no. 20; Albino 1968, no. 1; Bergamo 1979, no. 48

REFERENCES
Gregori 1979, pp. 113, 299–300, no. 183, with full bibliography; Gregori 1982, p. 91; Previtali 1981, pp. 22, 24–31, 51, 62–64

67

The Mystic Marriage of St. Catherine

228 × 147 cm
Signed on the base of the throne:
IO:BAP: MORONUS. P.
Inscribed on the scroll: VENISTI CATERINA UT DESPONDERERIS IMMORTALI SPONSO / CHRISTO
Parish church, Almenno San Bartolomeo
[*repr. in colour on p. 101*]

This painting is directly inspired by Moretto's *Rovelli Altarpiece* of 1539 (Pinacoteca Tosio Martinengo, Brescia), while the asymmetrical composition with the Madonna placed on a high podium is derived in both paintings from Titian's *Pesaro Altarpiece* (Frari, Venice). But these borrowings do not detract from the beauty of the work. The painting is more mannerist than Moretto's; this impression is augmented by the tension created by the architectural elements, the intellectualised use of lighting and the spiritual intensity expressed by the Virgin and St. Catherine. The unusual depiction of the haloes suspended in space augments the mystic sense and the poetry of the scene; the motif was used by Moretto in his altarpiece in Sant'Andrea, Bergamo.

M.G.

PROVENANCE
1668–70 recorded by Calvi in the chapel of St. Catherine; now in the second chapel on the right

EXHIBITIONS
Bergamo 1920, no. 21; Bergamo 1979, no. 57

REFERENCES
Gregori 1979, p. 223, no. 9, with full bibliography

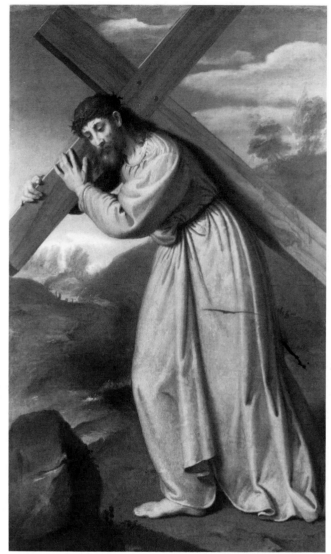

68

68

Christ Carrying the Cross

182 × 115 cm
Parish church of San Giuliano in Albino, Bergamo; on deposit at the Santuario della Madonna del Pianto

This painting was first mentioned by Francesco Maria Tassi, who saw it in S. Rocco, Albino. In 1816 it was transferred to the parish church of San Giuliano and from there it was moved to its present location. It is one of the religious paintings executed by Moroni for his home town Albino, where he is recorded in documents between 1555 and 1557 and where he probably lived from 1561 to 1578. For many years this work was attributed to Moretto, but Tarchiani (1920) re-ascribed it to Moroni. A stylistic analysis of the painting suggests that it belongs to the very last years of the artist's life, certainly no earlier than 1565.

The subject of Christ carrying the cross became popular in the sixteenth century; there are examples by Sebastiano

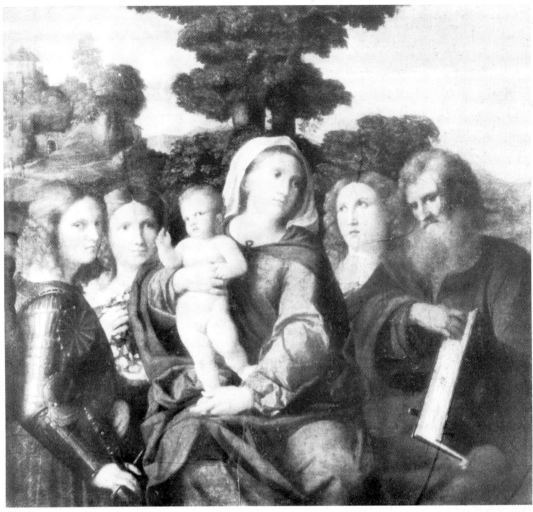

72

PROVENANCE
1635 Duke of Buckingham; from the early eighteenth century in Prague
(inventories of 1685, 1718 and 1738); 1922 passed from Prague Castle to
the Národni Galerie

REFERENCES
Berenson 1932, p. 410; Gombosi 1937, p. 12; Mariacher 1968, p. 52;
Novotny 1960, no. 125; Puppi 1962², p. 153

73
Sacra Conversazione

105 × 136 cm
Oil on canvas, transferred from panel
Baron Thyssen-Bornemisza Collection, Lugano

The donor in this painting was identified as a member of
the Priuli family in the will of Marina Priuli made in 1656;
it is likely that he was Francesco q. Zuane Priuli who was
the great-great-grandfather of Marina Priuli's husband and
also, according to Francesco Sansovino, Palma Vecchio's
patron. Francesco Priuli was appointed a Procurator in

1522, and since the donor wears black, rather than the
purple garments that were the privilege of a procurator,
1522 can be taken as a *terminus ante quem* for the painting.
Stylistically this is, in any case, a relatively early work of
c. 1518. St. Catherine, for example, shares the puffy,
boneless hands and the sharply-lit sleeve folds of the Mary
Magdalene in the Uffizi *Rest on the Flight into Egypt*
(*c.* 1514), while the Virgin recalls the work of Andrea
Previtali in her facial type, her robes and even her gesture.

Yet the energy of the composition and the strong impulse
of all the figures to lean towards each other show us, for
the first time, the fully developed idiom of Palma's *sacre
conversazioni*. Mary Magdalene and John the Baptist are
posed like Averroes and Pythagoras in Raphael's *School of
Athens*. St. John, with his dipped shoulder and thrusting
neck, draws on the more innovative elements in previous
works, such as a drawing of the *Adoration of the Shepherds*
(Uffizi, Florence; Rearick 1976, pp. 71–2) and a half-length
Sacra Conversazione (Gemäldegalerie, Dresden, no. 188).
The saints are crowded in two shallow planes, slightly
before and slightly behind the Virgin, while the landscape
is of minor importance.

P.B.R.

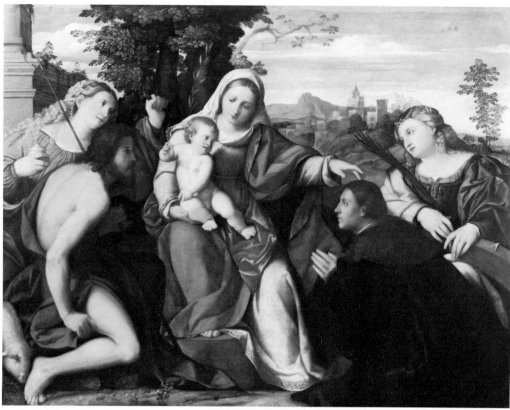

73

PROVENANCE
1520s collection of Procurator Francesco Priuli at S. Severo, Venice; 1656 Palazzo Priuli at S. Polo, Venice; 1661 bequest of N. D. Marina Priuli to the Council of Ten; Sale d'Armi, Doge's Palace, Venice; after 1808 Prince Eugène Beauharnais, Villa Pisani, Strà; Duke of Leuchtenberg collection, no. 67, St. Petersburg and Schloss Seeon, Chiemsee, Oberbayern; 1935 acquired by Baron Thyssen-Bornemisza

EXHIBITIONS
Stockholm 1962–63, no. 84

REFERENCES
Berenson 1957, I, p. 124; Boschini 1664, p. 31; Crowe and Cavalcaselle 1871, II, p. 472; Freedberg 1971, pp. 106, 221, 481–83; Gombosi 1937, pp. 26–27; R. Heinemann 1958, pp. 81–82; Hendy 1964, pp. 89–90; Mariacher 1968, p. 68; Mariacher 1975, pp. 196, 207–08, 234; Neoustroieff 1903, pp. 342–44; Sansovino 1581, p. 143a; Spahn 1932, pp. 68–70, 142–43; Zanetti 1771, pp. 206–07

74
Nymph in a Landscape

112 × 186 cm
Staatliche Kunstsammlungen Gemäldegalerie, Dresden (no. 190)
[repr. in colour on p. 66]

The attribution of this painting to Palma Vecchio has never been questioned. He painted several such pictures, called traditionally 'Venus' but referred to sometimes quite simply as 'donne nude'.

In this case the composition and the pose are based on Giorgione's *Venus*, also in Dresden; Palma most likely knew the latter painting, which then belonged to Gerolamo

Marcello, since a *Lady with a Lute* (see Cat. 75) was in the same collection. Palma, however, has omitted any of Venus's attributes and purged the painting of the poetic elements that were an essential component of Giorgione's picture. By awakening the girl, raising the broader planes of her body towards the spectator and removing her hand from its modest act of concealment, Palma has given the picture a more prosaic tone. Indeed, the painting has the novel feature that the drapery beside the naked girl is not just a sheet or wrap, but her chemise, which she has just removed.

This painting seems to have been the inspiration for a *Cleopatra* (Rijksmuseum, Amsterdam) by Jan van Scorel, who visited Venice in 1520. Palma's picture was probably painted very shortly before this. It is even possible that it was seen by Scorel in the collection of Francesco Zio, who owned a *Nymph* by Palma in 1521, as well as a *Drowning of Pharaoh* by Scorel. The landscape may have been repainted, perhaps by a seventeenth-century northern artist.

P.B.R.

PROVENANCE
1521 collection of Francesco Zio, Venice(?); 1532 collection of Andrea Odoni, Venice(?); 1728 acquired for the Saxon Electoral Collections through the dealers Lorenzo Rossi and Kindermann

EXHIBITIONS
Dresden 1968², pl. 53

REFERENCES
Berenson 1957, I, p. 123; Crowe and Cavalcaselle 1871, II, pp. 474–75; Dresden 1860, pp. 51–52; Dresden 1968², p. 79; Gombosi 1937, p. 61; Hubner 1880, p. 133; Ludwig 1903, p. 77, note 10; Mariacher 1968, p. 76; Morelli 1800, p. 70; Spahn 1932, pp. 91, 162

75

Lady with a Lute

97 × 71 cm
His Grace the Duke of Northumberland KG, PC, GCVO, TD, FRS
(no. 575)
[repr. in colour on p. 64]

When the painting was acquired by the Duke of Northumberland in 1857 it was attributed to Giorgione. Crowe and Cavalcaselle's re-attribution to Palma Vecchio in 1871 has, however, never been disputed.

Among Palma's extant paintings this corresponds most closely to one seen by Marcantonio Michiel in the collection of Gerolamo Marcello in 1525: 'La tela della donna insino al cinto, che tiene in la mano destra el liuto e la sinistra sotto la testa, fu de Iacomo Palma.' ('A canvas of a woman, waist length, who holds in her right hand a lute, and has her left hand under her head, by Jacopo Palma.') The hands are reversed in the painting exhibited here, which may suggest that Marcello's painting was a simple variant, or vice-versa. This would be typical of Palma's approach to the genre. The girl, for example, re-appears in a near-identical pose, without the lute, in Palma's so-called *Three Sisters* (Gemäldegalerie, Dresden, no. 189). The somewhat fortuitous placement of the lute and the curious fact that the girl leans her head on her hand without making any apparent impression on her hair, suggests that this painting is a re-use of a previous composition with only partially integrated variations. Half-length paintings of women are one of the most characteristic themes of Palma's *oeuvre*. It is most likely that they are not portraits as such, but generalised and idealising images of female beauty in the same spirit as the Petrarchan sonnets and the treatises on women that were fashionable in Venice in the sixteenth century.

The free, even ample, disposition of the *Lady with a Lute* across the picture surface suggests that she was painted in the early 1520s.

P.B.R.

PROVENANCE
Before 1800 collection of Gerolamo Manfrin, Venice; 1857 acquired by the Duke of Northumberland

EXHIBITIONS
London 1915, no. 62; London 1939, no. 22; London 1950–51, no. 215; Manchester 1957, no. 65

REFERENCES
Berenson 1932, p. 408; Berenson 1957, I, p. 123; Crowe and Cavalcaselle 1871, II, p. 481; Freedberg 1971, p. 495, note 22; Frizzoni 1884, p. 170; Gombosi 1937, pp. 84, 137; Manfrin Collection 1856, no. 262; Mariacher 1968, p. 90; Mariacher 1975, p. 206; Morelli 1800, p. 66; Pallucchini 1951, p. 219; Spahn 1932, pp. 53, 131

76

Mars, Venus and Cupid

91.4 × 137.2 cm
Private collection, England;
on loan to Southampton City Art Gallery
[repr. in colour on p. 67]

First published by Borenius in 1939, this painting has been either overlooked or undervalued by subsequent scholars. Although it is not identifiable with any picture described as the work of Palma Vecchio before 1892, there can be no doubt that it is an autograph work of high quality.

Given the presence of Cupid and the armour behind the man, the protagonists must be Mars and Venus. The God-like apparition in the sky to which Venus is pointing is hard to identify, for Apollo, who in most versions of the myth spied on the adulterous couple and reported their liaison to Venus's husband Vulcan, is usually depicted in a sunburst or chariot; this figure may be holding a scroll, for the object seems too wide to be identified as the magic aphrodisiac girdle used by Venus to attract lovers. Palma illustrated a similar situation in a *Rape of Ganymede*, in which he included the figure of the jealous Juno in the clouds witnessing Jove's infidelity (Sansovino 1663). The painting may be intended as a warning against adultery, for Venus has deflected Cupid's arrow and is fully dressed. She may be alerting Mars to the danger of the heavenly scandal that could result from their affair.

The composition derives from Titian's *Three Ages of Man* (Duke of Sutherland's collection, on loan to the National Gallery of Scotland, Edinburgh); Mars resembles the young man in that picture in both expression and posture, while Cupid is close to the same character in Palma's *Venus* (Fitzwilliam Museum, Cambridge), which is usually dated c. 1520–25.

J.F.; P.R.H.

PROVENANCE
Collection of F. R. Leyland; 28 May 1892 acquired by 'Prinsep', Christie's, London sale; 1939 collection of A. T. Bulkeley Gavin; private collection; currently on loan to Southampton City Art Gallery

REFERENCES
Berenson 1957, I, p. 124; Borenius 1939, pp. 141–42; Mariacher 1968, p. 101; Sansovino 1663, p. 378

77

Nymphs Bathing

77.5 × 124 cm
Oil on canvas, transferred from oak panel
Kunsthistorisches Museum, Gemäldegalerie, Vienna
(inv. no. 6803)
[repr. in colour on p. 67]

This painting, which illustrates the purely sensual element in Palma's work, seems to have introduced a new theme into Venetian painting. That the girls are classical nymphs is suggested by the distant arrival of satyrs. It is not clear that any narrative, such as the story of Diana and Callisto proposed by certain critics, is involved. In 1637 the painting was described simply but accurately as, 'A bath with 14 figures washing themselves at a fountain in a faire landskip . . .' Titian may have been referring to a similar painting when he wrote to Federigo Gonzaga in 1530 promising 'Le Donne del Bagno' (Panofsky 1969).

A clue to Palma's intention, however, rests in the studied diversity of the poses of the girls, who are seen from before and behind, standing, sitting and lying. Vasari, in the

proemio of the 1568 edition of his *Lives of the Artists*, described a picture by Giorgione which rivalled sculpture by offering several views of the human figure in a single picture. In any case, Palma's quest for variations on the theme of the nude led him virtually to eclecticism. Among his 'borrowings' from Rosso Fiorentino, Domenico Campagnola and classical art, perhaps the most complete is the derivation of the seated girl behind the reclining Venus-like figure from a print by Marcantonio Raimondi of *Pan and Syrinx* (after Giulio Romano, Bartsch no. 325). The advanced secularity of this painting, Palma's assurance (despite the fragmentary composition), his acceptance of non-Venetian models and his tendency in certain details, such as the coiffures, to adopt a mannered elegance and refinement, suggest a date in the late 1520s.

P.B.R.

PROVENANCE
c. 1637 Collection of Bartolomeo della Nave, Venice, no. A.55; collection of 1st Duke of Hamilton, England; collection of Archduke Leopold Wilhelm, Brussels; 1662 bequeathed to Emperor Leopold I of Austria; Stallburg, Vienna; 1781 Château de Pozsony, Bratislava; 1784 Château de Buda; 1849 Hofburg, Vienna; Belvedere, Vienna; 1930 transferred to Kunsthistorisches Museum

EXHIBITIONS
Los Angeles 1979, no. 14

REFERENCES
Berenson 1957, I, p. 127; Demus 1973, p. 129; Freedberg 1971, p. 222; Garas 1967², pp. 67, 70, 76; Garas 1969, p. 118; Gombosi 1937, p. 101; Mariacher 1968, p. 77; Panofsky 1969, p. 97, note 18; Spahn 1932, pp. 197–98; Teniers 1660, pl. 206; Waterhouse 1952, p. 16; Wilde 1930, pp. 248–49

Giovanni Antonio de'Sacchis, called

Pordenone

Pordenone *c.*1484 – Ferrara 1539

De' Sacchis was probably trained in Pordenone, where the foremost painters were Gianfrancesco da Tolmezzo and Pellegrino da San Daniele. Among his early works are the frescoed triptych in the parish church of Valeriano, signed and dated 1506, and the fresco cycle in S. Lorenzo in Vacile, which shows the influence of Mantegna, Carpaccio and Bellini. The *Madonna della Misericordia* in the Cathedral at Pordenone (1515–16) is the most Giorgionesque of his works, while the influence of Roman painting is evident in the Malchiostro chapel in the cathedral at Treviso (1520) and in the frescoes of 1520–22 in Cremona Cathedral. These are violently expressive in character, drawing on elements borrowed from northern painting and motifs taken from the schools of Tuscany and Rome, particularly the work of Michelangelo. These frescoes earned him the epithet '*pictor modernus*'. Returning to Friuli, he painted the organ shutters in Spilimbergo Cathedral (1523–24).

Towards the end of the 1520s Pordenone went to Venice, where he frescoed the choir of S. Rocco (1528–29), also decorating the doors of a silver cupboard there with figures of St. Martin and St. Christopher in radically foreshortened, dynamic poses. While working on the extensive decorative schemes in S. Maria di Campagna, Piacenza (1530–32), and in the Franciscan church at Cortemaggiore (*c.* 1529), he

would have been able to study the work of Parmigianino and Correggio at first hand.

Pordenone worked chiefly in fresco and decorated many palaces, particularly their façades; sadly most of these decorations have disappeared, and are known only through drawings (eg. Palazzo Doria, Genoa; Palazzo Tinghi at Udine and Palazzo d'Anna, Venice [Cat. D43]). As the protégé of the influential Jacopo Soranzo he was commissioned to paint in the Doge's Palace, and in the 1530s he was Titian's principal rival, sometimes competing with him for work for churches and confraternities (see Cat. D40). His most famous works include the frescoes in the cloister of S. Stefano (*c.* 1532), the vault decoration of the Scuola di S. Francesco (now divided between the Budapest Museum of Fine Art and the National Gallery, London) and the altarpieces for S. Maria dell'Orto, S. Giovanni Elemosinario (*c.* 1535; Cat. 78) and S. Maria degli Angeli at Murano (1537–38). Pordenone died in Ferrara in 1539, where he had been summoned by Ercole II d'Este to design tapestry cartoons.

C.F.

78

St. Sebastian, St. Roch and St. Catherine

173 × 115 cm
Inscribed: IO¹ˢANT¹¹POR
S. Giovanni Elemosinario, Venice

Vasari said that this painting was made in competition with Titian's *St. John Distributing Alms*, and both works still hang in S. Giovanni Elemosinario. But Titian's altarpiece is usually dated 1545–50 (Wethey 1969), while Pordenone's is more likely to date from the mid-1530s as a comparison with the altarpiece of San Marco of 1533–35 in Pordenone Cathedral suggests. The figure of St. Sebastian in the Pordenone altarpiece re-appears in the painting shown here, in reverse and with a few alterations. Moreover, the position of the arms and head of the same saint are close to those of the prophet Habbakuk in the cupola of S. Maria di Campagna, Piacenza, of 1530–32. Boschini also attributed to Pordenone the cupola decoration of the church of S. Giovanni Elemosinario which no longer exists. A drawing of *St. Augustine* (Royal Library, Windsor) has been linked to this decoration (Friedlaender 1965), but it may also be related to the fresco of the same subject at Piacenza.

Although the rich colour is purely Venetian and the dynamic rhythm of the composition is typical of the artist, the ecstatic pose of St. Catherine and the sinuous arching of the naked figure of St. Sebastian, with its elongated proportions and small head, suggest that Pordenone was influenced by Parmigianino and Perino del Vaga, whose work he probably studied while in Genoa and Emilia. The composition is completely dislocated and the figures have no psychological relationship to each other; they are compressed within a space devoid of perspectival framework. Features of this and other works executed by Pordenone in Venice during the late 1530s and alien to the local tradition were influential in developing the mannerist traits in younger artists like Tintoretto and Bassano.

C.F.

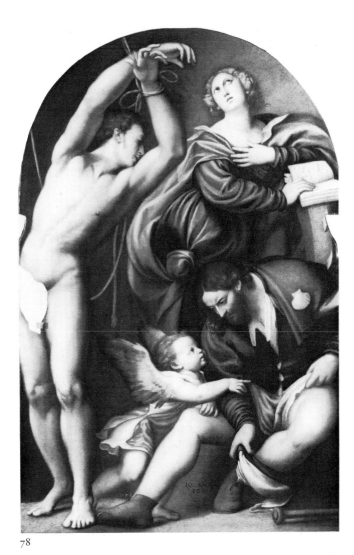

78

Ludovico Toeput, called

Pozzoserrato

Antwerp or Malines *c.* 1550 – Treviso 1603/05

Ludovico Toeput was probably born in Antwerp around
1550; it is thought that he was trained in the studio of
Martin de Vos (Menegazzi 1957). In the late 1570s he went
to Italy. It is assumed that he was in Florence during the
reign of Francesco I de' Medici because there are exact
quotations from a painting by Pontormo in his *Autumn*
(Národni Gallerie, Prague; Ballarin 1969), and a drawing of
the *Ruins of the Coliseum* (Albertina, Vienna), dated 1581,
proves he was in Rome in that year. In 1582 he settled in

Treviso, where he Italianised his name to Pozzoserrato.

His work combines the Netherlandish landscape
tradition with contemporary Venetian styles. In his early
paintings he is close to Tintoretto (eg. the *Saletta dei Rettori*
in the Monte di Pietà, Treviso), but subsequently he was
influenced by Veronese and his school, as can be seen in his
frescoes in the abbot's rooms at Praglia and the Villa
Chiericati-Mugna, Longa di Schiavon. Pozzoserrato
produced some altarpieces and portraits, but he specialised
in landscapes, in which he achieved an extraordinarily
delicate style in his last years. The *Fall of Phaeton* of 1599
(Niedersächsische Landesgalerie, Hanover) illustrates his
personal style, which Ridolfi analysed so well: 'He
delighted in painting distant objects, pleasing the eye with
the haziness of the air strewn with orange and vermilion
clouds, with the burgeoning dawn, the rising sun, and
sometimes rain, whirlwinds and storms.'

E.M.

REFERENCES
Ballarin 1969, p. 62; Menegazzi 1957, p. 175; Ridolfi 1648, II, p. 86

79

The Fire in the Doge's Palace in 1577

61.5 × 96.5 cm
Inscribed at left on the first step: TOE
Museo Civico, Treviso (inv. P.473)

This painting, considered by the present writer to be the
first work produced in Italy by Pozzoserrato, is probably the
prototype for Hoefnagel's engraving of the same subject,
dated 1578. But Mason Rinaldi suggested that Hoefnagel
made the engraving having been an eyewitness to the event,
and that Pozzoserrato's painting was dependent on the
print.

There are some differences between the print and the
painting, most of them due to the different formats: the
print is vertical and the painting horizontal. Pozzoserrato
expands the scene to the left to include the detail of the
scaffolding set against Sansovino's Library, which was still
being built. The subdued colouring may be due to the
impact of Venetian artists, particularly Tintoretto, although
Pozzoserrato's paintings for the Monte di Pietà in Treviso,
produced soon afterwards, show a return to the northern
landscape tradition. However, Pozzoserrato's characteristic
method of representing views 'as if seen through the wrong
end of a telescope' (Mason Rinaldi) is already evident here.
He achieves a remarkable sense of depth: the clock and the
distant buildings appear almost hazy. The work can
probably be identified with a painting in the house of the
artist Ascanio Spineda at Treviso, described by Ridolfi as
'the conflagration in the Doge's palace in Venice, in which
can be seen the converging of the workforce from the
Arsenal, in an attempt to extinguish the fire'.

E.M.

79

Casotti or the *Baglioni Madonna* (both in the Accademia Carrara), although Previtali never absorbed Lotto's fantastic imagination or his deep moral unease. His awareness of Lotto's work resulted in a more immediate understanding of the concrete and the familiar, in both his perception of the essential nature of his sitters and the painting of everyday objects. In 1525 Lotto employed him to outline his designs for the *tarsie* in S. Maria Maggiore, Bergamo, but by that time Previtali was already moving towards the soft, warm colours of Palma and Cariani (*St. Benedict Altarpiece*, 1524, Bergamo Cathedral; the *Mystic Marriage of St. Catherine* [Cat. 80]). He died of the plague in 1528.

F.R.

REFERENCES
Rossi 1980, p. 75

EXHIBITIONS
London 1975, no. 277, pp. 155–56 (Fairbairn); Venice 1980, no. 64 (Piva)

REFERENCES
Howard 1975, p. 25; Lorenzetti 1926, p. 416; Menegazzi 1957, p. 175; Menegazzi 1963, p. 257; Ridolfi 1648, II, p. 86; Venice 1981, p. 243 (Mason Rinaldi); Zugni Tauro 1978, p. 255

Andrea Previtali

Berbenno (?) *c.* 1480 – Bergamo 1528

Andrea Previtali, or Cordeliaghi as he signed himself in his youth, was probably born in Berbenno, in the Val Imagna. He was one of the Bergamasque artists who emigrated to Venice in the late fifteenth century (Rossi 1980). Like the Santacroce he joined Giovanni Bellini's workshop, and his youthful works – sometimes signed *dissipulus Joannis Bellini* (*Virgin and Donor*, 1502, Museo Civico, Padua; *Virgin and Two Saints*, 1506, Accademia Carrara, Bergamo) – are clear and serene variations on Bellini's style: the models and composition are somewhat stereotyped, but balanced and chromatically elaborate. This phase ended around 1505.

Previtali's later works are closer to Cima da Conegliano (*The Annunciation*, S. Maria del Meschio, Vittorio Veneto) and early Giorgione (*Tales of Damon and Thyrsis*, National Gallery, London, no. 4884). In 1512, Previtali was in Bergamo, perhaps called there by the Casotti family, who commissioned him to paint the lunettes of the Villa La Zogna (1512), the *Transfiguration* (1513; formerly in S. Maria delle Grazie, now in the Brera, Milan), the *St. John the Baptist with Saints* (1515, S. Spirito) and the *Madonna Casotti* (Accademia Carrara, Bergamo). He arrived there almost at the same time as Lotto, just as Venetian rule was being consolidated and at a time of Bergamasque cultural revival. His first Bergamasque works, (*St. Sigismund*, 1512, S. Maria del Conventino; *St. John the Baptist and Saints*, 1515, S. Spirito; *Trinity*, 1517, Almenno S. Salvatore; *St. Ursula and Companions*, formerly in S. Agostino, and the *Berbenno Polyptych*, both Accademia Carrara, Bergamo), show the impact of local Lombard realism and an emphasis on the religious significance of the image. Lotto's influence is apparent only later, in such works as the *Madonna*

80

The Mystic Marriage of St. Catherine, with St. Roch, St. Joseph, St. John the Evangelist and St. Francis

Lunette, 166 × 305 cm
Pinacoteca dell' Accademia Carrara, Bergamo (no. 112)

The fact that the group of saints was painted to be seen from below is very marked: originally the painting must have been placed high up, either as the uppermost section of a large altarpiece (Zampetti 1975) or, more probably, as the lunette above an altar, presumably in a Bergamasque church. The painting was described at length by Tassi, who attributed it to Cariani and suggested that St. John was a self-portrait, and it was still ascribed to Cariani while it was in the collection of Count Giacomo Carrara (Pallucchini and Rossi 1983). This attribution is illuminating: only the Bellinesque central group belongs to Previtali's normal repertoire and bears direct comparison with works such as *The Adoration of the Magi* of 1518 (Madonna dei Campi, Stezzano) or the lunette of a *Virgin with Saints* (S. Maria Maggiore, Bergamo). Lotto's influence is very strong, particularly in the pose of St. Roch, the devotional fervour of St. Francis and the pathos permeating the whole group (Zampetti 1975).

The influence of Cariani is evident in the composition, which is built up of diagonally intersecting blocks, while the warmer colour range is derived directly from Palma (Rossi 1981). These qualities should be compared to Previtali's work in his late Bergamasque period: the *St. Benedict* (1524 Bergamo Cathedral) and the *Pentecost* (Accademia Carrara, Bergamo), both painted after Lotto had left the city, when the work of Cariani, and of Palma Vecchio in the Val Seriana, was establishing a new style.

F.R.

PROVENANCE
1796 collection of Count Giacomo Carrara

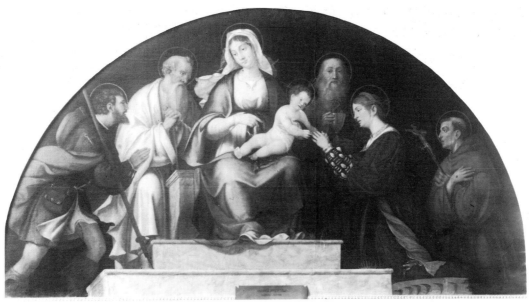

80

REFERENCES

Crowe and Cavalcaselle 1912, I, p. 285; Heinemann 1962, p. 137,
no. S 304; Meyer zur Capellen 1972, p. 73, no. 192; Pallucchini and Rossi
1983, forthcoming publication; Rossi 1979, p. 147; Rossi 1981; Tassi 1793,
I, p. 34; Zampetti 1975, p. 129, no. 12

Girolamo Romanino

Brescia 1484/87 (?) – Brescia 1562

Romanino was trained in the tradition of Foppa and Bramantino, but early in his career (c. 1508–12) he assimilated the lessons of Giorgione, Titian and Dürer.

Romanino's most Venetian paintings, full of shimmering reflected highlights and brilliant colours, date from 1513 onwards. The influence of his friend Melone, and of Lotto, is evident in the frescoes at Cremona Cathedral and the paintings in S. Giovanni, Brescia (1521–24). These works display a distinct originality in approach and composition, a skilful use of light and colour and a decisive manner of drawing. Romanino was the most Venetian of the Brescian painters and the precursor of the move away from Titian's style (Longhi). He next came into contact with Moretto, but this influence was already over by 1532, when he was painting at Trent, his work there displaying an overt sensuality and realism.

The impact of northern painting and of Pordenone is apparent in Romanino's frescoes at Pisogne, Breno and Bienno. These works are relatively free in style, possibly due to the less exacting requirements of his patrons; his combination of the Lombard realism with a Venetian use of colour is sometimes reminiscent of Gothic painting and sometimes almost proto-baroque.

Romanino's last phase began in 1540: by this time the exuberant and impulsive quality of his earlier works had been tempered into a form of mannerism, sometimes dull, occasionally full of life, and he produced a series of paintings with complex compositional schemes and strongly modelled figures in which skilful lighting effects heightened the sense of drama. He collaborated with his son-in-law Lattanzio Gambara, who was an associate of the Campi brothers of Cremona. This Cremona Brescia school co-existed alongside the more famous, realistic school of Brescia and Bergamo to which Foppa, Moretto, Moroni, and later Caravaggio belonged.

G.P.

81

Virgin and Child Crowned by Two Angels

152 × 110.8 cm
Pia Opera Congrèga della Carità Apostolica, Brescia
[repr. in colour on p. 96]

The Madonna sits enthroned with the Infant Christ standing on her knee in an apsidal niche surmounted by a gold mosaic semi-dome; two angels hold a crown over her head.

Romanino uses this archaic architectural scheme both to create an intimate, yet sumptuous setting, and enhance the atmosphere by means of delicate chiaroscuro effects which mute the colours of the Virgin's silvery cloak and rosy dress; her solemn and dignified bearing is in the Lombard tradition. It can be dated c. 1530.

G.P.

PROVENANCE

1743–57 Oratorio di S. Pietro della Casalta; 1855 Annibale Maggi Via

EXHIBITIONS

Brescia 1878, no. 43; Brescia 1904, no. 44; London 1930, no. 724; Brescia
1939, no. 129; Brescia 1965, p. 87, no. 37, with full bibliography

REFERENCES

Boselli 1965, p. 206; Cassa Salvi 1965, pp. 6–7; Cheney 1966, p. 107

82

The Mystic Marriage of St. Catherine with St. Lawrence, St. Ursula and St. Angela Merici

153 × 207.7 cm
Brooks Memorial Gallery, Memphis, gift of the Samuel H. Kress
Foundation (1961.202)
[*repr. in colour on p. 97*]

This painting records the foundation of the Order of the Orsoline Dimesse by St. Angela Merici in 1535; it probably dates from that year, or soon after. In the foreground are the Virgin and Child with St. Catherine kneeling before them, while St. Lawrence leans against a marble pillar; behind the Virgin are St. Ursula, holding a standard, and St. Angela Merici, wearing a nun's habit and kneeling in prayer. In the background there is the castle at Brescia.

The composed, dignified figures, harmoniously arranged in a row, are uncharacteristic of Romanino and make this work exceptional in his *œuvre*; there is no heightened drama or movement, but instead a strong sense of religious intimacy. The colour is extremely rich, and the effect of the highlights on the silk drapery is particularly exquisite, even if the painting has been over-cleaned. Again, the painting shows a skilful mixture of the Venetian style, derived from Titian and Lotto, and that of Lombardy; the silvery cascade of the Virgin's cloak is reminiscent of Foppa's work, whilst her figure is stylistically close to Bramantino.

G.P.

PROVENANCE
1760 Maffei Collection; 1871 Erizzo Maffei, Brescia; 1871 Cook
Collection, Richmond; 1948 Kress Collection

EXHIBITIONS
Brescia 1965, no. 59, with full bibliography

REFERENCES
Boselli 1965, p. 208; Bossaglia 1965, II, p. 169; Fredericksen and Zeri 1972,
p. 176; Kossoff 1965, p. 518; Vezzoli 1974, p. 394

83

Christ Carrying the Cross

81 × 72 cm
Private Collection

The subject of Christ carrying the Cross was painted frequently by north Italian painters, and often by Romanino. There is a tondo by him of this subject (Pinacoteca Tosio Martinengo, Brescia) with Christ wearing a silvery tunic, the composition of which is carefully constructed to create a peaceful effect. By contrast, the painting in Hanover and, above all, this work, are both imbued with a sense of pathos, accentuated by the exaggerated expression of the figures, the tentative modelling of the knotted hands and the wrinkled folds in the drapery. In addition, Romanino has crammed the figure

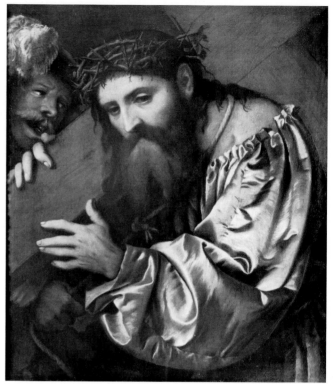

83

into a small space and used no tonal gradations, passing abruptly from a bright red to a faded pink, and to the ashen-coloured flesh of the figure of Christ.

Romanino was deeply influenced by Pordenone and northern painting at this period (*c.* 1535) as can be seen in the frescoes in Pisogne and Breno, and in the Asola pulpit.

G.P.

PROVENANCE
1853 Averoldi Collection, Brescia; 1907 Crespi Collection, Milan; 1914
Paris sale; later acquired in Milan by a private collector

EXHIBITIONS
Brescia 1878, no. 33; Brescia 1965, no. 51, with bibliography

REFERENCES
Boselli 1965, p. 208; Cheney 1966, p. 107; Kossoff 1965, p. 518

Giovanni Girolamo Savoldo

Brescia (?) *c.* 1485—Venice after 1548

Savoldo certainly came from Brescia, as may be deduced less from the phrase '*da Brescia*' always applied to him than from his lifelong contacts with patrons in the town, but this is not documented. He first appears in Florence, where he joined the painters' guild in 1508; later he lived in Venice from at least 1520 to 1548. Although evidently trusted and liked by pupils and neighbours (several of the few documents relating to Savoldo name him as executor of wills), he was notably unsuccessful in his career. His pupil Pino observed that his few works brought him little fame, his only patron being the last Duke of Milan.

Perhaps more than any other artist of his age, Savoldo specialised in paintings of a single figure – when there are two or more, the figures are detached and immobile. The figures often nearly fill the frame, their imposing volume suggesting a quattrocento-like conservatism, and his work shows a traditional duality of mass and void. However, Savoldo's sense of atmosphere, his ability to animate his figures by clothing them in sensuously vivid colours (often large blocks of local hue), and his use of the wide portrait all address his own century's demand for modernity. He thus provides the vibrant age of Titian with heroes of meditative dignity.

The idea of including Savoldo in the Brescian School, along with Foppa, Moretto and Moroni, is made dubious by these artists' preference for grey tonal worlds and humble still-life motifs, so unlike Savoldo's concentration on contrasting blocks of colour and figures. More closely related to the Titian of the phase of *Sacred and Profane Love* and *The Assumption*, Savoldo is no more Brescian than Veronese is Veronese.

C.E.G.

REFERENCES

Berenson 1899, pp. 129ff; Boschetto 1963; Crowe and Cavalcaselle 1912, pp. 308ff; Gilbert 1955; Gilbert 1969; Ortolani 1925, pp. 193ff; Pino 1548, ed. 1946; Vasari (ed. Milanesi) 1878, VI, pp. 507ff; A Venturi 1925–34, IX, iii, pp. 749ff; von Hadeln 1925¹, pp. 72ff

NOTE: THE CHRONOLOGICAL SEQUENCE IS 84, 88, 87, 85, 86.

84

The Rest on the Flight into Egypt

87 × 124 cm
Private Collection, Italy
[*repr. in colour on p. 72*]

This canvas, a favourite size for Savoldo, contains figures painted on a scale unusually small for him. Of 40 surviving pictures, this occurs only in two other versions of the *Rest on the Flight into Egypt*, an *Adoration of the Shepherds*, and his two paintings of *The Temptation of St. Anthony*. While the last theme documents Savoldo's fascination with Flemish painting, the first two, from the infancy of Christ, are those incidents most adaptable to Giorgione's arcadian tone.

This work is perhaps the earliest of the four versions of the subject painted by Savoldo, which may explain the unusually literal dependence on several sources, notably prints. The composition, with all the standard subject matter to one side and a wide vista on the other, follows the formulae of Giulio Campagnola, as in Cat. P9, which, like this painting, includes a view of the Doge's Palace, and Cat. P8 and P11, which also show the figures in shadow before a backdrop.

More generally, the two-sided formula, balancing all the figures against a wide view, is a major Venetian tradition, illustrated by Giovanni Bellini's famous *St. Francis* (Frick Collection, New York) and Giorgione's *Three Philosophers* (Kunsthistorisches Museum, Vienna). A print by Fogolino had Italianised the popular Flemish theme of the Rest on the Flight into Egypt, with its ruined buildings and figure

of Joseph at the well. As to specific details, Benedetto Montagna's *Orpheus* included the buttressed tower – on fire, as it is when Savoldo uses it again in his *St. Catherine* (Pesenti Coll.) – while the Child, shown in perspective lifting Mary's veil, is copied from an engraving by Mabuse.

The date usually given to the painting, c. 1520–27, is supported by that of the Mabuse engraving (after 1520) and if indeed this is Savoldo's first version of the theme, by documents of 1527 recording a set of four canvases by him on the theme of the Flight into Egypt. Ridolfi (1648) mentioned a version with Joseph at the well among ruined buildings and the Child at his mother's breast, evidently very close to this one. Savoldo's preference for the subject of the Rest on the Flight, rather than the conventional subject of the Flight itself, demonstrates his liking for still figures; the disjuncture of the environmental motifs from the setting was to remain a problem for him.

C.E.G.

PROVENANCE
By 1869 in Palazzo Albani, Urbino (Burckhardt); thereafter by descent

EXHIBITIONS
Venice 1955, no. 109

REFERENCES
Berenson 1899, pp. 129ff; Boschetto 1963, pls. 51–53; Burckhardt 1869, III, p. 995; Capelli 1950, p. 404; Fiocco 1956, p. 166; Gamba 1939, p. 382; Gamulin 1955, p. 254; Gilbert 1955, pp. 92–94, 183–84; Longhi 1927², p. 75; Nicco Fasola 1940, pp. 62, 67; Ortolani 1925, pp. 171–72; Serra 1924, p. 65; Suida 1935, p. 511; A Venturi 1925–34, IX, iii, pp. 755–56; L. Venturi 1915, p. 206

85

Shepherd with a Flute

97 × 78 cm
Private Collection
[*repr. in colour on p. 74*]

The theme of the musical shepherd is obviously Giorgionesque, a quality reinforced by the passivity (not actually playing the flute) and light (that this is evening is insisted upon by the fact that the sheep have been brought into the fold). Formally, however, it is related to the much more old fashioned Madonnas of Giovanni Bellini, where a solid heroine is contrasted with very distant landscape anecdotes. Savoldo maintains the massive grandeur of the figure with his almost slick large areas of strong local colour and by sharply silhouetting the figure against sky, thus retaining his dualistic quattrocento instinct for the balance of mass and space, as against the tendency in Venice amongst his contemporaries to absorb forms into a luminous unity. In spite of this, he is able to produce a modern mood and give the light an emphatic value by suggesting tremendous depth of air (through the inescapable intricacy of the far away scene) and by the dimming of the hero's face (through the device of the big hat). Conservative techniques for a modern expression are essential to him, nowhere more elegantly achieved than here. The device of silhouetting is splendidly handled to this end in a group of works of this date, about 1525, notably the *Transfiguration* (Uffizi, Florence), where the iconography evokes it, the Brera altarpiece and the

Cleveland *Pietà*. Later it is combined in the *St. Matthew* (New York) with a similar distant busy scene in an even more sophisticated way. The *Shepherd* is one of the few Savoldos that was repeatedly copied; one copy, at Gosford House, was noted by Cavalcaselle and regularly attributed to Savoldo long before the discovery of the original, which then was wrongly reported for a time (first by Longhi) to be the same painting in new ownership.

C.E.G.

PROVENANCE
Duke of Anhalt, Buerlitz; *c.* 1927 sold to Cassirer, Berlin, and thence immediately to Contini, Florence; 1970s sold to the present owner

EXHIBITIONS
Brescia 1939, no. 176; Milan 1953, no. 19; Venice 1955, no. 110

REFERENCES
Boschetto 1963, p. 50; Capelli 1950, p. 412; Gilbert 1955, pp. 83–84, 169–70; Longhi 1927², p. 74; Longhi 1929, p. 288; Suida in Thieme-Becker 1935, p. 511; A. Venturi 1925–34, IX, iii, pp. 766–67

86
Tobias and the Angel

96 × 126 cm
Galleria Borghese, Rome (inv. no. 547)
[*repr. in colour on p. 75*]

In most images of this theme, the angel Raphael is the protagonist. Usually an adult, he often holds the boy Tobias's hand as they walk, or, in another version common at this period, he leans over to help Tobias pull the fish from the water. The seated angel here not only evokes quietude, but also enables the child to be a co-protagonist.

There are a remarkable number of parallels between this painting and the artist's *St. Matthew and the Angel* (Metropolitan Museum, New York), beginning with the shared theme of an angel helping a saintly person, which is not found again in Savoldo's work. The *St. Matthew* is also the same size (to within 3 cm, 93 × 124.4), which is unique among Savoldo's religious works (two portraits measure approximately 91 × 123 cm, but reports of the measurements vary). Since the present painting and the *St. Matthew* were both discovered in central Italy in 1912, it is suggested that they were a pair and had been together until shortly before 1912. Although the lighting is very different, the paintings are similar in other respects: such as the disjuncture of the figures in woolly red and blue robes of high key from the very dark background or the unusual debt in both to figure types of Leonardo. As St. Matthew dominates his angel, the connection would also explain the greater emphasis on Raphael.

As a pair, exceptional in Savoldo's work, they might well then be identified as the two survivors of his 'four paintings of night and fires' reported by Vasari in the Mint at Milan. Matthew, the tax-collector, is the patron of mints; Tobias made his journey to collect money. Mints, which are rarely adorned with pictures, have no settled iconography, so that a planner of one would start with Matthew and then have to work up other harmonizing themes. Savoldo's *Matthew*

as a picture of the mint's Saint, with a night and a fire, indeed matches Vasari's specifications nicely. And the stylistic date most often given to both paintings, in the early 1530s, also matches the information that Savoldo's only long-term patron was a duke of Milan who reigned principally from 1530 to 1535, inasmuch as the mint is a ducal building. Admittedly the Tobias only evokes evening rather than night, and lacks a fire; one would have to presume that Vasari responded to the imagery of the paintings as a group rather than to motifs found in every one, a presumption less awkward when it is noted that in this period there seem not to be sets of paintings where all are nocturnes.

C.E.G.

PROVENANCE
Palazzo Alfani, Perugia; R. Pompili, Tivoli; 1911 Galleria Borghese

EXHIBITIONS
London 1930, no. 123; Paris 1935, no. 188; Brescia 1939, no. 171; Venice 1955, no. 114

REFERENCES
Capelli 1951, pp. 18–20; D'Achiardi 1912, pp. 81–83; Della Pergola 1955, p. 128; Gamba 1939, p. 385; Gilbert 1955, pp. 113–16; Longhi 1927², p. 75; Nicco Fasola 1940, pp. 67–68; Suida in Thieme-Becker 1935, p. 511; A. Venturi 1925–34, IX, iii, p. 771; L. Venturi 1913, pp. 220–21; von Hadeln 1925, p. 78

87
Virgin and Child with Two Donors

102.2 × 139.7 cm
Her Majesty The Queen (no. 235)
[*repr. in colour on p. 73*]

Composing a row of half-length figures is a standard way of bringing them closer to the front of the picture plane and filling the canvas: Giovanni Bellini's classic prototype, with Mary between the two other figures, is followed here. This is a less individual work than most of Savoldo's, and a more standard devotional image of the time, yet there is an elegance in the suspension in shadow of the immobile heavy forms that evokes meditation. The Child is on some sort of crib, which implies that the adults are kneeling, but no other adjustments are made along these lines.

Most remarkable is the single, central action in which the male devotee raises the cloth from the Child and, with a glance towards us, offers him to our view, as well as to the prayerful response of the women. This unveiling, or *revelatio*, is clearly a reference to the distinction between the New Testament's message of salvation from the 'veiled' one of the Old, a distinction achieved by Christ's incarnation. No analogous images are known, other than Savoldo's own variant in Turin (93 × 139 cm), in which instead of the donors we see St. Jerome lifting the cloth and St. Francis in adoration. Since saints seem more plausible in this role, one might infer that the Turin picture was painted earlier and that the donors in the present painting especially asked for the variant. To be sure, as Shearman noted, there is no obvious reason why Jerome should have been shown lifting the cloth, but Shearman's alternative suggestion that this donor might be named Joseph, and so

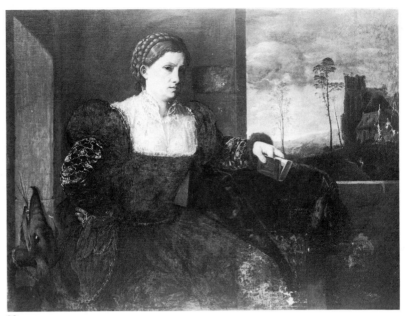

88

constitute an allusion to Joseph of Arimathea's role in Christ's burial, does not seem to fit the donor's gesture, which is the opposite of shrouding. In contemporary Nativities that have been cited as parallels, it is only Mary who lifts the cloth from Christ, or, as in other Savoldo Nativities, the Infant himself. But as one of the church's great teachers, Jerome might conceivably have been regarded as appropriate for the role of revealing the incarnate Christ to the faithful.

C.E.G.

PROVENANCE
Probably in Charles I's collection (see Gilbert 1955, pp. 173–74, and Shearman 1983, p. 221, for somewhat varied selections of items in inventories of that and later reigns that might match this picture); in James II's collection

EXHIBITIONS
London 1946, no. 223

REFERENCES
Boschetto 1963, pls. 42–43; Crowe and Cavalcaselle 1912, III, p. 316; Gamba 1939, p. 382; Gilbert 1955, pp. 71, 173–74; Longhi 1917, p. 113; Ortolani 1925, p. 172; Shearman 1983, pp. 221–22; A. Venturi 1925–34, IX, iii, p. 756; L. Venturi 1913, p. 221

88

Lady with a Dragon Fur

91 × 123 cm
Pinacoteca Capitolina, Rome (inv. no. 49)

In the 1520s, when the schema of the Venetian Renaissance portrait in its steady expansiveness first permitted the knee-length figure as an option, a few of these are in addition on canvases wider than they are high, a truly bold oddity for the single-figure portrait, which in all ages is unusually invariant. The format was invented by Savoldo and Lotto, but Lotto continued to centre the figure on the canvas (least so in his *Portrait of a Man*, c.1526 [Accademia, Venice],

where the head is in the centre but not the body). It is one of their ways of linking portraits to other painting, which Lotto also did by introducing vigorous action into his portraits. Savoldo retained the stillness, but, as in *The Rest on the Flight* (Cat. 84), allotted the figure only the left half of the canvas.

The lady has often been identified as St. Margaret (whose attribute is the dragon), but the fur head on a chain, seen also in Lotto's *Lucina Brembate* of 1532, would have been luxury wear in the early sixteenth century. Other costume elements here have inexact analogues between the 1520s and the 1540s; however, the absence of any head-dress, usually restricted to figures in prayer, is strange, and may suggest that the lady is in the very private interior of her house. Surface losses of paint have made it difficult to date the painting; the even, dark tone probably suggests a late date, c. 1540, which was preferred by Longhi and others until earlier ones were proposed by Gilbert (c. 1523–24) and Boschetto (c. 1527–30), on the basis of the relatively linear contours, similar to those in Cat. 87.

The late date of the painting and the fact that it was once called a portrait of Duchess Eleanor of Urbino reflect its remarkable parallels with Titian's portrait of the Duchess of 1536 (Uffizi, Florence): they share specific details, such as the fur head on the chain and the landscape through a window, as well as their general composition. It is natural to think Savoldo followed Titian, and he may well have done, but there is a good deal to be said for the converse view. For Titian this was an unusual project, only his third (surviving) female portrait in 30 years – as against dozens of portraits of men – and of the two preceding pictures, the London *Schiavona* and *Laura de' Dianti* are so unlike in design as to offer no precedent. Titian, like Shakespeare, had no hesitation in borrowing old formulas, even from sources far more humble than this, and patrons (including Eleonora's mother, Isabella d'Este) regarded them with favourable interest.

C.E.G.

PROVENANCE
Cardinal Carlo Pio (1622–89), bought with his other paintings in
Venice, with the aid of Giovanni Bonatti; his great-nephew, Giberto Pio;
1750 acquired by Benedict XIV; Pinacoteca Capitolina, founded by
Benedict XIV; 1767 reported by Venuti in the second gallery, where the Pio
collection was hung (as 'in the manner of Giorgione'); 1871 reported by
Cavalcaselle, rejecting official attribution to Giorgione; for further gallery
history see Pietrangeli 1951

EXHIBITIONS
Brescia 1939, no. 166

REFERENCES
Barbier de Montault 1870, p. 38; Bruno 1978, p. 25; Capelli 1950, p. 410;
Crowe and Cavalcaselle 1912, III, pp. 47, 319; Donovan 1843, III, p. 578;
Gamba 1939, p. 386; Gilbert 1955, pp. 94–96, 185–86; Longhi 1927, p. 75;
Morelli 1893, p. 149; Nicco Fasola 1940, p. 57; Pietrangeli 1951, p. 62;
Righetti 1836, II, p. 15, repr.; Tofanelli 1818, p. 108; A. Venturi 1925–34,
IX, iii p. 781; L. Venturi 1913, p. 22; Venuti 1976, pp. 480, 799

Andrea Meldolla, called

Schiavone

Zara c. 1510/15 – Venice 1563

Andrea Meldolla was born in Zara, Dalmatia (at that time
under Venetian jurisdiction) of a family which had
originally come from Meldolla in the Romagna. Although
the artist's birthdate is unknown, Richardson (1980, p. 16)
has persuasively argued for a date of c. 1510/15; Schiavone
died on 1 December 1563.

The artist's early training and the circumstances of his
establishment in Venice are entirely matters for speculation.
Most likely Schiavone was living in Venice by the late
1530s, and in 1540 he was commissioned by Vasari to paint
a large battle scene, subsequently given to Ottaviano de'
Medici, but now lost. The earliest surviving dated work
by Schiavone is the *Abduction of Helen*, an etching of 1547.
He must have produced etchings throughout his career, for
they constitute a fundamental part of his *oeuvre*. The
influence of Parmigianino is widespread in Schiavone's
prints, paintings and drawings; but other central Italian
artists such as Raphael and Francesco Salviati, and
Venetians such as Giorgione and Titian also affected his art.
In 1548 Pietro Aretino wrote to Schiavone, commenting on
his speed of execution and lack of finish, which evidently
amazed Titian.

In the 1550s Schiavone's work lost some of its more
exaggerated elements and became closer to Venetian
naturalism. The three tondi completed in 1556–57 for the
ceiling of the Libreria Marciana document this
development; they also demonstrate the freedom and
virtuosity of his brushwork. In May 1563 Schiavone was
named an expert witness in the dispute between the
Procurators of San Marco and the Zuccati family of
mosaicists. Some of his late paintings are among his most
arresting and original creations.

D. McT.

REFERENCES
Richardson 1980, with full bibliography

89

The Adoration of the Magi

185 × 222 cm
Pinacoteca Ambrosiana, Milan (inv. no. 198)
[repr. in colour on p. 115]

This agitated and engaging canvas represents Schiavone's
painting at its most imaginative. The contorted and
frequently unanatomical figures have been improbably
compressed into a shallow, frieze-like space, with only the
cloudy sky for a backdrop. Even the Solomonic column
bends as if made of rubber. The colour is reminiscent of
such contemporary Tuscan painters as Vasari, with
dissonant contrasts of wine-red and dull gold, copper-green
and smokey-blue, but the paint itself has been applied with
a verve and indifference to the precise definition of contours
that are singularly Venetian. The result is an animated relief
pattern of skilfully interwoven arabesques looping in and
out of highlight and shadow. Since these features represent
the counterparts, in oil paint, to Schiavone's etching of the
Abduction of Helen, dated 1547, Richardson has proposed
a similar date for this canvas.

While many of the figures are generically
Parmigianesque, the angel with crown and laurel wreath –
an unusual iconographic feature – may reflect the angel
with equally spindly limbs in Francesco Salviati's Corpus
Domini altarpiece (c. 1540). It is also possible that
Schiavone knew Francesco Salviati's drawing of the
Adoration of the Magi (British Museum, London), which
has also been dated to Salviati's Venetian visit of 1539–41
(Cheney 1963).

Nothing is known about the original commission of this
ecstatic epiphany. It is first recorded in the inventory of
Cardinal Federico Borromeo's bequest to the Ambrosiana
in 1618 (Falchetti 1969). The painting was correctly
attributed to Schiavone at that time.

D. McT.

PROVENANCE
Cardinal Federico Borromeo

EXHIBITIONS
Venice 1981, no. 30

REFERENCES
Berenson 1957, I, p. 160; Cheney 1963, p. 348; Falchetti 1969, pp. 252, 291;
Freedberg 1971, pl. 238; Fröhlich-Bum 1913–14, p. 206; Hope 1980, p. 104;
Pallucchini 1944², II, p. IX; Pallucchini 1950, p. 30; Richardson 1980,
pp. 31, 144–45; A. Venturi, 1925–34, IX, iv, 1929, pp. 741–43

90

Diana and Callisto

19 × 49 cm
Musée de Picardie, Amiens (no. 248)

The story of Diana and Callisto is told in Ovid's
Metamorphoses (II, 401–503). Callisto, the daughter of the
King of Arcady, joined the retinue of Diana, but was then
violated by Jupiter. When her companions stopped by a

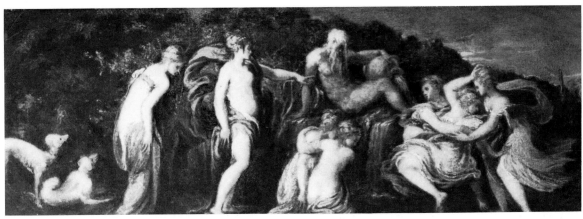

90

stream to bathe, Callisto refused to join them, in order to
conceal her pregnancy. In the painting, Diana, the cruel
goddess of Chastity, imperiously orders Callisto to be
undressed; her condition is then revealed and she is
banished from Diana's retinue. Callisto was eventually
transformed by Jupiter into the constellation Ursa Maior.

As Gould observed, the present canvas is listed in the
Vivant Denon collection along with two unidentified
mythological pictures (of approximately the same height),
now in the National Gallery, London. Probably all three
were together in the Algarotti collection in the eighteenth
century, but nothing is known of their whereabouts before
that. Such small-scale representations of figures in a
landscape were commonly undertaken in Renaissance
Venice as decoration for domestic interiors, frequently for
pieces of furniture. Ridolfi mentions that on roundels and
cupboards Giorgione had painted stories from Ovid,
including this very subject: *Diana con molte Ninfe ignude
ad una fonte, che della bella Callisto le violate membra
scoprivano*. Because Giorgione's composition is now lost,
its relationship with later interpretations of the subject,
including Titian's painting of 1559 for Philip II (National
Gallery of Scotland, Edinburgh), is impossible to establish.
Richardson has dated Schiavone's picture to the late 1540s,
and it is conceivable that his *Diana and Callisto* exerted an
influence on Titian's picture. Especially relevant are Diana's
commanding gesture and the frenzied agitation of the
disrobing of Callisto, the two features which Panofsky
(1969, p. 160) found most original in Titian's interpretation.

Richardson describes this canvas as 'a happy balance
between painterly brilliance and poised, decorative
elegance'. While the influence of Parmigianino is generally
reflected here, in a particularly refined and delicate vein, the
picture also resembles a more painterly and naturalistic
reworking of one of Francesco Salviati's ceiling frescoes of
1540 in the Sala di Apollo in the Palazzo Grimani, Venice.

D. McT.

PROVENANCE
Algarotti (?); Vivant Denon; E. and O. Lavalard

EXHIBITIONS
Paris 1965–66, no. 255

REFERENCES
Gould 1959, p. 75; Richardson 1980, pp. 37, 152, with full bibliography;
Ridolfi 1648, I, p. 98

91

Sacra Conversazione

122 × 96.5 cm
British Government Art Collection

The Christ Child reaches forward to embrace the young
John the Baptist, who is presented by his mother, Elizabeth;
Zacharias is further to the right. Behind the Virgin Mary
are St. Catherine of Alexandria, Joseph, and an unidentified
female figure. Aspects of a Holy Family and the traditional
sacra conversazione are thus combined, with the figures
unconventionally aligned along a diagonal from the right

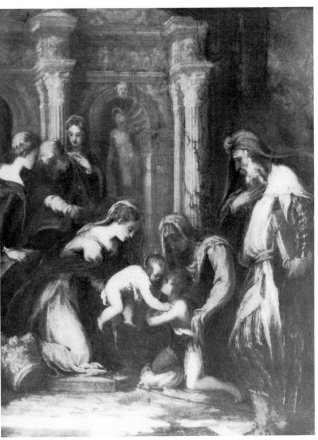

91

[207]

foreground to the left middleground. The subject of the introduction of the Christ Child and John the Baptist, each supported by his kneeling mother, was also treated by Schiavone in an etching (Bartsch 63). Although the scene is clearly set out of doors, the figures are placed in a somewhat dilapidated architectural setting with a richly decorated façade, reminiscent of Jacopo Sansovino's Loggetta (begun in 1537).

Both the elegantly posed figures and the elaborately decorated architecture seem to be viewed through a faint mist, and the landscape vista at the right suggests a night view. Richardson has proposed a date of *c.* 1552–54 for this lovely canvas, which would make it an early instance of a nocturne. As such, it prophesies the increasing vogue for these pictures by such artists as Jacopo Bassano, Paolo Veronese and Palma Giovane in the succeeding decades.

D. McT.

PROVENANCE
Lady D'Abernon

REFERENCES
Berenson 1957, I, p. 161; Richardson 1980, pp. 44–47, 172

92 & 93
The Annunciation

Two canvases, each 272 × 156 cm
S. Pietro, Belluno
[*repr. in colour on p. 116 and p. 117*]

These canvases were formerly the outsides of the organ shutters of the church of S. Pietro, with Schiavone's paintings of St. Peter and St. Paul on the insides; all four paintings now hang separately in the church. The custom of including figurative paintings on the shutters of pipe organs has a long history in Venice and the Veneto. Frequently the figures are shown in an architectural setting, usually in arched openings, as are the saints on the interior of the Belluno shutters (cf. Cat. 95 and 96). The Annunciation may also be set in an arch (as on the shutters by Cosmè Tura in the cathedral of Ferrara), or in an elaborate chamber (as in the shutters ascribed to Giovanni Bellini from S. Maria dei Miracoli, in which SS Peter and Paul appear in separate niches on the inside). But here Schiavone has chosen to minimise architecture and to concentrate on atmospheric conditions and landscape. The descending vaporous cloud that unifies the two canvases and surrounds the dove of the Holy Spirit obliterates the wall behind the Virgin, while the landscape below the angel constitutes one of the most outstanding details in any work by Schiavone. The broken brushwork of trees, hills and twilit sky looks forward to similar treatments of landscape in works by Titian (Richardson 1980). Equally impressive is the vigorous execution of the angel's fluttering draperies and curly hair.

The angel retains much of the gracefulness of Parmigianino's figures and is very close to the same figure in Schiavone's etching of *The Annunciation* (Bartsch 5), whilst the figure of the Virgin approaches that in Titian's lost *Annunciation* of 1536, known through the print by Caraglio (Richardson 1980). Thus the two major stylistic elements in Schiavone's art – the inventive gracefulness of Parmigianino and the elevated naturalism and painterly handling of Titian – are combined here.

Although these paintings are not mentioned in Ridolfi's life of Schiavone, they are recorded as his works in the accounts of Lucio Doglioni and Florio Miari, local historians. Fiocco dated the canvases to Schiavone's last years, while Richardson has convincingly argued for a date of *c.* 1554–55, just before the tondi in the Libreria Marciana.

D. McT.

EXHIBITIONS
Belluno 1950, nos. 27–28; Los Angeles 1979, no. 28 (the Archangel);
Venice 1981, nos. 32–33

REFERENCES
Berenson 1957, I, p. 159; Doglioni 1780, p. 30; Doglioni 1816, p. 36;
Fiocco 1950, p. 42; Miari 1843, p. 146;
Richardson 1980, pp. 47–48, 154

94
Christ Before Herod

130 × 209 cm
Museo di Capodimonte, Naples (no. 863)
[*repr. in colour on p. 118*]

The original destination of this deeply moving painting is unknown. In subject and composition it is related to a number of similar paintings by Schiavone of Christ before Pilate. According to Ridolfi (1648, p. 251), one version – probably the painting now at Hampton Court – was owned by Jan Reynst, a Dutch resident of Venice, and it is likely that all these pictures were intended for private possession.

In terms of both format and approach to subject matter, these half-length narratives follow works like the canvases depicting Christ and the Adulteress by Titian and Lotto. Usually Christ and another figure have been forced together by the clamorous protestations of the crowd, but in Schiavone's interpretation of this rare subject, taken from *Luke* XXIII, 6–12, the drama has been internalised, the gestures abated and the glances stilled. A number of subsidiary figures merge almost totally with the surrounding deep brown shadow. In this respect, Schiavone's picture compels comparison with Rembrandt's mature work a century later, and, indeed, it is quite possible that the Dutch master had access in Amsterdam to some of Schiavone's paintings (Richardson 1980, p. 68).

Christ Before Herod represents Schiavone's late style at its most eloquent. The gracefulness and the exaggerated contortions of the earlier figures have been replaced by a more uniform naturalism that also extends to the lighting of the scene. The paint has been very freely applied, and drawing, in the central Italian sense, has been largely ignored. What remains most impressive, however, is the pathos of this silent drama. Richardson dates the picture to *c.* 1558–62.

D. McT.

PROVENANCE
1821 Neapolitan Royal Collection

REFERENCES
Richardson 1980, p. 167, with full bibliography

Sebastiano del Piombo

Venice (?) *c.* 1485 – Rome 1547

Vasari, who knew Sebastiano in his later years, states that he was aged 62 when he died in 1547; a birth date of around 1485 is likely to be correct. Early accounts state that the painter became a pupil or associate of Giorgione, and the works of his Venetian years fully substantiate this. Before he left Venice for Rome in 1511, Sebastiano had undertaken three major commissions: the organ shutters for S. Bartolomeo a Rialto (Cat. 95, 96), *The Judgement of Solomon* (Cat. 97) and the high altarpiece of S. Giovanni Crisostomo. A smaller Venetian work, the National Gallery *Salome*, is dated 1510.

The move to Rome brought Sebastiano into contact with a radically different artistic environment dominated by Michelangelo and Raphael and led to a gradual abandonment of the Venetian style. Decisive in effecting a change to more monumental forms and to an increasingly cool range of colour was his friendship with Michelangelo. In the 1510s he produced a number of major altarpieces, including a *Pietà* for Viterbo and the *Raising of Lazarus*, now in the National Gallery, London. Michelangelo had a share in the design of both these works. From the time of his arrival in Rome, Sebastiano established himself as a great portrait painter, producing masterpieces such as the *Ferry Carondelet* (Thyssen Coll., Lugano) and after Raphael's death in 1520 he had scarcely a rival as a portraitist in central Italy. Involved in the Sack of Rome in 1527, he sought refuge in his native Venice, but soon returned to Rome, receiving the office of papal *piombatore* from Pope Clement VII in 1531.

Sebastiano's inactivity as a painter in his latter years has been exaggerated, but these late works assume an intensely personal character; often painted on stone supports, they take on an almost crepuscular quality. A late mural altarpiece in this style is in S. Maria del Popolo, Rome.

M.H.

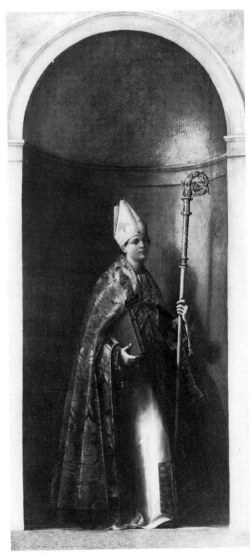

95 (*before restoration*)

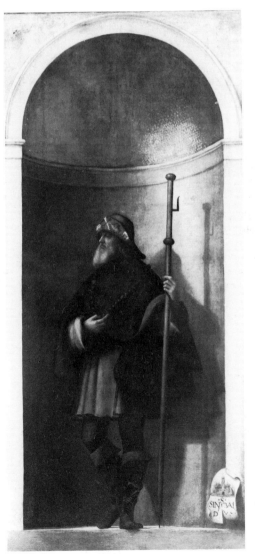

96 (*before restoration*)

95 & 96
St. Louis of Toulouse
St. Sinibaldus

Each 293 × 137 cm
S. Bartolomeo a Rialto, Venice

These two canvases formed the interior sides of shutters made to cover the organ (now destroyed) of a church in the commercial centre of Venice at the Rialto. Painted organ shutters, of which a number survive from the fifteenth century, became a highly popular form of Venetian church decoration. SS Louis and Sinibaldus, here depicted in shallow niches crowned by a mosaic semi-dome (a setting recalling those in works of Bellini's circle), were revealed when the shutters were open and the organ in use. Two other saints, Bartholomew and Sebastian, shown standing before a unified architectural setting, decorated the exterior of the shutters.

The paintings are first recorded in print by Scanelli as late as 1657; he ascribed them to Sebastiano, an attribution later endorsed by Boschini. Subsequent attempts to advance alternative attributions, or to argue for Giorgione's involvement in their design, have for the most part wisely been abandoned since the painstaking restoration by Pellicioli in 1940 (Pallucchini 1941).

Our two saints are closer in style to the work of Giorgione than their external counterparts; they share the meditative calm of the figures in Giovanni Bellini's altarpiece in San Zaccaria (Accademia, Venice) and Giorgione's *Three Philosophers* (Kunsthistorisches Museum, Vienna). The profile head of St. Sinibaldus is a personal variation by Sebastiano of the head of the oldest philosopher in the latter painting, carried out in a less broad, more prismatic style. Other features, such as the acute observation of the fall of light, owe more to Giovanni Bellini than to Giorgione, whilst the virtuosity of some passages, for example in St. Louis's cope, are difficult to match in Venetian art of the period.

The shutters were painted c. 1508–09 (Nardini 1788) and constitute one of Sebastiano's earliest major commissions. The choice of saints is due to local circumstances: Louis reflects the name of the *vicario* in charge of the church, while the pilgrim Sinibaldus was patron saint of Nuremberg; his presence in S. Bartolomeo a Rialto can probably be explained by the interests of the German colony in Venice (von Erffa 1976). Their rebuilt *Fondaco dei Tedeschi* stood a few paces from the church of S. Bartolomeo, in which Dürer's *Feast of the Rose Garlands* had recently been installed. X-rays of the heads of the saints show minor changes in the painting of St. Sinibaldus and a more significant change in the design of St. Louis, whose head was originally painted on a vertical axis and subsequently shifted to an inclined position.

M.H.

EXHIBITIONS
Venice 1955, nos. 83 and 84

REFERENCES
Hirst 1981, pp. 9–13, with bibliography; Lucco 1980, pp. 92–93;
Pallucchini 1941, pp. 8–12; Wilde 1974, pp. 94–98; von Erffa 1976,
pp. 8–11

97
The Judgement of Solomon

208.3 × 315 cm
The National Trust, Kingston Lacy
[details repr. in colour on p. 56 and p. 57]

Imposing in scale and ambitious in its treatment of the scene described in I *Kings*, III, 16–28, this is one of the most important Venetian paintings to have survived from the early sixteenth century. The circumstances of its inception have, however, remained obscure, and the identity of the artist has been much debated. No early mention of the work seems to exist; the first known reference to it is by Ridolfi in 1648, who saw it in the Palazzo Vendramin (a palace built for Andrea Loredan, who had died in 1513). Ridolfi attributed the work to Giorgione, and the painting enjoyed this ascription when acquired by William Bankes on the advice of Byron (see the latter's letter of 26 February 1820). But the enormous number of paintings attributed to Giorgione by Ridolfi gravely weakens his authority. In 1903 Berenson rejected the traditional attribution, seeing in the work the hand of Sebastiano and, although he subsequently changed his mind, his earliest attribution was endorsed by, among others, Longhi and Wilde (Lucco 1980).

The present writer shares this view (Hirst 1981). The design of the architecture can be matched most closely in that of the *all'antica* arch invented by Sebastiano for the exterior of the S. Bartolomeo organ shutters, on which he was probably engaged as early as 1508 (Cat. 95, 96). The receding perspective of the pavement, incised in the gesso ground, has no real parallel in Giorgione's surviving work and the deliberation over spatial construction points to Sebastiano. Whilst the figures are still redolent of Giorgione, their gestures and their individual morphology are most closely paralleled in Sebastiano's other Venetian paintings. Cleaning of the painting has revealed that the figure of the true mother is one of the best preserved areas of the painting, and her features are a paradigm of Sebastiano's ideal of female beauty in his Venetian period. The closest parallels for the style of painting are the external sides of the S. Bartolomeo organ shutters and the S. Giovanni Crisostomo high altarpiece. These comparisons suggest that *The Judgement of Solomon* preceded the Crisostomo altarpiece and may have been begun about 1508, scarcely after 1509.

Never previously exhibited in public, restoration of the painting is still in progress at the time of writing. It has been cleaned of subsequent overpainting, which has confirmed, as was already clear from the absence of the two babies, that the painting was never finished. A different interpretation of the same subject lies beneath the incomplete final paint layer. Figures on a smaller scale, previously just detectable (Hirst 1981), are now more apparent; underdrawing, clearly readable in infra-red photographs, shows that this earlier composition even included a horseman. In all, there were two earlier attempts at the composition, the most obvious being a painted architectural setting with tall lateral tabernacles instead of the basilican interior which was finally adopted. The change shows how radically Venetian painters of the early

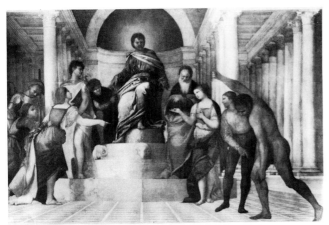

97 (*before restoration*)

sixteenth century could alter their compositions on the canvas itself. It also suggests that the artist arrived at his later solution on the advice of someone familiar with the judicial implications of the antique basilican form: the painting has become a more learned one. The position of the earlier tabernacles suggests that the canvas may have been cut by about 40 cm on the left, implying that the final design was planned to be symmetrical. The left edge has no original pigment on the turnover; against this, scrutiny of the canvas during relining has revealed cusping of the material on both lateral edges. Resolution of the question of the painting's original size must await completion of the restoration, but uncertainty over this issue cannot seriously impair our appreciation of one of the masterpieces of Venetian narrative painting.

M.H.

PROVENANCE
Before 1648 Palazzo Vendramin Calergi, Venice; Marescalchi Collection, Bologna; 1820 (?) Bankes Collection, Kingston Lacy

REFERENCES
Hirst 1981, pp. 13–23, with bibliography; Lucco 1980, pp. 91–92, with bibliography; Ridolfi 1648 (ed. von Hadeln), I, p. 102

Lambert Sustris

Amsterdam *c.* 1515 – after 1568

Sustris was born in Amsterdam and trained in Scorel's workshop in Utrecht. He was probably in the Veneto by the late 1530s, most likely in Titian's studio. A document of 1543 states that *Alberthus de Olandis Amsterdam* was in Padua in the company of Gualtieri dall'Alzere (in 1541 Giuseppe Salviati was there too), at which date Padua was undergoing a cultural renaissance inspired by the example of Mantua. In 1542–43 he was commissioned to decorate the Villa dei Vescovi at Luvigliano (Ballarin 1966, 1967, 1968); although Titian's influence is evident in this work, it is also apparent that Sustris had learnt from the Mantuan and Emilian schools.

Sustris was in Augsburg in 1548 with Titian; he returned there in 1552. During these visits Sustris worked mainly as a portrait painter: the *Portrait of William IV the Elder of Waldburg-Trauchburg* (Augsburg, Gallery) dates from his first stay while the portraits of *Hans Christoff* and *Veronika Vöhlin* (Alte Pinakothek, Munich) date from his second visit. The *Portrait of Otto Truchsess von Waldburg* in the Castle of Zeil dates from 1553 and the same family also commissioned Sustris to paint *The Baptism of Christ* at Caen (Ballarin, 1962–63 presumes that all Sustris's paintings now in France originally came from Germany).

After this, Sustris probably returned to Venice and was associated with the circle of artists around Tintoretto, but practically nothing is known about the latter part of his life; we can now exclude the possibility (Ballarin 1968) that the payments for the portraits in the Procuratoria de Supra from 1572 and 1584 are connected with Sustris. According to Vasari he was still alive in 1568.

S.M.R.

REFERENCES
Ballarin 1962, pp. 61–81; Ballarin 1962–63, pp. 335–66; Ballarin 1966, pp. 244–49; Ballarin 1967, pp. 77–101; Ballarin 1968[2], pp. 115–26; Vasari (ed. Milanesi) 1881, VII, p. 588; Venice 1981[1], no. 36

98

Venus

116 × 186 cm
Rijksmuseum, Amsterdam (inv. A3479)
[*repr. in colour on p. 120*]

This painting belongs to a small group of works, securely datable to 1548–52, which includes the *Noli Me Tangere* (Lille) and the *Birth of the Virgin* (formerly in Hanover). These are stylistically close to Titian's work around 1548, but Sustris was also open to a variety of influences, including that of Flemish art (Ballarin 1962).

This *Venus* is a direct reflection of Titian's *Venus of Urbino* (Uffizi, Florence; fig. 15): it has the same composition, with the nude goddess seen in an interior setting and chambermaids leaning over a chest in the background. Sustris has added a musician playing a clavichord and two lovers on the balcony. However, his use of colour is different from Titian's: Sustris defines areas with clear outlines and enhances his fine tonal range and sensitive draughtsmanship with silvery highlights. Although his style is fundamentally dependent on Titian's work, there are diversities which can probably be explained by the influence of Giulio Romano and Paris Bordone. Sustris did not manage to develop an independent style of his own until the *Mars, Venus and Cupid* (Louvre, Paris), in which the delicately wrought composition and subtle eroticism is finely balanced.

S.M.R.

PROVENANCE
Before 1824 acquired by W. Buchanan from the Villa Borghese, Rome; Mr Willett; after 1829 Mr Neeld; 1945 acquired by T. Harris; 1946 Rijksmuseum

EXHIBITIONS
Venice 1981, no. 36

REFERENCES
Ballarin 1962, pp. 64, 67; Ballarin 1967, p. 86; Ballarin 1968[2], p. 122; Berenson 1957, I, p. 173; Buchanan 1824, I, p. 223; Amsterdam 1961, p. 296; Rijksmuseum 1976, pp. 529–30; Waagen 1854, II, p. 244

Jacopo Robusti, called

Tintoretto

Venice 1519–Venice 1594

Jacopo Robusti, called Il Tintoretto because his father was a dyer by trade, began his artistic career in about 1537. He worked primarily for a Venetian clientèle, both religious and lay patrons, private and State. According to some sources he was, for a brief period, a pupil of Titian, but he was never tied to one master and was variously influenced by the narrative elements of Bonifazio's painting, Pordenone's plasticity and dynamism, the study of copies after Michelangelo's paintings and copies after the antique. He also assimilated Schiavone's Parmigianesque elegance and painterliness and, around 1554–55, Veronese's use of colour and light.

Tintoretto's youthful compositions already show the fundamental elements of his art: an ability to illustrate a narrative, a remarkable sensibility to the spatial and dynamic values of a composition, extreme skill in the use of colour, light and three-dimensional form. The influence of mannerist art is evident in his mature works in his bold chiaroscuro effects. His treatment of narrative subjects is extremely dramatic and seems to involve the observer in the action. In both his religious compositions and his profane paintings, the realistic evocation of settings and figures brings to his subjects a sense of everyday life, making his works immediately accessible on an emotional level.

P.R.

REFERENCES
Pallucchini and Rossi 1982, with full bibliography

99

Christ Among the Doctors

197 × 319 cm
Museo del Duomo, Milan
[repr. in colour on p. 121]

This painting, formerly in the Galleria Arcivescovile in Milan, was traditionally attributed to Tintoretto; this is now universally accepted, as is its dating in the early 1540s.

At the outset of his career Tintoretto was influenced by Pordenone and Michelangelo, as is evident in this painting, which is close to the *Sacra Conversazione* of 1540 (private coll., London) in the dynamic tension of the composition, the vigorous build of some of the figures and the twisted poses, emphasised here by the use of a particularly bright range of colours in which yellow predominates. Details are painted with lively brushstrokes: the ruffled hair of the venerable doctors, the tiny figures fading into the distance and the minute statuette, which glows like a spectre, show that Tintoretto was already assimilating ideas from Schiavone. This becomes increasingly obvious in the works he painted immediately afterwards.

According to Arcangeli, Tintoretto included in the painting a self-portrait (the curly-headed youth by the colonnade in the background to the left, who is watching his companion reading), a portrait of Titian (the old man on the left leaning on a stick, disdainfully turning his back on Tintoretto) and also, perhaps, one of Michelangelo (the bearded man at the end of the left-hand group), thus alluding to the position Tintoretto had assumed between these two great artists. It is a rather fanciful interpretation, but undoubtedly reflects the influences evident in this work, which formed the basis of the young artist's mannerist style.

P.R.

PROVENANCE
Galleria Arcivescovile, Milan

EXHIBITIONS
Venice 1981[1], p. 150, no. 41 (Rossi)

REFERENCES
Arcangeli 1955, pp. 21–34; Latuada 1737, p. 84; Pallucchini and Rossi 1982, pp. 17–20, 136–37, no. 41, with full bibliography; Torre 1674, p. 394

100

Apollo and Marsyas

137 × 236 cm
Wadsworth Atheneum, Hartford, the Ella Gallup Sumner and
Mary Catlin Sumner Collection (no. 1950. 438)
[repr. in colour on p. 123]

It is generally accepted that this work can be identified with a ceiling painting of *Apollo and Marsyas* painted by Tintoretto, together with another work (now lost) of *Argos and Mercury*, for Aretino's house in Venice, for which Aretino thanked the artist in a letter dated 15 February 1545.

However, the letter lacks the details that might have conclusively identified Aretino's ceiling painting with the present picture. Also, the *Apollo and Marsyas* is unique among Tintoretto's ceiling paintings of the early 1540s: whereas the rest are painted with foreshortened figures to give a *trompe l'oeil* effect when viewed from below (eg. the paintings in the Galleria Estense, Modena), in this picture no foreshortening was used and no modifications were made for its supposed position on a ceiling (Arcangeli 1955; A. Pallucchini 1969, 1982).

However, the fact remains that the date of Aretino's painting – shortly before February 1545, which can be deduced from the letter since Aretino specifically mentions the rapidity of execution – coincides perfectly with the style of *Apollo and Marsyas*. The picture belongs to the end of Tintoretto's youthful phase when he was influenced by Bonifazio (evident in the vivacity of the colour) and, especially, by Schiavone. At this stage the artist was moving away from his small-scale, highly decorative, narrative style towards broader and airier compositions. If the standing figure on the right is a portrait of Aretino, as Schulz convincingly suggested (1968), his presence would of course be consistent with his having commissioned the picture. Given that Aretino came from Tuscany it would have been appropriate for Tintoretto to follow the central Italian practice of *quadri riportati* (ceiling paintings in which the figures are not foreshortened).

P.R.

PROVENANCE
By 1618 possibly in England (Sir Dudley Carlton); Duke of Abercorn, Sir W. Bromley Davenport, London

REFERENCES
Arcangeli 1955, pp. 30–31; A. Pallucchini 1969, pp. 11, 28; R. Pallucchini and Rossi 1982, pp. 25, 143–44, no. 82, with full bibliography; Schulz 1968, pp. 25, 117, no. 46

101
The Washing of Feet

215.5 × 533.3 cm
The Chapter of the Cathedral Church of St. Nicholas,
Newcastle-upon-Tyne
(on loan to the Shipley Art Gallery, Gateshead)
[*detail repr. in colour on p. 124*]

This painting was published as an autograph Tintoretto by Pallucchini (1976), who believes that it is contemporary with, or a little earlier than *The Last Supper* of 1547 in S. Marcuola, Venice. Previously it had been thought to be either a copy of *The Washing of Feet* (Prado, Madrid) or a partly autograph replica of it. It differs from the Prado canvas only in a few background details, which are, however, present in the copy now facing *The Last Supper* in S. Marcuola. From this fact, and other details concerning the provenance of the Prado version, Pallucchini convincingly argued that *The Washing of Feet* in Newcastle (and not the one in the Prado) is the painting originally executed for the Venetian church, and that the copy still in S. Marcuola (Ridolfi 1642, p. 13) had already been substituted for it in the seventeenth century. The Prado version is also autograph and must have been painted shortly afterwards (1547–48).

The painting was cleaned in 1972 and is in a relatively good state of conservation except for a few areas. Tintoretto abandoned some of the fantastic qualities of his earlier works by this stage, and here emphasised the human nature of the event in details like that of the apostle pulling off his companion's stockings, or the conversation between the two apostles seated at the end of the table; the one on the left must certainly be a portrait.

P.R.

PROVENANCE
Alexis Delahante; 2 June 1814 Phillips's sale; H. Baring; 3 June 1814 acquired privately; 1818 presented to the cathedral of St. Nicholas, Newcastle-upon-Tyne, by Sir Matthew White Ridley; 1980 on loan to Shipley Art Gallery

REFERENCES
Borenius 1932, p. 103, note 3 (as a copy); Gould 1959, p. 88 (as a copy); Gould 1975, pp. 258ff; Newton 1952, p. 75 (as a copy); Osmaston 1915, I, p. 54, note 2; II, p. 180 (as perhaps partly autograph); Pallucchini 1976, pp. 81–97; Pallucchini and Rossi 1982, pp. 31–33, 153–54, no. 124

102
The Visitation

250 × 146 cm; originally with an arched top, made up at the sides
Pinacoteca Nazionale, Bologna (inv. 520)

This painting is recorded in the church of S. Pietro Martire, Bologna, in the seventeenth century; it has always been attributed to Tintoretto. The dating, however, is controversial: Venturi (1928, 1929) placed the work at the beginning of the artist's career, and Pittaluga, Tietze and von der Bercken all believe it to be before 1548. But Coletti, Pallucchini and De Vecchi place it in the 1550s, a dating accepted by the present writer.

It reflects on the one hand the artist's early mannerist formation based on the work of Pordenone and Michelangelo, and, on the other, his new sensitivity to landscape, which is found in other works of this decade.

The Virgin and St. Elizabeth dominate the scene, and their meeting is the centre of the painting in both compositional and emotional terms. Their deliberate, measured gestures of greeting are typical of Tintoretto's interpretation of biblical subjects in human terms; it is the

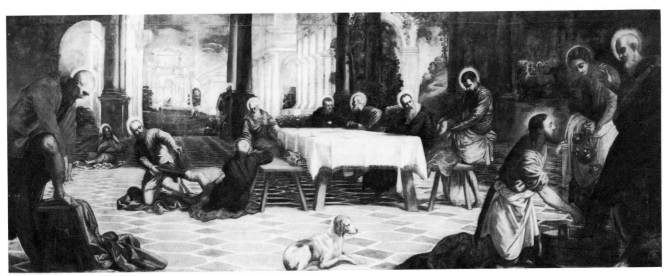

101

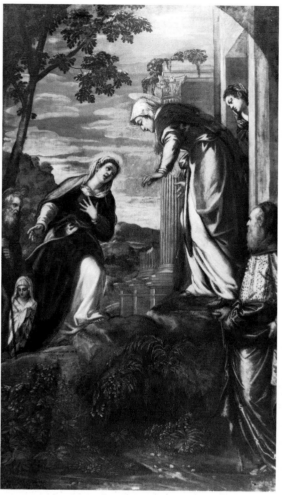

102

subordinate figures who emphasise the significance of the meeting.

P.R.

PROVENANCE
S. Pietro Martire, Bologna; after the Napoleonic suppressions acquired by the Pinacoteca Nazionale

REFERENCES
Pallucchini and Rossi 1982, p. 160, no. 143, with full bibliography

103

St. Louis, St. George and the Princess

226 × 146 cm; arched top
Gallerie dell'Accademia, Venice (no. 899)

This painting, together with two other canvases representing *St. Andrew and St. Jerome* and the *Virgin and Child with Four Provveditori* (Accademia, Venice), was commissioned for the first Sala del Magistrato del Sale in the Palazzo dei Camerlenghi, where it was recorded as the work of Tintoretto (Ridolfi 1648). It was apparently commissioned by Giorgio Venier and Alvise (Louis) Foscarini, who retired from the Venetian magistracy on 13 November 1551 and 1 May 1552 respectively, and who, as

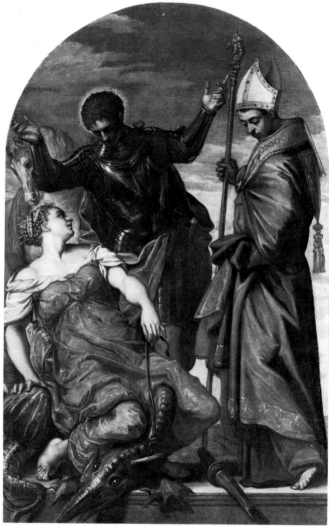

103

was customary on retirement, offered a votive painting of their patron saints to the magistracy in which they had held office. The earliest date for the painting is therefore 1552.

The composition is centred around the princess. Her tense and twisted pose, the plasticity of her figure and her heroic scale all reveal Michelangelo's influence. The extreme plasticity of the three figures, the slightly muted colours and the accentuated contrasts between light and shade are paralleled in other contemporary works of Tintoretto in which a mannerist pictorial language is in evidence. There is a school copy in the Royal Collection (Collins-Baker 1929, p. 142, no. 181).

P.R.

PROVENANCE
Palazzo dei Camerlenghi (Sala del Magistrato del Sale); 1777–1937 in the *antichiesetta* of the Doge's Palace

EXHIBITIONS
Paris 1935, no. 455; Venice 1937, no. 11; Rome 1945, no. 36

REFERENCES
Boschini 1664, p. 271; Ludwig 1902, p. 45; Ridolfi 1648, II, p. 58; Pallucchini and Rossi 1982, pp. 165–66, no. 162, with full bibliography; Zanetti 1771, p. 153

104
Portrait of a Man

145.5 × 87.5 cm
The Governing Body, Christ Church, Oxford (no. 100)

The attribution of this portrait to Tintoretto, first suggested by Borenius, has been unanimously accepted. Borenius considered it to be a very early work of the artist, dating from the 1540s. Von der Bercken, who placed it between 1544 and 1548, and Byam Shaw both considered the portrait to be very close to the *Portrait of a Young Man Aged Twenty-Five* of 1545 (Her Majesty the Queen). Pallucchini, on the other hand, found it very close to the *Portrait of a Young Man* dated 1551 (Metropolitan Museum, New York), and the present writer has dated it *c.* 1553. It is an early masterpiece comparable to the *Portrait of a Young Man Aged Thirty-Five* dated 1553 (Kunsthistorisches Museum, Vienna). The imposing presentation of the sitter is created by the use of strong chiaroscuro, which also accentuates the intensity of his glance.

P.R.

PROVENANCE
1765 Guise

EXHIBITIONS
London 1960, no. 85

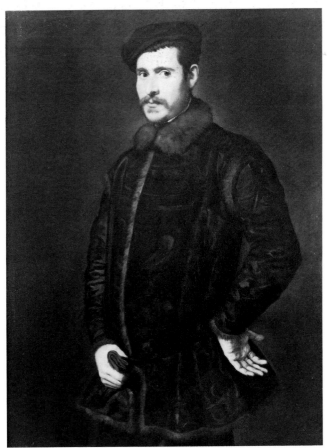

104

REFERENCES
Borenius 1938, pp. 37–38; Byam Shaw 1976, p. 76; Pallucchini 1950, pp. 141–42; Pallucchini and Rossi 1982, p. 56; Rossi 1974, pp. 37, 38, 118, with full bibliography; von der Bercken 1942, p. 119, no. 270

105 & 106
Judith and Holofernes

58 × 119 cm
[*repr. in colour on p. 122*]

The Finding of Moses

56 × 119 cm
Museo del Prado, Madrid (nos. 389 and 396)
[*repr. in colour on p. 122*]

These paintings are from a series of six pictures depicting biblical stories, which Sánchez Cantón suggested might be identified with a group of ceiling paintings of stories from the Old Testament. They were bought for Philip IV in Venice by Velázquez during his second trip to Italy (Palomino). According to Palomino, there was an oval painting in the centre of *The Fall of Manna*, which Sánchez Cantón identified with a *Purification of the Midianite Virgins* in the same format. This identification has been accepted by all but Schulz. Coletti dated the series in the mid-1550s, when Tintoretto was deeply influenced by Veronese, and this has been generally accepted.

The influence of Veronese's style is evident in other works by Tintoretto dating from around 1555, but it is usually less pronounced than in this series – except in the case of *The Assumption* in the church of the Gesuiti, Venice, which was deliberately painted in the manner of Veronese. Here his influence is combined with Tintoretto's own characteristics in a particularly felicitous way. These decorative scenes, fully mannerist in idiom, are imbued with a particularly Venetian spirit by Tintoretto's use of colour and light, and the subjects are presented with his usual narrative verve. Two maidservants flank Pharaoh's daughter who holds the infant Moses; the group creates a calculated rhythm of movement. They are dressed in brilliantly coloured garments which stand out against the luxuriant foliage in the background, yet the precious elegance of form is accompanied by an extraordinary freshness in the treatment of this narrative subject.

P.R.

PROVENANCE
1686 inventory of the Alcázar, Madrid; collection of Isabella Farnese, La Granja

REFERENCES
Coletti 1940, pp. 14–15; Palomino 1947, p. 911; Pallucchini and Rossi 1982, pp. 50, 171–72, no. 184, 187, with full bibliography; Sánchez Cantón 1949, pp. 640–43; Schulz 1968, pp. 125–26

107

Pietà

108 × 170 cm
Pinacoteca di Brera, Milan (no. 149)
[*repr. in colour on p. 125*]

This painting can be identified with a lunette formerly in the courtyard of the Procuratie, for which Tintoretto was paid in part on 19 February 1563, receiving the balance on 31 July 1571. In 1590 Tintoretto restored the work when it was installed in the interior of the new building by Scamozzi (von Hadeln). Ridolfi recorded the painting in the Procuratia de Supra.

Presumably it was painted soon after 1563, given its similarity to *The Deposition* of 1559–60 (Accademia, Venice); the ample proportions and the pose of the Magdalen are derived from *The Deposition*. The mourners are arranged around the lifeless figure of Christ in a kind of syncopated rhythm; all their eyes turn to him and they seem transfixed by the grief they are suppressing.

P.R.

PROVENANCE
1590 Procuratia de Supra

EXHIBITIONS
London 1930, no. 339; Paris 1935, no. 452; Venice 1937, no. 39

REFERENCES
Ridolfi 1648, II, p. 57; Pallucchini and Rossi 1982, p. 185, no. 246, with full bibliography; von Hadeln 1911[1], pp. 39, 54, 57; von Hadeln 1911[2], pp. 125, 129; Zanetti 1771, p. 153

108

Portrait of Sebastian Venier

104.5 × 83.5 cm
Kunsthistorisches Museum, Gemäldegalerie, Vienna (no. 694)

The attribution of this portrait to Tintoretto has been generally accepted, although Venturi and von der Bercken thought it was a copy and De Vecchi rejected it altogether. There are many elements which suggest that it is autograph: notably the virtuoso use of light glinting on the armour and creating a shot effect on the cloak, and the vivid view of the Battle of Lepanto (Sebastian Venier was one of the foremost Venetian commanders) are painted with light, rapid touches of colour on the petrol-blue sea. However, some details are rather less impressive, in particular the hands, which are somewhat harshly modelled.

The portrait must have been painted at about the same time as *Sebastian Venier with a Page* (private coll.; cf. Rossi 1974, p. 134, fig. 160), not long after the Battle of Lepanto

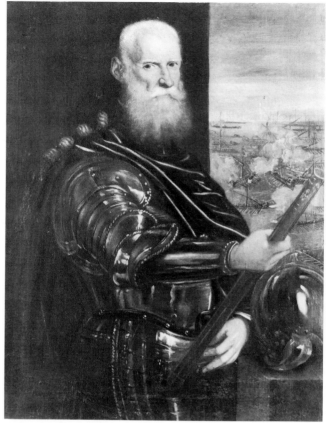

108

in 1571. Between November 1571 and 1572, Tintoretto also painted a large scene of the battle for the Sala dello Scrutinio in the Doge's Palace, which was destroyed by fire in 1577 (Rossi 1982, p. 265). The present painting is a typical state portrait intended for public display. It is more conventional in its positioning of the sitter on the canvas than the portrait in the private collection, and appears to be derived from it. Tintoretto succeeded in infusing a touch of freshness into the penetrating characterisation of Venier.

Ridolfi (1648, II, p. 54) recorded two portraits of Venier by Tintoretto in Venetian collections – one 'in the apparel of a general', in the possession of the Barbarigo family, the other belonging to Nicolò Crasso, which, he said, was 'executed with great diligence'. Lacking further details, it is impossible to know whether the Vienna portrait corresponds with either of them.

P.R.

PROVENANCE
Archduke Leopold Wilhelm

REFERENCES
De Vecchi 1970, p. 137, F. 63; Rossi 1974, pp. 64–65, 130, with full bibliography; Venturi 1925–34, IX, iv, pp. 418, 619; von der Bercken 1942, p. 133, no. 560

109
Portrait of an Elderly Senator

84 × 60 cm
National Gallery of Ireland, Dublin (no. 1122)
[*repr. in colour on p. 127*]

This portrait is unanimously attributed to Tintoretto; the dating of *c.* 1570 proposed by Tietze should be advanced slightly to 1575–80, since the painting is so close in style to the three portraits of Marco Grimani (Prado, Madrid, no. 379; Kunsthistorisches Museum, Vienna, no. 700; Royal Collection), which can all be dated 1576–83 (cf. Rossi 1974, pp. 108, 113, 130).

The four portraits all depict old men who held high positions in the Venetian magistracy, and it is possible that, indirectly, they represent the crisis of values in the society which the sitters themselves represented and served. The drawn features, limp hands and stupefied, although still animated, expression of the senator's eyes, reveal almost shockingly his advanced age. His position in the magistracy is no longer a subject for celebration; instead the emphasis is placed on his years of accumulated experience, and his tragic and profound awareness of the imminence of death. Tintoretto has captured a moment in the sitter's existence and endowed it with the dignity, sensibility and human warmth that distinguish his best portraits.

P.R.

PROVENANCE
Cook Collection, Richmond; 1945 F.A. Drey

REFERENCES
Rossi 1974, pp. 71, 104, with full bibliography; Tietze 1948, p. 359

Jacopo and
Domenico Tintoretto

110
Santa Giustina and the Treasurers

216 × 183 cm
Inscribed bottom right: *1580*; below, corresponding to the three coats of arms, the initials M.A. (originally M.Z., wrongly restored as A); A.M.; A.B.
Gallerie dell' Accademia (no. 225); on deposit at the Museo Correr, Venice
[*repr. in colour on p. 126*]

According to Ridolfi (1648), Boschini (1664) and Zanetti (1771), this painting hung in the Palazzo dei Camerlenghi and was attributed to Jacopo Tintoretto. It may have been a pendant to the *St. Mark with Three Treasurers* (Dahlem Museum, Berlin, no. 316).

On the basis of the coats of arms and the initials, the three treasurers have been identified as Marco Giustiniani (Zustinian), Angelo Morosini and Alessandro Badoer – all magistrates who held office in 1580, the date of the painting. The three figures behind the treasurers are clerks; the inscription '*el nostro fascicolo*' – our documents – (now darkened) which was next to the clerk on the left suggests he was the usher responsible for the Treasury documents.

Mariacher and De Vecchi have suggested that the painting was partly painted by assistants, and certainly there are weak points such as the treasurers' hands, the lifeless glance of the man on the left, a certain forced emphasis in the painting of Santa Giustina – for which a drawing by Jacopo survives (The Hermitage, Leningrad, no. 25641) – and the weak highlighting of the saint's robe. Domenico Tintoretto has been suggested as a collaborator (Rossi). This is a late, routine composition in which Tintoretto's inspiration congealed into the more conventional tones necessary for an official commission.

P.R.

PROVENANCE
Palazzo dei Camerlenghi, first Sala del Magistrato del Sale

REFERENCES
Boschini 1664, p. 226; De Vecchi 1970, pp. 123–24, no. 245 (as Jacopo and assistants); Mariacher 1953, p. 207; Ridolfi 1648, II, p. 58; Rossi 1974, pp. 72, 126; Rossi 1975, p. 41; Pallucchini and Rossi 1982, p. 218, no. 406, with full bibliography (as Jacopo and Domenico Tintoretto); Zanetti 1771, p. 153

Jacopo Tintoretto

111
Modello for 'Paradise'

152.4 × 490.2 cm
Baron Thyssen-Bornemisza Collection, Lugano
[*repr. in colour on pp. 128–29*]

This painting has recently been included in the corpus of Tintoretto's work as the *modello* for the *Paradise* in the Sala del Maggior Consiglio in the Doge's Palace, a vast canvas painted between 1588 and 1592 to replace Guariento's fresco, which was damaged beyond repair in the fire of 1577.

The present *modello* provides a new document in the complex evolution of this work. There is another *modello* (Louvre, Paris), which the present writer believes can be linked to the competition of 1579–80, as a result of which Veronese and Francesco Bassano were chosen to undertake the commission. This *modello* may be linked to a later, undocumented stage of the commission; when Veronese died in 1588, neither he nor Bassano had begun work on the painting and the commission must have been passed on to Tintoretto.

The grandiose conception of the composition seems to have flowed effortlessly from Tintoretto's brush; it must post-date the Louvre *modello* in which the composition was established. Obviously his experience of creating ample, airy, epic canvases in the Scuola di S. Rocco and the Doge's Palace must have contributed to this facility. The present *modello* is closer than the one in Paris to the final canvas, which was painted almost entirely by Domenico Tintoretto, perhaps with help from other assistants. Schulz believes that the two *modelli* could be part of an initial project for the

replacement of Guariento's fresco, perhaps dating from around 1564, in which Zuccari may also have been involved. Pallucchini, however, believes that the Louvre *modello* was executed in competition with Zuccari, and that the present work was painted around 1580.

P.R.

EXHIBITIONS
Los Angeles 1979, no. 37

REFERENCES
Pallucchini and Rossi 1982, pp. 98–99, 231–32, no. 461, with full bibliography; Schulz 1980, pp. 112–26

112

The Deposition

288 × 166 cm
S. Giorgio Maggiore, Venice

Recorded in seventeenth-century sources as a work by Tintoretto, *The Deposition* belongs to the very end of the artist's career. Work began on the Cappella dei Morti, where the painting still hangs, in 1592, and two years later 70 ducats were paid for this altarpiece (Cicogna).

Venturi suggested that Tintoretto's son, Domenico, assisted in the execution of the painting, and the present writer agrees that he was involved in a very minor capacity, but overall, the work reveals a sensibility typical of Jacopo, who was still able to create a work of contained dramatic force by using a sombre tonality interrupted by brilliant flashes of light, and by setting the desolate, limp body of Christ against that of the unconscious Virgin in the background.

P.R.

EXHIBITIONS
Venice 1937, no. 74

REFERENCES
Boschini 1664, p. 566; Cicogna 1834, p. 353 (note 270), 385, 388; Ridolfi 1648, II, p. 60; Pallucchini and Rossi 1982, pp. 108–09, 234, no. 468, with full bibliography; Venturi 1925–34, IX, IV, pp. 613, 618

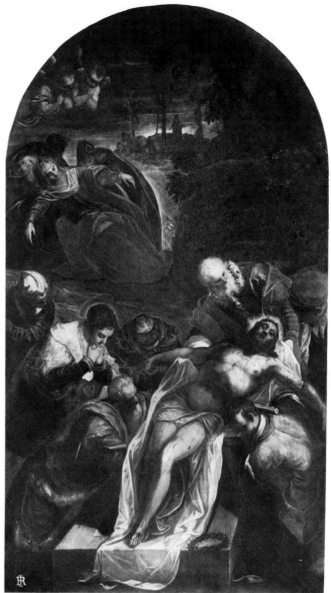

112

Tiziano Vecellio, called

Titian

Pieve di Cadore *c.* 1480/85 – Venice 1576

Contemporary evidence can be adduced to support a variety of dates between 1473 and 1490 for Titian's birth. Much recent criticism, exemplified by Wethey, favours the latest possible dating, but Panofsky and Hope have argued more convincingly for a date in the first half of the 1480s, which is accepted here. According to Dolce and Vasari, Titian was sent to Venice as a young boy and trained by Gentile and/or Giovanni Bellini, adopting the new manner of Giorgione in about 1507. In 1508 he frescoed the side façade of the Fondaco dei Tedeschi in Venice; in 1516 he was appointed to work in the Sala del Maggior Consiglio in the Doge's Palace and in the same year he began work on the *Assunta* (fig. 19) for the high altar of the Frari. At this time he also began working for Alfonso d'Este, Duke of Ferrara, his first courtly patron outside Venice. From 1523 Titian worked also for Federigo Gonzaga, Marquis and later Duke of Mantua. His *Death of St. Peter Martyr* (see fig. 14), completed for SS. Giovanni e Paolo in Venice in 1530 and widely considered to be his masterpiece, was destroyed by fire in 1867, while the great battlepiece for the Sala del Maggior Consiglio, completed in 1538, suffered a similar fate in 1577. The Emperor Charles V became a major patron after 1532, but Titian also worked for Pope Paul III and other members of the Farnese family, visiting Rome in 1545–46. In 1548 and 1550, he travelled to the Imperial court at Augsburg, and between 1551 and 1554 he was working on the great *Trinity* (also called the *Gloria*) now in the Prado, Madrid, which the Emperor took with him on his retirement to Yuste. In the 1550s Philip II of Spain

became Titian's principal patron and received from the artist a splendid series of religious and mythological pictures (fig. 16).

G.R.

REFERENCES

Dolce 1557, pp. 51–52; Hope 1980, pp. 10–11; Panofsky 1969, pp. 176–79; Vasari (ed. Milanesi) 1881, VII, pp. 426–28; Wethey 1969, I, pp. 40–42

113

Jacopo Pesaro Presented to St. Peter by Pope Alexander VI

145 × 183 cm

Inscribed on a tablet: RITRATTO DI VNO DI CA^{sa} PESARO / IN VENETIA CHE FV FATTO / GENERALE DI S^{ta} CHIESA. / TITIANO F.

Musée Royal des Beaux-Arts, Antwerp (no. 357)

[*repr. in colour on p. 55*]

The inscription is clearly not contemporary, but the information it gives seems to be correct, if imprecise. The kneeling figure is certainly Jacopo Pesaro, who was portrayed again by Titian in the *Pesaro Madonna* in the Frari. He was appointed papal legate to command a detachment of galleys against the Turks on 20 April 1502 and won a victory at Santa Maura (Leucadia) on 23 August.

Mather has suggested that the picture must have been painted, or at least commissioned, before the engagement, as it shows no battle, but it seems much more likely that it is an *ex voto* expressing thankfulness for the victory. Crowe and Cavalcaselle thought that it must have been painted before Pope Alexander's death in 1503, since hatred of the Borgias would have prevented his being portrayed later, but Hope has plausibly suggested that it must postdate his death as a living pope would not have been shown standing in the presence of the saint. He also argues that, since Pesaro was absent from Venice from early 1503 until 1506, the picture dates from the latter year. Other authorities, such as Wethey, who accept a late date for Titian's birth, date the whole picture as late as *c*. 1512, Suida even suggesting that the portraits were not finished until about 1520. Others have proposed that the execution of the picture falls into two distinct phases and this has been most fully elaborated by Meyer zur Capellen, who has supported this view with arguments based on supposed differences in the surface appearance of the picture and spatial confusion on its left-hand side, and on discrepancies in the treatment of the head of St. Peter and those of the other two figures revealed by x-rays. The differences of surface and the spatial confusion are not apparent to the present writer, to whom the picture appears a unity, and the admitted discrepancies shown in the x-rays might be explained by the hypothesis that Titian adopted a different approach in his portraits and in the conventional portrayal of a saint.

The composition is certainly the most primitive in Titian's surviving work, perpetuating a familiar scheme of the fifteenth century, and the St. Peter is, in general terms, Bellinesque. In the view of the present writer, the design was made not later than 1506, perhaps earlier, and the picture

was completed later, shortly after Pesaro's return to Venice in that year. The iconography of the pseudo-antique relief decorating the socle of St. Peter's throne, which has some analogies with the grisaille fragments from Titian's part of the decoration of the Fondaco dei Tedeschi, has been studied by Wittkower, who interprets Cupid (on the altar in the centre) as Divine Love, his spiritual character emphasised by the juxtaposition of St. Peter's keys. He shoots at Venus Victrix, the figure next to the corselet, whose portrayal here has special significance since Pesaro was titular bishop of Baffo, the ancient Paphos. The whole relief echoes the theme of the papal victory. It has also been studied by Tressider, who noted stylistic resemblances to the contemporary reliefs of Antonio Lombardo, as well as to antique sources, and further elaborated the iconographical interpretation.

G.R.

PROVENANCE

Presumably commissioned by Jacopo Pesaro, probably for his palace rather than a church; 1623 seen by Van Dyck in Venice; 1639 in the collection of Charles I at Whitehall; 1650 Thomas Bagley; Don Gaspar Henríquez de Cabreras, Duque de Medina de Rioseco; Convent of S. Pascuale, Madrid; Godoy; Principe de la Paz; King William of Holland; 1823 donated by King William to the Musée Royal des Beaux-Arts

EXHIBITIONS

London 1930, no. 158 (commemorative catalogue, no. 356); Venice 1935, no. 3

REFERENCES

Crowe and Cavalcaselle 1877, I, pp. 74–79; Hope 1980, pp. 23–26; Mather 1938, pp. 18–19; Meyer zur Capellen 1980, pp. 144–52; Suida 1935, pp. 23–24, 151; Tressider 1979, I, pp. 142–59; Wethey 1969, pp. 152–53; Wittkower 1938–39, pp. 202–03

114

Salome

90 × 72 cm

Galleria Doria-Pamphilj, Rome

[*repr. in colour on p. 65*]

This composition exists in three early versions, of which this is widely accepted as the finest. It was ascribed to Titian in early inventories, but was attributed to Giorgione by the time Crowe and Cavalcaselle wrote. They confidently ascribed it to Pordenone, but Morelli, in rare agreement with von Bode, argued convincingly for Titian's authorship, which has been generally accepted. It is usually dated about 1515, but Hope has noted its dependence on Sebastiano del Piombo's version of the same subject of 1510 (National Gallery, London). He also considers that the model was the same as that used by Giorgione for his *Venus* (Gemäldegalerie, Dresden) and has suggested a date of about 1511.

Panofsky has emphasised the erotic elements in the picture and pointed out that the tradition of Salome's love for the St. John the Baptist goes back at least as far as the twelfth century, when it formed the subject of a Latin poem. The cupid on the keystone of the arch in the background, while emphasising this element, also reflects the widespread use of winged putti as keystone decoration on the arches of

public buildings in fifteenth-century Venice (as, for instance, in the Arco Foscari, the Arsenal gateway, the main door of the Scuola Grande di San Marco and the choir arch of S. Giobbe) and this also stresses the official nature of St. John's imprisonment and execution. Panofsky has suggested that the head of the Baptist may be a self-portrait.

G.R.

PROVENANCE
1592 Lucrezia d'Este, Duchess of Urbino (?); 1602 Cardinal Pietro Aldobrandini, Rome; by 1665 Olimpia Aldobrandini-Pamphilj; Giovanni Battista Pamphilj; Galleria Doria-Pamphilj

EXHIBITIONS
London 1930, no. 165 (commentary to no. 359)

REFERENCES
Crowe and Cavalcaselle 1912, III, pp. 29, 178; Hope 1980, p. 32, pl. IV; Morelli 1982, I, p. 307; Panofsky 1969, pp. 20, 42–47; Richter 1937, pp. 227–28; Wethey 1969, pp. 155ff

115

Holy Family with a Shepherd

99 × 137 cm
The National Gallery, London

This is one of the earliest known examples of a type of religious composition that was to become immensely popular in Venice. Slight weaknesses in the drawing of the Madonna and the fact that she seems too small prompted various scholars from Crowe and Cavalcaselle onwards to question Titian's authorship. But the other names proposed – Lotto, Palma Vecchio and Bordone – are clearly unacceptable, and in the past thirty years the traditional attribution has been unanimously accepted. As with virtually all Titian's early works the precise date is controversial, and proposals range from *c.* 1510, favoured by the present writer, to *c.* 1516. The issue cannot be settled until agreement is reached about the authorship of *The Virgin and Child with St. Anthony and St. Roch* (Cat. 34) and *Christ and the Adulteress* (Cat. 35), which, if also by Titian, must both be of around 1510. The present exhibition provides a unique opportunity to compare these two problematic works with a group of undisputed early paintings by Titian, notably the votive picture from Antwerp (Cat. 113), which seems to be the earliest, this *Holy Family* and the *Salome* (Cat. 114), which is surely the latest of the three.

C.H.

PROVENANCE
1693 Palazzo Borghese, Rome; by 1799 acquired by W. Ottley; W. Champion; 1810 acquired by Holwell Carr; 1831 bequeathed to the National Gallery

REFERENCES
Crowe and Cavalcaselle 1877, II, p. 428; Freedberg 1971, p. 95; Gould 1975, pp. 267f; Hope 1980, p. 40 note 19; Pallucchini 1969², pp. 33, 247; Valcanover 1969, p. 99, no. 77; Wethey 1969, pp. 94f, with full bibliography

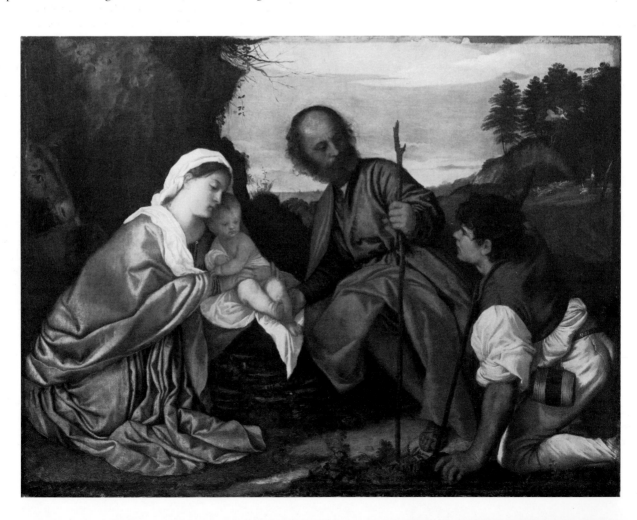

116

Portrait of a Man

85.6 × 72.5 cm
Her Majesty The Queen (no. 149)
[repr. in colour on p. 79]

Traditionally this portrait was said to represent Boccaccio and later Alessandro de' Medici, but neither identification can be supported. Gronau claimed to have seen a copy with an inscription identifying the sitter as the poet Jacopo Sannazaro, and this identification is not irreconcilable with other evidence of Sannazaro's appearance. But if it is intended to represent the poet it must be based on an earlier picture since this portrait cannot have been painted before 1510 when Sannazaro, who was born in 1458, was already in his fifties – much older than the man shown here.

The portrait was ascribed to Titian in Charles II's inventory, and to Giorgione in those of James II and Queen Anne, but Crowe and Cavalcaselle were unable to pronounce on the authorship of the picture in the state in which they saw it. The picture is indeed rubbed and badly damaged, but much of its original quality has been recovered and it has been accepted by recent critics, with the exception of Hetzer and Tietze, as an autograph work. Gronau and Fischel dated it about 1511, but Suida felt 1513–14 to be more appropriate and Ricketts, though he found its dating difficult, associated it with the *Physician Parma* (Cat. 117) and placed it *c.* 1514–16. More recently Valcanover and Pallucchini have advanced the date to *c.* 1518–20, but the costume would seem to favour an earlier dating, *c.* 1511–12.

G.R.

PROVENANCE
Gerrit van Reynst, Amsterdam; 1660 Dutch gift to King Charles II; Whitehall; Kensington Palace; 1834 Hampton Court

EXHIBITIONS
Manchester 1857, no. 256; Leeds 1868, no. 237; London 1872, no. 72; London 1915, no. 18; London 1946, no. 199; London 1960, no. 20; London 1964, no. 22; London 1976; London 1977, no. 23

REFERENCES
Berenson 1894, p. 124; Berenson 1957, p. 186; Collins-Baker 1929, pp. 143–44; Crowe and Cavalcaselle 1877, II, p. 465; Fischel 1911, p. 18; Gronau 1904, pp. 43, 279; Mahon 1950, p. 12; Pallucchini 1969², p. 254; Ricketts 1910, pp. 46, 54; Shearman 1983, pp. 251–52, no. 270, pl. 229; Suida 1935, pp. 33, 153; Valcanover 1969, no. 94; Wethey 1971, p. 138

117

Portrait of a Man
(called the Physician Parma)

88 × 75 cm
Kunsthistorisches Museum, Gemäldegalerie, Vienna (no. 708)
[repr. in colour on p. 81]

While there is general agreement as to the high quality of this painting, many scholars, notably Crowe and Cavalcaselle, have doubted the attribution to Titian. While there is nothing in the conception to make the composition irreconcilable with Titian's practice around 1510–20, the actual handling seems lighter and more delicate than we would expect from him. Wilde thought that the technique, painted *alla prima* without underpainting, ruled out Titian as the author, and the catalogue of the London exhibition of 1949 stated that 'Titian's authorship of this work . . . can no longer be upheld after the recent cleaning'. Wickhoff attributed the portrait to Domenico Campagnola, and Cook (predictably) to Giorgione, an opinion followed with some reserve by Justi. Hetzer ascribed it to an unknown painter of the first quarter of the century and Tietze omitted it from his catalogue. On the other hand, Morelli, followed by Berenson, Gronau, Suida and, more recently, Baldass, Klauner and Oberhammer, Valcanover, Pallucchini, and Wethey, stood firm for the Titian attribution. The attribution to Giorgione does not really seem possible, and the present author prefers the ascription to Titian, who was capable of great variations of style between contemporary works, rather than an attribution to a second-rate painter like Domenico Campagnola or an unknown artist. In its delicacy of finish the painting may be compared to the *Tribute Money* in the Gemäldegalerie, Dresden or, to a lesser extent, the *Portrait of a Man* in Copenhagen.

The identification of the sitter as Titian's physician, Parma, rests on the assumption that this is the picture described by Ridolfi in the collection of Bartolomeo della Nave in Venice. The description fits well and we know that much of the della Nave collection passed into that of Archduke Leopold Wilhelm, with which this picture came to Vienna, and, although the portrait cannot be identified with any of the items listed in della Nave's collection in the inventory published by Waterhouse from the Hamilton papers, Garas has identified it in another Hamilton inventory. Schupbach has plausibly identified Ridolfi's '*Medico suo detto il Parma*' with Gian Giacomo Bartolotti (active 1491–1530), a member of a medical family from Parma who was a doctor with the Venetian fleet in 1505–07 and Prior of the Collegio dei Medici in Venice in 1511 or 1512, and who left a number of writings in manuscript, including a vigorously obscene Macaronic poem. Schupbach also, again plausibly, identifies the same sitter at an earlier age, in Giorgione's *Terris Portrait* in San Diego, California.

Gronau suggested a date of 1511, from a comparison of this portrait with the Padua frescoes, and in this he was followed by Fischel, but Ricketts suggested a later date of *c.* 1514–16. Wethey suggested 1515–18 and Valcanover as late as 1520. The age difference between the sitters in this and the *Terris Portrait* – if that is of the same sitter – suggest a date towards the end of the second decade. The picture is often linked in discussion with the so-called Sannazaro portrait from the Royal Collection (Cat. 116).

G.R.

PROVENANCE
Collection of Bartolomeo della Nave (?), Venice; by 1659 Archduke Leopold Wilhelm, Brussels; Imperial Collection, Vienna

EXHIBITIONS
London 1930, no. 164 (commentary to cat. no. 360); London 1949², no. 181

REFERENCES
Baldass 1957, pp. 150–52; Berenson 1894, p. 127; Berenson 1957 p. 191;

Cook 1907, p. 148; Fischel 1911, pp. 19, 248; Garas 1967[1], pp. 39–80; Gronau 1904, p. 276; Hetzer cited in Wilde 1928; Justi 1908, II, no. 59; London 1949, p. 72; Morelli 1892, I, p. 308; Oberhammer and Klauner 1960, I, p. 134; Pallucchini 1969, p. 254; Ricketts 1910, p. 46; Ridolfi 1914, I, p. 169; Schupbach 1978, pp. 142ff.; Suida 1935, pp. 33, 152; Valcanover 1960, I, pl. 85; Valcanover 1969, no. 96; Waterhouse 1952, pp. 14–20; Wethey 1971, II, p. 121; Wickhoff 1893, pp. 135–36; Wilde 1928, pp. 231–32, amplified in conversation with the author in 1937

118

Portrait of Tommaso Mosti (?)

85 × 67 cm
Inscribed on back of canvas:
DI.THOMASO. MOSTI. / IN.ETA.DI.ANNI
XXV. L'ANNO. / M.D.XXVI. / THITIANO DA CADORO / PITTORE
Galleria Palatina, Palazzo Pitti, Florence (no. 495)
[repr. in colour on p. 78]

The inscription is old but certainly not contemporary; the picture is on its original canvas and has been neither relined nor transferred. While Berenson, Wethey and others have accepted the date of 1526, the content of the inscription has been challenged as regards both the date and the identification of the sitter. Tommaso Mosti was a Ferrarese courtier intimate with Alfonso d'Este, Duke of Ferrara, but by 1524, at the latest, he had taken holy orders and 1526 is not a year in which Titian is otherwise known to have been in Ferrara. Lazzari suggested that the sitter was Mosti's younger brother Vincenzo and this view has been widely accepted, but, as Wethey has pointed out, this can hardly be the case if we adhere to the date of 1526 and the age of 25 for the sitter, since Vincenzo is known to have distinguished himself at the Battle of Ravenna in 1512. Zecchini (Florence 1978–79) has suggested the possibility of the sitter being the third Mosti brother, Agostino, who was a literary figure and a follower of Ariosto, but if the inscription is to be relied on at all, then it is not very easy to understand how the wrong christian name came to be given.

Some of these difficulties are removed by Hope's suggestion that the date should read 1520, and one can see how a mistake might have arisen if the original inscription – perhaps on the stretcher, which, according to Zecchini, has been renewed – gave the date in arabic figures, as a nought might easily be confused with a six. Hope thinks this picture may be identical with one of an unidentified sitter that Alfonso is known to have commissioned from Titian in that year. He also draws attention to the analogies between this picture and Raphael's Portrait of Castiglione, (Louvre, Paris) which Titian might have seen on a visit to Mantua in 1519. Ricketts associated the picture with Titian's Man with a Glove and Man in Black in the Louvre, dating them about 1520, with which Valcanover agreed. On the other hand, Gronau proposed a date of 1516, which Suida and Tietze accepted, while Hetzer suggested 1515. The association with the Man with a Glove is compelling and suggests that Hope's emendation of the date to 1520 is correct.

G.R.

PROVENANCE
1675 entered the Palazzo Pitti with the collection of Cardinal Leopoldo de'Medici

EXHIBITIONS
Venice 1935, no. 20; Stockholm 1962–63, no. 89; Florence 1978–79, no. 55

REFERENCES
Berenson 1957, I, p. 185; Crowe and Cavalcaselle 1877, I, p. 303; Fischel 1911, pp. 34–35; Gronau 1904, p. 292; Hetzer in Thieme-Becker 1940, p. 161; Hope 1980, pp. 62–64; Lazzari 1951, pp. 185–86; Ricketts 1910, p. 64; Suida 1935, pp. 30–35; Tietze 1936, I, p. 124, II p. 289; Valcanover 1969, no. 95; Wethey 1971, II, pp. 119–20

119

St. John the Baptist

201 × 134 cm
Signed on the stone on which the saint rests his left foot: TICIANVS
Galleria dell'Accademia, Venice (no. 194)

Much praised by early writers, this impressive picture has not commended itself so strongly to more recent critics, who have also disagreed about its dating. It must have been painted before 1557, when Dolce wrote in praise of it, and Crowe and Cavalcaselle seem to have thought it not much earlier. Mayer, on the other hand, proposed a dating before 1533, on the grounds of, first, the spelling of the name in the signature – with a 'c' rather than a second 'T' – and, second, the stylistic resemblance to figures in the Brescia polyptych of 1522. He has been followed recently by Hope, who has dated the picture to 1531 and related it to the lost Death of St. Peter Martyr (see fig. 14). It is true that Titian seems in general to have abandoned spelling his name with a 'c' by the mid-1530s, but we cannot be certain he never reverted to it later, and strong stylistic relationships can be seen with works of the early 1540s, such as The Allocution of Alfonso d'Avalos (Prado, Madrid), The Crowning with Thorns of 1540–42 (Louvre, Paris) and, as Ricketts observed, the Ecce Homo of the following year (Kunsthistorisches Museum, Vienna). Brendel has suggested that the figure derives from the same antique model as the Risen Christ in Urbino of 1542–44, and certainly it is exceptional in Titian's work to find such an all'antica pose. Tietze dated the painting in this period, while Suida and Wethey placed it after Titian's return from Rome in 1546, but Valcanover, who had earlier accepted a date in the early 1540s, recently placed it in the late 1530s on the grounds of the similarity in terms of colour between St. John and The Presentation in the Temple (Accademia, Venice), revealed by the recent cleaning of both pictures (Venice 1981).

G.R.

PROVENANCE
S. Maria Maggiore, Venice; 1808 destined for the Accademia when the church was secularised, but considered for removal to the Brera, Milan; 1812 recorded in the Accademia

EXHIBITIONS
Venice 1935, no. 35; Venice 1946, no. 230; Venice 1981[1], no. 15

REFERENCES
Brendel 1955, pp. 121–22; Crowe and Cavalcaselle 1877, II, p. 251; Dolce 1557, p. 54; Hope 1980, pp. 69–70; Mayer 1937, p. 178; Ricketts 1910, p. 114; Suida 1935, p. 125; Wethey 1969, I, pp. 136–37

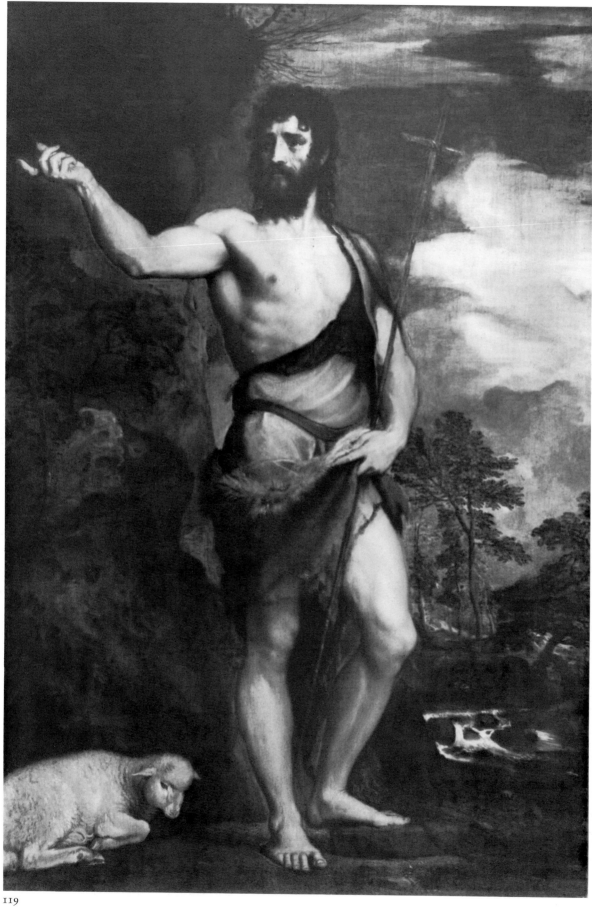

119

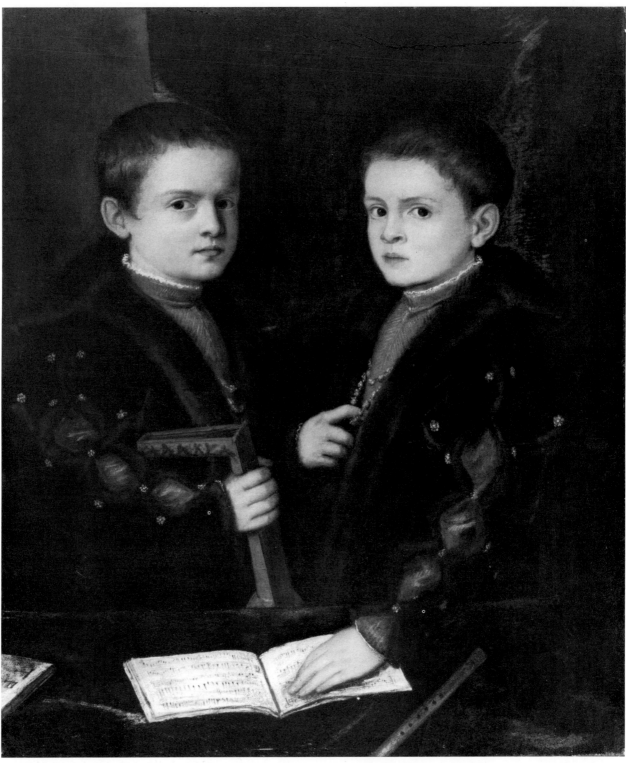

120

120

Portrait of Gerolamo Melchiorre and Francesco Santo da Pesaro

91.5 × 77 cm
Signed slantwise and upside down at lower left: TF
Private Collection

This, one of the very few double portraits by Titian which is known to survive, ranks high among his sensitive portrayals of children. None but he could tune his young sitters to such a pitch. The presence of the painting in the gallery at Ca' Pesaro in 1797 implies the family of the sitters; while their ages and the style of painting leads to their identification, for no other pair of Pesaro brothers, so close in age, could have been portrayed thus in the 1540s.

We know that the S. Benetto pictures were transferred to S. Stae (see provenance). The sons of Benedetto Francesco Giuseppe Pesaro and Lucrezia Valier were Gerolamo Melchiorre, born 30 June 1536, and Francesco Santo, born 7 November 1537. Close comparisons in Titian's style of painting can be made with the portrait of *Ranuccio Farnese* (Cat. 121), who was in Venice from 1541 to 1542, aged 12; and with that of *Clarice Strozzi*, signed and dated 1542 (Dahlem Museum, Berlin). When the Procurator Girolamo Pesaro came to make his last will (7 November 1549), he referred to the children of his sole surviving son, Benedetto, as 'his dearest grandsons Gerolamo and Francesco da Pesaro'.

X-rays have revealed Titian's effort to establish the most meaningful relationship between the boys' heads before elaborating the composition. The back contour of the elder child's head was reduced in order to lift it and bring it a shade closer to the centre of the canvas. Many experimental strokes were made to determine the rest of the picture: the elder boy's right forearm was originally bent acutely upwards to grasp some object other than the neck of the lute as finally painted; a slight ebullience in the leaves of the open part-book was calmed to keep a balance between the heads and what is, in effect, the third major light; and a pentimento in the younger child's hand, moving the fingers further toward the gutter of the book, also mutes this third light. The pattern of a carpet can be descried beneath what became a plain cloth.

The tenor part lies shut beside the lutenist. In the superius part there is a C-clef, an ornament initial (perhaps G) followed by four breves, then a quicker continuation in the French style; all are consonant with sixteenth-century Venetian taste in madrigals. But the staves indicated are not transcribed from a precisely identifiable piece, and the musical apparatus does not appear to be symbolic.

M. J.

PROVENANCE

c. 1544 presumably painted for Benedetto Francesco Giuseppe Pesaro da S. Benetto, or for his father the Procurator Girolamo Pesaro; thence by family descent to Senatore Lunardo Pesaro (b. 20 February 1689), Ca' Pesaro, S. Stae; October 1797 listed for his sons in the gallery at Ca' Pesaro by Pietro Edwards and Francesco Maggiotto as *No. 68 detto* (Tiziano). *Ritratti di due Giovanetti, 7 × 2: P. 528* (Venetian feet followed by valuation in lire); November 1828 acquired from the Abate Luigi Celotti at the Ca' Barbarigo by James Irvine on behalf of Sir William Forbes, 7th Bart. of Pitsligo (1773–1828), Edinburgh; Lord Clinton

EXHIBITIONS

Edinburgh 1883 (as Titian *Two Princes of the Pesaro Family*)

REFERENCES

Jaffé 1971, pp. 696–702; Wethey 1975, p. 266, no. 77a

121

Portrait of Ranuccio Farnese as a Knight of Malta

89.7 × 73.6 cm
Incribed on background to right: TITIANVS/F
National Gallery of Art, Washington D.C., Samuel H. Kress
Foundation (K. 1562)
[*repr. in colour on p. 80*]

It is known that Titian painted a portrait of Ranuccio Farnese (1530–65), the grandson of Pope Paul III, in Venice in 1542 from a letter of 22 September of that year from Gian Francesco Leoni to Cardinal Alessandro Farnese, Ranuccio's elder brother. That the boy represented here is Ranuccio is established by a comparison with a figure in a fresco at the Farnese villa of Caprarola, which Vasari tells us contained a portrait of Ranuccio. He is shown as a Knight of Malta because he was *prior in commendam* of the knights in Venice.

Before cleaning the picture was widely regarded as a copy or a studio work, but its autograph status has been confirmed by the high quality of the painting revealed when it was cleaned. It is now generally accepted as a masterpiece fit to stand beside the portrait of *Clarice Strozzi* (Dahlem Museum, Berlin) of the same year, as an example of Titian's sensitive approach to child portraiture.

G. R.

PROVENANCE

Farnese Collection, Rome; probably by 1620, certainly by 1680 Farnese Collection, Parma; probably by 1734 Royal Collection, Naples; before 1885 brought to London by Sir George Donaldson; Contini Collection, Florence; 1948 Kress Collection; 1951 National Gallery of Art, Washington D.C.

REFERENCES

Kelly 1939, p. 75; Ricketts 1910, p. 107, no. 1; Ronchini 1864, p. 130; Suida 1935, p. 165; Vasari (ed. Milanesi) 1881, VII, p. 113; Wethey 1971, pp. 98–99, with full bibliography

122

Portrait of Francesco Savorgnan della Torre (?)

123 × 96 cm
Inscribed on back of canvas: CA ZORZI
The National Trust, Kingston Lacy
[*repr. in colour on p.87*]

The sitter was traditionally identified as the famous military commander Girolamo Savorgnan. This was questioned by Crowe and Cavalcaselle and cannot be maintained, both on chronological grounds (since Girolamo died in 1529 and the picture clearly dates from the 1540s), and because the man here seems to be a statesman rather than a commander. The picture was acquired by Henry Bankes from the Marescalchi Collection in Bologna around 1820. Fabbro has shown that the del Torre branch of the Savorgnan family died out in 1810 and that its collections, probably including family portraits ascribed to Titian, were sold at that time, and he has suggested that the Marescalchi family then acquired the picture. He has also suggested that it represents not Girolamo but Francesco Savorgnan della Torre (1496–1547), a member of the Maggior Consiglio. This is plausible, but there is no actual proof that the picture came from the Savorgnan Collection.

The inscription CA ZORZI, recently revealed on the back of the canvas, might suggest that we should look for the sitter among members of the Zorzi family. Lorenzetti records two Zorzi palaces – one on the Rio S. Giorgio dei

Greci, the other the well-known palace by Mauro Codussi near S. Maria Formosa – and a number of Zorzi monuments in the church of S. Stefano. The portrait seems closely related in style to the *Vendramin Family* in the National Gallery, London.

G.R.

PROVENANCE
Possibly Venice, Palazzo Savorgnan della Torre at S. Geremia; 1810 sold; Marescalchi Palace, Bologna; *c.* 1820 acquired by Henry Bankes of Kingston Lacy, possibly on the advice of Lord Byron

EXHIBITIONS
London 1902, no. 84; London 1960, no. 83

REFERENCES
Crowe and Cavalcaselle 1877, II, pp. 20–21; Fabbro 1951, pp. 185–86; Gronau 1904, p. 279; Lorenzetti 1926, pp. 306, 358, 473, 475; Wethey 1971, pp. 138–39, with full bibliography

123

Portrait of a Knight with a Clock

122 × 101 cm
Museo del Prado, Madrid (no. 412)
[*repr. in colour on p. 82*]

Although this picture was ascribed to Tintoretto in the Alcázar inventory of 1666, the attribution to Titian is generally accepted and the painting dated about 1550 or a little later. The cross on the sitter's breast was formerly supposed to indicate that he was a Knight of Malta, but its form differs from the Maltese pattern (as may be seen by comparison with the *Portrait of Ranuccio Farnese* [Cat. 121]) and the suggestion has been abandoned. No convincing identification of the sitter has been advanced.

Wethey (1971) states inaccurately that the clock is the same as that which appears in the *Portrait of Eleanora Gonzaga* in the Uffizi, Florence, and infers that it belonged to Titian. In fact, Titian shows table-clocks of this type in a number of his portraits, but each one is different. He might be painting variations of his own clock, but it is more likely that the clocks belonged to the individual sitters, and that, being expensive and exclusive toys, they were introduced in part, as Panofsky has suggested, as status symbols. Panofsky has also drawn attention to their function as symbols both of temperance and of transience.

Alice Wethey, who has examined the problem, considers that clocks are not grand enough to be status symbols and also questions the other symbolic functions suggested by Panofsky. She concludes that they are variations on clocks in Titian's possession. (Wethey 1975, appendix by A. Wethey).

G.R.

PROVENANCE
By 1633 perhaps Ludovisi Collection, Rome; 1637 presented to Philip IV by Prince Niccolò Ludovisi; by 1666 Alcázar, Madrid; 1827 probably transferred to the Museo del Prado

EXHIBITIONS
Geneva 1939, no. 167

REFERENCES
Allende-Salazar and Sánchez Cantón 1919, pp. 54–56; Panofsky 1969, pp. 88–90; Wethey 1971, II, p. 114, with full bibliography; Wethey 1975, III, pp. 249–50

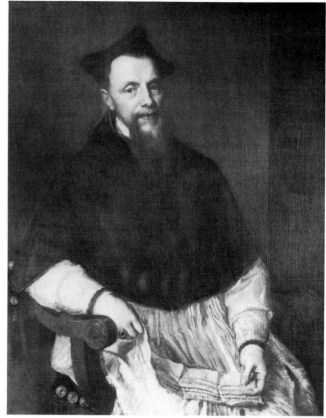

124

124

Portrait of Ludovico Beccadelli

117 × 97 cm
Inscribed on the open letter held by the sitter:
IULIUS PP. III/*Venerabili fratri Ludovico Epō. Ravelleñ. apud Dominium Venetorum nostro et Aplīcae sedis Nuntio/ Cum annum ageret* LII. *Titianus Vecelius faciebat. Venetiis* M.D.LII *Mense Julii;* added below: *Translatus deinde* MDLV. *die* XVIIJ. *septembris a Paulo Quinto Pont. Maximo ad/ Archiepiscopatum Ragusinum; quo pervenit die* IX. *Decembris proxime subsequenti*
Gallerie degli Uffizi, Florence (no. 7457)

Ludovico Beccadelli of Bologna (1501–72) was tutor to Ranuccio Farnese from 1544 to 1549 (see Cat. 121), in which year his grateful pupil persuaded his grandfather, Pope Paul III, to make him Bishop of Ravello. He was appointed Papal Nuncio to Venice in 1550 and Archbishop of Ragusa in 1555; in 1563 he became tutor to Ferdinando de' Medici and in the following year Bishop of Prato. The latter part of the inscription on the letter, referring to Beccadelli's appointment as Archbishop of Ragusa, is clearly a later addition; the date of 1552 given in the earlier part of the inscription is confirmed by a letter of Aretino of October that year, enclosing the usual tedious adulatory sonnet, and may safely be accepted as that of the picture.

The painting is generally considered a fine original, surely rightly so, but Salvini and Berti have suggested that it may be no more than an old copy. Apart from the quality of the

painting, the fact that the addition to the inscription appears to be in a different hand makes this very unlikely.

G.R.

PROVENANCE

By 1663 collection of Cardinal Leopoldo de' Medici, probably acquired from Bologna in 1553, possibly from the Beccadelli family; 1675 Grand Ducal Collection

EXHIBITIONS

Florence 1978–79, no. 56, with full bibliography

REFERENCES

Aretino 1957, II, pp. 411–12; Berti 1971, p. 86; Salvini 1952, p. 63; Wethey 1971, II, p. 81, with full bibliography

125

Portrait of Cristoforo Madruzzo, Cardinal and Bishop of Trent

210 × 109 cm
Inscribed on the paper below the sitter's right hand: *Anno* MDLII *aetatis suae* XXXVIIII. *Titianus fecit*; *1552* on the clock
Museu de Arte de São Paulo, São Paulo
[*repr. in colour on p. 103*]

Cristoforo Madruzzo was appointed bishop of his native city of Trent in 1539 and made a cardinal in 1543. He was a staunch supporter of the Spanish cause, closely linked to the Emperor, which perhaps explains why he did not have himself shown as a cardinal in this picture. The portrait was formerly dated 1542 on the strength of a letter supposed to date from that year, published by Oberziner, but this is inconsistent both with a letter of introduction to Madruzzo, given to Titian by Count Gerolamo della Torre on his way to Augsburg in 1548 and printed by Crowe and Cavalcaselle, which rules out any earlier acquaintance, and with the dates now to be read on the picture itself. Moreover, the pose of the figure, which appears a little awkward in its context here, is derived directly from the *Portrait of Philip II* of 1551 in the Prado. The inscription is more likely to be a contemporary record than a signature, but the picture has been generally accepted as an autograph work, except by Morelli and Ricketts, who both assigned it to Moroni; this reaction may be due to an element of studio intervention in the work. The picture is listed by Vasari as one of Titian's comparatively rare full-length portraits. The symbolism of the clock is discussed in the entry for the *Portrait of a Knight with a Clock* (Cat. 123).

G.R.

PROVENANCE

1599 Castello di Buonconsiglio, the Bishop's residence at Trent; Roccabruna family; by 1735 Baron Gaudenti della Torre; 1859 Valentino de' Salvadori, Trent; *c.* 1905 Trotti and Co., Paris; before 1907 James Stillman (Paris and New York); 1942 Mrs Avery Rockefeller, New York; 1950 Museu de Arte de São Paolo

REFERENCES

Crowe and Cavalcaselle 1877, II, pp. 167, 186; Morelli 1893, II, p. 65; Oberziner 1900, p. 12; Ricketts 1910, p. 100; Tietze 1936, pp. 179, 184, 304; Vasari (ed. Milanesi) 1881, VII, p. 445; Wethey 1971, pp. 116, 117, with full bibliography

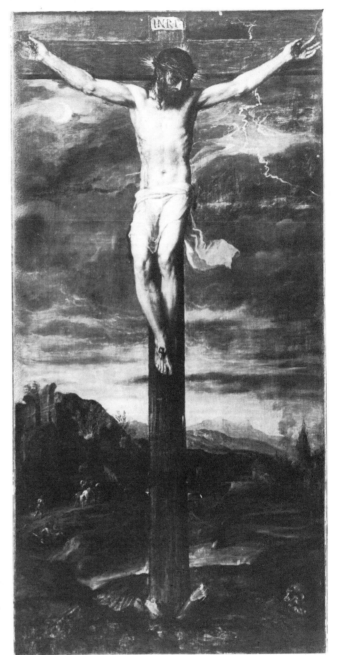

126

126*

Christ on the Cross

214 × 109 cm
Sacristy, El Escorial

This painting, which until a few years ago was in need of cleaning and is difficult to see in the Escorial, is among the most underrated of Titian's later works. First recorded in 1574 in a list of paintings sent by Philip II to the Escorial, it has been dated *c.* 1555 by Wethey and *c.* 1565 by Valcanover and Pallucchini. In fact, a close examination of the numerous documents about Titian's work for Philip II seems to exclude the later dating. In all probability this was one of a group of pictures sent by the artist to the king in

Flanders in 1556 (Cloulas 1967). These apparently included not only *Perseus and Andromeda* (Wallace Collection, London), but also 'a most devout work which I have had on my hands already for ten years', mentioned by Titian in a letter to Philip II, datable to about 10 September 1554 (Cloulas 1967). If the work to which he was referring was indeed the present picture, then it must initially have been destined for another patron; a possible candidate is Cardinal Alessandro Farnese, for whom Titian painted one, if not two, pictures of unspecified subjects in the second half of the 1540s, neither of which seems to have been delivered (Ronchini 1864).

A date of *c.* 1555 is consistent with the style of the painting, even though the basic composition could well be a decade earlier. The picture is only slightly less highly finished than the *Venus and Adonis* of 1554, and notably more so than the more colourful *Entombment* of 1559 (Cat. 127) and *Crucifixion* completed in 1558 (S. Domenico, Ancona).

C.H.

PROVENANCE
1574 sent by Philip II to the Escorial

REFERENCES
Cloulas 1967, pp. 227 note 2, 230–31; Hope 1980, pp. 127–28; Pallucchini 1969², I, pp. 178, 317; Ronchini 1864, pp. 136–38; Valcanover 1969, p. 132, no. 453; Wethey 1969, p. 85, no. 29, with full bibliography

127

The Entombment

137 × 175 cm
Signed on the tablet: TITIANᵛˢ VECELLᶦ VS AEQVES CAES.
Museo del Prado, Madrid (no. 440)
[*repr. in colour on p. 85*]

This splendid picture is generally accepted as the one that was sent to Philip II in September 1559 (together with *Diana and Actaeon* and *Diana and Callisto* [National Gallery of Scotland, Edinburgh]), which had been ordered the previous year to replace one lost in transit. But Ricketts, who grouped the painting with a number of works in which he thought the broken handling of colour rivalled the achievement of the 'great Englishman' G. F. Watts, considered that it must be later, and probably identical with the picture of this subject seen by Vasari in Titian's studio in 1566. It is indeed a fine example of the freedom of handling of Titian's later style and shows the stronger colour which Hope sees as a response to the art of Paolo Veronese. The reliefs depicting the Sacrifice of Isaac and (probably) Cain killing Abel on the sarcophagus are similar in handling to those on the fountain pillar in the Edinburgh *Diana and Callisto*.

G.R.

PROVENANCE
1559 probably despatched from Venice to Madrid; 1574 sent to the Escorial; 1837 removed to the Museo del Prado

REFERENCES
Hope 1980, pp. 37, 128, 131, 133; Ricketts 1910, pp. 140 note 141, 142, 148; Vasari (ed. Milanesi) 1881, VII, p. 458; Wethey 1969, I, pp. 90–91, with full bibliography

128

Boy with Dogs

99.2 × 117 cm
Boymans-Van Beuningen Museum, Rotterdam
[*repr. in colour on p. 86*]

The sketchy, impressionistic technique of this picture – and of *The Flaying of Marsyas* (Cat. 132) – are usually considered typical of Titian's style after about 1570. But the present writer believes that such pictures are unfinished, since they look different from *Tarquin and Lucretia* (Cat. 130) and *St. Jerome in Penitence* (Cat. 131), which Titian sent to Philip II in 1571 and 1575 respectively.

Although the canvas has been cut on all sides, the idea that this is a fragment of a larger mythological composition is now generally rejected. Observing that the dog on the right is virtually identical to the one in Titian's *Portrait of a Man in Red* in Kassel, Ost has recently argued that the two pictures were in the studio together and were made for the same patron, who owned this dog. Since the present picture was formerly in the Serbelloni Collection, he has suggested that the patron was Gabriele Serbelloni, a soldier and military engineer, that Titian began the portrait at Augsburg in 1548 and took it back to Venice, where he probably completed the landscape in the 1560s, and that the present picture would date from 1575, when Serbelloni may have passed through Venice. Ost regards it as an allegory with allusions to Rome, especially in the dog with puppies, which he relates to a famous statue of the wolf suckling Romulus and Remus.

It seems inconceivable, however, that any patron would have left his portrait in Titian's studio for 27 years, and if the dog was meant to be a portrait in both pictures, it is difficult to see why the tail is smooth in one and bushy in the other. The date and purpose of this picture therefore remain mysterious; and, like Bassano's *Two Hunting Dogs* (Cat. 6), it may not even be allegorical.

C.H.

PROVENANCE
Serbelloni Collection, Milan; 1930 Goudsticker, Amsterdam; 1931 Arnold Seligman, New York; van Beuningen Collection, Rotterdam; 1958 acquired by the Boymans-van Beuningen Museum

EXHIBITIONS
Amsterdam 1930, no. 61; Rotterdam 1930–31, no. 16; Amsterdam 1934, no. 386; Amsterdam 1936, no. 158; Rotterdam 1938, no. 48; Rotterdam 1949, no. 103; Paris 1952, no. 32; Rotterdam 1955, no. 34

REFERENCES
Ost 1982, esp. pp. 49–66; Wethey 1975, pp. 129–30, no. 2, with full bibliog.

129

Portrait of a Man with a Palm (Antonio Palma ?)

138 × 116 cm
Inscribed below the window to the left: MDLXI/ANNO . . . NATVS/
AETATIS SVAE XLVI/TITIANVS PICTOR ET/AEQVES CAESARIS
Staatliche Kunstsammlungen Gemäldegalerie, Dresden
[*repr. in colour on p. 83*]

The inscription seems unlikely to be an original signature, but there is no reason to doubt its being a reliable contemporary authentification. Titian's authorship has not been disputed and the date (1561) is generally accepted.

Discussion has centred on the identity of the sitter. Tseuschner thought that the partitioned box on the window sill was the medicine-box of an apothecary and that the palm identified the sitter with a martyred patron saint. Gronau suggested that this was probably the portrait of a painter, and Cook, apparently independently, pursued the same line further and suggested that the palm was an allusion to the sitter's name. He identified him as Antonio Palma, nephew of Palma Vecchio and father of Palma Giovane, a pupil of Bonifazio Veronese, who, though we do not know his exact date of birth, would probably have been of the right age at the time the portrait was painted. This identification has been accepted in successive Dresden catalogues since 1908 and was also accepted in the 1935 Titian exhibition in Venice. No other portrait of Palma is known by which this identification can be checked. While it is ingenious and attractive, the connection of the objects on the window sill with the art of painting is disputable. The box is not an ordinary palette, and the object that lies across it is a spatula rather than a brush. One would like evidence of the use of such accessories in contemporary studios.

G.R.

PROVENANCE
Casa Marcello, Venice; by 1750 Dresden (Guarienti Inventory no. 432)

EXHIBITIONS
Venice 1935, no. 88

REFERENCES
Cook 1904/05, pp. 451–52; Gronau 1904, p. 287; Tseuschner 1901, pp. 292–93; Wethey 1971, II, pp. 120–21, with full bibliography

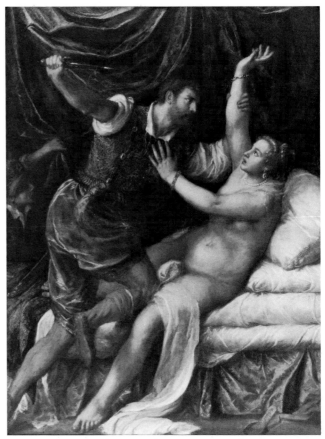

130

130

Tarquin and Lucretia

188.9 × 145.4 cm; reduced on all sides
Signed in red pigment on the slipper lower right: TITIANVS. F.
Fitzwilliam Museum, Cambridge (no. 914), given by Charles
Fairfax Murray, 1918
[*repr. in colour on p. 84*]

The episode most commonly depicted from the story of Sextus Tarquinius and Lucretia, wife of Tarquinius Collatinus, is that of her stabbing herself after recounting to her husband and father the outrageous conduct of Sextus Tarquinius towards her the previous day (Livy, *History of Rome*, I, 58). Titian had painted the suicide as an elegant dance movement in a landscape in the picture of about 1520 (Royal Collection, London). Half a century later he chose to depict, for Philip II of Spain, the scene of Tarquin compelling Lucretia to submit to his desires by threatening to kill her – the killing to appear as retribution for adultery with a servant. Titian himself described the painting as 'an invention involving greater labour and artifice than anything, perhaps, that I have produced for many years'.

His decision to shock, even so brutally, seems to reflect

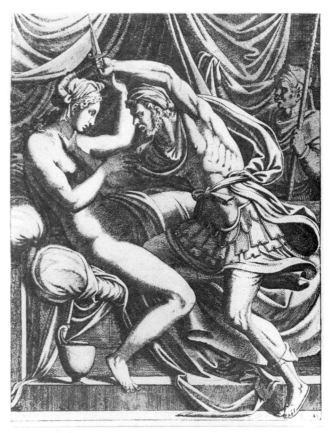

fig. 24 Master L.D. *Tarquin and Lucretia*

[229]

a fascination, shared with other cinquecento painters, with the inventions of printmakers beyond the Alps. Heinrich Aldegrever had twice, at Soest, engraved the rape as a claustrophobic scene in a curtained bedchamber, once in 1539 working after Georg Pencz, and once in 1553 as an essay of his own (Hollstein 63[11] and 64); and E. C. Chamberlain has called attention to the likely relevance of these prints, both easily available to Titian in Venice. In both Lucretia is shown naked, seated on her bed. In the 1539 engraving, Tarquinius has seized her by her upstretched left arm (although he uses his own right arm). In both prints Tarquinius is naked, and is raising his knee to keep her thighs apart. In the 1553 version, bedroom slippers litter the foreground. Attention has not hitherto been called to the print of the subject (fig. 24) by the Master L.D., the finest of the Fontainebleau etchers (generally identified as Leon Daven or Davent), whose last dated sheets are of 1547. He could well have known at least the 1539 engraving by Aldegrever. His etching certainly anticipates Titian's painting. A *terminus ante quem* for the latter is provided by the Cort engraving after it, which is evidently from some authorised *modelletto* and dated 1571, and also by Titian's own letter of 1 August 1571 from Venice, stating his belief that Philip II had received '*Lucretia romana violata da Tarquino*'. Not only does the Master L.D. show Tarquinius fully clothed, one knee already thrust upon the sheet, and brandishing his dagger above Lucretia's head, but he also shows behind Tarquinius a servant, dressed and hatted, who is lifting folds of the parted bed curtains. Moreover, the etching shows the platform of the bed, which raises and distances the action in the Cort engraving and which was presumably part of what has been trimmed from the lower edge of the painting.

That Titian, while chiefly influenced in his dramatic composition by the Fontainebleau etching, was aware also of the Soest engravings, is made the more plausible by the version of *Tarquin and Lucretia* purchased, probably by Lord Arundel in Venice in 1613, a painting which ranks effectively as a workshop production. In that version (Musée des Beaux-Arts, Bordeaux), the weapon of Tarquinius (his grasp of it corrected from his left to his right hand as in the 1553 print) is also kept low, for an upward thrust. X-rays of the Fitzwilliam version show that action to have been tried and abandoned. That the downward stab was the solution more satisfying to Titian is to be seen not only in the Fitzwilliam version, a work finished entirely by the master himself for his royal patron, but also in his unfinished variant in 'dead colour' (Akademie der bildenden Künste, Vienna).

Outside Titian's studio and the Spanish court, this masterpiece gained fame through Cort's engraving, which reverses the design, and through a reversal of that print published in Rome. The coarsely painted copy (198 × 146 cm; Brukenthal Museum, Sibiu) depends on the reverse copy of the Cort engraving rather than on the original painting, as the scheme of the draperies makes abundantly clear. The x-rays of the Fitzwilliam original are of wider interest to Titian studies, particularly for the stormy energy in his draughtsmanship at an advanced age. His drawing of *A Couple in Embrace* (Cat. D75) exhibits very similar characteristics.

M. J.

PROVENANCE
1571 Philip II of Spain (2 August 1571 Guzmán de Silva, Spanish ambassador in Venice, announced to Philip II that Antonio Tiepolo, the Venetian ambassador, would take the picture via Genoa); 1626 described by Cassiano del Pozzo in the Madrid Alcázar; 1636, 1686, 1700/1743 Alcázar inventories; 1747 Buen Retiro; 1813 taken from the Spanish Royal Collection by Joseph Bonaparte in his flight from the Spanish throne; 24 May 1845 entered for sale by Joseph Bates as 'Property of a distinguished Foreign Nobleman' (J. Bonaparte), Christie's sale (lot 71), bought in; acquired by C. J. Nieuwenhuys; 9 June 1849 William Coningham sale, Christie's (lot 57), bought in; John, 2nd Lord Northwick; 29 July 1859 acquired by Nieuwenhuys, Lord Northwick's sale, Phillips, Thirlestane House, Cheltenham (lot 1001); Charles Scarisbrick; 17 July 1886 acquired by Charles Fairfax Murray, anon. sale (C. J. Nieuwenhuys), Christie's (lot 53); 25 May 1911 acquired by Agnew & Sons Ltd., Charles Butler (decd.) sale, Christie's (lot 91); resold to Charles Fairfax Murray; Fitzwilliam Museum

EXHIBITIONS
London 1959, no. 320

REFERENCES
Berenson 1957, p. 184; Crowe and Cavalcaselle 1877, II, pp. 391–92, 538; Goodison and Robertson 1967, pp. 172–75; Hope 1980, pp. 149–57, 160–71; Pallucchini 1969², p. 325; Panofsky 1969, p. 139; Suida 1935, pp. 126–27, 178; Tietze 1936, p. 285; Valcanover 1960, II, p. 136; Waagen 1854, II, p. 155; Wethey 1975, III, pp. 180–81; Winter 1958, p. 53

131*

St. Jerome in Penitence

186 × 143 cm
Inscribed on the rock below the saint's left knee: TITIANVS.F
Nuevos Museos, El Escorial

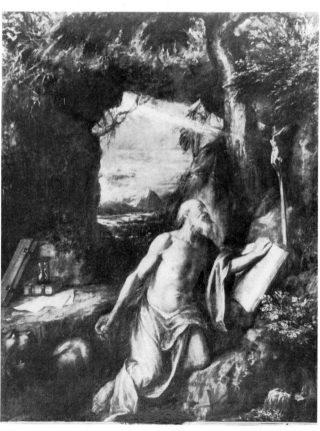

131

This was part of the last consignment of paintings sent by Titian to Philip II in 1575, and has reasonably been taken by Hope as an example of a finished work by the master at the end of his career. Longhi dated it, without supporting argument, to about 1560, and this has been accepted by Valcanover. Suida cited Hetzer as suggesting that Titian was here influenced by Dürer's woodcut of 1512, in which the landscape is also viewed through a hole in the rock of similar form. Such a view through to an intensely blue landscape also occurs in Bellini's little painting of the same subject, formerly in the Benson Collection and now in the National Gallery of Art, Washington. It would be characteristic of Titian to have turned back to works of an earlier period, as we know from the *Nymph and Shepherd* (Kunsthistorisches Museum, Vienna), *The Entombment* (Accademia, Venice) and the *Flaying of Marsyas* (Cat. 132). The figure of the saint is related to, but not identical with that in his altarpiece of the 1550s, now in the Brera, Milan.

G.R.

PROVENANCE
Autumn 1575 shipped to Spain; 1584 sent to the Escorial; until *c.* 1843 on an altar in the chapter house; 1843 Museo del Prado, Madrid; 1860 returned to the Escorial; 1968 transferred to Nuevos Museos

REFERENCES
Hope 1980, p. 161; Longhi 1946, p. 65; Suida 1935, p. 149, no. 66; Valcanover 1969, no. 423; Wethey 1969, I, p. 136, with full bibliography

132

The Flaying of Marsyas

212 × 207 cm
Fragmentary signature on stone in foreground: . . . NVS P
Kroměříz, Statnzamek (no. 102)

132 (*detail*)

According to Neumann, strips of six or seven centimetres were cut from the top and bottom of the canvas in the eighteenth century and small additions, wider on the right than on the left, were made to both sides. The canvas may originally have extended further to the left to include the elbow of the standing figure playing the viol, but Tietze's conjecture that we have the right-hand part of an oblong composition which showed the contest on the left is unlikely. Though consistently attributed to Titian in inventories from the time of its first appearance in the Arundel Collection, this picture did not enter critical literature until 1909, when it was cited as a Titian by Frimmel. Since the 1930s it has been widely accepted as an important late work, though Hetzer rejected it outright and Panofsky expressed grave reservations. Neumann regards it as a fully finished picture, but it seems not unlikely that it was still in the studio and that Titian was working on it up to the time of his death.

As in a number of other late works, we see Titian turning back to earlier models, in this case to a work of Giulio Romano's, a small and now somewhat damaged fresco in the Palazzo del Te, Mantua, for which a preliminary drawing survives in the Louvre. There is some doubt about the identification of the figures on the left. In Giulio's

132 (*detail*)

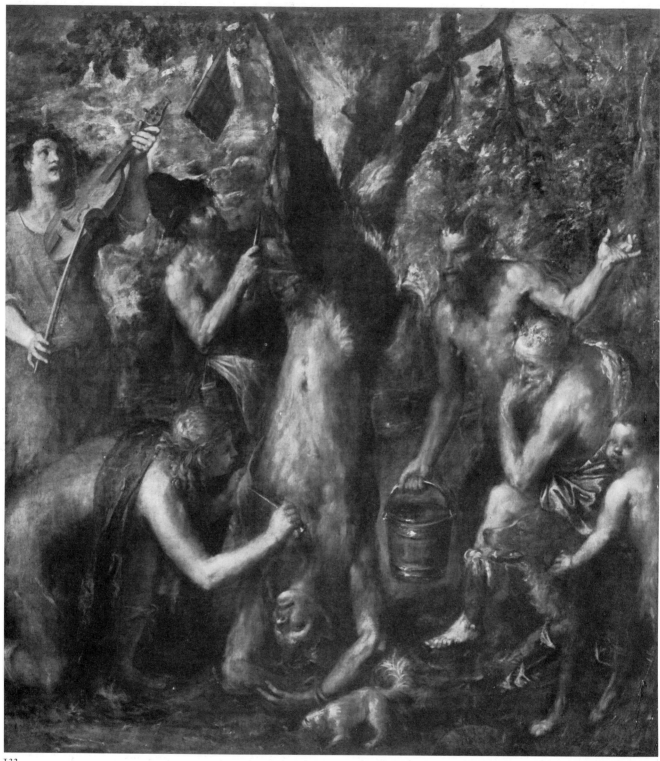

132

composition there is no ambiguity: Apollo, identified by his quiver, bends down – where Titian's figure kneels – to strip off the skin, while a servant stands behind, holding a lyre of antique form; but in Titian's picture, while the skin-stripping figure is again apparently identified as Apollo, this time not by a quiver but by a laurel wreath, the former servant no longer stands as an accessory, but joins in the action, striking up on his instrument, now of modern form,

and possibly singing. Winternitz has claimed that this is Apollo, while Neumann thinks the god is shown twice under different aspects. Possibly, if the painting is unfinished, Titian was in the process of transferring the role of the god from one figure to the other. The subject is, superficially at least, repellent, and it was the brutality of the treatment that stuck in Panofsky's throat, but the execution, especially of the group on the right with Midas,

is equal to the best parts of the contemporary *Entombment* (Accademia, Venice) and to the *St. Sebastian* in the Hermitage, Leningrad. The figure of Midas is sometimes taken as a self-portrait. Neumann and Fehl have probed into the deeper meaning of the picture.

G.R.

PROVENANCE
c. 1620 probably acquired in Italy by Lady Arundel; Arundel inventory of 1655, no. 356; *c.* 1655 acquired by Franz Imstenraed from Arundel estate; 1673 acquired at a lottery by Karl von Lichtenstein, Bishop of Olmütz, for the archiepiscopal palace at Kroměříž (Kremsier); 1800 Kremsier inventory, no. 25

REFERENCES
Benesch 1928, pp. 22–24; Dostal 1924, pp. 32–40; Dostal 1930, see Valentiner 1930, no. 26; Fehl 1969, pp. 1387–1415; Frimmel 1909; Hetzer in Thieme-Becker 1940, p. 167; Neumann 1965; Panofsky 1969, p. 171; Wethey 1975, pp. 153–54, with full bibliography; Winternitz 1967, p. 156

Paolo Caliari, called
Veronese

Verona 1528 – Venice 1588

Until 1555 Veronese used the family name Spezapreda, which is unlikely to mean that his father was a stonecutter (its literal meaning); then he changed it to Caliari. He was described as a painter by 1541, but his training is uncertain and his first surviving work, *Christ Preaching in the Temple* (Prado, Madrid), dates from 1548. He was one of a group of near-contemporaries who began working in and around Verona, but his contacts with Venice began early (see Cat. 133).

By 1555 he had moved there and begun an enormous range of work; over 300 paintings are listed in the most recent catalogue of his work and 150 drawings, although many have been lost. He produced frescoes for façades (now lost) and for the decoration of the Villa Barbaro, Maser, and S. Sebastiano; ceiling paintings in S. Sebastiano and the Doge's Palace; altarpieces, feast scenes for refectories, mythological paintings and portraits. Veronese was equally successful in his works on a huge scale, such as the feast in S. Giorgio Maggiore, Venice, or in his small devotional pictures or *cassoni* panels (marriage chests). His appearance before the Inquisition in 1573 to answer queries about the *Feast* painted for SS. Giovanni e Paolo, Venice, evoked a clear defence in terms of decorum, and the outcome was a compromise by which the picture's title was changed. His success continued unabated in Venice, the Veneto and even beyond the Alps, although he never rivalled the international status of Titian. The last decade of Veronese's life was perhaps the busiest, and his drawings reveal the care with which he organised the workshop to undertake many commissions. His success continued after his death, when his paintings, especially the feasts, were highly sought after.

R.C.

REFERENCES
Cocke 1980[1], pp. 96ff.; Cocke 1984; Pignatti 1976; Trecca 1940, p. 17

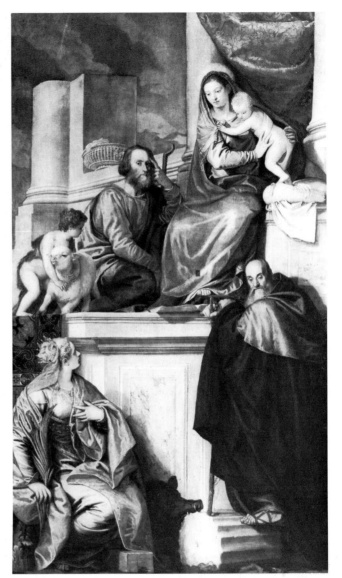

133

133
The Holy Family with St. John the Baptist, St. Anthony Abbott and St. Catherine

313 × 190 cm
S. Francesco della Vigna, Venice

This picture completed the decoration of the fifth chapel on the left of the nave, which is dedicated to the memory of Antonio and Lorenzo Giustiniani. The inscriptions recording the chapel's dedication (it had been built by 1543) are dated 1551. This is usually taken to be the date of the altar, although Veronese had not yet moved to Venice.

The composition, with the Holy Family raised asymmetrically above the saints by the architectural setting and framed by twin columns, reflects that of Titian's *Pesaro Madonna*, completed by 1526. Veronese's assimilation of the principles of Titian's art goes beyond that of any artist

working in Verona in the late 1540s and early 1550s, including Antonio Badile, with whom he may have trained. This is true both of the composition and of the handling with its brilliant use of scumbles. The colour reveals the independence of his palette, which looks back to an older tradition, that of Andrea Mantegna. The interest in the depiction of rich surfaces in the marble of the plinth and the cloth of honour also recalls quattrocento paintings, particularly those of Carpaccio.

The devotional gesture of St. Catherine and the elegance of her drapery and features reflect the Magdalen in Schiavone's etching of *The Holy Family with St. John the Baptist, St. Joseph and the Magdalen*. Veronese developed this ideal of elegance further in the kneeling Virgin in *The Coronation of the Virgin* on the ceiling of the sacristy of S. Sebastiano, Venice, dated late 1555. Neither St. Catherine's gesture, nor the positioning of St. Anthony's head above the marble plinth link the saints effectively with the Holy Family. In this respect Veronese's altarpieces from the 1560s – that from S. Zaccaria (Accademia, Venice) and the Marogna altarpiece of 1565 (still *in situ* in S. Polo, Verona) – are more successful.

R.C.

PROVENANCE
Giustiniani chapel, S. Francesco della Vigna, Venice

EXHIBITIONS
Venice 1939, no. 10

REFERENCES
Cocke 1980², p. 24; Howard 1975, pp. 66ff, 159; Paolucci 1980, p. 285; Pignatti 1976, p. 104, with full bibliography; Sansovino 1581, 14 b; no mention of the author in Agostino Carracci's engraving of 1582

134
The Temptation of St. Anthony

198 × 151 cm
Musée des Beaux-Arts, Caen (inv. 54)
[*repr. in colour on p. 131*]

This was one of the altarpieces commissioned by Cardinal Ercole Gonzaga for Mantua Cathedral. In March 1553 Veronese, together with Domenico del Moro, Paolo Farinati and Domenico Brusasorci, wrote to the cardinal saying that their canvases were ready. Other artists involved in the project had included Fermo Ghisoni, Costa and G. M. Bedoli. In the first decade of his career Veronese was often asked to contribute to larger decorative schemes. His three paintings for Sansovino's library (painted between 1556 and 1557) were recognised by his fellow artists as the best of the group and he alone of his immediate contemporaries achieved a successful career in the demanding Venetian art market.

The other paintings sent to Mantua Cathedral pale by comparison with this great canvas, which has probably been cut down. Only Veronese could paint the rich purple of the saint's robe and combine it with the rippling muscles and dramatic musculature of the devil and the sexual innuendo of the temptress scratching his hand with her over-long fingernails. This vivid handling of the narrative

reflects central Italian sources. The devil's pose is derived from the small wax *modello* by Michelangelo, now in the Casa Buonarotti, Florence. This also influenced Tintoretto in the *Cain and Abel* painted for the Scuola della Trinità between 1551 and 1553 (Accademia, Venice). Earlier, the same source had been used by Alberto Cavalli, an obscure follower of Giulio Romano, in his now lost frescoes on the façade of Palazzo Mazzanti, Verona. Veronese derived the motif from yet another source: the wild figure of Hercules dashing forward to attack Cacus in Caraglio's engraving of a design by Rosso Fiorentino.

Veronese's choice of sources indicates how seriously he took the pious cliché of contemporary Venetian art theory that the artist should strive to combine the *colorito* (colour) of Titian, seen here in the robes of St. Anthony, with the *disegno* (drawing or design) of Michelangelo (represented here by the devil). Veronese's drawing of this subject in the Louvre, Paris, is most probably not a *modello*, but a later revision in which the saint is further emphasised at the expense of the devil.

R.C.

PROVENANCE
1552–53 painted for Mantua Cathedral; 1797 removed on the orders of Napoleon; 1798 taken to Paris; 1801 assigned to Caen

EXHIBITIONS
Paris 1965, no. 309; Verona 1974, pp. 41ff.; Venice 1981, no. 61, p. 184

REFERENCES
Blumer 1936, p. 268, no. 119; Cocke 1980², p. 25; Cocke 1984, cat. 36; Marani and Perina 1965, 3, pp. 340–44; Pignatti 1976, p. 107, with full bibliography; Wilde 1937, pp. 140–53

135
Virgin and Child Appearing to St. Anthony and St. Paul

285 × 170 cm
Chrysler Museum, Norfolk, Virginia, gift of
Walter P. Chrysler Junior
[*repr. in colour on p. 133*]

This was one of three paintings commissioned from Veronese for S. Benedetto Po in December 1561 and completed by March of the following year. It was painted for the second altar to the right of the nave, where it was replaced in the late eighteenth century by a copy. The lunette above the altar frescoed by an earlier, unknown artist, shows St. Anthony basket-making in a rocky wilderness.

The saints' study of the bible held on St. Paul's lap is interrupted by the divine appearance of the Virgin and Child. St. Anthony rises in wonder and Veronese makes him tower over the spectator, who is drawn into his awed response. The appearance of the Virgin and Child must be understood as a response to the prayer of 'Hail Mary' offered by the saint with the rosary that he holds aloft.

There is a similar emphasis upon divine intervention in the appearance of the angel flying down with sceptre and mitre in *The Consecration of St. Nicholas* from the same series (National Gallery, London). Copies of the third

painting, *St. Jerome* (now lost), show that while the saint was contemplating his crucifix his prayers were answered by the appearance of the Virgin and Child. As hermits, both St. Anthony and St. Jerome were often shown in the desert, but the Holy Family is shown appearing to them extremely rarely. The major saints of the sixteenth century (St. Ignatius, St. Philip Neri and St. Teresa of Avila) were all famous for mystical experiences, and by the mid-1560s this aspect of their lives had begun to influence the choice of scenes from the lives of older saints. The decoration in 1564 of the local oratory dedicated to St. Catherine of Siena (d. 1380) is one of a number of such examples. It included, along with by then traditional scenes, that of the saint's mystic marriage, which, although described by her early biographer, had previously been neglected. The same impulse must have suggested the choice of subject in the present canvas.

R.C.

PROVENANCE
Painted for S. Benedetto Po, Mantua; late eighteenth century replaced by a copy and hung in the monastery's gallery; in the Napoleonic era removed to Mantua; thence to a private collection, France; 1962 acquired by Walter P. Chrysler

REFERENCES
Cocke 1980², p. 55; Pignatti 1976, p. 124, with full bibliography; Piva 1975, p. 65, figs. 2, 11

136
The Miracle of St. Barnabas

260 × 193 cm
Musée des Beaux-Arts, Rouen (inv. D. 803–17)
[*repr. in colour on p. 130*]

This was painted to go beneath the organ of S. Giorgio in Braida, Verona. It can probably be dated to 1566, the year in which Veronese completed *The Martyrdom of St. George* for the high altar of the same church. Scenes from the life of St. Barnabas are rare; after leaving St. Paul he went to Cyprus (*Acts*, XIII, 2–5), where he is said to have used the Gospel of St. Matthew to cure the sick (Voragine, *The Golden Legend*).

Veronese shows the saint opening the gospel and laying it on the head of the cripple, who is supported by John Mark. The composition is handled with consummate skill, with St. Barnabas forming the apex of a pyramid rising through the heads of the black boy and the sick youth, and falling to the group around another cripple in the background. This major axis is supplemented by others connecting the saint with the spectators who witness the miracle.

St. Barnabas's miracle is contrasted with the old woman leaning out of the temple to offer a jug to a cripple, alluding to the strength of Christianity at a time when the institutional buildings were pagan. The temple recalls Bramante's *Tempietto* in S. Pietro in Montorio, but it has been modified by the use of the Corinthian order, reflecting Palladio's illustration in Book IV of Daniele Barbaro's 1556 edition of Vitruvius.

Two detailed studies for the painting survive, one for the black boy, executed in black and red chalks (Louvre, Paris), the other a recently discovered nude study in black chalk for the central cripple, whose pose recalls Michelangelo's *ignudi* on the Sistine ceiling.

R.C.

PROVENANCE
S. Giorgio in Braida, Verona; removed on the orders of Napoleon; 18 May 1797 exhibited at the Louvre, Paris; 1803 sent to Rouen

EXHIBITIONS
Bordeaux 1953, no. 74; Paris 1965, no. 312

REFERENCES
Blumer 1936, no. 125; Cocke 1984, cat. nos. 54, 55; Pignatti 1976, p. 132, with full bibliography

137*
Pietà

147 × 111.5 cm
The State Hermitage Museum, Leningrad

Veronese here returned to the theme of the *Pietà* which Giovanni Bellini had introduced into Venetian painting but which had been of only marginal interest to Titian. The present canvas breaks with the older tradition, both in the choice of the full-length format and in the combination of the Virgin with the angel (x-rays reveal another angel on the left of the canvas). Veronese heightened the pathos by his use of the gesture with which the angel interlocks his fingers with those of the dead Christ's left hand, a motif used again in the *Cephalus and Procris* (Cat. 146). Raphael had adopted this motif in his *Entombment* (Galleria Borghese, Rome) and it had been introduced into Venetian painting in Titian's *Entombment* (Louvre, Paris).

The heroic figure of Christ is far removed from the figure ideals of the late Quattrocento, but is close to the Michelangelesque cripple in *The Miracle of St. Barnabas*, probably of 1566 (Cat. 136). This is also probably the decade in which Veronese painted this *Pietà* for SS. Giovanni e Paolo, Venice. Most historians date it to the end of his career and connect it with the *Pietà* in the National Gallery of Canada, Ottawa. This convincing parallel, which is accepted by most scholars, was suggested before the publication of the documentation for the fragment in Ottawa, which von Hadeln left in his notes in the Kunsthistorisches Institut, Florence. These show that the Ottawa canvas, and the two other sections of the same altarpiece (now in Edinburgh and Dulwich), came from the Petrobelli altar in S. Francesco, Lendinara; and a manuscript description of the church records a date (perhaps on the frame) of 1565.

Such a dating is borne out by the way in which Veronese used the pose of this *Pietà* as the starting point for the Berlin drawing for the Ostuni *Deposition* of 1574. Its design was further developed in a group of workshop paintings that include a *Pietà* (Dahlem Museum, Berlin) dated 1573 by a drawing in Stuttgart, the closely related *Dead Christ Appears to a Monk* (Chicago) and the *Dead Christ with an Angel and Nicodemus* (whereabouts unknown). The handling of these paintings contrasts both with that of the

Leningrad *Pietà* and the small variant in Boston, which is autograph. The idealisation of Christ in the Leningrad painting gives way to a moving sense of pathos in the *Dead Christ Appearing to St. Mark, St. James and St. Jerome* (S. Giuliano, Venice) painted in the 1580s.

R.C.

PROVENANCE

By 1582 in SS. Giovanni e Paolo, Venice; before 1648 removed to France; by 1740 in the collection of Pierre Crozat, Paris; thence by descent; 1774 acquired by Catherine II of Russia

REFERENCES

Cocke 1984, cat. nos. 64, 74; Pignatti 1976, p. 167, with full bibliography; von Hadeln 1978, pp. 161–62

138

Portrait of a Woman

106 × 87 cm
Musée de la Chartreuse, Douai
[*repr. in colour on p. 136*]

Veronese, working in the tradition established by Titian, was one of the great portraitists of the sixteenth century. When Sir Philip Sidney was in Venice in 1574, he was undecided whether his portrait should be painted by Tintoretto or Veronese, who, he considered, 'hold by far the highest place in the art'. He decided in favour of

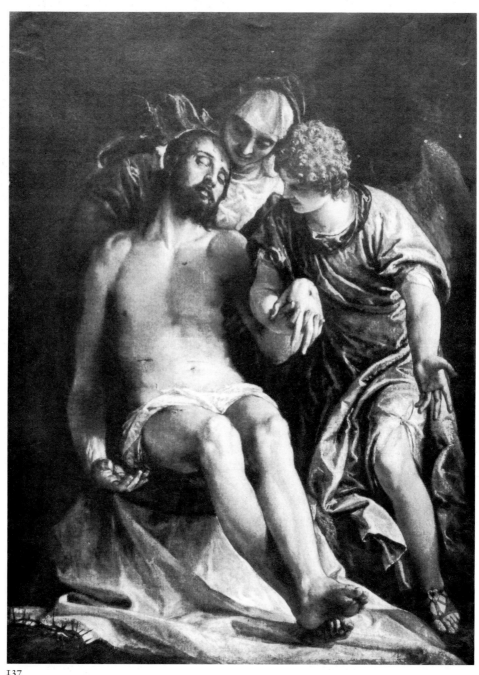

137

[236]

Veronese, in part on the basis of portraits like this, although Veronese's style by that date is better indicated by the *Portrait of a Member of the Soranzo Family* (Cat. 141).

The format, with its direct presentation of the sitter against a neutral background, the brilliance of the colour and virtuosity in rendering the sitter's pearls and great jewel show the influence of Titian's portraits from the 1520s onwards. Since nothing is known about the sitter, dating is difficult. Veronese had begun to absorb Titian's principles in his earliest surviving portrait, that of *Francesco Franceschini* of 1551 (Ringling Museum, Sarasota). By the time of the *Count Giuseppe da Porto and his Son Adriano* (ex-Contini Bonacossi Coll., Florence) and its companion piece *Livia da Porto Thiene with her Daughter Porzia* (Walters Museum, Baltimore) of 1553–54, he overcame the hesitancy in the *contrapposto* of his earlier portrait. The directness of vision of the present portrait and of the closely related *Bella Nani* in the Louvre, Paris, can be related to the portrait-like figures introduced into the frescoes of the Sala dell' Olimpo at Villa Barbaro, Maser, which suggests that they should be dated to the end of the 1550s or the early 1560s.

R.C.

PROVENANCE
Collection of the Duc de Luynes; ceded to Mme Wagner; 1871 sold by her to the Musée de la Chartreuse

EXHIBITIONS
Venice 1939, no. 47; Paris 1965, no. 313

REFERENCES
Cocke 1980², p. 46; Pignatti 1976, p. 121, with full bibliography

139
Portrait of a Woman and Child with a Dog

115 × 95 cm
Musée du Louvre, Paris (inv. 1199)

Veronese's portraits range from a straightforward presentation of a sitter against a neutral setting, as in the Douai *Portrait of a Woman* (Cat. 138), to a more complex handling. In some cases he uses a strip of sky and landscape to one side, as in the present portrait, or in the marvellous *Portrait of a Man* in Budapest, in others he adds columns, curtains and chairs, as in the *Portrait of a Member of the Soranzo Family* (Cat. 141).

The present picture was in the Bevilacqua Collection in Verona, which was housed in the family palace on the Corso designed by Michele Sanmichele in the 1530s for Antonio and Gregorio Bevilacqua. The collection was started in the latter part of the sixteenth century by Mario Bevilacqua, who amassed an outstanding group of antiquities. There was a striking series of marbles (now in Munich), including a fine series of portrait heads, the *Dead Niobid* (acquired in Rome), a *Dionysus* and an *Aphrodite*. The finest piece was the *Adorante* (East Berlin), which had come to Venice from Rhodes in the early part of the sixteenth century and which entered the Bevilacqua Collection in 1570.

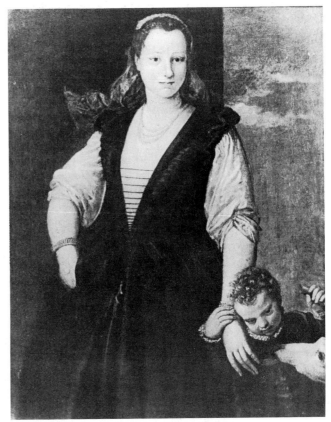

139

The paintings in the collection did not match the antiquities. They were assembled later as a representative group of works by local artists, including G. F. Caroto, Orlando Fiacco and Veronese, but the attributions were optimistic. Modern scholars attribute the small *Holy Family* (Louvre, Paris) to Brusasorci and the *Venus and Cupid* (Fogg Art Museum, Cambridge, Mass.) to Veronese's workshop, a fate shared by the *Venus* in Omaha. In the light of this it is interesting to compare the present portrait, which is more informal than the one in Douai and so probably dates from the later 1560s, with the other portraits in the exhibition.

R.C.

PROVENANCE
By 1648 in the Bevilacqua Collection, Verona; May 1797 removed on the orders of Napoleon; 1798 Musée du Louvre

EXHIBITIONS
Paris 1960, no. 1

REFERENCES
Blumer 1936, p. 269, no. 122; Franzoni 1970, pp. 56ff; Pignatti 1976, p. 121, with full bibliography

140
The Holy Family with St. John the Baptist and St. George

41 × 50 cm
The Visitors of the Ashmolean Museum, Oxford (inv. A863)

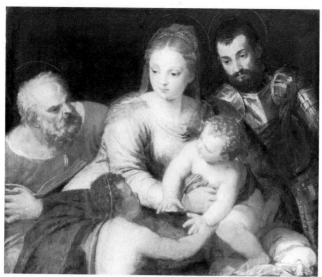

140

Veronese's great fresco cycle in Villa Barbaro, Maser, underlined the Christian faith of the patrons, Daniele and Marcantonio Barbaro, by including two lunettes of the Holy Family. The success of the cycle, which was finished by 1559, prompted a variant on the lunettes, the *Virgin and Child with St. Peter and an Unidentified Saint* (Museo Civico, Vicenza). The present canvas is a variant of the Vicenza painting, reduced to about half its size.

From the outset of his career Veronese fulfilled a demand for small versions of both religious and mythological paintings. The first datable canvas in the series is the *Madonna and Child with St. George, Santa Giustina and a Donor* (Girolamo Scrocchetto, in the Louvre). Scrocchetto is recognisable as the abbot who commissioned the *Feast* for S. Giorgio (Louvre), but here is shown as a much younger man, so this painting presumably dates from early in his first period of office as abbot, between 1551 and 1554. The small *Mystic Marriage of St. Catherine* at Christ Church, Oxford, precedes the Louvre painting, and the Montpellier version of this theme can be dated to 1568 on the evidence of a drawing. Other pictures of this type from the decade 1560–70 probably include the Verona *Deposition*, the Boston *Pietà*, the Detroit *Muse of Painting* and the Turin *Mars, Venus and Cupid*. The recently rediscovered and over-restored *Death of Procris* in a private collection in London probably dates from the 1570s.

Modern catalogues of Veronese's paintings include many more small paintings as autograph, but their claims need to be re-examined against this corpus. Some were produced with considerable workshop assistance, while others may have been painted by followers in the 1580s as a tribute to a style already in enormous demand. It is particularly instructive to be able to compare here the Oxford painting with the altarpieces from S. Francesco della Vigna and the Chrysler Collection (Cats. 133 and 135).

R.C.

PROVENANCE
Collection of Sir Richard Green Price; 1952 acquired by the Ashmolean Museum

REFERENCES
Pignatti 1976, p. 111, with full bibliography

141

Portrait of a Member of the Soranzo Family

184 × 113 cm
The Earl of Harewood
[*repr. in colour on p. 137*]

This notable portrait can be identified with one of a pair in the sale of the Flemish-born painter, Niccolò Renier. He lived and worked in Venice where his collection was sold after his death in 1666. G.15 of the sale catalogue was a portrait of a man shown 'seated in Roman style with, behind, architecture, a frame with touches of gold'. This fits with the Harewood painting, as do the dimensions of the companion picture, 11½ by 8 *quarte* (196 × 136 cm).

Veronese had painted frescoes in the country villa of one branch of the Soranzo family in the early 1550s and was in contact with Francesco Soranzo in June 1584, discussing his spinach. The Soranzo are, however, a large patrician family with a number of branches, so that it is not possible at present to suggest a precise identification for the Harewood portrait.

The marvellously accomplished composition, based upon the diagonal running from top left to bottom right, must be understood as balancing that of the lost companion painting of the sitter's wife, which must have hung to the left of the present picture with the diagonal movement reversed. The handling of the costume retains the brilliance of the earlier portraits, but the contrasts are softened and there is a new sense of informality in the pose (although not in the choice of costume). This fits with portraits which, on external grounds, can be dated to the 1570s: they include the *Portrait of Alessandro Vittoria* (Metropolitan Museum, New York) probably of 1575, the *Portrait of Jacob König* in Prague, and the *Portrait of the Grand-Duke Francesco I Medici* in Kassel, which must date from after 1574.

Veronese's costume study for the present portrait was on the London art market in 1970. The handling of the black chalk on the blue paper has the almost abstract quality of his chalk preparatory sketches, but this is combined with accurate observation of the white highlights, which are followed closely in the painting, and of the fur, which he annotated with a 'P' (*pelliccia* means fur).

R.C.

PROVENANCE
1648 Reinst Collection; 1666 sale of Niccolò Renier's Collection, Venice, no. G.14; acquired by the 6th Earl of Harewood from the collection of Sir Charles Robinson.

EXHIBITIONS
Venice 1939, pp. 180–81

REFERENCES
Cocke 1984, cat. no. 77; Pignatti 1976, p. 153, with full bibliography; Savini-Branca 1965, pp. 96ff

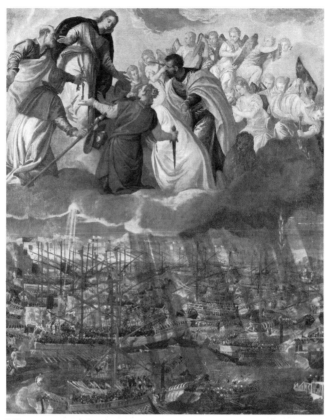

142

dimensions given for it in the 1682 inventory of the collection, 14 by 6½ *quarte* (238 × 110 cm), clearly differ from those of the present canvas.

Veronese developed the contrast between the main figures and the heavenly host in the votive picture of the battle painted for the Sala del Collegio in the Doge's Palace between 1577 and March 1578, which was commissioned by the Venetian naval commander Sebastiano Venier (see Cat. 108). This suggests that the Accademia painting was painted shortly after the battle.

R.C.

PROVENANCE
1664 S. Pietro Martire, Murano; 1812 Gallerie dell' Accademia

EXHIBITIONS
Venice 1939, no. 60

REFERENCES
Cocke 1984, cat nos. 61–63, 87; Gattinoni 1914, no. 13; Pignatti 1976, p. 133, with full bibliography

143
The Resurrection of Christ

136 × 104 cm
Staatliche Museum, Gemäldegalerie, Dresden (inv. 235)
[*repr. in colour on p. 132*]

The Resurrection had been a popular theme in Venetian painting since Bellini's altarpiece for S. Michele in Isola (Dahlem Museum, Berlin). Titian's reworking of Bellini's design in his altarpiece in SS. Nazaro e Celso, Brescia, completed by 1522, was the starting point for Veronese's elegant painting. Titian heightened the asymmetry by his use of the dawn light behind the head of the standing soldier, and by the sweeping diagonal which runs through the landscape and is echoed in the poses of the soldiers. He balanced it by increasing the scale of the figure of Christ, which was based on a cast of the Laocoön.

Veronese retained the asymmetry, but used more dramatic gestures in the reactions of the soldiers. Christ is reduced in scale to match the other figures, but is isolated by the introduction of ruins, which symbolise the area that housed the sepulchre, and he stands out against a sky dominated by shades of green. The receding diagonal movement was developed by showing in the background the three Marys approaching the empty tomb guarded by an angel, the passage with which the account of the Resurrection in the Gospels opens. Christ appears suspended above the sepulchre, rather than bursting upwards; later Veronese improved on this in two altarpieces in which the Christ is developed from the figure in the present canvas. That from S. Giacomo, Murano (Westminster Hospital, London) can be dated to 1577–78, together with *The Visitation* from the same church now in the Barber Institute, Birmingham. The great altarpiece in S. Francesco della Vigna, which is often doubted and is in need of restoration, must date from before 1584, since it must be one of the two pictures in the church mentioned by Borghini in that year. The present painting must

142
Allegory of the Battle of Lepanto

169 × 137 cm
Gallerie dell' Accademia, Venice (inv. 136)

This painting is one of a series by Veronese celebrating the establishment of the Holy League and its defeat of the Turks at the Battle of Lepanto on 7 October 1571. The psychological impact of that victory for Christendom was enormous and outweighed any other considerations, including the loss of Cyprus.

The victory in the naval battle in the bottom half of the painting is attributed to divine intervention, indicated by the dramatic burst of light under the Virgin and by the angels throwing down flaming arrows through the storm clouds. The Virgin, as Queen of Heaven, receives the prayers of a group of saints: from left to right, Peter, who stands for the Papacy, James, who represents Spain, Giustina, on whose feast day the battle occurred, and Mark, the patron saint of Venice. The three saints who represent the members of the Holy League – Peter, James and Mark – also appear, throwing down palms of victory from the sky, in a highly finished drawing at Chatsworth. The absence of Santa Giustina from the drawing shows that it must celebrate the signing of the League in July 1571.

Ridolfi, writing in 1648, described another version of this subject in the collection of the Caliari family, in which the Virgin knelt in prayer before the Trinity, together with a personification of Venice between Mark and Giustina. The

therefore have been painted either in the late 1560s or the early 1570s, at a moment when Veronese developed from the blue skies of his earlier paintings to the green ones used in many later works.

R.C.

PROVENANCE
1741 acquired by the Elector Frederick August III, Dresden; it was said to have come from the Imperial collection, Vienna, and may have been no. 559 in the 1737 Prague collection whose dimensions (2 *elen* 11 by 1 *elen* 15 [about 150 × 102 cm]) match the present painting

EXHIBITIONS
Venice 1939, no. 53

REFERENCES
Cocke 1980², pp. 90–91; Dresden 1929, no. 235; Köpl 1899, no. 559; Pignatti 1976, pp. 137–38, with full bibliography

144

The Crucifixion

102 × 102 cm
Musée du Louvre, Paris (inv. 1195)

This deeply moving canvas illustrates Veronese's ability to work on a small scale. The oblique setting of the crosses, with Christ seen from the side, and the dramatic sky, had been used slightly earlier in the large altarpiece of this subject which Veronese painted for S. Niccolò ai Frari in 1581–82 (Accademia, Venice).

Although there is less dramatic movement in this painting than in the Frari altarpiece, intensity of feeling is achieved through the swooning Virgin supported by St. John, and by the gesture of the Magdalen who hides her face in grief. The clouds roll over the sun to heighten the mood of mourning and to illustrate the passage in St. Matthew's gospel: 'Now from the sixth hour there was darkness over all the land unto the ninth hour.'

The composition was worked out in a drawing (Fogg Art Museum) which differs from the painting in many details. It was doubted by earlier critics, most notably the Tietzes, but the present writer believes that its free but controlled use of pen and ink and wash matches that of many autograph drawings from the last decade of Veronese's career.

R.C.

PROVENANCE
1683 Le Brun inventory of the French Royal Collection, no. 36

EXHIBITIONS
Venice 1939, no. 54

REFERENCES
Cocke 1980², p. 92; Cocke 1984, cat. 121; Engerand 1899, p. 93, no. 10; Pignatti 1976, p. 138, with full bibliography

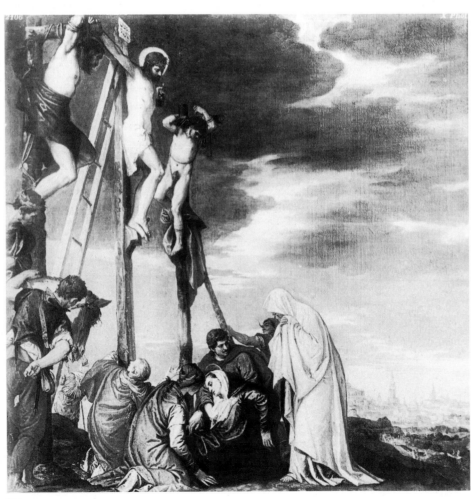

144

145
Venus and Adonis

212 × 190 cm; originally 162 × 190 cm
Museo del Prado, Madrid (inv. 380)
[repr. in colour on p. 134]

In 1584 Borghini described Veronese's latest works: 'his most recent and exceptionally beautiful paintings are of Procris, and Adonis in Venus's lap, with nearly life-size figures'.

The Venus and Adonis and its companion Cephalus and Procris (Cat. 146) remained together in Venice, where they were acquired by Velázquez c. 1650 for the Spanish Royal Collection. The subsequent separation of the pair led to confusion in modern accounts of Veronese, in which they were said to have been commissioned for Rudolph II and the connection between the two canvases was overlooked, which is unfortunate, since they are linked with great care in both subject and composition. This was also masked by the additions at top and bottom of the present canvas, which have been revealed during the recent restoration and cleaning.

In the Venus and Adonis Veronese illustrates the passage from Ovid's Metamorphoses, X, 555ff, where the description of the lovers' idyll is a prelude to a warning about the dangers of hunting, tragically fulfilled in the Cephalus and Procris. Titian departed from this Ovidian text in his poesia of Venus and Adonis painted for Philip II in 1553–54, and invented a passionate leave-taking. This influenced Veronese's earlier version of this subject, now in Augsburg. That canvas, like many other mythologies, can be dated to the 1560s through its connection with the broad, sun-filled handling of the Honor et Virtus and Omnia Vanitas (Frick Collection, New York), painted for Albrecht V of Bavaria by 1567.

Borghini's admiration for the Venus and Adonis is justified by the marvellous handling of the blue brocade thrown over Venus's lap, the treatment of light and shade on the surface of her skin and the more abstract red of Adonis's cloak. In his poesia Titian exploited the naked female, to the evident satisfaction of contemporary voyeurs. Veronese, by contrast, suggests the psychological reality of love in the discreet gesture with which Venus fans her reclining lover and glances at Cupid, who restrains the dogs that will lure Adonis out to the hunt and so to his death. This is echoed in the dark sky behind the figures, which transforms the light-hearted mood of the paintings created in the 1560s into something more profound and striking.

R.C.

PROVENANCE
Before 1854 painted in Venice; c. 1650 acquired by Velázquez; 1666 Alcázar inventory no. 595; remained in the Alcázar until transferred to the Museo del Prado

REFERENCES
Bottineau 1958, p. 156; Borghini 1584, p. 563; Cocke 1980², p. 96; Lorente Junquera 1969, pp. 235ff; Pignatti 1976, p. 149, with full bibliography

146
Cephalus and Procris

162 × 190 cm
Musée des Beaux-Arts, Strasbourg (inv. 634)
[repr. in colour on p. 135]

This is the companion painting to the Venus and Adonis (Cat. 145) described by Borghini in 1584 as having been painted recently. Both were acquired for the Spanish Royal Collection by Velázquez c. 1650. By the beginning of the nineteenth century the connection had been forgotten and the present picture was looted by Joseph Bonaparte. An old engraving confirms its dimensions matched those of the Venus and Adonis before the eighteenth-century additions, which have been revealed in the recent restoration and cleaning.

The painting illustrates the tragic killing of Procris by Cephalus in Ovid's Metamorphoses, VII, 835ff. While out hunting Cephalus used to cry out to Aura (the breeze) and this innocent invocation led Procris to suspect him of marital infidelity. As she spied on Cephalus one day he mistook the rustling in the bushes for a wild animal, with the result that he killed his wife with the spear she had given him.

The legend was often included in woodcuts of the illustrated editions of Ovid, which were extremely popular in the sixteenth century. Veronese based the earlier, small version of Cephalus and Procris (private collection, London) on an illustration in the 1557 Lyons edition, with minor modifications and the addition of Cephalus's unfortunate invocation in the background. In the present painting the figures are enlarged, Procris is given a brocade dress to match that of Venus in the Madrid picture and the group is reversed to form a suitable complement to the Venus and Adonis.

Ovid's narrative continues with Cephalus tending his wife, who manages in her dying words to beg him not to let Aura take her place. Too late her husband realises the confusion that has led to the tragedy. This is conveyed in the grouping of the composition, with Procris stretched out on the ground and her husband leaning over in concern.

R.C.

PROVENANCE
By 1584 painted in Venice; c. 1650 acquired by Velázquez; 1666 Alcázar inventory, probably no. 601 (the dimensions fit but the subject is not mentioned); until at least 1784 remained in the Alcázar; by c. 1809 transferred to the Museo de Madrid in the Palacio de Buenvista; acquired by Joseph Bonaparte; 24 May 1845, Christie's sale (lot 69); 12 April 1851, William Coningham sale (noting the provenance from Joseph Bonaparte), Christie's sale (lot 59); G. Pulsford; 1912 acquired by the Musée des Beaux-Arts

REFERENCES
Borghini 1584, p. 563; Bottineau 1958, p. 157; Cocke 1980², p. 98; Lorente Junquera 1969, pp. 253ff; Pignatti 1976, p. 149, with full bibliography

147

San Pantaleone Healing a Child

277 × 160 cm
S. Pantalon, Venice

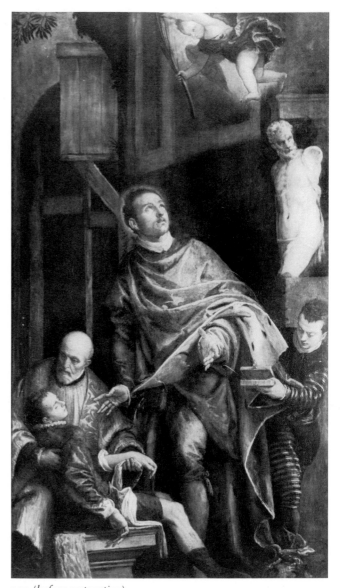

This altarpiece, painted for the main altar of S. Pantalon,
was commissioned by the parish priest, Bartolommeo
Borghi, in 1587. The church was later rebuilt and the
picture moved to its present site on the second altar on the
right of the nave in 1732. It is difficult to see *in situ*.

San Pantaleone's shrine at Ravallo became famous for
healing people beyond conventional medicine; legends later
grew up around the saint, who was believed to have been
a court physician. In the painting he drives out a rather
charming small devil from the possessed boy, who is held
by Bartolommeo Borghi. The miraculous nature of the cure
is underlined by his neglect of the medicine-box held by an
assistant and by his upward glance at the angel bearing the
martyr's palm. His charity is emphasised by the contrast
between his rich cloak and the poverty of the setting, which
reflects those used by Tintoretto in his cycle in the Scuola
di San Rocco, Venice. The Christian character of the
miracle is brought out by the contrast with the statue,
which is intended to remind us of Asclepius, the pagan god
of medicine, whose helplessness is symbolised by his lack
of arms and legs. In the newly discovered preparatory
drawing (Louvre, Paris; Cat. D82), the miracle is combined
with the appearance of the Virgin and Child crowned by
angels. Such a scheme could not fit into the proportions of
the present altarpiece, but its emphasis on divine healing,
as in other late paintings, carries an intimation that
Veronese was aware of his own impending death.

R.C.

EXHIBITIONS
Venice 1939, no. 89; Venice 1971, p. 68

REFERENCES
Cocke 1980², p. 106; Cocke 1984, cat. 127; Pignatti 1976, p. 168,
with full bibliography

147 (*before restoration*)

DRAWING IN VENICE

James Byam Shaw

The existing material of drawings by Venetian artists of the Renaissance is certainly less than that which survives of the Florentine School. Of the fifteenth century, I do not forget that there is a large collection of drawings by Pisanello and his followers in the so-called Vallardi Codex in the Louvre, and in the Louvre and the British Museum two precious volumes by Jacopo Bellini, the father of two great artists and father-in-law of a third. But these (which in any case are not within the scope of the present exhibition) have survived by lucky accident; drawings by the Bellini sons, Gentile or Giovanni, or their brother-in-law Mantegna, are not common even in the great museums; and of the later fifteenth and early sixteenth century only Carpaccio is really familiar as a draughtsman. And yet Venice was not quite without collectors of drawings; we know that Gabriele Vendramin, whose art treasures were seen and described by Marcantonio Michiel in 1530, owned for example at least one famous drawing by Raphael, and one might have expected such a collection to have included drawings by Giorgione and Titian. But in fact only one drawing, now at Rotterdam, is generally accepted as Giorgione's autograph, and drawings by Titian are decidedly rare by comparison with the surviving material of his Florentine contemporaries: Michelangelo, Fra Bartolomeo or Andrea del Sarto, only one of whom lived as long as he did. This may be due partly to accident; and it is no doubt also due to some extent to the emergence in Florence of great collectors of drawings in the sixteenth and seventeenth centuries: Vasari, the Medici family and Baldinucci, much of whose accumulations have been preserved. Nevertheless, it seems likely that Giorgione and Titian and other famous Venetians of the Renaissance, at least in the first half of the sixteenth century, were less interested in drawing than the Florentine artists, and less inclined to consider it an integral part of the process of producing a picture. Vasari, in the introduction to his *Lives of the Artists*, speaks of drawing as 'the father of our three arts, Architecture, Sculpture and Painting', and discusses at some length the processes and functions of drawing. I doubt whether most Venetian artists of the sixteenth century attached so much importance to it. There was never an *Accademia del Disegno* in Venice. A Venetian of Titian's generation preferred to draw with soft scumbling chalk or with the brush, a painter's medium, rather than with the pen or the hard chalk of the Florentines; and this applies to Carpaccio, a prolific draughtsman, and to most artists in the immediate circle of Titian, to Paris Bordone and the Bassano family particularly, if it is only partly true of Pordenone and Lotto. Those two important artists (of whom one was not strictly speaking Venetian, while the other worked much away from the capital) did use soft chalk in Titian's fashion; but also the pen and wash technique to produce pictorial compositions, which might be *modelli* for paintings, or presentation pieces for friends or patrons (Cat. D23).

Of the few known drawings – about fifty at most – that modern authorities attribute to Titian himself, eight are exhibited here, and the majority of these – indeed the majority of all that are accepted generally as his – are studies in chalk or charcoal. The attribution to him of certain pen drawings, especially landscapes, though of early authority, is now much more generally disputed; and it may be thought, even from the one good example in the present exhibition (Cat. D69), that this was not the medium that suited Titian best. Was it to some extent forced upon him by the required practice, in his earlier days, of drawing upon a wood-block, so that a block-cutter could work upon a clear linear design, and so multiply and popularise his productions in the form of prints? With soft black chalk or a charcoal stick and some white, on his blue Venetian paper, he was certainly much better able to suggest form, even colour. Any painter, I suspect, would recognise the hand of a master in the splendid *Horse and Rider Falling* from Oxford (Cat. D73); fewer would feel the same enthusiasm for the drawing of the Duke of Urbino's armour (Cat. D71).

Giorgione's fashion of painting (and probably also drawing, though Vasari said that Giorgione never drew at all) is represented here not by any example by that rare master himself, but by one probable copy and two drawings by his little-known disciple, the engraver Giulio Campagnola (Cat. D9, D10 and D19), and also by one Giorgionesque subject attributed to Titian (Cat. D69). Titian's style in the pen and ink medium, in composing a 'landscape with figures', is represented not only by this drawing, which I believe to be by his own hand, but also in a drawing signed by a follower, Domenico Campagnola (Cat. D7), who was Giulio Campagnola's adopted son and pupil. The earliest of Domenico's landscapes, such as this, are close imitations of drawings by Titian himself. In later drawings, Campagnola debased this style of landscape into a kind of facile mannerism; nevertheless he furnished inspiration for Italian draughtsmen for generations to come, including Girolamo Muziano in the later Cinquecento, and Agostino and Annibale Carracci, and Domenichino and Grimaldi later still. But it was Titian's manner of drawing freely with chalks on blue paper, exemplified here by figure studies and the rare composition sketch for the *Battle of Spoleto* (Cat. D72), that was adopted by Jacopo Bassano and his sons' prolific studio, and by Paris Bordone and others of that generation – even occasionally by some (Lotto, Palma Vecchio, Pordenone) who were probably older than Titian himself.

Though Alvise Vivarini, Bartolomeo Montagna, Buon-

consiglio and Boccaccio Boccaccino all outlived the turn of the fifteenth–sixteenth centuries, and are all represented by drawings in the exhibition here, they belong essentially to the tradition of Giovanni Bellini and his pupils; breaking away, as Bellini himself did, from the hard linear style of Mantegna, but still some way from the 'painter's style' of drawing as practised by Titian and his contemporaries. It may be noticed that the comparatively small representation of drawings in the exhibition – the selection of which, I may add, was not mine – is not proportionate to the number of known drawings by the artists included: there are, for instance, eleven by Pordenone and six by Lotto (who is not generally familiar as a draughtsman), whereas there are only six by Jacopo Tintoretto and seven by Paolo Veronese, both far better known in this respect. But there are good reasons for bringing lesser-known draughtsmen to wider recognition, and it was thought appropriate to emphasise here the work of Pordenone and Lotto, who spent most of their working lives away from Venice, but were leading artists of the Venetian *terraferma*.

We know far more drawings by Tintoretto than by Titian; and indeed of the great Venetians of the High Renaissance only Jacopo Tintoretto and Paolo Veronese were really prolific draughtsmen – with Domenico Tintoretto imitating his father in the second rank, and Palma Giovane following the example of both of them in this respect. Michelangelo's sculpture, according to Ridolfi, was almost a second master, after Titian, to Tintoretto; and there is a whole series of early studies by Tintoretto after plaster casts or small copies of Michelangelo's famous works in the Medici Chapel, more or less straightforward, but sometimes drawn in foreshortening or in artificial lighting. But I doubt whether Tintoretto's drawings in general, whatever Titian may have thought of them, would have much impressed Michelangelo. Tintoretto was of a different temperament, more extravagantly dramatic, perhaps more superficial in his aspirations so far as drawing was concerned. Ridolfi says too that he made little figure models in clay or wax, 'mannikins' of his own invention, and suspended them from the ceiling, artificially lit, in order to observe figures in sharp foreshortening and in different light effects. There are among his drawings numerous single figures, roughly drawn in chalk or charcoal, with unnaturally swelling contours, anatomically impossible, some nude, some in contemporary dress or armour; and many of these have been connected with the huge battle-pieces painted in Tintoretto's maturity – the Gonzaga *Triumphs* now in Munich, and those in the Doge's Palace in Venice. They are very different from the careful academic life-studies that the Florentines produced, often with details of hand or foot drawn at the side, as preliminaries to their paintings of the same period. Occasionally Tintoretto may have studied a static living model; but much more often his drawings are of struggling distorted figures in violent action – archers drawing their bows, soldiers brandishing swords or banners, falling horsemen – in poses such as no model could keep in the studio. More detailed studies might have been more useful to himself and to his pupils in carrying out their great works; but above all the *tempo* of violence had to be maintained; and where studies used in known paintings have been identified (see Cat. D62, D64, D67), they are studies of action or gesture rather than of the human

body or of drapery or other details. Hardly any large sketches for whole compositions, like Titian's for the *Battle of Spoleto*, have survived; if Tintoretto made such sketches, we must suppose that they disintegrated because of their size, through use in the studio.

The distinction between the work of the master and that of his best pupils is often a matter of subjective judgement, and of disagreement among the experts; and this difficulty is particularly apparent in the Venetian School, where family studios were the rule, and several members of the family assisted the founder of the studio and drew more or less in his style.[1] Some small, dashing oil sketches on paper, once supposed to be by Jacopo Tintoretto, have turned out to be almost certainly by his son Domenico, who was born in 1560 and lived well into the next century (Cat. D60 of this exhibition may be as late as 1630); he and his sister Marietta both made drawings from an antique bust (the supposed *Vitellius*) which was among the studio properties and had been drawn by Jacopo himself in his younger days;[2] and Tintoretto's other son, Marco, and his son-in-law Sebastiano Casser must also have drawn in the 'Tintoretto' style.

Apart from Tintoretto's own family, and certainly more important than any of them, Palma Giovane (born in 1544) in his early figure studies comes very near to the Tintorettos in style and character. But Jacopo Tintoretto seems only very occasionally to have drawn in any medium but chalk or charcoal, heightened with white on blue paper; whereas Palma Giovane, though he sometimes imitated Tintoretto in this, used also pen and pale wash to great effect, imitating the method of free sketch practised so brilliantly by Paolo Veronese, who was nearer to him in age. Palma's earlier drawings in this medium have sometimes been mistaken for Paolo's; though in the latter part of his long life, in the early decades of the seventeenth century, Palma's handling of the pen became looser, his line more broken, his forms more mannered, and the influence of Paolo is less obvious.

Paolo Veronese was indeed not only a great painter, but a great draughtsman too, the best of the Venetians of the later Renaissance period. He did produce early in his career some figure-studies in the chalk manner of Titian, Bassano and Tintoretto; but the most characteristic of his drawings are of two quite different sorts, both represented by fine examples here: either finished compositions in pen and wash, carefully heightened with white bodycolour on grey or blue coloured paper – completely pictorial, like *modelli* for paintings, though apparently seldom used for that purpose by Paolo himself; or, more commonly, rough sketches made with a fine pen and a light touch, very lightly washed, of single figures or small groups, all confused together on the same large sheet of paper, which can often be identified as ideas for important paintings, sometimes two or three different subjects on the same sheet. From those swift notations there emerge beautiful rhythms, graceful combinations of figures in motion or in relationship to one another, that exceed in elegance and charm anything produced before in Venetian drawing of the sixteenth century. They set a fashion in drawing that was followed not only into the seventeenth century by Palma Giovane and others, but even into the eighteenth, in Venice by Sebastiano Ricci, and in England by Sir James Thornhill.

1] Such family studios flourished in Venice from the time of the Vivarini in the fifteenth century to that of the Tiepolos in the eighteenth; in the period covered by this exhibition the case of Jacopo Bassano and his four sons is particularly notable; but Hans and Erica Tietze, in the valuable introduction to their *Drawings of the Venetian Painters*, draw attention to several other examples, one as early as the fourteenth century.

2] Domenico's *Temptation of St. Anthony Abbot* (Cat. D60) has a study of the *Vitellius* head on the back.

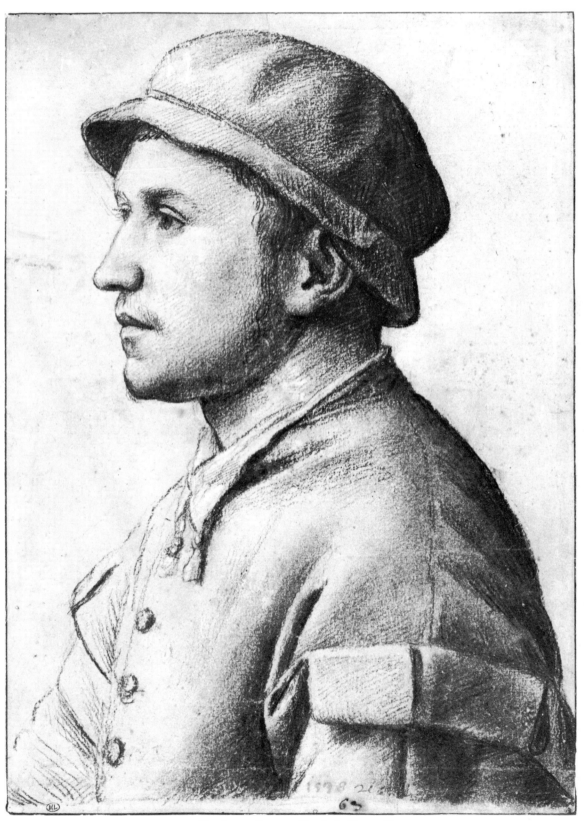

D2 Jacopo Bassano *Head of a Young Man*

Jacopo Bassano
[Biography on p. 146]

DI
Diana in the Clouds

508 × 379 mm
Black chalk, heightened with white bodycolour, on blue paper
The Governing Body, Christ Church, Oxford (no. 1341)

This drawing is exceptional in Bassano's *œuvre* in its size, quality, and unusual subject matter, as James Byam Shaw has pointed out. He suggests that it represents the goddess Diana, identified by her crescent moon, appearing at the sacrifice of Iphigenia. But since the expression on the goddess's face is as much of wonder as dismay, and since the gesture of her open arms could indicate amazement, the drawing may alternatively represent Diana discovering Endymion.

D.E.S.

PROVENANCE
Sir Peter Lely; Guise; Christ Church

REFERENCES
Byam Shaw 1976, no. 751, pl. 464, with full bibliography

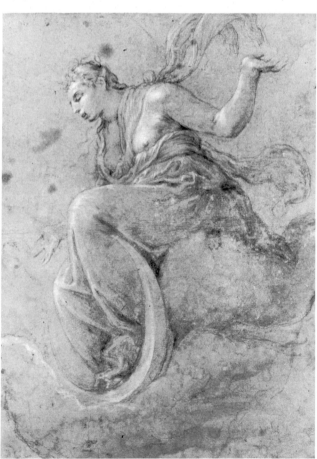

DI

D2
Head of a Young Man

339 × 244 mm
Black chalk with traces of red chalk, heightened with white, on beige paper, laid down; bordered on all sides by a line of brown ink
Inscribed in brown ink lower right of centre:
1538, 21 anno and *63* (?)
Cabinet des Dessins, Musée du Louvre, Paris (no. 5679)
[*repr. on p. 245*]

This drawing was first attributed to Bassano orally by Linzeler, who based the attribution on the resemblance to a figure in Jacopo's *Adoration of the Magi* (Edinburgh), which is generally dated in his early period. The Tietzes were not entirely convinced by this argument, but they agreed that the drawing was close to other early portraits by Jacopo.

The inscription seems to indicate that the sitter was 21 years of age, and the date of 1538 is consistent with the suggestion that the drawing is an early work. Arslan comments that Pordenone's influence on Bassano is evident here for the first time, but the high finish of the drawing points also to contacts with northern art.

D.E.S.

PROVENANCE
Modena Collection, marks of Alfonso III d'Este and Francesco II Gonzaga; late eighteenth century entered the Louvre collections

EXHIBITIONS
Venice 1957, no. 13 (drawings)

REFERENCES
Arslan 1960, p. 49; II, fig. 31;
Rearick 1978, p. 161, fig. 3;
Tietze and Tietze-Conrat 1944, no. 192, pl. CXLI;
von Hadeln 1925², pl. 15 (as Licinio)

Boccaccio Boccaccino

Ferrara *c.* 1465 – Cremona 1524/25

Boccaccino worked in Genoa in 1493, in Ferrara from 1497 to 1500 and in Venice; but his main centre of activity, particularly after 1506, was Cremona. A number of authenticated pictures and frescoes exist, of which the best known are in Cremona Cathedral. Boccaccino's style reflects both Ferrarese and Venetian influences.

D.E.S.

D3
Christ in Majesty

234 × 179 mm
Point of the brush and brown ink, heightened with white, on prepared paper squared in black chalk
The Visitors of the Ashmolean Museum, Oxford

This drawing is a study for Boccaccino's fresco of *Christ between the Patron Saints of Cremona* (SS. Imerio,

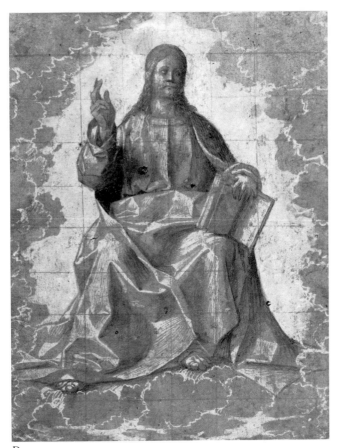

D3

Omobuono, Pietro and Marcellino) in the half dome of the apse of Cremona Cathedral, said by Grasselli (*Abecedario dei Pittori Cremonesi*, 1827) to have borne the date 1506. The head of Christ, tilted towards the left in this drawing, is seen from the front in the fresco. Puerari related this sheet stylistically to the drawing of *St. Jerome* in Munich (Puerari 1957, fig. 163), which he dated 1505/06, but the *Christ in Majesty* is a much more accomplished drawing.

D.E.S.

PROVENANCE
Liechtenstein; 1950 presented anonymously to the Ashmolean Museum

EXHIBITIONS
Venice 1958, no. 7; London 1970, no. 8

REFERENCES
Macandrew 1980, III, p. 248, no. 5;
Parker 1956, II, no. 5, pl. II, with full bibliography;
Puerari 1957, p. 235, fig. 158 (as in Albertina, Vienna)

Paris Bordone

[Biography on p. 154]

D4
Two Studies of St. Joseph

255 × 295 mm

Black chalk, heightened with white, on blue paper
Inscribed in black chalk in a contemporary hand:
Josef and in ink in a later hand: *Titiano*
Verso: two studies of a similar figure viewed frontally,
and a partially draped leg
Victoria & Albert Museum, London (Dyce 265)

This drawing was first ascribed to Bordone by the Tietzes on stylistic grounds; they observed that the study of the leg on the *verso* was used by Bordone in his *Pentecost* (Brera, Milan), *Holy Family* (Strasbourg) and *Madonna with Saints* (Simmons Collection, Glasgow). Tietze-Conrat was the first to note the connection of the drawings on the *recto* to Bordone's painting of *The Rest on the Flight into Egypt* in the Berenson Collection.

D.E.S.

PROVENANCE
Sir Peter Lely; Rev. Alexander Dyce;
1869 bequeathed by him to the Victoria & Albert Museum

REFERENCES
Tietze-Conrat, 1938, p. 189;
Ward-Jackson 1979, p. 41, no. 53, with full bibliography

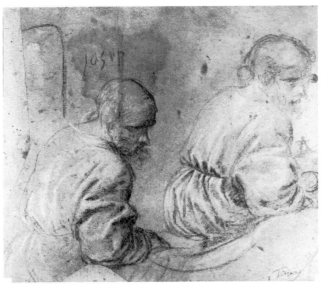

D4

Giovanni Buonconsiglio,

called il Marescalco

Active Venice 1495–1535/37

An artist of the Vicenza school, Buonconsiglio seems to have lived mostly in Venice after 1495, although he continued to work in Vicenza. Dated works exist from 1497 onwards. His style shows the influence of Montagna and Bellini.

D.E.S.

D5
Christ at the Column

392 × 244 mm, the top shaped
Pen and brown ink and brown wash on faded white paper
Cabinet des Dessins, Musée du Louvre, Paris (RF 444)

Originally attributed to Mantegna, Borenius was the first to assign this drawing to Buonconsiglio. As he observed, the modelling of the chest and the characterisation present affinities with the Christ in Buonconsiglio's early *Pietà* from San Bartolomeo at Vicenza, and the pose is not dissimilar to the St. Sebastian in his altarpiece at S. Giacomo dell'Orio, Venice. The head and main section of the torso are carefully delineated with close hatching, derived from Mantegna, which gives the impression of form; and the rendering of light on the right half of Christ's torso is most effective. Idiosyncratic features are the curious tuck of flesh across the middle of the body, almost like a belt, and the continuation of the line of the neck straight down the chest. The foreshortening of the head is ambitious.

The central figure is flanked by smaller sketches of full-length standing figures in architectural niches: on the left, a figure of Justice holding a sword and a balance, on the right St. Peter holding keys (?). Both these sketches and the architectural details above the figure on the right are drawn much more rapidly than the central figure.

D.E.S.

PROVENANCE
Sir Thomas Lawrence; His de la Salle;
1898 presented to the Musée du Louvre

REFERENCES
Borenius 1909, p. 204, no. 71;
Parker 1927, no. 59; Tietze and Tietze-Conrat 1944, no. A412

Domenico Campagnola

[Biography on p. 324]

D6
A Scene of Sacrifice

320 × 213 mm
Pen and brown ink on white paper, laid down
Signed: *Campagnola* (lower left partially cancelled)
Gabinetto dei Disegni, Uffizi, Florence (no. 1451E)

Rearick has dated this drawing *c.* 1514, considering it an example of Domenico's work as a student in Giulio Campagnola's studio, and some clumsiness in the modelling of several of the heads and limbs supports his early dating. The technique, with strong hatching, is derived from that of engraving.

The drawing is based on a supposedly antique bas-relief that no longer survives, but it is known from an engraving by Girolamo Mocetto (Hind 1948, II, p. 161, no. 6) and is reproduced in several plaquettes from the first quarter of the sixteenth century (examples in the Bode Museum, East Berlin; the Bargello, Florence; the Louvre, Paris). Rearick has pointed out that Andrea Riccio used the same relief as a model for the right-hand section of his *Sacrifice to Aesculapius* on the Della Torre tomb (see Cat. S17 and S18). If the original bas-relief was antique, it was probably Roman, dating from the first century AD, but it may have been a contemporary work in the antique manner.

D.E.S.

PROVENANCE
Fondo Mediceo-Lorenese, Uffizi

EXHIBITION
Florence 1976, no. 61 (Rearick), with full bibliography

D5

D6

D7
Landscape with Two Youths

185 × 274 mm
Pen and brown ink on white paper, laid down
Signed upper left in brown ink: *Dominicus/Campagnola*;
inscribed 76
The Trustees of the British Museum, London (1895-9-15-836)

The Tietzes assigned this work to a group of drawings
which they dated before 1517. The group, which includes
The Stigmatization of St. Francis (Weimar) and *Christ
Sleeping in the Boat* (University Library, Uppsala) shows no
trace of Titian's influence. All the drawings are somewhat
awkward in composition and, occasionally, in handling.
The dominating influences are those of Dürer and
Giorgione, and it is obvious that Domenico studied Dürer's
engravings: as the Tietzes observed, here the engraving tool
rules the pen.

D.E.S.

PROVENANCE
P. J. Mariette; Comte de Fries; Durand(?); Sir Thomas Lawrence;
A.C. (de) Paggi; J.C. Robinson (?); Malcolm;
1895 acquired by the British Museum

REFERENCES
Popham 1939, p. 322, repr.; von Hadeln 1927, pp. 16, 24, no. 48

D7

D8

D8
St. Mark Healing a Demoniac

242 × 316 mm
Pen and brown ink
Inscribed in the right-hand corner: *Dom/co Ca/gn. . .*
George Goldner Collection, Los Angeles

This is a characteristic example of a pen sketch by
Domenico; the attribution is supported by the inscription
(which may be a signature). The drawing was first
published by Julien Stock, who connected it to a bronze
relief of the same subject by Jacopo Sansovino, one of a
series made for San Marco, Venice, which was cast in 1537.
The sketch, which appears to be a study made after the
relief had been installed in the church, testifies to the impact
these works by Sansovino had on contemporary artists such
as Jacopo Bassano and Tintoretto. Although Campagnola
does not quite master the perspective arcading in the
background, in other respects this is a faithful copy.

B.B.

EXHIBITIONS
Sotheby's, London 18 November 1982, lot 6, p. 34

REFERENCES
Boucher 1976, pp. 560, 565; Stott 1982, pp. 370ff

Giulio Campagnola

Padua *c.* 1482 – Venice (?) *c.* 1515/18

Giulio Campagnola was born in Padua *c.* 1482. His father,
a learned man, attempted to place Giulio at the court of
Francesco Gonzaga at Mantua in 1497, in order that he
might work under Mantegna. Whether Giulio ever settled
there is not known, but he is recorded at the court of Ercole I
at Ferrara early in 1499, and in Venice in 1507. He is
mentioned in the will of Aldo Manuzio, the celebrated
printer, in January 1515; nothing certain is known about
Giulio thereafter. It is possible that one of his engravings
was completed by his pupil Domenico Campagnola
c. 1517–18, and it has been inferred from this that Giulio
was dead by that date.

Altogether, there are seven engravings signed by Giulio
Campagnola, and several more may be attributed to him
with confidence. Some show the influence of Mantegna,
while others contain passages copied directly from Dürer's
prints. However, the largest and best known group of
engravings is more closely related to the work of Giorgione:
these usually represent contemplative figures situated in
gentle landscapes with rustic buildings in the background.
In several of the engravings, Giulio achieved the sense of a
soft atmosphere by employing a dotted technique.

Contemporary accounts suggest that apart from working as a painter, Giulio was also a musician and well-versed in classical languages. Although various paintings, including the *Trial of Moses* and *Judgement of Solomon* (also attributed to Giorgione) in the Uffizi, Florence, have been ascribed to him, there are no attributions supported by documentary evidence.

D. McT.

REFERENCES

Fiocco 1915, pp. 137–56; Hind 1938–48, v pp. 189–205;
Kristeller 1907; Luzio 1888, pp. 184ff.;
Petrucci 1958, pp. 12ff.; Suida 1935–36, pp. 285–89;
Tietze and Tietze-Conrat 1944, pp. 132–37; Washington 1973, pp. 390–413

D9

Three Philosophers in a Landscape

183 × 274 mm
Pen and brown ink
Fondation Custodia (Coll. F. Lugt), Institut Néerlandais, Paris
(1978–T.21)

This characteristic example of a Giorgionesque landscape has only recently come to light. Although the drawing was attributed at auction first to Domenico Campagnola and later to the 'circle of Giorgione', James Byam Shaw has provided a detailed justification for attributing it to Giulio Campagnola. Of the various works associated with Giulio, only the engravings are securely attributed: Byam Shaw has indicated a number of compelling similarities between this drawing and Giulio's prints. These include the general similarity of subject matter to that of the engraving, *The Astrologer*, dated 1509 (Cat. P9); the analogous manner of

rendering foliage – in the bushes behind and to the right of the philosophers – in this drawing and in such prints as the *St. John the Baptist* (Cat. P10) and the *Stag at Rest* (Hind 1938–48, no. 14); and the related parallel lines of the sky in the prints *The Astrologer* (Cat. P9) and *Christ and the Woman of Samaria* (Hind 1938–48, no. 11).

The drawing also possesses numerous features frequently encountered in early sixteenth-century Venetian landscapes. Learned personages, who are not readily identifiable but often wear hoods or turbans and hold cryptic diagrams, appear in several other landscapes, most notably Giorgione's *Three Philosophers* in Vienna. The small reclining figures and the sheep at the right of the drawing, and the gabled rustic buildings in the background, are also elements repeatedly included in the idyllic landscapes produced in the Veneto at this time.

The vast majority of surviving landscape drawings from early sixteenth-century Venice are executed solely in pen and ink, and many, such as this example, suggest the hand of an engraver. However, other techniques were occasionally employed: a landscape drawing related to Giulio Campagnola's engraving of *St. John the Baptist* was executed with the point of the brush (Louvre, RF 1979; repr. Venice 1976[1], no. 2), while a landscape drawing attributed to Giorgione in Rotterdam is in red chalk.

D. McT.

PROVENANCE

21 November 1974, Sotheby's, London sale, (lot 4); R. Day;
anonymous collection; 29 November 1977, Christie's, London sale,
(lot 37); Frits Lugt, Fondation Custodia

EXHIBITIONS

London 1976, no. 5; Venice 1981[2], no. 37

REFERENCES

Byam Shaw 1983, p. 236, no. 231, pl. 264, with full bibliography

D9

D10

D11

D10
Landscape with a Watermill

162 × 263 mm
Pen and brown ink
Gabinetto dei Disegni, Uffizi, Florence (no. 463P)

Traditionally ascribed to Marco Basaiti, this drawing was first attributed to Giulio Campagnalo by Kristeller in 1907, an attribution that has since received repeated support in discussions of Campagnola's drawings.

The corpus of Giulio's drawings has been established by analogies with his engravings and, although no exact relationships exist between this particular drawing and his engravings, a number of similarities are evident. Especially characteristic is the manner of rendering shrubbery, such as the bush on the bank in front of the buildings, so that the trunks radiate like the ribs of a fan and are silhouetted against shadow created by dense cross-hatching, while the leaves appear as schematic, flat areas. In contrast, the row of trees on the right represents a more unusual and particularly sensitive transcription of nature. Also typical is the picturesque variety of texture and outline in the buildings. Related to motifs in prints by northern artists, and to details in paintings by Giorgione and his circle, these buildings are made particularly distinctive by their steeply-pitched, hipped roofs – often with finials at the apexes – and by walls boarded with vertical planks.

This classic example of pastoral stillness and repose has been dated by Rearick (Florence 1976) to about 1512/14, while Oberhuber (Venice 1976) would evidently prefer a somewhat earlier date.

D. McT.

EXHIBITIONS
Florence 1961, no. 63; Florence 1976, no. 8;
Venice 1976, no. 4

REFERENCES
Florence 1976, p. 27; Venice 1976¹, p. 54, with full bibliography

Vittore Carpaccio

[Biography on p. 166]

D11
St. Augustine in his Study

277 × 427 mm
Pen and brown ink and brown wash
The Trustees of the British Museum, London (1934-12-8-1)

This study for the painting in the Scuola di S. Giorgio degli Schiavoni, Venice, was thought formerly to represent St. Jerome. According to legend, when St. Augustine was sitting in his study writing to St. Jerome, a miraculous light appeared announcing the latter's death.

Popham and Pouncey think that the drawing is preparatory to the painting, and not, as Muraro suggested,

a documentary drawing showing the 'state of play' of the picture. Pignatti has observed that Carpaccio was interested here in the use of light and shade, which give pictorial values to the composition as a whole, whereas in his earlier drawings (eg. *Prince Conan Taking Leave of his Father*; Chatsworth, Derbyshire) he concentrated on realistic details. One of the related scenes in the Scuola di S. Giorgio is dated 1502, and this drawing must belong to the first decade of the sixteenth century.

D.E.S.

PROVENANCE
P. & D. Colnaghi; 1934 presented by the National Art Collections Fund
to the British Museum

REFERENCES
Pignatti 1972, no. 15; Popham and Pouncey 1950, no. 35

D12

D12
Head of a Bearded Man

197 × 141 mm
Black chalk, brush and brown wash
touched in places with the pen,
heightened with white, on faded brown paper (formerly blue?)
Verso: a draped left leg, a left foot and
the lower part of the drapery of a kneeling figure
Fondation Custodia (Coll. F. Lugt), Institut Néerlandais, Paris
(no. 5070)

As has often been observed, this head resembles that of an apostle in *The Calling of St. Matthew* in the Scuola di S. Giorgio degli Schiavoni, Venice, which is dated 1502. The drawings on the *verso* may be preparatory designs for *The Annunciation* from the Scuola degli Albanesi (now in the Ca d'Oro), datable *c.* 1504, as von Hadeln first suggested.

D.E.S.

PROVENANCE
Bonfiglioli Coll., Bologna; 1728/34 bought by Zaccaria Sagredo;
1763 John Udny; the Earls of Sunderland;
George Spencer Churchill, 8th Duke of Marlborough;
1883 Christie's, London sale; J. Heseltine;
1912 P. & D. Colnaghi and Obach; H. Oppenheimer,
1936 Christie's, London sale; Frits Lugt, Fondation Custodia

EXHIBITIONS
Rotterdam 1938, no. 447, pl. 23;
Paris, Rotterdam, Haarlem 1962, no. 36, pl. XXIX;
Nice 1979, no. 23, repr. (*recto* and *verso*);
Venice 1981[1], no. 28, repr.; London 1983, no. 79

REFERENCES
Byam Shaw 1983, I, no. 223; II, pls. 252, 253, with full bibliography

DI3
Young Man in a Cap

265 × 187 mm
Black chalk, brush and a little pale brown wash,
heightened with white, on blue paper
The Governing Body, Christ Church, Oxford (no. 0282)

This drawing is generally thought to be of the same period
as the paintings for the Scuola di Sant' Orsola, Venice, now
in the Accademia. Although this sheet does not correspond
with any of the numerous portraits introduced into that
series, Byam Shaw considers that it can safely be dated
1495–1500, rejecting Ricci's attempt to identify the man
with one of the bystanders in the *Preaching of St. Stephen*
(1514) in the Brera, Milan.

D.E.S.

PROVENANCE
Sebastiano Resta; John, Lord Somers (?); Jonathan Richardson Senior;
Lansdowne MS. 803, R. 52, p. 28 (as Gaudenzio Ferrari);
Guise; Christ Church

REFERENCES
Byam Shaw 1976, no. 710, pl. 404, with full bibliography

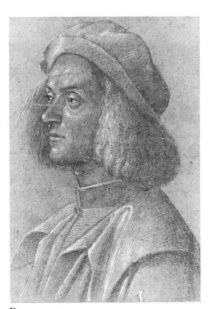

DI3

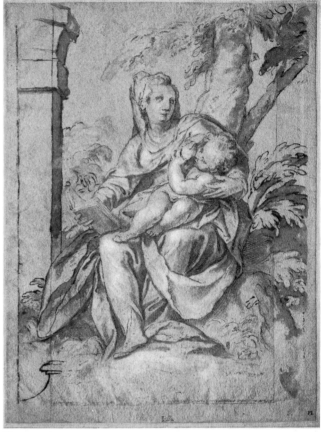

DI4

Paolo Farinati

[Biography on p. 347]

DI4
Virgin and Child in a Landscape

277 × 210 mm
Pen and brown ink and wash, heightened with white,
on blue paper
Inscribed in W. Gibson's hand: *P. Farinat. 5.2.*
Verso: study of a male figure holding an open book
and another figure, cut off; brush and brown wash
National Gallery of Scotland, Edinburgh (no. D. 1577)

A late drawing, datable in the 1580s according to Mullaly;
Andrews suggests the *verso* may relate to a decorative
scheme for a villa.

D.E.S.

PROVENANCE
Sir Peter Lely; Jonathan Richardson Senior; W. Gibson;
David Laing; Royal Scottish Academy;
1910 transferred to the National Gallery of Scotland

REFERENCES
Andrews 1968, p. 49, with bibliography

D15
Zephyr and Psyche

283 × 412 mm
Pen and brown ink and brown wash over traces of black chalk,
heightened with white (partly oxidised), on faded blue paper
Inscribed in the artist's hand in brown ink:
Zefiro vict [?]/*porta psiche/isola al pa*[*lazzo*]*di chupido* and *Borea
Capo de venti/rapise orithia sua diva/sua zovene cenza barba*; this
has been crossed out in the same hand; lower left: *piedi 6. Verso*
inscribed: *Zefiro che porta psiche la zovene cēza barbe cō le ale/
Venenere che spenachia lali a chupido cō cavezzo roto estrali/
favēdoli il carchaso tolto et favelle in ato schoriciato/e amore che
si dolia e patischa di tale ofeso fate da venere sua madre/
Merchurio che porta psiche col suo caduceo et alle al capelo e
piedi*; dated lower centre in the same hand: *Ultimi mazo 1588*:
inscribed lower right in W. Gibson's hand: *P. Farinato/8.2.*
Fitzwilliam Museum, Cambridge (no. 2956)

A similar drawing, inscribed *Mercurio porta psiche al cielo*,
also from the Lely, Gibson and Reynolds collections, is in
the Ashmolean Museum (Parker 1956, II, no. 223). Both
drawings are designs for octagonal ceiling paintings
illustrating the legend of Cupid and Psyche, reminiscent of
those by Giulio Romano in the Palazzo del Te at Mantua.
The elaborate contortion of the figures, heavy use of wash
and abundance of white highlights are characteristic of
Farinati's later work, this sheet being dated to the end of
May 1588.

D.E.S.

PROVENANCE
Sir Peter Lely; William Gibson (?); Sir Joshua Reynolds;
Dr H. Wellesley, 1886 Sotheby's, London sale (lot 529);
Sir James Knowles; 28 May 1908, acquired by G. T. Clough at
Sir James Knowles's sale, Christie's, London (part of lot 232);
1913 presented to the Fitzwilliam Museum

EXHIBITIONS
Cambridge 1960, no. 27; Cambridge 1980–81, handlist, pp. 11, 12

REFERENCES
Macandrew 1980, III, p. 261, no. 223

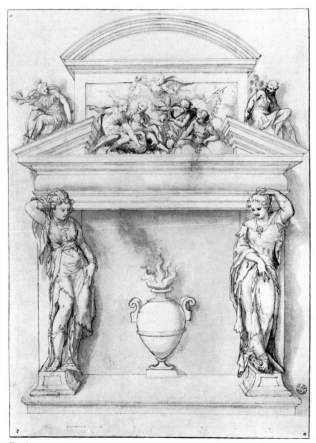

D16

D16
Design for a Fireplace

397 × 283 mm
Pen and brown ink and brown wash over black chalk,
laid down on a Mariette mount
Inscribed on the cartouche: J. BAPTISTA/ZELOTTI
Cabinet des Dessins, Musée du Louvre, Paris (no. 5598)

The former attribution to Zelotti cannot be sustained:
Pouncey observes that this is a characteristic example of
Farinati's draughtsmanship. Presumably it was intended as
a design for a fireplace in a country villa, since the caryatid
on the left sports hunting dress and a boot held in place by
a crescent moon – a symbol of Diana, goddess of the chase.
Above the fireplace are grouped several gods with their
attributes: Jupiter with his eagle, Mars with helmet and
shield, Cupid holding thunderbolts, Neptune with a trident,
standing on a dolphin, and Bacchus with his thyrsus. The
figures set on plinths flanking the architectural framework
each hold a spray of flowers.

D.E.S.

PROVENANCE
P. J. Mariette; 1775, Mariette's sale, Paris (lot 801)

EXHIBITIONS
Paris 1965, no. 246, repr.

REFERENCES
Tietze and Tietze-Conrat 1944, no. 2263 (as Zelotti)

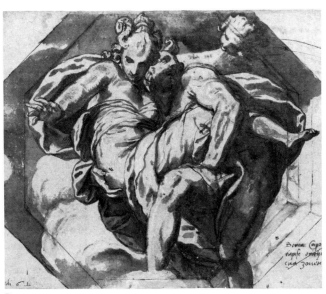

D15

D17

D17
The Emperor Vespasian Standing in a Niche

394 × 270 mm
Pen and brown ink and brown wash over
black chalk, heightened with white
Inscribed upper right:
INP. CAES. VESPASIA / AVG. P.M.T.R.P.P.C/ OS. III
Verso: the reverse of a medal with the inscription IVDEA CAPTA
SC and in Farinati's hand: *P[er] riverso di la medalia di vespisiano
seli fa una palma arbore grāde aqu . . . / modo una dona asentata
tuta pensosa.e ū armado cō le mane ligate de di/[ētro] cone pregiō/
il drito di la medalia se li fa: IMP.CAES VESPA/AUG COS III/
Anche se lifa ū altro riverso luna figura cō unasta imano ch afronta
ū perchi/cō un albor di drio la qual figura sia p[er] dito vespasiano
caciatore over p[er]. . ./ meleagro*
Her Majesty The Queen (no. 4995)

This is one of a group of eight drawings at Windsor
representing Roman emperors and antique heroes. Of these,
two are in architectural niches, and presumably formed part
of a project for the decoration of a palace. The inscription,
which is related to a hybrid silver coin dated AD 70, is taken
from Rovillius's *Prontuario*, the first edition of which was
published at Lyon in 1553, the first Italian edition appearing
the same year.

D.E.S.

REFERENCES
Popham and Wilde 1949, no. 300, pl. 174

Giovanni Battista Franco,
called il Semolei

Venice 1498–Venice 1561

Franco, a painter, etcher, engraver and prolific
draughtsman, was born in Venice and worked there before
moving to Rome, where he was much influenced by
Michelangelo and Raphael. He also worked in Florence and
Urbino, where he produced designs for majolica.

D.E.S.

D18

[256]

D18
Standing Figure of a Cloaked Man

260 × 126 mm, upper corners cut
Pen and brown ink and wash over black chalk
The Trustees of the British Museum, London (no. 5211–25)

A characteristic example of this prolific artist's work; the chalk underdrawing is freely handled whereas the penwork is similar to an engraver's technique. There are several pentimenti on the head. Popham suggested this might have been a study for one of the two philosophers in niches which, according to Vasari (VI, p. 586), were painted by Franco between the windows of the Libreria in Venice. Gere and Pouncey date the drawing between 1557 and 1561.

D.E.S.

PROVENANCE
R. Houlditch; W. Fawkener Bequest 1769

REFERENCES
Gere and Pouncey 1983, no. 114, pl. 103

D19

After Giorgione

D19
The Adoration of the Shepherds

227 × 194 mm, upper left-hand corner made up
Point of the brush and brown wash over black chalk, heightened with white, on blue paper
Her Majesty The Queen (no. 12803)

The Tietzes concluded that this drawing is a copy of a

picture painted before the Allendale *Adoration of the Shepherds* (National Gallery, Washington D.C.), with part of which it corresponds, and that the Allendale panel was based on the earlier picture. Popham agreed that the drawing appears to be more primitive than the painting; he commented that the technique and appearance come very close to Carpaccio, but suggested that equally it might well be a translation of the Allendale picture by a draughtsman of an older generation into his own archaic idiom. However, Oberhuber regards this drawing as an original by Giorgione (Venice 1976).

D.E.S.

EXHIBITION
Venice 1976[1], no. 1, with full bibliography

REFERENCES
Popham and Wilde 1949, no. 343, pl. 162;
Tietze and Tietze-Conrat 1944, A719, with bibliography;
von Hadeln 1925[2], p. 32, pl. 1

Bernardino Licinio
[Biography on p. 174]

D20
Woman Holding a Vase

D20

214 × 147 mm
Black chalk, heightened with white, on blue-grey paper
Inscribed lower left in pencil: *A del Sarto*
Yale University Art Gallery (1961-65-46)

This drawing was first recognised as a work of Licinio by Rearick. His attribution is based on two representations of drawings in Licinio's painting *An Artist with Five Pupils* (Alnwick Castle, Northumberland). Most pertinent is a *Crouching Venus* in red chalk heightened with white on light blue paper. Of this he comments, 'while it is rather timid and tight in outline, its softly textured combination of chalks and the bland fidelity to appearance accord well with the style of the Licinio drawing at Yale'. Rearick notes that the artist used this drawing of a *Woman Holding a Vase* as the model for the Madonna in at least eight paintings. Several of these are dated, the earliest 1530 and the latest 1535, but two others, although undated, are considerably earlier; Rearick proposes that they are close

to 1520. While the figure in the drawing is never repeated exactly in any of these paintings, the pose is always similar.

The somewhat unusual idea of making a life study for the figure of the Madonna, using a simple vase as a stand-in for the Child, is, as Rearick points out, entirely compatible with the literal-minded simplicity of spirit that pervades all Licinio's work. The attribution to him is confirmed by the outline drawing on the *verso* of the painting of the *Virgin and Child between St. Joseph and St. Catherine* in Split, Yugoslavia (*Arte Veneta* 1980, pp. 151–53, fig. 4).

D.E.S.

PROVENANCE
Egmont; Sterling Memorial Library; Yale University Library;
1961 transferred to Yale University Art Gallery

REFERENCES
Haverkamp-Begemann and Logan 1970, no. 273, pl. 141;
Rearick 1967, pp. 382–83, pl. 22

D21

Lorenzo Lotto

[Biography on p. 175]

D21

Study for the Tarsia of Judith and Holofernes

315 × 246 mm
Pen and brown ink and brown wash, with traces
of white highlights
(the sheet has several old repairs, worm holes,
water stains and is somewhat faded)
Inscribed with extensive colour notes including
left to right, top to bottom:
nocte; veste di laca; biaco; nocte; laca; b[ianco]
Private Collection, London

Only two drawings relating to the *tarsie* in S. Maria
Maggiore, Bergamo have been identified: this sheet and the
drawing of *Samson Slaying the Philistine* in Janos Scholz's
collection, New York (Pouncey 1965, pl. 22). Whereas the
Scholz drawing is a compositional sketch, the *Judith and
Holofernes* is a detailed study for the intarsia: the contours
are carefully defined and internal details are indicated, an
elaborate wash and white highlights suggest the pictorial
and spatial distinctions and Lotto has added colour notes.
But this is not a fragment of a *modello* (it is slightly smaller

than the wooden panel); it must have immediately preceded
it.

In the creation of any design, either for a painting or a
tarsia, Lotto would have made use of various types of
drawings; this is a unique survivor of a category of drawing
which must have been fairly common in his work.

The work was in hand on 29 August 1527 and Lotto was
paid for it on 4 September (Rearick 1980).

D.E.S.

PROVENANCE
1957 acquired by the present owner

EXHIBITIONS
Edinburgh 1969, no. 42, pl. 5

REFERENCES
Chiodi 1962, p. 57, pl. 3; Pouncey 1965, pl. 20;
Rearick 1980, p. 31, fig. 15

D22

Sacra Conversazione

168 × 200 mm, the top slightly shaped
Pen and brown ink and grey wash, heightened with white,
squared with red chalk; slightly oxidised
Verso: list of accounts
Cabinet des Dessins, Musée du Louvre, Paris (no. 11.339)

D22

It is the superabundance of white and the subtlety with which Lotto uses this medium to indicate both movement and characterisation which astonishes in this enchanting drawing discovered by Pouncey. St. Anthony Abbot, identified by his pig, is led by an angel to the Infant Christ, who raises his hand in benediction. Berenson remarked of this drawing that it is 'by far the most interesting sketch for a composition by Lotto that has appeared yet. Pictorial to the last degree.' Pignatti dated it 1539 and related it to the *Madonna del Rosario*, but Pouncey followed Berenson in placing it between 1528 and 1530.

D.E.S.

EXHIBITIONS
Venice 1953, no. 8; Paris 1965, no. 97, repr.

REFERENCES
Berenson 1956, fig. 226; Pignatti 1953, p. 157;
Pouncey 1952, p. 325; Pouncey 1965, pl. 14

D23
An Ecclesiastic in his Study

165 × 199 mm
Point of the brush and brown wash over traces of black chalk
The Trustees of the British Museum, London (1951–2–8–34)

Popham (1951) first attributed this drawing to Lotto; Pouncey (1952) tentatively placed it *c.* 1530, a dating which seems preferable to Popham's suggestion of 1510–20 and which found favour with Berenson.

It is most interesting to compare Lotto's drawing with Carpaccio's *St. Augustine in his Study* (Cat. D11). Carpaccio was concerned with the overall composition while the personality of the saint was scarcely considered, but in Lotto's drawing the personality of the young prelate, 'so contented with his possessions', as Berenson observes, dominates the room, and he is in much closer communion with his lapdog than with the older man seated on the right.

D.E.S.

D23

D24

PROVENANCE
S. Woodburn; 1860 Christie's, London sale (lot 1087); Phillipps Fenwick;
1951 presented anonymously to the British Museum

REFERENCES
Berenson 1956, fig. 205; Fenwick catalogue 1935, p. 21, no. 1;
Popham 1951, p. 72 f.; Pouncey 1952, p. 32; Pouncey 1965, pl. 15

D24
Festivities in Honour of Padua

265 × 160 mm
Point of the brush and wash, heightened with white,
on white paper squared with red chalk for transfer
Inscribed: PADVA
Biblioteca Reale, Turin (no. 15909)

This drawing was recognised by Pouncey as an example of Lotto's draughtsmanship in its full maturity, close in date to the *Sacra Conversazione* (Cat. D22).

It is interesting to note how well the handling of the faces corresponds with that of the Leipzig drawing (Cohen 1975), all of which accord with the preliminary drawing in the

Rijksmuseum (Pouncey, fig. 7) for the *Double Portrait* (Cat. 44). But the closest correspondence is with the roundels of Lotto's altarpiece at Cingoli of 1539, which suggests a date that would coincide with the artist's stay in Venice from 1535 to 1538.

Pouncey argued that the illusionistic representation of the frame, including section drawings of its mouldings, shows that the drawing was a design for a painting of a fictive open doorway, and that the inscription, Padua, identifying the city represented in the little model carried by the man crowned with laurel, might imply that it was for a series illustrating the various cities under Venetian dominion, to be executed for some public room in the capital. The finished nature of the sheet, together with its squaring, shows it was intended as a model to be transferred to a larger scale.

Griseri has commented on the unpretentious manner, which is so characteristic of Lotto: 'Far from glorious is the trophy on the aching neck of the man bent in the effort to support it. As always, it is the humblest and most human attitudes with which Lotto identifies and by which he is most inspired.'

D.E.S.

REFERENCES

Bertini 1958, p. 32, no. 184 (as Girolamo del Santo); Cohen 1975²; Griseri 1978, no. 35; Pouncey 1965, pl. 26; Tietze and Tietze-Conrat 1944, no. 739, pl. 41

D25

Girls and Boys Singing

251 × 323 mm
Point of the brush and grey-brown wash, highlighted with white (slightly oxidised), over traces of black chalk, on faded blue-grey paper squared in black chalk
Gabinetto dei Disegni, Uffizi, Florence (no. 684E)

An old inscription on the *verso* attributes this drawing to Giorgione. Marini published it as an example of the finished draughtsmanship of Sebastiano Florigerio, comparing it to a drawing in Berlin for the head of Isaiah in S. Daniele del Friuli. Pouncey recognised the sheet, classed in the Uffizi as the work of Pordenone, as characteristic of Lotto's mature style and connected it in terms of technique, style and subject matter with the drawing of *Festivities in Honour of Padua* (Cat. D24). The sense of depth achieved by the grouping of the figures is particularly successful.

D.E.S.

REFERENCES
Marini 1956, pl. 7

D25

D26

PROVENANCE
Skippe; Mrs Rayner Wood; British Museum

REFERENCES
Berenson 1956, fig. 340; Popham 1938, p. 49;
Pouncey 1965, fig. 17; Tietze and Tietze-Conrat 1944, no. 766

Bartolomeo Cincani, called

Montagna

Vicenza (?) c. 1450 – Vicenza 1523

The exact date of birth of Bartolomeo Cincani (who at an early stage took the name Montagna by which he was subsequently always known) is not recorded, but there are reasonable grounds for placing it around, or perhaps a little before, the middle of the fifteenth century. Nor has it been established whether he was born in Vicenza, where the first documentary reference to him dates from 1459, or at Orzinovi in the province of Brescia, from where his father, Antonio, came.

Montagna is identified as a painter ('*pictor*') in documents from 1474 onwards, but we know that in 1469 he was living in Venice ('*in . . . civitate Venetiarum*'), undoubtedly while training in the studio of Giovanni Bellini. He is known to have been working in 1478 for the church of Piovene in the province of Vicenza, but even before then, already enjoying recognition as an outstanding artist ('*egregio maistro*'), he owned a workshop in the Berici hills that was patronised by a clientele of high social and cultural standing.

In 1482 Montagna was commissioned to execute two canvases – now lost – for the Scuola Grande di San Marco in Venice. Thereafter he monopolised the most important painting commissions in Vicenza and was summoned to work in other towns in the Veneto: firstly to Padua, where, with Pierantonio degli Abati and Benedetto Bordone, he contributed to the fresco decorations of the monastery of S. Giovanni di Verdara, begun in 1488, and to those in the upper hall of the new Bishop's Palace completed in 1506. He was to return to Padua after the events of the League of Cambrai, in about 1509, and remained there until 1514, executing, amongst other things, a fresco in the Scuola del Santo in 1512. Between 1504 and 1506 he painted the chapel of S. Biagio in SS. Nazaro e Celso, Verona.

From 1515 until his death it is evident that Montagna was slowing down his activities and his fame also declined. He can be considered one of the most original exponents on the Venetian mainland of Antonello da Messina's revolutionary style, as interpreted and enriched by Bellini.

L.P.

REFERENCES
Azzi Visentini 1980, pp. 5–10; Barbieri 1964, pp. 282–85;
Barbieri 1965, *passim*; Barbieri 1981, pp. 23–31; Gilbert 1967, pp. 184–88;
Mantese 1968–69, pp. 240–48;
Puppi 1962[1], *passim*, with earlier bibliography; Puppi 1964, pp. 194–204;
Puppi 1968[2], p. 219; Puppi 1975, pp. 23–29; Sambin 1962, pp. 104–08

D26
Study for St. Matthias

407 × 283 mm
Black chalk, heightened with white, on blue paper
squared in black chalk
Inscribed: *Lorenzo Lot l'opera è in Ancona*
The Trustees of the British Museum, London (1958–12–13–2)

This study for the *Virgin and Child Enthroned with St. Stephen, St. John the Evangelist, St. Matthias and St. Lawrence* (Cat. 53) is of great beauty, although, in Berenson's words, 'it sheds no light on the gestation of the figure for which it is a sketch'.

It does however tell much about Lotto's drawing technique. Popham first commented on the obvious northern influence: 'The cast of the drapery and its handling recalls not so much any contemporary Italian work as that of a German – Matthias Grunewald.' Pouncey notes how meticulously Lotto worked on his preparatory drawings in his old age, notwithstanding his long and experimental career. Even so, the translation from drawing to painting is not pedestrian, and although the basic pose is maintained there are several significant differences in the painted figures.

D.E.S.

D32

D33

D33

Self-portrait (?)

256 × 184 mm
Black chalk, heightened with white, on blue paper
Verso inscribed: *Nᵒ 473, del Palma Vecchio dipinto da lui per
Serinalda nella palla di S. Giovanni Battᵃ nelᵒ studio Arconati*
Dr. K. K. Andrews

The inscription on the *verso* is a mystery: the parish church
of Serinalta, or Serina (Palma Vecchio's birthplace) has no
altar dedicated to John the Baptist; no other church or
oratory there was dedicated to him. We do not know that
either of Palma's polyptychs in Serina contained a portrayal
of John the Baptist. Nevertheless, the inscription is clearly
old and, in mentioning Serinalta, well informed. The
Arconati (if this is the correct reading of the word) were an
aristocratic Milanese family.

When Rowlands published this drawing, he argued that
it was a self-portrait, but the angle of the head and the
direction of the gaze are standard in Palma Vecchio's male
portraiture. The resemblance between this elegant drawing
and Palma's painted portraits goes further: the details of
modelling, such as the shadow extending from the bridge
of the nose to the cheek, or the line of light down the nose
itself are the same. The effect of softness is achieved partly
through rubbing, perhaps stumping the chalk, particularly
on the shaded side of the face.

The handsome youth (whom Mariacher unaccountably
called an old man) brings to mind Palma's characterisation
of John the Baptist in his altarpiece in Zerman (near
Treviso) and in the *St. Peter Enthroned* in the Accademia,
Venice. In quality the drawing is comparable to such fine
heads as Palma's so-called '*Ariosto*' in the National Gallery,
London, and is datable probably to the early 1520s (the
same period as the Zerman and Accademia altarpieces
mentioned above, although slightly later than Cat. D32).

P.B.R.

PROVENANCE
Sir Peter Lely

EXHIBITIONS
Edinburgh 1969, no. 50; Venice 1980, no. 11

REFERENCES
Ballarin 1970, p. 47; Mariacher 1968, pp. 116–17;
Rowlands 1966, pp. 372–75; Ruggeri 1969, p. 167

D34

Sacra Conversazione

126 × 195 mm
Pen and brown ink over black chalk on white paper
Inscribed in a later hand: *palma vecchio*
Verso: accounts for some clothes
Teylers Museum, Haarlem (Inv. no. B. 21)

In his unpublished notes in the British Museum, Popham tentatively suggested that this sheet was fairly early in date, probably before 1600. Mariette's attribution to Tintoretto cannot be sustained; the style of the drawing is identical to other sheets by Palma Giovane, such as *The Crucifixion with Saints* (Albertina, Vienna, no. 17655), the *Dead Christ Supported by Angels* (Louvre, Paris, no. 5188) and *St. Martin and the Beggar* (National Gallery of Scotland, no. D.697).

This drawing may be connected with *The Last Judgement* of 1587–94 in the Doge's Palace, Venice, but, as Popham observes, 'in the case of so prolific and inventive a draughtsman it is difficult to be certain that studies which have a superficial resemblance to a picture are necessarily for this'.

D.E.S.

PROVENANCE
P. J. Mariette; Francois Falconnet (?); E. E. Pulteney;
1941 presented by the National Art-Collections Fund to the British Museum

REFERENCES
Grassi 1978, pp. 262–71, fig. 8

D31
Sheet of Studies of Nude Women

379 × 222 mm
Recto: pen and brown ink
Verso: red chalk
The Trustees of the British Museum, London (1946–7–13–431)

D31

On the *recto* of the sheet there are three studies for a naked woman, with two draped figures above, and on the *verso* a similar study of a naked woman in red chalk and the profile of a bearded man. Popham suggested that the studies were for a painting of Bathsheba, but the presence of the head of a bearded man on the *verso* suggests that these characteristic late studies could have been for a painting of Susanna and the Elders.

D.E.S.

PROVENANCE
Woodburn sale (lot 1304); Phillipps Fenwick collection;
1946 presented anonymously to the British Museum

REFERENCES
Popham 1935, p. 77

Jacopo Palma il Vecchio

[Biography on p. 194]

D32
Head of a Young Woman

222 × 160 mm
Black chalk, heightened with white, on faded blue paper
Cabinet des Dessins, Musée du Louvre, Paris (no. 482)

This drawing has been attributed to Palma Vecchio since at least 1881 (Tauzia). He seems to have used chalk when preparing details for his paintings, but pen and ink for sketching entire compositions. The young woman portrayed here appears in several paintings by Palma: most literally in a *Christ and the Adulteress* in Leningrad, but also in the *Adam and Eve* Brunswick, and the Capra altarpiece in Santo Stefano, Vicenza. Indeed the drawing seems to have been kept in the studio and used repeatedly for his paintings.

Like the more finished pen drawings (eg. the right-hand side of the Cambridge *Holy Family*), this sketch shows a characteristic use of hatching combined with emphatic contours. A feature of Palma Vecchio's chalk sketches is the hatched shading behind the motif to give it relief, which is indicative of Palma's fundamental approach – the playing off of light against dark planes, with a tonal range limited virtually to a light tone (occasionally heightened in white), a pale and a dark shadow. The confidence apparent in Palma's delineation of the features, and the directness of the woman's gaze suggest a date early in Palma's artistic maturity, *c.* 1520.

P.B.R.

PROVENANCE
His de la Salle

REFERENCES
Gombosi 1937, p. 33; Mariacher 1968, p. 118; Rearick 1976, p. 73;
Tauzia 1881, p. 54; Tietze and Tietze-Conrat 1944, p. 229;
von Hadeln 1925, p. 34

Jacopo Palma il Giovane

[Biography on p. 192]

D29
The Agony in the Garden

415 × 188 mm
Pen and brown ink and brown wash, heightened with white,
over slight traces of black chalk on brown paper;
bordered on all sides by a line of brown ink
Signed (?) and dated lower left in brown ink: *giovine 1575*;
added in different ink: *Palma*
Fitzwilliam Museum, Cambridge (no. 3070)

The Tietzes dated this drawing *c.* 1600 or later on stylistic
grounds, taking the signature for a later inscription. The ink
used for the inscription *giovine 1575* is identical to that of
the drawing and there seems no reason to doubt that it is
genuine.

Another drawing of the same subject by Palma Giovane
is in the Albertina, Vienna (no. 1538), dated *c.* 1590 by Heil
(*Jahrbuch der Preussischen Kunstsammlungen*, Berlin,
1926, vol. 47, p. 60 ff.). The composition of both sheets
appears to derive from Veronese's painting of *Christ in the
Garden supported by an Angel* (Brera, Milan no. 241),
which Coletti has dated *c.* 1570, but which Pignatti placed
in the 1580s, at the very end of Veronese's career.

D.E.S.

PROVENANCE
Unidentified (Dutch?) collector;
Earl of Aylesford; acquired by G. T. Clough at sale of Earl of Aylesford;
1913 presented to the Fitzwilliam Museum

EXHIBITION
Cambridge 1980–81

REFERENCES
Tietze and Tietze-Conrat 1944, p. 201, no. 859

D30

D29

D30
Study for the Fall of the Rebel Angels

410 × 263 mm
Black oil and chalk, heightened with white oil,
on light brown paper (perhaps once blue?)
Inscribed below in an eighteenth-century hand: *Jacomo Tintoret*
The Trustees of the British Museum, London (1941–11–8–15)

D27

D27
Standing Figure of a Crowned Man

264 × 141 mm
Point of the brush and blue wash, heightened with white
on blue paper
The Visitors of the Ashmolean Museum, Oxford (Parker no. 25)

Previously attributed to Dürer, Parker recognised this
drawing as the work of Montagna, pointing out that the
technique was typically Venetian. He dated it fairly early
and remarked that the foreshortening has obvious analogies
to Mantegna's *sotto in sù*, which recalls Vasari's statement
that Montagna learnt to draw with Mantegna.

The purpose of the drawing is as uncertain as its subject:
Constantine, David and even Christ have been suggested.
The two vertical lines on either side of the figure may
indicate a niche; but in any case the figure would certainly
have been painted in a high position.

D.E.S.

REFERENCES
Macandrew 1980, III, p. 249, no. 25, Parker 1934, p. 8, pl. 9;
Parker 1956, II, no. 25, pl. X;
Puppi 1962[1], p. 149, fig. 75

D28
Three Standing Women

313 × 219 mm
Point of the brush and grey wash strengthened with pen and
brown ink and heightened with white, on faded blue-grey paper;
the two figures on the right are silhouetted, the outline of the
figure on the extreme right is strengthened in black chalk; laid
down; bordered on all sides by a line of brown ink
Inscribed in brown ink upper left:
Dosso da ferrara and *la duchessa*
Cabinet des Dessins, Musée du Louvre, Paris (no. 8224)

Morelli was the first to attribute this sheet to Montagna.
Both Borenius and Puppi have grouped it with his late
work, comparing it particularly with the group of women
on the right in the *Discovery of St. Anthony's Tomb* of 1512
in the Scuola del Santo, Padua, for which the present
drawing could be a discarded study. The handling of the
drapery and the figures can also be compared to the
altarpiece of *St. Mary Magdalene* in S. Corona, Vicenza,
and the woman on the right is close to a figure in *The
Mystic Marriage of St. Catherine*, formerly in the
Rothermere Collection. The subtly observed
characterisation is typical of Montagna's better work.

D.E.S.

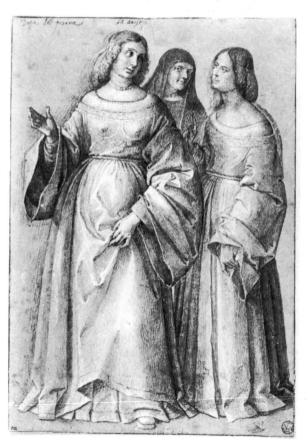

D28

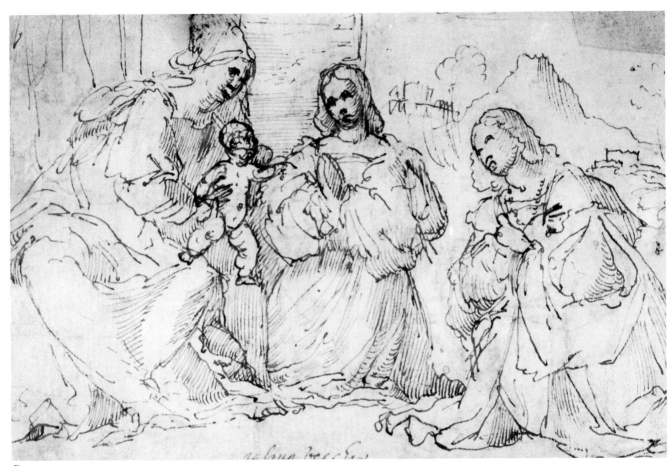

D34

Since von Hadeln published this drawing in 1923, most critics have agreed on Palma Vecchio's authorship. The attribution to Palma Giovane by Tietze and Tietze-Conrat and by Mariacher is based on the mistaken theory that a *Holy Family* in the British Museum (1895–9–15–810) is a copy of a Palma Vecchio by Palma Giovane. They rightly pointed out that, stylistically, the Haarlem drawing is extremely close to the London *Holy Family*, which is in fact a genuine Palma Vecchio. The pen work, with long swaying hatching for the shadows, worked-over contours and a looseness, amounting to scribbling, in the lit drapery is common to both drawings. However, there is greater breadth of form in the Haarlem drawing and the amplitude of the kneeling women recalls Palma's *Sacre Conversazioni* of the early 1520s.

P.B.R.

PROVENANCE
Queen Christina of Sweden, Rome;
Cardinal Azzolino and the Princess Odescalchi, Rome;
1790 acquired by Pieter Teyler

EXHIBITIONS
Venice 1976, no. 79

REFERENCES
Ballarin 1970, p. 47; Gombosi 1937, p. 60; Lugt 1962, p. 69;
Mariacher 1968, p. 117; Rearick 1976, p. 71; Regteren Altena 1966, p. 79;
Ruggeri 1969, p. 167; Spahn 1932, p. 65;
Tietze and Tietze-Conrat 1937, p. 84; ibid. 1944, pp. 206, 228;
von Hadeln 1923, p. 173; ibid. 1925¹, pp. 21, 33

D35
Rest on the Flight into Egypt

214 × 310 mm
Pen and light brown ink over black chalk
Fitzwilliam Museum, Cambridge (no. 954)

The attribution of this drawing to Palma Vecchio, first made by Benesch (Fitzwilliam Museum files), is beyond doubt. Rearick (1976) suggested a parallel with a *Rest on the Flight into Egypt*, (ex-Gentile di Giuseppe Coll., Paris), while Pouncey pointed out that the penmanship links the drawing to the Malcolm *Holy Family* (British Museum) which is stylistically extremely close to the present drawing in the more loosely drawn passages, such as the figures of St. Joseph and the Infant Christ. The Madonna, the landscape and the donkey are drawn with far greater finish, precision and finesse, but they are obviously by the same hand. The Madonna's drapery is the resolution in compact form of the pen strokes of the woman in the Haarlem drawing (Cat. D34).

P.B.R.

PROVENANCE
Sir Joshua Reynolds; 1919 bequest of Joseph Prior to the Museum

EXHIBITIONS
Cambridge 1960, no. 39; Cambridge 1980–81

REFERENCES
Ballarin 1970, pp. 47–49; Mariacher 1968, p. 116; Rearick 1976, p. 71

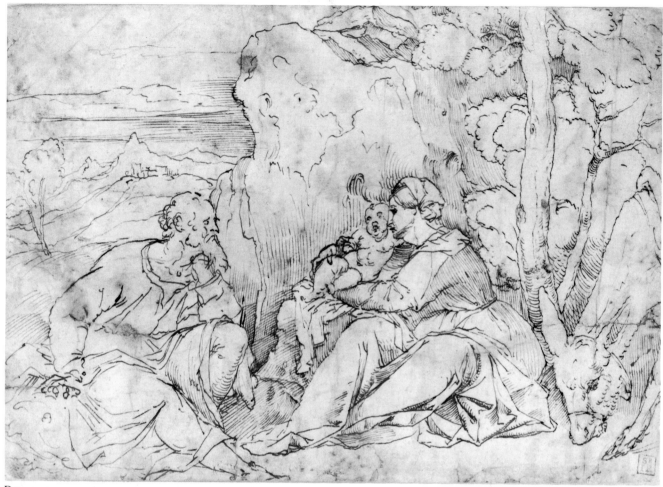

D35

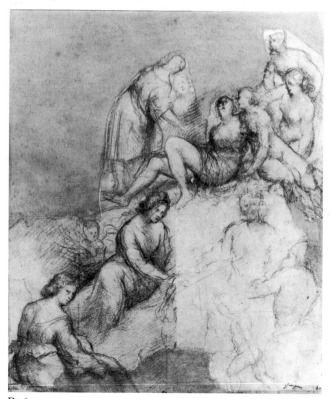

D36

Giovanni Antonio de' Sacchis, called

Pordenone

[Biography on p. 198]

D36
Seven Female Figures on a Hillock with Two Men Below

330 × 275 mm
Red chalk on white paper, silhouetted and laid down
Inscribed lower right in black: *Giorgione*
Cabinet des Dessins, Musée du Louvre, Paris (no. 4649)

The subject of this much disputed Giorgionesque drawing is unresolved. The top section may show Callisto and the nymphs; the central section has a seated woman wearing a diadem, possibly Diana, who appears to be writing on a scroll held by a centaur (?) attended by amorini and another centaur (?); to the left there is a seated woman looking out from the composition. These appear to be two separate episodes, and the work itself shows different states of completeness.

Various authors, including Moretto, Giorgione and Sebastiano del Piombo, have been proposed for this

drawing, but the attribution to Pordenone is now widely accepted. Cohen regards this as one of Pordenone's earliest drawings, made shortly before his trip to Rome in about 1516. In certain details the drawing resembles the studies in the Ambrosiana, Milan (Cod. F. 271, inf. no. 40) and the allegorical figures for the Palazzo d'Anna (Cat. D44).

D.E.S.

D37
Lamentation over the Dead Christ

368 × 278 mm
Recto: red chalk and perspective lines, squared with a stylus
Verso: standing figure and study for the Dead Christ,
red chalk and pen and brown ink
The Trustees of the British Museum, London (1958–2–8–1)

This is a design for the fresco of the *Lamentation over the Dead Christ* painted near the West door of Cremona Cathedral in 1522, but, as Pouncey observed, the fresco differs from this drawing in various ways. Cohen recognised that the figure of Christ was derived from Altdorfer's woodcut of *Jael and Sisera* (Bartsch 43) and saw in the changes from drawing to fresco a deliberate attempt by Pordenone to 'coarsen features, harden form, and make emotions more overt'.

The large drawing in red chalk on the *verso* may be one of Pordenone's rare life studies. It was later used for a St. John, but, as Pouncey has pointed out, the figure may represent Nicodemus or Joseph of Arimathea since he holds nails and a rope. The pen and ink study of Christ corresponds, except for the arm, with the chalk study on the *recto*.

D.E.S.

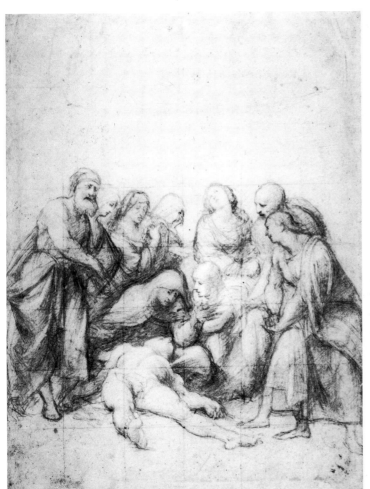

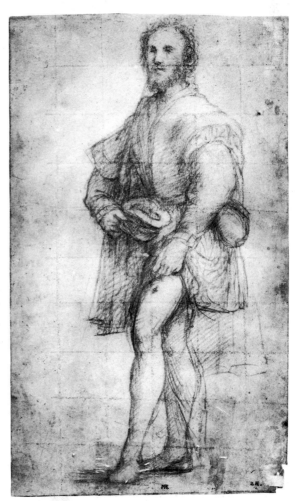

D37

D38

D38
Study for St. Roch

262 × 156 mm
Red chalk, squared
Verso: Woman with Outstretched Arms
Verso inscribed in pen: *Qui erat*; in chalk *Guercino*
The Art Museum, Princeton University, Platt Collection,
(no. 49–42)

Cohen published this sheet, formerly attributed to
Guercino, in 1972, identifying the *recto* as a study for the
St. Gothard altarpiece (1525–26) in the Museo Civico,
Pordenone. He also proposed that the figure of the woman
on the *verso* was a study for Mary Magdalene, possibly for
the Cividale *Noli me Tangere* of 1538.

Gibbons has noted that the relationship between the
drawing on the *verso* and the Cividale painting is only very
general, but Cohen (1980) still argues in favour of the
connection between these two works, adding as a sop to
Gibbons, 'it is possible that Pordenone used a drawing
made much earlier'. In fact, the style of the drawing on the
verso is much closer to Pordenone's work of the 1520s than
to sheets securely datable in the late 1530s, as Cohen himself
admits. The woman is not, as Cohen states, kneeling (the
lower part of the drawing is missing), but in movement,
with arms outstretched, so Cohen's identification with the
Cividale *Magdalene* is untenable. The drawing is close in
style to the *Youth Running* in Rotterdam (Boymans-van
Beuningen Museum, no. 1, 37 *recto*) a sheet which Cohen
dates to the early 1520s.

D.E.S.

PROVENANCE
R. Houlditch; P. Huart; Charles Fairfax Murray with Parsons;
1921 purchased by Dan Fellows Platt;
The Art Museum, Princeton University

EXHIBITIONS
Washington, Fort Worth and St. Louis 1974–75, no. 14

REFERENCES
Cohen 1972, pp. 12–19; Cohen 1980, p. 120, fig. 34, with full bibliography;
Gibbons 1977, no. 502

D39
Female Grotesque Figure with Two Putti

284 × 225 mm
Red chalk on faded blue paper
Inscribed lower left in brown ink
*questo friso e di mano di/Giovanni Antonio licinio detto
il Pordenone . . . ssimo(?); 251;* and *Lelio*
Cabinet des Dessins, Musée du Louvre, Paris (RF 594)

This design was presumably related to a project for a fresco
decoration on the exterior of a palace façade and similar
motifs can be seen on the top floor of the Palazzo d'Anna
(*c.* 1531–32). First attributed to Pordenone by Pouncey, the
drawing is typical of Pordenone's style from the late 1520s
onwards. The morphology of the children is close to that

in his *Design for a Fountain with Putti* (Cat. D42), and the
sheet can be dated to his Emilian period. Muraro (1971)
suggested a much earlier date, but this seems untenable.

Cohen's suggestion that the woman is a satyress cannot
be sustained.

D.E.S.

PROVENANCE
His de la Salle; 1878 Musée du Louvre

REFERENCES
Cohen 1980, p. 118, fig. 60, with full bibliography

D39

D40
Study for the Death of St. Peter Martyr

244 × 207 mm
Red chalk
The Trustees of the Chatsworth Settlement, Chatsworth,
Derbyshire (no. 746)

First attributed to Pordenone by Morelli in 1890, this is a
study for the *Death of St. Peter Martyr*, of which an
elaborate finished drawing is in the Uffizi, Florence (725 E).

Titian and Palma Vecchio competed to paint an
altarpiece of this subject for SS. Giovanni e Paolo, Venice,
in around 1527. The Uffizi drawing appears to be a *modello*
submitted for the competition by Pordenone. Titian won
the competition, but his painting completed in 1530 was
destroyed by fire in 1867. It was frequently copied and
engraved, one of the best known engravings being that of
Martino Rota (fig. 14).

D.E.S.

D40

The sheet is a rare example of the initial scheme for a composition by Pordenone: the concentrated draughtsmanship in the foreground is very striking, and the artist has particularly emphasized the contours by pressing hard with the chalk.

D.E.S.

PROVENANCE
E. Jabach; 1671 Cabinet du Roi; Musée du Louvre

EXHIBITIONS
Paris 1977–78, no. 22

REFERENCES
Cohen 1980, p. 117, fig. 105, with full bibliography

D41

PROVENANCE
Flinck; William, 2nd Duke of Devonshire;
Trustees of the Chatsworth Settlement

EXHIBITIONS
London 1930, no. 673; United States of America/Canada 1962–63, no. 51;
London 1969, no. 51

REFERENCES
Cohen 1980, p. 66, fig. 38, with full bibliography

D41
Pelias Persuading Jason to Search for the Golden Fleece

154 × 137 mm
Red chalk
Cabinet des Dessins, Musée du Louvre, Paris (no. 10666)

This sketch, first attributed to Pordenone by Pouncey, was associated by Cohen with the finished drawing (West Berlin [no. 5176]) for the fresco on the garden façade of the Palazzo Doria in Genoa. The fresco is now destroyed but known through a copy in East Berlin (B 2000–1902). Cohen dated Pordenone's work for Genoa to *c.* 1533–34, and Furlan independently dated the West Berlin drawing 1532–33, without associating it with Pordenone's work in Genoa.

Cohen has remarked on the stylistic similarities between this drawing and studies in the Ambrosiana, Milan, which he has dated to the mid-1530s, and he has drawn attention to the unusual number of major pentimenti, such as the left arm of the enthroned Pelias and the arms and face of Jason.

D42
Design for a Fountain with Putti

245 × 170 mm
Red chalk
The Trustees of the British Museum, London (1953-4-11-112)

This sheet, acquired in Paris under an absurd attribution to Benvenuto Cellini, was later identified by Popham with a drawing attributed to Correggio in the Knapton Sale of 1807. Popham suggested a date between 1515 and 1519. However, in recent years Pouncey has come to the conclusion that the drawing is by Pordenone.

Both the medium and the facial type of the putti, comparable to an early Correggio drawing in the Louvre (no. 1307), show an awareness of Correggio. Nonetheless, the modelling of the forms of the putti is much tighter than Correggio's drawings and similar putti appear in

D42

Pordenone's *God the Father Supported by Angels* (Chatsworth, no. 236), while the shading and the handling of the chalk compare more closely with the nude figure on the *verso* of the *Lamentation over the Dead Christ* (Cat. D37) than with Correggio's work. The lower section of the drawing in particular appears to confirm Pordenone's authorship: compare the vigorous hatching in the *Study for the Death of St. Peter Martyr* (Cat. D40). The drawing of trophies in the Metropolitan Museum, New York, in which the morphology of the putti is strikingly similar to this drawing, was catalogued as the work of Correggio by Popham (1957, cat. 47), but has been shown by Laskin to be a preparatory study for Pordenone's decorated pilaster (*c.* 1529) in the Pallavicini Chapel in S. Francesco, Cortemaggiore (Laskin 1967).

While hesitating to discount Popham's knowledge of Correggio, the drawing points to Pordenone, and a date between 1522 and 1529 seems appropriate.

D.E.S.

PROVENANCE
Jonathan Richardson Senior;
G. Knapton; 27 May 1807 T. Phillippe sale (lot 289);
private collection, Paris; S. Higgins; British Museum

REFERENCES
Popham 1954, p. 34, pl. IX;
Laskin 1967, pp. 355–56; Popham 1967, no. 1, with full bibliography
(as Correggio)

D43

D43
The Façade of the Palazzo d'Anna

412 × 559 mm
Pen and brown ink
Inscribed in the artist's hand upper left:
azuro; upper right: *mare*.
Inscribed in Padre Resta's hand:
*Quest'opera diede il Grido al Pordenone de il maggior Pittore di
Venezia. Il Vasari fa mentione di quest'opera del Pordenone
admirando singolarm.ᵗᵉ il rilievo del Curtio e l'optica del Mercuro.
Vedi a fol 791; and in another hand disegno della faciata de
Martino d'Anna in Venetia sopra il canal grando fatto dal
Pordenone*
Victoria & Albert Museum, London (no. 2306)

Although this drawing has usually been regarded as a copy,
Cohen believes it to be autograph and Ward-Jackson does
not exclude this possibility. While the style is not precisely
comparable to that of other accepted Pordenone drawings
(in particular, it is less vigorous than the group of pen
studies in the Ambrosiana, Milan), the sheet is exceptional.
Even if the drawing is only an early copy, it is the only
complete record of Pordenone's celebrated fresco
decoration on the façade of the Palazzo d'Anna, the palace
of the Flemish merchant Martino d'Anna on the Grand
Canal in Venice. The elaborate decoration apparently had
no single coherent iconographic scheme, but was made up
of isolated scenes from mythology and ancient history, and
various personifications (Cat. D44).

Cohen first suggested a date *c.* 1535 for the frescoes on
stylistic grounds, but subsequently revised this to *c.* 1531–
32, because the figure of *Time*, based on a drawing by
Pordenone at Chatsworth (no. 234), was reproduced in a
woodcut ascribed to Ugo da Carpi, who died in 1532. This
woodcut is reattributed by Landau to Niccolò Vicentino
(Cat. P35) in the present catalogue, so the question of the
date of the façade is once more open.

D.E.S.

PROVENANCE
Padre Resta; Lord Somers; Count Moritz von Fries;
Sir Thomas Lawrence; S. Woodburn;
6 June 1860 acquired for the Victoria & Albert Museum at Christie's sale

EXHIBITIONS
Manchester 1965, no. 562

REFERENCES
Cohen 1980, p. 84, figs. 78, 79, with full bibliography;
Ward-Jackson 1979, I, no. 250, with full bibliography

D44

Attributed to Pordenone by Popham in his catalogue of the
1958 Skippe sale, this drawing is a study for a figure once
frescoed on the *piano nobile* of the façade of the Palazzo
d'Anna. Cohen has commented on the influence of
Michelangelo in the 'difficult posture', and notes that both
the *contrapposto* and the 'swelling but attenuated
anatomy' can be associated with Pordenone's first series of
commissions in Piacenza of *c.* 1530–32. He seems inclined
to date the drawing towards the end of this period,
c. 1531–32 (cf. Cat. D43).

D.E.S.

PROVENANCE
John Skippe; his descendants, the Martin family, including Mrs A. D.
Rayner-Wood;
Edward Holland Martin; 20–21 November 1958 acquired by the Musée
du Louvre at Skippe sale, Christie's, (no. 162)

REFERENCES
Cohen 1974, pp. 445–57; ibid. 1980, p. 119, fig. 81;
Ward-Jackson 1979, I, no. 2

D44
Study for the Allegorical Figure of Metalwork

213 × 170 mm
Black chalk on blue-grey paper squared for transfer in black chalk,
laid down on a washed mount
Cabinet des Dessins, Musée du Louvre, Paris (RF 31.169)

D45
The Expulsion of Joachim from the Temple

234 × 308 mm
Pen and brown ink and grey-brown wash, heightened with white,
over traces of black chalk on faded green paper, laid down on
blue-grey paper (torn in several places)
Gabinetto dei Disegni, Uffizi, Florence (no. 731E]

D45

This sheet has the same provenance, technique and format as another drawing in the Uffizi (730E), *The Birth of the Virgin*, which is a study for a fresco in S. Maria di Campagna at Vicenza. As Rearick observed (Florence 1976), the subject matter would be appropriate for a chapel dedicated to St. Anne, thus confirming the old hypothesis that Pordenone had intended to paint a third chapel in that church. The date of *c.* 1532–35, proposed by Schulz on the basis of documentary evidence, has been modified to 1534–35 by Cohen on stylistic grounds.

Despite the damaged condition of the drawing, this is still an extremely forceful sheet: the psychological characterisation of all the protagonists is unusually well developed and there is a splendid sense of movement and energy. The marked use of chiaroscuro shows a Roman influence that was uncharacteristic of Venetian drawings until the advent of Giuseppe Salviati in the 1540s.

D.E.S.

PROVENANCE
Anonymous Bolognese collection; Cardinal Leopoldo de'Medici; Uffizi

EXHIBITIONS
Udine 1939, no. IX (drawings); Florence 1976, no. 98

REFERENCES
Cohen 1980, p. 77, fig. 118, with full bibliography; Schulz 1967, p. 46

D46

The Annunciation

389 × 250 mm
Black chalk, heightened with white, on grey-green paper squared for transfer in black chalk (generally faded)
Her Majesty The Queen (no. 6658)

D46

This is a study for the painting in S. Maria degli Angeli, Murano, said by Vasari to have replaced a Titian altarpiece which was judged by the patrons to be too expensive. Since Titian's painting was completed by November 1537, Pordenone's picture, and consequently this drawing, must date from 1537–38. The drawing differs in several ways from the completed altarpiece.

Like the early drawing in the Louvre (Cat. D36), this sheet combines areas with a high degree of finish with other more loosely handled areas, and there are many pentimenti. The upper section is a variation on Pordenone's cupola designs, principally those at Cortemaggiore and S. Maria di Campagna, Piacenza. This study is more subtle and luminous than the finished drawings of Pordenone's maturity, demonstrating his continued fascination with Correggio.

D.E.S.

EXHIBITIONS
London 1972–73, no. 100; Venice 1980, no. 10

REFERENCES
Cohen 1980, p. 127, fig. 136, with full bibliography;
Popham and Wilde 1949, no. 743, fig. 136

Girolamo Romanino

[Biography on p. 201]

D47
A Party of Musicians in a Boat

Oval, 236 × 333 mm
Black chalk and grey wash
Her Majesty The Queen (RL 0338)

First published as the work of Romanino by Popham, Ferrari later related this drawing stylistically to the frescoes in S. Antonio, Breno, which are generally dated 1530 or shortly afterwards. The lyrical mood of this sheet, clearly dependent on the work of Giorgione, is characteristic of Romanino; it is to be found especially in the frescoes of the castle of Buonconsiglio at Trent.

D.E.S.

EXHIBITIONS
Brescia 1965, no. 132

REFERENCES
Ferrari 1961, pl. 82; Popham and Wilde 1949, no. 873, pl. 167;
Blunt 1973, p. 113

D48
Study of an Executioner

267 × 192 mm
Pen and brown wash, heightened with white, over red chalk on blue paper
The Trustees of the Chatsworth Settlement, Chatsworth, Derbyshire (no. 759)

The painterly use of contrasting washes of brown and white on blue paper is most effective in this study; note the stocky proportions of the figures, with their sturdy thighs and the poor articulation of the feet and ankles, which are characteristic of Romanino's slightly provincial style. The use of strong tonal contrasts is paralleled in contemporary German drawings of similar *landsknechts*. This drawing is presumably a section cut out of a highly finished preparatory drawing, or *modello*, for the martyrdom of a saint.

D.E.S.

D47

D48

Giuseppe Porta, called

Giuseppe Salviati

Castelnuovo *c.* 1520/25 – Venice *c.* 1575

Born in Castelnuovo, Garfagnana, north of Lucca, at an unknown date, Giuseppe Porta was taken to Rome in 1535 by his uncle, secretary to the archbishop of Pisa. There Porta studied under the Florentine painter, Francesco Salviati, whose name he later adopted. In 1539 master and pupil visited Venice, and Porta eventually decided to settle in the city. With time, much of the gracefulness and imaginative artifice of Francesco Salviati's style disappeared from that of his pupil, although an emphasis on sculptural solidity remained.

The first known independent work by Giuseppe Porta is a signed woodcut frontispiece to Francesco Marcolini's *Le Sorti*, published in Venice in 1540. The next year the artist worked in Padua, and in 1542 he painted frescoes for the façade of the villa Priuli (now destroyed) at Treville. In 1548 Aretino praised Porta's façade frescoes (now entirely lost), which evidently established the artist's reputation. At the same time, Salviati was receiving important commissions, not only for altarpieces in such churches as the Frari, S. Maria de' Servi, S. Francesco della Vigna and S. Zaccaria, but also for mosaics in San Marco. He also worked in the Doge's Palace and in 1556 made three circular paintings for the ceiling of the reading room of the Libreria Marciana. In 1562 Salviati returned to Rome to execute frescoes in the Sala Regia of the Vatican. In Venice he then completed the ceiling of the Sala dell'Anticollegio in the Doge's Palace (destroyed in 1574).

Salviati also devoted considerable time to pursuits of a theoretical and quasi-scientific nature and in 1552 he published a brief treatise on how to draw the volute of the Ionic capital. He is last mentioned in 1575.

D. McT.

REFERENCES
McTavish 1981, with full bibliography

D49

The Presentation of Christ in the Temple

547 × 295 mm
Pen and brown ink and wash over black chalk,
heightened with white, on greenish paper;
triangle of buff-coloured paper, backed, added at the lower right
Inscribed in pen and ink at the lower left,
probably in the hand of the collector Miron:
*Joseph Porta/Vulgò Salviati/delin. pro sacell/in aede
Francisc./Venetiis*
Fondation Custodia (Coll. F. Lugt), Institut Néerlandais, Paris
(no. 7617)

A note by Mariette on the *verso* of this drawing indicates that it is a preparatory study for Giuseppe Salviati's altarpiece on the right-hand nave wall of the Frari, Venice. The altar is dedicated to the Purification of the Virgin, which is shown with the related Presentation of Christ in the Temple in the upper part of the altarpiece; six saints are included below. Nicolò Valier acquired the rights to the chapel in December 1517, but although he agreed to provide an altarpiece at that time, the one that is now in the chapel does not seem to have been painted until the late 1540s (McTavish 1981).

There are many differences between the altarpiece and this drawing, most notably in the architectural setting of the upper storey and the absence in the drawing of the angel bearing the crown of thorns and lance, but the major components are the same. Some of the differences in the saints are mediated by two red chalk drawings: one for St. Paul in a private collection in Paris and another for St. Mark in the Ashmolean Museum.

The drawing was cut diagonally at the lower right at an early date. An anonymous sixteenth-century copy after the drawing in Munich (Jaffé 1955, fig. 4) shows the composition with the lower corner already removed. The

D49

present drawing was subsequently acquired by Rubens, who supplied the missing areas of the three saints at the lower right and also retouched certain other parts of the composition.

D. McT.

PROVENANCE
P. P. Rubens; P. Crozat; P. J. Mariette; President Haudry; A. Miron; Monsieur B.; 25 January 1855 Paris sale (lot 86); L. Lucas; C. Lucas; M. B. Asscher; 1961 Frits Lugt; Fondation Custodia

EXHIBITIONS
Paris 1962² (ex catalogue); Paris 1967, no. 201; London 1972, no. 74; Nice 1979, no. 38; Venice 1981², no. 48; London 1983, no. 95

REFERENCES
Byam Shaw 1983, p. 248, no. 244, pl. 277, with full bibliography; McTavish 1981, pp. 142–57, 301–03

D50
The Descent from the Cross

287 × 170 mm
Pen and brown ink and wash, heightened with white, over black chalk on faded blue paper, squared for transfer in red chalk
Cabinet des Dessins, Musée du Louvre, Paris (no. 5761)

Von Hadeln first identified this sheet as a study for a painting by Giuseppe Salviati, formerly on the high altar but now on the left wall of S. Pietro Martire, Murano. The drawing includes all the main components of the altarpiece, although the two acrobatic angels that appear in the upper corners of the painting are only faintly discernible in black chalk; but most of the figures underwent various changes, especially of dress, between the drawing and the painting. In the drawing, St. Dominic appears with St. Peter Martyr behind the cross, but in the painting St. Dominic is moved to the left, at the foot of the cross, and St. Peter Martyr is omitted altogether. Portraits of an unidentified man and woman, who must be the donors, appear in their place; in the drawing they are probably indicated at the extreme left.

D50

The final pose of the swooning Virgin and an attendant figure were evolved in a detailed drawing discovered by John Gere in the Hamburg Kunsthalle (repr. McTavish 1981, fig. 183). Lastly, a drawing in Montreal (*ibid.*, fig. 185) shows the entire composition, with the addition of the two flanking crosses, but in reverse. The altarpiece and its preliminary drawings probably date from the early 1550s (*ibid.*, pp. 157–59, 274–76).

Although the composition of the present drawing relates to numerous sixteenth-century interpretations of the subject, it is not directly dependent upon any of them. The drawing's graphic manner is indebted to the artist's teacher, Francesco Salviati, but the complex combination of media on blue paper produce a more pictorial effect.

D. McT.

PROVENANCE
Everard Jabach (L. 2959 and 2953); 1671 entered the Cabinet du Roi; Musée du Louvre

EXHIBITIONS
Paris 1931, no. 139; Paris 1965, no. 111; Paris 1977, no. 67

REFERENCES
Jaffé 1955, p. 331; McTavish 1981, pp. 157–59, 274–76, 347–48; Tietze and Tietze-Conrat 1944, p. 243; von Hadeln 1926, p. 23

D51

Cloelia Fleeing from the Etruscan King Porsena

140 × 181 mm
Pen and brown ink and wash, heightened with white, over black chalk
Inscribed faintly on the mount: *Salviati 1510–1573.*
National Gallery of Scotland, Edinburgh (no. D. 3139)

Cloelia, a Roman maiden, had been delivered to the Etruscan king, Lars Porsena, as a hostage, but she and her companions eluded the guards and escaped to Rome by swimming across the Tiber. Porsena demanded Cloelia's return in order to proclaim her courage publicly and to set her free. The Romans erected an equestrian statue of her at the top of the Sacred Way (Livy, *History of Rome*, II, 13).

Ridolfi (1648, I, p. 241) mentioned a fresco of Cloelia among Giuseppe Salviati's scenes from early Roman history on the façade of the Palazzo Loredan in Campo Santo Stefano, Venice. In particular, Ridolfi praised the lively colour of the façade, which appeared as if it were done in oil paint, but he also observed that some of the frescoes were already in a ruinous condition, and today nothing remains of them. The frescoes, which were probably executed in the mid-1550s, included a scene of Mucius Scaevola, from whom the Loredan family believed themselves descended. A drawing in Weimar may be a preliminary study for this fresco, while a carefully finished sheet of *Lucretia and her Handmaidens* in the Ashmolean Museum (Parker 1956, no. 687) may be related to another of the frescoes.

A second drawing of Cloelia by Giuseppe Salviati was once in the Grand Ducal collection at Weimar (McTavish 1981, fig. 200), but it is now untraceable. Though differing in detail, both that drawing and this one were probably preparatory studies for the façade of the Palazzo Loredan. The ex-Weimar drawing is the more carefully finished of the two and may show the composition in a form closer to the finished fresco.

D. McT.

PROVENANCE
Sir Peter Lely (L. 2092); W. F. Watson; 1881 bequeathed by him to the National Gallery of Scotland

REFERENCES
Andrews 1968, I, pp. 112–13, 164; Ballarin 1967, pp. 96–97; McTavish 1981, pp. 211–12, 325–26

D51

Attributed to
Jacopo Sansovino

[Biography on p. 381]

D52
St. James the Greater

263 × 122 mm
Red chalk and red wash on buff paper squared in black chalk
National Gallery of Scotland, Edinburgh (no. D. 1896)

This drawing was catalogued by Andrews as the work of an anonymous north Italian artist who, Andrews suggested, had been 'remotely influenced by Titian'.

D52

In a letter of 1975 to the National Gallery of Scotland Howard Coutts observed the relationship of this drawing to the figure by Sansovino on the upper left of the sacristy door of San Marco, Venice (Pope-Hennessy 1963). The door was modelled in 1546 and assembled in 1569, but not installed until 1572. The vitality of the drawing and the subtle modelling of the head in particular, together with its squaring, suggest that it was an original design for the door, rather than a later copy.

D.E.S.

PROVENANCE
Allan Ramsay?; Lady Murray;
1860 presented to the National Gallery of Scotland

REFERENCES
Andrews 1968, I, p. 150; II, ill. p. 180; Pope-Hennessy 1963¹, I, fig. 113

Andrea Schiavone

[Biography on p. 206]

D53
Cupid Presenting Psyche to the Gods

374 × 603 mm
Pen and brown ink and wash, heightened with white,
over traces of black chalk on brown washed paper
Metropolitan Museum of Art, New York, Rogers Fund 1963
(63.93)

The composition of this imposing drawing is based on Raphael's fresco (1518) of the same subject on the vault of the loggia of the Villa Farnesina, Rome. However, Schiavone has completely reversed Raphael's composition and the figures are altered throughout, both in pose and dress. Other parts of the composition, such as the seated man at the extreme left and the horse at the right, are additions.

According to a note on the old mount, the drawing was once ascribed to Parmigianino and, indeed, the proportions of Raphael's original figures have been modified to reflect Parmigianino's elegant figural types. The figure of Psyche herself reflects Francesco Salviati's Psyche on the ceiling of the Palazzo Grimani, Venice, and is still closer to the preliminary drawing of the figure in Budapest (Cheney 1963, fig. 5). However, Schiavone's own style is revealed in both the pen line, especially its use to define individual features, and the broad applications of wash.

The story of Psyche is told in the *Metamorphoses* of Apuleius (IV, 28–VI, 24). Raphael's frescoes of Psyche in the Farnesina were followed by numerous decorative cycles featuring the subject, including those by Perino del Vaga in the Castel Sant'Angelo and Giulio Romano in the Palazzo del Te. Battista Franco's treatment of *Cupid Presented to the Gods* in an oval format (Pierpoint Morgan Library, New York, no. IV, 73) was again derived from Raphael's fresco.

D53

Richardson has suggested that the present drawing may have been made for one of Schiavone's lost ceiling paintings of Psyche, mentioned by Ridolfi (1648, I, p. 256), in the Castello di Salvatore near Susegano, Conegliano. The elongated oval format of the drawing was often used for Venetian ceiling paintings in the mid-sixteenth century. The drawing itself is usually dated to the 1540s (Richardson 1980). Paintings by Schiavone depicting the marriage of Cupid and Psyche are in the Palazzo Strozzi, Florence, and the Metropolitan Museum, New York.

D. McT.

PROVENANCE
C. R. Rudolf

EXHIBITIONS
London 1962, no. 62; New York 1965, no. 116

REFERENCES
Bean 1982, no. 236, with full bibliography; Richardson 1980, p. 129

D54

D54
The Annunciation

170 × 249 mm
Brush and yellow-brown wash, heightened with white,
over black chalk on yellow prepared paper
Cabinet des Dessins, Musée du Louvre, Paris (no. 9954)

This striking example of Schiavone's distinctive draughtsmanship has been realised with brush and black chalk alone; the conventional use of pen to define forms has been omitted altogether. Schiavone frequently used paper prepared in coloured washes, and the yellow paper of this drawing contributes significantly to the pictorial effect.

Originally classified among the anonymous sixteenth-century Italian drawings, this sheet was first attributed to Schiavone by Pouncey, and Châtelet related it to Schiavone's painting of the same subject in the church of the Carmini in Venice. Richardson, however, has suggested a possible connection with Schiavone's etching of *The Annunciation* (Bartsch 5).

D. McT.

PROVENANCE
During the French Revolution entered the Louvre collections

EXHIBITIONS
Paris 1964, no. 102

REFERENCES
Bacou and Viatte 1968, no. 62; Châtelet 1953, p. 90;
Richardson 1980, p. 131

Sebastiano del Piombo

[Biography on p. 209]

D55
Figure Studies for The Death of Adonis

275 × 425 mm
Black chalk and stump with traces of white chalk
worked into the stump
Recto: A River God; black and white chalk, red chalk and stump
Pinacoteca Ambrosiana, Milan (F.290, inv. no. 22)

The figure of Venus is a study for Sebastiano's painting of *The Death of Adonis*, *c.* 1512 (Uffizi, Florence). Despite earlier commentators' suggestions that the putto is a study for the same painting, Hirst has demonstrated convincingly that it relates to the Christ Child in the severely damaged *Adoration of the Shepherds* in the Fitzwilliam Museum, Cambridge.

The putto was drawn first and the figure of Venus was added later on top, and both studies are drawn with a freedom of handling and a pictorial use of chalk that show Sebastiano's Venetian origins, qualities which re-appear in his later drawings. The drawing after the antique on the *recto* is a study of the fragmentary torso of Hercules now in the Vatican collection, which was on the Quirinal in the mid-sixteenth century.

D.E.S.

EXHIBITIONS
Venice 1976¹, no. 9, with full bibliography

REFERENCES
Hirst 1981, p. 38, fig. 46

D56
Study for St. Agatha

354 × 189 mm
Black chalk, heightened with white, on blue paper
Cabinet des Dessins, Musée du Louvre, Paris (no. 10.816)

Pouncey first identified this sheet amongst the anonymous Italian drawings as a study for the principal figure of *The Martyrdom of St. Agatha* in the Palazzo Pitti, Florence. Hirst (1981) has shown that the painting, commissioned by Cardinal Ercole Rangone to celebrate his elevation to the cardinalate by Leo X on 1 July 1517, was completed by late 1519, and has observed that here Sebastiano was following 'Michelangelo's practice of making full-length studies for figures never planned to be depicted in entirety in the completed work'.

The figure is reminiscent of Michelangelo's design for the Christ in the *Flagellation* in the Borgherini Chapel, but Sebastiano obviously returned to a life-study in the drawing. The pentimento over the eyes appears to have been a preliminary idea for a blindfold, which was abandoned in the finished painting. The coagulations of white are very marked on the nude's left breast and the contour is heavily reinforced along the whole left flank of the body. The modelling of the torso is particularly subtle, with a soft and beautiful swell to the belly.

D.E.S.

PROVENANCE
E. Jabach; 1671 entered the Cabinet du Roi

D55

D56

D57
Study for St. James

237 × 444 mm
Black chalk and brown wash, heightened with white, on blue-grey
paper, squared in black chalk
The Trustees of the Chatsworth Settlement, Chatsworth,
Derbyshire

This is a study for the figure of St. James in Sebastiano's
Transfiguration in the Borgherini Chapel in S. Pietro in
Montorio, Rome. Pierfrancesco Borgherini commissioned
the chapel decoration in 1516. By November of that year
Sebastiano was working on cartoons of the prophets, and
work in the chapel seems to have begun in March 1517. The
Transfiguration in the half dome, for which this is a study,
was probably painted in 1519, and the chapel was unveiled
in 1524. Michelangelo provided sketches and detailed
studies for the *Flagellation*, and may have also helped with
the design of the *Transfiguration* (Hirst 1981, p. 59). Both
figures of the prophets derive from the prophets in the
Sistine Chapel, especially that on the right, which is based
directly on the prophet Joel.

This drawing is highly finished, and pictorial to a
remarkable degree; it was probably the final *modello* before
the preparation of the cartoon, a fragment of which – the
head of St. James – also survives (Hirst, pl. 87). Another
drawing for the *Transfiguration* is a study for the head of
St. Peter (British Museum, London). Of the surviving
drawings for the Borgherini project by Sebastiano, only the
recently discovered study for the left-hand prophet (Hirst,
pl. 82) has the same combination of vigour, pictorial

D57

Jacopo Robusti, called
Jacopo Tintoretto

[Biography on p. 212]

D62
Figure Study for The Crucifixion

368 × 188 mm
Black chalk, heightened with white, on blue-green paper
Her Majesty The Queen (no. 4823)

This is a study for the man placing a ladder against the cross
in the centre of the *Crucifixion* (Accademia, Venice,
no. 231). The sheet is in an unusually good state of
preservation for Tintoretto's work.

Rossi has cited two other drawings for the *Crucifixion*:
one for the two figures playing dice in the right foreground
(Uffizi, no. 13005F) and one related to the figure to the right
of the Virgin at the foot of the cross (Princes Gate
Collection, Courtauld Institute, no. 369). All three sheets
have been dated 1554–55 by Rossi.

D.E.S.

REFERENCES
Popham and Wilde 1949, no. 952;
Rossi 1975, p. 58, fig. 52, with full bibliography

D63
Nude Woman Lying Down

259 × 384 mm
Black chalk and some use of stump(?), heightened with white,
on blue paper faded to grey, squared for transfer
Gabinetto dei Disegni, Uffizi, Florence (no. 13001F)

D62

D63

D60

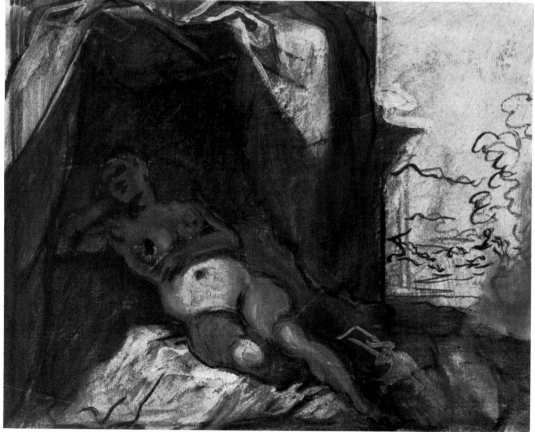

D61

D59

In the early sixteenth century a few artists, Correggio and Beccafumi amongst them, occasionally dispensed with preparatory drawings in chalk or pen and ink and sketched the outlines of their composition in paint. This became an increasingly common practice towards the end of the century and Annibale Carracci quite often used the technique. Most artists who employed it would only make a single monochrome study: Domenico Tintoretto, however, multiplied this stage of the preparation, executing as many as ten, or even more, such sketches.

This unfinished sketch is one of a group of more than 30 extracted from the same album; all of them are now in the British Museum. No painting can be associated with them, although the *Temptation of St. Anthony* in the Harrach Collection, Vienna, is quite similar in composition. The attributes in this sketch identify the tormented saint as St. Anthony Abbot, but the identity of the central character in several other drawings in the same series is less certain, and Domenico Tintoretto may have had a series of paintings of related themes in mind. Violent contrasts of light and shade characterise the whole group of drawings, and it is clear that Tintoretto liked experimenting in the medium of oil; the speed with which he worked is apparent in the fluidity of his application of the paint. His awareness of Flemish art is evident in the composition.

D.E.S.

Domenico Robusti, called

Domenico Tintoretto

Venice 1560 – Venice 1635

The son and pupil of Jacopo Robusti il Tintoretto, Domenico imitated his father's style, assisted him in several of his late works and carried on the studio after his father's death.

D.E.S.

D60
The Temptation of St. Anthony Abbot

245 × 313 mm
Brown, black and cream oil, with pink tints for flesh tones, on paper which has been stained brown and varnished
Verso: Head of a Roman Emperor (Vitellius); black chalk with traces of white
The Trustees of the British Museum, London (1907–7–17–53)

D61
Venus Sleeping in a Landscape

213 × 272 mm
Brown, black and cream oil, with pink tints for flesh tones, over black chalk on paper, varnished
The Trustees of the British Museum, London (1907–7–17–75)

This is one of four oil sketches of a sleeping Venus by Domenico Tintoretto from the Guzmán sketchbook; all of them relate directly in composition to prototypes by Titian.

In a characteristically Venetian way, Tintoretto emphasises the voluptuousness of his nude, who reclines beneath a canopy, recalling in her pose Titian's paintings of Danaë as much as those of Venus. A hunter, presumably Adonis, as Martin Kisch has suggested, can be discerned in the landscape on the right.

D.E.S.

confidence and finish as the Chatsworth sheet. The features of St. James are similar to those of the donor in the *Madonna and Child with St. Joseph and St. John the Baptist* (National Gallery, London, no. 1450), but there is no certain evidence that he is Pierfrancesco Borgherini, as has been suggested.

D.E.S.

PROVENANCE
William, 2nd Duke of Devonshire

EXHIBITIONS
London 1949², no. 21;
United States and Canada 1962, no. 68, with bibliography

REFERENCES
Hirst 1981, pp. 59–60, fig. 86

D58

D58
Madonna and Child

253 × 187 mm
Black chalk, heightened with white, on faded blue-grey paper
The Trustees of the British Museum, London (1974–9–14–1)

This drawing is clearly related to the late *Holy Family* (Capodimonte, Naples), for which two other drawings of the Virgin survive: one a full-length study (Ambrosiana, Milan), the other of the Virgin's head, recently discovered at Christ Church, Oxford. The British Museum sheet could have been an alternative design for that commission, as Gere has suggested. Certainly the posture of the Virgin and the placing of her left arm are very similar to the finished painting.

Despite an obvious Roman classicism, both the facial type and painterly use of chalk betray Sebastiano's Venetian origin, particularly in the handling of the Virgin's sleeve. The quotation from Raphael's *Madonna di Foligno* for the child so late in Sebastiano's career – certainly after 1530 and probably later – shows that his admiration for Michelangelo did not blind him to the invention of other artists.

D.E.S.

REFERENCES
Gere 1974, pp. 270 ff; Hirst 1981, p. 139, fig. 179

D59
Modello for The Birth of the Virgin

766 × 493 mm
Black chalk, heightened with white, on 18 pieces of grey paper joined together
Cabinet des Dessins, Musée du Louvre, Paris (no. 5050)

This sheet has been traditionally attributed to Sebastiano since it entered the Louvre collections in 1671 and was particularly renowned in the early nineteenth century; its autograph status was once doubted, but has been reconfirmed by Gere and Hirst. Sebastiano was commissioned to paint the altarpiece for the Chigi Chapel in S. Maria del Popolo, Rome, in 1530. In the summer of 1532 he asked Michelangelo to help with its invention, although there is no evidence that the design of *The Birth of the Virgin* was anything other than Sebastiano's own work.

This *modello* is by far the largest and the most elaborate extant drawing by Sebastiano. Its unusual scale, as Hirst has noted, possibly reflects the inspiration of Michelangelo, whose *modello* for the *Last Judgement* may have been prepared at the same time. Although the drawing is more highly finished than an earlier compositional study in West Berlin (no. 5055) it exhibits some striking pentimenti, which give the stamp of 'work in progress' (Hirst 1981). Sebastiano died before completing the mural altarpiece, which was finished by Francesco Salviati, probably in 1554.

D.E.S.

PROVENANCE
E. Jabach; by 1671 in the Cabinet du Roi

EXHIBITIONS
Paris, Louvre, an v, no. 174; an VII and an X, no. 258; Paris 1811, no. 341;
Paris 1815, no. 274; Paris 1818, no. 304; Paris 1820, no. 356;
Paris 1841 and 1845, no. 618; Paris 1977–78, no. 25, repr.

REFERENCES
Hirst 1981, pp. 141–42, pl. 186, with full bibliography

A copy of this drawing, formerly attributed to Domenico Tintoretto, is also in the Uffizi (no. 7513S). Michelangelo's influence is particularly obvious. The use of white throughout the drawing not only gives form to the body, but also suggests the texture of the sheets on which the woman is lying and the reflection of water in the distant landscape. Either a stump, or the tip of the finger, has been used to create shadows on the thighs and in the white highlights. Pentimenti are clearly visible in both legs. The drawing is stylistically comparable with the *Study of a Woman* (Uffizi 1833F) dated to the late 1550s by Forlani.

D.E.S.

EXHIBITIONS
Florence 1956, no. 65, with full bibliography (as Domenico Tintoretto)

D64
Study for a Philosopher

295 × 200 mm
Black chalk, heightened with white, on grey-white paper
squared for transfer
Gabinetto dei Disegni, Uffizi, Florence (no. 12986F)

D64

This is a preparatory study for a *Philosopher* in the Libreria Marciana (1571–72), but in the painting the globe has been replaced by a pile of books. As von Hadeln observed, Tintoretto first drew the figure nude and then superimposed a cloak over it. The conjunction of the vigorous modelling of the legs with the softness in the handling of the cloak is particularly effective and more evident in the drawing than in the painting.

Other studies related to the *Philosopher* are in the Uffizi, namely 12937F, which Rossi accepts as autograph, and 12970F, which she assigns to the workshop, together with those in the Horne Foundation, Florence, and the Kunsthalle, Hamburg (no. 21547).

D.E.S.

EXHIBITIONS
Florence 1956, no. 21

REFERENCES
Rossi 1975, pp. 31, 32, fig. 101, with full bibliography

D65
Compositional Study

375 × 269 mm
Black chalk and charcoal, with traces of white, on blue paper
lightly squared in white
Verso: Three studies of a horse, one rearing, with a trainer; red
chalk
Gabinetto dei Disegni, Uffizi, Florence (no. 7498s)

Von Hadeln and Pittaluga suggested this was a study for a Flagellation of Christ, but the Tietzes and Forlani related this unusually elaborate drawing to the *Return of the Prodigal Son* on the ceiling of the Sala degli Inquisitori in the Doge's Palace. Rossi, however, has noted that only the figure on the right of the drawing corresponds exactly with the painting. The drawing is squared for transfer, which would suggest that a design for a picture had been established, but there remains some doubt as to the subject. On stylistic grounds the sheet must date quite late in Tintoretto's career and this would be consistent with a connection with the *Return of the Prodigal Son*, which Zorzi has established was painted in 1576.

There is an extreme, mannerist extension to the figures, which have considerable sense of movement, provided in part by the many pentimenti, particularly notable in the figure to the right of the central character. Tintoretto's sharp foreshortening of the architectural details at the top gives a sense of great depth.

D.E.S.

PROVENANCE
Santarelli; Uffizi

EXHIBITIONS
Florence 1956, no. 38;
Florence 1967, no. 41

REFERENCES
Rossi 1975, p. 39, fig. 118, with full bibliography

D65

PROVENANCE
Cardinal Leopoldo de' Medici; Uffizi

EXHIBITIONS
Florence 1956, no. 81

REFERENCES
Ridolfi, ed. Von Hadeln II, p. 42;
Rossi 1975, p. 35, fig. 171, with full bibliography

D66

D66

St. Martin and the Beggar

399 × 244 mm
Black chalk, heightened with white, on grey-brown paper squared
for transfer
Verso inscribed in brown ink in a later hand: *di Tintoretto
Vecchio l'opera e afresco a Santo Stefano di Venezia*
Gabinetto dei Disegni, Uffizi, Florence (no. 13009F)

Few drawings by Tintoretto for complete compositions
survive: this sheet and the early *Venus and Vulcan* (Dahlem
Museum, Berlin; no. 4193) are the most elaborate. Forlani
(Florence 1956) suggested that this drawing was stylistically
compatible with Palma Giovane's *St. Martin and the Beggar*
(National Gallery of Scotland, D.697), but there is little in
common between the two drawings apart from the subject.
Pignatti's attribution to Domenico Tintoretto is equally
unconvincing. Rossi is surely correct in re-asserting the
traditional attribution to Tintoretto. She associates it with
the designs for the *Battle of Zara* for the Doge's Palace
painted in 1584–87, and stylistically the drawing fits well
with Tintoretto's later work.

The inscription on the *verso* refers to a fresco at Santo
Stefano, Venice; both Ridolfi (1648) and Boschini (1674,
p. 87) recorded a fresco by Tintoretto, representing S. Vitale
in armour on horseback, above a fireplace at Campo Santo
Stefano. This drawing shows clearly the attributes of St.
Martin rather than S. Vitale, yet it may have some
relationship with the lost fresco.

D.E.S.

D67

Study of a Warrior for The Investiture of Gianfrancesco Gonzaga

322 × 169 mm (irregular)
Black chalk, heightened with white, on blue paper faded to grey
squared with black chalk
Gabinetto dei Disegni, Uffizi, Florence (no. 13041F)

This drawing is a study for the figure of the warrior in
armour on the right of the painting of *The Investiture of
Gianfrancesco Gonzaga* (Alte Pinakothek, Munich), datable
to the end of the 1580s. Rossi has suggested that the
relatively high finish of this and other drawings related to

D67

Tiziano Vecellio, called

Titian

[Biography on p. 218]

D68

Virgin and Child Enthroned

265 × 185 mm
Red chalk and pen and brown ink
Inscribed below: *di mā di P.V. . . .ian*
The Governing Body, Christ Church, Oxford

The close relationship between this drawing and an altarpiece by Francesco Vecellio (Titian's brother) once in the church of S. Croce in Belluno led von Hadeln to attribute it to Francesco. But Byam Shaw and Oberhuber (Venice 1976) agree that the drawing is of notably higher quality than the painting, and have suggested that it was made by Titian for his brother. In the absence of any certain drawings by Francesco, the question of authorship cannot be finally resolved. However, Oberhuber discerns certain similarities between this drawing and two others assigned to Titian around 1511: the black chalk study of a *Young Woman* (Uffizi, no. 718E) and the pen sketch of the *Miracle of the Speaking Child* (Fondation Custodia, no. 1502). He

D68

the Gonzaga series is to be explained by the fact that much of the painting in those canvases was carried out by the workshop.

Tintoretto produced an extraordinary variety of tone by varying the pressure of the chalk; the outlines are drawn with the chalk's sharp edge while details, such as the articulation of the knee joints, are emphasized by a hard twist of the point. The dark areas were created by rubbing the soft side of the chalk across the paper, which may then have been smeared with a stump or finger. A strong sense of plasticity and texture is created by the use of white highlights, effects that are reproduced more or less faithfully in the finished painting.

D.E.S.

EXHIBITIONS
Florence 1956, no. 30

REFERENCES
Rossi 1975, p. 37, fig. 121, with full bibliography

believes the pen and ink additions are in Titian's hand and dates the drawing *c*. 1511.

D.E.S.

D69
Landscape with St. Eustace

214 × 316 mm
Pen and brown ink and a little green oil paint on the stag, lightly
squared in pencil (some old repairs)
Inscribed lower right in brown ink: *titian*
numbered lower right in brown ink: *22*
Verso inscribed: *Titian D.10*
The Trustees of the British Museum, London (1895–9–15–818)

As with many other pen drawings associated with Titian, the attribution of this sheet has been the subject of intense controversy. But Oberhuber is surely correct in assigning it to Titian (Venice 1976). He compares the vigorous pen strokes, particularly evident in the drawing of the horse, to the sheet of studies (Berlin, no. 5692) that relates to the Brescia *St. Sebastian* dated 1520–22, and draws a parallel between the figure of St. Eustace and the saints in Titian's Gozzi altarpiece at Ancona of 1520. But there is also a certain resemblance, particularly in the use of a broad outline to emphasise prominent features, to the drawing (Fondation Custodia, no. 1502) for the fresco of the *Miracle of the Speaking Child* of 1511. The most likely date for this sheet would therefore seem to be in the second decade of the century. The masterly means by which the artist defines the middle distance, hinting at the rise and fall of the land, is far more subtle than anything produced by Domenico Campagnola, to whom the sheet has also been ascribed.

D.E.S.

D69

instead associated the drawing with another picture, also from the same cycle, of *The Battle at the Porta Sant' Angelo*, painted by Titian's son, Orazio Vecellio, in 1562–64 and likewise destroyed in 1577. They did so because another sheet (Munich no. 2981), very similar in style to this one, shows a horse and rider with a man lying on the ground, a feature recorded in Vasari's description of this painting. But on the whole it seems most likely that both drawings are connected with Titian's *Battle of Spoleto*.

The attribution to Titian himself is now generally accepted, and the style of the present sheet is obviously consistent with that of the compositional study for the *Battle*.

D.E.S.

PROVENANCE

Lanière; Jonathan Richardson Senior; June 1820, B. West sale; Lawrence; 4 July 1866, Esdaile, Wellesley, 1866 Sotheby sale; Josiah Gilbert; 1895 presented to the Ashmolean Museum by Mrs Josiah Gilbert

EXHIBITIONS

Paris 1935, no. 720; Venice 1958, no. 20; London 1970, no. 15; Venice 1976[1], no. 39

REFERENCES

Macandrew 1980, Appendix 2, 287, no. 718; Pignatti 1979, no. 36; Wethey 1975, p. 230, fig. 60, with full bibliography

D74

monies already paid to him. Titian promptly set to work and finally completed the canvas by 10 August 1538.

Tietze-Conrat first established the connection between this rapidly drawn study and Titian's lost Battle canvas. Of the extant copies, the painted version in the Uffizi, Rubens's drawing in Antwerp and the anonymous print in Vienna (Wethey, III, figs. 51, 52, 56) all follow the composition of the drawing. This might indicate that Giulio Fontana's print of 1569, which shows a somewhat wider composition, may not be a faithful record of the original.

Technically the drawing is exceptional: the speed of execution is clearly apparent and the sheet has extraordinary vigour. The extreme softness of modelling in the cataract below the bridge is in marked contrast to the cloud formations which seem to erupt in the sky. The rhythmic composition of the fighting men is most effective, and the plasticity of handling of the horse on the left and effortless realization of musculature on the back of the man's torso on the right are extraordinary. Titian's importance for an understanding of Tintoretto's draughtsmanship is immediately apparent here; nor should it be forgotten how much Rubens's *Battle of the Amazons* (Alte Pinakothek, Munich) depends on this composition.

D.E.S.

PROVENANCE
Bourgevin Vialart de Saint-Morys;
during the French Revolution entered the Louvre collections

EXHIBITIONS
Paris 1962, no. 18; Paris 1965, no. 104, repr.;
Paris 1978, no. 15

REFERENCES
Bacou and Viatte 1968, pl. 46; Parker 1956, s.v. no. 718, p. 385;
Pignatti 1979, no. 35; Tietze-Conrat 1948, pp. 237–42, fig. 2;
Tietze 1950, p. 403, fig. 105; Venice 1976², pp. 33, 35, fig. 18;
Wethey 1975, pp. 225–32, Wethey 1982, pp. 177–83

D73
A Horse and Rider Falling

274 × 262 mm
Black chalk on discoloured grey paper squared in red chalk
Inscribed in pen below centre: T^{an};
inscribed, perhaps by Van Dyck: *Titiano*; *T. . .*
The Visitors of the Ashmolean Museum, Oxford (no. 718)

This drawing is generally associated with Titian's lost painting of the *Battle of Spoleto* (see Cat. D72), in particular with the group in the left foreground. This view has been challenged by Tietze-Conrat and Pallucchini, who have

D73

painting in a sonnet of the same year. The painting must have been completed by 14 April 1538, when its arrival in Pesaro is mentioned in a letter from Giovanmaria della Porta to the Duke's wife, Eleonora Gonzaga della Rovere.

Several scholars, including Wethey, have argued that this study is a preparatory drawing for the painting, which must subsequently have been cut down to make a pendant to the portrait of the Duchess Eleonora, which is also in the Uffizi. But Rearick has pointed out that the head in the drawing is not that of Francesco Maria. He believes that this is a study of the armour worn by a model and that Titian drew the figure full length to make sure that the pose was realistic. If this argument is correct there seems no reason to doubt that the painting was three-quarter length from the start.

The technique of this drawing is similar to that of the study of *St. Sebastian* (Frankfurt) dating from *c.* 1520, but this sheet must obviously date from *c.* 1536.

D.E.S.

PROVENANCE

Mariano Urbinelli; Giuseppe Corradini;
Principe Staccoli Castracane(?); Gluck; Morelli; Ginoulhiac;
1908 acquired by the Uffizi

EXHIBITIONS

Florence 1911; London 1930, no. 675; Florence 1961, no. 61;
Florence 1976, no. 21, fig. 28, with full bibliography

REFERENCES

Pignatti 1979, no. 34; Venice 1976[1], fig. 16

D72
The Battle of Spoleto

383 × 446 mm
Black chalk and grey-brown and brown wash, heightened with
white, on blue paper squared in black chalk
Cabinet des Dessins, Musée du Louvre, Paris (no. 21.788)

The long controversy about the identity of the battle depicted in Titian's canvas for the Sala del Maggior Consiglio in the Doge's Palace, destroyed in 1577, has now been resolved; it seems certain that the subject is the Battle of Spoleto and not that of Cadore (Wethey 1982).

Titian was granted his petition to paint a battle for the hall by the Council of Ten on 31 May 1513. In November 1514 he explained to the Council that he had already prepared *modelli* for his picture (no trace of these survives). His application for a brokerage, a sinecure which was the only certain source of payment for his work for the State, was conceded by the Council of Ten on Giovanni Bellini's death in 1516, and thereafter the *Battle* was repeatedly postponed – Titian's first completed mural for the Council of Ten was in fact *The Humiliation of Emperor Frederick Barbarossa* in 1523. His increasing fame, and the constant requests for his work from the great princes of Italy, as well as the Emperor Charles V, appear to have been the reason for further delay. Finally, on 23 June 1537, the Council stated that Titian had been contracted to paint the Battle in 1513, and threatened to demand the reimbursement of all

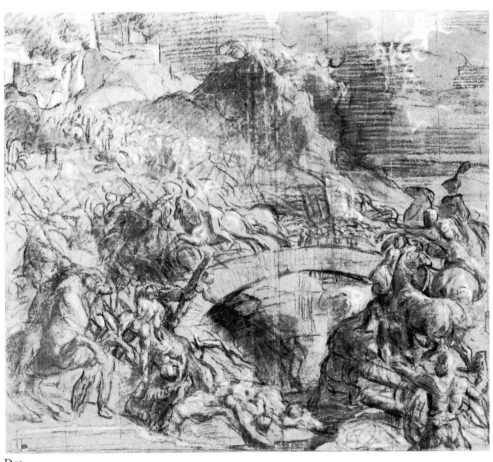

D72

D70

Study of an Apostle for
The Assumption of the Virgin

157 × 134 mm
Charcoal, heightened with white, on blue paper
Verso: Study of two caricatured heads
The Trustees of the British Museum, London (1895–9–15–823)

Recognised by von Hadeln as a study for the seated figure of St. Peter in the *Assumption of the Virgin* (fig. 19), which was commissioned about 1516 and installed in 1518, this drawing is universally accepted as autograph.

As Oberhuber has pointed out (Venice 1976), Titian was striving here to give a clear, geometric structure to body, head, and draperies, whilst simultaneously creating a marvellous softness in the modelling of the draperies; he successfully realised spatial depth by contrasting light with dark tones. In the finished painting Titian modified the drapery of St. Peter with a rich series of folds, which give the figure a greater monumentality appropriate to his position in the centre foreground.

The heads on the *verso* could also be by Titian.

D.E.S.

PROVENANCE
Sir Joshua Reynolds; Sir Thomas Lawrence; William Esdaile;
18–25 June 1840, William Esdaile's sale, Christie's, London (no. 121);
John Malcolm of Poltalloch; 1869 Robinson, p. 142, no. 378

EXHIBITIONS
Venice 1976[1], no. 26, repr., with full bibliography

REFERENCES
Pignatti 1979, no. 19

D71

Study for the Portrait
of Francesco Maria della Rovere

237 × 141 mm
Pen and brown ink over traces of red chalk on white paper stained light brown and squared with pen and brown ink
Inscribed below in an eighteenth century hand, apparently a transcription of an earlier inscription:
*Dietro al disegno di Tiziano leggevasi sopra un assetto: – 1693 – Ritratto di Fran*co*. M*a*. p*o*. della Rovere Duca quarto d'Urbino di mano di Titiano Ecc*mo* Pittore, quale fu donato a me Giuseppe Coradini dal Sig Mariano Urbinelli con haverli io fatto fare le cornigie et altro, come qua si vede, Tutto costa grossi tredici in circa, da tenersene gran conto, che cosi desidero.*
Pregate dio per me.
Gabinetto dei Disegni, Uffizi, Florence (no. 20767F)

This is a preparatory study for the *Portrait of Francesco Maria I della Rovere*, Duke of Urbino (1480–1538), now in the Uffizi, Florence. In a letter of 17 July 1536, Francesco Maria mentioned that his armour had been sent to Titian to be painted for the portrait and Aretino eulogised the

D71

D74
Study for The Angel of the Annunciation

422 × 279 mm, irregular
Black chalk and charcoal, heightened with white, on blue paper
faded to grey and stained
Verso: Study for a draped male figure; same technique
Gabinetto dei Disegni, Uffizi, Florence (no. 12903F)

Loeser published this drawing as a study for the Angel of
the Annunciation in Titian's altarpiece in S. Salvatore,
Venice, painted between 1559 and 1566. There are several
points of difference between the drawing and the finished
painting that have led Rearick (Florence 1976) to suggest
that the sheet is more closely related to the outside of the
lateral canvas of the *Assumption* in Dubrovnik Cathedral,
c. 1550.

Rearick has also related the drawing on the *verso* to the
1558 *Crucifixion* at Ancona. Noting a similarity in handling
between the draperies of the Virgin in the *Crucifixion* and
those of the drawing, he has ingeniously postulated that this
is a preparatory study for the figure of St. John to the right
of the cross. Certainly, the sheet is characteristic of Titian's
late style and a date of *c.* 1560 is more acceptable than
c. 1550.

The sense of weight in the moving draperies of the lower
section of the sheet, accentuated by the use of black chalk
and by the horizontal strokes of shading on the floor to the
right, is particularly successful. The white highlights are
sadly abraded, but a suggestion of tonal contrast is still
evident, and the softness of modelling in the wings is of the
greatest delicacy. Despite Rearick's *caveat*, it seems most
probable that this drawing is preparatory to the S. Salvatore
Annunciation.

D.E.S.

PROVENANCE
Fondo Mediceo-Lorenese (?)

EXHIBITIONS
London 1930, no. 670;
Florence 1976, no. 27, *verso* exhibited, figs. 31, 32, with full bibliography

REFERENCES
Pignatti 1979, no. 48; Venice 1976[1], figs. 26, 27

D75
A Couple in Embrace

252 × 260 mm
Charcoal and black chalk, heightened with white,
on faded blue paper
Fitzwilliam Museum, Cambridge (no. 2256)

The attribution of this drawing to Titian, made by Ricketts,
has been generally accepted. Fröhlich-Bum, Tietze and
Tietze-Conrat dated the drawing *c.* 1550–55. Jaffé has
proposed a considerably later date, *c.* 1570, comparing the
drawing with the x-rays of the painting of *Tarquin and
Lucretia* (Cat. 130) engraved by Cornelis Cort in 1571, and
with the unfinished painting of the same theme in the

D75

Akademie der bildenden Künste, Vienna, of *c.* 1570.

A copy of the present drawing (Louvre, inv. no. 5660)
was published in error as the original (*Kunstgeschichtliches
Jahrbuch der Zentralcommission*, III, 1909, p. 24, pl. III) by
Wickhoff, who suggested a date between 1510 and 1520.
That sheet, inscribed *Ti . . . Titiaen*, has now been
convincingly attributed to Jordaens by Meijer. Jordaens
was never in Italy and he derived any knowledge he had of
Titian's drawings from his contact with Rubens. This,
together with the existence of a free adaptation by Rubens,
c. 1617, of Titian's design of the embracing couple in his
so-called *Rape of the Daughters of Leucippus* (Alte
Pinakothek, Munich), points to the strong probability that
the Fitzwilliam drawing was once part of Rubens's
collection. The composition re-appears, modified and in
reverse, in the painting of *Mars and Venus* from the School
of Titian in the Kunsthistorisches Museum, Vienna
(no. 13). In the Jordaens copy there are much better
preserved areas of white highlight, which accord with the
faint traces of white in the Titian drawing. The sense of
weight in the woman's body and its abandoned sensuality
are the graphic equivalents of Titian's most voluptuous
painted nudes.

D.E.S.

PROVENANCE
Sir Peter Paul Rubens (?); Jonathan Richardson Senior;
Ricketts and Shannon;
1937 bequeathed to the Fitzwilliam Museum by Charles Haselwood
Shannon

EXHIBITIONS
London 1930, no. 669; London 1953, no. 56; Cambridge 1960, no. 54;
Venice 1976[1], no. 43, with full bibliography;
United States of America and Cambridge 1976–77, no. 45;
Cambridge 1979, no. 202; Cambridge 1980–81

REFERENCES
d'Hulst 1980, p. 361, fig. 1; Paris 1976, pp. 27–28, no. 16 (Meijer)

Paolo Caliari, called
Veronese

[Biography on p. 233]

D76
Five Studies of a Man

175 × 295 mm
Black chalk, heightened with white, on blue-grey paper
Cabinet des Dessins, Musée du Louvre, Paris (RF 38.932)

One of a group of ten drawings by Veronese acquired by
the Louvre in 1982 (see also Cat. D79 and D82), this sheet
came from a collection known as the 'Borghese Albums',
which was assembled by an unidentified collector, probably
in Venice, in the second half of the eighteenth century.

Four of the studies relate to *The Family of Darius before
Alexander* (National Gallery, London): the three on the left
are for the figure on the right – pointing to his comrade –
who is usually identified as Hephaeston, Alexander's
general. The second from the right is a study for Alexander
himself, his right hand on his chest and his left hand holding
his cloak on his hip. Roseline Bacou observes that the
second study from the left could have been used for the man
with outstretched arms in the foreground of *Christ in the
House of Levi* of 1573 (Accademia, Venice).

This elegant sheet reveals a remarkable analysis of
movement, and is new evidence for Veronese's style as a
draughtsman in black chalk. Pignatti has dated *The Family
of Darius c.* 1565, but the evidence of this new drawing and
its relationship to the painting in the Accademia, as noticed
by Bacou, supports Gould's dating on the grounds of the
style of the costume to *c.*1570 or later.

D.E.S.

PROVENANCE
'Borghese Albums' collection, numbered on the mount *P. no. 57(?)*;
acquired by the Musée du Louvre

REFERENCES
Bacou 1983, forthcoming publication

D77

D77
Study for the Allegorical Figure of Moderation

211 × 227 mm
Black chalk, heightened with white, on blue paper
Inscribed upper right: *Moderatia*; lower right: *di Paolo Veronese*
The Trustees of the British Museum, London (1969-4-12-4)

This is a study for the figure of Moderation on the ceiling
of the Sala del Collegio in the Doge's Palace. Veronese was
commissioned to paint this ceiling in January 1575, and his
pictures were certainly finished by 3 March 1578.

The cycle of the ceiling glorifies Venice and includes eight
canvases of the Virtues. These are generally considered to
be in part by Benedetto, or from Veronese's workshop,
although Marini (1968) thought the figure of *Moderation*,

D76

depicted with an eagle, which she holds by the wing, was painted by Paolo with some studio assistance.

The drawing is characteristic of Veronese's use of chalk for studies of individual figures. White highlights are used to give the flesh a firm sense of modelling, despite the softness of the handling. Another study for one of the Virtues employing the same technique was acquired by the Louvre in 1982 (RF 38921); although not many of these preparatory drawings in chalk have yet been identified, it is clear that they must have been as regular a part of Veronese's studio practice as the more common pen and brown wash sketches and the finished *modelli*.

D.E.S.

PROVENANCE
27 March 1969, Sotheby's sale;
presented anonymously to the British Museum

REFERENCES
Pignatti 1976, I, no. 202; II, fig. 498

D78
The Martyrdom of Santa Giustina

470 × 240 mm
Pen and brown ink and point of the brush and brown wash, heightened with white, on greyish-blue paper squared in black chalk
The Trustees of the Devonshire Collection, Chatsworth, Derbyshire (no. 279)

This is a *modello* for the altarpiece in S. Giustina, Padua, commissioned from Veronese in 1575 and generally believed to have been painted in collaboration with Benedetto. It may have been the drawing mentioned by Carlo Ridolfi (1648, vol. I, p. 317), which was at that time kept in the rooms of the Abbot of S. Giustina.

The use of very elaborate highlighting with white is characteristic of Veronese's *modelli*, the luminous effect created giving a high degree of painterly finish. In the painting the two sections of the composition are closer together and the clouds are lower and heavier, to the detriment of the completed work. The figure to the left of Christ has been changed in the painting to John the Evangelist as opposed to John the Baptist who appears in the drawing.

D.E.S.

PROVENANCE
Lankrink; William, 2nd Duke of Devonshire;
Trustees of the Devonshire Collection, Chatsworth

EXHIBITIONS
United States and Canada 1962, no. 72 (Wragg)

REFERENCES
Pignatti 1976, fig. 470; Tietze and Tietze-Conrat 1944, no. 2056

D78

D79
Sheet of Studies for
The Adoration of the Magi

222 × 215 mm
Pen and brown ink and brown wash
Inscribed in the artist's hand in pen and brown ink upper left: numerals; near the soldier lower left: *tributa* (?); near the servant bending over lower left: *porta/una cassa*
Verso: drawn on the back of a letter which bears the address *Al Molto Mag*co *S. Paolo Caliari Veronese Pictor* ecl*mo*. . . .
Cabinet des Dessins, Musée du Louvre, Paris (RF 38. 927)

D79

These are studies either for Veronese's *The Adoration of the Magi* (National Gallery, London) dated 1573, or for another similar painting of the same subject in S. Corona, Vicenza, generally dated *c.* 1575–80.

At the top of the sheet is a study for the group of the Virgin holding the Child, with St. Joseph near the column, and a study for one of the Magi kneeling in front of the Virgin. Behind the Virgin are little angels, and, on the right, children playing with a dog. The overall composition is sketched below. Many changes occur between this preliminary study and the finished painting.

D.E.S.

PROVENANCE
'Borghese Albums' collection;
1982 acquired by the Musée du Louvre

REFERENCES
Bacou 1983, forthcoming publication

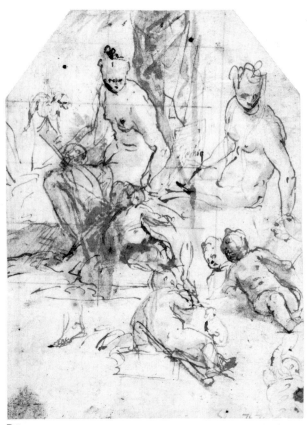

D80

D80

Study for a Seated Venus and Cupid with a Mirror

175 × 126 mm
Pen and brown ink and brown wash, the upper left hand
of the sheet squared in black chalk
Inscribed by the artist in brown ink:
spechio; traces of a further inscription below
The Trustees of the British Museum, London (1951-11-10-79)

Yapou observed, correctly, that this drawing was a
preliminary study for Veronese's painting of *Mars and
Venus* (National Gallery of Scotland, Edinburgh), dated by
Pallucchini and Pignatti to the late 1570s or 1580s.
Brigstocke rejects Cocke's theory, based on the evidence of
the drawing, that the painting was originally conceived as
a Venus with a mirror, or that the figure of Mars, which
fits awkwardly into the composition, was added later,
adducing evidence from x-ray photography that 'no
important change appears to have been made as work on
the picture progressed'.

D.E.S.

PROVENANCE
Colnaghi and Co.; 1951 acquired by the British Museum

REFERENCES
Brigstocke 1978, fig. 42; Cocke 1977, p. 122, fig. 6;
Pignatti 1976, vol. II, fig. 587; Yapou 1968, p. 3, no. 3, pl. 3

D81

Sheet of Studies for The Finding of Moses

308 × 210 mm
Pen, brown ink and brown wash
Inscribed in brown ink in the artist's hand upper left: *sonagi* (?);
centre left *strada*
Fitzwilliam Museum, Cambridge (PD 21-1977)

The drawing relates most closely to the *Finding of Moses*
(Galleria Sabauda, Turin) sent to Carlo Emmanuele I of
Savoy by Veronese together with the *Queen of Sheba before
Solomon* (Borghini 1584). The painting is generally
considered to be a workshop production after Veronese's
own design, and has usually been ascribed to the hand of
Benedetto Caliari (Pignatti 1976). Three sections of the
drawing are exactly repeated in the painting: the figure of
the woman, upper left, holding back a branch of a tree; the
figures of the dwarf and the mastiff, which occur twice on
the sheet; and the group of the maid handing up the infant
Moses to the daughter of Pharaoh.

The central group of the daughter of Pharaoh with her
attendants, part of which is repeated on the upper right, is
close, but not identical, to the painting. The sense of
movement evident in the stance of these figures – which
differ so markedly from those in the versions in Madrid,
Washington and Dresden – is maintained in the Turin
picture, dated by Cocke *c.* 1582. Cocke drew attention to
similarities with the drawing formerly in the Von Hirsch
Collection, which he related to the painting in the Walker
Art Gallery, Liverpool. He dated both the Liverpool and the
Turin paintings *c.* 1582 and added, 'the complete execution
of both pictures by different hands in the studio is a token
of Veronese's growing success in the last decade of his life'.

Cocke also noted that the pose of the standing woman
under the main group in this drawing anticipates the
Pharaoh's daughter worked out in the sheet in the Pierpont
Morgan Library, New York. He suggested (in a letter to the
Fitzwilliam Museum) that Veronese was working on the
Liverpool, Turin, Madrid and Washington paintings
simultaneously. The architectural studies have not yet been
related to any known painting by Veronese or his studio.

D.E.S.

PROVENANCE
Sir Peter Lely; Jonathan Richardson Senior; Sir Joshua Reynolds;
A. M. Champernowne; G. Bellingham-Smith; Tancred Borenius;
Captain N. Colville; 1977 accepted by Her Majesty's Treasury in lieu of
death duties and allocated to the Fitzwilliam Museum

EXHIBITIONS
Venice 1939, no. XII; Cambridge 1977, *hors catalogue*; Cambridge 1978;
Cambridge 1980–81

REFERENCES
Borenius 1921, pp. 54ff;
Cocke 1973, p. 142; Fiocco 1928, p. 208; von Hadeln 1926, no. 33;
Osmond 1927, p. 107; Pignatti 1976, A. 312, vol. I, p. 210; vol. II, fig. 986;
Tietze and Tietze Conrat 1944, p. 346, no. 2099

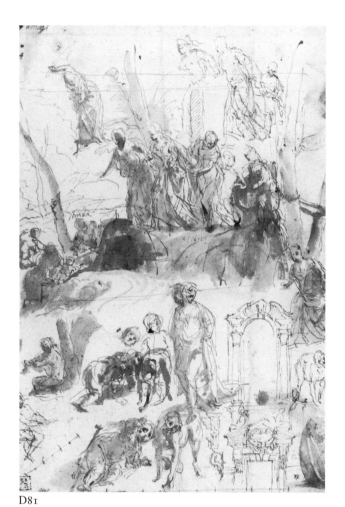

D81

D82
Sheet of Studies for
San Pantaleone Healing a Child

214 × 245 mm, irregularly shaped
Pen and brown ink, brown wash
Inscribed in the artist's hand upper left: numerals
Verso: writing, undeciphered, visible when held to the light;
inscribed below on the backing paper in pen and brown ink:
Carletto Caliari
Cabinet des Dessins, Musée du Louvre, Paris (RF 38. 928)

In 1587, one year before his death, Veronese painted *San Pantaleone Healing a Child* (Cat. 147). Apart from the two little sketches of a standing Madonna holding the Child crowned by putti, the studies on this sheet are directly related to the painting. This drawing, dating from the very end of Veronese's career, is of remarkable freedom.

Roseline Bacou has noted that the reference to Carletto Caliari on the backing probably shows that the drawing belonged to the artist's son. In the old 'Borghese Album' collection it was misattributed to Carletto, whose initials, C.C., are again found in the double numbering system. It is generally accepted that Carletto played a small part in the execution of the S. Pantaleone painting.

D.E.S.

PROVENANCE
'Borghese Album'; 1982 acquired by the Musée du Louvre

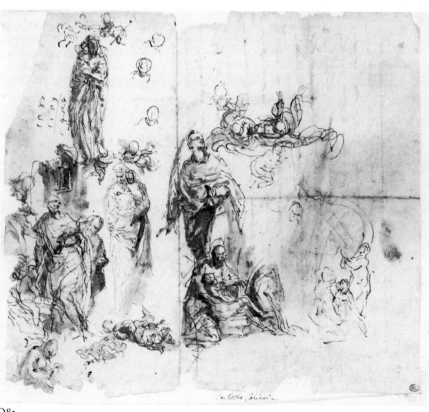

D82

Alvise Vivarini da Murano

Venice after 1446 – Venice 1505/06

Son of Antonio Vivarini, nephew of Bartolomeo and pupil of both, Alvise was trained in the workshop traditions of his family. Under the influence of Giovanni Bellini, he brought these traditions up to date; for example his altarpiece (1480) for S. Francesco, Treviso (now Accademia, Venice), has the horizontal format of the family tradition, but it is thoroughly modern in the treatment of space and light.

In the 1480s Alvise was strongly influenced by Antonello, the principles of whose art he probably followed more completely than any other Venetian painter. With his altarpiece for S. Maria dei Battuti, Belluno (c. 1490, ex-Kaiser Friedrich Museum; destroyed), he made an important contribution to the Venetian round-topped altarpiece, in which the architecture of the painting is continuous with that of the frame. At the time he was influenced by the architecture and sculpture of Pietro Lombardo and by Antonio Rizzo. In 1488, at his own request, he received permission to work alongside the Bellini in the Sala del Maggior Consiglio of the Doge's Palace, and appears to have been assigned three canvases, two of which were unfinished at his death and the third not begun.

In the last years of his life Alvise Vivarino's art developed away from Giovanni Bellini towards a more dynamic and dramatic style, which had important implications for the development of Venetian cinquecento painting. The much damaged *Resurrection* (1498) in S. Giovanni in Bragora and the *Sacra Conversazione in a Landscape* at Amiens (signed and dated 1500) are examples of his late style.

J.S.

D83

Six Studies of Hands

278 × 193 mm
Fondation Custodia (Coll. F. Lugt), Institut Néerlandais, Paris,
(no. 2226)
Metal point, heightened with white, on a pink ground on paper
Verso: small outline study of a dog's head in red chalk

This sheet is securely datable to 1480 or just before, since four of the hands are for saints in Alvise Vivarini's *Virgin and Child with Six Saints*, painted for S. Francesco, Treviso (now Accademia, Venice), which is signed and dated to that year. The right hand and arm at the bottom are for the *St. John the Baptist* now in Denver, and the small left hand above it and to the left, for its companion *St. Jerome*.

The four large hands are evidently studies from life, 'posed' by Alvise in relation to what he planned for the painting. Thus the right and left hands (top left), both for St. Anthony of Padua, already hold respectively his lily and book. The right hand of St. Louis of Toulouse (top right) holds the staff of his crozier, but is not yet clothed in the glove it wears in the painting.

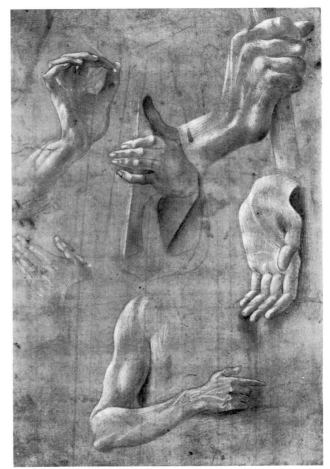

D83

The two drawings for the Denver panels are sketchier and of less high quality. The drawing of the arm and hand of St. John the Baptist appears to have been designed to adapt the placing of the arm from its upward diagonal position in two earlier versions of the figure (Thyssen Coll., Lugano; Accademia, Venice) to its horizontal position in the Denver panel.

J.S.

PROVENANCE
Max von Heyl zu Hernsheim, Darmstadt; H. G. Gutekunst;
22 June 1903, sale Stuttgart, no. 67, repr. (as Buffalmacco); F. Güterbock,
Berlin; 1925 Frits Lugt, Paris

EXHIBITIONS
Nice 1979, no. 46, repr.; Venice 1981[2], no. 26, repr.;
London 1983, no. 78

REFERENCES
Byam Shaw 1983, I, pp. 223–25, no. 221, pl. 251, with full bibliography;
Gonzalez-Palacios 1969, p. 38, pl. 38;
Pallucchini 1962, pp. 73, 141, pl. 281; Parker 1926, pp. 6, 10;
Parker 1927, p. 31, pl. 43;
Steer 1982, pp. 28, 29, 31, 169–70, cat. no. 43, pl. 13;
Tietze and Tietze-Conrat 1944, pp. 363–64, no. 2245, pl. XXVII

D84

Virgin and Child Enthroned with St. John the Baptist, St. Sebastian and Two Other Saints

347 × 249 mm
Pen and brown ink over ruled stylus lines, heightened with white, on paper
Her Majesty The Queen (no. 069)

The drawing is securely attributable (Popham and Wilde, Steer) to Alvise's workshop *c.* 1500. Ames-Lewis and Wright (Nottingham and London 1983) point out that, as would be natural in a working drawing, the detailed forms of the architecture, which are ruled with a stylus and precede the sketchier figures in execution, are only completed on the left-hand side, not on the right, which would be their mirror image. No other working drawing for an altarpiece, showing both the painting and the frame which it was to occupy, survives, although such drawings must have preceded altarpieces like Giovanni Bellini's *S. Giobbe* altarpiece in the Accademia, Venice, or Alvise's own destroyed *pala* for S. Maria dei Battuti at Belluno,

where an integrated relationship between the real frame and the fictive architecture of the painting certainly existed. In conception the architecture in the drawing is closest to Alvise's last work, the *St. Ambrose Enthroned with Saints* in the Frari, Venice, which was completed by Basaiti and, if on this scale with full-size figures, it, and particularly its frame, would have been very grand indeed. It must however be noted that for S. Cristoforo, Murano, Alvise produced a smaller version of an altarpiece of this type (now in East Berlin: it measures 259 × 188.6 cm) in which the figures are only half-size; and Basaiti actually painted a miniature version of his full-size altarpiece of the *Calling of the Sons of Zebedee* (Kunsthistorisches Museum, Vienna: the full-scale painting is in the Accademia, Venice) in which he represented fictively not only the painting but also its frame. It is just possible therefore that the drawing is for an imaginary altarpiece of this type.

J.S.

EXHIBITIONS
London 1975, no. 487;
Nottingham and London 1983, p. 276, no. 62, repr.

REFERENCES
London 1975, p. 262, no. 487, repr.;
Popham and Wilde 1949, p. 178, no. 31, repr.;
Steer 1982, pp. 165, 170–1, no. 44, repr.

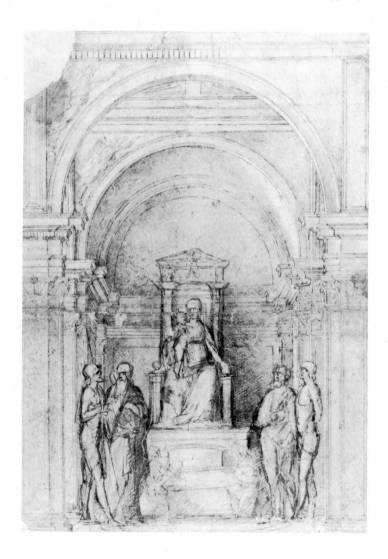

PRINTMAKING IN VENICE AND THE VENETO

David Landau

Two of Titian's greatest masterpieces, the huge *Battle* in the Doge's Palace and the altarpiece of the *Death of St. Peter Martyr* in the church of SS Giovanni e Paolo, were completely destroyed by fire and are now known only through sixteenth-century prints (fig. 14). Some members of the public, and particularly some art historians, will initially be puzzled and annoyed, if not outraged, *not* to find these prints on the walls of this exhibition. While it is true that some 95% of the prints produced in Venice and its artistic territories in the sixteenth century were reproductive – that is to say copies of frescoes, paintings or drawings – and were sold just as postcards or photographs are now sold in the Piazza San Marco, throughout the century a very small number of prints continued to be produced as independent, original works of art by artists who felt they could express some of their thoughts better in a black and white print than in a drawing or a painting. These are the prints which cover the walls of the Royal Academy, and it is hoped that their beauty will convert even those art historians who walked into the room looking for the reproduction of a lost masterpiece.

We should not forget that while today we may be bored with, and perhaps spoiled by, decades of black and white photographs, films and television, this was not the case with sixteenth-century Venetians; prints were then the only black and white images, and, since they had been invented only a couple of generations earlier and were only just beginning to be known, they were still a novelty. Moreover, at the beginning of the century there were still many exciting ways of exploiting the new invention, and of exploring the rather odd light effects that could be obtained by engravers or woodcutters in producing a new kind of art.

A quick glance at the prints in the exhibition makes it clear that the most exciting period of Venetian printmaking was more or less confined to the first three decades of the century. In those 30 years printmakers refined the known techniques, such as woodcutting and engraving, to the highest degree, and experimented with new techniques, such as stipple-engraving and chiaroscuro woodcutting. The great technical innovations introduced in those years produced some beautiful prints, but they were also the very cause of the decadence of printmaking, for they taught printmakers some easy rules for copying other artists' works. As the years went by, printmaking increasingly became a craftsman's business, a profession like any other, and during the rest of the century only some isolated artists attempted to master the technique.

The difference between original and reproductive prints is an important feature of our story; but it is equally important to differentiate between engravings and woodcuts: they originated from different traditions, were practised by different types of artist and their evolution followed quite different paths. With a few exceptions, engravings were the product of the mind and hand of a single artist. The engraver worked quite independently in his own workshop, incising a metal plate (usually copper) with various pointed tools, such as burins and drypoints, and printing these plates on a roller press which could be used only for producing engravings. Woodcuts, on the other hand, were more laborious to produce since a designer, a cutter and often several other people were involved in the process. The design was first drawn directly on to the wood block by the artist, the areas between the lines were then painstakingly carved out by the woodcutter, and eventually the block was printed, usually by a professional printer, on a flat press exactly the same as that used for printing books. Book publishers were, therefore, very often directly involved in the production, and consequently also in the sale, of woodcuts. So, while the engraver could freely experiment with new techniques and waste precious hours in producing unsatisfactory proofs, the assembly line lying behind every impression of a woodcut had to follow very precise guild rules and was subject to commercial laws. And while engravings were produced for a small, refined market and their price needed only to cover the artist's expenses, woodcuts, probably cheaper and aimed at a much wider audience, had to be produced in much larger editions to cover the higher labour and production costs. The two worlds were far apart and, as such, will be considered separately here.

Engraving, which had first been exploited on any scale in Italy by Andrea Mantegna in the early 1460s, developed technically only in the last few years of the fifteenth century. Mantegna's technique allowed him to pull few impressions from a plate, as did the different technique used by the Florentine goldsmiths in the same period. But in the 1470s a new way of using the burin, which allowed, for the first time, a great number of impressions to be pulled from the plate, was imported into Italy, probably from Germany; and it had a great impact on printmaking. For historical reasons which lie outside the scope of this essay, this new technique of engraving was mostly used, and developed, by goldsmiths turned printmakers; the first *artist* to attempt it – a figure central to our story – was Jacopo de' Barbari. Almost certainly a Venetian, his surname suggests that he could have been of German parentage, which might have had some bearing on his interest in printmaking, for he might have been closer to Dürer when the latter was in Venice in 1494 than hitherto suspected. Jacopo produced about 17 prints

during the last few years of the fifteenth century and steadily improved his command of the technique. By the time he left Venice in 1500, he had left a profound mark on the history of printmaking in Italy: mostly small and refined, his beautiful engravings of profane and often mysterious subjects compared well with those of Dürer, whose own engravings were being imported into Venice by its thriving German community.

Jacopo's prints stimulated young artists, such as Giulio Campagnola and Marcantonio Raimondi, to take up the northern challenge. In those years Dürer was rapidly advancing in the development of a standard engraving technique which exploited more and more cross-hatching and dotting as a means of obtaining an effective scale of shades between black and white. Giulio and Marcantonio responded in two very different ways, the first as the artist that he was, the second as a craftsman. Giulio invented a new technique, stipple-engraving, whereby shadows were obtained by dots produced by the point of the graver; by the end of the first decade of the century his prints, now entirely made of dots, offered collectors the possibility of buying a work of art as mysterious, refined and precious, even if not as beautiful, as Giorgione's rare and expensive paintings. Giulio was no craftsman. Hailed by his contemporaries as a great painter, sculptor and poet, he spoke Latin, Greek and Hebrew, and his company might well have been enjoyed by Giorgione and his circle of humanist friends. This was important, for it meant that engraving became fashionable in Venice, and remained so for some time.

Marcantonio arrived in Venice probably late in 1505 and spent most of his first year there copying Dürer's woodcuts in engravings. Although this long training got him into trouble with the German master, it taught Marcantonio a great deal: during this period he refined his technique, inventing a most effective, though economic, system of lines, cross-hatching and dots, which could produce on paper all the possible tones of grey and black. The mastery he achieved is most evident in the so-called (apparently for no good reason) 'Dream of Raphael' (Cat. P15), the first engraved night scene. Marcantonio eventually left Venice, perhaps because of his obvious lack of artistic skill (he could not remotely compete with an artist such as Giulio), but his equally obvious skill as an engraver had an immense impact on Italian printmaking: it made possible his collaboration with Raphael and it was one of the most important causes of the transformation of printmaking from an independent expression of artistic thought to a system of reproducing other works of art.

It is now commonly held that all sixteenth-century prints were reproductive; consequently many of the beautiful engravings by Giulio shown here have, at some time or another, been connected with lost paintings, or drawings, by Giorgione. The same was thought true of the prints Marcantonio engraved during his short stay in Venice, but his copies of Dürer's woodcuts were, in fact, forgeries: reproductive engraving did not appear in Venice until much later. Collectors stimulated a market for small, precious images in black and white and many artists, such as Domenico Campagnola (the adopted son of Giulio), Previtali, Fogolino and Martino da Udine, tried engraving. The last two, in fact, produced mostly drypoints, which could only be printed in very few impressions (normally less than ten) before the plate

started showing evident signs of wear. Who, other than sophisticated and avid collectors who wanted to fill their albums with rare and beautiful things, would possibly buy these prints? The taste for them probably lasted no more than 15 years or so, for they become much rarer after c. 1520.

By this time, and especially in Rome, engraving had become a craftsman's business, mostly in the hands of professional reproductive printmakers attached to a printer's workshop. The role of engraving as an original medium of artistic expression was taken over for some time by etching, first used on some scale in Italy by Parmigianino. Etching was a much freer method than engraving in that it was closer to drawing: the artist needed only to draw on a thin film of wax which covered the plate, and it was left to the acid to incise these lines, a task dependent on the arm muscles in engraving. By the middle of the century etching in Venice was practised by such artists as Battista Franco and Andrea Schiavone; in the Venetian territories it was especially practised in Verona by the equally unexciting Paolo Farinati and Battista Angolo del Moro. Its only high point during the rest of the century was the isolated attempt by Jacopo Tintoretto, who unfortunately experimented with etching only once and then very late in his life (Cat. P57).

If Jacopo de' Barbari played an important role in the history of engraving, his example was fundamental to the development of Venetian woodcuts. Jacopo designed two very influential woodcuts in the last few of the fifteenth century: one, the *Map of Venice* (Cat. H1), first published in the year 1500; the other, a *Triumph of Men over Satyrs* (fig. 24), of which the only fine impression is in Vienna and unfortunately could not be borrowed. The novelty of these woodcuts was manifold: both their size, which could be achieved only by using several blocks, and their subject matter, which was secular, meant that woodcuts were given for the first time a 'decorative' value. They were not used, as most woodcuts had been in the past, as private devotional images to be pasted to the wall, inside a box or piece of luggage, or kept folded in a pocket. They became objects of aesthetic enjoyment, and, in this respect, Jacopo's special contribution to the evolution of woodcuts lay in the fact that he was the first artist of some standing to design a woodcut which was not a book illustration. The impact of these two prints must have been extraordinary, and it can safely be said that without Jacopo's example we would not have such an impressive selection of woodcuts in this exhibition.

When Jacopo de' Barbari left Venice in the year 1500, enticed away by the Emperor Maximilian's offers, it was left to Titian to take up his artistic inheritance. Titian's answer to Jacopo's pagan *Triumph*, printed from three blocks, was an impressive *Triumph of Christ* (Cat. P16) more than 2.5 metres long – almost exactly twice as big as Jacopo's print – obtained from ten blocks. A few years later Titian designed *The Submersion of Pharaoh's Army in the Red Sea* (Cat. P19), in my view the greatest woodcut ever conceived, which can surely compare with any of his paintings, and which influenced artists all over Europe throughout the century.

As Peter Dreyer has argued, there can be no doubt that Titian drew directly on to these blocks and those of all his other woodcuts. He was probably working in close collaboration with the cutters, supervising their work and probably making changes in relation to their needs and those of the medium itself. Thus, for instance, it is evident from the deve-

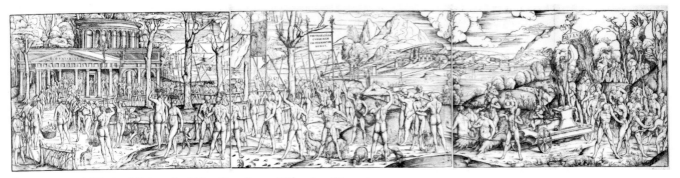

fig. 25 Jacopo de' Barbari *Triumph of Men Over Satyrs* (Albertina, Vienna)

lopment of Titian's woodcuts that he soon realised that cross-hatching had to be more or less evenly spread in the composition, for concentrated areas of it could come out in the print as black patches against the white of the paper, and changed his style accordingly.

The whole problem of the character of the collaboration between Titian and his cutters must now be completely revised in the light of Peter Dreyer's brilliant discovery that all the so-called Titian preparatory drawings for his wood-cuts are, in fact, forgeries obtained by drawing on lightly printed counterproofs of the prints (a counterproof is a re-verse impression obtained by running a wet proof through a roller press with a sheet of plain paper). Unfortunately lack of space makes it impossible here either to discuss the ques-tion in the detail it deserves or to prove that Domenico Cam-pagnola was the forger. However, I feel I have enough evi-dence to send Domenico's reputation to the gallows and my arguments will be elaborated at somewhat greater length elsewhere. That he was the culprit was first suggested by James Byam Shaw, and it became increasingly clear to me given the unexpected number of counterproofs of Domeni-co's prints, both engravings and woodcuts, some of which were very peculiar indeed. Without going into much detail, I can state that Domenico experimented for some time in taking counterproofs from early impressions of his prints; that he most probably printed some impressions of both engravings and woodcuts on specially sized (or otherwise treated) paper, which could help him to obtain particularly even, though faint, counterproofs; and that he experimented in masking off parts of the composition of woodcuts when taking counterproofs of them. This technique closely links these experimental counterproofs with those found by Peter Dreyer beneath the Titian 'drawings'. If one also takes into consideration Domenico's fame as a draughtsman in his own lifetime and the fact that few other artists could have been sufficiently versed in technical matters, close to Titian and skilled at drawing to produce such convincing forgeries, then the conclusion that Domenico was the forger must be close to the truth.

Whatever the identity of the forger, we must now accept, as a result of Peter Dreyer's discovery, that there are *no* known detailed preparatory drawings by Titian for his woodcuts. This is certainly in accordance with the known practice of the designer drawing directly on to the block and then collaborating with the cutter as Titian did this all his life, working with three or four cutters, but mostly with Gio-vanni Britto. Woodcuts, however, were not always the result of such a collaboration: apart from the very rare instances in which the designer cut the block himself, they were often, especially later in the century and, in particular, thanks to Boldrini's bad example, the work of cutters who were either copying another work of art, such as a drawing, painting or fresco, or putting together, at their fancy, details taken from many different sources. The difference in quality between original and reproductive woodcuts can best be seen in the two versions of Pordenone's *Marcus Curtius* (Cat.P36 and P37). Both, incidentally, are chiaroscuro woodcuts – that is to say, woodcuts obtained by printing two or more blocks, one on top of another. Some of the most outstanding exam-ples of this technique, which was introduced to Venice (and Italy) by Ugo da Carpi, are to be found in this exhibition in particularly fine impressions.

Most of the prints in the exhibition are shown in very early impressions, so that they can be seen as the artists conceived them, and not as they were when reprinted in later editions. This has necessarily involved the exclusion of many prints that could only be found in late impressions. But the final selection of prints for the exhibition was shaped above all by personal taste, with the intention of showing what I con-sider to be the most beautiful prints produced in Venice and the Veneto in the sixteenth century, irrespective of their his-torical interest, importance or influence. It is this that ac-counts for the decision not to show reproductive prints, to show very few prints by such artists as Farinati or Schiavone, and, above all, as many as possible by Jacopo de' Barbari and Giuseppe Scolari. I can only hope that the public will enjoy them as much as I did when I chose them.

The prints are arranged in chronological order. The following publications are referred to in abbreviated form:

A. Bartsch, *Le Peintre Graveur*, 21 vols., Vienna, 1803–21
A. M. Hind, *Early Italian Engravings*, 7 vols., London, 1938–48
D. Rosand and M. Muraro, *Titian and the Venetian Woodcut*, Washington, 1976

I. H. Shoemaker and E. Broun, *The Engravings of Marcantonio Raimondi*, Lawrence (Kansas), 1981

Other publications are listed in the general bibliography

Jacopo de' Barbari

Born Venice (?), active 1497 – the Netherlands before 1516

Very little is known about Jacopo's life. Although he is described in 1511 as an old and sick man, the earliest document connected with him, albeit indirectly, is the privilege (a sort of copyright) for the large *Bird's-eye View of Venice* (Cat. H1) granted to the printer Anton Kolb in 1500. Since it took three years to produce the map, it is likely that Jacopo was already working on it in 1497. In 1501 he was in Nuremberg, working as portrait and miniature painter to the Emperor Maximilian I, and several documents show that he was active in Germany between 1503 and 1505, under the patronage of Frederick the Wise of Saxony. He was probably in Frankfurt-an-der-Oder in 1508, painting for the court of the Elector Joachim I of Brandenburg. It is here proposed that before moving to the Netherlands, where he was first in the service of Philip of Burgundy and then in that of his grand-niece, the Archduchess Margaret, Regent of the Netherlands, he returned to Venice. A document of 1516 states that he was dead.

D.L.

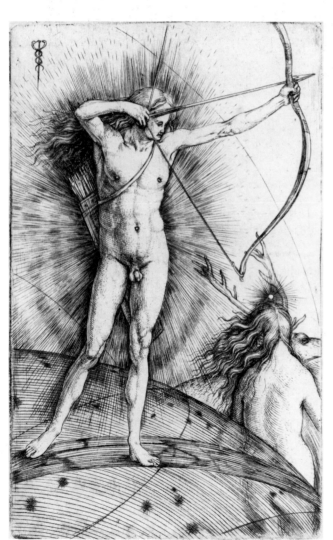

P1

P1

Apollo and Diana

160 × 100 mm Engraving (Hind V, 153, 14)
Signed with the caduceus
The Visitors of the Ashmolean Museum, Oxford

P2

Virgin and Child Reclining against a Tree

227 × 166 mm Engraving (Hind V, 150, 2)
Signed with the caduceus
Metropolitan Museum of Art, New York,
Harris Brisbane Dick Fund 1937

Both these prints are probably early works of Jacopo. None of his prints is dated, and their chronology has been totally re-arranged by each scholar who has written on the artist: the prints that seem obviously the earliest to some scholars are described by others as the most mature achievements.

It seems to me that there is a clear evolution in Jacopo's prints, both in technique and style. Starting from a print such as the *Victory Reclining Amid Trophies* (Hind V, 5), in which the hatching is spare, the lines rather thick and the cross-hatching very confused, he increasingly uses finer lines and more regular cross-hatching, as in this *Apollo and Diana* or, even more so, in the *Virgin and Child*. But although the development from print to print may seem clear, this is of very little help in dating them, for their style does not evolve as much as their technique (the idiosyncratic heads always droop on the elongated bodies), and so slight are the changes between one print and another that one might assume that they were all produced within a short period of time. The fact that some of them are found in a book bound in 1504, that they show a clear indebtedness to Venetian artists (particularly to Alvise Vivarini, who has recently been proposed as Jacopo's teacher), that Jacopo left Venice in the year 1500 and that Dürer copied some of Jacopo's prints in the first years of the sixteenth century, all lead to the conclusion that this rather large group of prints might have been produced in the last years of the fifteenth century in Venice.

The watermarks on these prints may give us more definite help. Hind listed the watermarks found on the paper used for Jacopo's prints, but did not feel they were conclusive evidence in determining whether a print had been produced south or north of the Alps. The use of watermarks for the purpose of dating is normally very complex, and in the case of Jacopo it has not always been wisely applied by art historians less accustomed to prints than Hind. This method can only help if, first, one can convincingly compare the watermark with others used by contemporary artists – for German paper was used in Italy and French paper in the Netherlands – and, second, if one can establish whether an impression with a particular watermark is early or late.

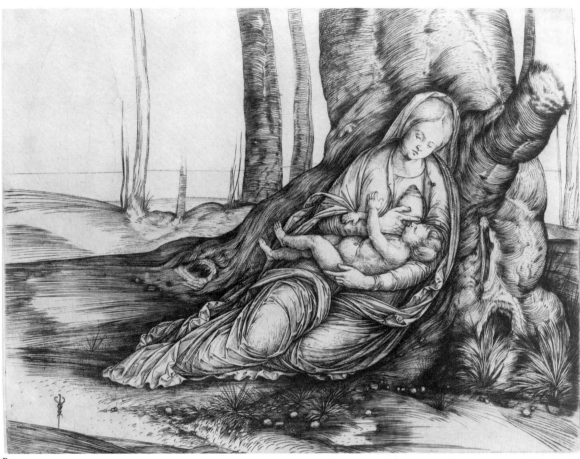

P2

For this group of prints, which includes 17 on Hind's list, I found that all the early impressions bear watermarks found on contemporary prints in Italy, and only later impressions are printed on paper with watermarks found exclusively north of the Alps. This is not surprising, for Jacopo retained most of the plates himself – they were in the Archduchess Margaret's possession after his death – and probably printed new impressions from them during his travels. For instance, early impressions of this *Virgin and Child Reclining against a Tree* are printed on paper with an Ox Head watermark found on Italian prints by Mantegna, Giovanni Antonio da Brescia and others, while late impressions are found on paper with a Gothic P and Flower watermark, which I have never seen used in Italy, but often in the Netherlands; Jacopo used it there for early impressions of *The Guardian Angel* (Cat. P4).

D.L.

P3

Head of a Woman

337 × 260 mm
Engraving (Hind V, 158,30)
Metropolitan Museum of Art, New York,
Harris Brisbane Dick Fund 1925

This is the only large engraving by Jacopo; stylistically it is close to the two preceding prints. It is not signed, and its attribution, though generally accepted, has been questioned. Even allowing for its exceptionally large scale, which must have been a new experience for Jacopo, the unusually hard face of the woman and the somewhat insensitive cross-hatching are perplexing.

The answer may be that the plate was reworked by a later hand: all the impressions known to me are pulled from a reworked and damaged plate. Jacopo might have started it in Venice and taken it to Nuremberg when he went there in April 1500. The example exhibited here seems to be a very early impression from the reworked plate, the lines richly inked and showing little sign of wear; it is, however, printed on paper with a Nuremberg Coat of Arms watermark (similar to Meder no. 210), which is, in my experience, found only on Dürer prints or Nuremberg woodcuts printed around 1540 to 1560. The discrepancy clearly visible in very late impressions – always printed on Nuremberg paper (Munich and Louvre, Paris) – between the original work on the face, now faint, and the reworked hair reinforces the hypothesis of a substantial gap in time between Jacopo's engraving of the plate and the intervention of another hand.

D.L.

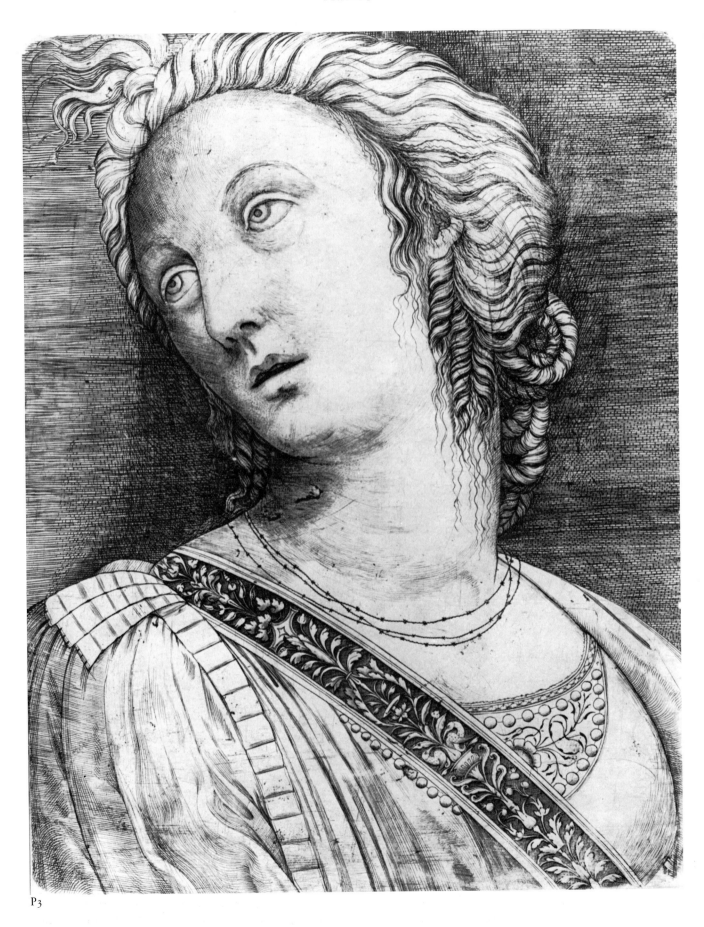

P3

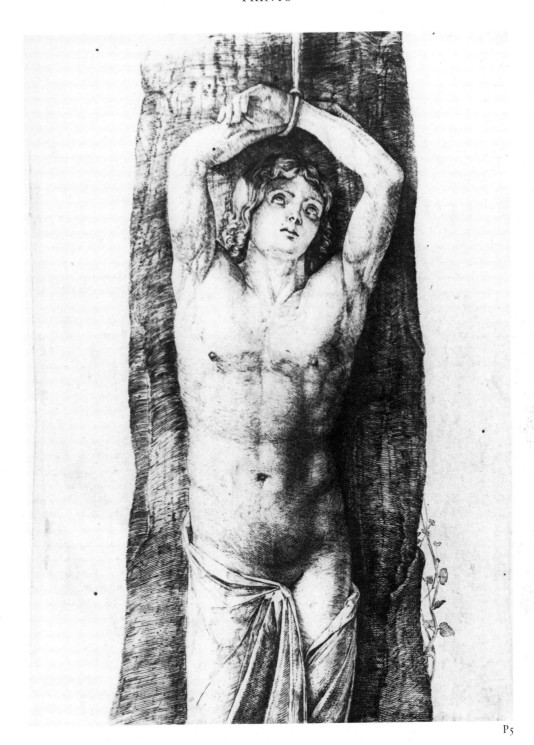

P5

P4 & P5
The Guardian Angel

224 × 159 mm Engraving (Hind V, 152, 12)
Signed with the caduceus
Rijksprentenkabinett, Rijksmuseum, Amsterdam

St. Sebastian

212 × 151 mm Engraving (Hind V, 152, 9)
Whitworth Art Gallery, University of Manchester

These two prints belong to the rather small group of
Jacopo's later engravings. Their technique is most refined,
achieving a rare subtlety in the rendering of tonal values
through a dense and regular web of cross-hatching. Like the
other prints in this group, the impressions are all printed
on paper used in the Low Countries and they were probably
engraved there.

Their style is quite different from the prints of the early
group: they show stocky figures with large, round heads.
A mixture of influences is visible: the body types are close
to those of Jan Gossart (Mabuse), while the greater
modelling of the heads and new treatment of beards is like

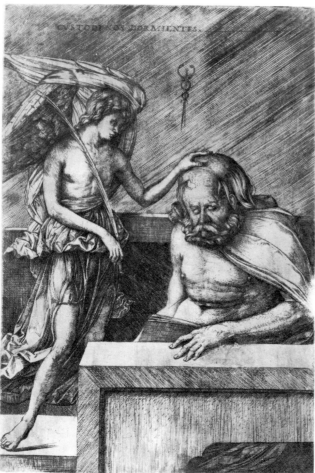

P4

that of Venetian artists such as Giorgione and Bellini (the latter in his *Baptism* in S. Corona, Vicenza, or the *San Zaccaria Altarpiece*, Venice). In fact *The Guardian Angel* is very close, in reverse, to the St. John in the Vicenza altarpiece. But these works were all painted after Jacopo had left Venice in 1500. He must have returned there, which would have been normal for a Venetian who had been working abroad for eight years.

There are no documents relating to Jacopo in 1508 and 1509, but if he had been in Venice during those years a subsequent change of style would not be surprising; Mabuse's influence could be explained by the close relationship which developed between the two artists soon afterwards, but before the prints were engraved. Mabuse was in Italy in 1508, following Count Philip of Burgundy on a diplomatic mission and making drawings after the antique for him, and there were frequent contacts between members of the mission (such as Father Lucas de Reynaldes or the doctor, Liberale da Treviso) and the Venetian Senate as we know from Marin Sanuto's *Diaries*. It is possible that Jacopo went from Venice to the Netherlands with the Count and Mabuse, since the two artists are known to have been engaged on the frescoes of the palace of Suytborg soon after the Count's return home.

D.L.

Girolamo Mocetto

Murano *c.* 1450 – Venice *c.* 1531

Mocetto was born into a family of glass painters in Murano in the 1450s; he married in Venice in 1494, and in 1507 was probably helping Bellini to complete the paintings for the Sala del Maggior Consiglio that had been left unfinished by Alvise Vivarini. Recorded as being in Venice in 1514 and in Verona in 1517, Mocetto made his will in Venice in 1531.

D.L.

P6

Virgin and Child Enthroned with Saints and Angels

492 × 362 mm Engraving (Hind, v, 168, 16, II)
Signed bottom centre: HIERO·M (reversed)
Bibliothèque Nationale, Paris

It is unlikely, as has often been suggested, that this print is a record of a lost altarpiece by Bellini. Though strongly Bellinesque in character, and probably engraved *c.* 1505–10, it borrows elements from several contemporary paintings, as do most of Mocetto's prints. In this case the main sources are Bellini's *San Giobbe Altarpiece* and *San Zaccaria Altarpiece*, and Cima's *Virgin and Child Enthroned with Saints* in Parma. The mixture of elements derived from Bellini and Cima is a kind of trademark in Mocetto's work of this period, as shown by his *Baptism* (Hind 14), which combines Bellini's *Baptism* (Vicenza) with Cima's painting of the same subject in S. Giovanni in Bragora, Venice. Strictly 'reproductive' prints are unlikely to have been produced in Venice for at least another decade, if not longer.

D.L.

Giulio Campagnola and Domenico Campagnola

[Giulio: biography on p. 250]
[Domenico: biography on p. 324]

P7

Shepherds in a Landscape

135 × 257 mm Engraving (Hind v, 196, 6)
Rijksprentenkabinett, Rijksmuseum, Amsterdam

Despite the objections of scholars such as Petrucci and Oberhuber, Hind's chronology of Giulio's prints based on strictly technical grounds is, in my view, brilliant and inescapable. The prints develop from pure line engravings – stylistically indebted to Mantegna and Dürer – to

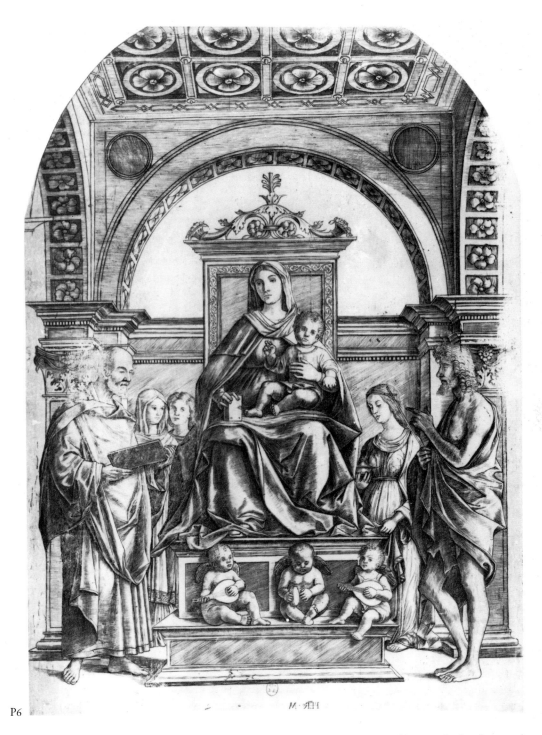

P6

engravings obtained only with dots – obviously close to Giorgione and early Titian. Some incongruities, noted by Hind and discussed at length by his critics, can, I believe, be explained by the fact that Giulio, an experimental engraver, may have left many prints unfinished, only to take them up again at a later date. This might be the case with *The Old Shepherd* (Cat. P8; Hind 8), the *St. John the Baptist* (Cat. P10; Hind 12) and *The Astrologer* (Cat. P9; Hind 9). Apart from the *St. Jerome* (Hind 7), this *Shepherds in a Landscape* is possibly the only print that Giulio left unfinished and did not work on at a later date. He first engraved the landscape and printed it by itself (there is a

contemporary copy showing the landscape alone), then abandoned it, probably because he was unhappy with it – not because he died, as believed by most scholars.

It is a print in Giulio's early style; that he was not satisfied with it can be appreciated by comparing it with the beautiful preparatory drawing in the Louvre. This drawing is pricked for transfer all over (not, as most writers seem to think, only in the landscape); evidently Giulio thought of transferring the whole composition. Left in the studio, the plate was completed by Domenico Campagnola soon after the death of his adopted father, Giulio, *c.* 1517.

D.L.

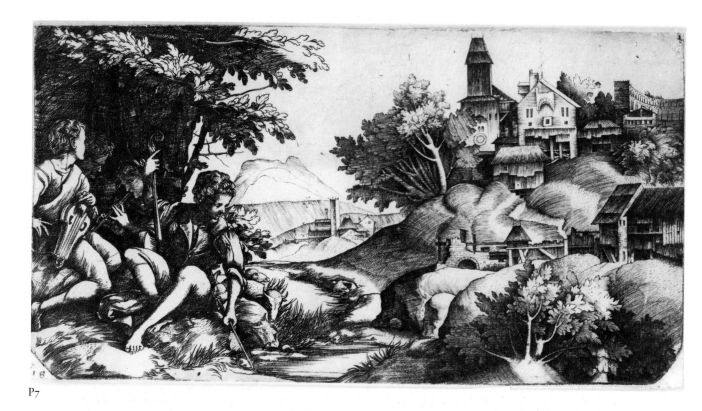

P7

Giulio Campagnola

[Biography on p. 250]

P8
The Old Shepherd

79 × 133 mm Engraving and stipple-engraving (Hind v, 197, 8, II)
Signed top right with monogram: IC
The Visitors of the Ashmolean Museum, Oxford

This impression is in the second state, after the plate was reworked in the dotted manner. These dots were almost certainly obtained with the point of the graver and not with a tool similar to a goldsmith's punch as has often been suggested; in all Giulio's prints the dots, when magnified, can be seen to be different in size one from another, to have an overall triangular or trapezoidal shape, and to have produced some burr in the early impressions, all characteristics that are compatible only with a graver.

Only one impression of the first state survives (Bibliothèque Nationale, Paris). It reveals two important facts. First, it is a late impression, the lines being worn, which proves that the print cannot be a working proof and that it must have been made well before being re-engraved in the dotted manner. This explains the indebtedness to Dürer that has puzzled many scholars. Second, it lacks the monogram used in the second state, which is found in this form only on first-state impressions of *The Astrologer* (Cat. P9); the implication is that the second state of *The Old Shepherd* and the first state of *The Astrologer* are contemporaneous, dating from *c.* 1509.

D.L.

P9
The Astrologer

99 × 152 mm Engraving and stipple-engraving (Hind v, 198, 9, II)
Dated: *1509*
The Trustees of the British Museum, London

The only dated print by Giulio, *The Astrologer* provides the one sure reference to his style during Giorgione's lifetime. Its first state, in pure line, bears the same monogram found on the second state of *The Old Shepherd* (Cat. P8) which is in the dotted manner; this might mean that the two states of *The Astrologer* were produced quite close together. This could only be true if the one surviving impression of the first state (in West Berlin), which I have not myself been able to examine, is a working proof and shows no sign of wear, and if its monogram can be proved to have been cancelled from the plate, rather than disappearing through wear, as Hind seems to imply.

Whatever conclusion can be drawn from the Berlin impression, it seems to me that most prints by Giulio in the dotted manner, whether old plates reworked or new ones made only of dots, show a clear stylistic affinity to *The Astrologer* and could easily have been produced in a very short period around 1509.

D.L.

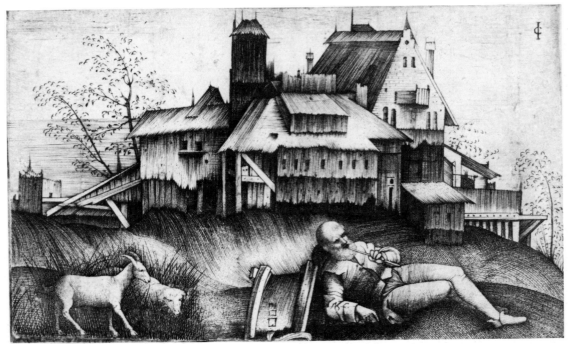

P8

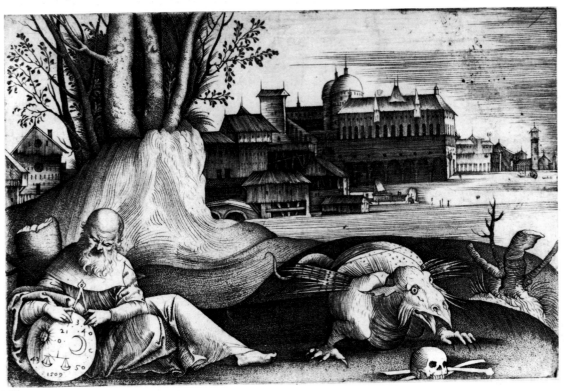

P9

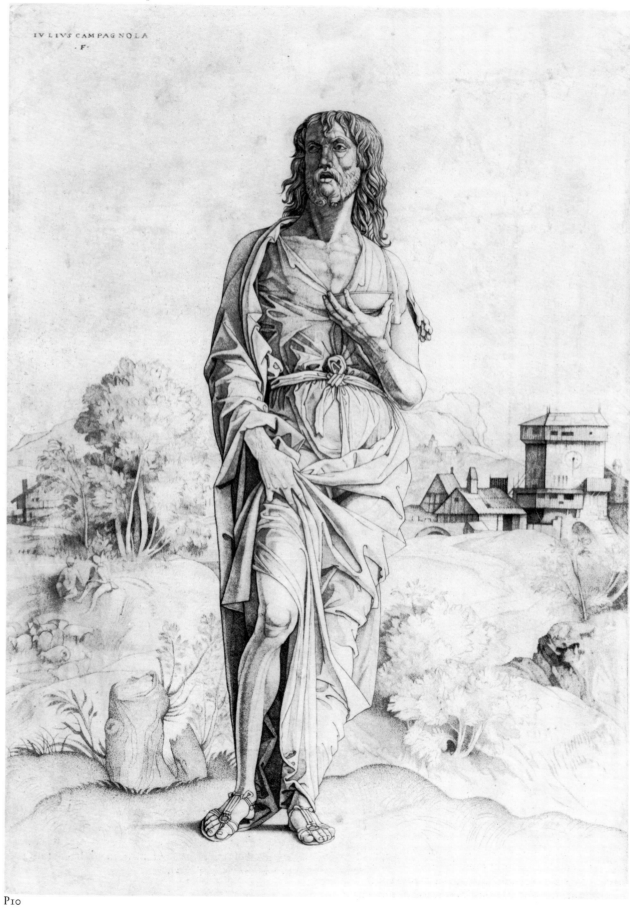

P10

PIO
St. John the Baptist

351 × 240 mm Engraving and stipple-engraving (Hind v, 201, 12)
Signed top left: IVLIVS CAMPAGNOLA / ·F·
The Trustees of the British Museum, London

Giulio probably used a drawing by Mantegna for the figure
of the saint, as Mocetto had done for his print (Hind 9).
The very Mantegnesque character of the figure strongly
contrasts with the Giorgionesque style of the landscape, an
oddity which could be explained, as it has been explained
for other prints by Giulio in this catalogue, by the
possibility that he started this engraving when young and
under the influence of the Mantuan master (I believe he
actually went to Mantua to be taught by Mantegna),
abandoned it for a few years and then returned to it
towards the end of the first decade of the century, after he
had invented the stipple technique.

This can be argued on two counts. First, this is the only
large print by Giulio, and in this respect has no relation to
his later works, whereas it is close to late fifteenth-century
Mantuan prints; the size itself might have been a good
reason for leaving the print unfinished. Second, and even
more conclusive, is the comparison with the preparatory
drawing in the Louvre which shows that the figure was first
outlined on the sheet with great care and that nothing at
all was drawn inside this outline. But a very fine and
detailed landscape was added around it with the point of
a brush, and a later hand completed the figure. The
landscape, which has often been proposed as a work by
Giorgione himself, was very carefully pricked for transfer
up to the outline of the figure. It seems obvious that Giulio
had already finished the figure and had probably already
engraved it, and that he therefore drew only the landscape
around it in order to transfer it and complete the plate. It
seems very unlikely that he would have gone to Giorgione
with a silhouette on a sheet of paper, asking him to add the
landscape, unless his relation with Giorgione was far closer
than we can possibly envisage from the evidence we have.

Most known impressions of this print were probably
printed in the second half of the sixteenth century, for they
bear the signature of a printer of the late 1560s. This
impression, though cut, is printed on a sheet with a late
fifteenth-century watermark and it is probably early.

D.L.

PII
The Young Shepherd

135 × 78 mm Engraving and stipple-engraving
(Hind v, 199, 10, II)
Staatliche Graphische Sammlung, Munich

This very fine impression of the second state, with dots
added with a burin, shows that Giulio not only dedicated
himself to inventing new techniques in order to achieve
more refined tonal effects, but also experimented at the
stage of printing the plate. In this impression he left a light

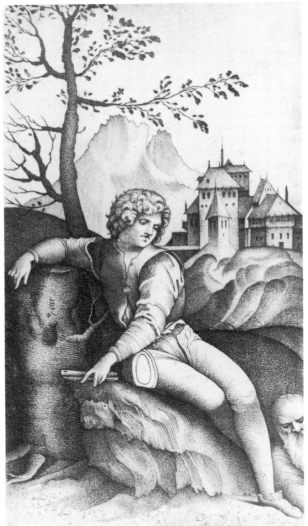

PII

surface tone in the background landscape and sky (obtained
by leaving on the plate the thin film of grease and ink
produced while preparing it for printing), but carefully
wiped the boy's arms and legs clean so that they would be
highlighted.

D.L.

PI2
Venus Reclining in a Landscape

112 × 159 mm Stipple-engraving (Hind v, 202, 13)
The Trustees of the British Museum, London

Composed entirely of dots, this must be one of Giulio's last
prints in the group considered here. Though obviously
Giorgionesque, it does not relate to any of Giorgione's
works. As with the *St. John the Baptist* and *The Young
Shepherd* (Cat. PIO and PII), I feel that this *Venus* cannot
be a copy of a Giorgione painting or drawing but that it
shows instead that artist's overpowering influence on
contemporary Venetian art.

D.L.

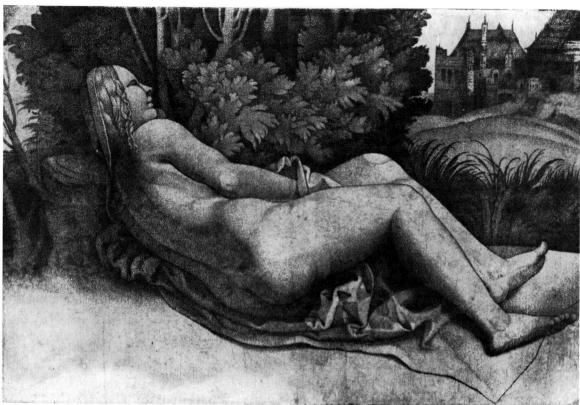

P12

Marcantonio Raimondi

Argini (?) *c.* 1480 – before 1534

Probably born near Bologna and trained in the studio of
Francesco Francia, Marcantonio is praised as a master in
the art of engraving in a sonnet of 1504. He was in Venice
in 1506 and Vasari recounted the story of his troubles with
Dürer, whose series of woodcuts of *The Life of the Virgin*
he had copied in engraving, a dispute settled only when
Marcantonio agreed to sign the subsequent prints with his
own monogram and not with that of the German.

Around 1508 Marcantonio went via Florence to Rome
and soon became associated with Raphael, who portrayed
him as a bearer of the papal chair in *The Expulsion of
Heliodorus* fresco of 1512. In 1524 he was imprisoned for
having engraved a series of erotic prints drawn by Giulio
Romano which were accompanied by Aretino's licentious
sonnets, but he was apparently released a few months later.
According to Vasari he had to ransom himself from the
Spanish invaders during the Sack of Rome in 1527 and was
left penniless. He is supposed to have gone back to Bologna,
where he must have died before 1534, for in Aretino's *La
Cortigiana* he is said to be dead.

D.L.

P13

Venus Wringing her Hair

210 × 137 mm Engraving (Bartsch XIV, 234, 312;
Shoemaker and Broun 68, 9)
Signed in the tablet with monogram: MAF; dated *1506 S.ii*
(September 11, 1506)
The Trustees of the British Museum, London

This must be one of the earliest prints Marcantonio
engraved in Venice after completing his copies of Dürer's
The Life of the Virgin. It is dated early September 1506; if
we accept that Dürer took his series of woodcuts to Venice
late in 1505, it is likely that Marcantonio spent most of the
following year making the copies. Of the 17 subjects he
copied, only one (Bartsch 637) bears Marcantonio's
monogram; this fits well with Vasari's account of the story
if we take it that this exception was the last of the series,
engraved with Marcantonio's signature to appease Dürer in
the quarrel over the plagiarism of his famous monogram.
Excluding those copies Marcantonio might have made
before his arrival in Venice, this would imply that some 22
monogrammed copies predate the last plate of *The Life of
the Virgin*. One such copy, the *St. John the Evangelist and
St. Jerome* (Bartsch 643) is dated *1506.A.1.* (either April or
August 1506).

An independent composition, the *Cupid and Three Putti* (Bartsch 320) is dated 18 September 1506, a week after the completion of this *Venus Wringing her Hair*. It must have taken more than a week to engrave each plate of *The Life of the Virgin*, since they are all substantially larger than the *Cupid and Three Putti* and would have required the reversal of the drawing to produce a result in the same direction as the Dürer originals. So Marcantonio is likely to have spent most of 1506 making copies of Dürer prints, and it is possible that that this very Düreresque, though fully Venetian, *Venus* was the first independent composition he produced in Venice.

D.L.

P14
Young Man Protected by Fortune (?)

147 × 91 mm Engraving
(Bartsch XIV, 286, 377; Shoemaker and Broun, 72, 11)
Signed on the globe with monogram: MAF
Graphische Sammlung Albertina, Vienna

The subject of this print has never been satisfactorily explained, and even in Raimondi's time it might have been

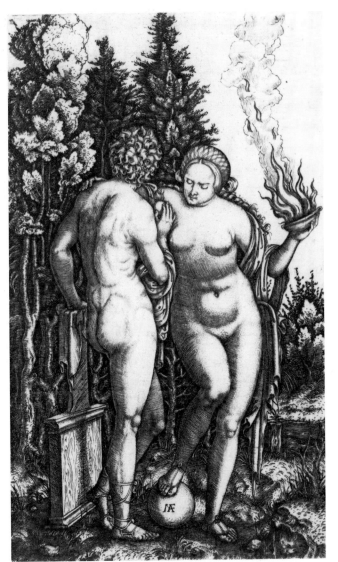

P14

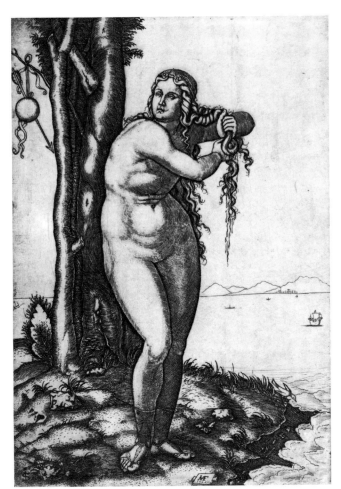

P13

clear only to the refined Venetian collectors for whom it was probably engraved. The mystery of its meaning, its small scale and the search for a rich tonal quality (only seen in early impressions such as this) connect this print with the contemporary works of Giulio Campagnola. The background, as pointed out by Innis Shoemaker, is very Düreresque and recalls in particular the woodcuts of *The Life of the Virgin* that Marcantonio had copied in Venice, while the technique is still reminiscent of his Bolognese prints.

The very Venetian beauty of Fortune must have deeply offended the decorous nature of Pope Leo XII, since in 1823 he had the plate – together with hundreds of other Renaissance prints of nudes – scored through in what must be one of the most extraordinary cases of censorship in the history of prints, if not of art.

D.L.

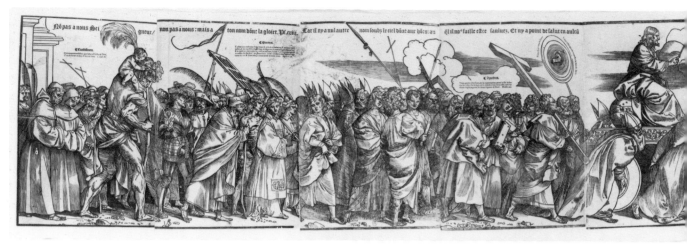

P16

P15
'The Dream of Raphael'

237 × 334 mm Engraving
(Bartsch XIV, 274, 359; Shoemaker and Broun, 74, 12)
Signed at the bottom of the pilaster, centre left, with monogram:
MAF
Graphische Sammlung Albertina, Vienna

This so-called *Dream of Raphael* is the first depiction of a dream in an Italian print and the first attempt to engrave a night scene; it shows how skilful Marcantonio had become during his Venetian stay. The refinement of the tonal passages, the contrast between the deepest black, obtained with fine, dense hatching, and the white of the paper, the varied shades of darkness in the clouds and the very successful rendering of the reflections on the water

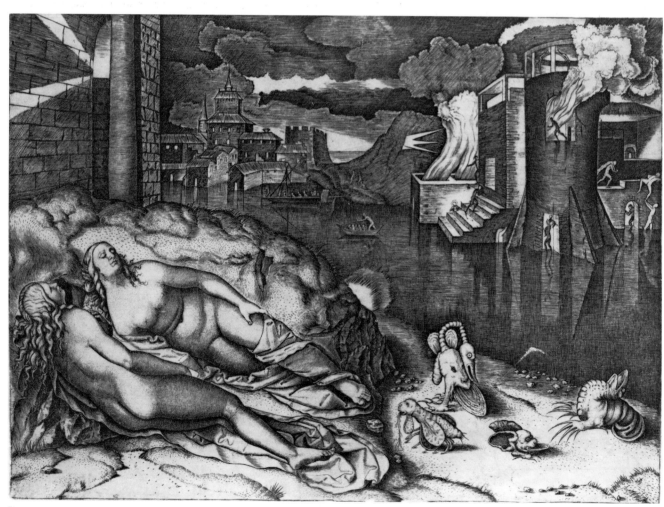

P15

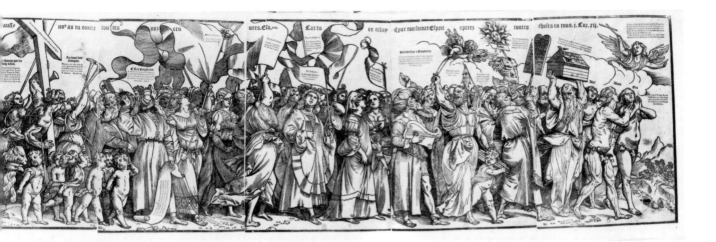

demonstrate how instructive the copying of Dürer's prints had been to Marcantonio's technique.

The richness of texture of this early impression might indicate that it was intended as a demonstration of Marcantonio's mastery of line engraving to rival Giulio Campagnola's stipple-engraving. This explanation seems more plausible if the print is compared to Giulio's *Venus Reclining in a Landscape* (Cat. P12); the figure in Giulio's print is very similar to that of the woman in the foreground here.

On the other hand, there are sufficient differences in the pose of the two figures to make it unlikely, in my view, that they are both copies of a lost work by Giorgione, as has been suggested. If a source is needed, one must look much further afield; the combination of a night scene, a burning town and small monsters are the trademark of Hieronymous Bosch, some of whose paintings (such as *The Martyrdom of St. Julia*, the shutters with *The Blessed* and *The Damned* and the altarpiece of the *Hermit Saints*, all of them incorporating these elements) were probably already in Venice. It is thus probable that Marcantonio put Giorgionesque figures in a Bosch-like landscape to show off his ability, and that the idea of reproducing another work of art, which so haunts art historians today, was far from his mind.

D.L.

Titian and an Anonymous Cutter

P16
The Triumph of Christ

385 × 2680 mm Woodcut from ten blocks
(Rosand and Muraro 1)
Inscribed along the top: *Nō pas a nous Seigneur / non pas a nous: mais a ton nom dōne la gloire. Ps. cxiij. Car il ny a nul aultre nom soubz le ciel dōne aux hōes: au q̄l no faille estre saluez. Et ny a point de salut en aulcū (aultre. Act, iiij.) Et aussy no as tu ouure toutes nos oeuures. Esa, xxvj. Car tu es celuy q par ton Sainct Esprit operez toutes choses en tous. j. Cor. xij.*
Bibliothèque Nationale, Paris

The original of this very popular woodcut, which was copied several times, is known only from later impressions, such as the one exhibited here, printed in Antwerp around 1547. The first edition was issued either in 1508, as stated by Vasari, or around 1510/12 as most scholars now seem to believe; the point is not entirely academic because a polemic about the precedence of Titian over Raphael, or vice-versa, centres around it.

In the woodcut the figures of both St. Christopher and the Good Thief carrying the cross seem to be based on a figure in Michelangelo's lost cartoon of *The Battle of Cascina*, drawn copies of which were circulating in Italy at the time. Titian's figures, although related to Michelangelo's, are not, in my opinion, very close to it; they are much closer to a *Standard-Bearer* engraved by Marcantonio (Bartsch XIV, 357, 481). The crux of the problem is whether Marcantonio's print is after Titian's woodcut or after a lost drawing by Raphael – in other words, whether this type of figure, inspired by Michelangelo's cartoon, was conceived by the Venetian or the Umbrian, who was in Florence in 1508. I will not risk an opinion in this Raphael centenary year, in which several great experts in the field will publish their conclusions, and will add only that it should be borne in mind that Marcantonio's figure is facing in the same direction as Titian's and that we know that Marcantonio, when in Venice, had copied Dürer's woodcuts without reversing them.

Moreover, there is a drawing in Rome, attributed by Petrucci to Marcantonio, which shows the same figure reversed. Whether by Marcantonio or not, this drawing must be either a preparatory drawing for the engraving or a copy of such a drawing; on close examination it is evident that part of the outline is a tracing of Titian's figure and that where the model is not followed the drawing becomes much weaker. This would seem to exclude the possibility that the drawing in Rome is a copy of a lost study by Raphael, while it would naturally place it between Titian's woodcut and Marcantonio's engraving.

D.L.

PI7

Giulio Campagnola and Ugo da Carpi

PI7
The Sacrifice of Abraham

790 × 1065 mm
Woodcut from four blocks (Rosand and Muraro 3)
Signed on a leaf at the bottom left of the top right block : UGO ;
inscribed in the tablet top right : *In Venetia per Ugo da carpi /
Stampata per Bernardino/benalio : Cū privilegio [con]cesso/per lo
Illustrissimo Senato./Sul cāpo de san Stephano.*
Staatliche Museen Kupferstichkabinett und Sammlung der
Zeichnungen, East Berlin

The print is listed in the publisher Bernardino Benalio's privilege of February 1515 and his name, together with that of Ugo da Carpi, appears in the tablet on this, the only known impression of the first state.

The attribution of the woodcut to Titian has been based on its relationship to a drawing in New York, which, as pointed out by Dreyer, is certainly a forgery (see p. 305), and on the presence of Titian's name in the tablet, which, however, occurs only in the third state printed decades later. Whatever date is given to the print (those proposed range between 1508 and 1518), there is no work by Titian that can convincingly be compared with it ; the composition is unbalanced, the figures are too static and their faces idiosyncratic and utterly different to those of Titian, the borrowings from Dürer in the landscape are too many and too literal. But the most obvious reason for rejecting Titian's authorship for this woodcut is the total dissimilarity between it and the magnificent *Submersion of Pharaoh's Army in the Red Sea* (Cat. PI9), an undoubted autograph work.

Nor are the attributions of this *Sacrifice of Abraham* to Palma Vecchio or Aspertini convincing. However, an attribution to Giulio Campagnola, whose name has never before been connected with a woodcut, might, in the view of the present writer, be a better guess. We know very little of Giulio's activity after *c.* 1510; the only document referring to him after that date links him with the greatest printer of the age, Aldo Manuzio, who, in his will of January 1515, left dispositions for Giulio to finish cutting the celebrated italic type Aldo had invented. Book publishers were closely connected with the production and sale of woodcuts, and it is possible that Giulio was also responsible for two of the woodcut illustrations to the *Apocalypsis Ihesu Christi* printed by Paganini in 1515/16, which are stylistically very close to the figures in *The Sacrifice of Abraham*. The three foreground figures in *The Sacrifice* appear in reverse in a drawing in the Louvre, but I do not believe it to be, as Dreyer proposed, by the same hand as the forger of the Titian drawings, here identified as Domenico Campagnola. The Louvre drawing is closer to the preparatory drawing for Giulio's engraving of the *Shepherds in a Landscape* (Cat. P7) and to *The Viola Player* in the Ecole des Beaux-Arts, Paris, which is unanimously attributed to Giulio.

If we accept the attribution of these woodcuts to Giulio, many other peculiarities could be explained: the borrowing from various prints by Dürer for the background of this *Sacrifice*, a typical feature of Giulio's work; the fact that Domenico, the adopted son of Giulio, had a hand in two other, much less successful, illustrations to the *Apocalypsis Ihesu Christi*; and the intriguing possibility that Domenico had access to the blocks of *The Sacrifice*, which he used to forge the so-called Titian drawing in the Metropolitan Museum of Art, New York, a crime of which he is accused in this catalogue.

D.L.

Titian and Ugo da Carpi

PI8

St. Jerome

156 × 96 mm
Chiaroscuro woodcut from two blocks, greenish-grey and black
(Rosand and Muraro 6)

PI8

Signed centre left: TICIANVS; bottom right: VGO
The Trustees of the British Museum, London

Most scholars agree that this woodcut is Ugo's first attempt at chiaroscuro, and that it should therefore be dated around 1516, when he applied for a copyright for the invention of this technique, which had, however, been invented in Germany about ten years earlier. It is certainly likely that the foremost contemporary painter was asked to share the glory of the first example in the new medium, and this might justify the almost excessive prominence given to the names. A much better effect was obtained when the names were printed in a very diluted ink (much lighter than the ink used for the rest of the key block), as in the early impressions in the Louvre and the Estense Library, Parma, which must have been experiments.

D.L.

Titian and an Anonymous Cutter

PI9

The Submersion of Pharaoh's Army in the Red Sea

1225 × 2215 mm Woodcut from twelve blocks
(Rosand and Muraro 4)
Inscribed in the tablet bottom right:
La crudel persecuzione del ostinato Re, contro il populo tanto da Dio/amato, Con la sommersione di esso Pharaone goloso dil inocente / sangue. Disegnata per mano dil grande, et immortal Titiano. / In Venetia, p[er] domeneco dalle greche depentore Venitiano. / M.DXLIX
The Trustees of the British Museum, London

Arguably the greatest woodcut ever made, *The Submersion of Pharaoh's Army in the Red Sea* is mentioned in Benalio's application for a privilege to the Venetian Senate of February 1515, but it is known only in later impressions, printed by Domenico dalle Greche in 1549. It is also the largest Venetian figurative woodcut, Titian's extraordinary extrapolation from the monumentality of Jacopo de' Barbari's *Triumph of Men over Satyrs* (fig. 25) and his own *Triumph of Christ* (Cat. PI6). The forerunner of all the large woodcuts shown here, its enormous size probably relates it very closely to *The Battle of Spoleto* (see Cat. D72) on which Titian was starting work at this time. As rightly pointed out by Siegfried and Oberhuber, this print became the natural outlet for the artist's ideas and studies for the large painting for the Sala del Gran Consiglio in the Doge's Palace, the commission for which seemed more than once in jeopardy between 1513 and 1516.

D.L.

P19

P20

Domenico Campagnola

Venice (?) *c.* 1500 – Padua after 1552

The son of a German artisan, Domenico was probably born in Venice and trained by his adoptive father, Giulio Campagnola. While still young, following Giulio's example, he turned his hand to painting, drawing, engraving and woodcutting and acquired great proficiency in all these media. After Giulio's death in about 1516, Domenico became for a few years Venice's foremost engraver, and his experiments at cutting woodblocks himself (rather than employing a professional woodcutter) were, albeit unsuccessful, very daring.

Domenico was a gifted draughtsman and also specialized in drawing landscapes, which were celebrated by his contemporaries and which he continued to produce all his life, selling them as finished compositions. His knowledge of the roller press (which he had used for printing his engravings), and of the flat press (used for woodcuts), and his expert draughtsmanship no doubt proved very useful for the forging of a group of Titian drawings intended to look like preparatory drawings for woodcuts. These forgeries might have been produced on one of Domenico's many trips to Venice, or even in the more secure tranquillity of Padua,

where he may have moved as early as 1520. He spent the rest of his life there as the city's busiest and most praised painter, although the reason for the praise escapes us today.

D.L.

P20

Landscape with Two Trees and a Group of Buildings

127 × 171 mm Engraving (Hind v, 214, 14)
Boymans-van Beuningen Museum, Rotterdam

Tentatively attributed to Domenico by Hind, this is probably one of the artist's first attempts at engraving. It shows an evident indebtedness to Giulio's landscapes, without sharing their refined technique, and might be considered the link between the still very crude *Youth Seated Contemplating a Skull* (catalogued by Hind as possibly by Giulio, Hind 20) and the signed *Venus Reclining in a Landscape* (Cat. P12; Hind 13) dated 1517. It should therefore be dated earlier.

D.L.

P21

Battle of Naked Men

218 × 226 mm Engraving (Hind V, 211, 4)
Signed and dated bottom left: DOMINICUS / CĀPAGNOLA / ·1517·
Bibliothèque Nationale, Paris

Although inspired by such examples as Titian's woodcut of
The Submersion of Pharaoh's Army in the Red Sea (Cat.
P19), Leonardo's *Battle of Anghiari* or Michelangelo's
Battle of Cascina, drawn copies of which were apparently
circulating widely in Italy at the time, Domenico's
treatment of the battle is confused and confusing, and it is
very difficult to make sense of the entanglement of bodies
and horses. The very tight cross-hatching and the
predominantly dark background of interlacing trees are also
to be found in Domenico's contemporary woodcut designs,
especially in those he is supposed to have cut himself.

D.L.

P22

The Assumption of the Virgin

284 × 198 mm Engraving (Hind V, 212, 3, 1)
Signed and dated bottom right:
DOMINICUS / CAMPA / GNOLA / 1517
The Trustees of the British Museum, London

This, Domenico's largest and most ambitious engraving, is
thought to reproduce an early idea by Titian for his
Assumption of the Virgin in the Frari, which was not
completed until the next year. Though prone to copying,
and probably even forging the great master's works (see
p. 305), I do not think that Domenico actually reproduced
any of them in his prints, for there is no direct correlation
between any of his prints and a Titian painting or drawing
– or, for that matter, any other known model.

D.L.

P21

P22

P23

St. Jerome

127 × 97 mm Engraving Hind v, 213, 10)
Signed top left: DOMINICUS / ·CAMP·; dated bottom left *1517*
Museum of Fine Arts, Boston, Harvey D. Parker Collection

This is Domenico's most successful engraving; it shows his freest and most daring use of line. It should be compared with *The Vision of St. Augustine* (Cat. P24), a woodcut of similar dimensions probably cut by Domenico himself at the same time as this engraving. Seeing them side by side is most instructive; the image of the woodcut is more sharply defined than that of the engraving, the line is thicker, blacker, and more contrasted to the whiteness of the paper.

D.L.

P24

The Vision of St. Augustine

148 × 103 mm Woodcut (Rosand and Muraro 19)
Signed bottom left: .DO. CDO. CĀP.
The Trustees of the British Museum, London

Only one impression survives of this beautiful woodcut, Domenico's masterpiece in the medium. As the Tietzes first proposed and Rosand and Muraro confirmed, the artist probably cut the block himself, for such a freedom and energy is found in none of his other woodcuts, and certainly not in those signed by a professional cutter, such as Lucantonio degli Uberti. Together with the engraved *St. Jerome* (Cat. P23), it can be regarded as an enthusiastic, if

P23

P24

short-lived, response to Titian's woodcut of *St. Jerome* cut by Ugo da Carpi (Cat. P18), which had probably appeared a year earlier, in 1516.

D.L.

P25
Sacra Conversazione in a Landscape

320 × 457 mm Woodcut (Rosand and Muraro 18)
Signed and dated bottom right:
DOMINICUS / CAMPAGNOLA / .M.D. XVII.
Bibliothèque Nationale, Paris

1517 must have been Domenico's busiest year: all his dated engravings, except for one inscribed 1518, and all his dated woodcuts belong to that year, and those which are not dated can be confidently assigned to the same year on the basis of their style. It is quite a prodigious output, even for a young man aged 17.

The 13 engravings are mostly small, but a few are fairly large and very complex, and each must have taken an average of at least a week to engrave if one goes by two Marcantonio engravings of similar size, one dated 11 September, the other 18 September, 1506 (Bartsch 312, Cat. P13; Bartsch 320). If one also takes into account the time needed to print the engraved plates, a task certainly undertaken by Domenico himself – probably on the roller press he inherited from Giulio (for a printer or publisher would only have a flat press) – the production of these engravings must have occupied him for a third, or more probably half, of the year.

But he also found time for woodcuts: as we have noticed with *The Vision of St. Augustine* (Cat. P24), it seems most unlikely that a professional woodcutter would have produced blocks whose lines are so free and full of energy. The fact that Domenico was so young might also suggest that he would have tried to cut the blocks himself, either by choice or necessity. But this job takes a very long time, especially for an unskilled and inexperienced cutter, since every white area has to be painstakingly cut out from the block. Just how painstakingly can be seen in this woodcut, which was surely cut by Domenico himself; the dense cross-hatching must have taken weeks of hard work gouging the tiny white squares, one by one, between the crossing lines. Domenico went through the same laborious process for his *Christ Healing the Leper*, only known in the impression in the Bibliothèque Nationale, Paris, but probably abandoned cutting his own blocks because, as in this example, they failed to print satisfactorily.

D.L.

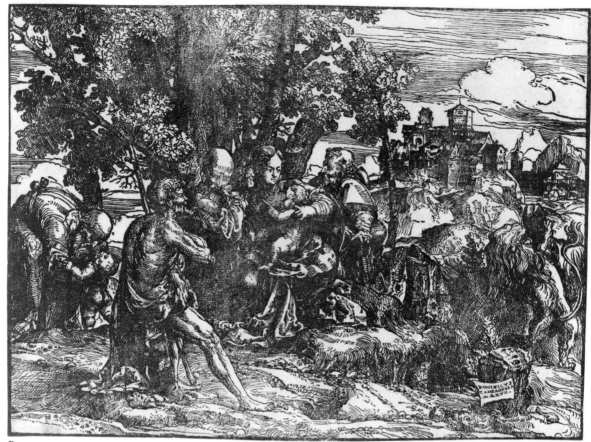

P25

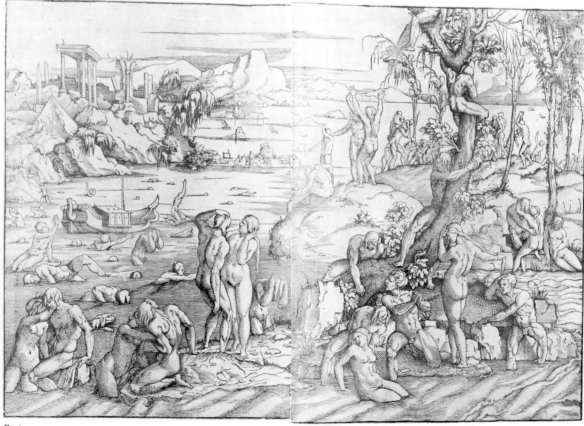

P26

Jan van Scorel

Schorel 1495 – Utrecht 1562

A Dutch artist, Jan van Scorel started a pilgrimage that was to take him eventually to Jerusalem by visiting Jan Gossart (Mabuse), Jacopo de' Barbari's great friend; he then proceeded via Basle and the Danube region to Nuremberg, and having stopped in Carinthia to paint an altarpiece, arrived in Venice by 1520. After reaching the Holy Land he returned to Italy and settled in Rome, where in 1522 he became a supervisor of the Belvedere for the newly elected Dutch Pope, Adrian VI. Some months after Adrian VI's death in 1523, Jan returned to Holland early in 1524.

D.L.

Jan van Scorel
and an Anonymous Cutter

P26
The Deluge

473 × 366 mm Woodcut from two blocks
(Rosand and Muraro 80)
Metropolitan Museum of Art, New York, Harris Brisbane Dick
Fund 1935

The attribution of this woodcut, certainly one of the most beautiful, though problematic, produced in Venice in the sixteenth century, has veered between Titian, Giulio Campagnola and Palma Vecchio. It suggests a late homage to Jacopo de' Barbari by an artist familiar with the Danube School and profoundly impressed by large contemporary Venetian woodcuts.

Although it would be natural to assume that Jan van Scorel designed this woodcut while in Venice in 1520, it seems to me more likely that he conceived it after his Roman stay. The altarpiece Jan painted just before reaching Venice shows no Italian influence at all and, since he stayed in Venice for only a short time, it is unlikely that his style would change so dramatically and so quickly. On the other hand, he could well have designed a woodcut such as this after spending almost two years in Rome and travelling back through Florence (hence the clear influence of Michelangelo's *Battle of Cascina*). Further confirmation of this is provided by two paintings. One of these, dated 1521 (Düsseldorf), does not show many affinities with the print, although it was certainly painted in Italy. The other, a *Baptism of Christ* (Frans Hals Museum, Haarlem) painted soon after Jan's return to the Netherlands, is as close to the woodcut as a picture can be.

There is a contemporary copy of this woodcut which, in its early impressions, is very deceptive and could be taken as the original; its status can be recognised because it has only one boat instead of two in the sea (top right). Later, the two blocks of the copy split (or were cut?) horizontally

and the woodcut appears as if printed from four blocks.

The impression of the original exhibited here was printed on a sheet of paper which was first washed in yellow, with white highlights added. It is clearly an imitation of a chiaroscuro woodcut; it should not be forgotten that Ugo had left Venice about six years before this print was made, taking with him to Rome the secret of chiaroscuro printing.

At the time of going to press I read that Molly Faries has reached the same conclusion about the attribution of the design of this woodcut to Jan van Scorel. Although I have not found any watermark on the few impressions of the original of this print that I have seen, her contention that the blocks were cut in the Netherlands appears to contradict the fact that the paper used for the early copy described here is always Italian and also the fact that the print (and not its copy) was later copied by Andreani.

D.L.

Martino da Udine,
called Pellegrino da San Daniele

San Daniele (?) 1467 – Udine 1547

Martino, the son of a painter, was probably born in 1467 in San Daniele, near Udine. By the end of the century he was the most respected and busiest painter of the Friuli region. Such was his fame that he was invited to become Court painter to the Este family in Ferrara. He lived there between 1504 and 1513, often returning to Udine and San Daniele to take care of his ever increasing possessions, and to fulfil his commissions. He then settled in Friuli, and for three decades was awarded all the most important commissions for painting, frescoes, and sculpture in that region. Vasari recounted that the nickname Pellegrino (Pilgrim) was given to him by Giovanni Bellini whom Martino repeatedly visited in Venice: it seems more likely that the name is connected with a trip, almost certainly a pilgrimage, to Rome in 1497, since Martino is also documented, again probably a pilgrim, in Assisi in 1534. He died, rich and famous, in 1547, and was buried in Udine Cathedral.

D.L.

Martino da Udine and
Lucantonio degli Uberti

P27
The Martyrdom of the Ten Thousand
Christians on Mount Ararat

1065 × 1565 mm (Rosand and Muraro 14)
Woodcut from eight blocks
Signed by Lucantonio with monogram: L*;
inscribed by the printer bottom right: IN.VENETIA.IL.VICERI.
The Trustees of the British Museum, London

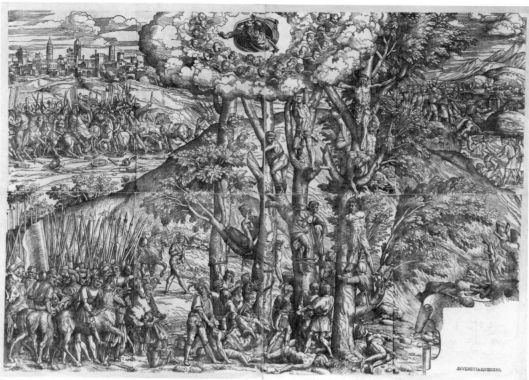

P27

One of the largest woodcuts produced in Venice in the sixteenth century, this print is also one of the most difficult to categorise. Stylistically it is different both from the large woodcuts designed by Titian and from those by Domenico Campagnola, yet its general appearance suggests that it dates from the same period as some of these, towards the end of the second decade of the century. As noted by Rosand and Muraro, it shows some Ferrarese influence. The use of so many different sources has led Oberhuber to suggest that it is the work of a provincial artist working in Venice, such as Cariani or Previtali, since Dreyer's attribution to Domenico Campagnola is untenable (he has probably changed his ideas since he brilliantly demonstrated that the so-called preparatory drawing in Christ Church, Oxford, is a forgery). To complicate matters further, the very bold foreshortening of some of the figures and the imaginative and lively movements of others strongly suggest Pordenone as the author, to whom I would be inclined to attribute the whole design, were it not for the many dull passages and the strong Ferrarese feeling that permeates the scene.

The only name that might fit all these requirements is that of Pellegrino da San Daniele, at the time of his closest association with Pordenone – between 1522, when he finished the frescoes in the church of Sant'Antonio Abate in S. Daniele, and 1528, when he completed the polyptych for S. Maria dei Battuti, Cividale. Unfortunately, only late impressions of this woodcut are known; the empty tablet at the bottom right may have contained very precious information relating to its authorship.

D.L.

Martino da Udine

P28
Three Soldiers:
Standard-bearer, Drummer and Flautist

142 × 143 mm Drypoint
(Hind, V, 244, 1 as Monogrammist CAMS?)
Signed bottom centre with monogram: MA; on either side S and D
The Trustees of the British Museum, London

This very fine drypoint, known only in this impression, is part of that group of rare small prints of a type made fashionable by Giulio Campagnola, represented in this exhibition by the work of Fogolino, Previtali and Marconi. It is an intriguing print, recognized by Hind to be Venetian, c. 1510–20, and shows a clear debt to Dosso, particularly to his paintings of the same decade, such as the *Melissa* (Villa Borghese, Rome), the *St. Jerome* (Silj Coll., Rome) and the *Standard-bearer* (Allentown, Pennsylvania). The only painter whose style is consistent with these different stimuli and whose works are of sufficient quality is Martino da Udine. The monogram can be read as MA for Martino and S and D on the sides for San Daniele. Stylistically, the print is close to Martino's work in the early 1520s, particularly to the frescoes in Sant' Antonio Abate in S. Daniele, which he completed in 1522. The influences of Dosso (Martino had been to Ferrara several times), Pordenone and Florigerio could thus be accounted for. The technique might have been suggested to Martino by Fogolino (or vice-versa?); he is thought to have helped Martino with the S. Daniele frescoes.

Martino's interest in printmaking might be greater than has been realized if my tentative attribution to him of the design of *The Martydom of the Ten Thousand Christians on Mount Ararat* (Cat. P27) were to be verified.

D.L.

P28

P29

Andrea Previtali

[Biography on p. 200]

P29

Three Flautists

146 × 124 mm Engraving and stipple-engraving (Bartsch XVI, 98.3)
Signed top right with monogram: A.P.
Graphische Sammlung Albertina, Vienna

Listed by Bartsch under the general heading 'after Titian', this very characteristic Bergamasque print was ascribed by Nagler to Andreas Pauli, a Flemish artist of the early seventeenth century, on the basis of the inscription *tisiaen in.* This appears in most impressions in the bottom left-hand corner and looks northern in its spelling. But the very early impression of a first state exhibited here, without this inscription, confirms that it was added much later; in fact, it only appears in late, worn impressions.

This early, possibly unique example shows the influence of Giulio Campagnola in the search for tonal effects through the use of dots, and in the size and subject. It was probably produced for specialised collectors of small, fine prints of profane subjects, a market which must have developed in the Veneto at the end of the first and through the second decade of the century; works of similar character by Giulio and Domenico Campagnola, Fogolino, Martino da Udine and possibly Rocco Marconi are exhibited here. The *Three Flautists* should be dated to the second decade of the sixteenth century when Previtali was deeply influenced by Lotto.

D.L.

Marcello Fogolino

Active *c.* 1510 – Trent (?) after 1548

P30

Woman and Child beside a Classical Building

166 × 195 mm Drypoint and stipple-engraving (Hind V, 219, 7)
Signed bottom right: MARCELO / FOGOLINO
Rijksprentenkabinett, Rijksmuseum, Amsterdam

Marcello Fogolino was probably born of a Vicentine family living in Friuli; in 1519 he was in Vicenza and from 1521 in Pordenone. Having been exiled from the Veneto in 1527 for murder, he moved to Trent where he became a spy for the Venetian Senate; consequently he was often granted leave to go back to Friuli. He probably died in Trent after 1548. Only seven small prints by Fogolino are known and all are either pure drypoints, or drypoints with stipple-engraving added in the deepest shadows. This technique, strongly reminiscent of Giulio Campagnola's prints, allowed very few impressions to be taken from each plate before it wore out. These prints were surely destined for a limited market of refined collectors who would paste them in albums. They are in fact very rare, five of them being known only in a single impression, and were probably all produced in the third decade of the century.

The print shown here is stylistically indebted to the Ferrarese School, particularly to Mazzolino (the architecture and frieze are very close to his style), and also

P30

P31

characterised by numerous figures crowded into a small space, as in this print. The treatment of this *Lamentation* is reminiscent of Palma's *Pietà* in S. Maria Formosa, Venice, and it is known that Marconi was associated with Palma for a considerable period. However, the print seems to be of a quality rarely found in Marconi's works and, even more puzzling, it is an etching. This technique, popular north of the Alps, particularly in the second decade of the century, was not commonly used in Italy, especially in Venice, until much later.

Bartsch was the first to notice the very thin signature at the bottom which reads *Marconi . . . in scp*; he read the second word as *rocco*. But unless we accept that Marconi learnt to etch from Parmigianino, or from one of his pupils – and there is no evidence of any such link – it is hard to believe that this very inspired work is by him. The date of the print (stylistically it could be much later) and the signature remain a mystery.

D.L.

to Pordenone, who was working in Spilimbergo in 1524/25. It was probably made before Fogolino left for Trent.

D.L.

Rocco Marconi (?)

Active *c*. 1504–*c*. 1529

P31
The Lamentation of the Virgin

104 × 113 mm
Etching (Bartsch XVI, 103, 1)
Inscribed bottom centre: *Marconi . . . in. scp.*
The Trustees of the British Museum, London

A Venetian, possibly of Bergamasque extraction, Rocco Marconi is documented in Venice between 1504 and 1529, first as a pupil of Giovanni Bellini, then as an independent artist close to Titian, Palma and Paris Bordone. He was an undistinguished artist, and his works are often

Anonymous Artist of the Veneto-Ferrarese School
and Ugo da Carpi

Ugo: Carpi *c*. 1480–*c*. 1532

P32
Archimedes

443 × 348 mm
Chiaroscuro woodcut from five (?) blocks, four shades of brownish-grey and black (Bartsch XII, 97, 6; Johnson 72, 14)
Graphische Sammlung Albertina, Vienna

P32

Recently Jan Johnson (1982) rightly attributed this magnificent print to Ugo and compared it with his *Diogenes*, probably made around 1527 when Ugo was in Bologna, having fled from Rome. Johnson has also discovered the close relationship between the figure of *Archimedes* and that of a *St. Jerome* (Kunsthalle, Hamburg). This painting, ascribed to Lotto by Berenson, might instead be the product of a Ferrarese painter, as suggested by Longhi, and it would not be unreasonable to think of it as an early work by Girolamo da Carpi. Such an attribution, tentatively proposed to me by Professor Testori, might make sense in connection with this print, for Ugo might understandably have wanted to apply his refined chiaroscuro technique to the design of a fellow citizen who was working at the time in nearby Ferrara.

D.L.

Titian
and Giovanni Britto

P33
St. Jerome
in the Wilderness

390 × 532 mm Woodcut (Rosand and Muraro 22)
Boymans-van Beuningen Museum, Rotterdam

In an important paper read at the 1976 Titian Congress in Venice, Konrad Oberhuber discussed the style of the cutters

P33

P34

of Venetian woodcuts and very convincingly changed all the accepted attributions. He rightly restored the *St. Jerome in the Wilderness* to Giovanni Britto, whose presence in Venice can consequently be assumed to go back to the early 1530s, the likely date of the design.

Either because of the plank used, or because of the conditions in which it was kept, the block seems to have cracked horizontally fairly soon, and impressions pulled before this happened are rare. Unfortunately, it was not possible to obtain one of these impressions for the exhibition, but this sharp, though late impression still shows the quality of this fine woodcut.

D.L.

Titian
and Niccolò Boldrini

Boldrini: active *c.* 1530–*c.* 1570

P34
Six Saints

378 × 538 mm Woodcut (Rosand and Muraro 35)
Rijksprentenkabinett, Rijksmuseum, Amsterdam

As rightly suggested by Oberhuber, this is probably the only woodcut for which Titian collaborated with Boldrini, rather than with Britto. It was made in the early 1530s and

relates to the altarpiece for S. Niccolò ai Frari, now in the Vatican, where the six saints appear in very similar poses, though in a different setting. This is also conceivably the only print in which Titian paralleled his well-known custom of continuously making changes to the painting he was working on. In the woodcut, he altered the face of St. Sebastian; no impressions are known before the new plug was inserted.

D.L.

Pordenone
and Niccolò Vicentino

[Pordenone: biography on p. 198]
Niccolò: active *c.* 1510–*c.* 1550

P35
Saturn

324 × 435 mm
Chiaroscuro woodcut from four blocks, tan, two shades of green
and black (Bartsch XII, 125, 27, I)
Signed in pen at left by the French collector and dealer:
Pierre Mariette, 1661
Graphische Sammlung Albertina, Vienna

Described by Bartsch as the work of Ugo da Carpi after Parmigianino, the design was long ago recognised as Pordenone's, since the figure appears in a drawing (Cat.

P35

D43) of the façade of Palazzo d'Anna, Venice which was frescoed by the artist around 1533. The exact date of these lost frescoes is unknown; it was thought to be not later than 1532, when Ugo da Carpi died, for the chiaroscuro woodcuts of *Saturn* and *Marcus Curtius* are clearly related to that cycle. However, neither woodcut is by Ugo da Carpi; the *Saturn* was certainly cut by Niccolò Vicentino, and the two versions of the *Marcus Curtius* shown here (Cat. P36 and Cat. P37) are by Vicentino and Boldrini respectively.

The cutting of the *Saturn* has nothing to do with Ugo, as Johnson has observed. The name of Niccolò Vicentino, on the other hand, fits the cutting style very well if one compares this print with Vicentino's signed chiaroscuro woodcuts (Bartsch XII, 39, 15; 64, 23; 96, 5; 99, 9 etc.). The colours used in the early impressions of this *Saturn* are typical of Niccolò and are never found in Ugo's prints. The second state of the *Saturn* bears Andreani's signature: Andreani, who must have bought Niccolò's stock (almost all Niccolò's chiaroscuros were re-issued with Andreani's signature), never reprinted a true chiaroscuro by Ugo, as Jan Johnson also noticed. Last, but certainly not least, an early impression of the *Saturn* in the British Museum (1858–4–17–1577) has on its verso an accidental counterproof of an early impression of the tone block of Vicentino's signed *Virgin and Child with Saints* (Bartsch 23).

D.L.

P36

Pordenone
and Niccolò Vicentino

P36
Marcus Curtius

408 × 271 mm
Chiaroscuro woodcut from three blocks,
two shades of blue-green and black
(C. Dodgson, *The Burlington Magazine* XXXVII, 1920, p. 61)
Signed bottom centre: PORDONONE INVT
The Trustees of the British Museum, London

Niccolò Boldrini
after Pordenone

P37
Marcus Curtius

408 × 294 mm
Chiaroscuro woodcut from three blocks,
two shades of chocolate-brown and black
(Rosand and Muraro 74)
Graphische Sammlung Albertina, Vienna

This version of *Marcus Curtius*, known only in the British Museum impression, is almost certainly the unique product of the collaboration of designer and cutter. It is connected, as is the *Saturn* (Cat. P35), with the frescoes of the façade of the Palazzo d'Anna; in fact, this impression has a pen inscription, possibly contemporary, which reads *Vinetia, à S. Benetto sopra la casa dil Danna* (i.e. on Palazzo d'Anna). On the basis of the attribution of these chiaroscuro woodcuts to Ugo da Carpi, the frescoes were dated before 1532, the year of his death. Although this *terminus ante quem* is not valid, I would tend to follow the early scholars and retain a date in the early 1530s (that is, close to the decorations of Palazzo Tinghi, Udine, of 1533) rather than during Pordenone's last stay in Venice between 1535 and 1538.

The second version, evidently cut by Boldrini, may be considered 'a later repetition', as Campbell Dodgson put it, and was probably copied from the Vicentino original long after Pordenone's death, possibly around the time of the *Venus* of 1566.

D.L.

P37

The cutting is different from that of any other woodcut by Campagnola and seems to me close only to the works of Antonio da Trento done for Parmigianino. It is possible that Antonio went to Venice in 1530 after escaping from Bologna where, according to Vasari, he had stolen all Parmigianino's drawings and prints. Such an attribution and date would fit well with the unusual medium: Antonio was probably one of the very few cutters in Italy at that time capable of making chiaroscuro woodcuts, which were becoming fashionable again in Venice under the auspices of Pordenone.

D.L.

P38

Domenico Campagnola
and Antonio da Trento (?)

[Domenico: biography on p. 324]
Antonio: active *c.* 1527–1540 (?)

P38

*Two Goats
at the Foot of a Tree*

493 × 217 mm Chiaroscuro woodcut from two blocks,
light grey and black
(Rosand and Muraro 25)
Graphische Sammlung Albertina, Vienna

Among the group of woodcuts which were the result of a collaboration between the artist and a professional cutter, this is probably the most successful. The attribution to Domenico could hardly be questioned, after Caroline Karpinsky read his signature on the Budapest impression of the very similar *Landscape with Peasant and Dog.*

P39

working methods are also recalled by the fact that in many cases each early impression is a new state: Schiavone seems to have gone back to some of his plates again and again, experimenting with techniques, tools, papers and inks in order to obtain new tonal effects.

D.L.

Andrea Schiavone

[Biography on p. 206]

P39
Moses and the Burning Bush

125 × 217 mm Etching and drypoint
(Bartsch XVI, 41, 3; Richardson 79, 3)
Graphische Sammlung Albertina, Vienna

Richardson, who has dated this print in the mid-1540s, has noted its indebtedness to the works of Giorgione, the early Titian and the prints of Giulio Campagnola, all of which seem to have deeply impressed the artist at this point in his career. The experimental quality of Giulio's engravings is recalled particularly in very early impressions, probably working proofs, such as this one.

The print demonstrates Schiavone's imaginative use of drypoint and the tonal effects created by its burr (for instance in the bushes and sheep on the left, and in Moses's hair or in the burning bush on the right), which call to mind, though not in terms of aesthetic achievement, Rembrandt's experimental printmaking. Rembrandt's

Polidoro da Lanciano (?) and an Anonymous Cutter

Polidoro: Lanciano 1515 – Venice 1565

P40
The Holy Family with the Infant St. John and St. Elizabeth in a Landscape

212 × 304 mm Woodcut (Rosand and Muraro 79)
Metropolitan Museum of Art, New York,
Harris Brisbane Dick Fund 1935

The number of painters in Venice who specialised in *Sacre Conversazioni* in the fourth and fifth decades of the century makes any attribution of a print such as this very difficult, particularly because it seems to be the only woodcut by this hand. But the setting of the figures in a wide landscape, the ruins on the left hung with peculiar vegetation, the rather eccentric faces and gestures all suggest Polidoro da Lanciano as the author. He was living in Venice in the late 1540s and was influenced by Giuseppe Porta Salviati, as is evident in this print. A further link with Salviati is the fact that, as noticed by Rosand and Muraro, the cutter of his *Crucifixion* was almost certainly responsible for this woodcut and probably also cut the landscapes in Vesalius's *De humani corporis fabrica*. This most gifted cutter then disappears as suddenly as he appeared at the beginning of the decade, leaving no clue to his identity.

D.L.

P40

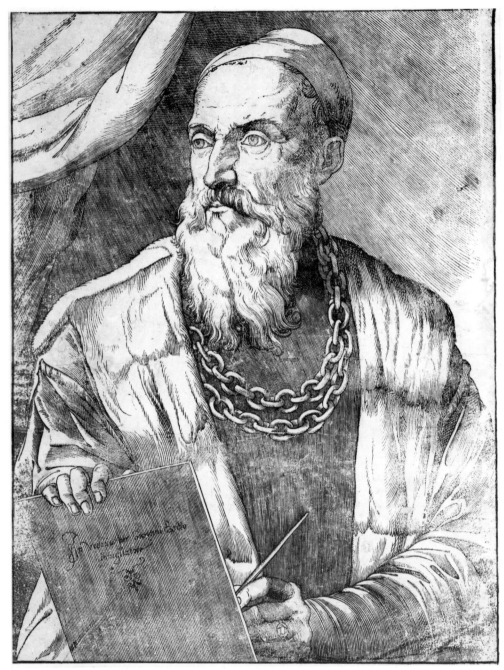

P41

Titian
and Giovanni Britto

P41
Self-portrait

415 × 325 mm Woodcut (Rosand and Muraro 45)
Signed on the tablet: *In Venetia per Gioanni Britto/Intagliatore*
Rijksprentenkabinett, Rijksmuseum, Amsterdam

In 1550 Pietro Aretino wrote a sonnet dedicated to Britto about this print. Since we know that the cutter pestered Aretino for a long time before he eventually wrote the sonnet, it may have been intended to be attached to the woodcut when it was sold, as was customary in contemporary Germany. Unfortunately no early impressions of the print survive, and of the four known – all late – this seems to be the best.

It has often been argued that Titian is shown here drawing on a woodblock, but it seems to me that he is holding a tablet on which a piece of paper could be laid for drawing, for it is far too thin to be a woodblock. A professional cutter would not make such a mistake.

D.L.

P42

Titian
and Giovanni Britto

P42
The Stigmatization of St. Francis

293 × 433 mm Woodcut (Rosand and Muraro 23)
Private Collection

In re-attributing this woodcut to Britto, Oberhuber compared it to the *Venus and Cupid*, signed and dated 1566, by Boldrini, to whom *The Stigmatization of St. Francis* had always been attributed. He noticed the striking similarities in style between the two prints, but also their very different cutting, and argued that Britto had cut this *St. Francis* in the early 1530s and that Boldrini had cut the *Venus and Cupid* in 1566, using a design of the 1530s.

It seems to me that the affinity of the two prints derives from the fact that *The Stigmatization of St. Francis* was probably conceived in the early 1550s, after Titian's return from Augsburg. The trees are clearly Germanic in character, for the first time in the artist's *œuvre*; moreover, the figure of St. Francis is so close, in reverse, to the apostle in the foreground of the *Pentecost* in S. Maria della Salute,

possibly completed in the early 1550s, that one might assume Titian drew on the block while conceiving that altarpiece.

The trees and landscape in Boldrini's *Venus and Cupid* are very close to those in *The Stigmatization of St. Francis*, but the figures are in Titian's style of the 1530s; Boldrini clearly used a drawing of that period for the figures and added a more recent landscape, perhaps one drawn by himself. This was an unheard-of initiative at the time, but it is interesting that it happened in the year before Titian asked the Senate for protection from piracy of his designs. Although he speaks about engravings and not woodcuts, Titian's words about forgeries 'made by greedy people, in order to bring dishonour on their real creator, rob him of his hard-earned profit, and deceive the public with a fake print of no real value', might well be applied to Boldrini's *Venus*.

It seems that copies were not Titian's only problem. It ought to be mentioned that a 'copy' of *The Stigmatization of St. Francis*, described by all scholars as an insult to Titian's art, is in fact an impression from a very late edition in which too thick an ink was used, thus greatly altering its appearance. Apart from the substitution of the cross, top right, a crack through the saint's right hand and the increased number of wormholes, no major differences can be noticed between the two states of the print.

D.L.

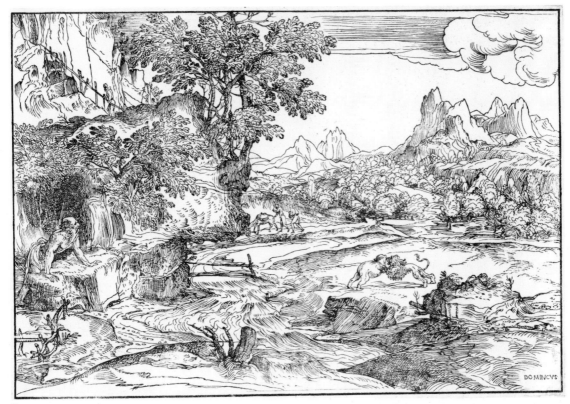

P43

Domenico Campagnola and an Anonymous Cutter

P43

Landscape with St. Jerome and Two Lions

287 × 418 mm Woodcut (Rosand and Muraro 26)
Signed bottom right: DOMINCVS
Collection of the late Edward Morris

A first state of this print exists with Campagnola's surname under his first name in the bottom right-hand corner (it is not exhibited here because it is known to me only in damaged impressions). The surname must have broken off very early since there are impressions of the second state, which are pulled from a block in perfect condition with no breakages or other damage.

It is difficult to date Domenico's woodcuts when they are not closely linked with the early group made around 1517. This landscape, with its open view, the unusually thin trees and elongated figure of the saint, reminiscent of Salviati, may be a late work; it compares well with drawings such as the *Landscape with a Dragon* (Albertina, Vienna) or *Christ Walking on the Lake* (Chatsworth) which are certainly late works.

D.L.

Giovanni Battista Franco (?)

[Biography on p. 256]

P44

Landscape with a Horseman and his Groom

333 × 448 mm Etching (Bartsch XVI, 101, 8)
Signed (?) bottom right with monogram: FV
Mrs Ruth Bromberg, London

Bartsch knew only the second state of this intriguing print, with an added inscription attributing it to Titian. The attribution to Marco Angolo del Moro proposed by Maria Catelli Isola is equally untenable; his prints are never as refined in style and technique as this, nor are the works of his father Battista in any way similar.

Dillon, on the other hand, has noticed the similarity between this landscape and that of Battista Franco's *Moses Drawing Water from the Rock* (Bartsch 2), which, he argued, must be a later addition because it does not compare with any other prints by Franco. By contrast, in the *Adoration of the Magi* (Bartsch XVI, 154, 2) only the tree on the right, very close in style to the two landscapes discussed here, is attributed by Bartsch to Battista Franco. His pure etchings, probably done after he returned to Venice in 1554, are very different from his other prints (compare for instance Bartsch 59) and it is conceivable that all these landscapes are, in fact, by him and show the impact of contemporary landscapes by Titian and Domenico Campagnola.

P44

The problem of attribution is compounded by the presence on this print of a small reversed monogram, so far unnoticed, in the bottom right-hand corner, which probably reads FV (Franco Venetus ?), but differs from Franco's usual monogram that includes a letter B.

D.L.

Sebastiano de Valentinis

Active *c.* 1540–*c.* 1560

P45

The Rest on the Flight into Egypt

213 × 145 mm Etching (Bartsch XVI, 241, 1)
Signed bottom right: SEBASTI/ANO D'. VL; inscribed on the tablet
top left: PIV ALTO/ NON SO/ DIR CHE MAT/ ER DEI
Paul Prouté S.A., Paris

P46

Prometheus

270 × 184 mm Etching (Bartsch XVI, 241, 2)
Signed and dated bottom right: SEBASTIANO/ .D'. VAL'. VT$^{P.}$
15558[sic]
Metropolitan Museum of Art, New York,
Rogers Fund by exchange 1970

Very little is known of this artist, a painter who was active in and around Udine and Gorizia between about 1540 and 1560, and who seems to have produced only three prints (a

P45

P46

del Moro. De Valentinis's prints, like *The Stigmatization of St. Francis* by Titian and Britto (Cat. P42) or the *Venus and Cupid* by Boldrini after Titian, show the impact of the so-called Danube School on Venetian art of the mid-century, which is probably related to Titian's trip to Augsburg in 1548.

D.L.

Andrea Schiavone

[Biography on p. 206]

P47

The Nativity

214 × 327 mm Etching and drypoint (Bartsch XVI, 42, 6; Richardson 81, 6)
Kunsthalle, Kupferstichkabinett, Hamburg

Probably made ten or fifteen years after the *Moses and the Burning Bush* (Cat. P39), this print shows a considerable refinement in Schiavone's technique. This extraordinary impression, which is slightly damaged, demonstrates how experimental this artist could be: the effects of the sudden light in a night scene are created with great care and technical ability. While the group of the Virgin, the Child and St. Joseph are very lightly inked (some lines do not even print), and the burr is carefully scraped off the drypoint lines and the plate wiped clean in the top half of the figures, the whole group of the shepherds is immersed in a dark surface tone that also covers the Child's face, but is cleaned off the top of the shepherds' heads; the etched lines in the right half of the print are richly inked and the darkest details, such as mouth, eyes and hair, are obtained with a drypoint, the rich burr of which has been left untouched. No other printmaker, either in Italy or elsewhere, had ever achieved such technical mastery in etching and in creating tonal effects with drypoint and surface tone. It is somehow a pity that this happened in the case of such an aesthetically unexciting artist as Schiavone.

D.L.

large undescribed *Turkish Army*, also dated 1558, is in the British Museum). The influence of the Veronese school on his prints, observed by Oberhuber, is not obvious to me, but it might help to justify the unexpected proficiency of de Valentinis's etching technique.

Verona was probably the only centre in the Venetian territory where etching was practised on some scale at this time by artists such as Paolo Farinati and Battista Angolo

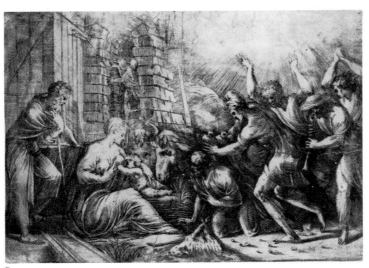

P47

P48

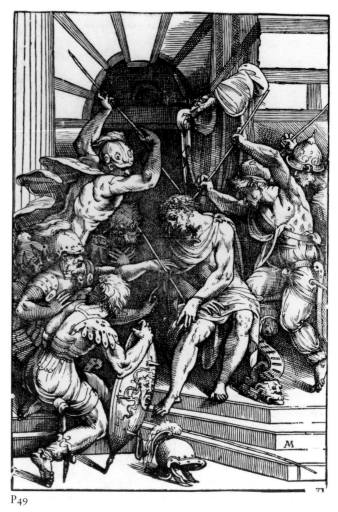

P49

P48

The Mystic Marriage of St. Catherine

308 × 225 mm Woodcut
(Rosand and Muraro 93; Richardson 108, 132)
The Trustees of the British Museum, London

The ineptitude of the cutting of this print, combined with
its experimental quality, suggests that Schiavone must be
responsible for it, as is now accepted by most scholars. The
formal quality of this very successful print indicates that the
artist probably adopted this technique in his maturity, and
its technical pitfalls suggest that this woodcut is the first of
only two he probably cut himself, the other being the *Christ
Crowned with Thorns* in Berlin.

All impressions of this woodcut known to me are late;
a slightly earlier state than the one shown (in which, for
instance, St. Catherine's gown at the left of her foot is still
unbroken) is not exhibited because the two impressions I
have found (Amsterdam and Rotterdam) are both damaged.

D.L.

Andrea Schiavone and an Anonymous Cutter

P49

Christ Crowned with Thorns

328 × 225 mm Woodcut
(Rosand and Muraro 91; Richardson 106, 130)
Signed bottom right with the monogram: AM
The Trustees of the British Museum, London

In my view Richardson is right in accepting Caroline
Karpinski's suggestion that the Berlin version of this
woodcut is the original and rejecting Rosand and Muraro's
idea that it is a copy after this signed original (the signature
AM stands for Andrea Meldolla, his proper name). But I do
not agree with the assumption made by these scholars that
one must be a copy of the other. I feel rather that the much
freer version in Berlin was cut by Schiavone himself some
time after *The Mystic Marriage of St. Catherine*, and that
the print exhibited here is a version cut by a professional
woodcutter, commissioned, as for *The Entombment*
(Rosand and Muraro 92), by the artist himself when

confronted with the technical failure of his own cutting, which, however, appears much more exciting to our twentieth-century eyes.

D.L.

Niccolò Boldrini
after Pordenone

Boldrini: active *c.* 1530–*c.* 1570
[Pordenone: biography on p. 198]

P50

A Leaping Horseman

229 × 184 mm (Rosand and Muraro 73) Chiaroscuro woodcut
from two blocks, dark chocolate brown and black
Inscribed bottom left: PORDO/·INV·;
signed bottom centre: *nic°. bol./.inci*
Graphische Sammlung Albertina, Vienna

The style of the cutting of this woodcut is very close to Boldrini's *Venus and Cupid* of 1566, and it is probable that the *Horseman* was cut around that date, based on a drawing by Pordenone, possibly made in connection with the Palazzo d'Anna. If this print and his version of the *Marcus Curtius* (Cat. P37) were made so many years after Pordenone's death in 1539, Boldrini's unauthorised use of other artists' designs was not confined to those of Titian, and might actually have had a part in prompting the great

artist's reaction against forgeries in 1567. From the little documentary evidence about 'reproductive' prints in sixteenth-century Venice before Cornelis Cort's time, it seems that they were mostly engravings (Enea Vico applied in 1546 for a privilege to engrave some 'rare and beautiful drawings' he had found) and rarely, if ever, woodcuts.

D.L.

P51

P51

Milo of Croton

300 × 415 mm
(Rosand and Muraro 75)
Chiaroscuro woodcut from two blocks,
olive green (faded) and black
The Trustees of the British Museum, London

As with Cat. P50, it is likely that the *Milo of Croton* was not the result of a collaboration between Pordenone and Boldrini, but instead was copied by the cutter from a drawing by Pordenone many years after his death. The drawing might have been for the lost frescoes in the Palazzo Rorario, Pordenone, since an engraving after the frescoes published by Fiocco records a composition very close to that of this *Milo*. Both that engraving and a painting recently sold at Sotheby's (21 March 1973) show very similar figures to those in the woodcut, but with a different background. This might indicate that Boldrini borrowed figures from one artist and added landscapes by another, or possibly drew these himself. We have seen this happen in the *Venus and Cupid* of 1566, and there is a good chance that *Hercules and the Nemean Lion* (Bartsch XII, 120, 18) consists of a fanciful landscape by Boldrini, used as a setting for a faithful copy of Niccolò Vicentino's chiaroscuro woodcut after Raphael (Bartsch XII, 119, 17).

D.L.

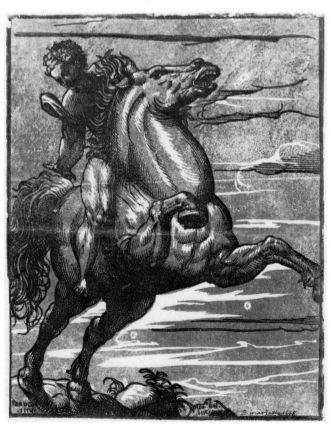

P50

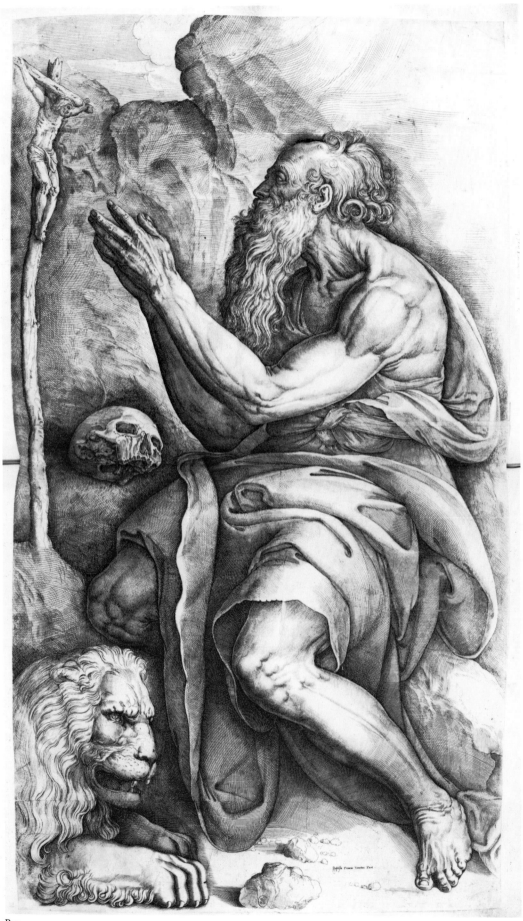

P52

Giovanni Battista Franco

P52
St. Jerome

872 × 480 mm Etching and engraving (Bartsch XVI, 131, 38)
Signed bottom right: *Baptista Francus Venetus fecit*
Bibliothèque Nationale, Paris

One of the most impressive etchings of the second half of
the sixteenth century, the *St. Jerome* reflects both the
monumentality of Michelangelo so much admired by
Battista during his years working in Rome, and the
impression that Titian's works must have made on him
when he returned to his native Venice in 1554. In addition,
this print is a monumental achievement from the technical
point of view, for it is accomplished with a single plate,
possibly the largest plate used in Italy in the sixteenth
century: etching, engraving, inking and printing it must
have posed many problems. In fact, all the impressions
known to me are printed on two or three sheets of paper,
but I have not been able to establish whether the print was
originally printed on several sheets because no sheet of
paper large enough was available, or whether the original
was cut at a later date to fit collectors' albums of different
sizes.

D.L.

Paolo Farinati

Verona 1524–Verona 1606

Paolo Farinati spent most of his life in his native Verona,
becoming a respected painter and citizen, receiving
commissions from the Town Council and the most
important private and ecclesiastical patrons of his time.
Together with Veronese and two other painters from
Verona he went to Mantua in 1552 to paint in the Duomo,
and seemed for a period to be greatly influenced by
Veronese, whose friend he became and whose wedding he
attended as best man in 1566.

D.L.

P53
Cupid and Apollo

208 × 107 mm Etching (Bartsch XVI, 166, 5; Albricci 20.5.1)
Signed bottom right, with the shell
Metropolitan Museum of Art, New York,
Harris Brisbane Dick Fund 1926

This *Cupid and Apollo* is certainly indebted to Veronese
and was probably etched in the mid-1560s, perhaps as a
result of the impact of the extraordinary frescoes of the
Villa Maser. There is a second state of this print, discovered
by Albricci, in which considerable additions have been
made with the burin; a very fine early impression of this
second state can be found also in the Metropolitan
Museum, New York.

D.L.

P53

P54
Sleeping Cupid

137 × 195 mm Etching (Bartsch XVI, 167, 8; Albricci 21, 8)
Signed bottom right with monogram: P.F; bottom left, under the
bow, with the shell
Boymans-van Beuningen Museum, Rotterdam

The style and technique of this etching are close to the
Cupid on a Dolphin (Bartsch 7) dated 1568, though slightly
more refined. The meaning of the shell, which Paolo
included in all his works, is still a complete mystery.

D.L.

P54

P55

P56

Giovanni Paolo Cimerlini

Active *c.* 1568

P55
The Aviary of Death

427 × 644 mm Etching and engraving (Bartsch XVI, 198, 36 [?])
The Visitors of the Ashmolean Museum, Oxford

The attribution of this print is based on its similarities with
a signed *St. Christopher*, dated 1568, the only certain work
by this mysterious artist, who was probably of Veronese
extraction. Bartsch lists a print with this title under Battista
Angolo del Moro, but most writers have noted that this one
must be by Cimerlini. Maria Catelli Isola was probably
right when she pointed out that Bartsch's detailed
description cannot be of the same print, for it omits such
important features as the 'muscle man' in the foreground,
the angel in the sky and the inscription. I was unable to find
an impression of the print described by Bartsch, or an
impression of an earlier state of this print by Cimerlini,
which must have had an inscription of several lines at the
centre bottom, and a coat-of-arms in the shield held by the
angel. The subject of the snares of death, often treated by
German artists of the first half of the century (for example
Flötner or Schoen), was most unusual in Italy; the fact that
two different prints depicting it appeared at the same time
might conceivably suggest a literary source.

D.L.

Anonymous Veronese Artist
after Titian (?)

P56
The Flautist

310 × 443 mm Etching (Bartsch XVI, 100, 7)
Graphische Sammlung Albertina, Vienna

As in the case of the *Landscape with a Horseman and his
Groom* (Cat. P44), it is very difficult to find a convincing
attribution for this print. Maria Catelli Isola suggested
Marco Angolo del Moro as the author, but although I
would agree with a Veronese origin and a date in the second
half of the century, I cannot see much affinity with Marco's
works. There are several drawings connected with this print
(or with its many copies), at least two of which (Louvre,
Paris and Albertina, Vienna) are in reverse and variously
attributed to Titian, Francesco Bassano and Domenico
Brusasorci. There are also some related paintings attributed
either to Brusasorci or Campagnola. Van Marle believed
that they all stemmed from a Titian painting of around
1530. In attributing the Albertina drawing to Titian,
Oberhuber also suggested a date of *c.* 1530; it is likely that
the etching, if indeed after that drawing, is much later.

D.L.

P57

Jacopo Tintoretto

[Biography on p. 212]

P57
Portrait of Pasquale Cicogna

244 × 210 mm Etching and engraving (Bartsch XVI, 105, 1)
Signed at left: I. TENTORETO;
inscribed top right: PASCHALIS./.CICONIA./.DUX./.VENETIAR[UM]
Metropolitan Museum of Art, New York,
Harris Brisbane Dick Fund 1923

Nagler rejected Bartsch's attribution to Tintoretto, arguing
that the master would have been too old to start etching
when Pasquale Cicogna was created Doge in 1585, and
Kristeller also dismissed the attribution on aesthetic
grounds. Oberhuber attributed the etching to Palma
Giovane, noticing the affinities with his prints. It seems to
me that the quality of this print alone would exclude
Palma's authorship and that it suggests Tintoretto, who
was 67 in 1585. But in order to produce this striking portrait
he would not have needed to learn all the secrets of the art
of etching, but only to draw with a needle in wax: he must
have called on the help of a professional printmaker, who
also engraved the inscription on the right and took care of
the technicalities.

As far as the similarities with Palma's etchings are
concerned, these seem to me explicable through
Tintoretto's influence. Palma, as far as we know, did not
start etching before *c.* 1608, and it would have been quite
extraordinary for him to have abandoned etching for more

than two decades if he had been as technically proficient as the author of this print. Moreover, his hatching is not quite the same, as can best be seen in a drawing of a Doge that is similar in general character to this print and probably contemporary to his etchings of the first decade of the seventeenth century (Sotheby's sale of the Rudolph Collection, 4 July 1977, lot no. 19).

D.L.

Prospero Scavezzi

Active *c.* 1589

P58

Portrait of Sixtus V

425 × 308 mm Etching (Bartsch XVI, 107, 1)
Inscribed, signed and dated bottom centre:
SIXTVS.V.P.M/*Prosper de Scavezzi, Brixiensis inventor. 1589*
Paul Prouté S.A., Paris

This is the only print signed by Prospero Scavezzi of Brescia, who was identified by Fenaroli in his *Dizionario degli Artisti Bresciani* as the Prospero Bresciano described by Boschini as a painter of chiaroscuri in Venice, and by Baglione as a sculptor under Gregory XIII in Rome. It is, in fact, possible that the etcher is the same person as the sculptor, for the latter was commissioned to make two statues for S. Maria Maggiore (as reported by Fenaroli) by Sixtus V, who is portrayed in this print. Moreover, the technique of this print is close to that of Ventura Salimbeni, who was in Rome making etchings in 1589 when this portrait was produced. If the identification is correct, it must be one of the most 'Venetian' images ever produced in Rome.

D.L.

P58

Giuseppe Scolari

Active *c.* 1592–*c.* 1607

Scolari, the Veronese of Venetian printmaking, is a mysterious artist about whom we know for sure only that he was registered in the guild of Venetian painters between 1592 and 1607. No paintings or drawings are associated with him and no date appears on his woodcuts, the only works signed by him. These are extraordinary, both for their beauty and for their technical novelty and skill. His chief innovation was the use of the burin rather than the knife – the usual tool of the woodcutter – on a large scale to cut some of the white lines in the black background (Beccafumi and others had used it before but on a smaller scale), thus achieving effects which did not reappear until the early nineteenth century in England.

D.L.

P59

P59

Man of Sorrows

528 × 375 mm
Woodcut and wood-engraving
(Rosand and Muraro 94)
Signed at bottom: GIOSEPE. SCOLARI. VECENTINO.F.
Rijksprentenkabinett, Rijksmuseum, Amsterdam

The inscription on this striking *Man of Sorrows* gives the only clue to the artist's origin. Probably because of it the artist has been associated with Vicentine artists, and it has been suggested that he trained in Vicenza. While there are no similarities between his prints and the work of artists such as De Mio or Maganza, there are much closer affinities with Veronese artists, particularly Paolo Farinati. Whether this is the result of the general influence of Paolo Veronese on both of them I cannot say, but it is certain that it was to Verona rather than Vicenza that Giuseppe Scolari always looked for inspiration.

D.L.

St. Jerome

530 × 372 mm Woodcut and wood-engraving
(Rosand and Muraro 97B)
Metropolitan Museum of Art, New York,
Harris Brisbane Dick Fund 1926

Scolari was the only artist of sixteenth-century Venice to rework his woodcuts by recutting some parts of the composition and inserting these parts as plugs in the block. The only other example of this technique is Titian's *Six Saints* (Cat. P34), and the rarity of this practice

P60

is certainly due to the labour involved in such corrections. But Scolari cut the blocks himself and if dissatisfied did not need to discuss with the cutter his fees for changing a small detail. In this print he actually altered the shape and shading of both legs of the St. Jerome completely, thus obtaining quite a dramatic improvement on the first state.

D.L.

P61

St. George

530 × 368 mm Woodcut and wood-engraving
(Rosand and Muraro 96)
Graphische Sammlung Albertina, Munich

There are three states of this woodcut: in the first, exhibited in Venice in 1976, a line runs across the parallel hatching on the horses's neck. This line and most of the hatching on the white front of the horse, between the reins and the legs, was cut away in the second state, which is exhibited here (kindly pointed out to me by Lutz Riester). In the third state, a small plug has fallen off the centre of the bottom margin; many of the impressions thought to be in the second state are in fact later impressions in which the little white square has been carefully inked in. That the alterations to the block found in the second state are by Scolari can best be seen in this quite exceptional impression, certainly printed by the artist himself. The inking of the block is a technical miracle: in order to obtain the effect on the right of rocks receding, as if into a misty distance, Scolari diluted the ink more and more as he was inking the block from the bottom. He carefully applied this diluted ink on the rock (the further your eyes climb up it, the greyer the ink becomes), but maintained the very black ink for the horizontal hatching of the sky. This extremely laborious technique could not be used successfully on a large scale, and I only know of one other impression (Amsterdam) on which it was tried, albeit with a much less convincing result.

D.L.

P61

P62

P62
The Entombment

691 × 442 mm Woodcut and wood-engraving
(Rosand and Muraro 98)
Signed bottom right: *Gioseppe/Scolari inv.*
National Gallery of Art, Washington D.C.,
Ailsa Mellon Bruce Fund

Rosand and Muraro noticed that in this most dramatic
composition Scolari made much less use of the burin; it was
employed here only in the areas of thicker hatching.
Although the term 'wood-engraving' that I have been using
to describe these prints should be restricted to those relief
prints engraved with the burin from an end-grain block, it
is the only description that I could find for the hatching in
some parts of this composition, such as the white lines on
the right leg of the figure in the foreground. They show
Scolari's unique skill in using a much harder wood,
probably with very fine grain, than the type normally used
for woodcuts; almost certainly he developed the technique
himself, but unfortunately the secret died with him.

D.L.

P63
The Rape of Proserpina

450 × 350 mm Woodcut and wood-engraving
(Rosand and Muraro 104B)
Signed centre left: *Gioseppe Scolari* IVV
Fondation Custodia (Coll. F. Lugt), Institut Néerlandais, Paris

This is the only woodcut by Scolari that is not of a religious subject, and its completion evidently caused the artist some trouble. The impression shown here is in the second state, after a large plug was inserted in the right half, changing the position of the heads of both horses.

D.L.

P63

SCULPTURE

Bruce Boucher and Anthony Radcliffe

Venetian sculpture, like Venetian painting, always depended on a steady flow of foreign artists to enrich its native talent. During the Renaissance Pietro Lombardo, with his sons Tullio and Antonio, came from the shores of Lake Como; Antonio Rizzo and Girolamo Campagna from Verona; Andrea Riccio, Francesco Segala and Tiziano Aspetti from Padua; Niccolò Roccatagliata from Genoa, and Jacopo Sansovino and Danese Cattaneo from Tuscany. These artists were drawn to Venice by a variety of factors: it was one of the largest and wealthiest cities in Europe, the capital of an empire extending over much of northern Italy, and it provided ample opportunities for employment not only for stone carvers, but also for craftsmen in bronze, who had access to foundries in the Arsenal and elsewhere.

Many of the most characteristic forms of Venetian sculpture, including the great ducal tombs, marble reliefs and ornamental bronzes, were developed in the last quarter of the fifteenth century. By 1500 Venice and Padua were among the most sophisticated centres of sculpture in Italy, and in terms of the influence of the antique, perhaps the most sophisticated of all.

The most important innovator in the field of tomb sculpture was Pietro Lombardo. In the Roselli monument in Padua (1464–68) he introduced Florentine forms to the Veneto, albeit on a grander scale, while the series of great tombs of doges in the Frari by Rizzo and in SS. Giovanni e Paolo by Lombardo established a distinctive local type of large-scale memorial, fusing elements from Roman triumphal arches with more traditional funerary elements. The greatest and most characteristic example of this type was Tullio Lombardo's monument to Andrea Vendramin, underway in the 1490s, whose advanced, highly classical structure is submerged by a gothic multiplicity of statues. Some of the figures are still late gothic in style, while others, such as the *Adam*, achieve an almost classical perfection a decade before comparable types appear in painting. But it was a classicism less weighty and more decorative than that of Michelangelo, and one that could easily be combined with residual gothic elements.

A more profound break with local traditions occurred in the development of the marble relief, which is particularly associated with Tullio and Antonio Lombardo. In the panels on the façade of the Scuola di San Marco, Venice (c. 1488–90), the two brothers imitated the high reliefs of sarcophagi and triumphal arches, at the same time providing settings which create a perspectival illusion of space, while Tullio's altarpiece relief of *The Coronation of the Virgin* in S. Giovanni Crisostomo (1500) was the most rigorously antique treatment of a Christian subject to be produced anywhere in Italy at that date.

Soon afterwards the Lombardo brothers were able to apply their new style on a much more important project, the redecoration of the shrine of St. Anthony in the Basilica del Santo, Padua. Although the Paduan sculptor Riccio is traditionally credited with the basic design, the Lombardi, who carved the first two panels in 1501–03, are more likely candidates. The three interior walls of the chapel are based on the façade of the Scuola di San Marco, and are decorated with reliefs showing the miracles of St. Anthony. The decision to replace the earlier painted decoration with sculpture was obviously partly inspired by Donatello's famous bronze reliefs on the high altar of the Basilica, and Donatello's influence, tempered with Tullio's instinctive sense of classical decorum, is particularly evident in his contributions to the chapel, while the work of Antonio reveals a closer study of classical statues and greater understanding of the principles of Roman relief carving.

The vogue for *all'antica* marble reliefs was also promoted by Tullio and Antonio in secular works. These included Tullio's famous double portraits in Venice (Ca d'Oro) and Vienna (Cat. S10), which may have been inspired by Roman funerary monuments and classical gems, and the panels produced by Antonio between 1506 and 1516 for Alfonso d'Este, Duke of Ferrara, which were widely imitated by lesser sculptors (Cat. S7–9).

The interest in the antique which permeates the work of the Lombardo brothers and their followers must have been particularly fostered in Padua, a university town and the 'Latin quarter' of the Venetian empire. Resident scholars such as Raffaello Regio, Leonico Tomeo and Pietro Bembo collected both classical and modern art, and they knew practising artists such as Pyrgoteles (Zuan Zorzi), Riccio and Severo da Ravenna. It was in this milieu that Pomponius Gauricus published in 1504 his treatise *De Sculptura*; following Pliny the Elder, Gauricus held that the highest form of sculpture was in bronze.

The contemporary artist whom Gauricus praised most highly was Severo da Ravenna, but he criticised his inadequate knowledge of the classics. The same could not have been said of Riccio, the outstanding figure among the Paduan sculptors in bronze in the first quarter of the sixteenth century, and the one who, starting with his Paschal Candelabrum of 1507 for the Basilica, most completely fulfilled Gauricus's recommendations. Trained as a goldsmith, Riccio learnt the art of bronze sculpture from Donatello's pupil Bellano, but his style was closer to the Lombardi and Mantegna. By seeking inspiration in classical literature, as Gauricus had advocated, rather than simply borrowing the forms of ancient art, Riccio produced in his mature work, such as the della Torre tomb (Cat. S17, S18), an essentially

modern type of sculpture which could only have originated in the intellectual circles of the Veneto of his day.

In the late fifteenth century there was also a renaissance of bronze casting in Venice. One of the prime movers was Alessandro Leopardi, who had cast Verrocchio's model for the Colleoni monument in 1494. His handsome bronze flag bases facing San Marco, completed in 1505, which celebrate the glories of Venice in mythic terms, embody many of the ideals proclaimed by Gauricus, and they may have served as a stimulus for Riccio and the other Paduans.

Leopardi was also responsible for the casting of some of the figures in the funerary chapel of Cardinal Zen in San Marco. The Cardinal, who died in 1501, had stipulated that all the sculpture should be in bronze and 'as antique as possible'. The scheme as finally executed, with figures designed by Antonio Lombardo and architecture largely by Tullio, is among the most spectacular achievements of the sixteenth century, notable for the sophistication of the bronze casting and for Antonio's monumental figures, especially the *Madonna della Scarpa*, in which the influence of classical statues is brilliantly combined with a strong sense of physical presence.

The War of the League of Cambrai (1509–16) virtually put an end to the patronage of large-scale sculptural projects, and the market only began to revive in about 1520. In that year commissions for further reliefs for the shrine of St. Anthony were given to Tullio Lombardo, Giovanni Maria Mosca and Antonio Minello, and in 1524 to the Milanese Giovanni Rubino. But the work of these three younger artists never transcended a stilted version of Tullio's style, while even Tullio himself abandoned the classically detached approach to narrative which he and his brother had previously favoured, adopting instead a more dramatic style derived from Donatello's reliefs and Bacchic sarcophagi. Rather than marking a new beginning, the 1520s witnessed the disintegration of the Lombardo style, with the death of Minello in 1528, Rubino in 1529, Riccio and Tullio in 1532, and the departure of Mosca for Poland around 1530.

In 1527, however, a new sculptor appeared in Venice who, more than any other, would remould the local tradition in his own image. This was Jacopo Sansovino. After a distinguished career as an architect and sculptor in central Italy, he left Rome during the Sack, at the age of 41. Although originally planning to move to France, he was persuaded to stay in Venice as *proto*, or chief architect, to the Procurators of San Marco. His position, his reputation and the high patronage he enjoyed gave Jacopo the opportunity to introduce a new vocabulary into Venetian sculpture and architecture.

In his work in marble, such as the *St. John* in the Frari, the relief of *The Maiden Carilla* in the Basilica del Santo, or *Neptune* and *Mars* for the Doge's Palace, Sansovino adhered to a style that was essentially derived from central Italian art of the early sixteenth century. The *St. John*, for example, recalls Florentine terracottas of the first years of the century, while expressing a spiritual quality beyond the reach of any rival except Michelangelo; the Santo relief depends not on the classical format of the Lombardo school, but on an engraving of the *Lamentation over the Dead Christ* after Raphael, transposed into a poignant study of grief.

Even more influential were Sansovino's works in bronze. This was a relatively new medium for him, but it was ideally suited to the execution of commissions with a minimum of

fig. 26 Jacopo Sansovino *Mercury* (Loggetta, Venice)

time and effort. Moreover, the skills of professional Venetian casters enabled Sansovino to extend the painterly style of his marble carving into the more malleable medium of bronze, as for example in six panels illustrating the life and miracles of St. Mark, and in the sacristy door, all in San Marco. These works, which combined elements from Ghiberti, Donatello and contemporary mannerists, became a touchstone for narrative reliefs as well as influencing painters like Tintoretto and Bassano. Equally important were the attenuated and slightly androgynous deities on the Loggetta (fig. 26), which created a figure type imitated by younger artists such as Vittoria and Paolo Veronese.

Sansovino's sculptural ideas also found expression in his architectural projects. These required reliefs, stucco decoration and figure sculptures, which were executed by assistants and pupils such as Tiziano Minio, Francesco Segala, Danese Cattaneo and Alessandro Vittoria, of whom the last two were the most gifted. As a young man Cattaneo carved decorative elements for the Library and the Loggetta, and one of his first independent works was an *Apollo* for the courtyard of the Zecca (Public Mint). He was much admired as a portraitist, a field in which Sansovino never showed

much interest, and was probably the first to establish the central Italian type of *all'antica* portrait bust in Venice. Cattaneo's literary interests also had an important effect on the iconographic programmes which he devised for the tombs of the *condottiere* Giano Fregoso in Verona and of Doge Leonardo Loredan; they included secular allegorical figures and altered the conventional formula for such monuments.

Cattaneo's career was overshadowed by that of his younger contemporary Vittoria, who achieved a material success far greater than any of his fellow artists. As the imperial ambassador reported in 1569, Vittoria was considered the best sculptor in Venice after the aged Sansovino, with Cattaneo trailing a poor third. Entering Sansovino's workshop in 1543, Vittoria first gained fame as a stuccoist and medallist, collaborating with Palladio and enjoying the patronage of Pietro Aretino. Among his most brilliant achievements in stucco, combining elements derived from Sansovino, Michelangelo and Parmigianino, are the staircase of the Library and the Scala d'Oro of the Doge's Palace, which established a taste for such plasterwork throughout the Veneto. As a figural sculptor Vittoria was at his best on a small scale; his larger figures show a certain slackness, although the *St. Catherine* and the *Daniel* in the church of S. Giuliano are notable exceptions. He also excelled as a portraitist, creating some of the most heroic images of the Venetian society of his day, and his best achievements embody the image of the Republic so carefully fostered by government ceremonial.

Girolamo Campagna was arguably the dominant sculptor in Venice during the last two decades of the century. He had been a pupil of Cattaneo in his last years, inheriting several of his unfinished commissions, including the last relief for the cycle in the Basilica del Santo. The success of the Santo relief established Campagna's reputation, which he consolidated by redesigning the high altar of the Santo (1580–84) and producing various statues for the Doge's Palace and for Venetian noblemen. In 1583 he was commissioned to provide six allegorical figures for the tomb of Doge da Ponte, while Vittoria provided only the bust. Perhaps Campagna's greatest achievements are the sculptures for the high altars of the Redentore (1589–90) and S. Giorgio Maggiore (1592), which illustrate his remarkable ability in adapting the idiom of Sansovino's and Vittoria's bronzes to a monumental scale. His figures have a weight and dynamism matched at that time in Italy only by the best products of Giambologna's workshop.

The impact of Campagna can be seen in the work of the Paduan Tiziano Aspetti and the Genoese Niccolò Roccatagliata. Aspetti, who came from a famous family of founders, formed his style on that of his uncle, Tiziano Minio, and that of Campagna, with whom he may have studied. Particularly successful as a sculptor in bronze, his best early works were the figures of *Moses* and *St. Paul* on the façade of S. Francesco della Vigna (1592) and two relief panels for the altar of St. Daniel in the crypt of Padua Cathedral (1592–93), which led to a major commission for a series of bronze saints, angels and virtues in the Basilica del Santo.

Less is known of Aspetti's contemporary Niccolò Roccatagliata, who trained as a goldsmith in Genoa before coming to Venice, probably in the 1580s. He may have made models for Tintoretto and certainly produced a number of sculptures in bronze for S. Giorgio Maggiore in the 1590s. Figures like *St. Stephen* (Cat. s27) and *St. George*, or the recently identified *Virgin and Child* (Cat. s28) place Roccatagliata in the orbit of Campagna, but he sometimes struck a more fanciful and individual note. His few securely autograph works have assured him a distinguished place among the sculptors in Venice at the end of the century. Campagna, Aspetti and Roccatagliata have all been lumbered with a number of dubious attributions of firedogs and small bronzes, but most, if not all, of these minor Venetian bronzes were probably the work of highly competent founders. Thus two splendid well-heads in the courtyard of the Doge's Palace would surely be assigned to Vittoria if they were not signed by two master founders of the Arsenal, Niccolò dei Conti and Alfonso Alberghetti. Similarly, the magnificent Paschal Candelabrum made for S. Spirito in 1570 (now in the Salute) is very close to Vittoria, but signed by his close friend Andrea di Alessandro da Brescia, who cast Vittoria's statuette of *St. Sebastian* (Cat. s37). Artisan founders like Andrea di Alessandro, who is documented as making any number of small bronzes, were thoroughly conversant with the idiom of the greater sculptors and diffused a Venetian style in the applied arts in the form of door-knockers, ink-wells and the like.

At the beginning of the seventeenth century the school of sculpture founded by Sansovino was dying, much as that of the Lombardi had done in the 1520s. As the agent of the Duke of Urbino reported in 1604, Campagna could pick and choose his commissions because he had no real competition, and he 'had to be handled with kid gloves because sculptors suffer from the same malady as poets and painters, Campagna no less than the others'. As with the Lombardi, Sansovino's followers had been eliminated by death and migration: Segala died in 1592, Roccatagliata was away from Venice from 1596 to 1633, Aspetti left for good in 1604 and Vittoria died in 1608. Only Campagna, with an inferior protégé named Giulio del Moro, soldiered on until 1625, producing statues of substantial, if academic, quality.

In retrospect, one can see that Venetian sculpture of the sixteenth century falls into two periods. The earlier, dominated by the Lombardo family, was marked by an awareness of early fifteenth-century central Italian sculpture and of the antique. This latter element led to the development of a precociously classical style by the early sixteenth century, but one which was incapable of developing beyond those early decades, passing away with its major proponent, Tullio Lombardo. Then around 1530 Sansovino introduced a more versatile and cosmopolitan idiom, which paid lip-service to the classical ideal, but was really oriented towards central Italian art of the High Renaissance.

Its diffusion was assured by Sansovino's position in the Venetian art world of his day and by the substantial number of associates and followers who were conversant with his idiom and able to reproduce it. Sansovino's school proved a resilient one, and in the hands of his followers his repertoire was widened to include elements from the later work of Michelangelo and other aspects of classical sculpture. Though it had run its course by the death of Girolamo Campagna, the production of the Sansovino school remained a touchstone of elegance for subsequent generations of Venetian sculptors, even down to the juvenile works of Antonio Canova.

Tiziano Aspetti

Padua c. 1559 – Pisa 1606

Aspetti was the nephew and namesake of the sculptor Tiziano Aspetti, called Minio, and a grandson of the bronze founder Guido Lizzaro. His early career remains obscure, but he was probably trained in the family foundry, which his father continued after his uncle's death in 1552. By 1580 Tiziano is recorded in Venice in the circle of Giovanni Grimani, Patriarch of Aquileia and a great patron of the arts. His first known works, a relief of *The Forge of Vulcan* in the Anticollegio of the Doge's Palace (1588), and a *Giant* for the entrance to the Public Mint (1590), were carried out in conjunction with Girolamo Campagna, whose pupil Aspetti may have been. Aspetti also carved reliefs of *St. Mark* and *St. Theodore* for the Rialto Bridge, as well as statues of *Hercules* and *Atlas* for the entrance of the Scala d'Oro in the Doge's Palace. His other major works in Venice arose through the patronage of Giovanni Grimani at S. Francesco della Vigna – namely, the large bronzes of *Moses* and *St. Paul* on the façade, and smaller bronzes of *Justice* and *Temperance* for the family chapel (1592).

From 1592 to 1599 Aspetti's most important work was done for Padua: the bronze reliefs for the shrine of St. Daniel in the cathedral and the altar for the shrine of St. Anthony in the Basilica del Santo, which included eleven statues and a pair of bronze gates (1593–96). In that same period, he also furnished a marble *Christ* for one of the holy water stoups. Aspetti moved to Tuscany in 1599 but returned to the Veneto in 1602, when he made a number of silver statuettes for the Duchess of Mantua. He returned to Tuscany in 1604 with the apostolic nuncio, Antonio Grimani, and lived in the household of Camillo Berzighelli at Pisa and also at Massa Carrara where he set up as a stone carver. Before his death in 1606, Aspetti made a will in

which he referred to ten statues, some finished, and a pair of bronzes of *Hercules and the Centaur* and *Hercules and Antaeus*. None of these works has been identified; the one surviving work of his last years is the relief of *The Martyrdom of St. Lawrence* for the Usimbardi Chapel of S. Trinita, Florence. A number of other small bronzes have been attributed to Aspetti but they are probably the work of artisan founders.

B.B.

REFERENCES

Brunetti in D.B.I., IV, 1962, pp. 418–22 with full bibliography; Pope-Hennessy 1970, p. 419; Sartori 1976, pp. 11–13

S1 & S2

St. Daniel Dragged by a Horse
St. Daniel Nailed between Two Boards

Bronze; each 46.5 × 69.5 cm
Inscribed: TITIANI ASPECTI/PATAVINI OPVS (S1); TITIANI/ASPETTI/
PATAVINI OPVS (S2)
Museo Diocesano, Padua

These reliefs illustrate the torture and martyrdom of St. Daniel, a fourth-century deacon of Padua and one of the patron saints of the city. They were commissioned in 1592, when the saint's relics were translated to an altar in the crypt of the cathedral, and were completed by February 1593, when the overseers voted Aspetti a bonus for the quality of his work.

The reliefs have frequently been compared to the work of Donatello, Bellano and Riccio, all of whom were active in Padua; yet a closer point of departure can be found in Venice in the reliefs of Sansovino and Tiziano Minio in San Marco. Sansovino experimented with *rilievo spiccato*, in

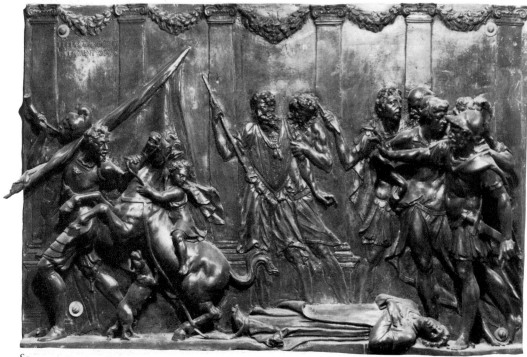

S1

which the foreground figures stand out prominently from the picture plane; his *Martyrdom of St. Mark* is especially close to Aspetti's *St. Daniel Dragged by a Horse*, while the sketchier background of *St. Daniel Nailed between Two Boards* may have been suggested by the treatment of architectural elements in the background of Sansovino's *St. Mark Healing a Demoniac*. Aspetti's figures, however, display an exaggerated fluidity closer in spirit to the reliefs of his uncle, Tiziano Minio, on the baptismal font of San Marco and in the Odeo Cornaro in Padua.

The authenticity of Aspetti's Paduan reliefs has recently been questioned by Olga Raggio, who claims that a second pair, acquired in 1970 by the Metropolitan Museum, New York, are the originals and that the Paduan bronzes are late aftercasts. But the Metropolitan reliefs have no known provenance before the early twentieth century, nor is there evidence to confirm that one set was substituted for another. In addition, the Metropolitan reliefs have untrimmed borders, which suggest that these reliefs were not made for the marble frames of the crypt altar; nor are they identical to the ones in Padua, as one would expect in the case of an original cast and an aftercast.

The most plausible explanation for the existence of the two sets is that they are both late sixteenth-century casts from Aspetti's original models, but made for different purposes. This would explain the numerous small discrepancies between the two pairs. The elaborate detail of the Metropolitan bronzes suggests that they were destined for a collector's cabinet, while the comparative lack of finish on the Paduan reliefs can be explained by their original setting: high finish and chasing would have been scarcely visible in the dark crypt. Aspetti's relief of the *Martyrdom of St. Lawrence* in S. Trinita, Florence, is similar in this respect.

B.B.

EXHIBITIONS
Padua 1976, nos. 121–22

REFERENCES
Benacchio 1931, pp. 123–28, 145; Brunetti in D.B.I., IV, 1962, pp. 418–22; Raggio 1982, with full bibliography

Girolamo Campagna

Verona 1549 – Venice *c.* 1625

Campagna was the son of a furrier and was probably apprenticed to Danese Cattaneo while the latter was at work on the Fregoso monument in Verona (*c.* 1562–65). On his death in 1572 Cattaneo left all his plaster casts and drawings to his disciple Campagna, who subsequently won a competition to complete the last relief in the shrine of St. Anthony in the Basilica del Santo, Padua, a commission originally won by his master. After an interval in Augsburg restoring antiquities for Hans Fugger, Campagna finally finished the relief, his first major work, in 1577; two years later he won another competition for the new high altar of the Santo. In the 1580s he provided allegorical statues for the tomb of Doge Niccolò da Ponte (1583) and for the Doge's Palace (1583–84), and completed his first large-scale Venetian altarpiece, the *Virgin and Child* for the Dolfin family in S. Salvatore (1585–90).

By 1590 Campagna was the major statuary sculptor in Venice, and was commissioned to carve seven statues for the balustrade of Sansovino's Library (1589–91) and one of two *Giants* for the Piazzetta entrance to the Public Mint (1590); he also made the bronze figures for the high altars of the Redentore and S. Giorgio Maggiore (1589–92), which are amongst the finest executed in Italy at that time. Later commissions included a marble *Virgin and Child* for S. Giorgio Maggiore (1595), the sculpture for the tomb of

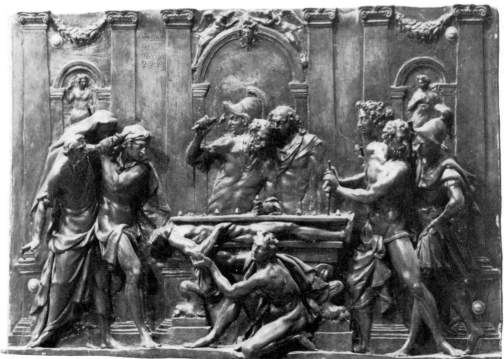

S2

Doge Marino Grimani (1601–04) and statues of *St. Lawrence* and *St. Sebastian* for the high altar of S. Lorenzo (1615–17). Campagna's last major undertaking was the statues for the high altar of the Scuola Grande di S. Rocco (1613–20). The exact date of his death is not known, but he died before June 1625.

B.B.

REFERENCES

McTavish 1980; Timofiewitsch 1972; Timofiewitsch in D.B.I., XVII, 1974, pp. 300–06, with full bibliography

S3
Angel Holding a Candlestick

Bronze; 74 cm to tip of wing
Inscribed: HIER.ˢ CAMPAGNA. V.ˢ F.
S. Maria del Carmelo (I Carmini), Venice

S3

The first reference to this angel, one of a pair, appears in a guide-book of 1815. At that time both figures were in their present location – on the balustrade of the third altar to the right of the nave – but they are not mentioned in a guide-book of 1604. They have been variously dated from the early 1590s to the first decade of the seventeenth century. Timofiewitsch's suggestion of 1590–92 seems plausible, given the close similarity in pose to the *St. Mark* that Campagna made for the Redentore in 1588–90.

Together the angels create a sinuous *contrapposto* which owes much to the *Daniel* and *St. Catherine* made by Vittoria for S. Giuliano in the early 1580s. The complementary poses suggest that they were originally intended to flank a tabernacle or to form part of a retable. Apart from the elaborate wings, which may derive from northern woodcuts, they are distinctively Venetian in style.

B.B.

REFERENCES

Niero 1965, pp. 39–40; Timofiewitsch 1972, pp. 74–75, 255–56, no. 13, with full bibliography

S4
St. Agnes

Bronze; 93 cm
Inscribed on the base: FR. BALTHASAR. STELLA VENETUS/HIER. CAMPAGNA VERON. SCUL.
S. Maria Gloriosa dei Frari, Venice

The saint is paired with *St. Anthony of Padua* on the holy water stoups in the Frari. An inscription on the *St. Anthony* is dated 1609 and states that Friar Balthasar Stella commissioned the works from Campagna. Little attention has been given to the female figure, which has been identified as Innocence or Gentleness; Timofiewitsch correctly identified her as St. Agnes, the early Christian martyr whose attribute is a lamb, and drew attention to the fragment of a martyr's palm in her left hand. In addition, he has convincingly suggested that *St. Agnes* and *St. Anthony* were commissioned as a pair by Stella and that the traditional date of 1593 for *St. Agnes* can be discounted.

Although its patination has suffered from humidity, the *St. Agnes* is one of the finest small bronzes produced by Campagna in the manner of his master, Danese Cattaneo; it is also reminiscent of his own stucco *Virgin Annunciate* of 1582 in S. Sebastiano. While a date of 1609 for *St. Agnes* must be correct, the style has more in common with Campagna's early works and the pose may be based upon an earlier model.

B.B.

REFERENCES

Timofiewitsch 1972, pp. 286–87, no. 29, with full bibliography

S4

gifts are attested by his poem, *L'amor di Marfisa* of 1562. In Padua, too, he first gained fame as a portraitist with his bust of Bembo for the latter's tomb in 1547, and subsequently with that of the classical scholar Lazzaro Bonamico (Cat. S5). He also undertook major commissions in Verona, including the statue of the celebrated physician and poet Girolamo Fracastoro and the imposing Fregoso monument in Sant'Anastasia. While in Verona, Cattaneo probably took on Girolamo Campagna as an apprentice and collaborator; it was to Campagna that he bequeathed his collection of models and drawings.

Cattaneo's most notable works in Venice are the *Apollo*, originally on the well-head of the Public Mint and now at the Palazzo Pesaro, one each of a pair of atlantes and caryatids for the Doge's Palace (with Pietro da Salò), and busts of Gasparo Contarini and Giovanni Andrea Badoer in S. Maria dell'Orto and S. Giovanni Evangelista respectively. His last projects, the Monument to Doge Leonardo Loredan (d. 1521) in SS. Giovanni e Paolo and a relief for the Santo, Padua, were unfinished at the time of his death, but were completed by Campagna.

B.B.

REFERENCES

Burns 1980, pp. 165–66; Macchioni and Gangeni in D.B.I., XXII, 1979, pp. 449–56, with full bibliography; Rigoni 1970, pp. 217–37; Sansovino 1575, p. 18; Temanza 1778, pp. 269–83; Vasari (ed. Milanesi) 1878–85, VII, pp. 522–26

Danese Cattaneo

Carrara *c.* 1509 – Padua 1572

'A most cultivated poet, an excellent sculptor, and a person of great spirit, full of unadorned goodness.' So wrote Francesco Sansovino of his friend Danese Cattaneo. Cattaneo was born in the mountains of Carrara and studied sculpture under Jacopo Sansovino in Rome. In 1527 he followed his master to Venice and soon set up as an independent sculptor. His first works include a group of figures probably executed for Sansovino in San Marco. These no longer survive, but a statuette of *St. Jerome*, completed by 1530, remains in S. Salvatore. According to both Vasari and Francesco Sansovino, Cattaneo executed some of the sculptural decoration on the Library and the Loggetta.

Cattaneo also worked outside Venice. In Padua, he was involved in some projects for the shrine of St. Anthony, although little came of them. More significantly, while there he became a friend of Alvise Cornaro, Pietro Bembo, and Bernardo and Torquato Tasso, among others. His literary

S5

Lazzaro Bonamico

Bronze; 75.3 × 77.4 cm
Inscribed on the base: LAZ. BON. BAS.
Museo Civico, Bassano del Grappa
[*repr. in colour on p. 144*]

Bonamico (1479–1552) was an eminent classicist at the University of Padua who moved in the same intellectual circles as Cattaneo. On Bonamico's death, his heirs decided to erect a monument in the Paduan church of S. Giovanni di Verdara and commissioned a bust from Cattaneo, whose portrait of Pietro Bembo in the Santo was widely admired. The monument to Bonamico was, in fact, an exact copy of that of Bembo, the architectural design of which has recently been attributed to Cattaneo's friend, Andrea Palladio. It is probable that Cattaneo simply copied the design of the Bembo monument, substituting a bronze portrait for the marble bust. The bust and monument of Bonamico parted company when the church of S. Giovanni was demolished in 1818; the monument, with a stone copy of the bust, was re-erected in the second cloister of the Santo, while the bronze was acquired privately and subsequently given to the museum of Bonamico's native town of Bassano.

Cattaneo's excellence as a portraitist is evident in the refinement and sensitivity of this bust. It is the only bronze by the sculptor, and one of only four portraits securely attributable to him.

B.B.

PROVENANCE
S. Giovanni di Verdara, Padua; 1818 G. B. Roberti; 1841 Museo Civico

EXHIBITIONS
Venice 1946, no. 224; London 1961, no. 139, with bibliography;
Amsterdam 1961–62, no. 138

REFERENCES
Avesani in D.B.I, 1969, pp. 533–40; Burns 1979, pp. 19–20; Chiarelli 1909,
pp. 82–98; Planiscig 1921, p. 424

Desiderio da Firenze

Florence—active Padua 1532–45

Presumably of Florentine origin, Desiderio is first documented in Padua on 7 March 1532, when he received an advance payment for the bronze voting urn for the Maggior Consiglio of the Comune of Padua (Cat. S6). In these documents he is described as a sculptor and founder. The advance payment for the voting urn was dated four months before Riccio's death on 8 July 1532, at a time when he is known to have been too ill to work, and it has been conjectured by Moschetti that Desiderio was his assistant and was entrusted with the work because of his master's infirmity. But this theory cannot be substantiated: the style of the urn seems to owe little to Riccio, and can to a great extent be explained in Florentine terms.

Desiderio is next mentioned in a letter from Pietro Bembo to Giambattista Ramusio, dated 23 June 1537, in which Bembo recommended him as the best sculptor to execute the bronze cover for the baptismal font in San Marco, Venice, in such warm terms that it suggests Desiderio and Bembo were intimate friends. In fact, it was not until 18 April 1545 that Desiderio actually contracted to make the font cover in collaboration with the Paduan sculptor Tiziano Minio. The credit for the reliefs on it is conventionally given to Minio, but the respective roles of the two collaborators have never been established.

Attempts to ascribe other bronzes to Desiderio have enjoyed little success: a group of elaborately decorated handbells, ascribed to him by Planiscig, has been shown to be from the workshop of Vincenzo and Gian Girolamo Grandi, and of three statuettes of satyrs attributed to him by Planiscig one is signed by Adriano Fiorentino, the second is an autograph work by Riccio (see Cat. S21) and the third is derived from a Riccio model (see Cat. S24), while a sword hilt ascribed to him in the Armeria Reale, Turin, has also proved to be the work of Riccio. Desiderio may, nevertheless, have been responsible for certain bronze artefacts which seem to reflect the styles of both Riccio and Sansovino.

A.F.R.

REFERENCES
Cessi 1967, pp. 65–67; Jestaz 1975; Jestaz 1983, p. 39; Leithe-Jasper 1981;
Moschetti 1927, pp. 148–49; Planiscig 1921, pp. 396–403; Planiscig
1930–31; Pope-Hennessy and Radcliffe 1970, pp. 152–57; Radcliffe 1982,
pp. 415–18; Ronchi 1933–34, p. 310, note 1

S6

Voting Urn of the Maggior Consiglio of the Comune of Padua

Bronze, parcel-gilt; 51 cm
Museo Bottacin, Museo Civico, Padua (no. 370)

This urn, which is cast in three sections, bears the arms of the city of Padua on the three faces of the base and the lion of St. Mark three times on the bowl. Documents referring to its execution, published by Moschetti, show that it was already in progress by 7 March 1532, when an advance payment was made to Desiderio, and that it was finished by 8 February 1533, when Desiderio received a final payment. Although described as derivative from Riccio's style, the urn's general design and most of its decorative elements can be traced back to Florentine sources, most notably to Verrocchio.

A.F.R.

EXHIBITIONS
London 1961, no. 74; Amsterdam 1961–62, no. 71; Florence 1962, no. 70;
Padua 1976, no. 92

REFERENCES
Mariacher 1971, p. 34; Moschetti 1927, pp. 148–9; Moschetti 1938, p. 219;
Planiscig 1930–31, pp. 71–72

S6

Antonio Lombardo

c. 1458 – Ferrara 1516

Antonio, thought to be the younger of Pietro Lombardo's sons, and his brother Tullio were already mentioned as promising assistants of their father in 1475, and both would have collaborated with Pietro on such major projects in Venice as the Mocenigo and Marcello monuments (1476–81, 1481–85), the church of S. Maria dei Miracoli (1481–89) and the façade of the Scuola Grande di San Marco (1488–90). They also worked together on the Zanetti and Onigo monuments in Treviso (1485, 1490). During the 1490s, Antonio may have helped his brother Tullio with the large monument to Doge Andrea Vendramin, formerly in the church of S. Maria dei Servi, as well as being involved with the growing family architectural practice.

Antonio began to emerge as an independent personality in 1500, when he contracted to carve one of the first two reliefs for the new shrine of St. Anthony in the Santo, Padua. The *Miracle of the Speaking Child* was finished in June 1501, and in the same month Antonio and Tullio Lombardo agreed to provide two more reliefs for the cycle, Antonio's subject being *The Miracle of the Miser's Heart*. Protracted disagreements between the brothers and their patrons put paid to this new project, which Antonio dropped in favour of a more attractive commission to make bronze figures for the funerary chapel of Cardinal Zen in San Marco (1503–06). His most important work there was the over life-size *Madonna della Scarpa*. Disagreements led Antonio to break off this project as well, and by early 1506 he had moved to Ferrara where he remained in the service of Alfonso I d'Este, Duke of Ferrara, for the rest of his life. His chief undertaking there was the decoration of Alfonso's apartments, from which a number of reliefs survive. His three sons, Aurelio, Girolamo and Ludovico, all became sculptors working principally in bronze at Loreto. The exact date of Antonio Lombardo's death is not known, but it occurred between January and June 1516.

B.B.

REFERENCES

Maek-Gérard 1980; Moschetti in Thieme-Becker, XXIII, 1929, p. 341; Munman 1977; Paoletti 1893, pp. 243–47, 250–51; Planiscig 1921, pp. 213–26; Planiscig 1937; Sansovino 1581, V, p. 12; Venturi 1935, pp. 379–400

S7

The Forge of Vulcan

Marble; 83 × 107 cm
The State Hermitage Museum, Leningrad

This is one of a series of 28 reliefs now in the Hermitage. The majority are small and decorative, but *The Forge of Vulcan* and its companion piece, *The Contest between Minerva and Neptune* (83 × 105 cm), are conspicuously larger and illustrate narrative subjects. All these reliefs, together with a frieze now in the Louvre, Paris, were once in the Este palace at Sassuolo, and among the inscriptions on them one records the date 1508 and three name the

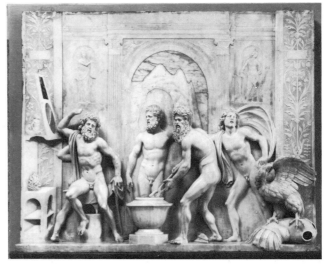

S7

patron, Alfonso I d'Este, Duke of Ferrara. They are universally accepted as the work of Antonio Lombardo. The traditional theory that these reliefs formed part of the decoration of Alfonso's famous *camerino d'alabastro*, which contained Bacchanals by Titian and other artists, has been challenged by Hope and Goodgal, who have suggested instead that most, if not necessarily all of them, were originally in the *studio di marmo*, a room constructed above the moat of the castle at Ferrara in 1508.

The subject matter of the two largest reliefs has not attracted much attention. Wind suggested that they contained a personal device of Alfonso, while Goodgal proposed that they symbolised the Duke's readiness for war or peace. Whatever the merits of these theories, the proposal of Zaretskaia and Kossaréva that the *The Forge of Vulcan* actually shows the birth of Minerva is very plausible. The man on the left, posed in a Laocoön-like study of suffering, could be Jupiter labouring to beget Minerva, who sprang from his head when Vulcan cleft it with an axe (an axe-head lies by Vulcan's right foot). But without knowing what Jupiter held in his right hand, some doubt must remain, and the identity of the other figures has still to be established. However, episodes concerning the goddess of wisdom would obviously have been appropriate for the decoration of Alfonso's study.

The subjects illustrated by Lombardo are rare in Renaissance art, and his attention may have been attracted to them through literary accounts of the work of the Greek sculptor Pheidias, notably Pausanias's description of the pediment sculptures of the Parthenon. The quotations from classical sculpture which abound in this relief certainly suggest that it was intended as an explicit recreation of a classical work of art. Although Pausanias's text was not published until 1516, it was known to Pomponius Gauricus by 1504, and as Gauricus was a friend of Tullio Lombardo, he may have discussed the passage with the two brothers.

B.B.; A.F.R.

PROVENANCE

Alfonso I d'Este, Duke of Ferrara; Palazzo Estense, Sassuolo; Count d'Espagnac; F. Spitzer, Paris; Count Polotzoff, Moscow; Stieglitz Museum, St. Petersburg

REFERENCES

Boucher and Radcliffe 1984, forthcoming publication; Campori 1874;
Chastel and Klein 1969, p. 21; Chevallier and Manheim 1893, pp. 210–12;
Goodgal 1978; Hope 1971; Piot 1878, pp. 594–98; Planiscig 1921,
pp. 222–25; Sheard 1978¹, nos. 19, 61; Walker 1956, p. 35; Wind 1948,
p. 38; Zaretskaia and Kossaréva 1970

s8

Mars

Marble; 44 × 37 cm
Inscribed: NON BENE MARS/ BELLVM POSITA NI/SI VESTE MINISTRO
Galleria Estense, Modena

This relief, first recorded in 1684 at the Este Villa delle
Pentetorri in Modena, was presumably among the works of
art brought from Ferrara at the extinction of the duchy in
1598. In both the carving and the presentation of the figure
it is close to the Leningrad reliefs (Cat. s7). The pose may
have been inspired by an engraved classical gem showing
Mars seated, in three-quarters profile, with shield and spear.
One such gem is in the British Museum; a similar figure is
on the reverse of a medal by Vettor Gambello (Hill 1930).

The *Mars* was attributed to Antonio Lombardo until the
1930s when Pallucchini assigned it to Mosca, comparing it
to the *Portia* (Ca d'Oro) and *The Judgement of Solomon*
(Cat. s14). But the handling of the anatomy and the
individualised treatment of the tight curls of Mars's hair are
far superior to the looser and more regularised handling of
the executioner in *The Judgement of Solomon*. Given that
Mosca had no documented contact with Antonio Lombardo
or Ferrara, the original attribution seems plausible.

It has recently been suggested that *Mars* once had as a
pendant a personification of *Peace*, and that both reliefs
commemorated the Battle of Ravenna of 1512 (Lewis 1978).
But there is no evidence for this theory, and the inscription
('I, Mars, do not conduct war well unless I have taken off
my clothes') would suggest that the pendant, if there was
one, showed Venus. That such a pendant may have existed
is suggested by an engraving of *Mars, Venus and Cupid* by
Marcantonio Raimondi, dated 16 December 1508. The
figure of Mars in this engraving, which is exceptional in
Raimondi's work for the fluency of the treatment of the
male nude, has been related to the *Belvedere Torso*, but it
is actually closer, if inferior in quality, to Antonio's relief.
The implication is that Marcantonio had direct knowledge
of this relief, which, in its turn, was inspired by the
Belvedere Torso. Since the print includes an intensely
Lombardesque Venus, it may be that the engraver simply
combined figures from two pendant reliefs.

B.B.; A.F.R.

PROVENANCE
Estense Collection, Ferrara (?); Villa delle Pentetorri, Modena

EXHIBITIONS
Ferrara 1933, pp. 212f, no. 252

REFERENCES

Boucher and Radcliffe 1984, forthcoming publication; *Documenti inediti*
1878–80, III, p. 26; Hill 1930, I, p. 118, no. 448; Lewis 1978; Pallucchini
1936; Planiscig 1921, pp. 222–24; Quintavalle 1959, p. 52; Shoemaker and
Broun 1981, pp. 76–79, no. 13

S8

s9

Philoctetes

Marble, inlaid with red and grey breccia; 41.3 × 24.8 cm
Insribed on the base: VVLNERA (LER)NAEO DOLET HIC
POEAN(TIUS) .HEROS.
Victoria & Albert Museum, London (A.9-1928)
[*repr. in colour on p. 141*]

This relief shows the hero Philoctetes, son of Poeas,
abandoned on the island of Lemnos by his companions on
the journey to Troy because of the intolerable stench of a
wound in his foot, caused accidentally by one of Hercules's
arrows poisoned with the blood of the Lernean Hydra
(Servius's commentary to the *Aeneid*, book III). But no
classical source has been found for the inscription, which
was probably composed specifically for the relief. The basic
composition is related to a Hellenistic cameo by Boethos
(Schlosser 1913), while the figure itself, like that in the relief
of *Mars* (Cat. s8), is derived from the *Belvedere Torso*.

The unusual popularity of the relief is demonstrated by
the existence of four other versions, now in Leningrad,
Mantua, Cleveland and an anonymous private collection.
Although Antonio Lombardo's responsibility for the design
is generally accepted, there is some doubt about the status
of the different versions. The one in Leningrad is certainly
autograph: not only is the carving of exceptional quality
and sensitivity, but it is unique amongst this group of reliefs

in the fact that elements such as a hand, the feet, the tree, and the bow and quiver all extend beyond the border in a manner very characteristic of Antonio's reliefs. The present relief is a closely related variant, which Pope-Hennessy regarded as autograph too; but the quality of the carving is obscured by the badly abraded surface. Of the other three versions, the one in Mantua comes closest to the Leningrad model, but it is too damaged to permit a clear assessment of its original quality.

A.F.R.

PROVENANCE

Private collection, England; 8 December 1927, Christie's, London sale (lot 82); J. Rochelle Thomas; 1928 acquired by the Victoria & Albert Museum

REFERENCES

Boucher and Radcliffe 1984, forthcoming publication; Furtwängler 1900, pl. 57, 3; Ozzola 1950, p. 38; Pope-Hennessy 1964¹, pp. 353–57; Ruhmer 1974, p. 64; Schlosser 1913, pp. 97f; Stechow 1906

Tullio Lombardo

c. 1455–Venice 1532

Neither the date nor the place of birth of Tullio Lombardo are known, but his early years would have been spent travelling and working with his father, the sculptor and architect Pietro Lombardo. Tullio and his brother Antonio are first mentioned as their father's assistants in a letter of 1475, and Francesco Sansovino reported their collaboration with Pietro on the monument to Doge Pietro Mocenigo in SS. Giovanni e Paolo (1476–81). Sansovino also stated that Tullio made the statues in the presbytery of S. Maria dei Miracoli, presumably the half-length figures on the choir balustrade. Tullio's earliest signed work is the group of four angels, originally made for the church of S. Sepolcro in 1484. He also helped his father on a number of sculptural and architectural projects such as the Zanetti and Onigo monuments in Treviso (1485, 1490), and assisted in the rebuilding of the presbytery of Treviso Cathedral (1485–88).

During the late 1480s and early 1490s, Tullio seems to have emerged as the dominant artistic personality in the family workshop. Sansovino credited him with the large narrative reliefs on the façade of the Scuola Grande di San Marco (c. 1488–90), which show his careful study of antique sculpture, and Tullio is generally held to be the chief designer of the monumental tomb of Doge Andrea Vendramin, now in the presbytery of SS. Giovanni e Paolo, which was underway in 1493. His signed double portrait relief (Ca d'Oro, Venice) may be contemporary.

Around 1500 Tullio carved the relief of *The Coronation of the Virgin* for the Bernabò Chapel of S. Giovanni Crisostomo, and that same year he and his brother contracted to carve the first two reliefs for the new shrine of St. Anthony in the Basilica del Santo, Padua. Tullio's contribution, *The Miracle of the Repentant Youth*, was probably finished by 1502 though a final payment was not agreed until 1505. He agreed to carve a second relief for the chapel in 1501 – this time the *Death of St. Anthony* – but

the project came to nothing. One of his few surviving works from the early 1500s may be the *Bacchus and Ariadne* (Cat. s10). During this period Tullio appears to have become more involved with architecture, which may partly explain the contraction of his sculptural output. He probably began supervising the reconstruction of the abbey church at Praglia, near Padua, in the 1490s and was involved in the architectural decoration of the Zen Chapel in San Marco from 1506. He also became *proto* of the Scuola Grande della Misericordia and from 1509 directed the construction of the recently begun church of S. Salvatore, as well as making a model for a new cathedral at Belluno in 1517. Tullio had finished his last major tomb, that of Doge Giovanni Mocenigo, by 1522 although it was probably started more than a decade earlier. Between 1520 and 1525 he carved a second relief for Padua, *The Miracle of the Miser's Heart*; he also designed the monument of the soldier Guidarello Guidarelli of Ravenna (Pinacoteca Comunale, Ravenna) and a *Pietà* for Rovigo Cathedral. A letter concerning the *Pietà* shows that Tullio was aware of contemporary debates on the merits of painting versus sculpture. In 1528 he designed the tomb of Matteo Bellati in Feltre Cathedral and agreed to carve a third relief for the shrine of St. Anthony, the *Miracle of the Ass*, but he died before starting it. He was buried in the cloister of S. Stefano.

B.B.

REFERENCES

Maek-Gérard 1980; Moschetti in Thieme-Becker XXIII, 1929, pp. 344–45; Paoletti 1893, pp. 190–255; Planiscig 1921, pp. 226–55; Planiscig 1937; Puppi 1972; Sansovino 1581, pp. 18ᵛ–19ʳ, 63ʳ, 102ʳ; Sartori 1976, pp. 137–41; Sheard 1977; Sheard 1978²; Stone 1972–73; Wilk 1978

s10

Bacchus and Ariadne

Marble; 56 × 71.5 × 20 cm
Kunsthistorisches Museum, Sammlung für Plastik und Kunstgewerbe, Vienna (inv. no. Pl. 7471)

This relief and a related work in the Ca d'Oro, Venice, both depict a young couple placed on a narrow base against a neutral background. The compositions may have been inspired both by ancient sepulchral statuary and by double portraits of a type that had originated north of the Alps and was adopted by Venetian painters in the early sixteenth century.

The subject is ambiguous. The traditional title, *Bacchus and Ariadne*, was given to the young couple solely because of the vine-leaves in the young man's hair, though these might equally be ivy. The work is in all probability a double portrait of a young Venetian patrician couple *all'antica*; the only question is whether it originally belonged with the related relief as part of a single sculptural decoration. The most likely date for the composition is *c.* 1510. A possible indication of date is afforded by Giovanni Bellini's painting of a young woman at her toilet (Kunsthistorisches Museum, Vienna), dated 1515; the woman wears her hair caught in

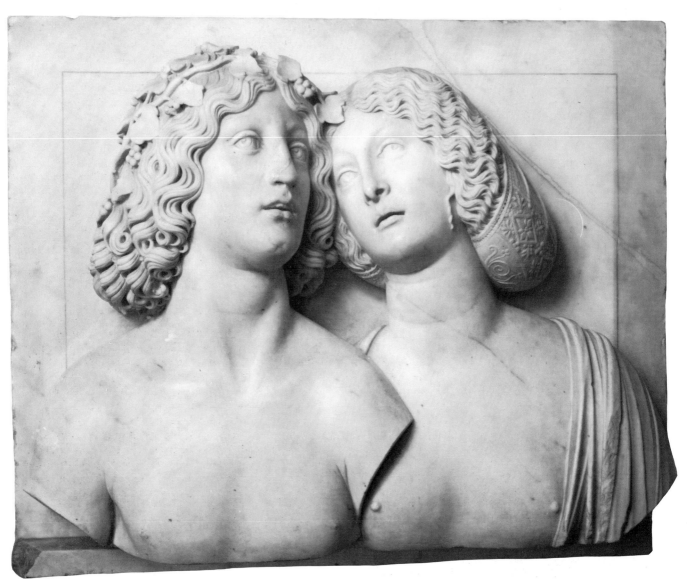

S10

a fashionable snood very similar to the one worn by
Ariadne in this relief. Compared with the *Adam*
(Metropolitan Museum, New York), which was originally
made for the Vendramin tomb, the detail of the present
work is more linear.

Sarah Wilk remarked that in these reliefs Tullio
Lombardo introduced 'poetry' into sculpture, while
Eberhard Ruhmer has spoken of 'antiquity experienced in
the manner of Giorgione'.

M. L-J.

PROVENANCE
Este Collection (?); Marchese Tommaso degli Obizzi, Castello del Cataio;
bequeathed by him to the Kunsthistorisches Museum

REFERENCES
Hinz 1974, pp. 139ff; Leithe-Jasper 1978, p. 119; Planiscig 1919, p. 58,
no. 100, with earlier bibliography; Planiscig 1921, p. 240; Pope-Hennessy
1958, p. 354; Ruhmer 1974, p. 62; Vienna 1966, no. 212; Wilk 1972–73,
pp. 67ff

S11

Female Bust

Rock crystal on a silver-gilt plaque; bust 9.5 × 7 cm, plaque
11 × 7.5 cm
Szépmüvészeti Múzeum, Budapest (79.2-s)

Planiscig proposed that this crystal had been cut by a
Venetian gem-cutter after a wax model supplied by Tullio,
and Szmodis-Eszláry, while recognising its close dependence
on the style and typology of Tullio, ascribed it to an
unknown Venetian gem-cutter of the early sixteenth
century. The crystal is the most outstanding surviving
example of the north Italian gem-cutter's art of its date.
Accounts of the gem-cutting industry in Venice in the early
sixteenth century are given by Planiscig and Kris.

The subject of the crystal, which depicts a woman with
her eyes closed, has never been satisfactorily identified,
although Planiscig suggested Althea, and Lucretia was
proposed by Kris. The crystal is mounted on a silver-gilt

plaque chased with a design analogous to that found on Venetian velvets. Szmodis-Eszláry dated the plaque 1550–1600, but the pattern is consistent with those found on textiles as early as the end of the fifteenth century.

Until recently the bust and its plaque were mounted in a pedimented wooden frame with flanking columns, bearing the inscription PROPRIO FILIO NON PEPERCIT, but the frame, which appeared to date from 1550–1600, was not necessarily made for the crystal, and the inscription is not therefore necessarily relevant to the subject.

A.F.R.

PROVENANCE
Wilhelm Gumprecht, Berlin; 1918 Wilhelm Gumprecht's sale Berlin (Cassirer), as Tullio Lombardo (lot no. 62); August Lederer, Vienna; private collection, Hungary; 1979 acquired by the Museum

REFERENCES
Kris 1929, pp. 42, 160; Planiscig 1921, pp. 245–48, 251; Szmodis-Eszláry, 1981

Antonio Minello

Active Padua 1484–Venice 1527/28

Born in Padua at an unknown date, Antonio was one of two sons of the sculptor Giovanni Minello. A document of 1484 suggests that one of Giovanni's sons was already working with him by that year, and this must have been Antonio

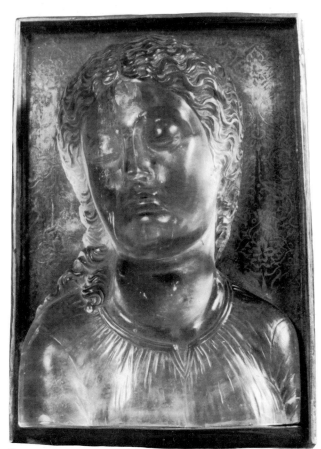

S11

since his only brother, Gerolamo, was not a sculptor but a tailor. Antonio is first documented by name in 1500 in a contract connected with the shrine of St. Anthony, when he and his father appear to have been working in partnership. His earliest independent work was probably the statue of *Santa Giustina* in one of the niches on the façade which forms part of the early decoration of the shrine; however, the overall scheme was supervised by his father. This figure is ascribed to Antonio by Marcantonio Michiel, and in terms of style the attribution seems to be correct.

In 1510, probably as a result of the War of the League of Cambrai, Antonio was in Bologna, where he worked on the great portal of S. Petronio begun by Jacopo della Quercia, carving the 15 panels of prophets for the archivolt with Antonio da Ostiglia. Returning to Padua he completed in 1512 his large narrative relief of *St. Anthony Receiving the Franciscan Habit* for the shrine in the Basilica del Santo, and in the same year had already begun his second relief for the chapel, *The Raising of the Child Parrasio*, which he abandoned after 1522 and which was finished in 1534 by Sansovino.

In 1525 Antonio left Padua for Venice, where he bought the contents of Lorenzo Bregno's workshop from his widow, undertaking to complete two works left unfinished by the sculptor. One of these was the altarpiece in S. Maria Materdomini, in which Minello's hand is clearly visible. His last dated work is the *Mercury* (Cat. S12) carved in 1527 for Marcantonio Michiel, and this is possibly also his last work, since documents published by Rigoni suggest that he died shortly before his father, whose death occurred in 1528. Other recorded works from his Venetian period were two colossal heads of *Hercules* and *Cybele* seen by Michiel in 1532 at the house of Andrea Odoni in Venice, but now lost. It is possible that Minello was also responsible for some of the small classicising marble reliefs generally associated with Antonio Lombardo and Mosca.

A.F.R.

REFERENCES
Frizzoni 1884, pp. 15–16, 155; Gonzati 1854, II, pp. xcv, xcix–c, civ; Paoletti 1893, p. 106; Pope-Hennessy 1952; Rigoni 1970, pp. 259–64; Sansovino 1663, p. 205; Sartori 1976, pp. 151–63; Supino 1914, pp. 29–30, 102; Venturi 1935, X, 1, pp. 410–19

S12

Mercury

Marble, inlaid with bronze; 76.8 cm
Inscribed: MERC. SIMULAC./ M. ANT. MICHAEL P.V./ ANN. VRB. VENET./ MC.VI.F.C./ CONSECRAVITQ./ ANT. MINELL. SCVLPT./ PATAVINVS./ XVI.KAL.MARTI. COEPTVM./ XVII.KAL. QVINT./ PERFECIT./ ANN. SAL./M.D.XXVII.
Victoria & Albert Museum, London (A.44-1951)

The inscription records that the statuette was commissioned by the Venetian patrician and humanist Marcantonio Michiel (1484–1552, the 'Anonimo Morelliano'); it was begun by Antonio Minello on 14 February 1527, and completed by him on 15 June of the same year. On the opposite side of the small altar from the

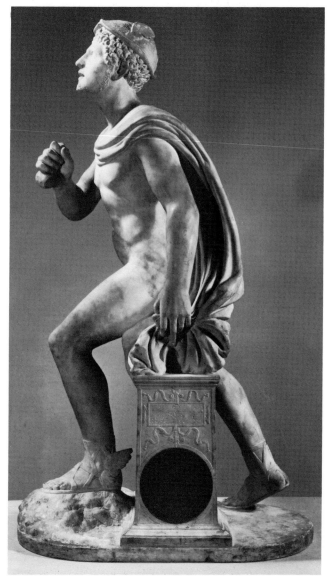

S12

he married Maffea Soranzo, and began to scheme for election to the Senate, in which he was finally successful on 28 September 1527. The peculiarly favourable conjunction of Mercury on 15 June 1527 would therefore have been a good omen for him. This interpretation has since been questioned by Fletcher, and more recently Eade has brought into question the astrological status of the plaque. Observing that the earlier astrological calculations were wrong and that on 15 June 1527 Mercury was unfavourably positioned, Eade interprets the plaque not as a horoscope, but as a simple astronomical diagram showing the position of Mercury on 15 June 1527 in relation to the other planets.

The *Mercury* appears in the earliest inventory of Michiel's collection, probably compiled soon after his death in 1552, and in 1576 was in the possession of Michiel's grandson. As noted by Fletcher, who published the early inventory, the collection was housed in Michiel's palace at Santa Marina in Venice, where the *Mercury* appears to have been paired with a marble *Apollo* of similar scale and valued at the same amount. There is no indication as to whether the *Apollo* was a classical or a modern work. It was conjectured by Pope-Hennessy that the pose of the *Mercury* was based on a classical statue of Hypnos of a type represented in the Prado, Madrid, of which a number of examples survive. The Madrid *Hypnos* was at one time thought to represent Mercury.

A.F.R.

PROVENANCE
Acquired in London by Dr W. L. Hildburgh; 1951 presented by him to the Victoria & Albert Museum

REFERENCES
Cicogna 1861; Eade 1981; Fletcher 1973, p. 383; Fletcher 1981, pp. 465–66; Hartner 1955; Pope-Hennessy 1952; Pope-Hennessy 1964[1], no. 539

Giovanni Maria Mosca

Active 1507–1573

Mosca was probably born at Padua at an unknown date. His father, a boatman named Matteo Mosca, apprenticed him while still a youth to the Paduan stonemason, Giovanni Minello, in April 1507. After five years this contract was rescinded, and Mosca spent the last year of his apprenticeship with another Paduan stonemason, Bartolomeo Mantello, for whom he executed figures in stone, wax, clay and plaster, in exchange for food and clothing. He seems to have had a similar working relationship with the bronze-founder Guido Aspetti, called Lizzaro since a number of terracottas by Mosca were seen in Aspetti's workshop by the Venetian writer Marcantonio Michiel. One surviving work from this collaboration is the bronze relief of *The Decollation of the Baptist* made for the Paduan Baptistry in 1516.

Mosca's only major Paduan commission came in 1520 when he was assigned one of the marble reliefs for the new shrine of St. Anthony; his relief of *The Miracle of the Unbroken Glass* was almost complete by late 1528. The following year he agreed to carve the perspective backdrop for his relief, although he subsequently gave the remaining

inscription, a circular bronze plaque is inlaid; it is engraved with a diagram of the planets, showing the motions of Mercury, placed at the top, the relative positions of the planets on 15 June 1527, the date of the completion of the figure. It has been interpreted as a horoscope by Hartner and Pope-Hennessy, with some difference as to the precise time, which Hartner places at 8.04 a.m. and Pope-Hennessy at 11.46.40 a.m. Pope-Hennessy argues that this shows Mercury in a particularly favourable position as Lord of the Ascendant and of the Midheaven, also in conjunction with the Sun and Jupiter, and that the moment was therefore clearly chosen with great care and must have had some special significance for the career of Marcantonio Michiel. He explains this in terms of Michiel's repeated attempts to secure public office, with a particular desire to serve as ambassador, which were dashed in September 1525 as a result of a disgraceful conflict with a relative that caused him to be debarred from public office for a year. By February 1527, when the statuette was commissioned, Michiel was free once again to try for office. In that month

work to another sculptor, Paolo Stella. A second surviving Paduan work, *The Judgement of Solomon* (Cat. S14), was commissioned by the Paduan professor of philosophy, Giambattista Leone, at about the same time.

In the 1520s Mosca worked in Padua and Venice. Francesco Sansovino recorded a number of Mosca's Venetian works that cannot be traced, as well as two which are still *in situ*, the *San Sebastiano* and *San Pantaleone* on the high altar of the church of S. Rocco. Mosca's name has also been connected with the tombs of Giambattista Bonzio and Alvise Trevisan, both in SS. Giovanni e Paolo, but the attributions are not universally accepted.

Mosca did not enjoy conspicuous success in Padua or Venice and emigrated to Poland around 1530. There he entered the service of King Sigismund I and played a notable role in the development of Renaissance sculpture in eastern Europe. He was still alive in 1573.

B.B.

REFERENCES
Bialostocki 1976, pp. 53–57, 66–69; Fiocco 1965; Frizzoni 1884, pp. 16, 74–75, 77; Kozakiewiczowa 1964; Munman 1970; Paoletti 1893, pp. 240–41, 281; Planiscig 1921, pp. 259–78; Planiscig in Thieme-Becker, XXV, pp. 174–76; Rigoni 1970, pp. 127–28, 138; Sartori 1976, pp. 171–73

S13

Venus Anadyomene

Marble; 40.6 × 25.1 cm
Inscribed on the base: NVDA VENVS MADIDAS EXPRIMIT IMBRE COMAS
Victoria & Albert Museum, London (A.19-1964)
[*repr. in colour on p. 140*]

The inscription is taken from Ovid's *Ars Amatoria* III, 224, and the subject reflects descriptions of the lost *Venus Anadyomene* by Apelles. The relief has been ascribed to Antonio Lombardo (Pope-Hennessy 1964; Ruhmer 1974), but the large empty spaces in the background are uncharacteristic of Antonio, as are the full, sensuous forms of the body and face, which are closer to the female figures of his brother Tullio, as, for example, in his relief of *The Miracle of the Miser's Heart* in Padua (1520–25). Yet there is a softness in the handling, particularly of the hair, face and waves, which is alien to Tullio, whose carving was always crisp and clear, and the unbalanced composition is foreign to both brothers. These considerations point to a sculptor, perhaps of a younger generation, influenced by Tullio's mature style.

The obvious candidate is Mosca. Indeed, a close analogy to Venus is provided by the true mother in his relief of *The Judgement of Solomon* (Cat. S14), especially in the curiously unstable pose, the handling of the anatomy and the physiognomy. Even the lettering of the inscription corresponds exactly with that on Mosca's relief, to the extent that the letters 'V' and 'S' are rendered defectively in just the same way. It is also significant that Marcantonio Michiel saw several terracotta models by Mosca in the house of Guido Lizzaro in Padua, including one for *The Judgement of Solomon* (Cat. S14) and another of *Venus Emerging from a Shell*, which could well have been the

model for this relief. If so, the *Venus* probably originated in Padua in the circle of Giambattista Leone during the 1520s.

A.F.R.

PROVENANCE
Thomas, 8th Earl of Pembroke (1645–1732), Wilton House; by inheritance to successive Earls of Pembroke, Wilton House; 2 June 1964 bought by Wildenstein, Christie's, London sale (lot 98); 1964 acquired by the Victoria & Albert Museum, with the assistance of the National Art-Collectors Fund

REFERENCES
Frizzoni 1884, p. 74; Pope-Hennessy 1964¹, II, p. 465; Ruhmer 1974, pp. 63f

S14

The Judgement of Solomon

Marble; 60.2 × 59.5 × 15.5 cm
Inscribed on the background panels: QVIS DICET REG/ NON SAPIEN/ IVDI/CASSE/ CONT EMP ET A/MOR E DIIVDIC/ EST VER/ITAS; on the base: POSTHVMVS
Département des Sculptures, Musée du Louvre, Paris (no. 647)

The relief illustrates I *Kings* III, 16–28. The head of Solomon was stolen in 1874; both he and the false mother have lost their right arms. Inlaid panels, which once adorned Solomon's podium and the base on which the infant rests, have also been lost.

Marcantonio Michiel saw a terracotta model for a relief of *The Judgement of Solomon* in the workshop of the Paduan founder, Guido Lizzaro. Michiel noted that the marble version, commissioned by Giambattista Leone, was given by Leone to 'an English bishop'. Planiscig connected this *Judgement of Solomon* with Mosca's lost marble relief and Saxl noted that 'Posthumus', which is inscribed on the base, was one of Giambattista Leone's names.

A comparison of this work with Mosca's relief of *The Miracle of the Unbroken Glass* in the shrine of St. Anthony at the Basilica del Santo, Padua, confirms that they are by the same hand. Both reliefs share similar figure types, based upon the work of Antonio Lombardo, and the same schematic drapery patterns which bear no relationship to the forms beneath; both reflect the work of a sculptor of some talent but with a derivative manner and facile technique. The difference in quality between *The Judgement of Solomon* and the relief of *Mars* (Cat. S8), here attributed to Antonio Lombardo, illustrates Mosca's limitations as a sculptor: the executioner here appears to be based on Lombardo's *Mars*, or a common prototype, but his expression is less focussed, his curls lack the crispness of those of Mars, and the anatomy, particularly his right shoulder, is much less assured. The most accomplished figure, the true mother, is a softer version of a type found in the reliefs of Tullio Lombardo and may be compared with the *Venus Anadyomene* (Cat. S13).

The subject of the Judgement of Solomon was popular in Venetian art, but Mosca's presentation differs from the painting by Sebastiano (Cat. 97). Mosca presents the scene in the manner of a classical *adlocutio*, or exhortation by a Roman emperor to his troops, an idea that may have been

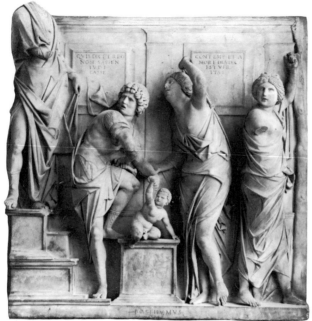

S14

suggested to him by Giambattista Leone. Leone was a professor of philosophy at Padua and belonged to a small group of intellectuals, including Pietro Bembo and Niccolò Leonico Tomeo, who were passionately interested in classical culture and encouraged contemporary artists to employ its styles and subjects. Leone commissioned the Paschal Candelabrum for the Santo from Riccio and may well have commissioned *The Judgement of Solomon* from Mosca after the sculptor was awarded the commission for *The Miracle of the Unbroken Glass* for the Santo in 1520. An approximate *terminus ante quem* for the relief can be taken from Leone's gift of the marble to the English bishop, who has been identified as the future Cardinal Reginald Pole. Pole was resident in Padua from 1521 to 1526 and studied philosophy with Leone. The relief was very likely executed during those years and given to Pole as a token of esteem by his former tutor.

B.B.; A.F.R.

PROVENANCE
Giambattista Leone, Padua; given by him to Cardinal Reginald Pole; *c.* 1800 acquired by Alexandre Lenoir in Paris, reputedly from a certain *marbrier* named Balleux, and incorporated in a fanciful reconstruction to his design of the monument of Michel de l'Hôpital in the Musée des Monuments Français by the sculptor Beauvallet

REFERENCES
Chastel and Klein 1969, pp. 15–19; Frizzoni 1884, pp. 74–75; Lenoir 1800–06, IV, pp. 111–12, no. 541; Planiscig 1921, pp. 262–63; Saxl 1938–39, pp. 354–55; Stechow 1960; Vitry 1922, p. 79

Maffeo Olivieri

Brescia 1484–Brescia 1543/44

Maffeo Olivieri seems to have passed his entire career in Brescia working as a bronze-founder and, in partnership with his brother Andrea, as a sculptor in wood. He is

known by one identified work in each of these media: the signed and documented pair of bronze candelabra presented in 1527 to San Marco, Venice (Cat. S15), and a fully-documented, polychromed wooden altarpiece in the church of S. Maria at Condino (Trentino), commissioned in 1538 and completed by his brother in 1544–45 after Maffeo's death. The suggestion that Olivieri and his workshop – which appears to have been of some size – were responsible for the sumptuous monument of Marcantonio Martinengo (d. 1526), with its ambitious bronze reliefs (formerly in the church of the Corpo di Cristo, Brescia; now in the Museo Cristiano) is probably correct. Less acceptable are attempts to ascribe to Olivieri, on the basis of comparison with the figures on the candelabra, a variety of bronze statuettes in exaggerated poses; one case has now been proved to be wrong. However, the ascription to him of a group of medals, formerly assembled under the name of the 'Medallist of 1523', is more plausible. If this is correct, Olivieri was a medallist of considerable distinction. Apart from Gaspare de Olivieri Macri (active 1548–98), whose signed candlestick of 1551 is now in the Museo Poldi-Pezzoli, Milan, Olivieri is the only one of the many recorded members of the sixteenth-century bronze-founding industry which flourished in Brescia to have been identified so far.

A.F.R.

REFERENCES
Bode 1909²; Hill 1930, pp. 126–30; London 1975, no. 117; Morassi 1936; Planiscig 1921, pp. 306–08; Planiscig 1932¹; Rossi 1977

S15
Candelabrum

Bronze, inlaid with silver, on a marble base; 171.5 cm, 184 cm with base
Inscribed: MAPHEVS OLIVERIVS BRIXIANVS FACIEBAT, and ALTOBELLVS AVEROLDVS BRIXIANVS EPIS. POLEN. VENET. / APOSTOLICVS DEO OPT. MAX. DEDICAVIT.
Basilica di San Marco, Venice

The candelabrum is one of a pair which differ only in the allegorical figures seated in the niches on the central register. Identical inscriptions appear on each candelabrum on two inlaid bands of silver set just below the socket and directly above the ring of male statuettes in the centre of the upper section of the stem. They record that the candelabra were made by Maffeo Olivieri of Brescia, and that they were commissioned by Altobello Averoldo of Brescia, Bishop of Pola and Apostolic Legate in Venice. Marin Sanuto noted in his diary on 24 December 1527 that on that day Averoldo had presented to San Marco two large candelabra which were placed before the high altar. Averoldo had been appointed Legate to Venice in 1526, and the gift would thus appear to have been connected with his appointment. Among the medals which have been ascribed to Olivieri is one of Averoldo. The inscription on this medal also describes him as Apostolic Legate to Venice, so it would seem likely that the medal was commissioned at much the same time as the candelabra.

The allegorical figures in the niches on the middle register of one of the candelabra, all female, are identifiable as the

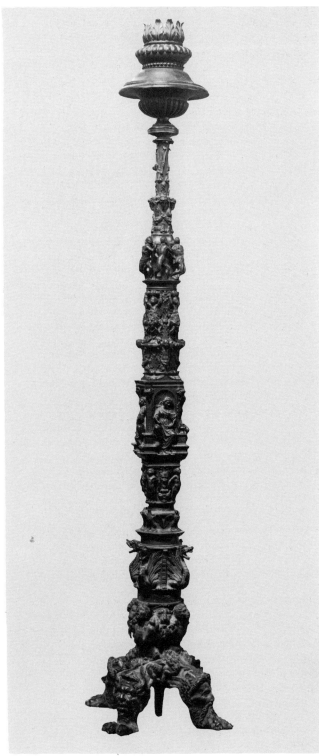

S15

Virtues Charity, Prudence, Temperance and Fortitude. Of the figures on the other candelabrum, three of which are female and one male, two of the female figures represent Faith and Hope, while the other two figures remain enigmatic.

A.F.R.

REFERENCES

Bode 1909; Hill 1930, no. 486; Planiscig 1921, pp. 306–08; Planiscig 1932[1]

Andrea Briosco, called
Riccio

Trent (?) 1470 – Padua 1532

Andrea Briosco, known as Riccio (Curly-head) was born in 1470, one of the six sons of the goldsmith Ambrogio di Cristoforo Briosco; his family was Milanese by origin, but had more recently settled at Trent. Riccio may have been born at Trent, although his father worked in Padua before his birth and settled there soon afterwards. Riccio was trained as a goldsmith in his father's workshop, but he abandoned the profession to learn the art of sculpture, in bronze and terracotta, from the Paduan sculptor Bartolommeo Bellano, a former assistant of Donatello.

His first documented activity was the completion in 1498 of Bellano's monument to Pietro Roccabonella in S. Francesco, Padua, after Bellano's death in 1496/97. In July 1506 he received the commission for two bronze reliefs of the *Story of Judith* and the *Transport of the Ark* which were to complete Bellano's cycle of reliefs of Old Testament subjects on the choir screen of the Basilica del Santo. These were finished and installed by March 1507, and in the same month he received the contract for the great bronze Paschal Candelabrum for the Santo, his most important work, finally installed only in 1516 because of interruptions caused by the war. Shortly afterwards he executed another major work, the monument to Girolamo and Marcantonio della Torre for S. Fermo Maggiore, Verona (Cat. S17, S18), and in 1520 one of his most important works in terracotta, a life-size statue of the seated Virgin and Child, was installed on the altar of the Scuola del Santo. His last recorded work was a life-size group in polychromed terracotta of the *Lamentation over the Dead Christ*, modelled for the church of S. Canziano in 1530, from which only the figure of the dead Christ survives in the church, while the upper halves of the statues of the two Marys are in the Museo Civico, Padua. Riccio was on intimate terms with the leading scholars of his day at the University of Padua, and this is reflected in the learned character of his work. It must have been largely for them that he made his bronze statuettes, a genre in which he excelled, and which he used as a vehicle for the expression of profound human insights.

A.F.R.

REFERENCES

Gonzati 1852, I, pp. 139–47; Planiscig 1927; Rigoni 1970, pp. 217–20, 230–31; Radcliffe 1983; Sartori 1976, pp. 198–230

S16
The Victory of Constantine

Bronze, parcel-gilt; 38.5 × 50.5 cm
Galleria Giorgio Franchetti alla Ca d'Oro, Venice

This relief, which depicts the victory of Constantine the Great over Maxentius at the Battle of the Milvian Bridge in 312, is one of a series of four reliefs with subjects from the *Legend of the Cross*. The other three represent *The*

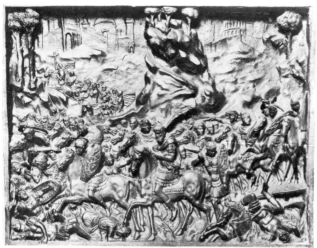

S16

Finding of the Crosses, The Proof of the True Cross, and *Constantine's Vision of the Cross.* The reliefs come from the church of S. Maria dei Servi in Venice (suppressed in 1812), where they were built into the altar of the Holy Cross, an altar with a tabernacle which housed a relic of the True Cross in a cruciform reliquary of jasper, enclosed in a silver casket. The tabernacle was closed by a pair of bronze doors modelled in relief with a scene representing the *Glorification of the Cross,* with *The Deposition* and *The Entombment* below. The bronze doors are now in the Ca d'Oro, along with the four narrative reliefs.

The relic was presented to the church in 1492 by the Venetian diplomat Girolamo Donato (1454–1511). However, there is no contemporary record for the construction of the altar, first mentioned only in 1581 by Francesco Sansovino, who gave no information as to its origin. As a result, the dating of the four reliefs and the tabernacle door has been the subject of considerable debate. It was assumed by Planiscig and other writers that the altar and its bronze reliefs were commissioned by Donato himself, although there is no documentary evidence for this. Since Donato died destitute, the commission could hardly date from the end of his life, or have been provided for in his will, as has been suggested. Planiscig, noting that Donato was active in Venice principally between 1501 and 1509, dated the bronze reliefs within these years, thus making them roughly contemporary with the two bronze reliefs by Riccio for the choir screen of the Basilica del Santo, which are documented to 1506–07. Draper has recently argued that the reliefs are stylistically more evolved than those in the Santo, and has dated them to *c.* 1507–10. However, Pope-Hennessy had already come to the opposite conclusion, seeing the reliefs as less evolved than those in the Santo, and therefore to be dated to not long after the gift of the relic, probably to the years 1495–1500, a dating supported by Cessi and, more recently, by Radcliffe. The tabernacle doors, with their scarcely assimilated references to Mantegna and Bellano and architectural features inspired by Pietro Lombardo, must themselves be a very early work by Riccio, probably made only shortly before the four narrative reliefs, since there are very close correspondences in handling, particularly in the treatment of the architectural elements.

A.F.R.

PROVENANCE
Church of S. Maria dei Servi, Venice; 1812 transferred to the Accademia di Belle Arti; later transferred to the Museo Archeologico in the Palazzo Ducale

REFERENCES
Cessi 1965², pp. 56–60; Draper 1978, pp. 170–71, 180, note 14; Planiscig 1927, pp. 211–20; Pope-Hennessy 1963¹, p. 18; Radcliffe 1972, p. 43; Radcliffe 1983, p. 44; Sansovino 1581, p. 57b

S17 & S18

The Illness of the Professor The Soul of the Professor in the Fortunate Woods

Bronze; each 37 × 49 cm
Département des Objets d'Art, Musée du Louvre, Paris

These two reliefs belong to a series of eight removed in 1796 from the tomb of Girolamo and Marcantonio della Torre in the church of S. Fermo Maggiore, Verona, all of which are now in the Louvre. The tomb, largely intact except, apparently, for six bronze figures of putti missing from the top of the sarcophagus, still stands today in the Cappella Turriana in S. Fermo Maggiore; the reliefs have been replaced by modern copies.

The tomb commemorates Girolamo della Torre (d. 1506), a distinguished physician who taught medicine at the University of Padua, and one of his sons, Marcantonio, also a distinguished professor of medicine, an anatomist, collaborator of Leonardo da Vinci and classical scholar, who died in 1511. Riccio's authorship of the tomb is attested in a document discovered by Morelli in the archive of S. Agostino, Padua; it contains a draft epitaph for Riccio's own tomb by Fra Desiderio dal Legname, which cites the tomb along with Riccio's other major masterpiece, the Paschal Candelabrum. This was rejected in favour of the more elegant epitaph by Girolamo del Negro, which mentions only the Candelabrum.

No other documents relating to the tomb have been discovered, and its date is therefore problematic. It was dated by Planiscig to the years 1516–21; that is, between the completion of the Paschal Candelabrum and the commencement of Riccio's next documented work in bronze, the bust of Antonio Trombetta. Saxl assumed that the scenes depicted in the narrative reliefs relate exclusively to the life of Girolamo della Torre, rather than to that of his son Marcantonio as well, and for that reason Pope-Hennessy has proposed that the tomb must have been commissioned before the death of Marcantonio in 1511. However, the scenes depicted are in no way specific to the father or the son, and could apply equally well in general terms to either of them. They show a medical professor teaching, his illness and his death and the subsequent progress of his soul. The protagonist, a conventional bearded classical type, is in no way characterised, and resembles neither Girolamo nor Marcantonio as they appear in the casts from their death-masks on the top of the tomb, or in their medals.

It seems unlikely that so ambitious a project could have

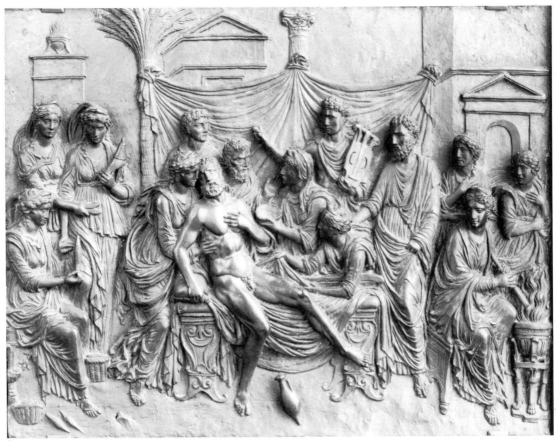

S17

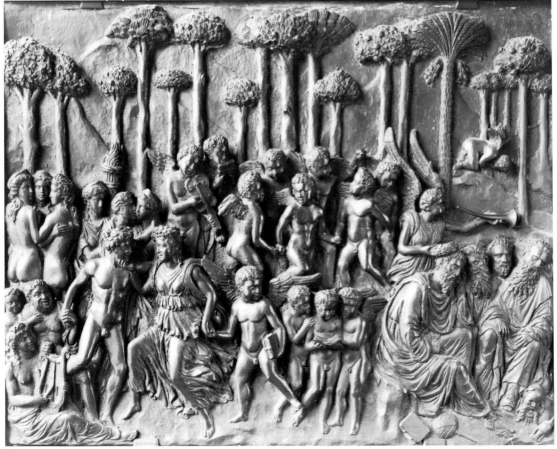

S18

been begun during the War of the League of Cambrai, and the years 1516–21, proposed by Planiscig, would appear to be the most appropriate period in Riccio's career for these reliefs. Such a dating would make absolute sense in terms of Riccio's stylistic development. It is to be presumed that the tomb was commissioned by the three surviving brothers of Marcantonio della Torre: Giulio, the jurist and distinguished amateur medallist, Giambattista, the philosopher and astronomer, and Raimondo, the essayist. It seems likely that they would have devised, or at least contributed to, its complex programme.

The reliefs from the tomb, in particular those of the death scene and of a pagan sacrifice, may be explained in part in terms of the writings of Girolamo Fracastoro, a close friend of the brothers della Torre (Saxl 1938–39). However, the clue to the meaning of four of the eight reliefs, which Saxl failed to grasp, is contained in a work to which he refers in another context, the dialogue *Alverotus* by Niccolò Leonico Tomeo, the Paduan philosopher. This describes a birthday party at the house of Francesco Alvarotti, the jurisconsult, at which Giambattista Leone, the patron and friend of Riccio, recites the account of the wanderings of the soul in the sixth book of Virgil's *Aeneid*; it is then discussed by the whole party. It is clear that Riccio followed the text in great detail, and that the reliefs which follow the death scene therefore depict the fortunes of the soul of the professor (whether Girolamo or Marcantonio, or indeed both) in pagan terms.

The eight reliefs in the series can now be seen to tell the following story:

1] A medical professor teaches in front of a statue of Minerva, while behind him stand figures of Hygea and Apollo.

2] The professor is taken ill. At the left stand the Fates, and Atropos prepares to cut the thread of his life (Cat. S17).

3] The professor dies, surrounded by his mourning friends, and his soul, in the form of a winged boy carrying a book and a palm frond, runs away in the foreground.

4] A pagan sacrifice to Aesculapius is performed in front of a classical temple in order to secure the passage of the soul of the deceased to heaven (Saxl).

5] A classical purification ceremony is conducted before the della Torre tomb. This is taken from Virgil's description of the funeral of Misenus in the sixth book of the *Aeneid*.

6] The soul of the professor, still in the form of a winged boy and identified from other souls by the book he carries, enters the underworld and is welcomed by Charon into his boat. Under the great tree are all the ghastly figures which, in Virgil's description, haunt the entrance to Hades; the Furies, hunger, fear, poverty, old age, sleep, and death together with the centaurs, harpies and chimaera.

7] This relief (Cat. S18) depicts three episodes: the wandering soul of the professor, still carrying his book, is welcomed into the company of carefree dancers in the Fortunate Woods (left foreground); he kneels and drinks the waters of the river Lethe, which will erase his memory and prepare him to return to earth a second time (right background); finally the professor, once more restored to his original earthly form and identified by the book at his feet, sits sleeping in company with

other restored souls waiting to return to earth, while Fame crowns him with a wreath (right foreground).

8] The final relief depicts the triumph of earthly fame over death: the figure of Fame (recognisable from the previous relief) strides over the globe, while Death shrinks away to the right; to the left Pegasus strikes the ground with his hoof and creates Hippocrene, the fountain of the Muses.

The wholly pagan character of the reliefs, and of the tomb itself, which is devoid of any Christian imagery, is in line with the views of Marcantonio and his brothers and friends, who, as thoroughgoing humanists, seem to have had little interest in conventional religion, in contrast with their father Girolamo, who, though a humanist, appears to have been a devout Christian. As Pope-Hennessy has observed, the tomb has no precedent. It amounts to a direct expression of the humanist thinking of the younger generation of the Paduan *scuola* of the first half of the sixteenth century, and as such is unique in the visual arts.

A.F.R.

PROVENANCE
S. Fermo Maggiore, Verona; 1796 removed to Paris and incorporated by Percier and Fontaine in the doors below the gallery in the Salle des Caryatides, in the Louvre

REFERENCES
Morelli 1800, p. 94; Planiscig 1927, pp. 371–400, 479, nos. 43–50; Pope-Hennessy 1971, p. 333; Saxl 1938-9, pp. 354, 355–9

S19

Curete Milking the Goat Amalthea (The Nourishment of Jupiter)

Bronze, parcel-gilt; 26 cm
Museo Nazionale del Bargello, Florence (no. 392)
[*repr. in colour on p. 143*]

This work is first recorded in 1588 in the inventory of the Grand Duke Francesco I, and formed part of a collection of bronzes in his gallery in the Casino di San Marco in Florence. There are substantial traces of gilding on the hair of the young man and on the remaining fleece of the partly shorn goat, corresponding with the inventory description '*velj e capelli tocchi d'oro*'; which proves that the bronze was never more than partially gilded. The bronze, which now stands on a figured marble block, was mounted until the present century on a moulded oval socle of partly-gilded chestnut wood set with hardstones. This typically Florentine late sixteenth-century socle is of a kind commonly used for statuettes in Francesco I's collection, and can still be seen on one or two old Medici bronzes in Florence which escaped resocling, such as the version of the *Ignudo della Paura* on deposit at the Uffizi (Florence 1980, no. 643).

The bronze was reproduced in the fresco of *April* by Falconetto in the Palazzo d'Arco at Mantua, datable to 1520, and it must therefore have been made before that date (Buddensieg). Pope-Hennessy and Ciardi Duprè related it to the reliefs of the della Torre tomb (see Cat. S17, S18) and

consequently dated it to 1516–20. However, it is intimately related to the figure of a *victimarius* preparing a goat for sacrifice in the bottom right-hand corner of the relief of *The Transport of the Ark* (1506–07) on the choir screen of the Basilica del Santo, and in terms both of style and facture it would appear to belong to the same phase in Riccio's career (Planiscig). The figure is unique amongst Riccio's surviving bronze statuettes in being parcel-gilt; this finish occurs only in the two reliefs of the choir screen and the four reliefs of the *Legends of the Cross* from S. Maria dei Servi, which must be dated even earlier (see Cat. S16). The use of parcel-gilding may therefore perhaps be taken as supporting evidence for an early date for this statuette.

Planiscig, who was under the false impression that the two statuettes shared a common provenance from the Carrand Collection, conjectured that the figure had at one time formed a group with the figure of '*Abundance*' (Cat. S25), which is a Carrand piece. He interpreted this figure as catching milk in the shell which she holds in her outstretched right hand. However, the handling and facture of the two bronzes differ, and there is no warrant for any iconographical connection between them (Pope-Hennessy). Furthermore, it is not possible to integrate them physically in any satisfactory manner, and the '*Abundance*' appears to belong to a much later phase in Riccio's development.

The subject was identified by Buddensieg as a Curete milking the goat Amalthea to nourish the infant Jupiter. In Falconetto's fresco in Mantua a small child kneels on all fours on the ground and drinks from the udder. However, in a drawing (Musée du Louvre, no. 10730) that is clearly after this bronze, there is no such figure of a child and the Curete directs the milk into a shallow bowl lying on the ground. It would thus seem unlikely that the bronze ever had an adjunct figure: if it did, it was lost by 1588, since there is no mention of it in the S. Marco inventory.

The drawing in the Louvre has been ascribed to Gianfrancesco Penni, and Buddensieg has conjectured that it may have been made by Penni in Mantua during his stay there in early 1528. Jestaz notes that the bronze is reproduced again in the stucchi of the Galleria dei Mesi in the Palazzo Ducale, Mantua, completed in 1573. This would seem to argue that either this bronze or another version of it was available and well-known in Mantua in the mid-sixteenth century. The only other known versions are obvious forgeries of recent date, and this work itself on superficial examination appears to be a direct cast, and therefore probably unique, like many of Riccio's finest bronzes. Circumstantial support for a Mantuan provenance can, perhaps, be found in the fact that in the inventory of the Gallery of the Casino di San Marco the bronze appears with the fine early cast of Antico's *Mercury*, now also in the Bargello, which could only have come from Mantua.

A.F.R.

PROVENANCE

Francesco I de'Medici, Grand Duke of Tuscany, Galleria del Casino di San Marco, Florence; 1637 Guardaroba Granducale; Gallerie degli Uffizi

EXHIBITIONS

London 1961, no. 56; Amsterdam 1961–62, no. 53; Florence 1962, no. 52; Florence 1980, no. 647 (Conti)

REFERENCES

Buddensieg 1963; Ciardi Duprè 1966; Jestaz 1983, p. 51; Planiscig 1927, pp. 193–96, 259–61, 480, no. 60; Pope-Hennessy 1971, p. 333

S20

S20

Walking Boy (Tobias?)

Bronze, black-brown varnish and dark green oxidation over natural brown patina; 12.8 cm
Kunsthistorisches Museum, Sammlung für Plastik und Kunstgewerbe, Vienna (inv. no. Pl. 5514)

The boy wears a tunic gathered up over tight trousers; leaves and fruit decorate his belt, and on his back hangs a bowl, possibly a container for a whetstone. In his right hand is an unidentifiable object, which is only partially preserved. The left hand, which has been restored, is stretched out and slightly raised, as is the head. The position of the hand and the direction in which the figure is looking suggest that the statuette was probably originally conceived not as an independent work of art, but as part of a group in which the boy was holding out his hand to another person (assuming that the hand is correctly restored). This led Bode to identify him as the young Tobias, though this is not supported by the boy's trappings, which seem to point to an ancient pagan cult, though they provide insufficient evidence to justify Planiscig's identification of the youth as the young Mercury. Old inventories describe the figure as a servant at a sacrifice, or as a genius of the harvest or the wine-gathering. Thus Ciardi Duprè may be right in seeing the boy as a participant in a mystery cult. The chronology of Riccio's work, and hence a dating of the statuette, has not been satisfactorily established.

M.L.-J.

PROVENANCE

1821 first definitely recorded in the inventory of Imperial coin and antique cabinet (p. 209, no. 50); 1880 transferred to the Kunsthistorisches Museum

REFERENCES

Bode 1906, I, pl. XXXVI; Bode 1922, pl. 45, p. 44 (wrongly said to be in Berlin); Ciardi Duprè 1966, II, no. 299; Planiscig 1924, p. 21, no. 28; Planiscig 1927, p. 199; Planiscig 1930, p. 18

S21

Satyr Drinking

Bronze, black-brown varnish over brown patina; 21.7 cm
Kunsthistorisches Museum, Sammlung für Plastik und
Kunstgewerbe, Vienna (inv. no. Pl. 5539)

The satyr is seated, his legs slightly spread. With his right
hand he raises a cup to his mouth, while his left hand rests
on his left knee. The body is powerfully modelled, the
hammered surface creating a lively effect, and the details of
the face and the hair are executed with extreme care; yet
the figure is characterised not by dynamic tension, but, like
many of Riccio's best statuettes, by a poetic expression of
relaxed contentment. It can no longer be determined
whether the figure – probably a late work – was conceived
as an independent statuette or perhaps as the crowning
glory of some more important piece.

　Two replicas, each with slight variations, are in the
Museo Civico, Padua, and the Louvre, Paris.

M.L.-J.

PROVENANCE
By 1863 in the Imperial coin and antique cabinet; 1880 transferred to the
Kunsthistorisches Museum

REFERENCES
Bode 1906, I, Pl. LXIII (wrongly stated to be in the Wallace Collection);
Bode 1922, p. 47; Ciardi Duprè 1976, no. 244; Jestaz 1975, pp. 159f; Jestaz
1983, pp. 33ff; Planiscig 1921, p. 401; Planiscig 1924, no. 157 (as Desiderio
da Firenze); Planiscig 1927, pp. 343f (as Riccio)

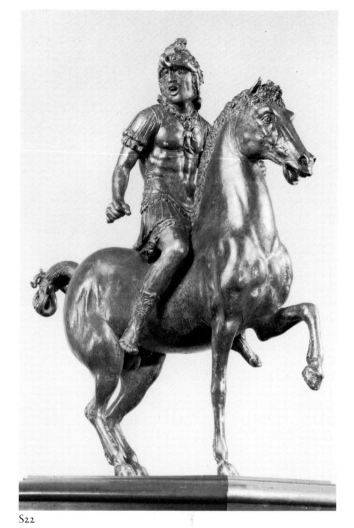

S22

S22

Shouting Horseman

Bronze; 33.5 cm
Victoria & Albert Museum, London (A.88-1910)

This bronze is severely damaged, and was partially repaired
whilst in the collection of Frédéric Spitzer in Paris in the late
nineteenth century. The three legs on which the horse
stands are largely restorations, and the tail, which is itself
original, has been broken off and refixed at an angle which
is probably incorrect. The crest of the rider's helmet is
missing, as is the blade of the sword, the hilt of which he
still holds in his right hand. The rider's left hand is drilled
to hold a fixture that is now lost, clearly a shaft, probably
of a spear. The entire surface was heavily repatinated after
the repairs were carried out.

　This is universally accepted as an autograph work by
Riccio. The horse is unique, but versions of the rider occur
on a variety of different horses of widely varying scales and
types (Staatliche Museen, Berlin; Liechtenstein Coll.,
Vaduz; Beit Coll., Russborough; Musée Jacquemart-André,
Paris; Wernher Coll., Luton Hoo; formerly Pierpont
Morgan Coll., London and New York). In all these cases
the rider is a modern copy (in some cases elaborated) of the

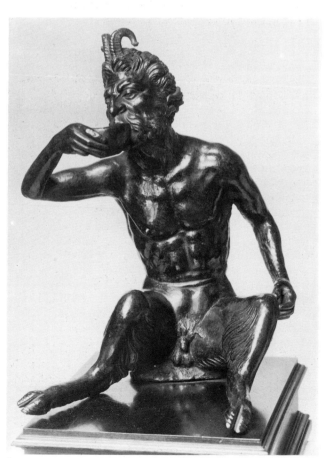

S21

rider in the present bronze, while the horses vary between genuine sixteenth-century pieces and modern pastiches. These frauds were probably perpetrated by Spitzer, who is notorious for such deceptions in the fields of armour and silver. The two components of the group, rider and horse, which were cast separately, are direct casts on modelled cores, and therefore unique (Stone).

The bronze clearly depicts a rider and horse in the stress of battle, and a close equivalent for the nervous horse and its tense rider is to be found in the relief of *The Victory of Constantine* (Cat. s16). But the very sophisticated elaboration of detail in the *Shouting Horseman* suggests that it is probably closer in date to the Paschal Candelabrum, in which the full range of Riccio's decorative repertoire is displayed.

It seems likely that this bronze was intended to represent a specific subject derived from classical history or mythology. Jestaz has suggested that it represents Alexander. Two passages in the treatise on sculpture by Pomponius Gauricus (1504) appear to have some relevance to the *Shouting Horseman*. In the first of these, he described, with reference to Pollux, the different riding postures of light and heavy cavalry with which the sculptor should be familiar: the posture of the rider in this bronze conforms with his description of the former. In the second he quoted a passage from the *Sylvae* of Statius describing a nervous and excited horse: so striking are the correspondences that it would appear Riccio had Gauricus's treatise in mind when he modelled the bronze.

A.F.R.

PROVENANCE
Frédéric Spitzer, Paris; 17 April 1893, acquired by George Salting at Frédéric Spitzer's sale, Paris 1893 (lot no. 1454); 1910 bequeathed by George Salting to the Victoria & Albert Museum

EXHIBITIONS
London 1961, no. 48; Amsterdam 1961–62, no. 48; Florence 1962, no. 47; London 1979, no. 50; Milan 1981, no. 40

REFERENCES
Bode 1907, I, p. 16, pl. XXIX; Chastel and Klein 1969, pp. 57–59, 67; Jestaz 1983, p. 45; Planiscig 1927, pp. 203–07; Stone 1982, pp. 111–13

S23
Satyr and Satyress

Bronze; 23.2 cm
Victoria & Albert Museum, London (A.8-1949)

This bronze is cast in one piece, together with a rough bronze base on which both figures sit. Internal examination and radiography have established that it is a direct cast with a modelled core, and therefore unique (Stone 1982). In terms of Riccio's documented work, the group comes closest in handling to the figures of satyrs, and to some elements on the Paschal Candelabrum in the Basilica del Santo, Padua, which was begun in 1507 and completed by early 1516, and it seems likely that it dates from the same period in Riccio's career.

The sources of the group have been discussed by Radcliffe in terms of Hellenistic erotic marble *symplegmata*

(groups of two figures entwined together), such as the so-called *Pan and Daphnis* in the Uffizi, Florence (an observation later made independently by Haskell and Penny), and of the engraving of the *Satyr Family* by the Master I.B. with the Bird (an observation recently endorsed by Jestaz). It seems clear that this engraving, which is dated c. 1507 by Oberhuber, must have been known to Riccio when he modelled the group.

A bronze in the form of a draped mound backed by a tree in the Cleveland Museum of Art, formerly thought to be an inkstand, was identified by Pope-Hennessy as a base for a satyr and satyress of this type. Like the group itself, the base (of which another version exists in the Louvre, Paris) also derives from the engraving of the *Satyr Family*. However, it is clearly not the original base for the present group, and is not an autograph work by Riccio. A suggestion by Radcliffe that it might have been the original base for a version in Budapest has proved on examination to be mistaken, since it is so constructed that the satyress has to sit 3 cm higher than the satyr. The existence of this base with its clear reference to the engraving does, however, raise the question of whether the present group was originally mounted in some similar way.

Planiscig knew the model in the form of two derivatives: a *Satyr and Satyress* (Szépművészeti Múzeum, Budapest) which he classified as a workshop production, and a *Satyress* detached from such a group (Herzog Anton-Ulrich-Museum, Brunswick), which he assigned to Riccio himself. Although technically of high quality, neither can be accepted as autograph; it would appear that they are direct copies of the present bronze produced in a different workshop, possibly at a much later date.

A.F.R.

PROVENANCE
Charles Holden White, London; 2 December 1948, acquired by Alfred Spero at Charles Holden White's sale, Christie's, London (lot no. 109); 1949 acquired by the National Art-Collections Fund and presented to the Victoria & Albert Museum

EXHIBITIONS
London 1961, no. 55; Amsterdam 1961–62, no. 52; Florence 1962, no. 51

REFERENCES
Balogh 1975, no. 192; Haskell and Penny 1981, p. 286; Jestaz 1983, pp. 34, 52; Planiscig 1927, pp. 261–62, 483, no. 184, 485, no. 135; Radcliffe 1974, p. 131 and note 28; Stone 1982, pp. 111–13; Washington 1973, no. 161 (Oberhuber); Wixom 1975, no. 85

S24
Satyr and Satyress

Bronze; 27.5 cm
Musée National de la Renaissance, Ecouen

Consigned out of prudery to the reserves of the Musée de Cluny in the late nineteenth century, this group was recently rediscovered and has been exhaustively published by Jestaz, who has re-integrated the two figures in their original arrangement. The type of the satyr was known in two derivative examples, one in the Beit Collection ascribed by Bode to Riccio, and the other ascribed by Planiscig to Desiderio da Firenze (ex-Lederer Coll; Victoria & Albert

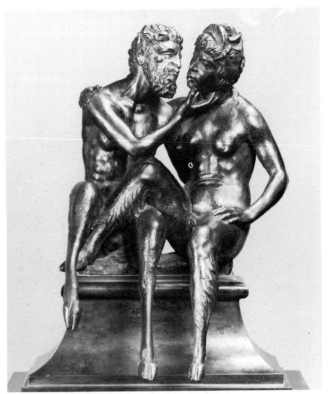

S23

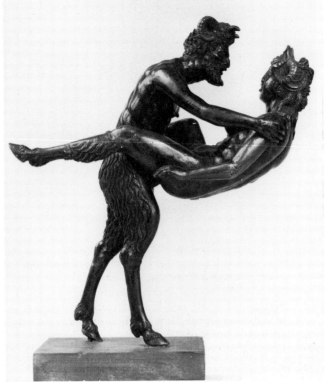

S24

Museum). The figure of the satyress is adapted from the same model as the satyress in the London *Satyr and Satyress* (Cat. s23).

The group was inspired by the notorious series of erotic engravings made by Marcantonio Raimondi after designs by Giulio Romano, the *Modi*, known today through the late copies by Waldeck (Jestaz). These were published in 1524, and this gives a firm *terminus post quem* for the group, which is thus the only work in bronze by Riccio that can be securely dated between the completion of his last documented work in bronze, the bust of Antonio Trombetta of 1524, and his death in 1532. This group differs markedly in style, handling and mood from the London *Satyr and Satyress* (Cat. s23), which would appear to date from the period 1507–16. Jestaz argues that the earlier bronzes of Riccio are characterised by a Giorgionesque mood of 'suspended action', but that later in his life he moved towards the direct representation of action in progress, as shown in the present bronze. This view is corroborated by the parallel development of Riccio's work in terracotta, in which his last datable work, the remaining fragments of his great *Lamentation* group for the church of S. Canziano of 1530, exhibits an immediate and intense emotionalism unknown in his earlier works in the medium.

A.F.R.

PROVENANCE
1858 acquired by Edmond du Sommerard in Paris from the dealer Aron Raphael Jacob for the Musée du Cluny; 1981 transferred to the Musée National de la Renaissance

REFERENCES
Bode 1913, pp. 56, 110, no. 230; Jestaz 1983; Planiscig 1921, pp. 400–01; Radcliffe 1983

S25

'Abundance'

Bronze; 23 cm
Museo Nazionale del Bargello, Florence (Carrand Collection)

The identification of this bronze as Abundance, proposed by Supino, is treated with reserve by Pope-Hennessy, and is open to question. The horn held by the mother in her left hand is not a cornucopia, but must be a container for wine for replenishing the shell which she proffers as a drinking vessel in her outstretched right hand.

Planiscig surmised that the figure might at one time have formed a group with the statuette of *A Curete Milking the Goat Amalthea* (Cat. s19), which he wrongly supposed to be also from the Carrand Collection. Apart from their different provenances, the two bronzes differ in handling and facture and must date from different periods of Riccio's activity. However, this bronze is rightly associated by Planiscig with the terracotta *Virgin and Child* (Cat. s26) thought by Radcliffe to be a mature work, dating from c. 1520. By analogy with the Ecouen bronze group of a *Satyr and Satyress* (Cat. s24), convincingly dated after 1524 by Jestaz, which it resembles closely in facture and in the handling of surfaces and detail, the present work would appear to date from 1520–30.

Unknown in any other old version, this model was probably a unique cast. A derivative formerly in the collection of Henry Harris, London (exhibited London 1930) is clearly a recent free-hand copy of the present bronze.

A.F.R.

PROVENANCE
Louis Carrand; 1888 bequeathed to Museo Nazionale del Bargello

EXHIBITIONS
London 1961, no. 57; Amsterdam 1961–62, no. 54; Florence 1962, no. 53

REFERENCES
Jestaz 1983, pp. 34, 44–45; London 1930, no. 937B; Planiscig 1927,
pp. 258–61, 480, no. 61; Pope-Hennessy 1971, p. 333; Radcliffe 1983;
Supino 1898, p. 81, no. 210

S26

Virgin and Child

Terracotta; 64.4 cm
Baron Thyssen-Bornemisza Collection, Lugano (K.16)

Despite a determined stripping, this terracotta still bears the
traces of a full polychromy, and it can be established that
both the Virgin and the Child had pale skin and dark hair.
The Virgin's mantle was originally blue, her gown red and
her diadem gilded, while the Child's garment was yellow.
Planiscig and other writers believed this group was intended
to be half-length, but Radcliffe has shown it to be the
surviving upper half of a full-length statue, which was
modelled in one piece and then cut in half for firing. In its
complete state, the statue must have stood some 165 cm
high – that is, fully life-size. The back is flat, indicating that
it was designed to be placed against a wall, and the angles

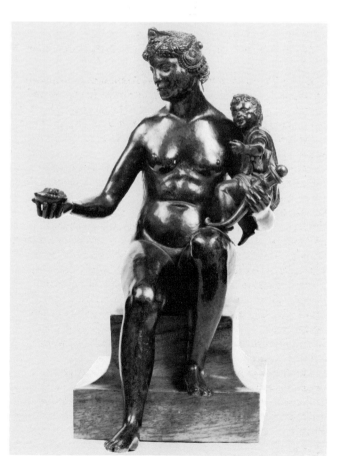

S26

of the heads of the two figures appear to indicate that it was
designed for a high position, possibly on an altar, like
Riccio's life-sized terracotta *Madonna* in the Scuola del
Santo, Padua.

The *Virgin and Child*, which may have come from a
suppressed church, was discovered in Padua in 1902–03 in
mysterious circumstances. Planiscig rightly associated it
with the fragmentary head of another *Madonna* by Riccio
of a closely similar type, found in 1906 at Legnaro and now
in the Museo Civico, Padua; he saw the two terracottas as
prototypes for the sphinxes at the base of the Paschal
Candelabrum, begun in 1507, and therefore dated them
earlier. However, Planiscig's entire chronology for Riccio's
work in terracotta is fundamentally mistaken (Radcliffe
1983). The one fixed point in the series of terracotta
Madonnas by Riccio is provided by the seated *Madonna* in
the Scuola del Santo, ignored by Planiscig, which was
placed on the altar there in 1520. It is argued by Radcliffe
that the present *Madonna* and the fragmentary head from
Legnaro must post-date that work. The sphinxes must be
late decorative elements of the Candelabrum, probably
dating from *c*. 1515, when the Candelabrum was
completed. There are closer correspondences with the
reliefs from the della Torre tomb (*c*. 1516–21), especially
with the three figures of the Fates in the relief of *The Illness
of the Professor* (Cat. S17). The highly elaborate dressing of
the hair, set with the shells, cameos, pearls and swags
familiar from Riccio's decorative work in bronze and
characteristic of him at this date, may derive from Etruscan
art (Enking 1941). The *Virgin and Child* may be compared

S25

with the '*Abundance*' of the 1520s (Cat. s25), which is virtually a secular Madonna. It represents a culminating point in the development of Riccio's regular works in terracotta. In his last known piece, the terracotta *Lamentation* group of 1530, of which three elements survive in the church of S. Canziano and the Museo Civico, Padua, the mood and style are quite changed.

A.F.R.

PROVENANCE
1902–03 discovered in Padua and sold by the Venetian dealer Salvatore to Julius Böhler, Munich; private collection, Paris; Dr Eduard Simon, Berlin; 10 October 1929, Dr Eduard Simon's sale, Berlin (lot 38), acquired by Baron H. Thyssen-Bornemisza

EXHIBITIONS
Munich 1930, no. 20

REFERENCES
Bode 1902–03; Enking 1941, p. 106; Feulner 1941, no. 16; Moschetti 1907, p. 62; Pignatti 1953, pp. 35–6; Planiscig 1927, pp. 258, 478, no. 27; Radcliffe 1983

Niccolò Roccatagliata

Active 1593–1636

Roccatagliata's career spanned four decades, but few documented works have survived. His earliest biographer, Raffaello Soprani, stated that Roccatagliatta was first apprenticed to the goldsmith Cesare Groppi in his native Genoa before travelling through Italy. He subsequently trained as a marble sculptor in Venice and was employed by Tintoretto as a maker of models, which could indicate the sculptor's presence in Venice from the 1580s. Whether or not Soprani's statements are true, Roccatagliata did work for the monastery of S. Giorgio Maggiore between 1593 and 1596; there he produced bronze statuettes of *St. George* and *St. Stephen* (Cat. s27), a number of sconces, two large candelabra for the presbytery and three pairs of bronze candelabra in collaboration with Cesare Groppi.

Soprani also stated that Roccatagliata returned to Genoa with the Venetian woodcarver Domenico Bissoni, which may be true, since Bissoni arrived in Genoa around 1597, the year after Roccatagliata disappeared from the accounts of S. Giorgio Maggiore. Soprani also identified a number of Genoese works by Roccatagliata, but none of them has survived. In 1633 he signed a bronze altar frontal in the sacristy of S. Moisè in Venice, which was executed with the assistance of his son Sebastiano. He is documented last in 1636, when he received a contract for the figures of angels for the high altar of S. Giorgio Maggiore, to be made in collaboration with Pietro Boselli. In the event Boselli executed the angels in 1644.

Roccatagliata is traditionally regarded as a maker of small bronzes. A number of firedogs, putti and other statuettes are commonly ascribed to him, but the majority of these are vastly inferior to the sculptor's known works and probably have little to do with him.

B.B.

REFERENCES
Planiscig 1921, pp. 597–628; Pope-Hennessy 1970, pp. 419–20; Soprani-Ratti 1768–69, I, pp. 353–55; Venturi 1937, X, iii, pp. 378–97

S27

St. Stephen

Bronze; 60.1 cm
S. Giorgio Maggiore, Venice

On 31 January 1593 Roccatagliata agreed to make bronze statuettes of *St. Stephen* and *St. George* for the recently completed choir of the Benedictine church of S. Giorgio Maggiore, Venice. The statuettes represent the principal saints honoured in S. Giorgio, namely the saint to whom the church was dedicated and the deacon martyr whose relics are preserved in the altar on the right-hand side of the transept. The *St. Stephen* and *St. George*, together with the signed *Virgin and Child* (Cat. s28), constitute the only known bronze figures by Roccatagliata, and thus form the point of departure for any attributions to the sculptor.

The *St. Stephen* shows the saint gazing heavenwards, dressed in his priestly vestments. The treatment of the chasuble is the most arresting feature of the bronze, showing the virtuosity of Roccatagliata as a bronze-caster. In style, the *St. Stephen* shows a certain similarity with the small bronzes of Campagna, such as the *Angel Holding a Candlestick* (Cat. s3).

B.B.

REFERENCES
Damerini 1956, pp. 73–74, 77; Pope-Hennessy 1970, p. 420, with full bibliography

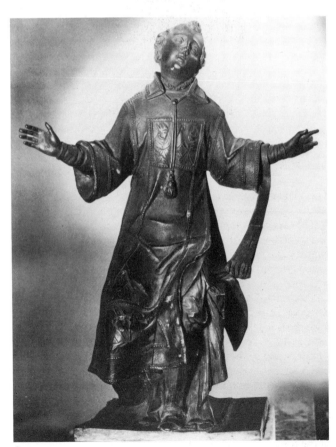

S27

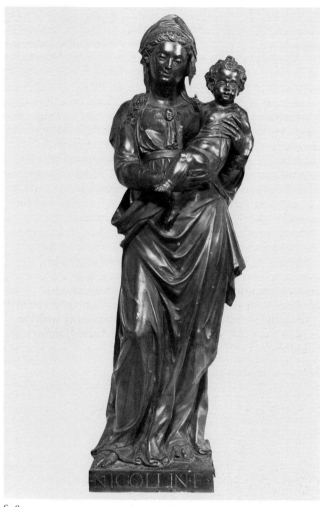

S28

S28
Virgin and Child

Bronze; 93 cm
Inscription on base: NICOLLIN F
Musée National de la Renaissance, Ecouen (CI.13.272)

The *Virgin and Child* was first published as a work of
Roccatagliata's by Weihrauch, who compared it with a
seated version of the same subject in the Metropolitan
Museum, New York. The attribution was subsequently
confirmed by Jestaz, who observed that Roccatagliata was
called Nicolino, the name on the figure's base, in a contract
for work in S. Giorgio Maggiore, Venice, in 1596. Both the
Ecouen and Metropolitan Madonnas probably date from
Roccatagliata's period in Venice and may be contemporary
with the sculptor's work of 1593–96 at S. Giorgio. The
Ecouen *Virgin and Child* shares the morphological features
so distinctive in the *St. Stephen* (Cat. S27) and *St. George*
of S. Giorgio – namely, the full, ovoid face, thickly
modelled locks of hair and substantial proportions. Though
its original location is not known, it must have been
intended to be placed high up on an altar or in a niche; this
would explain the pronounced elongation of the lower part
of the torso.

Roccatagliata's point of departure was Sansovino's
Nichesola Madonna (Cleveland), completed some fifty
years earlier, but his Virgin has the more monumental form
favoured by late sixteenth-century artists like Tintoretto,
for whom Roccatagliata worked, and Girolamo Campagna.
In fact, Roccatagliata's composition is extremely close to
two marble Virgin and Child groups by Campagna, one of
1585 in S. Salvatore, the other of 1595–96 in S. Giorgio
Maggiore. Given the presence of both sculptors in the same
church at the same time, the possibility of an influence of
one upon the other – most likely of Campagna on
Roccatagliata – seems inescapable.

B.B.

PROVENANCE
Mme Goldleer; 1896 bequeathed to the Musée de Cluny; Musée National
de la Renaissance

REFERENCES
Jestaz 1969, pp. 80–81; Weihrauch 1967, p. 161

Jacopo Tatti, called
Sansovino

Florence 1486–Venice 1570

Jacopo Tatti was born in Florence on 2 July 1486 and
apprenticed to the sculptor Andrea Sansovino, whose name
he adopted early in the sixteenth century. In around 1506
he went to Rome with Giuliano da Sangallo and there
perfected his knowledge of sculpture. Sansovino first
distinguished himself by winning a competition for the best
copy of the *Laocoön*. He appears to have had a precocious
talent, and early in his career he made models for other
artists, including a wax *Deposition* for Perugino, now in the
Victoria & Albert Museum, London. He returned to
Florence in 1511 and embarked upon two works, the *St.
James* in Florence Cathedral, and the *Bacchus* now in the
Bargello, Florence, which achieved the status of a semi-
classical piece of sculpture.

During these years, Sansovino began to demonstrate a
talent for architecture by designing a temporary façade for
Florence cathedral on the occasion of the entry of Leo X in
1515. From 1518 to 1527 he divided his time between
Florence and Rome where he designed a number of palaces
and sculptures, particularly for Florentine patrons.

The Sack of Rome in 1527 drove Jacopo to Venice where
he settled. With the backing of influential patrons he gained
the post of *proto*, or chief architect, to the Procurators of
San Marco, the body of noblemen responsible for
supervising the properties of San Marco in Venice and her
dependent territories. This position enabled him to play a
decisive role in shaping Venetian architecture and sculpture
over four decades.

Among Sansovino's notable contributions to the
appearance of Venice were the Public Mint, the Libreria
Marciana opposite the Doge's Palace and the Loggetta at
the foot of the Campanile. Both the Library and the
Loggetta were elaborately decorated with sculpture, largely
executed by pupils and followers. The pressure of his many
commissions led Sansovino to become more of a designer

of sculpture than a carver, and he quickly turned to bronze as the perfect reproductive medium for his purposes. He created an important series of reliefs and statuettes for San Marco, four bronze gods for the Loggetta and the occasional cabinet piece for private patrons. He also designed and supervised the erection of a number of churches and monuments for patrons as diverse as Doge Francesco Venier and Tommaso Rangone (fig. 6).

Sansovino, together with his friends Pietro Aretino and Titian, occupied a central place in the art and patronage of sixteenth-century Venice. He filled an artistic vacuum caused by the death of Tullio Lombardo in 1532 and thereby gained a virtual monopoly over most sculptural and architectural projects almost until his death in 1570. His best works reflect an adaptation of his Tuscan heritage, especially the work of Donatello, to the context of Venice.

B.B.

REFERENCES

Boucher 1976; Boucher 1979; Howard 1975; Lorenzetti 1913; Lotz 1963; Pope-Hennessy 1970, pp. 350–51; Weihrauch 1935; Weihrauch in Thieme-Becker, XXXII, pp. 465–70

S29
The Annunciation

Pigmented terracotta; Angel 85 cm, Virgin 89.7 cm
Baron Thyssen-Bornemisza Collection, Lugano
[*repr. in colour on p. 142*]

This *Annunciation* has occupied a peripheral place in accounts of Sansovino's sculpture, even though it is one of his few known terracottas and the only such treatment of the subject surviving from the Renaissance. It is highly finished and painted; its scale suggests that it was made for an altar in a chapel or a private house.

Although it has hitherto been suggested that *The Annunciation* belongs among Sansovino's Venetian works of the 1550s, stronger arguments can be advanced for seeing it as one of his earliest compositions. Small-scale, pigmented terracottas were a popular Florentine art form at the turn of the sixteenth century, for which there was no Venetian equivalent. Sansovino's *Annunciation* is very much rooted in the Florentine tradition, revealing strong links with the work of Donatello: the general conception of this work is indebted to Donatello's *Cavalcanti Annunciation* in S. Croce, while the Virgin is based upon Donatello's *Hope* in the baptistry of Siena Cathedral. *The Annunciation* also invites comparison with some of the paintings of Andrea del Sarto, with whom Sansovino shared a studio from 1511 to 1517. A comparison with Sarto's *San Gallo Annunciation* of 1512 is particularly telling and points to a dating around this time, when Sansovino was exerting a strong influence on Sarto.

Although *The Annunciation* is not a Venetian work, it nonetheless anticipates the kind of figures Sansovino popularised when he settled in Venice in 1527. In particular, he drew upon the pose of the Virgin for one of the female spectators in his marble relief of *The Maiden Carilla* in the Basilica del Santo, Padua. The work demonstrates that combination of quattrocento and classical elements which

is still present in Sansovino's Venetian sculpture and which influenced younger artists like Vittoria and Segala.

B.B.

PROVENANCE

Ferrarese Collection (?); Stefano Bardini; 1900 Oskar Huldschinsky Berlin; 1928 Thyssen-Bornemisza Collection

EXHIBITIONS

Berlin 1906, nos. 200–01; Berlin 1928, nos. 73–74

REFERENCES

Bode 1909[1], p. 11; Boucher 1983, with full bibliography; Fabriczy 1909, p. 25, no. 61; Feulner 1941, pp. 18–19

S30
Virgin and Child

Cartapesta and stucco relief, polychromed and gilded on a wooden support
132 × 102.9 cm
Mrs and Mrs Richard H. Rush

Devotional images of the Virgin and Child were extremely popular in Italy, and Florence had a special category of artists called *madoneri* who did nothing but turn them out. Moulded in terracotta or a mixture of plaster and *papier-mâché*, such reliefs were painted and sold to those unable to afford more expensive marble or panel versions. Three types of such reliefs can be associated with Sansovino and his workshop: one is a unique terracotta of the highest quality, formerly in the Villa Garzoni at Pontecasale and now in the Museo Civico, Vicenza; a second exists in two

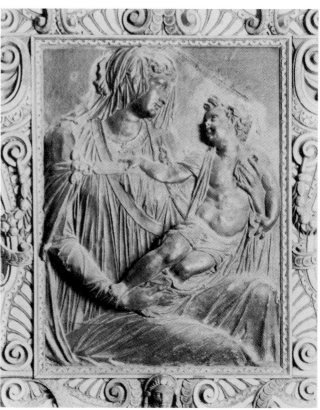

S30

examples in Berlin and Budapest; and the third type, which includes the version in the Rush Collection, exists in major museums across Europe and the United States. At least one of the replicas of the type in the Rush Collection bears an old signature of IACOBVS SANSVINVS; it is now in the Museo del Cenedese Vittorio Veneto. Bode published a line drawing of a seemingly identical one with a slightly different inscription. He referred to it simply as 'on the art-market' in Italy during the 1880s, but it has not been recorded since.

The type of the Rush relief and others ascribed to Sansovino are generally dated around 1551 because the Venetian printer Francesco Marcolini recorded one in Pietro Aretino's house in that year. This can only be an approximate date since the reliefs must have been produced over a period of years if not decades. There is no reason to assign them simply to Sansovino's Venetian career, for the original moulds could well date from before the sculptor's arrival in Venice in 1527. The Rush relief has strong overtones of Donatello's *Pazzi Madonna*, and the pose is also reminiscent of Sansovino's bronze *Nichesola Madonna*, now in Cleveland, in terms of the manner in which the Child is cradled by his mother.

B.B.

PROVENANCE
1963 acquired by the present owners

EXHIBITIONS
New York 1971, no. 19, with bibliography

REFERENCES
Bode 1886, pp. 33–34; Lorenzetti 1913, pp. 114–115, 148; Middledorf 1976, pp. 74–76; Pallucchini 1946, no. 221; Strom 1982; Wixom 1975, no. 112

Attributed to
Jacopo Sansovino

S31
Jupiter

Bronze, black varnish and traces of natural brown patina; 43 cm
Kunsthistorisches Museum, Sammlung für Plastik und Kunstgewerbe, Vienna (inv. no. Pl. 5655)

Jupiter stands completely naked, his body turned round to the left, his left hand raised and his right hand holding a thunderbolt. An eagle was formerly placed on the oval base at the god's left foot, as recorded in the inventory of Archduke Leopold William's collection in 1659, but it had been lost by the eighteenth century. Realistically modelled, the muscles of the ageing god appear flaccid, while the hair is executed almost as finely as if it were the work of a goldsmith. In its sophistication, this statuette may best be compared with the figure of Christ on the door of the tabernacle of San Marco, while the form of the standing figure is a ubiquitous feature in Sansovino's work. First attributed to him by Schlosser, the statuette is now usually associated with the Loggetta figures and dated to the 1540s.

M. L-J.

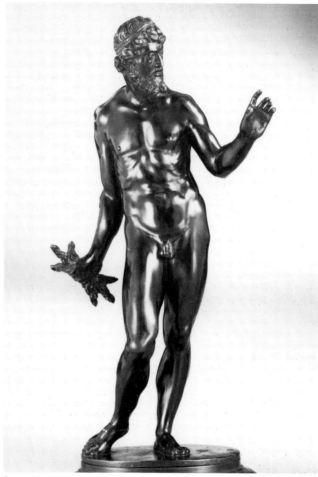

S31

PROVENANCE
14 July 1659 inventory of the art collections of Archduke Leopold William, fol. 448, no. 127 (*Jahrbuch der Kunsthistorischen Sammlungen des allerhöchsten Kaiserhauses in Wien*, 1/2, p. 188. Reg. no. 495, p. CLXIX)

EXHIBITIONS
London, Amsterdam, Florence 1961–62, no. 136

REFERENCES
Planiscig 1924, no. 152 (with earlier bibliography); Pope-Hennessy 1963[1], cat. p. 109, pl. 118; Timofiewitsch 1972, pp. 67f; Weihrauch 1935, p. 68; Weihrauch 1967, p. 139

Tuscan Follower of Jacopo Sansovino(?)

S32 & S33
Two Nude Male Figures

Bronze; 94 cm; 109 cm
The Detroit Institute of Arts, Detroit (Acc. no. 49. 417, 418)

These are among the most notable and intriguing sixteenth-century Italian bronzes. They were reputedly purchased around the middle of the nineteenth century by Graf William Pourtalès from the Palazzo Rezzonico in Venice, where they bore a traditional ascription to Jacopo

Sansovino. Nothing is known of their original purpose or owner, and even their identity is a matter of debate. They have been called *Neptune* and *Meleager*, *Neptune* and *Mars*, and even *Theseus* and *Hippolytus*, but there is no conclusive evidence to support any of these identifications. The trident and spear are not original and the significance of the tortoise and wolf skins has not been convincingly explained. It has been suggested that the bronzes formed part of a mantelpiece decoration or supported a shield; this cannot be ruled out, although such figures were generally made of stucco and occasionally given a bronze-like finish. It is clear that the two figures were once fixed to a structure, and their removal entailed the break in 'Neptune's' right foot and, possibly, the fracture of his right arm.

The original ascription to Sansovino has met with limited acceptance. Bode agreed, but with some misgivings; Planiscig initially felt the bronzes were Florentine, made in the early sixteenth century by Francesco da Sangallo, although he subsequently agreed to Sansovino's authorship. Weihrauch rejected both Sansovino and Sangallo, while Richardson re-affirmed the ascription to Sansovino. The question was considered most recently by Pope-Hennessy, who proposed Danese Cattaneo as their author. Draper suggested that the two figures were probably of nineteenth-century manufacture.

Of these explanations, the last proposition is the least persuasive, since the surface and casting of the bronzes place them firmly in the sixteenth century. Planiscig's identification of Sangallo as their author is also unconvincing, although it underscores Tuscan elements in these bronzes, something also noted by Middeldorf. Comparisons with works by Sansovino only indicate a generalised influence and do not sustain the case for his authorship. Pope-Hennessy's proposal of Cattaneo comes closer to a solution, since the bronzes appear to be the work of a mid-century Tuscan sculptor whose work has some affinity with Sansovino's; yet a comparison of the bronzes and autograph works by Cattaneo does not endorse his conclusion. A better candidate may be another of Jacopo's pupils, Bartolomeo Ammannati, who worked in Venice and Padua from 1543 to 1549. The sinuous quality of the 'Mars' is especially close to Ammannati's *Temperance*, now in the Bargello, Florence. If Ammannati is the sculptor in question and if the Venetian provenance is valid, then the bronzes could date from the latter part of the 1540s when Ammannati was in the Veneto and when his work was more closely attuned to Sansovino's than it was to be later in his career.

B.B.

PROVENANCE
Palazzo Rezzonico (?); Pourtalès Collection, Berlin

EXHIBITIONS
Berlin 1898; Berlin 1906

REFERENCES
Bode 1907–12, III, p. 23; Draper 1980, pp. xi–xii; Kriegbaum 1929; Planiscig 1921, pp. 353–54; Pope-Hennessy 1980, p. 333; Richardson 1950; Weihrauch 1935, p. 96

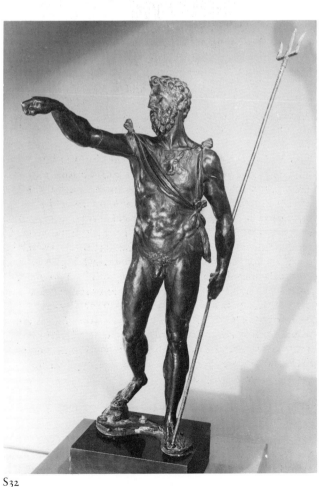

S32

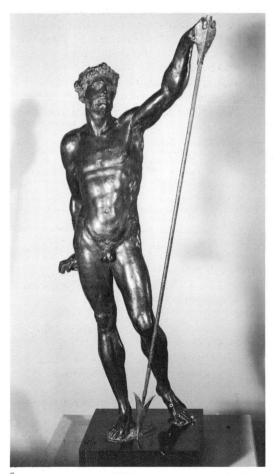

S33

Francesco Segala

Active Padua 1559–Padua 1592

Segala, unusual among sixteenth-century sculptors in coming from a middle-class family, was the son of an advocate and the son-in-law of a professor of Latin. The earliest reference to him records his marriage in 1559, by which date he would have finished his apprenticeship as a sculptor. The name of his master is not known, but given his style and his membership of Alvise Cornaro's circle in Padua, the most likely candidates are Agostino Zoppo or Tiziano Minio. Segala appears to have inherited the role of sculptor to Cornaro after the death of Minio in 1552, and Cornaro introduced Segala to other Venetian patrons. His earliest documented work is the bronze statuette of *St. Catherine* made for a holy-water stoup in the Basilica del Santo, Padua in 1564. Segala promised it to the Santo in exchange for the torso of a marble figure by Zoppo and some wax figures by Minio, then in the church's possession. Shortly afterwards Segala obtained a more significant commission for eleven stucco figures for the Oratory of San Prosdocimo in S. Giustina (1564–65); the ten surviving saints reflect a mixture of the styles of Zoppo, Minio and, to a lesser degree, Danese Cattaneo.

Segala's contact with Cattaneo came through the recommendation of Cornaro, and the elder sculptor stood surety for Segala's contract to make a bronze figure of *St. John the Baptist* for the baptismal font of San Marco in Venice in 1565. Eight years later Segala competed unsuccessfully against Girolamo Campagna for the commission for the last relief for the shrine in St. Anthony at Padua. His letter to the authorities on that occasion refers to unspecified works for the Patriarch of Aquileia, Giovanni Grimani, and to his portrait busts. Though none of these are named, several busts in Paduan churches can be ascribed to Segala. The most important example is on the tomb of the scholar Tiberio Deciano in the church of S. Maria del Carmine, a work already underway in 1579. Other portraits include those of Girolamo Michiel in the Santo (c. 1560) and Sperone Speroni in the cathedral, which was completed by Girolamo Pagliari after Segala's death in 1592. His skill as a portraitist in coloured wax is attested by the miniature of the Archduke Ferdinand of Tyrol (c. 1579).

Segala was a better sculptor in stucco than in stone. Among his finest achievements are the allegorical figures and busts in stucco made for the Sala dei Marchesi in the Palazzo Ducale, Mantua, around 1579. Their proportions are far more graceful than his contemporaneous marble statues such as the *Abundance* and *Justice* on the Deciano monument, or the *Charity* and *Abundance* on the Scala d'Oro of the Doge's Palace (c. 1581). Two 'bronzed' stucco saints made for the Santo in 1591 disappeared in the seventeenth century. His will of 1592 mentions several works in wax, small bronzes, three busts of Speroni and four '*quadri di Donato*', which would have been plaster copies of Donatello's Santo reliefs; none of these have been traced.

B. B.

REFERENCES

Pietrogrande 1942–54, 1955, 1961; Planiscig 1921, pp. 550–55; Sambin 1966, pp. 328–29; Sartori 1976, pp. 215–19

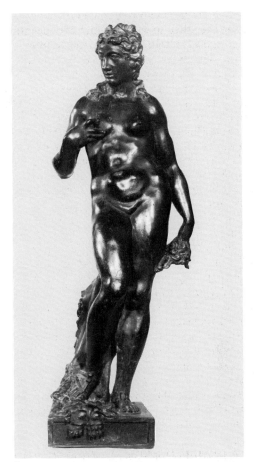

S34

S34
Omphale

Bronze; 72 cm
Museo Civico, Padua (no. 89)

Omphale and a companion statuette of *Hercules* were originally ascribed to the Tuscan sculptor Bartolomeo Ammannati, but an attribution to Francesco Segala has been proposed more recently by Ciardi Duprè on the suggestion of Middeldorf. An identical pair of bronzes in Berlin was recognised as the work of Segala on the basis of comparisons with other works by the sculptor. *Omphale* is virtually identical with a *St. Catherine* which Segala made for the Basilica del Santo in 1564, and both figures depend stylistically upon models like Sansovino's bronze *Peace* from the Loggetta and even the Virgin in the Thyssen *Annunciation* (Cat. S29). Similarities with the *St. Catherine* would suggest a date in the mid-1560s for the *Omphale*. This was the period in which Segala entered Sansovino's circle and in which Sansovino exerted a strong influence upon the young sculptor.

B. B.

EXHIBITIONS
Florence 1962, no. 109; Padua 1976, no. 114

REFERENCES
Ciardi Duprè 1962, p. 64; Lauts 1936; Moschetti 1938, I, p. 224

Severo Calzetta, called
Severo da Ravenna

Active Ravenna 1496–Ravenna 1525/43

Severo's father, Domenico Calzetta, is described in a document as Ferrarese and Severo himself, when first recorded in Ravenna in 1496, was described as '*de Feraria*'. However, in documents relating to his activity in Padua from 1500, he is invariably described as '*da Ravenna*', and it is clear that he was well established as a sculptor before 1500 in Ravenna, where he owned property. In 1500 he contracted in Padua to carve the marble statue of *St. John the Baptist* for one of the niches above the arcade of the shrine of St. Anthony. This was finished by 1502, and from that date until early 1509 he lived and worked in Padua. He seems to have left Padua in June 1509, when the intellectual and artistic life of the city was interrupted by the War of the League of Cambrai, and in 1511 he was once again in Ravenna, where he is recorded as making statues for the visit of Pope Julius II. From 1511 until 1525, when we have the last notice of him, Severo was living and working in Ravenna. A document of 1543 concerning his son Niccolò, also a sculptor and master of a workshop in Ravenna, refers to Severo as dead. Pomponius Gauricus in 1504 described Severo as an 'outstanding sculptor in bronze and in marble, chaser, wood-carver, modeller and painter'. The *St. John the Baptist* in Padua is the only marble by him which has so far been identified, but two signed bronze statuettes have come to light which have made it possible to assign to his workship an extensive group of bronze statuettes and vessels. These suggest that Severo's sculpture foundry was the most prolific in Italy in the first half of the sixteenth century. Severo's style is related to that of Pietro Lombardo, and it is possible that he had some experience in the Lombardo workshop.

A.F.R.

REFERENCES

Avery and Radcliffe 1983; Bernicoli 1914, pp. 555–56; Chastel and Klein 1969, p. 263; Middeldorf 1977, p. 290; Planiscig 1935; Ricci 1905, p. 18; Sartori 1976, pp. 36–37

S35
St. John the Baptist

Bronze; 26 cm
The Visitors of the Ashmolean Museum, Oxford
(Fortnum Bequest 1899)

This statuette was tentatively ascribed to Antonio Lombardo by Bode, who associated it with a small bronze figure of *St. Jerome* (versions in the Victoria & Albert Museum, London, and the Museo Cristiano, Brescia) and with the bronze reliefs from the Barbarigo Altarpiece (Ca d'Oro). But Planiscig ascribed it to Filippo da Gonzate on the strength of a supposed resemblance to Filippo's bronze statues of the Evangelists in Parma Cathedral (1508).

While Bode's view has some merit, Planiscig's is demonstrably wrong. Pope-Hennessy recognised the close

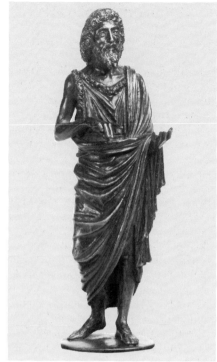

S35

connection of the statuette with Severo Calzetta's signed and documented marble statue of *St. John the Baptist* in one of the niches above the arcade on the façade of the shrine of St. Anthony in Padua, and attributed it to Severo. That the statuette is indeed by Severo, rather than a reduction by another hand from the marble, has been conclusively proved by recent radiography at the Victoria & Albert Museum, which has shown it to be wholly consistent in facture with the technically idiosyncratic bronzes that are certainly products of Severo's foundry. The marble *Baptist* was commissioned on 19 June 1500 and completed by 1502. Avery and Radcliffe, who group the bronze statuette with a very similar statuette of *St. Sebastian* in the Louvre and with a bronze of the *Crucified Christ* in the Cleveland Museum of Art, have proposed that all three are early Paduan works by Severo, probably contemporary with the marble *Baptist*. They further comment that it is of the same notably high quality as the two known signed bronzes by Severo, and is therefore probably autograph, unlike the many replications of varying degrees of debasement demonstrably from his workshop. Although the statuette is not by the same hand as the Barbarigo reliefs and the statuettes of St. Jerome, Bode's observations are valid to the extent that the figure is deeply imbued with the influence of the Lombardo.

A.F.R.

PROVENANCE

Charles Drury E. Fortnum, Stanmore; 1899 bequeathed to the Ashmolean Museum

EXHIBITIONS

London 1961, no. 88; Amsterdam 1961–62, no. 81; Florence 1962, no. 80

REFERENCES

Avery and Radcliffe 1983; Baldoria 1891; Bode 1907–12, I, p. 39, pl. LXXVII; Frizzoni 1884, p. 17; Planiscig 1929; Planiscig 1930, p. 24, pl. CXII, fig. 195; Pope-Hennessy 1963², p. 22; Sartori 1976, p. 36

Alessandro Vittoria

Trent 1525–Venice 1608

Alessandro was the son of a tailor, Vigilio Vittoria della Volpe. It may be assumed that in his home town of Trent he was apprenticed to the sculptors Vincenzo and Gian Girolamo Grandi from Padua. He arrived in Venice on St. James's Day (25 July) 1543, and entered the studio of Jacopo Sansovino, then the leading sculptor and architect. Following a quarrel with his master, Alessandro retired from Venice and spent the years 1551–53 in Vicenza, where he first encountered the work of north Italian mannerists, such as Parmigianino and Giulio Romano, which was to prove decisive for his future career. Through the offices of Pietro Aretino, he was reconciled with Sansovino and returned to Venice where, after the death of Titian in 1576 and Sansovino in 1570, he became the dominant figure in the artistic life of the city, both as sculptor and decorator, playing a role analagous to that of his contemporary, Giambologna in Florence. He practised as a sculptor, architect and painter and his influence endured until the eighteenth century. Little is known of his studio and pupils.

In addition to the great stucco decorations – the Scala d'Oro of the Doge's Palace and the Libreria Marciana – his major works include the altars of S. Francesco della Vigna, S. Maria Gloriosa dei Frari, S. Giuliano and S. Salvatore. Vittoria occupied a unique position as a portraitist, equal to that of the greatest Venetian painters, and as a sculptor he had no rival.

The finest examples of Vittoria's bronzes are the *Diana* in Berlin, the *Jupiter* (Cat. s36), the allegorical figure of *Winter* in Vienna and the so-called '*Fugger Altarpiece*' (Cat. s42).

M.L-J.

REFERENCES
Cessi 1960–62; Cessi 1965[1]; Giovanelli-Gar 1858; Leithe-Jasper 1963; Planiscig 1921, pp. 435ff; Serra 1921; Temanza 1778, pp. 475ff; Vasari (ed. Milanesi) 1881, VII, pp. 518ff

s36

Jupiter

Bronze traces of black varnish, brown patina; 71.1 cm
Signed:ˆAˆVˆEˆ
Musée National de la Renaissance, Ecouen (inv. no. 23)

The naked god is set diagonally on a small rectangular base. The balance of mass is striking: the upper part of the body leans slightly backwards, turning over the right leg which is drawn forwards and bears no weight. The head is slightly raised and turned to the left. Jupiter holds a thunderbolt in his left hand, which is raised against his chest, while the right hand is held behind him, resting on the right buttock. Though the body of the god is heavy and muscular, the composition lends it the airy grace of a dancer. This is matched by the extraordinarily soft modelling of the surface, which is fresh and spontaneous, especially in such details as the face, hair and nails.

As the statuette is not mentioned in the early sources, it can only be dated by means of stylistic comparison. This type occurs frequently in Vittoria's work, and the freshness of the modelling would suggest a date in the early 1560s when he was occupied on the great stucco decorations of the staircases of the Doge's Palace and the Libreria Marciana. It contrasts, however, with the series of statuettes of the gods, probably completed only slightly earlier, which can be connected with the statue of *Mercury* on the façade of the Doge's Palace of 1558; these are all more generously proportioned and smoother in modelling.

It is not until two decades later, in the 1580s, that one finds comparable stylistic features in Vittoria's work. By then the figures are somewhat stockier, the modelling softer and the pathos more marked. The question of dating cannot be decided until the completion of a technical analysis which is now underway. The statuette is unpublished; the first detailed publication is being prepared by the author of this entry.

M.L-J.

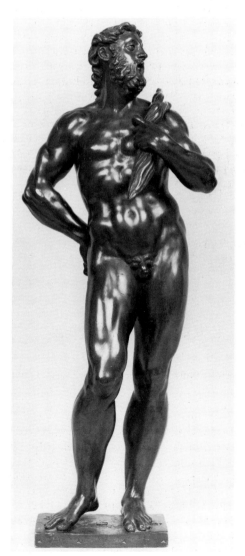

S36

S37
St. Sebastian (Marsyas?)

Bronze; black varnish, dark brown patina; 54 cm
Signed on the base: ALEXANDER VICTOR T(RENTINUS) F
The Metropolitan Museum of Art (inv. no. 40.24)
[*repr. in colour on p. 138*]

The naked youth leans against a tree-stump; his body is turned vigorously to the right and his right hand appears to be bound to the tree behind his back, while his left hand is held behind his head, which is turned to the right. The figure is mounted on a round base.

Vittoria drew inspiration for this figure from both Michelangelo's *Slaves* for the tomb of Julius II and, in particular, Carpaccio's picture of *The Martyrdom of the Ten Thousand* of 1515, which was copied by the young Tintoretto. Vittoria first used the pose for his *St. Sebastian* for the Montefeltro altar in S. Francesco della Vigna of 1563–64. The New York bronze and its variant in Los Angeles are to be seen as further developments of that figure; the turning of the body is more pronounced and derives only indirectly from the original prototypes.

On 14 December 1566 Vittoria recorded payments for the casting by Maestro Andrea (da Brescia) of a figure of St. Sebastian. He mentioned it again on 7 November 1570 in his third will, making the interesting remark that the statuette, if suitably adapted, could be used for both a St. Sebastian and for a figure of Marsyas. On 16 May 1575 Vittoria paid Orazio, the son-in-law of Maestro Andrea, for casting a second figure of St. Sebastian. Both figures are again mentioned in Vittoria's fifth will dated 6 March 1584, and in this the first variant (now referred to as Marsyas) is described as a signed piece. The Los Angeles bronze is unsigned. It is uncertain whether the St. Sebastian or the Marsyas figure came into the possession of Mario Bevilacqua, as stipulated in the will; it is at all events not mentioned again by Vittoria. The second bronze is still mentioned in the wills of 1595 and 1608, where it is even stated that it is to be offered for sale to an interested prince or gentleman. According to Temanza, Bartolomeo della Nave owned a *St. Sebastian* by Vittoria (see Cat. 70). The extraordinary artistic success of this composition by Vittoria is attested to by the numerous representations of the figure in paintings by Italian and Netherlandish artists. The model was known by the Augsburg silversmiths of the seventeenth century, as is proved by a statuette in the church of Mergentheim in Germany.

M.L-J.

PROVENANCE
Mr and Mrs Edwin S. Bayer; Glendenin J. Ryan; 1940 acquired by the Metropolitan Museum of Art, Lee Fund

REFERENCES
Cessi 1960, p. 47; Gerola 1925, pp. 346, 353–54; Goldsmith-Philipps 1940, pp. 126ff; Leithe-Jasper 1963, p. 118; Predilli 1908, pp. 132, 135, 225; Temanza 1778, p. 495; Valentiner 1942, pp. 149ff; Valentiner 1950, pp. 224 ff.; Valentiner 1951, p. 172, no. 66; Weihrauch 1965, p. 279

S38
Benedetto Manzini

Marble; 72 cm
Signed on right-hand edge: ALESSANDRO 'VITORIA' 'F'
Galleria Giorgio Franchetti alla Ca d'Oro, Venice

Benedetto Manzini wears a high-necked tunic with a folded cloak over the shoulder. The head is turned sharply to the right, the right shoulder being pulled somewhat forward, emphasising the movement which gives the portrait such immediacy and expressiveness.

The bust of Benedetto Manzini, who was the parish priest of S. Geminiano from 1545, was originally situated between two columns on the right-hand wall of the choir of the church, which was completed by Jacopo Sansovino during his incumbency. The church was demolished in 1807 to make way for the Napoleonic wing of the Procuratorie. Manzini's gaze is fixed on the altar so that he participates, as it were, in the eucharist. This is one of Vittoria's early portraits. It must have been made before 1568, since it is mentioned by Vasari. It was praised by contemporaries for its life-like quality and vivid expression. In this work, if not before, Vittoria showed himself to be a portraitist comparable to Titian, Tintoretto and Veronese.

M.L-J.

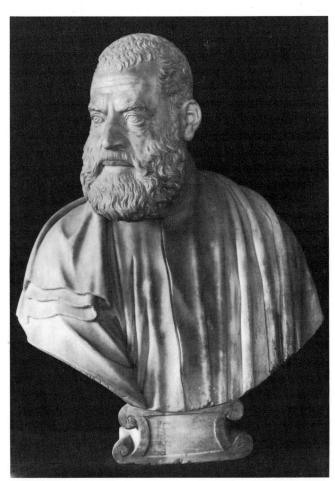

S38

PROVENANCE
S. Geminiano, Venice; 1807 Headquarters of the Knights of Malta

REFERENCES
Cessi 1961, p. 30; Cicogna 1834, VI, pp. 108, 814; Giovanelli and Gar 1858, p. 32; Sansovino 1581, pp. 60–61; Serra 1921, p. 51; Vasari (ed. Milanesi), 1881, VII, p. 520; Venturi 1937, X, 3, pp. 148f

S39
Tommaso Rangone da Ravenna

Bronze; 81 cm
Ateneo Veneto, Venice

The famous and enormously rich humanist, physician and philologist, Tommaso Giannotti of Ravenna (1493–1577), who adopted the name of the Emilian family Rangone, is portrayed in the costly satin robe of a knight of San Marco, a title conferred on him in 1564. His expressive face, framed by a full beard, is turned to the left. Rangone, one of the most colourful personalities of Venice in the second half of the sixteenth century, used his fortune for his own glorification. He supported numerous charitable foundations and commissioned decorative schemes, as well as several portraits of himself by Vittoria.

In 1554 he became procurator of the church of S. Geminiano, at the western end of the Piazza San Marco, which was designed by Jacopo Sansovino, and in 1571 he was granted permission to place his portrait over the door to the sacristy; presumably this bronze bust was made shortly afterwards. It was removed to the Ateneo Veneto when the church was demolished in 1807. It originally bore the inscription RELIGIONI VIRTUTI/THOMAS PHILOLOG.RANG.

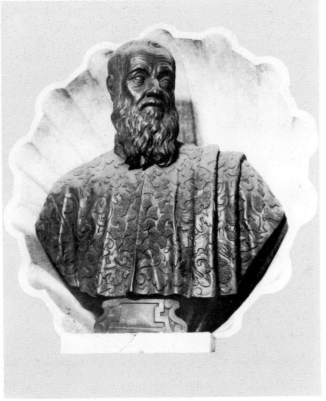

S39

RAVEN./PHYS. EQ./COM.MB.PAL.ECCL/ET FAB.PROCURATOR, alluding to the title to Count Palatine conferred on Rangone by the Emperor Maximilian II in 1572. Rangone mentioned the bust in his will of 1576. An earlier bust, in gilded terracotta, (Museo Correr, Venice) was probably intended to adorn a library which was to be built on the Piazza San Marco to house his collection of books. When this project came to nothing the bust, together with the books, was housed in the library of the Capuchins at the Redentore. This is the only bronze bust by Vittoria; otherwise he worked exclusively in clay or marble.

M.L-J.

PROVENANCE
S. Geminiano, Venice

EXHIBITIONS
London, Amsterdam, Florence 1961–62

REFERENCES
Cessi 1961, p. 39; Cicogna 1834, IV, p. 101; VI, p. 821; Planiscig 1921, p. 483; Sansovino 1663, p. 110; Serra 1921, p. 61; Venturi 1937, X, 3, p. 156; Weddingen 1974, pp. 67f

S40
The Virgin of Sorrows

Bronze, approximately 150 cm
Inscribed on base: ALEXANDER VICTORIA F
SS Giovanni e Paolo, Venice

Vittoria was consulted over the design for a new façade for the Scuola di San Fantin in 1583–84 which was subsequently constructed by his collaborators. The Scuola contained the altars of two confraternities, both adorned with statues signed by Vittoria. Although no documents survive it is likely that the altars were under way in the late 1580s and stylistically the statues seem to belong to the same period.

The Virgin of Sorrows was one component in a sculptural group of the Crucifixion made for the confraternity of S. Maria della Giustizia. The Virgin would have stood at the foot of the cross and would have been balanced by the figure of St. John the Evangelist. As the confraternity was dedicated to comforting condemned prisoners, the choice of the Crucifixion for its altarpiece would have been obvious, and the special nature of the commission inspired Vittoria to one of his most dramatic compositions. An imposing figure of grief, the Virgin is reminiscent of Titian's *Mater Dolorosa* (Prado, Madrid), while her pose is indebted to Michelangelo's *Rachel* on the Tomb of Julius II in Rome. This 'proto-Baroque' pose enjoyed a vogue in late sixteenth-century Venetian painting and sculpture, and was frequently used by Vittoria's friend, the painter Palma Giovane. The Virgin's elongated proportions and band-like drapery are similar to other works by Vittoria from the 1580s, notably the *Daniel* and *St. Catherine* in S. Giuliano, and the stucco figures in the chapel of the Rosary in SS. Giovanni e Paolo.

The Scuola di S. Fantin was suppressed in 1806, and parts of both altars were re-erected in SS. Giovanni e Paolo. Of the Altar of the Crucifixion, only the Virgin, St. John the Evangelist and two angels survive.

B.B.

achievements of contemporary Venetian portrait painting of this period.

M.L-J.

PROVENANCE
Reputedly bequeathed to Count Giusti del Giardino in Padua by the Giustiniani family; presented by Count Giusti del Giardino to the Museo Civico

EXHIBITIONS
Padua 1976, no. 110

REFERENCES
Cessi 1962, pp. 18f; Grossato 1957, p. 176; Moschetti 1938, p. 248; Venturi 1937, X, 3, p. 160; Zippel 1926, pp. 73f

S40

REFERENCES
Cessi 1960, pp. 55–56; Leithe-Jasper 1963, pp. 203–07; Predelli 1908, pp. 192–93; Zava Boccazzi 1965, pp. 230–33

S41
Orsato Giustiniani

Marble; 74 cm
Signed on the left: ALEXANDER.VICTOR.F
Museo Civico, Padua

The figure wears a high-necked tunic and a cloak which falls in rich folds, held by a clasp on the right shoulder; his head is turned to the left, his eyes slightly downcast.

In 1926 Zippel identified the subject of this portrait as Orsato Giustiniani (1538–1602), patrician and poet, whose tragedy *Edipo Tiranno* was performed in Vicenza in 1584. This identification was based on the not entirely compelling resemblance between the bust and a reproduction of a medallion showing the poet, published by Litta. If one assumes that the subject was about 50 years old, the bust must have been executed between 1585 and 1590. The style of dress and the graphic formation of the folds of the cloak would be more in keeping with a date of 1575–80.

However, there is no doubt about the high artistic quality of the portrait and the subtle psychological perception of the subject, which earn this bust a place alongside the finest

S42
The Annunciation
(The 'Fugger Altarpiece')

Bronze; dark brown varnish; 97.9 cm × 61.7 cm
The Art Institute, Chicago (inv. no. 42.249)

The composition derives from a pictorial invention by Titian which he used in his *Annunciation* in S. Salvatore, Venice, and which is also recorded in an engraving by Caraglio after a lost painting. The style of the figures, however, is closer to the work of Paolo Veronese, though Vittoria has not copied Veronese directly, as Cessi (1965)

S41

supposed. While the upper half of the altarpiece is to some extent modelled on the work of Vittoria's teacher, Sansovino, the plasticity and height of the relief, the dramatic movement and the pathos of the two main figures go far beyond anything previously achieved in Venetian sculpture and painting.

These qualities, together with the extraordinarily differentiated modelling of the figures, the rich draperies and the detail, place this relief stylistically on the threshold of the Baroque, and it is certainly one of the artist's finest creations. It was commissioned by Hans Fugger through Ott, his representative in Venice. In a letter of 12 November 1580 Fugger records the measurements and the subject. After this there is no mention of the work apart from a reference by Augustus the Younger, Duke of Brunswick-Wolfenbuttel, in an account of his travels, and a citation in the inventory of Schloss Kirchheim, 1615. The same proto-Baroque figure style is found in other works by Vittoria made between 1583 and 1590, such as the figures on the gable of the Scuola di S. Fantin, the altar figures in S. Giuliano or those on the doors of the Sala delle Quattro Porte and the Anticollegio in the Doge's Palace. After the deconsecration of the chapel of Schloss Kircheim, the relief appeared in the Fugger Collection in Augsburg, but it was no longer there in 1908. Its whereabouts was unknown until Planiscig published it in 1932.

M.L-J.

PROVENANCE
Property of the Fuggers: 1932 sold (?) in Germany, then in America; collection of Dr Preston P. Satterwhite, New York; 1942 appeared on the New York art market

EXHIBITIONS
Augsburg 1980, no. 577

REFERENCES
Cessi 1960, pp. 50ff; Cessi 1965[1], pp. 348ff; Dussler 1968, p. 107; Leithe-Jasper 1963, pp. 192f; Lill 1908, pp. 153f; Planiscig 1932[2], pp. 155f; Rogers and Goetz 1943, pp. 4ff; Venturi 1937, iii, x, p. 116

S42

HISTORY

HI
Bird's-eye View of Venice

Woodcut from six blocks; overall dimensions 1345 × 2818 mm
Attributed to Jacopo de' Barbari (biography on p. 306);
dated 1500
Department of Prints and Drawings, British Museum
[*repr. on p. 12*]

This extraordinarily detailed panorama was without precedent or equivalent for any other city, and the present example is probably the finest of the twelve known (five of these are still in Venice, and the original blocks survive at the Correr Museum). Little is known about its production, except that it took three years and that a German merchant, Anton Kolb, was closely involved. In October 1500 Kolb was granted a copyright for four years and a customs-free export licence; a paraphrase of his petition for this records that it was principally he 'for the fame of this exceedingly noble city' who had caused to be drawn and printed a work unequalled for its difficulty of composition and for its size, which marked a great achievement for the new art of printing. To recover Kolb's costs, the price needed to be at least three ducats. Publication of the *View* undoubtedly caused a stir; it is even mentioned by Sanuto in his diary. Its purpose (suggested by an obscure passage in the copyright) was to excite in the mind of intelligent beholders everywhere a vision of the city. Probably intended as a wall decoration – painted views were the nearest precedent – that would be both edifying and useful, it could serve as an accompaniment to the written description by Marcantonio Sabellico, *De Venetiae Urbis Situ*, first printed in 1490. In spite of the high price and the perishability of joined sheets of paper, the relatively large number of surviving copies point to the commercial success of the *View*, and it was the forerunner of other large-scale prints.

The attribution to Jacopo de' Barbari is conjectural, but now generally accepted. Although dated engravings by his hand are unknown before 1500, he had some reputation as a painter; he had already left Venice by April 1500 to work for the Emperor Maximilian and can be connected with Kolb by payments made to each of them by the Emperor in 1504, and by Dürer's reference to him in a letter of 1506. His sign, the caduceus, appears in the *View*, though as it is the necessary attribute of Mercury this is hardly conclusive evidence of his authorship, but stylistic similarities have been pointed out between heads in his later engravings and the heads of the Wind Gods. 'The indication of the major points around the plan suggest the instrument used was the compass. . . . There survive woodcut maps of 1492 and shortly after by a compass-dial maker of Nuremberg Kolb . . . may have brought knowledge of the technique with him.' (Schulz 1970, p. 21).

Although at first sight the *View* strikes one as so scientifically accurate that it almost resembles an aerial photograph, there are, in fact, many distortions of topography and individual buildings. It presents Venice from a vantage point of pure fantasy and seems the result of no accurate survey, but 'assembled from a myriad of small view drawings made from heights around the city'. A *modello* might have been made to guide the foreshortening, but 'in the last analysis the *View* can have been built only upon a vision of the imagination' (Schulz 1978, pp. 440–41). Nevertheless it provides a unique record of Venice in 1500. For instance, it shows the top of the Campanile of San Marco, which had been damaged by a thunderbolt in 1483, still with a temporary structure in position; the wooden bridge at Rialto, reconstructed in 1458 but notoriously unsafe, which after endless debate was demolished in 1588 to make way for the present one in stone; the Public Mint (with a conspicuous chimney) on the waterfront to the left of the Piazzetta, on the site where the Library designed by Sansovino would later be built; and the 'Newest Arsenal', the extension to the naval dockyard opened in 1473. Along the south shore of Dorsoduro one sees the many small wharfs and boatbuilding yards which in 1519 were to be replaced by the stone promenade of the Zattere; the pre-Palladian churches are shown on the Isola di S. Giorgio and the Giudecca, which was then clearly a fashionable inner suburb with opulent houses backing onto gardens and vineyards. Only lacking are signs of life: no-one walks on the Piazza or talks business on the Rialto; it is an almost deserted city. The exceptions are a few small groups of people about to embark near the Ponte della Paglia, and from landing-stages at San Giorgio and Sant' Elena. Otherwise the only human presence is on the water. To depict small boats in motion the artist could not have dispensed with rowers or gondoliers, and he even shows one or two of the ferries crossing the Grand Canal – though hardly suggesting the traffic congestion normally there – and a 'regatta' approaching at speed from the direction of the Lido. There are also two men stooping *in* the water beyond San Giorgio, a reminder of its shallowness outside the channels of navigation.

This overall impression of desertion and inactivity makes the interpretation of the work as a moralised view, 'a metaphor for the Venetian state' (Schulz 1978, p. 468), not altogether convincing. Certainly the density of safely anchored shipping demonstrates the maritime power of Venice (Neptune, astride a dolphin, is accompanied by the inscription 'I, Neptune, reside here, watching over the seas at this port'), even if there are few war galleys or munitions visible in the Arsenal. On the other hand, Venice as a marvel of political organisation and a feverish centre of business is left to the imagination. Mercury, the god of commerce, presides at the top with an inscription translatable as 'I, Mercury, give glory and good fortune to this above all other trading cities', but no ships are being unloaded or are on the point of arrival or departure, no trains of barges ply to and from the the mainland, no smoke pours from the glass workshops on Murano, no retail market stalls are visible and even the customs sheds are closed.

learned men: Daniele Renier, Francesco Bragadin and Giovanni Badoer, doctor and knight, who had been elected in the Senate and the Maggior Consiglio in 1528 to undertake the task of codifying the statutes. From the numerous laws which had accumulated during these three centuries they selected those they particularly wanted to be upheld. The promoter of this and other constitutional and archival undertakings was Doge Gritti, as is proudly stated in the preface dated 28 September 1529 (the Gritti coat of arms appears at the foot of this page). Such undertakings were essential to renew the myth of the Venetian state after the rout of Agnadello (1509) in which the Venetians were defeated by the concerted forces of the League of Cambrai.

Although there are precedents for this type of scene combining the saint and the doge, here it assumes a particular significance and alludes to the belief in the intrinsic freedom of the city of Venice and her dominions. The sole leader of the city was believed to be St. Mark, thus making Venice superior to any earthly sovereignty, even the Holy Roman Empire. The holy laws were derived from the teachings of St. Mark; they are the 'basis of a Republic because it is with them that the Republic is upheld and is able to maintain in all fields a sense of what is right and just'.

M.F.T.

REFERENCES
Canova 1967–68, pp. 319–34; Canova 1969; Cozzi 1983

H7

H7

Giuramento of the Procurator Girolomo Zane

Manuscript on vellum;
1 + 78 fols.; 295 × 210 mm; full-page illustration fols. 11v–12r
Artist unknown; scribe Giovanni Vitale of Brescia;
signed and dated on fol. 72v, 1568
British Library (King's MS 156)

The procurators of St. Mark, who held office for life (the only Venetian dignitaries to do so apart from the doge and chancellor), had to swear that they would observe many statutes, and they retained a finely made copy of the conditions of this *giuramento* (oath). Girolamo Zane (b. 1515, son of Bernardo Zane) was elected procurator *de citra* on 1 May 1568, but his distinguished career was to end in shame after his appointment in 1570 as captain of the fleet against the Turks in the Cyprus War. Held responsible for the loss of Nicosia, he returned to Venice to defend himself, but died in October 1572. His exceptionally fine *giuramento* has the oath itself, dated 2 October, written in gold on a purple background (f. 13v). The scribe, Giovanni Vitale, a priest from Brescia, is known to have made service books for the Basilica and other *giuramenti* for which he billed the Procuracy (Foucard). The full-page illustrations, unusual in these documents, must have been added slightly later (i.e. in 1570; both appear to have been stuck on to the ends of gatherings). The left-hand panel shows Zane with his commander's baton about to embark on a war galley, while a clerk is paying soldiers at a table in the background. The right-hand panel shows him distributing money to suppliants. St. Mark and a female figure holding a fish-spear, possibly personifying the Adriatic Sea (Warner and Gilson) but more probably Venice herself, are shown on a dais behind, with the winged lion between them.

D.S.C.

PROVENANCE
Joseph Smith, British Consul at Venice; 1773 acquired for George III at library sale

REFERENCES
Barbaro MS VII, pp. 320–21, 324; Cheney 1867–68, p. 60; Foucard 1857, pp. 97–98, 144–47; Mueller 1971; Romanin 1857, VI, pp. 288–89; Warner and Gilson 1921, III, p. 32

H8

Giuramento of the Procurator Alvise Tiepolo

Codex in parchment; 88 fols.
(10 numbered + 64 + 14 numbered, blank), bound in red velvet;
the original silver outer cover (now lost) had at the centre front a medallion of St. Mark, and on the back a medallion, perhaps with the Tiepolo coat of arms.
Artist unknown; scribe Giovanni Vitale of Brescia; signed and dated on f. 10v
Archivio Tiepolo, II, no. 10, Archivio di Stato, Venice
Dated 1571

H4

H5

H5
Promissione of Doge Antonio Grimani

Manuscript on vellum;
42 + 4 blank fols.; 305 × 220 mm; decorated facing panels ff. 6v–7r
Illuminator possibly Benedetto Bordon;
scribe unknown; dated 6 July 1521
British Library (Additional MS 18000)

Newly elected doges had to swear that they would observe
many statutory obligations; acceptance of the text of the
promissione (coronation oath) was part of the coronation
ceremony. As well as the original made for the doge, copies
were deposited with the chancery and the Procurators (cap.
lxxviii, f. 30r) and the doge had to have the text read every
two months (cap. lxv, ff. 28r–28v). Grimani (born 1434) had
been disgraced for his inactivity as naval commander
against the Turks in 1499, but was rehabilitated in 1510 and
elected doge on 21 July 1521; he died on 23 May 1523. On
his deathbed he urged his sons to keep his *promissione*
(presumably the manuscript exhibited) in safety (Sanuto).
The two decorated panels have been attributed to Benedetto
Bordon (Canova). On the left the doge receives the standard
of St. Mark from the saint and, while he wears only the
linen *camauro* on his head, he is being brought the ducal
horned beret (*corno*) by a page, possibly the *ballottino* boy
(see Cat. H3). The red velvet *corno* is shown, not the
jewelled *zoia* which would be worn on a solemn occasion.

D.S.C.

PROVENANCE
Joseph Smith, British Consul at Venice (library sale, 1773); Thomas Rodd;
February 1850 acquired by the British Museum at Thomas Rodd's sale,
Sotheby's, London (lot 251)
REFERENCES
Bradley 1896, pp. 272–73, pl. 1; Canova 1967–68, pp. 331–32, fig. 8;
Cecchetti 1864, pp. 34, 290–93; Cheney 1867–68, pp. 44–49; Musatti 1888,
pp. 95–96, 125–27; Sanuto XXXIV, 1879–1903, col. 127

H6
Libro d'Oro Vecchio

Register in parchment;
218 fols. bound in leather with gilt decorations
Dated 1529
Archivio di Stato, Venice

The book is open at f. 25: St. Mark sits enthroned and
hands a book of the laws of Venice to the kneeling Doge
Andrea Gritti (1523–38). At the saint's side is a lion with
the Gospel of St. Mark. The architectural surround and
landscape in the background may be intended to symbolise
the Venetian state on both land and sea.

The *Libro d'Oro Vecchio* is a capitulary of the Maggior
Consiglio which every doge had to sign on taking office. It
is a compilation of all the statutes concerning the governing
body of the Venetian state: its structure, the scope of its
jurisdiction and its internal rules and procedures, as first
formulated in the thirteenth century and subsequently
revised up to 1528. The compilation was the work of three

H3
'Il Gran Conseglio di Venetia'

Engraving; 547 × 430 mm
Paolo Forlani (active 1560–1574); 1566
British Library (Maps C.7. e.2, 67)

Admiration for the constitution of Venice may have stimulated demand for explicatory illustrations like this one showing a session of the Great Council (the fundamental, exclusive political body of hereditary patricians). The engraver, Paolo Forlani of Verona (he had a shop 'at the sign of the column' in the Merceria and worked with the publisher Bolognino Zaltieri), is best known for a large bird's-eye view of Venice, the first with a key to locations, dated December 1565. Forlani refers to this view in a dedicatory letter included (bottom left) on this sheet. Written in Latin, and dated at Venice 8 July 1566, it informs his patron, Nicolò Banda, about the present subject: 'This hall . . . most famous throughout the world, where the order of patricians meets every week to elect magistracies'. A key to the details is given in Latin as well as Italian, suggesting that the print was meant to appeal to educated foreign customers.

The occasion depicted is the final stage in electing an official, following the lengthy procedure for selecting nominees; the patricians are voting on a particular candidate. About 700 patricians are shown (the quorum was 600), most of them sitting back to back on nine long benches, with others seated alongside the walls. For the more important elections and statutory enactments at least twice this number might have been present, and all had to be seated; they would have been tightly squeezed, but even so, in representing a full house with less than 30 on each file, the engraver has distorted the hall's true capacity (its length is 54 m). He has also omitted the small gates at the bench ends, which effectively locked in the patricians. The doge sits with the nine other members of the Signoria, on a dais facing down the Hall; to the right are two heads of the Council of Ten, the third of whom sits with one of the Avogadori di Comun at the far end of the hall facing the doge; one censor sits to the left of the dais and the other two are seated in the middle of the benches on each side wall. The *auditori* also had specified places. Curiously, the grand chancellor, the only non-patrician high official, appears twice; seated to the left on the dais, but also perched with two assistants on top of the panelled screen projecting round the dais (at a point to the right marked 'D'). Written descriptions by Contarini and Giannotti explain that at an earlier stage in the proceedings the grand chancellor called out names from an elevated position and then returned to the dais, but they do not suggest he climbed to the precarious and undignified spot marked here. Perhaps Forlani, who would not have been allowed into a Council meeting himself, misunderstood the descriptions. Other non-patricians perform inferior duties; four *comandatori* (bearded) carry drum-like receptacles for distribution of the linen ballotting discs; secretaries ('B', 'C') are counting these ballots on the dais; about 40 *ballottini*, young boys (some of whom might be orphans from the various hospitals), pass between the benches collecting ballots in the *bussoli*, peculiar tripartite urns introduced in 1492 which had a white compartment for 'ayes', a green one for 'noes' and a red one for 'don't-knows' (*non sinceri*). The *ballottini* were supposed to call the name of the candidate as they held out the *bussoli*; occasionally they were detected in corrupt practices (carrying messages, or shifting and substituting ballots).

As impressive as the ceremonial order observed in the Great Council Hall were the didactic decorations on its walls. Above the dais Forlani provides an important record of Guariento's painting (1365–67), which was to be badly damaged in the fire of 1577; in his key he described it as '*Il paradiso depinto alla greca*' and included a verse about its subject, the Coronation of the Virgin. Unfortunately the textual panels conceal the Announcing Angel and the Virgin on either side; these details are included (though in reversed positions) on an anonymous engraving of about the same date (Lorenzi 1860, 1, p. 180), but neither it nor Forlani's engraving make any attempt to reproduce the history paintings on the walls by the Bellini, Titian and others, and the frieze of portraits of doges, soon to be destroyed, which the patricians must have spent so many hours staring at.

D.S.C.

REFERENCES
Contarini 1571, pp. 270–75; Finlay 1980, pp. 90, 201–02; Giannotti 1850, pp. xlii–xliii, 60–85; Lorenzi 1860, 1, p. 180; Maranini 1931, pp. 101–27; Sanuto 1980, pp. 145–54; Schulz 1970, pp. 25–26, 54–55; Sinding-Larsen 1974, p. 45, note 1, pl. xxxix a; Thieme-Becker XII, 1916, p. 599; Zanotto 1853, III, Inv. cxxv

H4
Oration in Praise of Doge Marco Barbarigo by Vettor Capello

Manuscript on vellum;
12 + 8 blank fols.; 150 × 100 mm; decorated frontispiece
Illuminator possibly Giovanni Pietro Birago;
scribe unknown; probably written in 1486
British Library (Additional MS 21463)

This Latin panegyric was delivered in the presence of the doge by his nephew Vettor Capello on 4 May 1486 (*4 nonas maii* MCCCCLXXXVI). Marco Barbarigo had been elected doge on 19 November 1485 and died on 14 August 1486. The text, as well as extolling his virtues, in particular his prudence and munificence, included a brief eulogy of Venice itself.

In the illuminated frontispiece Capello is handing the text of his oration to the seated doge, who is accompanied by a personification of Venice holding the standard of St. Mark. It has been described as 'the work of a Venetian painter under the influence of Mantegna' (Pächt), but it has also been attributed to the Milanese illuminator and engraver Giovanni Pietro Birago (Alexander, Canova).

D.S.C.

PROVENANCE
H. P. Ray; 5 July 1856 acquired by the British Museum at Ray's sale (lot 182)

REFERENCES
Alexander 1969, pp. 13–14; Canova 1967–68, pp. 322–24; Canova 1969, pp. 98, 139–40, 166 (cat. 140), fig. 210; Pächt 1948, p. 29

A rare second version of the *View*, with the original date erased, was printed some years later; it shows the pinnacle on the top of the Campanile of San Marco, completed *c.* 1511–14, and (similarly, by means of a plug inserted in the block) a weather-vane angel above it. This ornament (according to Sanuto hoisted into position in July 1513) is not visible in a copy in the British Museum (which varies in measurement from the 1500 original, being 1315 × 2745 mm). A third impression, later in the sixteenth century, attempted to restore the view to its first appearance. Clearly the amount of new building soon made it impossible to update the view without totally reworking it, and it became valued as a collector's piece and a historical monument in its own right, recording the physical appearance of Venice at the beginning of the century of her zenith.

D.S.C.

PROVENANCE
1895 gift of W. Mitchell

REFERENCES
Cassini 1971, no. 5, pp. 30–33; Kristeller 1896; Sanuto 1879–1903, III, col. 1006, XVI, col. 467; Mazzariol and Pignatti 1963; Schulz 1970, pp. 17–21, no. 1, p. 41; Schulz 1978, p. 468

H2
Procession of the Doge of Venice

Woodcut from eight blocks; overall dimensions 390 × 4170 mm
Matteo Pagan; *c.* 1560
Rijksprentenkabinett, Rijksmuseum, Amsterdam
[*repr. on p. 14*]

This scene may not represent any particular one of the regular processions (*andate in trionfo*) of the doge, but the presence of the patriarch does suggest that one of the purely religious festivals is intended, and so the editor of the facsimile edition may have guessed rightly in calling it the Palm Sunday Procession (Ongania, cf. Muraro and Rosand 1976). It was probably meant to serve as a wall decoration, recording the prescribed order in these spectacular processions and advertising the authority and majesty of the Republic. The (approximate) date of its appearance coincides with various other promotional works: a first version (1556) of Sansovino's description of Venice and a large bird's-eye view of the city also published by Pagan (1559).

The doge in the centre of the procession may be no doge in particular (Muraro and Rosand); on the other hand his bearded face does resemble that of Doge Girolamo Priuli (1559–67) as painted by Tintoretto in the Doge's Palace (Atrio Quadrato della Scala d'Oro) or shown on medals (Armand, II, 225.3, 224.2, 225.4; examples in the British Museum). He is accompanied by various emblems of authority and religious faith: the Eight Banners and Six Silver Trumpets, which head the procession, the Sword, White Candle and Umbrella, all of which, according to spurious tradition, were believed to have been conferred by the pope in 1177. Certainly the Sword and Throne (also shown here) were among the insignia used in the ducal

investiture as early as the ninth century (Pertusi 1965); a footcushion and the coronation biretta – a jewelled version of the horned cap (*zoia*) recorded since 1329 (Pertusi 1965) – are also carried. The first part of the procession includes more musicians, one playing a sackbut and five playing cornets (a similar group appears just behind the banner bearers in Gentile Bellini's painting of the *Corpus Domini Procession*; Accademia, Venice), and various non-patrician dignitaries. As the inscriptions explain, in both Latin and Italian, these include 'commanders' (a rank of minor functionaries), ambassadors' servants, chamberlains and squires of the doge, six of the canons of San Marco and other clergy accompanying the patriarch, secretaries and – nearest to the doge in the non-noble hierarchy of *cittadini* – the grand chancellor. The latter should, in fact, have been shown in front of the Throne and Cushion, though for convenience of the design he comes behind (Muir 1981, pp. 193–96). The doge's *ballottino*, a non-patrician boy who selected the voting balls from the urn in the voting procedure of the doge's election and thus appeared to personify the impartiality of the system, comes immediately before him at the central and focal point of the procession. Following the doge were the ambassadors of several leading powers and then the main patrician hierarchy. Pagan here made a severe contraction of the procession. Above the label 'Signoria' he shows eleven patrician figures, including seven in the robes of Procurators of San Marco; but the Signoria consisted of nine persons in addition to the doge (six counsellors and three Heads of the Forty); the procurators, other senior office-holders and members of the Senate should then follow. Presumably Pagan considered this would have made the overall length too great, and the final sheets too repetitive.

There is nevertheless some repetition (Muraro and Rosand): the same groups of women watching from the upper level of windows in the Procuratorie recur at intervals of 12 windows on every sheet, except where obscured by the banners and on the sheet including the doge. This sheet is remarkable not only for the insertion of Matteo Pagan's own name and sign of 'Fede' (Faith), but also for the appearance at the windows of various male spectators wearing curious head-dress, including turbans with the characteristic Ottoman baton in the middle; a Turk is also visible on ground level at a point just behind the patriarch and the Candle. Matteo Pagan, who was well known as a publisher of maps and other prints from his shop in the Frezzaria from 1538 to 1562, certainly exploited the vogue for oriental themes; he published, for instance, an enormous view of Cairo (1549) and also engraved portraits of the Sultan with his favourite lady; but the intrusion of infidel figures, if not just a decorative variation or documentation of the normal presence of Turks in the city, almost suggests ironical and irreverent humour, since the emphasis, including his own trademark, is so clearly upon the Christianity of Venice.

D.S.C.

REFERENCES
Bagrow 1940; Cassini 1971, no. 12, pp. 43–46; Maranini 1927, pp. 184–87; Maranini 1931, p. 291; Molmenti 1906, II, pp. 93–94; Muir 1981, pp. 106–18, 189–211; Muraro and Rosand 1976, no. 96, pp. 147–48; Ongania 1880; Pertusi 1965, pp. 68–70, 81, 85; Schulz 1970, pp. 50–53; Sinding-Larsen 1974, p. 157

H8

On the left the procurator kneels in profile, as he is presented by Faith and Charity to his patron saint, Luigi (which in Venetian dialect is Alvise), Bishop of Toulouse. In the background a mountainous landscape can be glimpsed. Tiepolo's head is drawn but not coloured; above, in the centre of the frame, is a medallion depicting St. Mark. The miniature on the right illustrates Psalm 85, 11: 'Righteousness and Peace have kissed each other'. Justice, having deposited her attributes on an altar guarded by a lion, embraces Peace, who comes towards her holding an olive branch; evidently this was intended as an allegory of Venetian government which preserved peace by means of justice.

Alvise Tiepolo was elected procurator for the east side of the Grand Canal, which includes the quarters of San Marco, Castello and Cannaregio, on 28 January 1571 after he had made conspicuous loans towards the prosecution of the war against the Turks.

The *giuramento* is a compilation of the laws every procurator had to swear to on his election. It starts on f. 10v and is written in gold lettering on a blue ground surrounded by an elaborate gold decorative border. The text is signed, '*Presbyter Iohannes Vitalis Brixianus protonotarius apostolicus scripsit et uteris aureis hunc librum. Anno salutis* MDLXXI'; it seems obvious that another artist was responsible for the illuminations. The Codex is open at 9v–10; the two miniatures are surrounded with mannerist decorative borders.

M.F.T.

REFERENCES

Canova 1969; Zuccolo Padrono 1969, pp. 4–18

H9

Isolario

275 × 185 mm; 58 fols. of vellum;
untitled and undated later brown leather binding
Bartolommeo dalli Sonetti (Zamberti), active 1477–85
Signed: *Per me bon Venetian Bartholomio dali Sonetti: ver compositor*; c. 1485
National Maritime Museum, Greenwich (P/21, a/c MS 38/9920)

This *isolario* (or island book) is based on Buondelmonte's *Liber insularum* of 1420. The commentary is in verse. The first three lines are a cryptogram dedicating the poem to Giovanni Mocenigo, Doge of Venice (1478–85). The book contains 49 charts of the Greek archipelago, including Crete and Cyprus and the Dodecanese Islands. It is open at f. 58 showing the island of Cyprus, which was to be acquired by Venice in 1489. A printed version with woodcut charts was produced by Guilelmus de Panceretto Tridineensis in 1485. A second edition was printed in Venice.

Bartolommeo Zamberti, a Venetian sailor and cartographer, called himself and was known by others as '*da li Sonetti*' because of his liking for that form of poetry. In the text of this volume, all in verse, he states that he has been to the Greek archipelago 15 times, first as an officer and then as captain of a ship.

R.J.B.K.

PROVENANCE

Crevenna (possibly acquired in 1784 at the La Vallière sale, Paris (lot 3695); 1790 catalogued by him as lot 5766 in Amsterdam, 1793 catalogued again as lot 264; Henry Pelham, fourth Duke of Newcastle; 1938 acquired by Sir James Caird for the Museum

REFERENCES

Destombes 1952; *Enciclopedia Italiana* XXXV, p. 174 (Almagi); Howse and Sanderson 1973, p. 21; Legrand 1897, pp. 71–72; Skelton 1966

H10

Sea Chart of the Mediterranean, Black Sea and Western Coasts of Europe and Africa from the British Isles to the Canaries

Manuscript; ink with gold and coloured washes on vellum;
520 × 920 mm;
traces of original red, white and green cord at neck
Signed and dated: *Gratiosus Benincasa Anconitanus Composuit ancone anno domini mcccclxx . die . viii . octubris*
Grazioso Benincasa; 1470
Department of Manuscripts, British Library,
(Additional MS 31318.A)

In geographical coverage and style this manuscript is typical of the maritime 'portolan' charts being produced in Venice in the middle of the fifteenth century, though it was actually executed during one of Benincasa's visits to his home town of Ancona. Portolan charts and atlases were primarily intended for use by sailors and belong to a cartographic

tradition quite distinct from that of medieval Christendom and the Ptolemaic tradition. Like *isolarii* (see Cat. H9), they were put together from written accounts of coastlines and coastal navigation; they show no inland topography other than the course of rivers. The graticule of rhumb lines, positioned and coloured in black, red and green according to convention, were an aid to navigation and may also have been used in the construction or copying of charts. Coastal towns and settlements, harbours and promontories are named in red or black, according to their importance. Portolan charts were among the first western cartographic artefacts to contain explicit, though inaccurate, scale bars.

The first portolan charts appeared, probably in Italy, towards the end of the thirteenth century, at about the time compasses came into use. The areas depicted most accurately were the Mediterranean region and the Black Sea. Over the following centuries, the increasing knowledge of the coastlines beyond the Mediterranean, and eventually beyond Africa and Europe, a result in part of intensifying commercial contacts, was reflected in the coverage of the charts. This process continued to the middle of the sixteenth century. In the same period two distinct styles developed: one, the more florid and decorative, being generally, but not exclusively, associated with Catalan chartmakers, many of whom worked in Majorca, the other, the plainer variety with inland areas left blank, associated on the whole with Italian, and particularly Venetian, cartographers.

This chart, by the most prolific of fifteenth-century chartmakers, falls into the latter category, though Benincasa did occasionally produce 'Catalan' style charts. The extent of the African and north European coastlines, the vignette of Venice – in this early instance a non-topographical town view (which was often coupled with or replaced by Genoa) – the Aragonese colours on Majorca and the cross of Rhodes, the seat of the Knights of St. John, are innovations characteristic of the mid-fifteenth century, while the cross on the island of Lanzarote and the fantastic islands of the Atlantic, such as Brazil to the west of Ireland, hark back to the charts of the previous century.

Grazioso Benincasa (*c.* 1410 – after 1482), a merchant and mariner as well as a chartmaker, belonged to a patrician family of Ancona, but most of his working life was spent in Venice and Genoa, with a short period in Rome. Given that atlases constitute the bulk of his *oeuvre*, this chart is exceptional. The curious knot 'tying' England to Scotland is a hallmark of his work. This chart was almost certainly never used at sea, but its early history is unknown.

P.M.B.

PROVENANCE
Before 1787 Chierichi Regolari Somaschi della Salute, Venice, Pinelli Library; *c.* 1800 (?) Alexander Dalrymple and the British Hydrographic Office, London Admiralty; 1877 presented to the British Museum; 1973 British Library

REFERENCES
British Museum 1982; Campbell, forthcoming publication; Emiliani 1936, pp. 2–27

HI1
A Venetian Compendium of Sea Charts

Manuscript on vellum with charts embellished with
gold and coloured washes;
79 fols.; 445 × 320 mm; late seventeenth-century(?) plate
with arms of Cornaro family on fol. 1
Unknown Venetian scribe; *c.* 1490
Department of Manuscripts, British Library, (Egerton MS 73)

The 'Cornaro Atlas', named after its earliest known owners, the Cornaro family of Venice, can be dated on internal evidence between 1489 and 1492. It contains copies of no less than 35 sea charts, dating back over several decades, together with a written *portolano,* copies of Venetian ordinances for its captains of the 1420s, lists of tariffs at different ports and of expenses for galleys going to Flanders, treatises in the Venetian dialect on navigation by rhumb lines and the making of sails, and astronomical tables for 1489–1683. It retains its fine original binding in wood and leather with heavy metal bosses.

The original purpose of the compilation is unknown, but it contains much information that a Venetian merchant or captain would have wished to have at hand. The profusion of charts covering the same area suggests a sophisticated, questioning attitude towards them and their accuracy, which seems to have been unusual at this early period. Several chartmakers are known only through the copies of their work in this atlas, though a comparison between the copies of charts by cartographers known from other sources, such as Grazioso Benincasa, and surviving originals by them suggests that this copyist interpreted the originals with considerable freedom.

P.M.B.

PROVENANCE
c. 1700 Cornaro family, Venice; Library of San Marco, Venice; Vendramini; Rev. C. Yonge; 1 March 1832 acquired by the British Museum at Rev. Yonge's sale (lot 928); 1973 British Library

REFERENCES
Campbell, forthcoming publication; d'Avezac-Macaya 1850, p. 217; Zurla 1818, II, pp. 353–58

HI2
'Il Golfo di Venetia'

Engraving; 238 × 425 mm
Paolo Forlani; *c.* 1565
British Library (Maps C.7.e.2.[3])

The author dedicated this map to the Venetian patricians Piero Badoer and Antonio Diedo and acknowledged the work of the famous Venetian cartographer Giacomo Gastaldi as one of his sources. The map exhibits some of the stylistic features of portolan (or compass) charts, with a compass rose and rhumb lines drawn across the sea.

Paolo Forlani, an engraver of Verona, worked in Venice from 1560 to 1568; he made copies of sea-charts (1562–69) and also published maps himself. This map forms part of a composite atlas of sixteenth-century Italian maps by

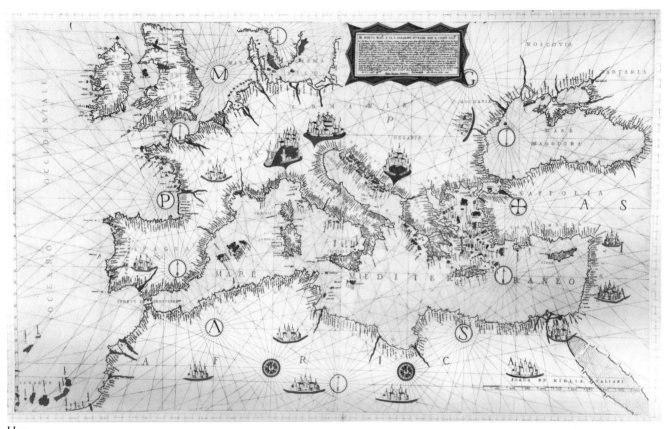

H13

Antonio Lafreri, Forlani and others. The name 'Golfo di Venetia', written boldly across the map, reflects Venice's claim to the Adriatic Sea, the artery of her trade with the cities of the eastern Mediterranean.

H.W.

PROVENANCE
Acquired 1969

EXHIBITIONS
Greenwich 1973, no. 11

REFERENCES
Destombes 1960, pp. 35–37; Destombes 1970, p. 5; House and Sanderson 1973, p. 33

H13
Chart of the Mediterranean

490 × 825 mm
Paolo Forlani (active 1560–1574)
National Maritime Museum, Greenwich (G.230:1/21)

This chart of the Mediterranean and Atlantic coasts of Europe was published in Venice by Paolo Forlani with a dedication to Giacomo Murari. It was the first chart (on a scale large enough to be useful at sea) to be printed by the copper-engraving process, which was to remain the primary method of producing sea charts for the next 350 years. It is based on an original by Diogo Homem (active 1547–76), one of the leading Portuguese cartographers of the sixteenth century.

Forlani was a Veronese who worked as an engraver and publisher in Venice. He engraved maps for Bertelli, Camocio and other publishers in Venice, as well as publishing maps himself. He also made manuscript copies of sea charts.

C.T.

H14
Sea Chart of the Western Mediterranean and Atlantic, including Great Britain

Variable scale; one chart; MS; ink with gold and coloured washes on vellum; 740 × 1140 mm
Signed and dated: *Diegus homem Cosmographus lusitanus fecit Venettis anno apartu Virginis, 1570*; endorsed in an eighteenth-century Italian hand '*Fascio secondo*'
Diogo Homem
Department of Manuscripts, British Library (Egerton MS 2858)

This chart was almost certainly made for the patrician's library and not for the merchant's ship. Although executed by a Portuguese, its relatively sober and restrained style and the cherubs' heads representing the winds are directly derived from the work of the Genoese-born Battista Agnese (active 1536–64), one of the most prolific chartmakers of mid-sixteenth-century Venice. The lettering is, however, Homem's distinctive contribution.

The chart is rather more sophisticated than Benincasa's of exactly a century earlier (Cat. H10). Latitude is indicated, the fanciful Atlantic islands have disappeared and western Scandinavia is shown, though rather sketchily. Moreover, minor changes in trading patterns are suggested by the appearance of new coastal place names, particularly in the Baltic, by the disappearance of others and by changes in those written in black or red.

To a great extent, however, the difference between Homem and Benincasa is one of style rather than content and is made more apparent by their different colouring and lettering conventions. The area depicted, with the exception of the Baltic and the top of the Red Sea (hatched in red in accordance with medieval precedent), is identical. For all its splendour, Homem's chart is essentially derivative and retrospective. In this it reflects the state of late sixteenth-century Italian marine cartography which, almost without exception, once again became entirely Mediterranean, or, at most, European-centred, oblivious of the new discoveries and even of Italian atlases and charts made earlier in the century. The innovative impulse in cartography had passed to the Netherlands.

Diogo Homem, son of the famous Portuguese cartographer Lopo Homem (active 1517–54), spent much of his life between 1547 and 1567 in England, where he had fled after being accused of the murder of a certain Antonio Fernandes in Lisbon. In London he enhanced the reputation he had already acquired as a producer of charts and atlases flamboyantly decorated in the Portuguese style, itself ultimately derived from the Catalan style. In 1568 he established permanent residence in Venice, where he died, probably shortly after 1576. This is the first chart in which he adopted the Italian style which is seen in all his later charts and was presumably a response to his patrons' wishes. Twelve of his atlases and eleven of his charts survive.

P. M. B

PROVENANCE
Unknown before the nineteenth century; 1841 John Hawkins, Bignor Park, Sussex; by descent to Mrs Josephine Johnstone; 1905 acquired from her by the British Museum; 1973 British Library

REFERENCES
Coretesao and Teixeira da Mota 1960, II, p. 39, pl. 146; London 1906

H15
'Nova Descrittion d'Italia'

Engraving on six sheets with colour wash; 1020 × 1240 mm
Giovanni Antonio Magini,
Amstelodami, Apud Clemendt de Ionghe; c. 1650
British Library (Maps K. Top. LXXV. 9, 11 Tab. end.)

This is an engraved wall-map of Italy, with marginal panels showing costumes of the inhabitants and views of the principal towns. Outside the panels, letterpress in Latin, French, Dutch and Italian provides a summary of Italian geography and history. The text in Dutch bears the imprint: *'t Amsterdam. By Danckert Danckertsz, woonende inde Calver-straet, inde Danck-baerheyt'.*

The map is based on the large map of Italy (1608) by Giovanni Antonio Magini (1555–1617), mathematician, cartographer and professor of astronomy at Bologna. This map was the most famous of its day and the source of many versions published in Italy and the Netherlands.

H. W.

H16
Plan of the Fortifications of Famagosta

580 mm × 850 mm
Paolo di Ferrari
Marciana Library, Venice (MS. It. VI, 10031, 21)

This is a fine example of a plan that is not only a decorative object – hence its appeal to Contarini – but a working drawing, with attached notes on channels and currents, for the discussions in Venice in the early 1560s about ways of strengthening Famagosta against Turkish attack. Major improvements in Cyprus were, however, largely centred on the even more weakly defended Nicosia, and the plan shows pretty well the state of the fortifications when the city was besieged by the Turks and, in August 1571, forced to surrender. Like others who described themselves, as he does, as an 'engineer', Paolo di Ferrari was an accomplished surveyor and cartographer.

J. R. H.

H17
Plan of Candia and its Defences

460 mm × 740 mm
Domenico de' Rossi;
17 January 1573
Marciana Library, Venice (MS It. VI, 10039, 17)

After the fall of Cyprus in 1571 and the realisation that the victory at Lepanto had not crushed the Turks as a naval power, plans were called for with an eye to strengthening the fortifications of Crete, especially those of Candia. This plan, by a Venetian surveyor-cartographer (he came from Este), incorporates suggestions made in 1571 by Venice's commander-in-chief, Sforza Pallavicino. Like the following two items, it was bequeathed in 1595 to the Marciana, the State Library in Venice, by the patrician collector and patron of cartographers, Jacopo Contarini.

J. R. H.

H18
Zara and its Territory

320 × 720 mm
Anonymous; undated
Marciana Library, Venice (MS. It. VI, 10039, 24)

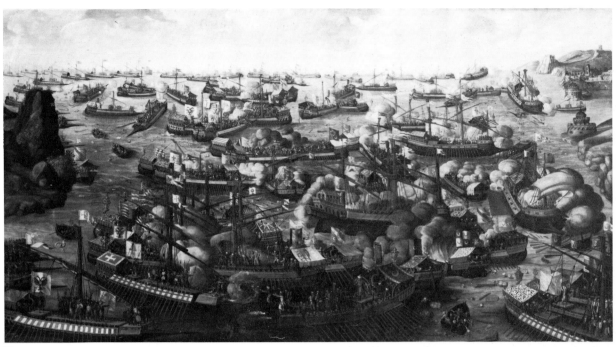

H19

This bird's-eye view of the coasts and islands centred on Venice's Dalmatian naval base of Zara (Zadar) is of quite unusual beauty of draughtsmanship, and it is hoped that its inclusion here might enable its author to be recognised. With its hinterland subject to Turkish pressure, and its off-shore islands to Turkish raids, the whole area surrounding 'the key and chief sinew of our maritime empire', as Zara was described in 1541, was of intense strategic concern. But while the subject itself is not unexpected, the delicacy of this drawing is.

J.R.H.

H19
The Battle of Lepanto

127 × 229 cm
Anonymous artist (Austro-Flemish School?)
Inscribed lower left, on galley: IL.GIO.ANDREA.DORIA;
left foreground, on galley: LA.CAPITANIA.DENEGRNI;
lower right, on galley:
OCHIALLRE.DALGIERIEVGE.DALLABATTA.GLIA.HLETTER
National Maritime Museum (no. 46–122)

The loss of Cyprus to the Turks in 1571 provoked concerted action by the Christian League. A fleet of over 200 galleys, mainly Venetian and Spanish, but also including squadrons from the Papal States and Genoa, collected at Messina under Don Juan of Austria, and proceeded to the Gulf of Lepanto where, on 7 October 1571, they met the Turkish fleet, which somewhat outnumbered them. The Christians were out-manoeuvred on the flanks, but they triumphed in the centre and the Turks' initial successes were turned to utter defeat.

In spite of this, however, the Turks' strategic position was not seriously affected, as the victory was never followed up. The action is memorable as the last of the great galley actions and for the very large number of people who were killed – about 25,000 Turks and 8,000 Christians.

The painting has a very high horizon and the sea is littered with galleys locked in combat. In the left foreground is the galley of Gian Andrea Doria, the commander of the Genoese squadron and the right wing of the Christian fleet. He is about to engage the galley of Uluch Ali, who commanded the Turkish left wing, in the centre foreground. Among the mass of galleys and galleasses behind him can be distinguished standards displaying the Lion of Venice and the red cross of Genoa, and the gold and silver standards of the Papal States.

Don Juan's flagship is in the middle distance, rather left of centre, with its standard of Christ on the Cross. She is assisting a Venetian galley in attacking what may be the flagship of Ali Pasha, the Turkish commander-in-chief. Just to their right is the flagship of Colonna, who commanded the division from the Papal States.

Especially noteworthy are the two galleasses on the right of the picture: their design was an attempt to combine a broadside of guns with oars. In the extreme left foreground some Turkish galleys are making off, while on each side of the painting can be seen the shores of the Gulf of Lepanto.

E.H.H.A.

PROVENANCE
1946, presented to the National Maritime Museum by Sir James Caird

REFERENCES
Guilmartin 1974; Warner 1963, pp. 19, 21

VENICE: SELECTIVE CHRONOLOGY
1500–1600

1500	Jacopo de' Barbari, *Bird's-eye View of Venice.*
1502	Work begun on Palazzo Vendramin-Calergi, designed by Codussi.
	Carpaccio painting for the Scuola di S. Giorgio degli Schiavoni.
1500–3	Venice at war with Turks. Naval defeat at Zonchio, loss of Methoni and Koroni.
1504	Proposal to counter Portuguese trade with India by cutting a Suez canal.
1505	Giovanni Bellini, S. Zaccaria Altarpiece.
1507–8	Venice attacked by German emperor Maximilian I; he is repelled, but the Republic loses Trieste and Gorizia.
1508	Giorgione working with Titian on the newly rebuilt Fondaco dei Tedeschi.
1509–17	Loss of all *terraferma* possessions (save Treviso) in 1509 to allies of League of Cambrai after Battle of Agnadello. All possessions recovered by January 1517 except for Cremona, Trieste and Gorizia.
1510	Plague in Venice, intermittently until 1514. Death of Giorgione.
1511	Sebastiano del Piombo leaves Venice for Rome.
1515	Death of Aldo Manuzio, founder of the Aldine Press. Antonio Lombardo, *Madonna della Scarpa*, Zen chapel, San Marco.
1516	Institution of Ghetto as residence for Jews. Death of Giovanni Bellini.
1518	Titian's *Assumption of the Virgin* installed in the Frari.
1521–29	To preserve its territories, Venice takes part in the wars in Italy between France and the Empire, from 1521–23 and 1526–29 as ally of the French, and from 1523–26 as ally of Charles V.
1523	Andrea Gritti elected doge.
1526	Completion of Procuratie Vecchie, designed by Bartolomeo Bon and Guglielmo dei Grigi.
1527	Sack of Rome. Jacopo Sansovino and Pietro Aretino settle in Venice.
1530	General Italian Peace of Bologna. Venice's *terraferma* still intact, but the Republic forced to give up temporary acquisitions in Romagna (Cervia, Ravenna) and Apulia (Bari, Brindisi).
1535	Unusually high *acque alte*.
1536–37	Work begun on Public Mint, Marciana Library and Loggetta, designed by Sansovino.
1537–40	War against Turks. Loss of Monemvasia and Nafplion.
1538	Pordenone painting in Doge's Palace. Titian, *Presentation of the Virgin*, Scuola della Carità.
1543	Work begun on Michele Sanmicheli's Fortress of S. Andrea to protect Lido entrance to lagoon.
1555–65	Veronese painting in S. Sebastiano.
1556	Abdication of Charles V; Philip II becomes King of Spain. Death of Pietro Aretino.
1563	High point of Venice's population: c. 168,000.
1564	Tintoretto begins painting for the Scuola di S. Rocco.
1566	Work begun on Palladio's S. Giorgio Maggiore. Andrea Gabrieli appointed organist at San Marco.
1567	Jacopo Sansovino's *Mars* and *Neptune* installed on Scala dei Giganti.
1570	Death of Jacopo Sansovino.
1570–73	War against Turks in alliance with Spain and Papacy. Naval victory of Lepanto but loss of Cyprus (both 1571).
1574	Fire in the Doge's Palace.
1575–77	Plague in Venice.
1576	Death of Titian.
1577	Foundation stone laid for Palladio's Il Redentore, founded as thank-offering for cessation of plague. Sebastiano Venier, victor of Lepanto, elected doge. Devastating fire in the Doge's Palace.
1578 seq.	Veronese and Tintoretto working on paintings for the restored rooms in the Doge's Palace.
1580	Death of Palladio.
1582	Work begun on Palazzo Balbi, designed by Alessandro Vittoria (d. 1608).
1584	Work begun on Procuratie Nuove, designed by Vincenzo Scamozzi.
1585	Giovanni Gabrieli appointed organist at San Marco.
1588	Death of Veronese.
1588–90	Tintoretto's *Paradiso* painted in the Sala del Maggior Consiglio, Doge's Palace.
1589	Fondamenta Nuove built.
1592	Completion of the Rialto bridge, designed by Antonio da Ponte.
1593	Decision to found new fortified frontier town of Palma in Friuli, against threats from Austrians and Turks.
1594	Death of Tintoretto.
c. 1600	Bridge of Sighs designed by Antonio Contino.

THE DOGES OF VENICE
1473–1615

Nicolò Marcello 1473–74	Francesco Venier 1554–56
Pietro Mocenigo 1474–76	Lorenzo Priuli 1556–59
Andrea Vendramin 1476–78	Girolamo Priuli 1559–67
Giovanni Mocenigo 1478–85	Pietro Loredan 1567–70
Marco Barbarigo 1485–86	Alvise Mocenigo 1570–77
Agostino Barbarigo 1486–1501	Sebastiano Venier 1577–78
Leonardo Loredan 1501–21	Nicolò da Ponte 1578–85
Antonio Grimani 1521–23	Pasquale Cicogna 1585–95
Andrea Gritti 1523–38	Marino Grimani 1595–1605
Pietro Lando 1539–45	Leonardo Donato 1606–12
Francesco Donato 1545–53	Marcantonio Memmo 1612–15
Marcantonio Trevisan 1553–54	

BIBLIOGRAPHY

Authors are listed alphabetically; exhibition catalogues and the proceedings of conferences are listed under their location.

Abbreviations used in the text:

D. B. I.: Dizionario Biografico degli Italiani, Istituto della Enciclopedia Italiana, Rome, 1960–(in course of publication).
J.K.S.W.: Jahrbuch der kunsthistorischen Sammlungen in Wien.
J.K.P.K.: Jahrbuch der königlich Preussischen Kunstsammlungen.
Thieme-Becker: U. Thieme, F. Becker, *Allgemeines Lexikon der bildenden Künstler*, Leipzig 1907–50.

G. ALBRICCI, 'Le Incisioni di Paolo e Orazio Farinati', *Saggi e Memorie di Storia dell'Arte*, XII, 1980, pp. 9ff.
J. J. G. ALEXANDER, 'Notes on some Veneto-Paduan illuminated Books of the Renaissance', *Arte Veneta*, XXIII, 1969, pp. 9–20.
J. ALLENDE-SALAZAR and F. DE J. SÁNCHEZ CANTÓN, *Retratos del Museo del Prado*, Madrid 1919, pp. 54–56.
AMSTERDAM 1961–62, *Meesters van het Brons Italiaanse Renaissance*, Rijkmuseum, Amsterdam, 1961–62.
ANCONA 1981, *Lorenzo Lotto nelle Marche*, exhibition catalogue edited by I. Chiappini, P. Dal Poggetto and P. Zampetti, Ancona, 1981.
K. ANDREWS, *National Gallery of Scotland, Catalogue of Italian Drawings*, 2 vols., Cambridge, 1979.
H. APPUHN and C. VON HEUSINGER, *Riesenholzschnitte und Papiertepeten der Renaissance*, Brunswick, 1976.
F. ARCANGELI, 'La "Disputa" del Tintoretto a Milano', *Paragone*, LXI, 1955, pp. 21–34.
P. ARETINO, *Lettere sull'arte di Pietro Aretino*, notes by F. Pertile, edited by E. Camesasca, 2 vols., Milan, 1957.
W. ARSLAN, *I Bassano*, Bologna, 1931.
W. ARSLAN, *I Bassano*, 2 vols., Milan, 1960.
B. ASHMOLE, *Cyriac of Ancona*, Italian Lecture, British Academy, London, 1957.
ASOLO 1981, *Lorenzo Lotto, Atti del Convegno Internazionale per il V Centenario*, Proceedings of the conference at Asolo and Venice, 1980, edited by P. Zampetti and V. Sgarbi, Treviso, 1981.
G. A. AVEROLDO, *Le scelte pitture di Brescia*, Brescia, 1700.
C. AVERY and A. RADCLIFFE, 'Severo Calzetta da Ravenna: new discoveries', *Studien zum europaischen Kunsthandwerk (Festschrift Yvonne Hackenbroch)*, Munich, 1983, pp. 107–22.
M. AZZI VISENTINI, 'In margine a un dipinto inedito di Bartolomeo Montagna', *Antichità Viva*, XIX, 5, 1980, pp. 5–10.
R. BACOU and F. VIATTE, *Dessins du Louvre, École Italienne*, Paris, 1968; English edition, London, 1968.
R. BACOU, forthcoming article, *Master Drawings*, publication, 1983.
G. BAGLIONE, *Le vite de' Pittori, Scultori ed Architetti dal pontificato di Gregorio XIII del 1572, infino ai tempi di Papa Urbano VIII nel 1642*, Rome, 1642.
L. BAGROW, *Matheo Pagano, a Venetian*

Cartographer of the 16th Century, Jenkintown, Pa., 1940.
L. BAILO and G. BISCARO, *Della vita e delle opere di Paris Bordon*, Treviso, 1900.
L. BALDASS, 'Neuaufgestellte venezianische Bilder der Gemäldegalerie im kunsthistorischen Museum', *Belvedere*, 1924, pp. 86–91.
L. BALDASS, 'Ein unbekanntes Hauptwerk des Cariani. Studie über den Entwicklungsgang des Künstlers', *J.K.S.W.*, N.F. III, 1929, pp. 91–110.
L. BALDASS, 'Tizian im Banne Giorgiones', *J.K.S.W.*, N.F. LIII, 1957, pp. 101–56.
L. BALDASS and G. HEINZ, *Giorgione*, Vienna and Munich, 1964.
B. BALDORIA, 'Nuovi documenti: statua di Severo da Ravenna', *Archivio storico dell'arte*, IV, 1891, pp. 56–7.
A. BALLARIN, 'Profilo di Lamberto d'Amsterdam (Lamberto Sustris)', *Arte Veneta*, XVII, 1962, pp. 61–81.
A. BALLARIN, 'Lamberto d'Amsterdam (Lamberto Sustris): le fonti e la critica', *Atti dell' Istituto Veneto di Scienze, Lettere ed Arti*, CXXI, 1962–1963, pp. 335–66.
A. BALLARIN, 'L'orto del Bassano (a proposito di alcuni quadri e disegni inediti singolari)' *Arte Veneta*, XVIII, 1964, pp. 55–72.
A. BALLARIN, *Palma il Vecchio*, Milan, 1965.
A. BALLARIN, 'Una villa interamente affrescata da Lamberto Sustris', *Arte Veneta*, XX, 1966, pp. 244–49.
A. BALLARIN, 'Jacopo Bassano e lo studio di Raffaello e dei Salviati', *Arte Veneta*, XXI, 1967, pp. 77–101.
A. BALLARIN, 'Pittura veneziana nei Musei di Budapest, Dresda, Praga, Varsavia', *Arte Veneta*, XXII, 1968, pp. 237–55 [1968¹].
A. BALLARIN, 'La decorazione ad affresco delle ville Venete nel quinto decennio del Cinquecento: la villa di Luvigliano', *Bollettino del Centro Internazionale di Studi di Architettura Andrea Palladio*, X, 1968, pp.115–26 [1968²].
A. BALLARIN, 'Quadri veneziani inediti nei musei di Varsavia e di Praga', *Paragone*, CCXXIX, 1969, pp. 52–68.
A. BALLARIN, 'Tre disegni: Palma il Vecchio, Lotto, Romanino (e alcune osservazioni sul ruolo del Romanino al Buonconsiglio)', *Arte Veneta*, XXIV, 1970, pp. 47–62.
A. BALLARIN, 'Introduzione a un catalogo dei disegni di Jacopo Bassano III', *Arte Veneta*, XXVII, 1973, pp. 91–124.
J. BALOGH, *Katalog der ausländischen Bildwerke des Museums der Bildenden Kunst in Budapest*, 2 vols., Budapest, 1975.
A. BANTI and A. BOSCHETTO, *Lorenzo Lotto*, Florence 1953.
M. BARBARO, *Arbori de' Patritii Veneti*, ms. in Archivio di Stato, Venice.
X. BARBIER DE MONTAULT, *Les Musées et Galeries de Rome*, Rome 1870.
F. BARBIERI, *Vincenzo Scamozzi*, Vicenza, 1952.
F. BARBIERI, Review of L. Puppi, *Montagna*, 1962, *Emporium*, LXX, 1964, pp. 282–85.
F. BARBIERI, 'Nuovi appunti sull'attività del Montagna a Monte Berico', *Maestri e opere d'arte del Quattrocento a Monte Berico*, Vicenza, 1965.

F. BARBIERI, *Pittori di Vicenza 1480–1520*, Vicenza, 1981.
F. BARTOLI, *Notizia delle pitture, sculture ed architetture che ornano le chiese ed altri luoghi pubblici di Bergamo*, Bergamo 1774; Venice 1776; another edition introduced by L. Tamburini, Turin, 1969.
A. BARTSCH, *Le Peintre Graveur*, 21 vols., Vienna, 1803–21.
E. BASSI, *Palazzi di Venezia*, Venice, 1976.
J. BEAN, *15th and 16th century Italian Drawings in the Metropolitan Museum of Art*, New York, 1982.
S. BÉGUIN, 'Une Annonciation de Paris Bordone', *La Revue du Louvre*, IV–V, 1968, pp. 195–204.
G. BELLAVITIS, 'I progetti di Palladio per due palazzi a Venezia' in *Palladio e Venezia*, exhibition catalogue edited by L. Puppi, Florence, 1982, pp. 55–70.
BELLUNO 1950, *Mostra d'arte antica: Dipinti della provincia di Belluno dal XIV al XVI secolo*, exhibition catalogue edited by F. Valcanover, Belluno, 1950.
M. BENACCHIO, 'Vita e opere di Tiziano Aspetti . . .', *Bollettino del Museo Civico di Padova*, n.s. VII, 1931, pp. 101–52.
O. BENESCH, 'Die Fursterzbischhöfliche Gemäldegalerie in Kremsier', *Pantheon*, I, 1928, pp. 22–26.
O. BENESCH, 'New contributions to Lorenzo Lotto', *The Burlington Magazine*, XCIV, 1957, pp. 410–12.
B. BERENSON, *The Venetian Painters of the Renaissance with an index to their works*, New York, London, 1894; 2nd edition 1895, subsequent editions 1899, 1905, 1911.
B. BERENSON, *Catalogue of a Collection of Paintings and some Art Objects*, I, *Italian Paintings*, Philadelphia, 1913.
B. BERENSON, 'The Missing Head of the Glasgow "Christ and Adulteress"', *Art in America*, XVI, 1928, pp. 147ff.
B. BERENSON, *Italian Pictures of the Renaissance*, Oxford, 1932.
B. BERENSON, *The Drawings of the Florentine Painters*, Chicago, 1938; Italian edition 1961.
B. BERENSON, *Italian Painters of the Renaissance*, New York, 1952.
B. BERENSON, *Lorenzo Lotto*, Milan 1955; London 1956.
B. BERENSON, *Italian Pictures of the Renaissance. Venetian Schools*, 2 vols., London, 1957; Italian edition, Florence, 1958.
B. BERENSON, *Italian Pictures of the Renaissance. Central Italian and North Italian Schools*, London, 1968.
BERGAMO 1799, *Catalogo dei quadri esposti sotto il Palazzo Vecchio della città e per le feste straordinarie dei Santi Alessandro, Fermo, Rustico e Procolo, l'anno 1799 in Bergamo*, Bergamo, 1799.
BERGAMO 1875, *Esposizione d'arte antica* exhibition catalogue, Bergamo, 1875.
BERGAMO 1979, *Giovan Battista Moroni*, exhibition catalogue edited by M. Gregori and F. Rossi, Bergamo, 1979.
BERLIN 1906, *Austellungen von Werken alter*

Kunst aus dem Privatbesitz der Mitglieder der Kaiser Friedrich-Museums-Verein, exhibition catalogue, Berlin, 1906.

BERLIN 1928, *Die Sammlung Oscar Huldschinsky*, Sale Catalogue (P. Cassirer, H. Helbing) by E. Bange and others, Berlin, 1928.

G. BERNARDINI, 'Poche spigolature in alcune gallerie tedesche', *Rassegna d'arte*, XI, 1911, pp. 37–42.

S. BERNICOLI, 'Arte e artisti in Ravenna', *Felix Ravenna*, IV, 1914.

A. BERRUTI, *I Cornaro*, Turin, 1952.

L. BERTI, *Gli Uffizi*, Florence, 1971.

A. BERTINI, *I Disegni Italiani della Biblioteca Reale di Torino*, Rome, 1958.

S. BETTINI, *L'arte di Jacopo Bassano*, Bologna, 1933.

J. BIALOSTOCKI, *The Art of the Renaissance in Eastern Europe*, Oxford, 1976.

PIERO BIANCONI, *Tutta la Pittura di Lorenzo Lotto*, Milan, 1955.

G. BIASUZ, *I Pittori Feltrini*, exhibition catalogue, Feltre, 1948.

M. BILLANOVICH, 'Coi Domenicani dei SS. Giovanni e Paolo dal Colonna al Lotto', *Italia Medioevale e Umanistica*, IX, 1966, pp. 453ff.

J. BISCONTIN, 'Une frise de marbre d'Antonio Lombardo au Musée du Louvre', *La Revue du Louvre*, XXV, 1975, pp. 234–36.

G. BISTORT, 'Il Magistrato alle Pompe nella Repubblica di Venezia', *Miscellanea di Storia Veneta*, III, V, 1912.

M-L. BLUMER, 'Catalogue des peintures transportées d'Italie en France de 1796 à 1814', *Bulletin de la Société de l'Histoire de l'Art Français*, 1936, pp. 244–348.

BLUNT 1973, see E. SHILLING, *The German drawings in the collection of the Queen at Windsor Castle and Supplements to the catalogues of Italian and French Drawings*, New York, 1973.

W. BODE, 'Die italienischen Skulpturen der Renaissance in den königlichen Museen zu Berlin . . .', *J.K.P.K.*, VII, 1886, pp. 23–29.

W. BODE, 'Ein neues Madonnenrelief Donatellos?' *Kunstchronik*, N.F. XIV, 1902–03, pp. 441–43.

W. BODE, C. v. FABRICZY, *Der Cicerone . . . von Jacob Burckhardt*, Leipzig, 4 vols., 1904.

W. BODE, *Die Italienische Bronzestatuetten der Renaissance*, Berlin, 1906.

W. BODE, *The Italian Bronze Statuettes of the Renaissance*, 3 vols., London, 1907–12.

W. BODE, *Die Sammlung Oscar Huldschinsky*, Frankfurt-am-Main, [1909].

W. BODE, 'Maffeo Olivieri', *J.K.P.K.*, XXX, 1909, pp. 81–88 [1909²].

W. BODE, *Catalogue of the collections of pictures and bronzes . . . of Otto Beit*, London, 1913.

W. BODE, *Die Italienische Bronzestatuetten der Renaissance*, Berlin, 1922.

M. BONICATTI, 'Per la formazione di Paris Bordone', *Bollettino d'Arte*, XLIX, 1964, pp. 249ff [1964¹].

M. BONICATTI, *Aspetti dell'Umanesimo nella pittura veneta dal 1455 al 1515*, Rome, 1964 [1964²].

BORDEAUX 1953, *Le Greco, de la Crète à Tolède; par Venise*, exhibition catalogue, Bordeaux, 1953.

T. BORENIUS, *The Painters of Vicenza 1480–1550*, London, 1909; Italian edition, Vicenza, 1912.

T. BORENIUS, *A Catalogue of the Pictures at Doughty House*, Richmond, 1913.

T. BORENIUS, 'A group of drawings by Paul Veronese', *The Burlington Magazine*, XXXVIII, 1921, p. 54ff.

T. BORENIUS, 'A great Tintoretto', *The Burlington Magazine*, LXI, 1932, pp. 99–104.

T. BORENIUS, 'A Tintoretto portrait at Christ Church, Oxford', *The Burlington Magazine*, LXXII, 1938, pp. 37–38.

T. BORENIUS, 'A Masterpiece by Palma Vecchio', *The Burlington Magazine*, LXXV, 1939, 1939, pp. 141–42.

R. BORGHINI, *Il Riposo*, Florence, 1584.

A. BOSCHETTO, *Giovan Gerolamo Savoldo*, Milan, 1963.

M. BOSCHINI, *Le Minere della Pittura*, Venice, 1664.

M. BOSCHINI, *I gioielli pittoreschi virtuoso ornamento della città di Vicenza*, Venice, 1676; reprint with introduction by N. Ivanoff, Florence, 1965.

C. BOSELLI, 'Alexander Brixiensis', *L'Arte*, XIV, 1943, pp. 95–130.

C. BOSELLI, 'Il Moretto da Brescia del Gombosi', *Arte Veneta*, I, 1947, pp. 297–302.

C. BOSELLI, 'Asterischi morettiani', *Arte Veneta*, II, 1948, pp. 85–98.

C. BOSELLI, *Il Moretto 1498–1554*, Brescia, 1954.

C. BOSELLI, 'La Mostra del Romanino', review, *Arte Veneta*, XIX, 1965, pp. 106ff.

R. BOSSAGLIA, 'La pittura bresciana del Cinquecento', *Storia di Brescia*, II, Brescia, 1963.

R. BOSSAGLIA, 'Il Romanino: bilancio di una mostra', review, *Arte Lombarda*, II, 1965, pp. 167–72.

Y. BOTTINEAU, 'L'Alcázar de Madrid et l'inventaire de 1686', *Bulletin Hispanique*, LVIII, 1956, LX, 1958.

B. BOUCHER, 'Jacopo Sansovino and the Choir of St. Mark's' (1), *The Burlington Magazine*, CXVIII, 1976, pp. 552–66; (2), CXXI, 1979, pp. 155–68.

B. BOUCHER, 'An Annunciation by Jacopo Sansovino', *Apollo*, CXVIII, 1983, pp. 22–27.

B. BOUCHER and A. RADCLIFFE, 'Small Marble Reliefs by Antonio Lombardo and his circle', *The Burlington Magazine*, forthcoming article, 1984.

J. W. BRADLEY, 'Venetian Ducali', *Bibliografica*, II, 1896, pp. 257–75.

O. BRENDEL, 'Borrowings from Ancient Art in Titian', *Art Bulletin*, XXVII, 1955, pp. 113–26.

BRESCIA 1878, *Catalogo dell'Esposizione della pittura bresciana*, Brescia, 1878.

BRESCIA 1939, *La pittura bresciana del Rinascimento*, exhibition catalogue edited by F. Lechi and G. Panazza, Brescia, 1939.

BRESCIA 1965, *Girolamo Romanino*, exhibition catalogue edited by G. Panazza, A. Damiani and B. Passamani, Brescia, 1965.

H. BRIGSTOCKE, *Italian and Spanish Paintings in the National Gallery of Scotland*, Edinburgh, 1978.

BRITISH MUSEUM 1882, *Catalogue of Additions to the Manuscripts 1878–1881*, British Museum, London, 1882.

BRITISH MUSEUM 1906, *Catalogue of Additions to the Manuscripts, 1900–1905*, British Museum, London, 1906.

R. BRUNO, *Roma: Pinacoteca Capitolina*, Bologna, 1978.

W. BUCHANAN, *Memoirs of Painting*, London, 1824.

T. BUDDENSIEG, 'Die Ziege Amalthea von Riccio und Falconetto', *Jahrbuch der Berliner Museen*, N.F., V, 1963, pp. 121–50.

J. BURCKHARDT 1869, *Der Cicerone*, second edition, Leipzig, 1869; later edition, 1907.

J. BURCKHARDT, *Beiträge zur Kunstgeschichte von Italien*, Basle 1896; Berlin and Stuttgart, 1911.

H. BURNS, 'Le opere minori del Palladio', *Bollettino del Centro Internazionale di Studi di Architettura Andrea Palladio*, XXI, 1979, pp. 9–34.

H. BURNS, 'Altare Fregoso', in *Palladio e Verona*, edited by P. Marini, Verona, 1980, pp. 155–66.

H. BURROUGHS, 'A Portrait by Moretto da Brescia', *The Bulletin of the Metropolitan Museum of Art*, XXIII, 1928, p. 216.

J. BYAM SHAW, *Paintings by Old Masters at Christ Church*, Oxford, 1969.

J. BYAM SHAW, *Drawings by Old Masters at Christ Church, Oxford*, 2 vols., Oxford, 1976.

J. BYAM SHAW, *The Italian Drawings of the Frits Lugt Collection*, 3 vols., Paris, 1983.

M. CALÌ, '"Verità" e "religione" nella pittura di Giovan Battista Moroni; (a proposito della mostra di Bergamo)', *Prospettiva*, 29, 1980, pp. 11–23.

D. CALVI, *Effemeridi sagro profane di quanto di memorabile sia successo in Bergamo . . .*, 3 vols., Milan, 1676.

CAMBRIDGE 1960, *Fifteenth and Sixteenth Century Drawings*, exhibition catalogue edited by C. van Hasselt, Fitzwilliam Museum, Cambridge, 1960.

CAMBRIDGE 1979, *All for Art*, exhibition catalogue edited by J. Darracott, Fitzwilliam Museum, Cambridge, 1979.

CAMBRIDGE 1980–81, *Venetian Drawings*, exhibition catalogue edited by D. Scrase, Fitzwilliam Museum, Cambridge, 1980–81.

A. CAMPBELL, 'The Sea Chart ca. 1470', *The History of Cartography: The Ancient and Medieval Worlds from Pre-History to ca. 1470*, Chicago, forthcoming publication.

L. CAMPBELL, 'Notes on Netherlandish pictures in the Veneto, in the fifteenth and sixteenth Centuries', *The Burlington Magazine*, CXXIII, 1981, pp. 467–73.

G. CAMPORI, 'Tiziano e gli Estensi', *Nuova Antologia*, ser. I, XXVII, 1874, pp. 581–620.

P. CANNON-BROOKES, *Old Masters from the City of Birmingham*, London, 1970.

G. CANOVA, 'I viaggi di Paris Bordone', *Arte Veneta*, XV, 1961, pp. 77–88.

G. CANOVA, *Paris Bordone*, Venice, 1964.

G. CANOVA, 'La decorazione dei documenti ufficiali in Venezia dal 1460 al 1530', *Atti dell'Istituto Veneto di Scienze, Lettere ed Arti*, CXXVI, 1967–68, pp. 319–34.

G. CANOVA, *La miniatura veneta del Rinascimento*, Venice, 1969.

U. CAPELLI, 'Nota al Savoldo Giovane', *Emporium*, CXIV, 1950, pp. 13–24.

U. CAPELLI, 'Appunti sul Savoldo', *Studia Ghisleriana*, series II, I, 1951, pp. 403–15.

A. CARAVIA, *Il Sogno dil Caravia*, Venice, 1541.

G. B. CARBONI, *Le pitture e le sculture di Brescia*, Brescia, 1760.

F. CAROLI, *Lorenzo Lotto e la nascita della psicologia moderna*, Milan, 1980.

E. CASSA SALVI, *Romanino*, Milan, 1965.

E. CASSA SALVI, *Moretto*, Milan, 1966.

G. CASSINI, *Piante e vedute prospettiche della città di Venezia (1479–1855)*, Venice, 1971.

CASTELFRANCO 1978, *Giorgione 1478–1978*, exhibition catalogue, edited by P. Carpeggiani, Castelfranco, 1978.

CASTELFRANCO 1979, *Giorgione – Atti del Convegno internazionale per il 5 centenario della nascita*, Castelfranco, 1979.

E. CASTELNUOVO, 'Il significato del ritratto pittorico nella societa', in *Storia d'Italia Einaudi*, V, I Documenti, 2, Turin, 1973, pp. 1031–94.

M. CATELLI ISOLA, *Immagini di Tiziano*, Rome, 1976.

G. B. CAVALCASELLE, *Manoscritti nella Biblioteca Marciana di Venezia*, Ms. It. VI, 2031 (12272, cartella I), 1866.

G. B. CAVALCASELLE, *La pittura friulana del Rinascimento*, 1876, edited by G. Bergamini, Vicenza, 1973.

B. CECCHETTI, *Il Doge di Venezia*, Venice, 1864.

B. CELLINI, *The Autobiography of Benvenuto Cellini*, edited by G. Bull, London, 1956.

F. CESSI, *Alessandro Vittoria, Bronzista*, Trent, 1960.

F. CESSI, *Alessandro Vittoria, Scultore (1525–1608)*, 2 vols., Trent, 1961–62.

F. CESSI, 'Note sulla genesi iconografico-stilistica della pala bronzea di Alessandro Vittoria per Giovanni Fugger', *Studi trentini storiche*, 1965 [1965¹].

F. Cessi, *Andrea Briosco detto il Riccio*, Trent, 1965 [1965²].

F. Cessi, *Vincenzo e Gian Gerolamo Grandi, scultori*, Trent, 1967.

R. Cessi and A. Alberti, *Rialto: l'isola, il ponte, il Mercato*, Bologna, 1934.

A. Chastel and R. Klein, ed., *Pomponius Gauricus: De Sculptura (1504)*, Geneva, 1969.

A. Châtelet, 'Alcuni disegni veneti nel Museo del Louvre', *Arte Veneta*, VII, 1953, pp. 89ff.

E. Cheney, 'Remarks on the illuminated Official Manuscripts of the Venetian Republic', *Miscellanea of the Philobiblon Society*, XI, London, 1867–68.

I. Cheney, 'Francesco Salviati's North Italian Journey', *Art Bulletin*, XLV, 1963, pp. 337ff.

I. Cheney, 'Romanino in Brescia', *Art Bulletin*, XLVII, 1966, p. 107.

P. Chevallier and C. Manheim, *Catalogue des objets d'art . . . Collection Spitzer*, 2 vols., Paris, sale catalogue, 17 April–16 June 1893.

Chiappini 1981 *see* Ancona 1981

L. Chiarelli, 'Iconografia bassanese', *Bollettino del Museo Civico di Bassano*, VI, 1909, pp. 82–98.

L. Chiodi, *Lettere inedite di Lorenzo Lotto*, Bergamo, 1962; second edition published in *Bergomum*, June 1968.

M. Ciampi, 'Notizie storiche riguardanti la vita e le opere di Palma il Giovane', *Archivio Veneto*, XLI, 1920, pp. 1–19.

M. Ciardi Duprè, 'Bronzetti italiani del Rinascimento', *Paragone-Arte*, XIII, 1962, no. 151, pp. 59–68.

M. Ciardi Duprè, *Il Riccio*, Milan, 1966.

E. Cicogna, *Delle inscrizioni veneziane*, 6 vols., Venice, 1834–61.

E. Cicogna, 'Intorno la vita e le opere di Marcantonio Michiel', *Memorie dell'Istituto Veneto*, IX, 1860, pp. 359–425.

L. Cittadella, *Documenti ed Illustrazioni risguardanti la storia artistica ferrarese*, Ferrara, 1868.

K. Clark, 'Tintoretto', *Old Master Drawings*, V, 1930–31, p. 64.

A. Cloulas, 'Documents concernant Titien conservés aux Archives de Simancas', *Melanges de la Casa de Velázquez*, III, 1967, pp. 197–288.

R. Cocke, 'Observations on some Drawings by Paolo Veronese', *Master Drawings*, II, 2, 1973, pp. 138ff.

R. Cocke, 'Veronese's Omnia Veritas and Honor et Virtus post mortem floret', *Pantheon*, XXXV, 1977, pp. 120ff.

R. Cocke, 'The development of Veronese's critical reputation', *Arte Veneta*, XXXIV, 1980, pp. 96–112 [1980¹].

R. Cocke, *Veronese*, London, 1980 [1980²].

R. Cocke, *The Drawings of Paolo Veronese*, London, 1984, forthcoming publication.

C. E. Cohen, 'Pordenone's Saint Roch and Magdalene', *Record of the Art Museum: Princeton University*, 1972, 1, pp. 12–19.

C. E. Cohen, 'Pordenone's Painted Façade on the Palazzo Tinghi in Udine', *The Burlington Magazine*, CXVI, 1974, pp. 445–57.

C. E. Cohen, 'Pordenone's Passion Scenes and German Art', *Arte Lombarda*, XLII–XLIII, 1975, pp. 74–96 [1975¹].

C. E. Cohen, 'The *modello* for a lost work by Lorenzo Lotto', *Master Drawings*, XIII, 1975, pp. 131–35 [1975²].

C. E. Cohen, *The drawings of Giovanni Antonio da Pordenone*, Florence, 1980.

L. Coletti, 'Girolamo da Treviso il Giovane', *La Critica d'Arte*, IV, 1936, pp. 172–80.

L. Coletti, *Il Tintoretto*, Bergamo, 1940.

L. Coletti, 'Problemi Lotteschi'; 'Il sentimento e il mondo di Lorenzo Lotto', *Emporium*, CXVII, 1953, pp. 3–16, 243–49.

L. Coletti, *Tutta la pittura di Giorgione*, Milan, 1955; English edition, New York, 1961.

C. H. Collins Baker, *Catalogue of the Pictures at Hampton Court*, London, 1929.

G. Contarini, *Opera*, Paris, 1571.

G. Contarini, *Argoa Vulgar*, Venice, n.d.

H. Cook, 'The Portrait of Antonio Palma by Titian', *The Burlington Magazine*, VI, 1904–05, pp. 451–52.

H. Cook, *Giorgione*, London, 1907.

A. Cortesao and A. Texeira da Mota, *Monumenta Portugaliae Cartographica*, 5 vols., Lisbon, 1960.

F. Cortesi Bosco, *Gli affreschi dell'oratorio Suardi: Lorenzo Lotto nella crisi della Riforma*, Bergamo, 1980.

G. Cozzi, *Venezia e gli Stati italiani*, Turin, 1983.

J. A. Crowe and G. B. Cavalcaselle, *An History of Painting in North Italy*, 2 vols., London, 1871; another edition edited by T. Borenius, 3 vols., London, 1912.

J. A. Crowe and G. B. Cavalcaselle, *Life and Times of Titian*, 2 vols., London, 1877; second edition, 1881; Italian edition, Florence, 1878.

V. Curi, *Guida di Fermo*, Fermo, 1864.

P. D'Achiardi, 'Nuovi acquisti della Galleria Borghese', *Bollettino d'Arte*, VI, 1912, pp. 92–93.

Dal Poggetto 1981 *see* Ancona 1981

G. Damerini, *L'isola e il cenobio di San Giorgio Maggiore*, Venice, 1956.

L. Dania, *La Pittura a Fermo e nel suo circondario*, Fermo, 1967.

P. Da Ponte, *L'opera del Moretto*, Brescia, 1898.

M. D'Avezac-Macaya, 'Note sur un Atlas Hydrographique aujourd'hui au Musée Britannique', *Bulletin de la Société de Geographie de Paris*, XIV, 1850, p. 217.

M. Dazzi, 'Sul architetto del Fondaco', *Atti del R. Istituto Veneto di Scienze, Lettere ed Arti*, XCIX, ii, 1939.

M. Dazzi, M. Brunetti and G. Gerbino, *Il Fondaco nostro dei Tedeschi*, Venice, 1941.

P. Della Pergola, 'Il ritratto n. 185 della Galleria Borghese', *Arte Veneta*, VI, 1952, p. 187–88.

P. Della Pergola, *La Galleria Borghese – I dipinti*, Rome, 1955.

G. De Logu, *Pittura veneziana dal XIV al XLIII secolo*, Bergamo, 1958.

K. Demus, *Verzeichnis der Gemälde. Kunsthistorisches Museum, Wien*, Vienna, 1973.

M. Destombes, *Catalogue des cartes gravées au XVe siècle*, Paris, 1952.

M. Destombes, *Portugaliae Monumenta Cartographica*, 5 vols., Lisbon, 1960.

M. Destombes, *Une Carte inedite de Diogo Homen, Circa 1566*, Columbia, 1970.

P. De Vecchi, *L'opera completa del Tintoretto*, introduction by C. Bernari, Milan, 1970.

A. De Witt, *Marcantonio Raimondi*, Florence, 1968.

R-A. D'Hulst, 'Jordaen's Drawings: Supplement I', *Master Drawings*, XVIII, 1980, pp. 360–70.

N. Di Carpegna, *Galleria Nazionale, Palazzo Barberini, Roma*, Rome, 1964.

G. Dillon, 'Le Incisioni' in *Da Tiziano a El Greco*, exhibition catalogue, Venice, 1981.

F. Di Maniago, *Storia delle belle arti friulane*, Venice, 1819.

W. Dinsmoor, 'The Literary Remains of Sebastiano Serlio', *Art Bulletin*, 1942, pp. 55ff.

Documenti inediti, *Documenti inediti per servire alla storia dei Musei d'Italia*, 4 vols., Florence and Rome, 1878–80.

C. Dodgson, 'Marcus Curtius: A Woodcut after Pordenone', *The Burlington Magazine*, XXXVII, 1920, p. 61.

L. Doglioni, *Notizie istoriche e geografiche appartenenti alla città di Belluno ed alla sua provincia*, Belluno, 1780; another edition 1816.

L. Dolce, *L'Aretino, ovvero dialogo della pittura*, Venice, 1557.

J. Donovan, *Rome Ancient and Modern*, 4 vols., Rome, 1843.

E. Dostal, *Studien aus der Erzbischöflichen Galerie in Kremsier*, Brno, 1924.

J. Draper, 'Andrea Riccio and his colleagues in the Untermyer Collection', *Apollo*, CVII, 1978, pp. 170–80.

J. D. Draper, ed., *The Italian Bronze Statuettes of the Renaissance by Wilhelm Bode*, New York, 1980.

Dresden 1860, *Die Königliche Gemälde-Galerie in Neuen Museum zu Dresden*, Dresden, 1860.

Dresden 1929, *Die Staatliche Gemäldegalerie zu Dresden*, museum catalogue by H. Posse, Berlin and Dresden, 1929.

Dresden 1968¹, *Gemäldegalerie Dresden, Alte Meister*, 11th ed., Dresden, 1968.

Dresden 1968², *Venezianische Malerei 15. bis 18. Jahrhundert*, exhibition catalogue, Albertinum, Dresden, 1968.

P. Dreyer, *Tizian und sein Kreis*, Berlin, 1971.

P. Dreyer, 'Tizianfälschungen des sechzenten Jahrhunderts . . .', *Pantheon*, XXXVII, iv, 1979, pp. 365ff.

P. Dreyer, 'Sulle Silografie di Tiziano', *Tiziano a Venezia*, Vicenza, 1980, pp. 503ff.

A. Dussler, ed., *Reisen und Reisende in Bayerisch-Schwaben*, Weissenhorn, 1968.

J. Eade, 'Marcantonio Michiel's Mercury statue: astronomical or astrological?', *Journal of the Warburg and Courtauld Institutes*, XLIV, 1981, pp. 207–09.

Edinburgh 1969, *Italian 16th Century Drawings from British Private Collections*, exhibition catalogue edited by K. Andrews, National Gallery of Scotland, Edinburgh, 1969.

M. Emiliani, 'Le Carte Nautiche dei Benincasa Cartografi Anconitani', *Bollettino della Reale Società Geografica Italiana*, VIII, i, 1936, pp. 2–27.

F. Engerand, ed., *Inventaire des Tableaux du Roy redigé en 1709 et 1719 par N. Bailly*, Paris, 1899.

E. Engerth, *Kunsthistorische Sammlungen des Allerhöchsten Kaiserhauses. Gemälde. Beschreibendes Verzeichniss*, Vienna, 1884.

R. Enking, 'Andrea Riccio und seine Quellen', *J.K.P.K.*, LXII, 1941, pp. 77–107.

C. Fabbro, 'Un ritratto inedito di Tiziano', *Arte Veneta*, V, 1951, pp. 185–256.

C. Fabriczy, 'Kritisches Verzeichnis Toskanischer Holz- und Tonstatuen bis zum Beginn des Cinquecento', *J.K.P.K.*, XXX, 1909, Beiheft, pp. 1–88.

G. Faggin, 'Bonifacio ai Camerlenghi', *Arte Veneta*, XVII, 1963, pp. 79–95.

B. Faino, *Catalogo delle Chiese di Brescia*, seventeenth-century ms. edited by C. Boselli, Brescia, 1961.

A. Falchetti, *La Pinacoteca Ambrosiana*, Vicenza, 1969.

M. Faries, 'A Woodcut of the Flood re-attributed to Jan van Scorel', *Oud Holland*, 97, 1983, pp. 5ff.

E. Favaro, *L'Arte dei Pittori in Venezia e i suoi Statuti*, Florence, 1975.

D. Federici, *Memorie trevigiane sulle opere di disegno*, Venice, 1803.

P. Fehl, 'Realism and Classicism in the Representation of a Painful Scene: Titian's Flaying of Marsyas', *Czechoslovakia Past and Present*, II, 1969, pp. 1387–415.

S. Fenaroli, *Alessandro Bonvicino soprannominato il Moretto, memoria*, Brescia, 1875.

S. Fenaroli, *Dizionario degli Artisti Bresciani*, Brescia, 1877.

Ferrara 1933, *La pittura Ferrarese del Rinascimento*, exhibition catalogue edited by N. Barbantini and others, Ferrara, 1933.

M. L. Ferrari, *Romanino*, Milan, 1961.

A. Feulner, ed., *Stiftung Sammlung Schloss Rohoncz, III Teil, Plastik und Kunsthandwerk*, Lugano-Castagnola, 1941.

R. Finlay, *Politics in Renaissance Venice*, Rutgers University Press and London, 1980.

G. FIOCCO, 'La Giovanezza di Giulio Campagnola', *L'Arte*, XVIII, 1915, pp. 137–56.

G. FIOCCO, *Paolo Veronese*, Bologna, 1928.

G. FIOCCO, 'Pietro de Marescalchi detto lo Spada', *Belvedere*, 1929.

G. FIOCCO, 'El Maestro del Greco', *Revista española de arte*, 1934.

G. FIOCCO, *Giovanni Antonio Pordenone*, Udine, 1939; another edition, Padua, 1943.

G. FIOCCO, 'Pietro de Marescalchi da Feltre', *Arte Veneta*, I, 1947, pp. 37–41, 97–107.

G. FIOCCO, 'Un opera giovanile del Moretto', *Bollettino d'Arte*, XXXIII, 1948, pp. 330–34.

G. FIOCCO, 'Un Pietro Marescalchi in Inghilterra e uno in Svizzera', *Arte Veneta*, III, 1949, pp. 161ff. [1949¹].

G. FIOCCO, 'Un Girolamo da Treviso il Giovane a Balduina', *Arte Veneta*, III, 1949, pp. 160–61 [1949²].

G. FIOCCO, 'Nuovi aspetti dell'arte di Andrea Schiavone', *Arte Veneta*, IV, 1950, pp. 33–42.

G. FIOCCO, 'The Flemish Influence on the Art of Gerolamo Savoldo', *Connoisseur*, CXXXVIII, 1956, pp. 166–67.

G. FIOCCO, 'Luca Cambiaso, Girolamo da Treviso e Pordenone', *Studi in onore di Matteo Marangoni*, Florence, 1957.

G. FIOCCO, 'Il Mosca a Padova', *Venezia e la Polonia nei secoli dal XVII al XIX*, Venice and Rome, 1965.

O. FISCHEL, *Tizian, des Meisters Gemälde*, Stuttgart and Leipzig, 1911.

J. FLETCHER, 'Marcantonio Michiel's collection', *Journal of the Warburg and Courtauld Institutes*, XXXVI, 1973, pp. 382–85.

J. FLETCHER, 'Marcantonio Michiel: his friends and his collection', 'Marcantonio Michiel: che ha veduto assai', *The Burlington Magazine*, CXXIII, 1981, pp. 453–67, 602–08.

FLORENCE 1911, *Catalogo dei ritratti eseguiti in disegno ed in incisione da artisti italiani fioriti dal sec. XV alla prima meta del sec. XIX, esposti nella R. Galleria degli Uffizi*, Florence, 1911.

FLORENCE 1956, *Mostra di disegni di Jacopo Tintoretto e della sua scuola*, exhibition catalogue edited by A. Forlani, Uffizi, Florence, 1956.

FLORENCE 1958, *Disegni di Palma il Giovane*, exhibition catalogue edited by A. Forlani, Uffizi, Florence, 1958.

FLORENCE 1961, *Mostra del disegno italiano di cinque secoli*, exhibition catalogue edited by A. Forlani, Uffizi, Florence, 1961.

FLORENCE 1962, *Bronzetti italiani del Rinascimento*, exhibition catalogue edited by J. Pope-Hennessy, Palazzo Strozzi, Florence, 1962.

FLORENCE 1967, *Mostra dei disegni italiani della collezione Santarelli*, exhibition catalogue edited by A. Forlani, Uffizi, Florence, 1967.

FLORENCE 1976, *Tiziano e il disegno veneziano del suo tempo*, exhibition catalogue by W. R. Rearick, Uffizi, Florence, 1976.

FLORENCE 1978, *Tiziano nelle Gallerie fiorentine*, exhibition catalogue edited by M. Gregori, Florence, 1978.

G. FOGOLARI, 'Il Museo di Feltre', *Le Tre Venezie*, 1929.

G. FOGOLARI, 'Il Processo dell'Inquisizione a Paolo Veronese', *Archivio Veneto*, XVI, 1935, pp. 352–86.

V. FONTANA, '"Arte" e "Esperienza" nei trattati di architettura veneziani del Cinquecento', *Architectura* VIII, 1978, pp. 49–72.

T. FORMICHEVA, 'An architectural perspective by Paris Bordone', *The Burlington Magazine*, CXIII, 1971, pp. 152–55.

E. FORNONI, *Notizie biografiche su Jacopo Palma Vecchio*, Bergamo, 1886.

L. FOSCARI, 'Autoritratti di maestri della scuola veneziana', *Rivista della Città di Venezia*, 1933.

A. FOSCARI AND M. TAFURI, *L'armonia e i conflitti*, Turin, 1983.

C. FOUCARD, 'Della pittura sui manoscritti di Venezia', *Atti della I. R. Accademia di Belle Arti in Venezia*, 1857.

L. FRANZONI, *Per una storia del collezionismo. Verona: La Galleria Bevilacqua*, Verona, 1970.

B. FREDERICKSEN and F. ZERI, *Census of Pre-Nineteenth-Century Italian Paintings in North American Public Collections*, Cambridge, (Mass.), 1972.

S. FREEDBERG, *Painting in Italy, 1500 to 1600*, Harmondsworth and Baltimore, 1971, revised edition, 1975.

L. FREEMAN BAUER, '"Quanto si disegna, si dipinge ancora", some observations on the Development of the Oil Sketch', *Storia dell'Arte*, 32, 1978, pp. 41–57.

W. FRIEDLAENDER, 'Titian and Pordenone', *The Art Bulletin*, XLVII, 1965, pp. 118–21.

T. FRIMMEL, *Der Anonimo Morelliano. Michiels Notizie d'opere del disegno*, Vienna, 1888.

G. FRIZZONI, ed., *Notizia d'Opere di Disegno pubblicata e illustrata da D. Jacopo Morelli*, Bologna, 1884.

G. FRIZZONI, 'I nuovi acquisti dei Musei del Palazzo di Brera in Milano', *Archivio Storico dell'Arte*, III, 1890, pp. 417–23.

G. FRIZZONI, 'Moretto und Moroni. Eine Charakterisierung auf Grund zwei massgebender Studienblätter', *Münchner Jahrbuch der bildenden Kunst*, VII, 1912, p. 28.

L. FRÖHLICH-BUM, 'Andrea Meldolla, genannt Schiavone', *Jahrbuch der kunsthistorischen Sammlungen der Allerhöchsten Kaiserhauses*, XXXXI, 1913–14, pp. 137–220.

C. FURLAN, 'Appunti su opere del Pordenone in Friuli', *Il Noncello*, 35, 1972, pp. 131–50.

A. FURTWÄNGLER, *Die antiken Gemmen*, Leipzig and Berlin, 1900.

M. GAGGIA, 'Intorno a Pietro Marescalchi', *Archivio storico di Belluno, Feltre e Cadore*, 1930.

M. GAGGIA, 'Due documenti inediti su Pietro Marescalchi', *Archivio storico di Belluno, Feltre e Cadore*, 1933.

L. GALLINA, *Giovanni Cariani*, Bergamo, 1954.

R. GALLO, 'Per la Datazione delle Opere del Veronese', *Emporium*, LXXXIX, 1939, pp. 145–52.

R. GALLO, 'Le mappe geografiche nel Palazzo Ducale di Venezia', *Archivio Veneto*, XXXII–XXXIII, 1943, p. 47–113.

R. GALLO, 'Andrea Palladio a Venezia', *Rivista di Venezia*, 1955, pp. 23–48.

R. GALLO, 'Contributi su Jacopo Sansovino', *Saggi e Memorie di storia dell'arte*, I, 1957, pp. 83–105.

R. GALLO, 'Michele Sanmicheli a Venezia', *Michele San Micheli: Studi raccolti dell'Accademia di Agricoltura, Scienze e Lettere di Verona*, edited by G. Fiocco and others, 1960, pp. 95–160.

C. GAMBA, 'Nuove attribuzioni di ritratti', *Bollettino d'Arte*, 1924/25, pp. 193–217.

C. GAMBA, 'Gian Girolamo Savoldo', *Emporium*, LXXXIX, 1939, pp. 373–88.

C. GAMBA, 'Il mio Giorgione', *Arte Veneta*, VIII, 1954, p. 172.

G. GAMULIN, 'Un nuovo dipinto di G. G. Savoldo', *Commentari*, IV, 1955, pp. 254–57.

K. GARAS, 'The Ludovisi Collection of Pictures in 1663, I', *The Burlington Magazine*, CIX, 1967, p. 287 [1967¹].

K. GARAS, 'Die Entstehung der Galerie des Erzherzogs Leopold Wilhelm', *J.K.S.W.*, LXIII, 1967, pp. 39–86 [1967²].

K. GARAS, 'La Collection des tableaux au Château Royal de Buda au XVIIIe Siècle', *Bulletin du Musée Hongrois des Beaux-Arts*, 32–33, 1969, pp. 91–121.

R. GASTON, 'Bonifazio Veronese's "Rest on the Flight to Egypt"', *Bulletin of the Art Gallery of South Australia*, XXXV, 1977, pp. 36–41.

G. GATTINONI, *Inventario di una casa veneziana del secolo XVII, la casa degli eccelenti Caliari, eredi di Paolo il Veronese*, Mestre, 1914.

P. GAZZOLA, 'Palladio a Verona', *Bollettino del Centro Internazionale di Studi di Architettura Andrea Palladio*, II, 1960, pp. 34–39.

GENEVA 1939, *Les chefs-d'oeuvres du Musée du Prado*, exhibition catalogue, Geneva, 1939.

GENOA 1946, *Mostra della pittura antica in Liguria*, exhibition catalogue edited by A. Morassi, Genoa, 1946.

GENOA 1952, *La Madonna nell'arte di Liguria*, exhibition catalogue edited by P. Rotondi, Genoa, 1952.

J. A. GERE, 'Drawings by Sebastiano del Piombo and Agnolo Bronzino', *British Museum Yearbook*, I, 1974, pp. 270 ff.

J. GERE and P. POUNCEY, with the assistance of R. WOOD, *Italian Drawings in the Department of Prints and Drawings in the British Museum. Artists working in Rome, c. 1550 to c. 1640*, London, 1983.

G. GEROLA, 'Per l'elenco delle opere dei pittori da Ponte', *Atti del R. Istituto Veneto di Scienze, Lettere ed Arti*, LXV, 1906.

G. GEROLA, 'Nuovi documenti veneziani su Alessandro Vittoria', *Atti del R. Istituto Veneto di Scienze, Lettere ed Arti*, LXXXIV, 1924–25, pp. 339–59.

P. GIANUIZZI, 'Lorenzo Lotto e le sue opere nelle Marche', *Nuova Rivista Misena*, VII, 1894, pp. 35–47, 74–94.

D. GIANNOTTI, ed. F.I. Polidori, *Opere politiche e letterarie: Libro de la Republica de Vinitiani*, Florence, 1850.

F. GIBBONS, *Catalogue of Italian Drawings in the Art Museum, Princeton University*, 2 vols., Princeton, 1977.

C. GILBERT, *The Works of Girolamo Savoldo*, unpublished dissertation, New York University; Ann Arbor, University Microfilms, 1955.

C. GILBERT, 'Problemi della documentazione bresciana per il Savoldo', *Commentari dell'Ateneo di Brescia*, CLVIII, 1959, p. 50.

C. GILBERT, 'Review of L. Puppi, 1962', *Art Bulletin*, XLIX, 1967, pp. 184–88.

C. GILBERT, 'Savoldo, Giovanni Girolamo', *McGraw-Hill Dictionary of Art*, New York, 1969, V, pp. 116–17.

B. GIOVANELLI and T. GAR, *Vita di Alessandro Vittoria*, Trent, 1858.

G. GLUCK, 'Ein Frauenbildnis von Moretto in der Wiener Galerie', *Pantheon*, II, 1928, p. 490.

J. GOLDSMITH-PHILLIPS, 'Renaissance Bronzes – A New Installation and Recent Acquisitions', *Bulletin of the Metropolitan Museum of Art*, XXXV, 1940.

G. GOMBOSI, *Palma Vecchio*, Stuttgart and Berlin, 1937.

G. GOMBOSI, *Moretto da Brescia*, Basle, 1943.

A. GONZALEZ-PALACIOS, 'Un Esercitazione su Alvise Vivarini', *Paragone*, XX, I, 1969, pp. 36–38, pl. 18.

B. GONZATI, *La basilica di S. Antonio di Padova descritta ed illustrata*, 2 vols., Padua, 1852–3.

D. GOODGAL, 'The Camerino of Alfonso I d'Este', *Art History*, I, 1978, pp. 162–90.

J. GOODISON and G. ROBERTSON, *Catalogue of Paintings, Italian Schools*, Fitzwilliam Museum, Cambridge, 1965.

GÖTEBORG 1968, *100 Malningar och techningar fran Eremitaget*, exhibition catalogue, Göteborg, 1968.

C. GOULD, *The Sixteenth-century Venetian School*, National Gallery Catalogues, London, 1959.

C. GOULD, 'The Cinquecento at Venice, IV. Pordenone versus Titian', *Apollo*, XCVI, 1972, pp. 106–10.

C. GOULD, *The Sixteenth Century Italian Schools*, National Gallery Catalogues, London, 1975.

L. GRASSI, 'Note sulla Grafica di Palma il Giovane', *Arte Veneta*, XXXII, 1978, pp. 262–71.

M. GREGORI, *Moroni*, Bergamo, 1979.

M. GREGORI, *Giacomo Ceruti*, Milan, 1982.

A. GRISERI, *The famous Italian drawings of the*

Royal Library of Turin, Milan, 1978.
H. W. GROHN, 'Bemerkungen zu zwei Bildern von Giovanni Cariani im Bode-Museum zu Berlin', *Festschrift Ulrich Middeldorf*, 1968.
G. GRONAU, *Titian*, London, 1904.
G. GRONAU, 'Kritische Studien zu Giorgione', *Repertorium für Kunstwissenschaft*, XXXI, 1908, pp. 403–36, 503–21.
L. GROSSATO, *Il Museo Civico di Padova*, Venice, 1957.
V. GUAZZONI, *Moretto. Il tema sacro*, Brescia, 1981.
J. GUILMARTIN, *Gunpowder and Galleys. Changing technology and Mediterranean warfare at sea in the sixteenth century*, London, 1974.
F. HARCK, 'Notizien über italienische Bilder in Petersburger Sammlungen', *Repertorium für Kunstwissenschaft*, XIX, 1896, pp. 413–34.
W. HARTNER, 'The Mercury horoscope of Marcantonio Michiel of Venice', *Vistas in Astronomy*, London and New York, 1955, pp. 83–138.
F. HARTT, *History of Italian Renaissance Art*, New York, 1969.
F. HASKELL and N. PENNY, *Taste and the Antique*, New Haven and London, 1981.
H. HAUG, *Le Musée de Strasbourg*, Strasbourg, 1926; another edition 1938.
E. HAVERKAMP-BEGEMANN and A-M. S. LOGAN, *European Drawings and Watercolours in Yale University Art Gallery, 1500–1900*, 2 vols., New Haven, 1970.
F. HEINEMANN, *Bellini e i Belliniani*, Venice, 1962.
R. HEINEMANN, *Sammlung Schloss Rohoncz*, Lugano-Castagnola, 1958.
P. HENDY, 'More About Giorgione's Daniel and Susanna', *Arte Veneta*, VIII, 1954, p. 167.
P. HENDY, *Some Italian Renaissance Pictures in the Thyssen-Bornemisza Collection*, Lugano-Castagnola, 1964.
L. HEYDENREICH and W. LOTZ, *Architecture in Italy 1400–1600*, Harmondsworth, 1974.
G. F. HILL, *A Corpus of Italian Medals of the Renaissance before Cellini*, 2 vols., London, 1930.
A. M. HIND, *Early Italian Engraving*, 5 vols., London, 1938–48.
B. HINZ, 'Studien zur Geschichte des Ehepaarbildnisses', *Marburger Jahrbuch für Kunstwissenschaft*, XIX, 1974, pp. 139ff.
M. HIRST, *Sebastiano del Piombo*, Oxford, 1981.
U. HOFF, *European painting and sculpture before 1800*, National Gallery of Victoria, Melbourne, 1973.
C. J. HOLMES, 'Giorgione Problems at Trafalgar Square, II', *The Burlington Magazine*, XLII, 1923, p. 230–39.
C. HOPE, 'The "Camerini d'Alabastro" of Alfonso d'Este', *The Burlington Magazine*, CXIII, 1971, pp. 641–50, 712–21.
C. HOPE, *Titian*, London, 1980
C. HOPE, 'Artists, Patrons and Advisers', *Patronage in the Renaissance*, edited by G. Fitch Lytle and S. Orgel, Princeton, 1981.
D. HOWARD, *Jacopo Sansovino: Architecture and Patronage in Renaissance Venice*, New Haven and London, 1975.
D. HOWARD, *The Architectural History of Venice*, London, 1980.
D. HOWSE and M. SANDERSON, *The Sea Chart*, Newton Abbot, 1973.
R. H. HUBBARD, *European Paintings in Canadian Collections. Older Schools*, Toronto, 1956.
J. HUBNER, *Catalogue de la Galerie Royale de Dresde*, translated and revised by C. Sevin, Dresden, 1880.
E. JACOBSEN, 'Le Gallerie Brignole-Sale-De Ferrari in Genova', *Archivo Storico dell'Arte*, II, 1896, pp. 88–129.
M. JAFFÉ, 'Giuseppe Porta, il Salviati and Peter Paul Rubens', *The Art Quarterly*, XVIII, 1955, pp. 330–40.
M. JAFFÉ, 'Pesaro Family Portraits: Pordenone, Lotto and Titian', *The Burlington Magazine*, CXIII, 1971, pp. 696–702.
A. JARVIS, *The National Gallery of Canada. Catalogue of Paintings and Sculptures. Other Schools*, Ottawa, 1957.
B. JESTAZ, 'Travaux recents sur les Bronzes: I. Renaissance italienne', *Revue de l'art*, V, 1969, pp. 79–81.
B. JESTAZ, 'Un bronze inedit de Riccio', *La Revue du Louvre et des Musées de France*, III, 1975, pp. 156–62.
B. JESTAZ, 'Requiem pour Alessandro Leopardi', *Revue de l'art*, LV, 1982, pp. 23–34.
B. JESTAZ, 'Un groupe de bronze érotique de Riccio', *Monuments et Mémoires*, LXV, 1983, pp. 25–54.
J. JOHNSON, 'Ugo da Carpi's Chiaroscuro Woodcuts', *Print Collector/Il Conoscitore di stampe*, LVII–LVIII, 1982, pp. 2ff.
K. JUSTI, *Giorgione*, 2 vols., Berlin, 1908.
G. S. KAKAY, 'Giorgione e Tiziano', *Bollettino d'Arte*, 1960, p. 320.
C. KARPINSKI, *Le Peintre Graveur Illustré – Italian Chiaroscuro Woodcuts*, Pennsylvania U.P., 1971.
F. M. KELLY, 'Note on an Italian Portrait at Doughty House', *The Burlington Magazine*, LXXV, 1939, p. 75.
B. KLESSE, 'Studien zu Italienischen und Französischen Gemälden des Wallraf-Richartz Museums', *Wallraf-Richartz Jahrbuch*, XXXIV, 1972.
K. KÖPL, 'Inventar der Kunst und Schatzkammer auf dem Prager Schlösse, Prag 5 Oktober 1737', *Jahrbuch der Kunsthistorischen Sammlungen des Allerhöchsten Kaiserhauses*, X, 1899, pp. CXLII ff.
F. KOSSOFF, 'Romanino in Brescia', *The Burlington Magazine*, CVIII, 1965, pp. 514–21.
H. KOZAKIEWICZOWA, 'Vita e attività di Gian Maria Mosca chiamato il Padovano nel suo primo periodo italiano', *Biuletyn Historii Sztuki*, XXVI, 1964, pp. 153-68.
F. KRIEGBAUM, 'Ein verschollenes Brunnenwerk des Bartolomeo Ammannati', *Mitteilungen des kunsthistorischen Instituts in Florenz*, III, 1929, pp. 71–103.
E. KRIS, *Meister und Meisterwerke der Steinschneidekunst in der italienischen Renaissance*, Vienna, 1929.
P. KRISTELLER, *Engravings and Woodcuts by Jacopo de' Barbari*, Berlin, 1896.
P. KRISTELLER, *Giulio Campagnola, Kupferstiche und Zeichnungen*, Berlin, 1907.
F. LANE, *Venice. A Maritime Republic*, Baltimore and London, 1973.
M. LASKIN, 'A note on Correggio and Pordenone', *The Burlington Magazine*, CIX, 1967, pp. 355–56.
S. LATUADA, *Descrizione di Milano*, 2 vols., Milan, 1737.
LAUSANNE 1947, *Trésors de l'art Vénetien*, exhibition catalogue, Lausanne, 1947.
J. LAUTS, 'Zwei Kaminböcke des Francesco Segala im Berliner Schlossmuseum', *Berliner Museen: Bericht aus den Preussischen Kunstsammlungen*, LVII, 1936, pp. 69–73.
J. LAUTS, *Carpaccio*, London, 1962, reviewed by T. Pignatti, *Master Drawings*, I, 1963, pp. 57ff.
A. LAZZARI, 'Il Ritratto del Mosti di Tiziano nelle Gallerie Pitti', *Arte Veneta*, V, 1951, pp. 209–216.
L. LAZZARINI and others, *Giorgione: La Pala di Castelfranco Veneto*, Milan, 1978.
E. LEGRAND, *Christophe Buondelmonti*, Paris, 1897.
M. LEITHE-JASPER, *Alessandro Vittoria – Beiträge zu einer Analyse des Stils seiner figurlichen Plastiken unter besonderer Berucksichtigung der Beziehungen zur gleichzeitigen Malerei in Venedig*, dissertation, University of Vienna, 1963.
M. LEITHE-JASPER and others, *Das Kunsthistorisches Museum in Wien*, Vienna, 1978.
M. LEITHE-JASPER, 'Inkunabeln der Bronzeplastik der Renaissance', *Die Weltkunst*, LI, 1981, pp. 3188–90.
LENINGRAD 1972, *The Art of the Portrait*, exhibition catalogue, Leningrad, 1972.
LENINGRAD 1976, *Musée de L'Ermitage. Peinture de L'Europe Occidentale. Catalogue*, I, *Italie, Espagne, France, Suisse*, Leningrad, 1976.
A. LENOIR, *Musée des Monuments Français*, 5 vols., Paris, 1800-06.
J. A. LEVENSON, K. OBERHUBER and J. L. SHEEHAN, *Early Italian Engravings from the National Gallery of Art*, exhibition catalogue, Washington, 1973.
M. LEVEY, 'Tintoretto and the Theme of Miraculous Intervention', *Journal of the Royal Society of Arts*, CXIII, 1965, pp. 707–25.
D. LEWIS, 'The Washington Relief of *Peace* and its Pendant: A Commission of Alfonso d'Este to Antonio Lombardo in 1512', *Collaboration in Italian Renaissance Art*, edited by W. Sheard and J. Paoletti, New Haven and London, 1978, pp. 233–41.
Lewis 1981 see WASHINGTON 1981/82.
G. LILL, *Hans Fugger und die Kunst*, Leipzig, 1908.
LONDON 1872, *Exhibition of Works by the Old Masters*, The Royal Academy, London, 1872.
LONDON 1902, *Exhibition of Works by the Old Masters*, The Royal Academy, London, 1902.
LONDON 1915, *Venetian Pictures. Titian and his Contemporaries*, exhibition catalogue by R. H. Benson, Burlington Fine Arts Club, London, 1915.
LONDON 1930, 1931, *Exhibition of Italian Art 1200–1900*, exhibition catalogue by Lord Balniel and K. Clark, catalogue of the drawings by A. E. Popham, The Royal Academy, London, 1930; commemorative catalogue, 1931.
LONDON 1939, *Venetian Paintings*, exhibition catalogue, Matthiessen Gallery, London, 1939.
LONDON 1946–47, *The King's Pictures*, exhibition catalogue, The Royal Academy, London 1946–47.
LONDON 1949[1], *Art Treasures from Vienna*, exhibition catalogue, London, 1949.
LONDON 1949[2], *Old Master Drawings from Chatsworth*, Arts Council, London 1949.
LONDON 1950–51, *Exhibition of Works by Holbein and Other Masters of the 16th and 17th Centuries*, exhibition catalogue, The Royal Academy, London, 1950–51.
LONDON 1959, *Treasures of Cambridge*, exhibition catalogue edited by C. Winter, Goldsmiths Hall, London, 1953.
LONDON 1960, *Italian Art and Britain*, exhibition catalogue by E. K. Waterhouse, Royal Academy, London, 1960.
LONDON 1961, *Italian Bronze Statuettes*, edited by J. Pope-Hennessy, Victoria & Albert Museum, London, 1961.
LONDON 1962, *Old Master Drawings from the Collection of Mr. C. R. Rudolf*, exhibition catalogue, London, 1962.
LONDON 1969, *Old Master Drawings from Chatsworth*, exhibition catalogue edited by T. Wragg, Royal Academy, London, 1969.
LONDON 1970 see CANNON-BROOKES 1970
LONDON, PARIS, BERNE, BRUSSELS 1972, *Flemish Drawings of the Seventeenth Century from the Collection of Frits Lugt, Institut Néerlandais, Paris*, exhibition catalogue by C. van Hasselt, London, Paris, Berne, Brussels, 1972.
LONDON 1972–73, *Drawings by Michelangelo, Leonardo, Raphael, and their contemporaries*, exhibition catalogue edited by A. Blunt, The Queen's Gallery, London, 1972–73.
LONDON 1973, *Chatsworth Drawings, II*, exhibition catalogue edited by J. Byam Shaw,

Royal Academy, London, 1973.
LONDON 1975, *Andrea Palladio 1508–1580: The Portico and the Farmyard*, exhibition catalogue edited by H. Burns, L. Fairbairn and B. Boucher, The Arts Council, London, 1975.
LONDON 1976, *Exhibition of Fifty Old Master Drawings*, exhibition catalogue, Baskett and Day, London, 1976.
LONDON and MILAN 1979–1981, *The Horses of San Marco*, exhibition catalogue, London, 1979; Milan, 1981.
LONDON 1983, *Italian Drawings from the Lugt Collection*, exhibition handlist by J. Byam Shaw, British Museum, London, 1983.
R. LONGHI, 'Cose bresciane del Rinascimento', *L'Arte*, XX, 1917, pp. 110–13.
R. LONGHI, 'Precisioni nelle gallerie italiane: Galleria Borghese', *Vita Artistica*, I, 1926, pp. 71–72.
R. LONGHI, 'Domenico Mancini', *Vita Artistica*, II, 1927, pp. 14ff. [1927¹].
R. LONGHI, 'Due dipinti inediti di G. G. Savoldo', *Vita Artistica*, II, 1927, pp. 72–75 [1927²].
R. LONGHI, 'Cartella tizianesca', *Vita Artistica*, II, 1927, pp. 216–26 [1927³].
R. LONGHI, 'Quesiti caravaggeschi II, *i precedenti*', *Pinacotheca*, V–VI, 1929, pp. 258–320.
R. LONGHI, *Ampliamenti nell'Officina Ferrarese*, Florence, 1940.
R. LONGHI, *Viatico per Cinque Secoli di Pitture Veneziane*, Florence, 1946.
M. LORENTE JUNQUERA, 'Sobre Veronese en el Prado', *Archivo Español de Arte*, XLII, 1969, pp. 235–43.
G. LORENZETTI, ed., *Vita di Jacopo Tatti detto il Sansovino di Giorgio Vasari*, Florence, 1913.
G. LORENZETTI, *Venezia e il suo estuario*, Milan and Rome, 1926; another edition, 1956.
G. B. LORENZI, *Documenti per servire alla storia del Palazzo Ducale di Venezia*, Venice, 1868.
LORETO 1980, *Lorenzo Lotto a Loreto e Recanati*, edited by F. Grimaldi, Loreto, 1980.
LOS ANGELES 1979, *The Golden Century of Venetian Painting*, exhibition catalogue by T. Pignatti with K. Donahue, Los Angeles County Museum of Art, 1979.
LOTTO 1969 see ZAMPETTI 1969.
W. LOTZ, 'The Roman Legacy in Jacopo Sansovino's Venetian Buildings, *Journal of the Society of Architectural Historians*, XXII, 1963, pp. 3–12.
M. LUCCO, *L'Opera Completa di Sebastiano del Piombo*, Milan, 1980.
G. LUDWIG, 'Bonifazio de' Pitati da Verona, eine archivalische Untersuchung', *J.K.P.K.*, XXII, 1901, pp. 61–78, 180–200; XXIII, 1902, pp. 36–66.
G. LUDWIG, 'Archivalische Beiträge zur Geschichte der venezianischen Malerei', *J.K.P.K.*, XXIV, (Beiheft) 1903, pp. 1–109; XXVI (Beiheft), 1905, pp. 1–157.
G. LUDWIG, 'Archivalische Beiträge zur Geschichte der venezianischen Kunst aus dem nachlass Gustav Ludwigs', edited by W. von Bode, G. Gronau and D. von Hadeln, *Italienische Forschungen*, IV, 1911.
G. LUDWIG and P. MOLMENTI, *Vittore Carpaccio*, Milan, 1906.
F. LUGT, J. Q. VAN REGTEREN ALTENA and J. C. EBBINGE WUBBEN, *Le dessin italien dans les collections hollandaises*, Paris, Rotterdam, Haarlem, 1962.
A. LUZIO, 'Giulio Campagnola fanciullo prodigio', *Archivio Storico dell'Arte*, I, 1888, pp. 184ff.
H. MACANDREW, *Catalogue of the Collection of Drawings in the Ashmolean Museum*, III, Oxford, 1980.
F. MACCARINELLI, *Le Glorie di Brescia* (ms. of 1747–51), edited by C. Boselli, Brescia, 1959.
D. McTAVISH, 'A Drawing by Girolamo Campagna for the High Altar of San Giorgio Maggiore', *Arte Veneta*, XXXIV, 1980, pp. 165–68.
D. McTAVISH, *Giuseppe Porta called Giuseppe Salviati*, New York and London, 1981.
M. MAEK-GERARD, 'Die "Milanexi" in Venedig: Ein Beitrag zur Entwicklungsgeschichte der Lombardi-Werkstatt', *Wallraf-Richartz Jahrbuch*, XLI, 1980, pp. 105–30.
MAGAGNATO 1952 see VENICE 1952.
L. MAGAGNATO, 'I Collaboratori veronesi di Andrea Palladio,' *Bollettino del Centro Internazionale di studi di architettura Andrea Palladio*, X, 1968, pp. 170–87.
L. MAGANATO and B. PASSAMANI, *Il Museo Civico di Bassano del Grappa. Dipinti dal 14° al 20° secolo*, Bassano, 1978.
A. MAGGIORI, *Dell'Itinerario d'Italia*, II, Ancona, 1832.
D. MAHON, 'Notes on the "Dutch Gift" to Charles II', *The Burlington Magazine*, XCII, 1950, p. 12.
F. MALAGUZZI VALERI, *Catalogo della R. Pinacoteca di Brera in Milano*, Bergamo, 1908.
D. MALIPIERO, 'Annali veneti dell'anno 1457 al 1500...', edited by A. Sagredo, *Archivio Storico Italiano*, VII, 1843.
R. MALSBURG, *Die Architektur der Scuola Grande di San Rocco in Venedig*, dissertation, University of Heidelburg, 1976.
MANCHESTER 1957, *European Old Masters*, exhibition catalogue, City Art Gallery, Manchester, 1957.
MANCHESTER 1965, *Between Renaissance and Baroque; European Art, 1520–1600*, exhibition catalogue edited by F. G. Grossmann, 1965.
MANFRIN COLLECTION 1856, *Catalogo dei Quadri esistenti nella Galleria Manfrin in Venezia*, Venice, 1856.
E. MARANI and C. PERINA, *Mantova: Le Arti*, 4 vols., Mantua, 1965.
G. MARANINI, *La costituzione di Venezia dalle origini alla serrata del Maggior Consiglio*, Venice, 1927.
G. MARANINI, *La costituzione di Venezia dopo la serrata del Maggior Consiglio*, Venice, 1931.
G. MARIACHER, 'Per il nuovo allestimento del Museo Correr. Dipinti restaurati: Lazzaro Bastiani, Gentile Bellini, Jacopo Tintoretto, Pietro Longhi', *Arte Veneta*, VII, 1953, pp. 205–08.
MARIACHER 1959 see VENICE 1959.
G. MARIACHER, *Palma il Vecchio*, Milan, 1968.
G. MARIACHER, *Bronzetti veneti del rinascimento*, Vicenza, 1971.
G. MARIACHER, *I Pittori Bergamaschi dal XIII al XIX secolo. Il Cinquecento*, Bergamo, 1975.
R. MARINI, *Sebastiano Florigerio*, Udine, 1956.
R. MARINI, *Tutta la pittura di Paolo Veronese*, Milan, 1968.
G. MASCHERPA, *Lorenzo Lotto a Bergamo*, Milan, 1971.
G. MASCHERPA, *Invito a Lorenzo Lotto*, Milan, 1980.
MASCHIO 1980 see VENICE 1980¹ (*ad vocem* Rialto)
S. MASON RINALDI, 'Un ritratto di Jacopo Palma il Giovane a Birmingham', *Per Maria Cionini Visani. Scritti di amici*, Turin, 1977, pp. 96–99.
S. MASON RINALDI, *Jacopo Palma il Giovane*, Milan, 1983.
F. MATHER, 'When was Titian born?', *Art Bulletin*, XX, 1938, pp. 13–25.
A. L. MAYER, 'Two Pictures by Titian in the Escorial', *The Burlington Magazine*, LXXI, 1937, pp. 178–83.
G. MAZZARIOL and T. PIGNATTI, *La pianta prospettica di Venezia del 1500*, Venice, 1963.
J. MEDER, *Dürer-Katalog*, Vienna, 1932.
B. MEIJER, 'Early Drawings by Titian: Some Attributions', *Arte Veneta*, XXVIII, 1974, pp. 75–92.
M. MEISS, 'Sleep in Venice. Ancient Myths and Renaissance Proclivities', *Proceedings of the American Philosophical Society*, CX, 1966, pp. 348ff.
L. MENEGAZZI, 'Ludovico Pozzoserrato', *Saggi e Memorie di Storia dell'Arte*, I, 1957.
L. MENEGAZZI, *Il Museo Civico di Treviso. Dipinti e sculture dal XII al XIX secolo*, Venice, 1963.
J. MEYER ZUR CAPELLEN, *Andrea Previtali*, Wurzburg, 1972.
J. MEYER ZUR CAPELLEN, 'Bellini in der Scuola Grande di S. Marco', *Zeitschrift für Kunstgeschichte*, XLIII, 1980, pp. 104–08.
F. MIARI, *Dizionario storico-artistico-letterario bellunese*, Belluno, 1843.
MICHIEL see FRIMMEL 1888, FRIZZONI 1884, MORELLI 1800.
U. MIDDELDORF, 'Glosses on Thieme-Becker', *Festschrift für Otto von Simson*, Frankfurt-am-Main, 1977, pp. 289–94.
MILAN 1953, *I pittori della realtà in Lombardia*, exhibition catalogue, Milan, 1953.
MILAN 1971, *Disegni di Manieristi Lombardi*, exhibition catalogue edited by G. Bora, Ambrosiana, Milan, 1971.
MILAN 1977, *L'Ermitage a Milano. Dipinti Italiani dal XV al XVIII secolo*, exhibition catalogue edited by T. Formiciova, T. Kustodieva and S. Vsevolozhskaja, Milan, 1977.
MILAN 1981 see LONDON AND MILAN 1979–1981.
E. MODIGLIANI, *Catalogo della Pinacoteca di Brera*, Milan, 1950.
MOLAJOLI 1939 see UDINE 1939.
P. MOLMENTI, 'Giorgione', *Bollettino di arti, industria, e curiosità veneziane*, 1878, p. 17.
P. MOLMENTI, *La storia di Venezia nella vita privata dalle origini alla caduta della Repubblica*, 3 vols., Turin, 1880; another edition Bergamo, 1906–08.
P. MOLMENTI, *Il Moretto da Brescia*, Florence, 1898.
P. MOLMENTI and G. LUDWIG, *The Life and Work of Vittore Carpaccio*, London, 1907.
G. MONGERI, *L'arte in Milano*, Milan, 1872.
A. MORASSI, 'Per la ricostruzione di Maffeo Olivieri', *Bollettino d'Arte*, XXX, 1936–37, pp. 237–49.
MORASSI 1946 see GENOA 1946
A. MORASSI, 'The Lotto Exhibition in Venice' review, *The Burlington Magazine*, XCIX, 1957, pp. 290–96.
J. MORELLI, *Notizia d'Opere di Disegno nella prima metà del secolo XVI... scritta da un anonimo di quel tempo*, Bassano, 1800; another edition edited by G. Frizzoni, Bologna, 1884.
G. MORELLI, *Die Werke italienischer Meister in den Galerien von München, Dresden und Berlin*, Leipzig, 1880; revised edition, 1893; Italian edition, 1886.
G. MORELLI, *Italian Painters. The Borghese and Doria Pamphili Galleries in Rome*, London, 1892.
A. MOSCHETTI, 'Di alcune terracotte ignorate di Andrea Riccio', *Bollettino del Museo Civico di Padova*, X, 1907, pp. 57–62.
A. MOSCHETTI, 'Andrea Briosco detto il Riccio', *Bollettino del Museo Civico di Padova*, n.s. III, 1927, pp. 118–58.
A. MOSCHETTI, *Il Museo Civico di Padova*, 2 vols., Padua, 1938.
S. MOSCHINI MARCONI, *Gallerie dell'Accademia di Venezia*, Rome, 1955, 1962.
MOSCOW 1958, *Musée de l'Ermitage. Département de l'Art Occidental. Catalogues de peintures*, Leningrad and Moscow, 1958.
MOSCOW 1982, *Antiquity in European Painting*, exhibition catalogue, Moscow, 1982.
R. C. MUELLER, 'The Procurators of San Marco in the Thirteenth and Fourteenth Centuries: a study of the office as a Financial and Trust Institution', *Studi Veneziani*, XIII, 1971,

pp. 105–220.

E. MUIR, *Civic Ritual in Renaissance Venice*, Princeton, 1981.

MUNICH 1930, *Sammlung Schloss Rohoncz: Plastik und Kunstgewerbe*, exhibition catalogue, Neue Pinakothek, Munich, 1930.

R. MUNMAN, 'Two lost Venetian Statues', *The Burlington Magazine*, CXII, 1970, pp. 386–87.

R. MUNMAN, 'The Lombardo Family and the Tomb of Giovanni Zanetti', *Art Bulletin*, LIX, 1977, pp. 28–38.

M. MURARO, *Carpaccio*, Florence, 1966.

M. MURARO and D. ROSAND *see* VENICE 1976²

E. MUSATTI, *Storia della Promissione Ducale*, Padua, 1888.

G. NAGLER, *Die Monogrammisten*, Munich, 1858–79

A. NAVAGERO, *Opera Omnia*, Venice, 1754.

A. NÉOUSTROÏEFF, 'I quadri italiani nella collezione del Duca G. N. von Leuchtenberg di Pietroburgo', *L'Arte*, VI, 1903, pp. 329–46.

J. NEUMANN, *Titian: The Flaying of Marsyas*, London, 1965.

E. NEWTON, *Tintoretto*, Bristol, 1952.

NEW YORK 1926, *Early Italian Paintings at the Duveen Galleries*, catalogue by W. R. Valentiner, New York, 1926.

NEW YORK 1963, *Venetian Paintings of the Sixteenth Century*, exhibition catalogue edited by R. L. Manning, Finch College Museum of Art, New York City, 1963.

NEW YORK 1965, *Drawings from New York Collections, The Italian Renaissance*, exhibition catalogue edited by J. Bean and F. Stampfle, New York, 1965.

NEW YORK and LONDON 1969–70, *Italian Drawings from the Ashmolean Museum, Oxford*, exhibition catalogue by D. Sutton and K. Garlick, Wildenstein, New York and London, 1969–70.

NEW YORK 1971, *The Richard H. Rush Collection*, exhibition catalogue introduced by R. L. Manning, Finch College Museum of Art, New York, 1971.

NEW YORK and PARIS 1974–75, *Italian Renaissance Drawings from the Musée du Louvre*, exhibition catalogue edited by R. Bacou and F. Viatte, Metropolitan Museum, New York; Musée du Louvre, Paris, 1974–75.

G. NICCO FASOLA, 'Lineamenti del Savoldo', *L'Arte*, XLIII, 1940, pp. 51ff.

NICE 1979, *L'art religieux à Venise, 1500–1600*, exhibition catalogue edited by P. Provoyeur, Musée National Bibliotheque Marc Chagall, Nice, 1979.

G. NICODEMI, *La Pinacoteca Tosio-Martinengo*, Bologna, 1927.

M. NICOLLE, *Le Musée de Rouen. Peintures*, Rouen, 1927.

B. NICOLSON, 'The Winter Exhibition at the Royal Academy – II', *The Burlington Magazine*, 1962, pp. 109–10.

A. NIERO, *La Chiesa dei Carmini*, Venice, 1965.

A. NIERO, *La Chiesa di S. Giacomo dall'Orio*, Venice, 1979.

NORFOLK 1967–68, *Italian Renaissance and Baroque paintings from the Collection of Walter P. Chrysler, Jr.*, exhibition catalogue edited by R. L. Manning, Norfolk Museum of Arts and Sciences, Norfolk, Virginia, 1967–68.

NOTTINGHAM and LONDON 1983, *Drawing in the Italian Renaissance Workshop*, exhibition catalogue by F. Ames-Lewis and J. Wright, University Art Gallery, Nottingham, and Victoria & Albert Museum, London, 1983.

V. NOVOTNY, *I Maestri del Colore. I Capolavori della Galleria Nazionale di Praga*, Prague, 1960.

V. OBERHAMMER and F. KLAUNER, *Die Gemäldegalerie des kunsthistorischen Museums in Wien. Malerei der romischen Länder*, Vienna, 1960.

V. OBERHAMMER, F. KLAUNER and G. HEINZ, *Kunsthistorisches Museum, Wien, Katalog der Gemäldegalerie, I Teil, Italiener, Spanier,*

Franzosen, Englander, Vienna, 1965.

K. OBERHUBER, *Graphische Sammlung Albertina – Renaissance in Italien*, Vienna, 1966.

K. OBERHUBER, *Rome and Venice – Prints of the High Renaissance*, Cambridge, Mass., 1974.

K. OBERHUBER, 'Titian Woodcuts and Drawings – Some Problems', *Tiziano e Venezia*, Vicenza, 1980, pp. 523ff.

L. OBERZINER, *Il Ritratto di Cristoforo Madruzzo di Tiziano*, Trent, 1900.

F. ONGANIA, ed., *La Processione del Doge nella Domenica delle Palme incisa in Venezia per Mattio Pagan 1556–69*, Venice, 1880.

P. A. ORLANDI, *Abecedario Pittorico*, Venice, 1753.

S. ORTOLANI, 'Di Giangirolamo Savoldo', *L'Arte*, XXVIII, 1925, pp. 163ff.

F. B. P. OSMASTON, *The Art and Genius of Tintoret*, 2 vols., London, 1915.

P. OSMOND, *Paolo Veronese, his career and work*, London, 1927.

H. OST, *Tizians Kasseler Kavalier*, Cologne, 1982.

L. OZZOLA, *Il Museo d'Arte Medievale e Moderna del Palazzo Ducale di Mantova*, Mantua, 1950.

O. PÄCHT, *Italian Illuminated Manuscripts from 1400 to 1550*, Oxford, 1948.

PADUA 1976, *Dopo Mantegna: Arte a Padova e nel territorio nei secoli XV e XVI*, Palazzo della Ragione, Padua, 1976.

F. PAGLIA, *Il Giardino della Pittura*, ms. of 1663–75, edited by C. Boselli, Brescia, 1967.

A. PALLADIO, *I Quattro Libri dell'Architettura*, Venice, 1570.

R. PALLUCCHINI, 'Sculture della R. Galleria Estense', *Emporium*, LXXXIV, 1936, pp. 301–08.

R. PALLUCCHINI, 'Vicende delle ante d'organo di Sebastiano del Piombo per San Bartolomeo a Rialto', *Le Arti*, 1941, pp. 448–56.

R. PALLUCCHINI, *La pittura veneziana del Quattrocento*, 2 vols., Novara, 1944 [1944¹].

R. PALLUCCHINI, *La pittura veneziana del Cinquecento*, 2 vols., Novara, 1944 [1944²].

R. PALLUCCHINI, *Sebastian Viniziano*, Milan, 1944 [1944³].

R. PALLUCCHINI, *I capolavori dei musei veneti*, Venice, 1946.

R. PALLUCCHINI, 'Veneti alle mostre di Brescia e di Genova', *Arte Veneta*, I, 1947, p. 148.

R. PALLUCCHINI, 'La Mostra di Feltre', *Arte Veneta*, II, 1948, p. 171.

R. PALLUCCHINI, *La giovanezza del Tintoretto*, Milan, 1950.

R. PALLUCCHINI, 'Veneti alla Royal Academy di Londra', *Arte Veneta*, V, 1951, p. 219.

R. PALLUCCHINI, *Tiziano*, Bologna, 1952–53.

R. PALLUCCHINI, *Giorgione*, Milan, 1955.

R. PALLUCCHINI, 'Jacopo Bassano e il Manierismo', *Studies in the History of Art dedicated to William E. Suida*, London, 1959.

R. PALLUCCHINI, *I Teleri del Carpaccio in San Giorgio degli Schiavoni*, Milan, 1961.

R. PALLUCCHINI, *I Vivarini*, Venice, 1962.

R. PALLUCCHINI, *L'Arte di Lorenzo Lotto*, University of Padua publication, 1965–66.

R. PALLUCCHINI, 'Due concerti bergamaschi del Cinquecento', *Arte Veneta*, XX, 1966, pp. 87–97.

R. PALLUCCHINI, *Tintoretto*, Florence, 1969 [1969¹].

R. PALLUCCHINI, *Tiziano*, 2 vols., Florence, 1969 [1969²].

R. PALLUCCHINI, 'Il Tintoretto di Newcastle-upon-Tyne', *Arte Veneta*, XXX, 1976, pp. 81–97.

R. PALLUCCHINI, *Jacopo Bassano e il Manierismo*, University of Padua publication, 1977–78.

PALLUCCHINI 1978 *see* VENICE 1978.

R. PALLUCCHINI, *La pittura veneziana del Seicento*, Milan, 1981.

R. PALLUCCHINI, 'Note carianesche', *Arte Veneta*, XXXVI, 1982 [1982¹].

P. PALLUCCHINI, *Jacopo Bassano*, 1982 [1982²].

R. PALLUCCHINI and G. MARIANI CANOVA,

L'Opera completa del Lotto, Milan, 1975.

R. PALLUCCHINI and F. ROSSI, *Giovanni Cariani*, Bergamo, 1983 (forthcoming publication).

R. PALLUCCHINI and P. ROSSI, *Tintoretto, Le Opere sacre e profane*, 2 vols., Milan, 1982.

A. PALOMINO DE CASTRO Y VELASCO, *El museo Pictórico*, 1724; reprinted Madrid, 1947.

G. PANAZZA, *I Musei e la Pinacoteca di Brescia*, Bergamo, 1959.

G. PANAZZA, 'La presenza a Bergamo di Alessandro Bonvicino detto il Moretto', *I Pittori Bergamaschi. Il Cinquecento*, III, Bergamo, 1979.

E. PANOFSKY, *Problems in Titian, mostly Iconographic*, New York, 1969.

P. PAOLETTI, *L'architettura e la scultura del Rinascimento in Venezia*, 3 vols., Venice, 1893.

P. PAOLETTI, *Raccolta di documenti inediti per servire alla storia della pittura veneziana nei secoli XV e XVI*, Padua, 1894.

A. PAOLUCCI, 'Rassegna dei Restauri', *Arte Veneta*, XXXIV, 1980, p. 285.

PARIS 1935, *Exposition de l'art italien de Cimabue à Tiepolo*, exhibition catalogue, Petit Palais, Paris, 1935.

PARIS 1960, *Exposition de 700 tableaux tirés des reserves du Louvre*, exhibition catalogue, Paris, 1960.

PARIS 1962¹, *Dessins du Louvre*, Musée du Louvre, Paris, 1962.

PARIS 1962², *Le dessin italien dans les collections hollandaises*, exhibition catalogue, Paris, Rotterdam and Haarlem, 1962.

PARIS 1964, *Dessins de l'Ecole de Parme*, exhibition catalogue edited by R. Bacou, Paris, 1964.

PARIS 1965, *Le seizième siècle européen. Dessins du Louvre*, exhibition catalogue edited by R. Bacou, Musée du Louvre, Paris, 1965.

PARIS 1965–66, *Le seizième siècle européen. Peintures et Dessins dans les collections publiques françaises*, catalogue edited by P. Rosenberg, M. Laclotte and A. Cacan, Paris, 1965–66.

PARIS 1967, *Le cabinet d'un grand amateur, P.-J. Mariette, 1694–1774. Dessins du XVe siècle au XVIIIe siècle*, exhibition catalogue, Paris, 1967.

PARIS 1976, *Hommage à Titien*, exhibition catalogue edited by B. Meijer, Institut Néerlandais, Paris, 1976.

PARIS 1977–78, *Collections du Louis XIV*, exhibition catalogue edited by R. Bacou, Orangerie, Paris, 1977–78.

PARIS 1978, *Nouvelles attributions*, handlist to exhibition, Musée du Louvre, Paris, 1978.

K. T. PARKER, 'Alvise Vivarini: Studies of Hands. Coll. Mr. Frits Lugt, Maartengdijk, Holland', *Old Master Drawings*, I, 1926, p. 6.

K. T. PARKER, *North Italian Drawings of the Quattrocento*, London, 1927.

K. T. PARKER, 'Bartolomeo Montagna', *Old Master Drawings*, IX, 1934, p. 8.

K. T. PARKER, *Catalogue of the Collection of Drawings in the Ashmolean Museum*, 2 vols., Oxford, 1956.

A. PERISSA, 'Scuola dei Sartori', in Gramigna, Perissa and Scarabello, *Scuole di Arti Mestieri e Devozione a Venezia*, Venice, 1981.

A. PERTUSI, 'Quedam regalia insignia', *Studi Veneziani*, VII, 1965.

A. PETRUCCI, 'Interpretazione di Giulio Campagnola', *L'Arte*, 1958, pp. 12ff.

A. PETRUCCI, *Panorama dell'Incisione Italiana – Il Cinquecento*, Rome, 1964.

PHILADELPHIA 1941, *John G. Johnson Collection. Catalogue of Paintings*, Philadelphia, 1941.

C. PHILLIPS, 'Some portraits by Cariani', *The Burlington Magazine*, XXIV, 1913, pp. 157–64.

G. PICCININI, *Guida di Reggio Emilia*, Reggio Emilia, 1931.

C. PIETRANGELI, 'Nuovo lavori nella più antica Pinacoteca di Roma', *Capitolium*, XXVI, 1951,

pp. 59–71.

L. Pietrogrande, 'Francesco Segala', *Bollettino del Museo Civico di Padova*, xxx–xliii, 1942–54, pp. 111–35; xliv, 1955, pp. 99–119; l, 1961, pp. 29–58.

A. Pigler (ed.), *Museum der Bildender Künste Szépmüvészeti Muzeum Budapest, Katalog der Galerie Alter Meister*, i, Tübingen, 1968.

T. Pignatti, *Pittura veneziana del Cinquecento*, Bergamo, 1947.

T. Pignatti, 'Gli inizi di Andrea Riccio', *Arte Veneta*, vii, 1953, pp. 25–38.

Pignatti 1963 see Lauts 1962.

T. Pignatti, 'La pianta di Venezia di Jacopo de' Barbari', *Bollettino dei Musei Civici Veneziani*, ix, 1964, pp. 9–49.

T. Pignatti, *Giorgione*, Venice, 1969; second edition 1978; English edition 1971.

T. Pignatti, *Vittore Carpaccio*, Milan, 1972.

T. Pignatti, *Veronese: l'opera completa*, 2 vols., Venice, 1976.

T. Pignatti, *Tiziano. Disegni*, Florence, 1979.

Pignatti 1979–80 see Los Angeles 1979

A. Pinetti, *Il conte Giacomo Carrara e la sua galleria secondo il catalogo del 1796*, Bergamo, 1922.

A. Pinetti, *Inventario degli oggetti d'arte d'Italia. Provincia di Bergamo*, Rome, 1931.

P. Pino, *Dialogo della Pittura*, Venice, 1548; another edition edited by R. Pallucchini, Venice, 1946.

E. Piot, 'La sculpture à l'exposition rétrospective du Trocadero', *Gazette des Beaux-Arts*, xviii, 1878, pp. 576–660.

M. Pittaluga, *Il Tintoretto*, Bologna, 1925.

P. Piva and G. Pavesi, 'Giulio Romano e la chiesa abbaziale di Polirone; documenti e proposte filologiche', *Studi su Giulio Romano*, Accademia Polironiana, San Benedetto Po, 1975, pp. 53–119.

Piva 1980 see Venice 1980[1].

L. Planiscig, *Die Estensische Kunstsammlung, I. Skulpturen und Plastiken des Mittelalters und der Renaissance*, Vienna, 1919.

L. Planiscig, *Venezianische Bildhauer der Renaissance*, Vienna, 1921.

L. Planiscig, *Die Bronzeplastiken, Kunsthistorisches Museum in Wien*, Vienna, 1924.

L. Planiscig, *Andrea Riccio*, Vienna, 1927.

L. Planiscig, 'Bronzeplastiken der da Gonzate', *Pantheon*, iii, 1929, pp. 43–47.

L. Planiscig, *Piccoli Bronzi italiani del Rinascimento*, Milan, 1930.

L. Planiscig, 'Desiderio da Firenze: Dokumente und Hypothesen', *Zeitschrift für Bildende Kunst*, lxiv, 1930–31, pp. 71–78.

L. Planiscig, 'Maffeo Olivieri', *Dedalo*, xii, 1932, pp. 34–55 [1932[1]].

L. Planiscig, 'Alessandro Vittorias Verkundigungsrelief für Hans Fugger', *J.K.S.W.*, n.f. vi, 1932, pp. 155ff [1932[2]].

L. Planiscig, 'Severo da Ravenna (der "Meister des Drachens")', *J.K.S.W.*, n.f. ix, 1935, pp. 75–86.

L. Planiscig, 'Pietro, Tullio, und Antonio Lombardo', *J.K.S.W.*, n.f. xi, 1937, pp. 87–115.

J. Pope-Hennessy, 'A statuette by Antonio Minelli', *The Burlington Magazine*, xciv, 1952, pp. 24–28.

J. Pope-Hennessy, *Italian Renaissance Sculpture*, London, 1958; second edition, 1971.

J. Pope-Hennessy, *Italian High Renaissance and Baroque Sculpture*, 3 vols., London, 1963 [1963[1]].

J. Pope-Hennessy, 'Italian bronze statuettes', *The Burlington Magazine*, cv, 1963, pp. 14–23, 48–71 [1963[2]].

J. Pope-Hennessy, *Catalogue of Italian Sculpture in the Victoria and Albert Museum*, 3 vols., London, 1964 [1964[1]].

J. Pope-Hennessy, 'Sculpture for the Victoria and Albert Museum', *Apollo*, lxxx, 1964, pp. 458–65 [1964[2]].

J. Pope-Hennessy, *Italian High Renaissance and Baroque Sculpture*, London, 1970.

J. Pope-Hennessy, assisted by A. Radcliffe, *The Frick Collection: an illustrated catalogue*, iii, *Sculpture: Italian*, New York, 1970.

J. Pope-Hennessy, 'The Relations between Florentine and Venetian Sculpture in the Sixteenth Century', *Florence and Venice: Comparisons and Relations, II. Cinquecento*, edited by S. Bertelli and others, Florence, 1980, pp. 323–35.

A. E. Popham, *Catalogue of the Phillipps Fenwick Collection of Drawings*, London, 1935.

A. E. Popham, 'Lorenzo Lotto', *Old Master Drawings*, xii, 1938, p. 49.

A. E. Popham, *A Handbook to the Drawings and Water Colours in the Department of Prints and Drawings*, British Museum, London, 1939.

A. E. Popham, 'A drawing attributed to Lorenzo Lotto', *British Museum Quarterly*, xvi, 1951, pp. 72ff.

A. E. Popham, 'Two Drawings of Correggio', *British Museum Quarterly*, xix, 1954, p. 34.

A. E. Popham, *Italian Drawings in the Department of Prints and Drawings in the British Museum. Artists working in Parma in the Sixteenth Century*, 2 vols., London, 1967.

A. E. Popham and P. Pouncey, *Italian Drawings in the Department of Prints and Drawings in the British Museum. The Fourteenth and Fifteenth Centuries*, London, 1950.

A. E. Popham and J. Wilde, *The Italian Drawings of the XV and XVI centuries in the collection of His Majesty the King at Windsor Castle*, London, 1949.

O. Popovitch, *Catalogue des peintures du Musée des Beaux-Arts de Rouen*, Paris, 1967; another edition, Paris, 1978.

Portland 1956, *Paintings from the Collection of Walter P. Chrysler, Jr.*, exhibition catalogue edited by B. Suida Manning, Portland Art Museum, Oregon, 1956.

P. Pouncey, 'A study by Sebastiano del Piombo for the Martyrdom of St. Agatha', *The Burlington Magazine*, xciv, 1952, p. 116.

P. Pouncey, 'Girolamo da Treviso in the service of Henry VIII', *The Burlington Magazine*, xcv, 1953, pp. 208–11.

P. Pouncey, 'Aggiunte a Girolamo da Treviso', *Arte Antica e Moderna*, 1961, pp. 209–10 [1961[1]].

P. Pouncey, 'A drawing by Pordenone', *British Museum Quarterly*, 1961, p. 27 [1961[2]].

P. Pouncey, Review of B. Berenson 'I Disegni dei Pittori Fiorentini', *Master Drawings*, ii, 1964, p. 291.

P. Pouncey, *Lotto Disegnatore*, Vicenza, 1965.

R. Predelli, ed., 'Le carte e le memorie di Alessandro Vittoria', *Studi Trentini*, 1908.

G. Previtali, 'Il bernoccolo del conoscitore (a proposito del presunto "Ritratto di Gian Girolamo Albani" attribuito al Moroni)', *Prospettiva*, 24, 1981, pp. 24–31.

P. Prodi, 'The Structure and Organisation of the Church in Venice: Suggestions for Research', *Venetian Studies*, edited by J. Hale, London, 1972, pp. 409–30.

A. Puerari, *Boccaccino*, Milan, 1957.

L. Puppi, *Bartolomeo Montagna*, Venice, 1962 [1962[1]].

L. Puppi, 'Maestri italiani del colore nella Galleria Nazionale di Praga', *Emporium*, cxxxv, 1962, pp. 147–58 [1962[2]].

L. Puppi, 'Qualche novità montagnesca', *Emporium*, lxx, 1964, pp. 194–204.

L. Puppi, ed., *Paolo Farinati, Giornale*, Florence, 1968 [1968[1]].

L. Puppi, 'Postilla montagnesca: una questione di Metodo', *Arte Veneta*, xxii, 1968, p. 219 [1968[2]].

L. Puppi, *Michele San Micheli architetto di Verona*, Padua, 1971.

L. Puppi, 'Per Tullio Lombardo', *Arte Lombarda*, xvii, i, 1972, pp. 100–03.

L. Puppi, 'Un'integrazione al catalogo e al regesto di Bartolomeo Montagna', *Antichità Viva*, xiv, 1975, pp. 23–29.

Puppi 1980 see Venice 1980.

L. Puppi and L. Olivato Puppi, *Mauro Codussi e l'architettura veneziana del Primo Rinascimento*, Milan, 1977.

A. Quintavalle, 'Jacopo Palma il Giovane nel modenese e nel reggiano', *Arte Veneta*, x, 1957, pp. 129–42.

A. Quintavalle, *La Galleria Estense di Modena*, Genoa, 1959.

A. Radcliffe, *European Bronze Statuettes*, London, 1966.

A. Radcliffe, 'Bronze oil lamps by Riccio', *Victoria and Albert Museum Yearbook*, iii, 1972, pp. 29–58.

A. Radcliffe, 'A portrait of Georg Vischer', *Apollo*, xcix, 1974, pp. 126–31.

A. Radcliffe, 'Ricciana', *The Burlington Magazine*, cxxiv, 1982, pp. 412–24.

A. Radcliffe, 'A forgotten masterpiece in terracotta by Riccio', *Apollo*, cxviii, 1983, pp. 40–48.

L. Ragghianti Collobi, *Il Libro de' Disegni del Vasari*, Florence, 1974.

O. Raggio, 'Tiziano Aspetti's Reliefs with Scenes of the Martyrdom of St. Daniel of Padua', *Metropolitan Museum Journal*, 1982, pp. 131–46.

C. G. Ratti, *Istruzione di quanto può vedersi di più bello in Genova in pittura, scultura ed architettura*, Genoa, 1780.

P. Ravaglia, 'Un quadro inedito di Sebastiano del Piombo', *Bollettino d'arte*, i, 1921–22, p. 474.

W. R. Rearick, 'A drawing by Bernardino Licinio', *Master Drawings*, v, 1967, pp. 382–83.

Rearick 1976 see Florence 1976.

W. R. Rearick, 'Early Drawings of Jacopo Bassano', *Arte Veneta*, xxxii, 1978, p. 161.

W. R. Rearick, 'Lorenzo Lotto, The Drawings, 1500–25', *Atti del Convegno Internazionale di Studi per il V Centenario della Nascita di Lorenzo Lotto*, Asolo, 1980.

W. R. Rearick in *Italian Paintings XIV-XVIII Centuries from the Collection of the Baltimore Museum of Art*, Baltimore, 1981, pp. 131–47.

Reggio Emilia 1955, *Catalogo della Mostra dei quadri . . . della Cassa di Risparmio di Reggio Emilia*, Reggio Emilia, 1955.

Q. van Regteren Altena, *Les dessins italiens de la reine Christine de Suède*, Stockholm, 1966.

S. Reinach, *Répertoire de peintures du Moyen Age et de la Renaissance (1280–1580)*, Paris, 1918.

A. Ricci. *Memorie Storiche delle Arti e degli Artisti della Marca d'Ancona*, Macerata, 1834.

C. Ricci, *Raccolte artistiche di Ravenna*, Bergamo, 1905.

C. Ricci, *La Pinacoteca di Brera*, Bergamo, 1907.

E. P. Richardson, 'Two Bronzes by Jacopo Sansovino', *Art Quarterly*, xiii, 1950, pp. 3–9.

F. Richardson, *Andrea Schiavone*, Oxford, 1980.

G. M. Richter, *Giorgio da Castelfranco called Giorgione*, Chicago, 1937.

C. Ricketts, *Titian*, London, 1910.

C. Ridolfi, *Vita di Giacopo Robusti detto il Tintoretto . . .*, Venice, 1642.

C. Ridolfi, *Le Maraviglie dell'Arte*, Venice 1648; another edition edited by D. von Hadeln, 2 vols., Berlin, 1914, 1924.

P. Righetti, *Descrizione del Campidoglio*, 2 vols., Rome, 1836.

F. Rigon, *Tiziano – Iconografia Tizianesca al Museo di Bassano*, Bassano, 1976.

F. Rigon, 'Taccuino Bassanesco', *Arte Veneta* xxxii, 1978, pp. 174–81.

E. Rigoni, *L'arte rinascimentale in Padova: Studi e documenti*, Padua, 1970.

Rijksmuseum 1961, *Rijksmuseum Amsterdam, Catalogue of Paintings*, Amsterdam, 1961.

Rijksmuseum 1976, *All the Paintings in the Rijksmuseum. A completely illustrated*

Catalogue, by G. Schwarz and others, Amsterdam, 1976.

G. ROBERTSON, *Vincenzo Catena*, Edinburgh, 1954.

G. ROBERTSON, 'The Giorgione Exhibition in Venice', *The Burlington Magazine*, XCVII, 1955, p. 272.

G. ROBERTSON, 'New Giorgione Studies', *The Burlington Magazine*, CXIII, 1971, p. 475.

M. C. RODESCHINI, 'Note sulle due pale del Moretto a Bergamo' *Notizie da Palazzo Albani*, X, 1981, pp. 23–34.

M. R. RODGERS and O. GOETZ, 'A Masterpiece of Italian Renaissance Sculpture', *Bulletin of the Art Institute of Chicago*, XXXVII, i, 1943.

S. ROMANIN, *Storia documentata di Venezia*, 10 vols., Venice, 1853–61.

ROME 1945, *Mostra d'arte italiana a Palazzo Venezia*, catalogue edited by E. Gagliardi, Rome, 1945.

ROME 1976, *Immagini da Tiziano*, exhibition catalogue edited by M. Catelli Isola, Rome, 1976.

O. RONCHI, 'La casa di Pietro Bembo a Padova', *Atti e memorie della R. Accademia di Scienze, Lettere ed Arti in Padova*, XL, 1933–34, pp. 285–329.

A. RONCHINI, 'Delle relazioni di Tiziano coi Farnesi', *Atti e memorie delle RR. deputazioni di storia patria per le provincie modenesi e parmensi*, II, 1864, pp. 129–46.

D. ROSAND, 'Palma il Giovane as Draughtsman. The early career and related observations', *Master Drawings*, II, 1970, pp. 148–61.

D. ROSAND, *Painting in Cinquecento Venice: Titian, Veronese, Tintoretto*, New Haven and London, 1982.

D. ROSAND and M. MURARO, *Titian and the Venetian Woodcut*, exhibition catalogue Washington, 1976.

T. ROSCOE, *Life of Lorenzo de' Medici*, 2 vols., second edition, London, 1796.

M. ROSKILL, *Dolce's 'Aretino' and Venetian Art Theory of the Cinquecento*, New York, 1968.

F. ROSSI, 'Maffeo Olivieri e la bronzistica bresciana del '500', *Arte Lombarda*, n.s., XLVII–XLVIII, 1977, pp. 115–34.

F. ROSSI, *Accademia Carrara. Catalogo generale dei dipinti*, Bergamo, 1979.

F. ROSSI, 'Pittura a Bergamo intorno al 1500. Ricostituzione di un patrimonio scomparso', *Atti dell'Ateneo di Scienze, Lettere e Arti*, 1980.

F. ROSSI, 'Bergamo e Palma il Vecchio. Un rapporto dialettico', *Serina a Palma il Vecchio*, Bergamo, 1981.

P. ROSSI, *Tintoretto: I ritratti*, Venice, 1974.

P. ROSSI, *I disegni di Jacopo Tintoretto*, Florence, 1975.

P. ROSSI 1982 *see* PALLUCCHINI and ROSSI 1982

ROTTERDAM 1938, *Meesterwerken uit vier eeuwen, 1400–1800*, exhibition catalogue, Museum Boymans-van Beuningen, Rotterdam, 1938.

ROVILLIUS, *Prontuario*, Lyon, 1553.

J. ROWLANDS, 'Two unknown works by Palma Vecchio', *Pantheon*, XXIV, 1966, pp. 372–77.

O. RUCKELSHAUSEN, 'Typologie des oberitalienischen Porträts im Cinquecento', *Giessener Beiträge zur Kunstgeschichte*, III, 1975, pp. 63–137.

U. RUGGERI, review of G. Mariacher, 'Palma il Vecchio', *Arte Lombarda*, XIV, 1969, pp. 166–67.

H. RUHEMANN, 'The Cleaning and Restoration of the Glasgow Giorgione', *The Burlington Magazine*, XCVII, 1955, p. 278.

E. RUHMER, 'Antonio Lombardo: Versuch einer charakteristik', *Arte Veneta*, XXVIII, 1974, pp. 39–73.

G. A. RUSCONI, *Della architettura . . . secondo i precetti di Vitruvio . . . libri 10*, Venice, 1590.

M. SABELLICUS, *De Venetae Urbis Situ*, Venice, 1502.

E. SACCOMANNI, 'Domenico Campagnola: gli anni della maturità', *Arte Veneta*, XXXIV, 1980, pp. 63ff., pp. 147ff.

E. SAFARIK, 'Giovanni Busi detto il Cariani', in *D.B.I*, XV, pp. 527–29.

R. SALVINI, *La Galleria Estense di Modena*, Rome, 1955.

R. SALVINI, *La Galleria degli Uffizi*, Florence, 1956.

R. SALVINI, 'Noterelle su Romanino e Dürer', in *Festschrift Ulrich Middeldorf*, Berlin, 1968, pp. 319–23.

P. SAMBIN, 'I testamenti di Alvise Cornaro', *Italia medioevale e umanistica*, IX, 1966, pp. 295–385.

P. SAMBIN, 'Nuovi documenti per la storia della pittura in Padova dal XIV al XVI secolo . . .', *Bollettino del Museo Civico di Padova*, LI, 1, 1972, pp. 99–126.

F. J. SÁNCHEZ CANTÓN, *Museo del Prado, Catalogo de los cuadros*, Madrid, 1949.

F. SANSOVINO, *Delle cose notabili che sono in Venetia*, Venice, 1565.

F. SANSOVINO, *Ritratto delle più nobili et famose città d'Italia*, Venice, 1575.

F. SANSOVINO, *Venetia città nobilissima et singolare*, Venice, 1581; another edition edited by G. Martinioni, Venice, 1663.

A. SANTAGIUSTINA PONIZ, 'Disegni tardi di Domenico Campagnola 1552–1564', *Arte Veneta*, XXXV, 1981, pp. 62ff.

M. SANUTO, 'Vita dei Dogi', *Rerum Italicarum Scriptores*, XXII, Milan, 1733.

M. SANUTO, *I Diarii*, 58 vols., edited by R. Fulin and others, Venice, 1879–1903.

M. SANUTO, *De Origine, situ et Magistratibus Urbis Venetae ovvero La Città di Venetia (1493–1530)*, edited by A. Caracciolo Aricò, Milan, 1980.

A. SARTORI, 'Il S. Giovanni Battista nel Deserto del Bassano, *Arte Veneta*, XII, 1958, pp. 200 ff.

A. SARTORI, *Documenti per la storia dell'arte a Padova*, Vicenza, 1976.

S. SAVINI-BRANCA, *Il Collezionismo Veneziano nel '600*, Padua, 1965.

F. SAXL, *Costumes and Festivals of Milanese Society under Spanish Rule*, British Academy Annual Italian Lecture, 1936; Oxford, 1938.

F. SAXL, 'Pagan Sacrifice in the Italian Renaissance', *Journal of the Warburg and Courtauld Institutes*, II, 1938–39, pp. 346–67.

F. SAXL, *Lectures*, London, 1957.

V. SCAMOZZI, *Idea dell'Architettura Universale*, Venice, 1615.

A. SCHAFFER, W. VON WARTENEGG and H. DOLLMAYR, *Kunsthistorische Sammlungen des Allerhöchsten Kaiserhauses. Führer durch die Gemäldegalerie. Alte Meister. I. Italienische, Spanische, und Französische Schulen*, Vienna, 1894.

J. SCHLOSSER, *Werke der Kleinplastik in der Skulpturensammlung des Allerhöchsten Kaiserhauses, I. Bildwerke in Bronze, Stein und Ton*, Vienna, 1910.

J. SCHLOSSER, 'Aus der Bildnerwerkstatt der Renaissance: III. Eine Reliefserie des Antonio Lombardi', *Jahrbuch der Kunstsammlungen des Allerhöchsten Kaiserhauses in Wien*, XXXI, 1913, pp. 87–100.

W. SCHMIDT, 'Zur Kenntnis Giorgione', *Repertorium für Kunstwissenschaft*, 1908, p. 155.

J. SCHULZ, 'Pordenone's Cupolas', in *Studies in Renaissance and Baroque Art presented to Anthony Blunt*, London and New York, 1967.

J. SCHULZ, *Venetian Painted Ceilings of the Renaissance*, Berkeley and Los Angeles, 1968.

J. SCHULZ, *The Printed Plans and Panoramic Views of Venice (1496–1799)*, Venice, 1970.

J. SCHULZ, 'Jacopo de' Barbari's view of Venice. Map Making, City Views and Moralized Geography before the year 1500', *Art Bulletin*, LX, 1978, pp. 425–74.

J. SCHULZ, 'Tintoretto and the first competition for the Ducal Palace "Paradise"', *Arte Veneta*, XXXIII, 1980, pp. 112–26.

W. SCHUPBACH, 'Doctor Parma's Medical Macaronic', *Journal of the Warburg and Courtauld Institutes*, XLI, 1978, pp. 147–91.

G. SCHUTZ-RAUTENBERG, *Kunstlergraber des 15. und 16. Jahrhunderts in Italien*, Dissertationnen zur Kunstgeschichte 6, Cologne–Vienna, 1978.

S. SERLIO, *Tutta l'opera d'architettura et prospettiva di Sebastiano Serlio Bolognese*, Venice, 1619.

L. SERNAGIOTTO, 'Discorso sopra il celebre pittore Bonifacio Veneziano', *Atti della Reale Accademia di Belle Arti in Venezia*, 1883, pp. 5–53.

L. SERRA, *Alessandro Vittoria*, Milan, 1921.

L. SERRA, 'Un dipinto del Savoldo', *Rassegna Marchigiana*, II, 1923–24, pp. 266–68.

U. SERVOLINI, *Ugo da Carpi*, Florence, 1977.

S. SETTIS, *La 'Tempesta' Interpretata: Giorgione, i committenti, il soggetto*, Turin, 1978.

C. SEYMOUR JR., *Art Treasures for America. An anthology of painting and sculpture in the Samuel H. Kress Collection*, New York, 1961.

V. SGARBI, *Palladio e la maniera. I pittori vicentini del Cinquecento e i collaboratori del Palladio 1530–1630*, exhibition catalogue edited by V. Sgarbi, 1980.

V. SGARBI, 'Giovanni De Mio, Bonifacio De' Pitati, Lamberto Sustris: indicazioni sul primo tempo del manierismo nel Veneto', *Arte Veneta*, XXXV, 1981, pp. 52–61.

V. SGARBI, '1518: Cariani a Ferrara e Dosso', *Paragone*, 389, 1982, pp. 3–18.

F. R. SHAPLEY, *Paintings from the Samuel H. Kress Collection, Italian Schools XVI–XVIII Century*, New York, 1973.

F. R. SHAPLEY, *Catalogue of the Italian Paintings in the National Gallery of Art, Washington*, Washington, 1979.

W. S. SHEARD, 'Sanudo's List of Notable Things in Venetian Churches and the Date of the Vendramin Tomb', *Yale Italian Studies*, I, 1977, pp. 219–68.

W. S. SHEARD, *Antiquity in the Renaissance*, Smith College Museum of Art, Northampton, Mass., 1978 [1978¹].

W. S. SHEARD, '"Asa Adorna": The Prehistory of the Vendramin Tomb', *Jahrbuch der Berliner Museen*, N.F., XX, 1978, pp. 117–56 [1978²].

J. SHEARMAN, 'Le seizième siècle européen', *The Burlington Magazine*, CVIII, 1966, pp. 59–67.

J. SHEARMAN, *The Early Italian Paintings in the Collection of Her Majesty the Queen*, Cambridge, 1983.

I. SHOEMAKER AND E. BROUN, *The Engravings of Marcantonio Raimondi*, Spencer Museum of Art, Lawrence, Kansas, 1981.

S. SINDING-LARSEN, 'Christ in the Council Hall. Studies in the Religious Iconography of the Venetian Republic', *Institum Romanum Norvegiae. Acta ad Archaeologiam et Artium Historiam Pertinentia*, V, Rome, 1974.

R. A. SKELTON, Introduction to the facsimile edition of Bordone's *Isolario (1528)*, Amsterdam, 1966.

J. SMIRNOVA, *Jacopo Bassano*, Moscow, 1976.

P. SOHM, 'The Staircases in the Venetian Scuole Grandi by Mauro Codussi', *Architectura*, VIII, 1978, pp. 125–49.

P. SOHM, *La Scuola Grande di San Marco 1437–1550: The Architecture of a Venetian Lay Confraternity*, Johns Hopkins, Baltimore, Doctoral Thesis; University Microfilms International, Ann Arbor, Michigan, 1981.

A. SOMOF, *Ermitage impérial, Catalogue de la Galerie des Tableaux. Première Partie, les Écoles d'Italie et d'Espagne*, St. Petersburg, 1899.

M. S. SOPHER, *Sixteenth Century Prints*, Claremont, Ca., 1978.

R. SOPRANI, *Vite de' pittori, scultori, ed architetti genovesi*, edited by C. G. Ratti, 2 vols., Genoa, 1768–69.

A. SPAHN, *Palma Vecchio*, Leipzig, 1932.

W. STECHOW, 'The Authorship of the Walters "Lucretia"', *Journal of the Walters Art Gallery*, XXIII, 1960, pp. 73–85.

J. STEER, *Alvise Vivarini: His Art and Influence*, Cambridge, 1982.

STOCKHOLM 1962–63, *Konstens Venedig*, exhibition catalogue, National Museum, Stockholm, 1962–63.

R. STONE, 'Tullio Lombardo's *Adam* from the Vendramin Tomb: A New Terminus ante Quem', *Marsyas*, XVI, 1972–73, pp. 87–88.

R. STONE, 'Antico and the development of bronze casting in Italy at the end of the quattrocento', *Metropolitan Museum Journal*, XIV, 1982, pp. 87–116.

D. STOTT, 'Fatte a Sembianza di Pittura: Jacopo Sansovino's Bronze Reliefs in S. Marco', *The Art Bulletin*, LXIV, 1982, pp. 370–88.

D. STROM, 'Desiderio and the Madonna Relief in Quattrocento Florence', *Pantheon*, XL, 1982, pp. 130–35.

S. A. STRONG, *Chatsworth Drawings*, London, 1902.

W. SUIDA, *Genua*, Leipzig, 1906.

W. SUIDA, 'Beiträge zu Lorenzo Lotto', *Belvedere*, 1932, pp. 170–73.

W. SUIDA, *Tiziano*, Rome, 1933; French edition, 1935.

W. SUIDA, 'Tizian, die beiden Campagnola und Ugo da Carpi', *Critica d'Arte*, I, 1935–36, pp. 285–89.

W. SUIDA, 'Spigolature giorgionesche', *Arte Veneta*, VIII, 1954, p. 153.

W. SUIDA, *The Samuel H. Kress Collection*, Birmingham, 1959.

I. SUPINO, *Catalogo del R. Museo Nazionale di Firenze*, Rome, 1898.

I. SUPINO, *Le sculture delle porte di S. Petronio in Bologna*, Florence, 1914.

B. SWEENY, *Johnson G. Johnson Collection. Catalogue of Italian Paintings*, Philadelphia, 1966.

E. SZMODIS-ESZLÁRY, 'Relief en cristal de roche d'un maître vénitien du début du XVIe siècle', *Bulletin du Musée Hongrois des Beaux-Arts*, 56–57, 1981, pp. 97–104.

M. TAFURI, *Jacopo Sansovino e l'architettura del 500 a Venezia*, Padua, 1969; another edition, 1972.

TAFURI 1980 see VENICE 1980.

F. M. TASSI, *Vite de' pittori, scultori e architetti bergamaschi*, Bergamo, 1793.

B. DE TAUZIA, *Notice des dessins de la collection His de la Salle*, Paris, 1881.

T. TEMANZA, *Vite dei più celebri architetti e scultori veneziani che fiorirono nel secolo Decimosesto*, Venice, 1778.

A. TEMPESTINI, 'Un inedito di Sebastiano Florigerio', *Scritti d'amici per Maria Cionini Visani*, Turin, 1977, pp. 81–3.

A. TEMPESTINI, *Martino da Udine*, Udine, 1979.

D. TENIERS THE YOUNGER, *Theatrum Pictorium*, Antwerp and Brussels, 1660.

M. THAUSING, 'Giorgione', in *Wiener Kunstbriefe*, Leipzig, 1884.

W. THOMAS, *The History of Italy 1549*, edited by G. Parkes, Ithaca, 1963.

H. TIETZE, *Tizian*, 2 vols., Vienna, 1936.

H. TIETZE, *Tintoretto. The Paintings and Drawings*, London, 1948.

H. TIETZE, *Titian, Paintings and Drawings*, London, 1950.

E. TIETZE-CONRAT, 'A drawing by Paris Bordone, not Titian', *The Burlington Magazine*, LXXII, 1938, p. 189.

E. TIETZE-CONRAT, 'The so-called "Adulteress" by Giorgione', *Gazette des Beaux-Arts*, XXVII, 1945, p. 189.

E. TIETZE-CONRAT, 'Titian's design for the Battle of Cadore', *Gazette des Beaux-Arts*, II, 1948, ii, pp. 237–42.

H. TIETZE and E. TIETZE-CONRAT, 'Contributi critici allo studio organico dei disegni veneziani del cinquecento', *Critica d'Arte*, II,

1937, pp. 77–88.

H. TIETZE and E. TIETZE-CONRAT, 'Titian's Woodcuts', *The Print Collector's Quarterly*, XXV, 1938, pp. 332ff. and pp. 464ff.

H. TIETZE and E. TIETZE-CONRAT, 'Domenico Campagnola's Graphic Art', *The Print Collector's Quarterly*, XXVI, 1939, pp. 311–33, 445–65.

H. TIETZE and E. TIETZE-CONRAT, *The Drawings of the Venetian Painters in the XVth and XVIth Centuries*, New York, 1944.

W. TIMOFIEWITSCH, *Girolamo Campagna – Studien zur venezianischen Plastik um das Jahr 1600*, Munich, 1972.

A. TOFANELLI, *Descrizione delle sculture e pitture che si trovano in Campidoglio*, Rome, 1818; another edition, edited by Frency, 1820.

C. TORRE, *Il ritratto di Milano*, Milan, 1674.

R. TOZZI, 'Disegni di Domenico Tintoretto', *Bollettino d'Arte*, 1937, pp. 19–31.

G. TRECCA, *Paolo Veronese a Verona*, Verona, 1940.

W. TRESSIDER, *The Classicism of the early work of Titian: its Sources and Character*, dissertation, University of Michigan, 1979.

F. TREVISANI, 'Osservazioni sulla mostra del "Lotto nelle Marche, il suo tempo, il suo influsso"', *Arte Veneta*, XXXV, 1981, pp. 275–88.

E. TRINCANATO, *Venezia Minore*, Milan, 1948.

E. TRINCANATO and U. FRANZOI, *Venise au fil du temps. Atlas historique d'urbanisme et d'architecture*, Boulogne-Billancourt, 1971.

E. G. TROCHE, 'Giovanni Cariani', *J.K.P.K.*, LV, 1934, pp. 97–125.

K. TSCHEUSCHNER, 'Über den Tizian no. 172, der Dresdener Galerie', *Repertorium für Kunstwissenschaft*, XXIV, 1901, pp. 292–93.

UDINE 1939, *Mostra del Pordenone e della pittura friulana del Rinascimento*, exhibition catalogue, edited by B. Molajoli, Udine, 1939.

UNITED STATES 1969, *Chatsworth Drawings II*, International Exhibitions Foundation, catalogue edited by J. Byam Shaw, 1969.

UNITED STATES and CAMBRIDGE 1976–77, *European drawings from the Fitzwilliam*, International Exhibitions Foundation, five museums in United States and The Fitzwilliam Museum, catalogue edited by M. Jaffé, Cambridge, 1976–77.

UNITED STATES and CANADA 1962–63, *Old Master Drawings from Chatsworth*, International Exhibitions Foundation, seven galleries in the United States and Canada, catalogue edited by T. Wragg, 1962–63.

U. VAGLIA, 'Sant'Antonio di Padova nei dipinti del Romanino esposti alla Mostra di Brescia', *Il Santo*, 1965, pp. 143–48.

F. VALCANOVER, *Museo Civico di Feltre*, Vicenza, 1954.

F. VALCANOVER, 'Il ritratto veneto da Tiziano al Tiepolo', *Arte Veneta*, X, 1956, pp. 240–44.

F. VALCANOVER, *Tutta la pittura di Tiziano*, Milan, 1960.

F. VALCANOVER, *L'opera completa di Tiziano*, Milan, 1969.

F. VALCANOVER, 'La Pala Pesaro', *Quaderni della Soprintendenza . . . di Venezia*, VIII, 1979, pp. 57–72.

W. R. VALENTINER (ed.), *Unknown Masterpieces*, London, 1930.

W. R. VALENTINER, 'Alessandro Vittoria and Michelangelo', *Art Quarterly*, 1942, pp. 149–57.

W. R. VALENTINER, *Studies of Italian Renaissance Sculpture*, London, 1950.

W. R. VALENTINER, *Gothic and Renaissance Sculptures in the collection of the Los Angeles County Museum*, Los Angeles, 1951.

W. R. VALENTINER, *Catalogue of Paintings. Raleigh, North Carolina Museum of Art*, Raleigh, 1956 (1956¹).

W. R. VALENTINER, 'The Raleigh Museum's First 220 Paintings: notes on the collection', *Art News*, IV, 1956 (1956²).

R. VAN MARLE, 'A Landscape painted by Titian about 1530', *International Studio*, XCVI, 1930,

pp. 118ff.

G. VASARI, *Le vite de' più eccellenti architetti, pittori et scultori*, Florence, 1550.

G. VASARI, *Le vite de' più eccellenti pittori, scultori, ed architetti*, edited by G. Milanesi, 9 vols., Florence, 1875–85.

VENICE 1935, *Mostra di Tiziano*, catalogue edited by N. Barbantini, Venice, 1935.

VENICE 1937, *Mostra del Tintoretto*, exhibition catalogue, edited by N. Barbantini, Venice, 1937.

VENICE 1939, *Mostra di Paolo Veronese*, exhibition catalogue by R. Pallucchini, Venice, 1939.

VENICE 1945, *Cinque secoli di pittura veneta*, exhibition catalogue by R. Pallucchini, Venice, 1945.

VENICE 1946, *I capolavori dei musei veneti*, exhibition catalogue edited by R. Pallucchini, Venice, 1946.

VENICE 1953, *Mostra di Lorenzo Lotto*, exhibition catalogue edited by P. Zampetti, Venice, 1953.

VENICE 1955, *Giorgione e i Giorgioneschi*, exhibition catalogue edited by P. Zampetti, Venice, 1955.

VENICE 1957, *Jacopo Bassano*, exhibition catalogue edited by P. Zampetti, Venice, 1957.

VENICE 1958, *Disegni Veneti di Oxford*, exhibition catalogue edited by K. T. Parker, Fondazione Giorgio Cini, Venice, 1958.

VENICE 1959, *La pittura del Seicento a Venezia*, exhibition catalogue by G. Mariacher, Venice, 1959.

VENICE 1963, *Vittore Carpaccio*, exhibition catalogue by P. Zampetti, Venice, 1963.

VENICE 1971, *Arte a Venezia, dal Medioevo al Settecento*, exhibition catalogue edited by G. Mariacher, Venice, 1971.

VENICE 1976¹, *Disegni di Tiziano e della sua cerchia*, exhibition catalogue by K. Oberhuber and H. Goldfarb, Fondazione Giorgio Cini, Venice, 1976.

VENICE 1976², *Tiziano e la silografia veneziana del Cinquecento*, exhibition catalogue by M. Muraro and D. Rosand, Venice, 1976.

VENICE 1978, *Giorgione a Venezia*, exhibition catalogue, Venice, 1978.

VENICE 1979, *Venezia e la Peste 1348–1797*, exhibition catalogue, Venice, 1979.

VENICE 1980¹, *Architettura e Utopia nella Venezia del Cinquecento*, exhibition catalogue, Venice, 1980.

VENICE 1980², *Disegni veneti di collezioni inglesi*, exhibition catalogue edited by J. Stock, Fondazione Giorgio Cini, Venice, 1980.

VENICE 1981¹, *Da Tiziano a El Greco. Per la storia del Manierismo a Venezia*, exhibition catalogue edited by R. Pallucchini, Venice, 1981.

VENICE 1981², *Disegni veneti della Collezione Lugt*, exhibition catalogue by J. Byam Shaw, Fondazione Giorgio Cini, Venice, 1981.

A. VENTURI, *Il Museo e la Galleria Borghese*, Rome, 1893.

A. VENTURI, 'Jacopo Tintoretto. L'esordio', *L'Arte*, XXI, 1928, pp. 178–86.

A. VENTURI, *Storia dell'arte italiana: IX La pittura del Cinquecento*, I–VII, Milan, 1925–34.

A. VENTURI, *Storia dell'arte italiana: X La scultura del Cinquecento*, I–III, Milan, 1935–37.

L. VENTURI, *Le origini della pittura veneziana*, Venice, 1907.

L. VENTURI, 'Saggio sulle opere d'arte italiana a Pietroburgo', *L'Arte*, XV, 1912, pp. 306–09.

L. VENTURI, *Giorgione e il giorgionismo*, Milan, 1913.

L. VENTURI, 'A traverso le Marche', *L'Arte*, XVIII, 1915, pp. 1–28, 172–208.

L. VENTURI, *Italian Paintings in America*, 3 vols., Milan and New York, 1933.

R. VENUTI, *Accurata e succinta descrizione di Roma moderna*, 4 vols., Rome, 1767.

G. VERCI, *Notizia intorno alla vita e alle opere de' Pittori . . . della Città di Bassano*, Venice, 1775.

VERONA 1980, *Palladio and Verona*, exhibition catalogue edited by R. Marini, Verona, 1980.

L. VERTOVA, 'Bernardino Licinio', *I Pittori Bergamaschi: Il Cinquecento*, I, Bergamo, 1975.

L. VERTOVA, 'Bianca Vertova Puella e Santa', *Antichità Viva*, XV, 1976, pp. 6–10.

G. VEZZOLI, 'Incontro di S. Angela Merici con l'Arte', in *Studi in onore di Luigi Fossati*, Brescia 1974, pp. 391–96.

VIENNA 1966, *Katalog der Sammlung für Plastik und Kunstgewerbe*, II, *Renaissance*, Kunsthistorisches Museum, Vienna, 1966.

P. VITRY, ed., *Musée National du Louvre: Catalogue des sculptures du Moyen Age, de la Renaissance et des Temps Modernes*, I. *Moyen Age et Renaissance*, Paris, 1922.

C. VOLPE, 'Primitives to Picasso' (review), *Arte Antica e Moderna*, Jan–March, 1962, pp. III–IV.

E. VON DER BERCKEN, *Die Gemälde des Jacopo Tintoretto*, Munich, 1942.

H. M. VON ERFFA, 'Der Nurnberger Stadtpatron auf italienischen Gemälden', *Mitteilungen des Kunsthistorisches Instituts in Florenz*, XX, 1976, pp. 1–12.

D. VON HADELN, 'Zum Oeuvre Paris Bordones', *Repertorium für Kunstwissenschaft*, XXXI, 1908, pp. 544–55.

D. VON HADELN, 'Beiträge zur Tintorettoforschung', *J.K.P.K.*, XXXII, 1911, pp. 1–58 [1911¹].

VON HADELN 1911² see LUDWIG 1911.

VON HADELN 1914, 1924 see RIDOLFI 1914, 1924

D. VON HADELN, *Handzeichnungen des Giacomo Tintoretto*, Berlin, 1922.

D. VON HADELN, 'Drawings by Palma Vecchio', *The Burlington Magazine*, XLIII, 1923, pp. 168–73.

D. VON HADELN, *Zeichnungen der Tizian*, Berlin, 1924; English edition, London, 1927.

D. VON HADELN, 'Notes on Savoldo', *Art in America*, XIII, 1925, pp. 72ff. [1925¹].

D. VON HADELN, *Venezianische Zeichnungen der Hochrenaissance*, Berlin, 1925 [1925²].

D. VON HADELN, *Venezianische Zeichnungen der Spätrenaissance*, Berlin, 1926.

D. VON HADELN, *Paolo Veronese, aus dem Nachlass des Verfassers herausgegeben vom Kunsthistorischen Institut in Florenz*, edited by G. Schweikhart, Florence, 1978.

S. VSEVOLOJSKAIA, *La peinture italienne xiiie–xviiie siècles*, Musée de L'Ermitage Leningrad, 1982.

G. WAAGEN, *Works of Art and Artists in England*, 3 vols., London, 1838.

G. F. WAAGEN, *Treasures of Art in Great Britain*, 3 vols., London, 1854; reprinted London, 1970.

J. WALKER, *Bellini and Titian at Ferrara*, London, 1956.

P. WARD-JACKSON, *Italian Drawings in the Victoria and Albert Museum*, 2 vols., London, 1979.

O. WARNER, *Great Sea Battles*, London, 1963.

G. F. WARNER and J. P. GILSON, *Catalogue of Western Manuscripts in the Old Royal and King's Collections in the British Museum*, London, 1921.

WASHINGTON 1951, *Paintings and Sculpture from the Kress Collection*, National Gallery of Art, Washington D.C., 1951.

WASHINGTON 1961–62, *Art Treasures for America*, exhibition catalogue, National Gallery of Art, Washington, 1961.

WASHINGTON 1973, *Early Italian Engravings from the National Gallery of Art*, exhibition catalogue by J. Levenson, K. Oberhuber and J. Sheehan, Washington, 1973.

WASHINGTON 1976 see ROSAND and MURARO

WASHINGTON 1981–82, *The Drawings of Andrea Palladio*, exhibition catalogue by D. Lewis, Washington, 1981–82.

WASHINGTON, FORT WORTH, ST. LOUIS, 1974–75, *Venetian Drawings from American Collections*, exhibition catalogue edited by T. Pignatti, The National Gallery of Art, Washington, Kimball Art Museum, Fort Worth, The St. Louis Art Museum, 1974–75.

WASHINGTON, LOS ANGELES, NEW YORK 1979, *The Heritage of Titian*, exhibition catalogue edited by E. Fahy, Washington, Los Angeles and New York, 1979.

E. K. WATERHOUSE, 'Paintings from Venice for seventeenth century England: some records of a forgotten transaction', *Italian Studies*, VII, 1952, pp. 1–23.

E. K. WATERHOUSE, *Giorgione*, Glasgow, 1974.

A. J. WAUTERS, 'Une Ambassade Flamande', *Revue de Belgique*, IV, 1904, pp. 290ff.

H. B. WEHLE, *The Metropolitan Museum of Art. A Catalogue of Italian, Spanish and Byzantine Paintings*, New York, 1940.

H. R. WEIHRAUCH, *Studien zum bildnerischen Werke des Jacopo Sansovino*, Strasbourg, 1935.

H. R. WEIHRAUCH, 'Italienische Bronzen als Vorbilder deutscher Goldschmiedekunst', *Festschrift für Theodor Müller*, Munich, 1965, pp. 263ff.

H. R. WEIHRAUCH, *Europäische Bronzestatuetten, 15.–18. Jahrhundert*, Brunswick, 1967.

P. P. WEINER, *Les chefs d'oeuvre de la Galerie de tableaux de l'Ermitage à Petrograd*, Munich, 1928.

D. WESTPHAL, *Bonifazio Veronese*, Munich, 1931.

H. WETHEY, *The Paintings of Titian: I The Religious Paintings; II The Portraits; III The Mythological and Historical Paintings*, London 1969, 1971, 1975.

A. WETHEY and H. WETHEY, 'Titian: Two Portraits of Noblemen in Armor and their Heraldry', *Art Bulletin*, LXII, 1980, pp. 76–96.

H. WETHEY 1982, 'Tiziano e la decorazione della Sala del Maggior Consiglio nel Palazzo Ducale di Venezia' *Atti del XXIV Congresso Internazionale di Storia dell'Arte*, X, Bologna 1982, pp. 177–83.

F. WICKHOFF, 'Der Saal des grossen Rathes zu Venedig in seinem alten Schmucke', *Repertorium für Kunstwissenshaft*, VI, 1883, pp. 1–37.

F. WICKHOFF, 'Les Écoles Italiennes au Musée Impérial de Vienna', *Gazettes des Beaux-arts*, IX, 1893, pp. 130–47.

J. WILDE and others, *Katalog der Gemäldegalerie*, Vienna, 1928.

J. WILDE, 'Widergefunde Gemälde aus der Sammlung des Erzherzogs Leopold Wilhelm', *J.K.S.W.*, N.F. IV, 1930, pp. 245–66.

J. WILDE, 'Ein unbeachtetes Werk Giorgiones', *J.K.P.K.*, LII, 1931, pp. 91–100.

J. WILDE, 'Die Probleme um Domenico Mancini', *J.K.S.W.*, N.F VII, 1933, pp. 97ff.

J. WILDE, 'Die Mostra del Tintoretto zu Venedig', *Zeitschrift für Kunstgeschichte*, VII, 1937, pp. 140–53.

J. WILDE, *Venetian Art from Bellini to Titian*, Oxford, 1974.

S. WILK, 'Tullio Lombardo's "Double Portrait" Reliefs', *Marsyas*, XVI, 1972–73, pp. 67ff.

S. WILK, *The Sculpture of Tullio Lombardo: Studies in Sources and Meaning*, New York and London, 1978.

C. WILLARD, 'Walter P. Chrysler, Jr. exhibits his Personal History of Art', *Look*, March 6, 1956.

E. WIND, *Bellini's Feast of the Gods*, Cambridge, Mass., 1948.

C. WINTER, *The Fitzwilliam Museum*, Cambridge, 1958.

E. WINTERNITZ, *Musical instruments and their significance in Western Art*, London, 1967.

R. WITTKOWER, 'Transformations of Minerva in Renaissance Imagery', *Journal of the Warburg and Courtauld Institutes*, II, 1938–39, pp. 194–205.

R. WITTKOWER, *Architectural Principles in the Age of Humanism*, third edition, New York, 1971.

W. D. WIXOM, *Renaissance Bronzes from Ohio Collections*, Cleveland Museum of Art, Cleveland, Ohio, 1975.

K. WOERMANN, *Die Italienische Bildnismalerei der Renaissance*, Esslingen, 1906.

Y. YAPOU, *Drawings of the sixteenth century School of Verona in the Department of Prints and Drawings, British Museum*, unpublished M.A. report, Courtauld Institute, University of London, 1968.

P. ZAMPETTI, *Lorenzo Lotto nelle Marche*, Urbino, 1953.

ZAMPETTI 1955 see VENICE 1955.

P. ZAMPETTI, *Jacopo Bassano*, Rome 1958.

P. ZAMPETTI, in *Kindlers Malerei Lexikon*, I, Zurich, 1974.

P. ZAMPETTI, *L'opera completa di Giorgione*, introduction by V. Lilli, Milan, 1968.

P. ZAMPETTI, *Lorenzo Lotto. Il Libro di Spese Diverse (1538–1556)*, edited by P. Zampetti, Venice and Rome, 1969.

P. ZAMPETTI, 'Andrea Previtali', in *I Pittori Bergamaschi: Il Cinquecento*, I, Bergamo, 1975.

P. ZAMPETTI and N. IVANOFF, 'Giacomo Negretti detto Palma il Giovane', in *I Pittori Bergamaschi: Il Cinquecento*, III, Bergamo, 1979.

ZAMPETTI 1980 see LORETO 1980.

A. ZANETTI, *Descrizione di tutte le pubbliche pitture della città di Venezia . . . o sia Rinnovazione delle Ricche Minere di Marco Boschini . . .*, Venice, 1733.

A. ZANETTI, *Della pittura veneziana e delle opere pubbliche de' veneziani maestri*, Venice, 1771.

V. ZANETTI, *Del Monastero della Chiesa di S. Maria degli Angeli*, Venice, 1863.

F. ZANOTTO, *Il Palazzo Ducale di Venezia*, 3 vols., Venice, 1853.

F. ZANOTTO, *Nuovissima guida di Venezia e delle isole della sua Laguna*, Venice, 1856.

Z. ZARETSKAIA and N. KOSSARÉVA, *La Sculpture de l'Europe occidentale à l'Ermitage*, Leningrad, 1970.

F. ZAVA BOCCAZZI, 'Tracce per Girolamo da Treviso il Giovane in alcune xilografie di Francesco De Nanto', *Arte Veneta*, XII, 1958, pp. 70–78.

F. ZAVA BOCCAZZI, *La Basilica dei Santi Giovanni e Paolo in Venezia*, Venice, 1965.

F. ZERI, *Italian Painting in the Walters Art Gallery*, Baltimore, 1976 [1976¹].

F. ZERI, 'La percezione visiva dell'Italia e degli italiani nella storia della pittura', in *Storia d'Italia Einaudi*, VI, Turin, 1976 [1976²].

H. ZERNER, 'Giuseppe Scolari' *L'Oeil*, 1965, I, pp. 25ff.

V. ZIPPEL, 'Un busto ignoto del Vittoria', *L'Arte*, XXIX, 1926, pp. 73–74.

G. ZORZI, *Le opere pubbliche e i palazzi privati di Andrea Palladio*, Venice, 1965.

G. ZORZI, *Le chiese e i ponti di Andrea Palladio*, Venice, 1967.

G. ZUCCOLO PADRONO, 'Miniature manieristiche nelle commissioni dogali dei Cinquecento presso il Museo Correr', *Bollettino del Musei Civici Veneziani*, XIV, 1969, pp. 4–18.

A. P. ZUGNI TAURO, 'La presenza di quattro artisti in Feltre: Ludovico Pozzoserato, Andrea Palladio, Giannantonio Selva, Tranquillo Orsi', *Arte Veneta*, XXXII, 1978, pp. 255–61.

ZURICH 1948–49, *Kunstschätze der Lombardei*, exhibition catalogue by C. Baroni and G. A. Dell'Acqua, Zurich, 1948–49.

P. ZURLA, *Di Marco Polo e degli altri viaggiatori veneziani più illustri*, Venice, 1818.

INDEX OF LENDERS

Also owners who prefer to remain anonymous

ROYAL ACADEMY TRUST

THE FRIENDS OF THE ROYAL ACADEMY

PATRON
H.R.H. The Duke of Edinburgh, KG, KT

The Friends of the Royal Academy receive the following privileges
FRIENDS £18.00
FRIENDS (Concessionary)
£15.00 annually for full-time
Museum Staff and Teachers
£12.00 annually for Pensioners and
Young Friends aged 25 years and under
Gain free and immediate admission to all
Royal Academy Exhibitions with a guest or
husband/wife and children under 16.
Obtain catalogues at a reduced price.
Enjoy the privacy of the Friends' Room
in Burlington House.
Receive Private View invitations to various
exhibitions including the Summer Exhibition.
Have access to the Library and Archives.
Benefit from other special arrangements,
including lectures, concerts and tours.

COUNTRY FRIENDS £10.00 annually for Friends
living more than 75 miles from London.
Gain free and immediate admission to
Royal Academy Exhibitions on 6 occasions
a year with a guest or husband/wife
and children under 16.
Receive all the other privileges offered to Friends.

ARTIST SUBSCRIBERS £30.00 annually
Recieve all the privileges offered to Friends.
Receive free submission forms for the
Summer Exhibition.
Obtain art materials at a reduced price.

SPONSORS £500 (corporate),
£150 (individually) annually
Receive all the privileges offered to Friends.
Enjoy the particular privileges of reserving the
Royal Academy's Private Rooms when
appropriate and similarly of arranging
evening viewings of certain exhibitions.
Receive acknowledgement through the inclusion
of the Sponsor's name on official documents.

BENEFACTORS £5,000 or more
An involvement with the Royal Academy
which will be honoured in every way.

*Further information and Deed of Covenant
forms are available from
The Friends of the Royal Academy,
Royal Academy of Arts, Piccadily,
London W1V 0DS*

BENEFACTORS
Mrs. M.G.T. Askew
Mrs. Hilda Benham
Lady Brinton
Mr. and Mrs. Nigel Broackes
Keith Bromley, Esq.
The John S. Cohen Foundation
The Colby Trust
Michael E. Flintoff, Esq.
The Lady Gibson
Jack Goldhill, Esq.
Mrs. Mary Graves
D.J. Hoare, Esq.
Sir Antony Hornby
George Howard, Esq
Irene and Hyman Kreitman
The Landmark Trust
Roland Lay, Esq.
The Trustees of the Leach Fourteenth Trust
Hugh Leggatt, Esq.
Mr. and Mrs. M.S. Lipworth
Sir Jack Lyons, CBE
The Manor Charitable Trustees
Lieutenant-Colonel L.S. Michael, OBE
Jan Mitchell, Esq.
The Lord Moyne
Mrs. Sylvia Mulcahy
G. R. Nicholas, Esq.
Lieutenant-Colonel Vincent Paravicini
Mrs. Vincent Paravicini
Richard Park, Esq.
Phillips Fine Art Auctioneers
Mrs. Denise Rapp
Mrs. Adrianne Reed
Mrs. Basil Samuel
Eric Sharp, Esq., CBE
The Revd. Prebendary E.F. Shotter
Dr. Francis Singer
Lady Daphne Straight
Mrs. Pamela Synge
Harry Teacher, Esq.
Henry Vyner Charitable Trust
Charles Wollaston, Esq.

CORPORATE SPONSORS
Bankers Trust Company
Barclays Bank International Limited
Bourne Leisure Group Limited
The British Petroleum Company Limited
Christie Manson and Woods Limited
Citibank
Consolidated Safeguards Limited
Courage Charitable Trust
Delta Group p.l.c.
Esso Petroleum Company Limited
Ford Motor Company Limited
The Granada Group
Arthur Guinnes and Sons PLC
Guinness Peat Group
House of Fraser plc
Alexander Howden Underwriting Limited
IBM United Kingdom Limited
Imperial Chemical Industries PLC
Investment Company of North Atlantic
Johnson Wax Limited
Lex Service Group PLC
Marks and Spencer p.l.c.
Mars Limited
Martini & Rossi Limited
The Worshipful Company of Mercers
The Nestlé Charitable Trust
Ocean Transport and Trading Limited (P. H. Holt
Ove Arup Partnership
Philips Electronic and Associated Industries Limited
The Rio Tinto-Zinc Corporation PLC
Rowe and Pitman
The Royal Bank of Scotland plc
J. Henry Schroder Wagg and Company Limited
The Seascope Group
Shell UK Limited
W. H. Smith & Son Limited
Thames Television Limited
J. Walter Thompson Company Limited
Ultramar PLC
United Biscuits (U.K.) Limited

INDIVIDUAL SPONSORS
The A.B. Charitable Trust
Abdulah Ben Saad Al-Saud
Ian Fife Campbell Anstruther, Esq.
Mrs. Ann Appelbe
Dwight W. Arundale, Esq.
Edgar Astaire, Esq.
Miss Margaret Louise Band
Godfrey Bonsack, Esq.
Peter Bowring, Esq.
Mrs. Susan Bradman
Cornelis Broere, Esq.
Jeremy Brown, Esq.
Simon Cawkwell, Esq.
W. J. Chapman, Esq.
Major A. J. Chrystal
Henry M. Cohen, Esq.
Mrs. Elizabeth Corob
Mrs. Yvonne Datnow
Raymond de Prudhoe, Esq.
Raphael Djanogly, Esq. JP
Mrs. Laura Dwyer
Mrs. Gilbert Edgar
Aidan Ellis, Esq.
Robert S. Ferguson, Esq.

Graham Gauld, Esq.
Victor Gauntlett, Esq.
Lady Gibberd
Peter George Goulandris, Esq.
J. A. Hadjipateras, Esq.
Mrs. S. Halliday
A. Herbage. Esq.
Mrs. Penelope Heseltine
H. J. Holmes, Esq.
Norman J. Hyams, Esq.
Roger Hughes, Esq.
Mrs. Manya Igel
J. P. Jacobs, Esq.
Mrs. Christopher James
Alan Jeavons, Esq.
Irwin Joffe, Esq.
S. D. M. Kahan, Esq.
Peter W. Kininmonth, Esq.
Bruce Lloyd Esq.
Owen Luder, Esq.
Mrs. Graham Lyons
Ciarán MacGonigal, Esq.
Dr. Abraham Marcus
Peter Ian McMean, Esq.
Princess Helena Moutafian, MBE

Raymond A. Parkin, Esq.
Mrs. Olive Pettit
Mrs. M. C. S. Philip
Cyril Ray, Esq.
Mrs. Margaret Reeves
The Rt. Hon. Lord Rootes
The Hon. Sir Steven Runciman
The Master, The Worshipful
Company of Saddlers
Sir Robert Sainsbury
R. J. Simia, Esq.
Christina Smith
Steven H. Smith, Esq.
Thomas Stainton, Esq.
Cyril Stein, Esq.
James Q. Stringer, Esq.
Mrs. A. Susman
Mrs. G. M. Susman
The Hon. Mrs. Quentin Wallop
Sidney S. Wayne, Esq.
Frank S. Wenstrom, Esq.
David Whithead, Esq.
Brian Gordon Wolfson, Esq.
Lawrence Wood, Esq.

There are also anonymous Benefactors and Sponsors